All the Songs

THE STORY BEHIND EVERY BEATLES RELEASE

PREFACE BY **Patti Smith**

JEAN-MICHEL GUESDON & PHILIPPE MARGOTIN

Scott Freiman, CONSULTING EDITOR

BLACK DOG
& LEVENTHAL
PUBLISHERS
NEW YORK

TABLE OF CONTENTS

PREFACE

On the eve of June 1, 1967, my friend Janet Hamill and I were camped in the family laundry room with a transistor radio, feverishly awaiting midnight. At that moment the Beatles new album, Sgt. Pepper's Lonely Hearts Club Band, was to be premiered across America over local FM radio stations. It was a unifying moment for our generation, and joining the collective mind, we listened transfixed. The moods swung madly from cut to cut—Ringo's inclusive "With A Little Help from My Friends," Paul's look into the future with "When I'm 64," George's trance-like "Within You Without You," the calliope of John's "Mr. Kite." By the time "A Day In The Life" unfolded and the final chord stretched out into forever, we were ecstatic. For two aspiring young poets, that midnight journey offered possibilities that spun off in all directions.

I had come late to the Beatles. In the great divide of the new groups from England, I preferred the darker, more visceral Animals and Rolling Stones. But as the Beatles grew musically and conceptually, I was drawn in. By Rubber Soul I felt myself along for their ride, and with Revolver I was sold, acknowledging their influence and their enduring effect on our cultural voice.

I joined the legions seduced by the words of their world—all four worlds, that is. The mystic paths lit by the lantern of George. The human and melancholic joy of Ringo. The cinematic visions of Paul. John's heightened, Joycean wordplay. They were so different from one another, like the four points on a compass, and yet contributed so much as a band. They combined the spiritual and the romantic, the absurd and political, and as they evolved, we evolved with them.

They aspired to literacy, which makes this book all the more revelatory. Even their earliest work, "She Loves You" or "I Want To Hold Your Hand," has the simplicity of a Hank Williams song, poetry reduced to its essential phrase. By the time they reach the emotionally surreal landscape of "Strawberry Fields Forever," which heralded the coming of Sgt. Pepper in that sacred spring, their abstract imagery had become dreamlike, hallucinatory. Somehow it all made sense.

Their songs got into your head, heard from passing cars, storefronts and jukeboxes. We sang along wholeheartedly. We sang lyrics knowing and yet not knowing their multi-leveled meanings. These songs offered a sometimes-undecipherable and poetic language made familiar with melodies and harmonies that fit hand-in-glove. We did not need to break them down. We felt them. They embraced the small in the humble and exquisite "Blackbird" and expanded humankind with the universal phrase "All you need is love." In between lies an arc only few are gifted-to embody the generational shift from adolescence into maturity. To grow and serve within one's words, one's music, one's art.

Patti Smith

FOREWORD

Between June 6, 1962, the date of the first audition of the Beatles at Abbey Road Studios, and May 8, 1970, the date of the release of their last album, John Lennon, Paul McCartney, George Harrison, and Ringo Starr wrote an exceptional page in the history of popular music and changed the musical panorama of the sixties. However, the four young men from Liverpool, the future Fab Four, could not have predicted anything so phenomenal in their early days. No one could imagine that a "group of guitarists" (three guitarists and a drummer) would become a strong influence on their contemporaries and future generations. When they landed on the tarmac at JFK Airport in 1964, Elvis did not even feel threatened.

How could have we guessed that the Beatles would open the doors to the New World to other British music groups such as the Stones, the Kinks, and the Who, and would attain such worldwide popularity?

Those who love and are interested in the Beatles are probably wondering why we would dedicate another book to the group. However, today, fifty years after the release of their first album, we have new and relevant documentation that allows us to understand more fully the creation of their songs.

In the following pages, we focus on words from the Beatles themselves and their immediate entourage to get closer to the truth and, above all, to keep us away from legends and myth. Our approach is based on verifiable content. To this end, we have cross-checked most of the existing sources and provided a footnote.

In this book, we analyze only the singles and the original English albums (omitting anthologies and collections of all kinds) planned and released by the Beatles themselves, in order to respect and have a better understanding of their artistic process. The content in the book is arranged by release date. However, without doing a comprehensive study on the Beatles discography, it seemed necessary to mention American single and album releases and their rankings (different from the British ones due to a track listing often at variance from the original) because the United States played a crucial role in their careers.

Finally, we attach an importance to technique, addressing methods, instruments, and studio practices at the time. Specialist readers will find useful information; a broader public will discover an exciting world that the Beatles themselves helped to develop, notably starting in 1966 when the Beatles decided to stop touring and focus on recording.

For readers of this book, some keys are needed. First of all, when some information is still unverifiable and when the Beatles and their immediate entourage contradict each other, directly or indirectly, we mention the lack of certainty with a question mark (?), especially in the credits. In these same credits, when we speak of one musician's singing, that means he takes all the vocal parts (chorus and harmony).

Hamburg: The Formative Years

It was August 1960. John Lennon, Paul McCartney, George Harrison, Stuart Sutcliffe, and Pete Best, five unknown musicians from Liverpool, who were then between seventeen and twenty years old, landed in the harbor of Hamburg, Germany. They had been hired by Bruno Koschmider, the manager of the Indra, a club located in the hottest neighborhood of the city. For their first concert, on August 17, he simply asked them to "supply a show." During the next two years, the group came back four times and performed nearly three hundred concerts in Germany, including at the Top Ten Club and the legendary Star Club. "We played what pleased us the most and, as long as we played loud, the Germans liked it," John remembered. The Beatles often emphasized the musical training they gained during their years in Hamburg, and John Lennon admitted, "I was perhaps born in Liverpool, but I grew up in Hamburg."

It was in Hamburg that the group played for the first time with Ringo Starr, who was then the drummer for another Liverpool band, Rory Storm & the Hurricanes, and met musician Tony Sheridan, who arranged for their first recording. A British guitar player and singer from Norwich, Sheridan was the featured artist of the Top Ten Club and was regularly accompanied by different bands, including the Beatles. In the spring of 1961, he was approached by Bert Kaempfert, a German composer, arranger, and orchestra leader whose claim to fame was having written "Strangers in the Night" (Frank Sinatra) and "L.O.V.E." (Nat King Cole). Kaempfert was also a record producer for Polydor, a prestigious label of Deutsche Grammophon, and he often hung around the club, searching for new talent. He offered Sheridan a recording contract and selected the Beatles to back him up. He wasn't very impressed by the group, but he liked an instrumental they played, "Cry for a Shadow."

Therefore, on Sunday, June 22 (this date differs according to various documents), the young musicians gathered at what they believed was a real recording studio but was actually a concert hall set up for this date. Under the name of Tony Sheridan & the Beat Brothers, they recorded five or six songs, including a rock version of the traditional "My Bonnie Lies over the Ocean," renamed "My Bonnie," as well as two other songs they performed without Sheridan, "Ain't She Sweet" and "Cry for a Shadow."

When the group returned to Hamburg for the second time on April 1, Stu Sutcliffe made the decision to return to his first love, painting. So Paul replaced him on bass.

When Raymond Met Brian

On October 28, 1961, a young eighteen-year-old entered NEMS, the largest record store in Liverpool and asked the manager if he had "My Bonnie" by the Beatles in stock. Without realizing it, this young man, Raymond Jones, had just changed the life of Brian Epstein! Epstein, the owner of NEMS, inquired about the identity of the group, the origins of the record, and finally discovered that it had been recorded in Germany by a band native to Liverpool. Intrigued, he decided to go hear them play at the Cavern Club, where they performed on a regular basis. On November 9, he went and discovered the ones with whom he later found fame and fortune. After meeting with the band on December 3, Epstein decided to become their manager.

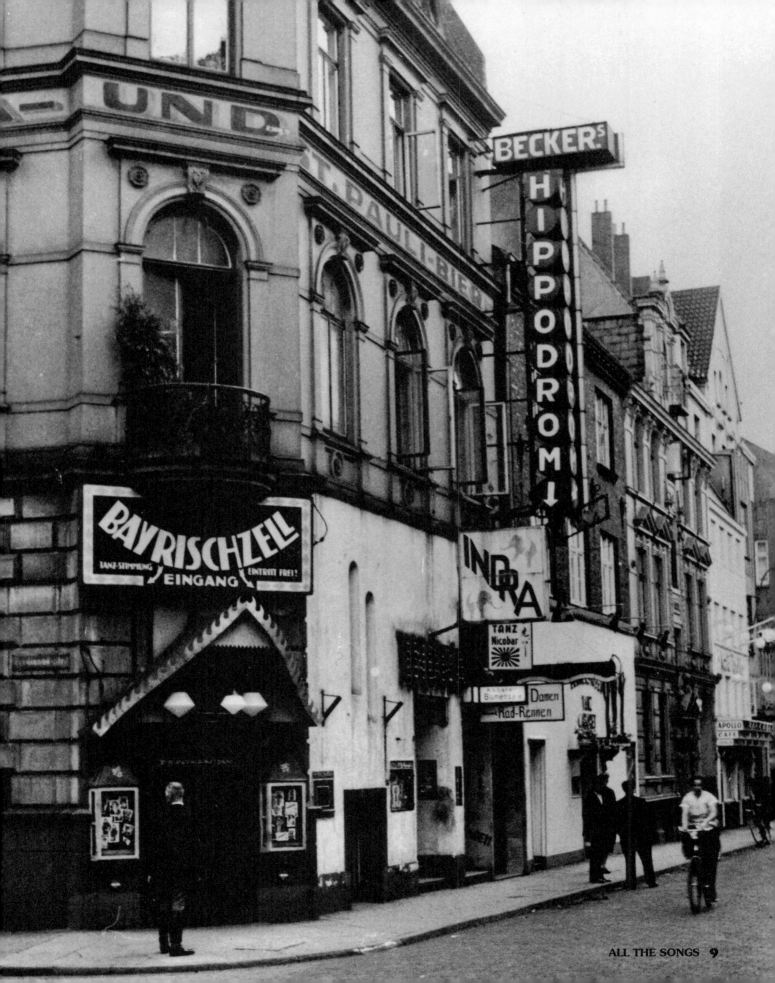

MUSICIANS
Tony Sheridan: vocal, lead guitar
John: rhythm guitar
Paul: bass, backing vocals
George: intro guitar, 2nd lead guitar, backing vocals
Pete Best: drums

RECORDED
Friedrich-Ebert-Halle (Hamburg), June 22, 1961

TECHNICAL TEAM
Producer: Bert Kaempfert
Sound Engineer: Karl Hinze

RELEASED AS A SINGLE

"My Bonnie" / "The Saints"
Germany: August 1961
Great Britain: January 5, 1962

The Very First Recording

Only three songs from this record involved the Beatles. "My Bonnie," with singer Tony Sheridan, began with a soft, very "Elvis" intro before taking off with a rock tempo. The Beatles had no problem providing the backup and proved they were already accomplished musicians.

"Ain't She Sweet," a song composed by Milton Ager and Jack Yellen in 1927, had become a standard of American pop music. The Beatles' version was nervous and rock 'n' roll, with John singing; it was rather distant from the Gene Vincent interpretation that inspired John to cover the song. John explained himself in 1974: "Gene Vincent's recording of 'Ain't She Sweet' is very mellow and high-pitched and I used to do it like that, but the Germans said, 'Harder, harder'—they all wanted it a bit more like a march—so we ended up doing a harder version."

"Cry for a Shadow" (with the initial title "Beatle Bop") was the only Beatles song that was written by Harrison-Lennon. Inspired by the Shadows, this instrumental was rather well done, and George's guitar sounded good. Were they aiming for the radio, which at that time was the domain of the Shadows? No one knows for sure.

The other songs, such as "The Saints" ("When the Saints Go Marching In") or "Why" were not very interesting in the recording history of the Beatles, except that they appeared in numerous album releases of Tony Sheridan & the Beatles. The original single came out in Germany under the name of Tony Sheridan & the Beat Brothers. Why not the Beatles? Apparently to avoid confusion with the word *Piddle*, which means "penis" in the regional dialect of northern Germany. Paul McCartney claimed: "They didn't like our name and said, 'Change to the Beat Brothers; this is more understandable for the German audience.' We went along with it—it was a record." But the name the Beat Brothers was soon forgotten.

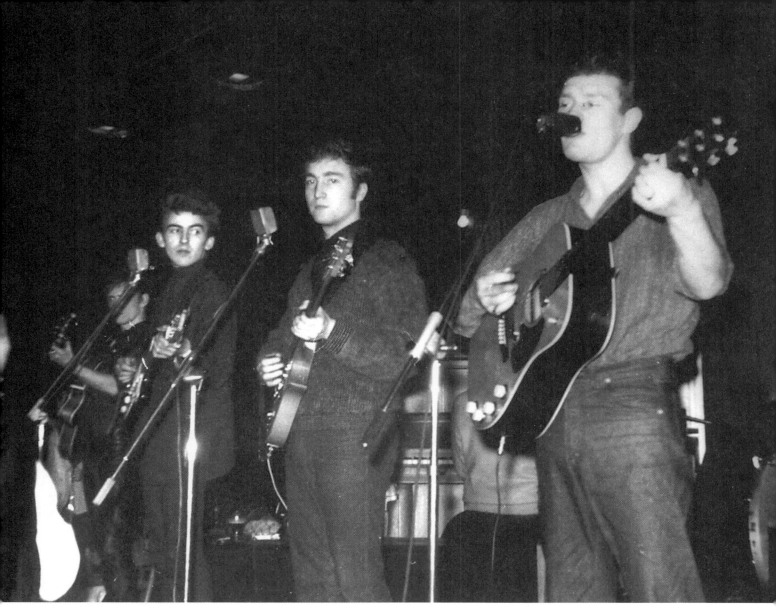

Tony Sheridan, right, who disappeared somewhat from the limelight after the Beatles collaboration, benefited nevertheless from their fame, since one of the Sheridan/Beatles albums became a golden record, selling over a million copies!

Uncertainty
The date of June 22 is still debated to this day. Conflicting documents call its validity into question.

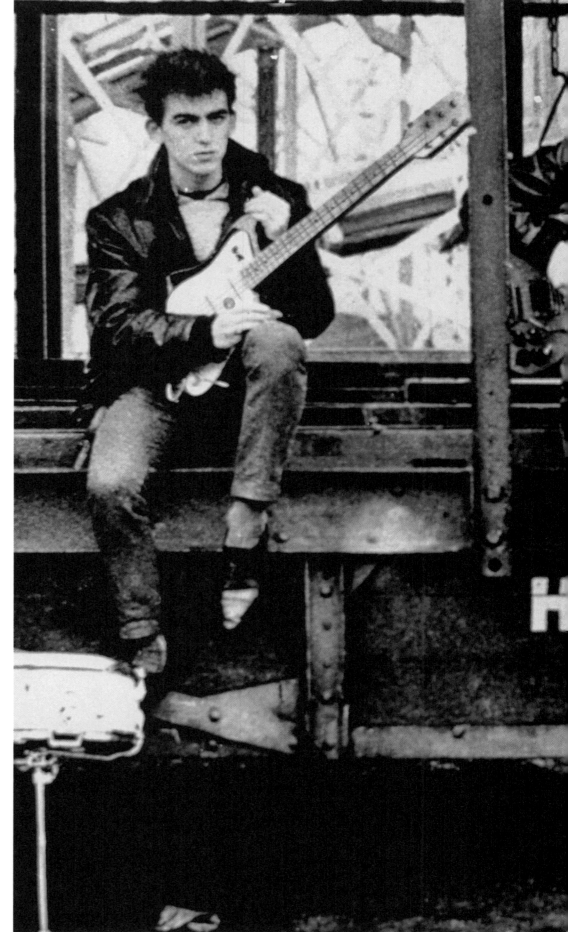

The Beatles visited Hamburg
four times between August
1960 and December 1962.
After appearing around fifty
times at the Indra, the four
young musicians were
moved to the Kaiserkeller,
another club in that city,
where they alternated with a
group that also came from
Liverpool, Rory Storm & the
Hurricanes. Every evening,
they gave concerts lasting six
straight hours, which was
physically very draining, and
during which they played like
madmen (*Mach Schau!*) John
later said about this period,
with some nostalgia, "We
were performers in
Liverpool, Hamburg, and
other dance halls. What we
generated was fantastic,
when we played straight
rock, and there was nobody
to touch us in Britain."

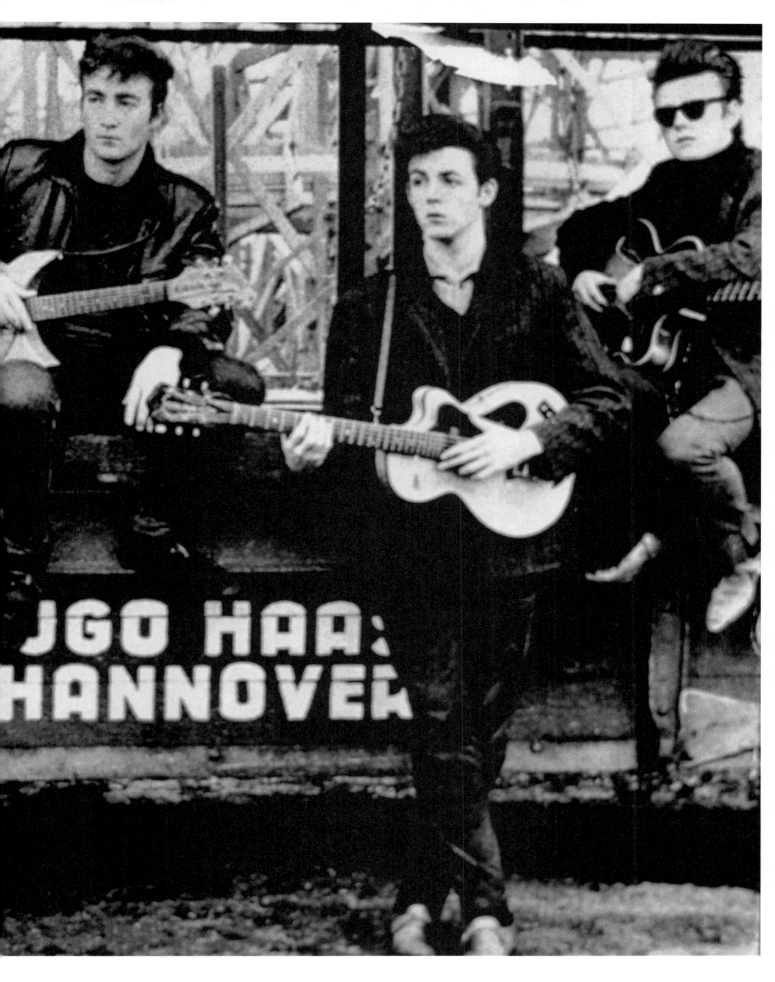

June 6: The Decisive Audition

June 6, 1962: On this exact date, the fate of the Beatles shifted. And so did the history of pop music. Around 6:00 P.M., John Lennon, Paul McCartney, George Harrison, and Pete Best entered EMI Studios in London for the first time—they would return for the following seven years. The studios, located at 3 Abbey Road, in the quiet residential neighborhood of St. John's Wood, were renamed Abbey Road in 1970, which is also the title of the Beatles' last album.

In June 1962, the Beatles were still artists on a quest for a record company. Their manager, Brian Epstein, had been desperately searching for a recording contract since December 1961, but was rejected by all London companies. All companies, except for one: in April 1962, he made one last-ditch phone call and landed an appointment with George Martin, who was in charge of the moderately small Parlophone label (which was under EMI). Interested in the track he heard, the latter agreed to let them try a test in the Abbey Road Studios. An appointment was made for June 6.

On June 6, a session of two hours was set aside for their audition: from 6:00 to 8:00 P.M., in Studio Three, according to George Martin, but in Studio Two, according to the rest of the team. The group's equipment left much to be desired. Norman Smith and Ken Townsend had to weld a jack for Paul's amplifier, which they connected to a Tannoy speaker cabinet they borrowed from an unused echo chamber. Rope had to be tied around John's amplifier to keep it from rattling. Then the session began with Ron Richards, George Martin's assistant, producing. The Beatles, including Pete Best, who had been their drummer since August 1960, had planned to perform four songs: "Besame Mucho" and three originals: "Love Me Do," "P.S. I Love You," and "Ask Me Why." When Norman Smith, the

sound engineer, heard "Love Me Do," his ears perked up. Chris Neal, the assistant engineer, went to fetch George Martin. Once Martin arrived, he ran the session from that point on.

The Beatles appeared nervous in the studio. Pete Best's drumming was inconsistent, especially in the bridge (listen to the version of "Love Me Do" on *Anthology 1*, which features Best's drumming from this session). Just prior to recording, Martin had instructed Paul to sing the phrase *Love Me Do* at the end of each verse so that John could play his harmonica part. You can hear the shakiness in Paul's voice. Finally, at the end of the recording session, Martin spoke to the group to find out their impression of the session. He could see they were not happy, so he insisted, "Is there anything you don't like?" After a pause, George Harrison said, "Yeah, I don't like your tie!"[1] Everyone cracked up!

This broke the ice, including for George Martin. A connection was made.

At the end of the two-hour session, Martin was impressed enough to offer them a one-year contract with four further options of a year each. Although only moderately impressed by their performance, he guessed they had extraordinary charisma and told himself that he had nothing to lose. Furthermore, Norman Smith was also sold on their potential. But there are always winners and losers: Pete Best was fired from the group and replaced by Ringo Starr. This was the first and last time that Best ever recorded at Abbey Road. A date was set for the group's first official recording session: Tuesday, September 4, 1962. The Beatles finally had a recording contract.

1. George Martin and Jeremy Hornsby, *All You Need Is Ears* (New York: St. Martin's Press, 1979).

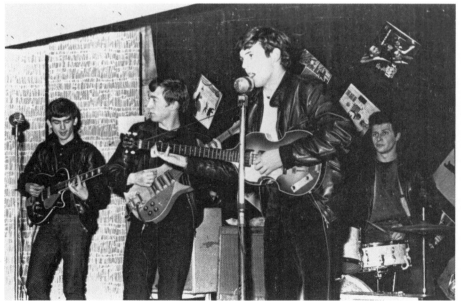

Before signing their recording contract with Parlophone, the Beatles performed in Liverpool clubs. Leather was then in style.

PL
PLEA
PL
PLEA

EASE ME

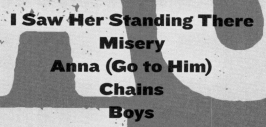

I Saw Her Standing There
Misery
Anna (Go to Him)
Chains
Boys
Ask Me Why
Please Please Me
Love Me Do
P.S. I Love You
Baby It's You
Do You Want to Know a Secret
A Taste of Honey
There's a Place
Twist and Shout

ALBUM

RELEASED

Great Britain: March 22, 1963 / No. 1 for 30 weeks

"Please Please Me"
The Beginning of the Legend

The First Two Singles

Very soon after the Beatles signed their first contract, it became critical for George Martin to produce a record. The Beatles' recording career began with two singles, songs that later appeared on their first album. On Tuesday, September 4, 1962, the four musicians once again entered the Abbey Road Studios for their first real recording session. Pete Best was no longer part of the group, having been replaced in August by Ringo. On the agenda, they were supposed to record "How Do You Do It?" by Mitch Murray, which George Martin believed would become a hit. The Beatles, who were reluctant to play this song, let him know they did not want to perform this kind of "schlock" but rather their own compositions. Martin's answer was, "When you can write material as good as this, then I'll record it, but, right now we're going to record this."[1] They finally did it, but demanded they also rerecord "Love Me Do." At the end of the day, George Martin did not seem satisfied with Ringo's drumming. He decided to book another date to redo the song.

Seven days later, on September 11, the Beatles returned to the studio. Ringo was replaced by Andy White, a professional drummer hired by George Martin "to make sure it was right." At the end of the session, the first single was complete—"Love Me Do" for the A side and "P.S. I Love You" for the B side. "How Do You Do It?" remained unreleased (it reappeared in 1995 on *Anthology 1*). The single came out in Great Britain on October 5, 1962, and by December, "Love Me Do" was in seventeenth place on the charts. On November 26, the Beatles recorded their second single, "Please Please Me," with "Ask Me Why" on side B, which came out in Great Britain on January 11, 1963. The single reached number 2 on the popular *Record Retailer* chart, but number 1 on most other charts.

A Live Album

Given the success of the first two singles, Martin decided to follow with an album as soon as possible. At first, he thought of recording in the Cavern Club in Liverpool, where the Beatles often performed, in order to capture their power onstage. But he realized that the technical conditions of the club were not good, so he tried to think of other ways of re-creating the sound of a live recording. Norman Smith came up with the solution. Smith was the group's first sound engineer, whom John later nicknamed "Normal Smith," and he worked alongside the Beatles from the first audition up to *Rubber Soul* in 1965. To re-create the live atmosphere that characterized the group in the studio, Smith did not try to isolate each of the instruments. Instead, he positioned the microphones away from the group's instruments to capture the general ambience of the performance. This method, which simulated the sound of a live performance, was contrary to the typical recording methods of the day.

On February 11, 1963, between 10:00 A.M. and 10:45 P.M., the Beatles achieved the incredible feat of recording eleven songs in barely more than twelve hours. However, when they entered Studio Two of Abbey Road on that Monday morning, they were not in top shape. Fatigued by the many concerts they had been playing for months, they were all ill, especially John, who had a sore throat. Norman Smith remembered the "big glass jar of Zubes throat sweets on top of the piano, rather like the ones you see in a sweet shop. Paradoxically, by the side of that, was a big carton of Peter Stuyvesant cigarettes, which they smoked incessantly."[2] Around 10:45 P.M., the eleven songs were recorded.

1. Martin and Hornsby, *All You Need Is Ears*.
2. Mark Lewisohn, *The Complete Beatles Recording Sessions* (London: The Hamlyn Publishing Group/EMI, 1988).

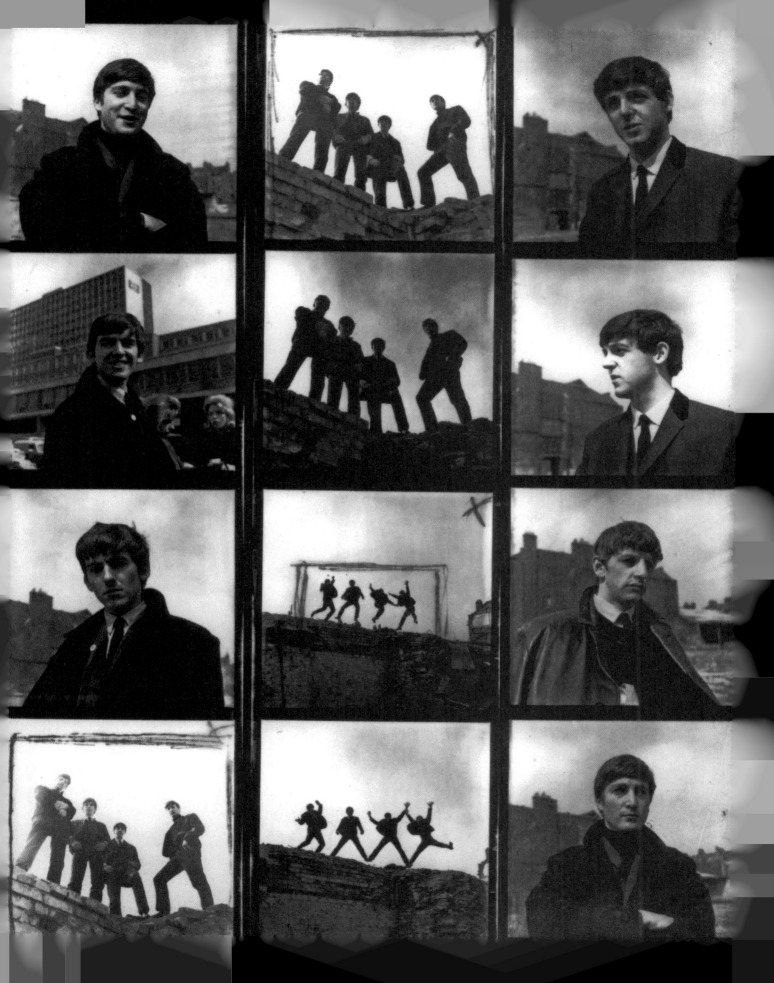

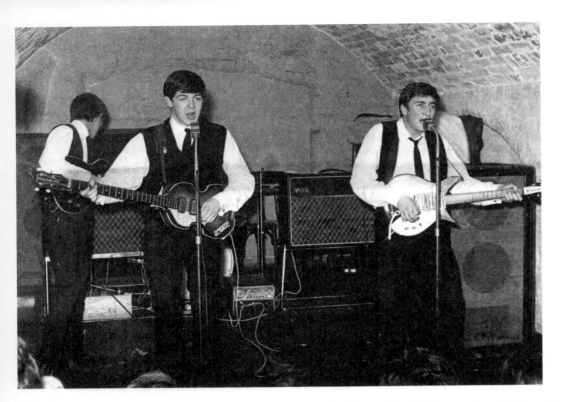

On August 22, 1962: The Fab Four were featured at the Cavern Club in Liverpool, on Mathew Street.

A single song, "Hold Me Tight," would not be finalized and would be found on their second album, *With the Beatles*. Five of the songs are original tunes composed by McCartney-Lennon. Their names were reversed on writing credits after their fourth single, "She Loves You" (with "I'll Get You" on side B), which came out on August 23, 1963. The total cost of the album was around £400 (or roughly $600 US). For the entire day's work on February 11, 1963, the Beatles each earned £14.10 ($21.25 US) as session musicians.

Please Please Me came out in Great Britain on March 22, 1963. As early as May 11, the album reached the top of the British charts. It stayed there for thirty weeks, which held the record for the entire sixties: it was bumped out of first place on December 7 by the group's second album, *With the Beatles*. In the United States, Brian Epstein had only found Vee Jay (a rather second-rate label specializing in blues) to sign the Beatles, since Capital Records (EMI's American affiliate) did not yet believe in their success. The album came out under the title *Introducing . . . The Beatles* on July 22, 1963 (but it was not marketed) and was rereleased first on January 6 and then on January 27, 1964, each time with different track listing than the British version.

The "Beatles Sound"

Norman Smith always disagreed with George Martin's choice to use reverb or an echo chamber when recording the Beatles' vocals or solo instrumentals. Contrary to Martin, Smith preferred a "dry" sound to maintain the genuine quality of the recordings. He also preferred to tone down the voices in order to highlight the rhythm section. They reached a compromise: fewer vocals for the first album and less rhythm section for the second. This was exactly what gave such a particular character to the Beatles sound, which was imitated by other groups. In a 1963 interview, John stated that they were all ready to record it a second time if it did not meet their expectations: "We are perfectionists but ultimately, we were more than happy with the results"—although in 1975, he qualified his opinion, believing that the record did not succeed in transmitting the excitement of their Hamburg and Liverpool performances. He admitted, "That record tried to capture us live, and was the nearest thing to what we might have sounded like in Hamburg and Liverpool. It's the nearest you can get to knowing what we sounded like before we became the 'clever' Beatles."[3]

The album was almost called *Off the Beatles Track*, an idea of George Martin's. For the cover, he recruited Angus McBean, a photographer with whom he worked regularly, who took the photo in which the four Beatles posed in the stairway of the Manchester Square Building, the headquarters of EMI (since then demolished). McBean would re-create the pose for the abandoned "Get Back" project. The two photos would appear on the covers of the *Red* and *Blue* albums, respectively.

3. Kevin Ryan and Brian Kehew, *Recording the Beatles* (Houston: Curvebender Publishing, 2006).

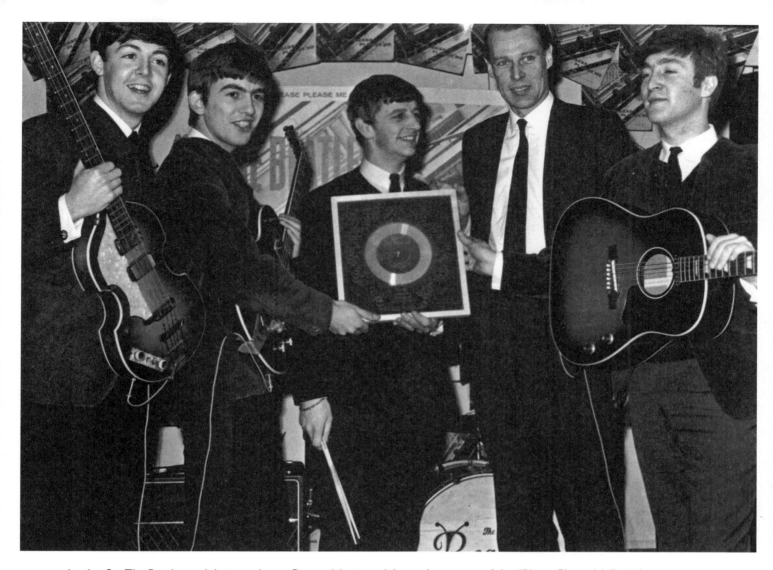

April 1963: The Beatles and their producer, George Martin, celebrate the success of the "Please Please Me" single.

THE SESSIONS

The album was recorded in one single day on February 11, 1963, which was divided into three sessions and breaks:

The Morning Session: 10:00 A.M. to 1:00 P.M.
"There's a Place" / "I Saw Her Standing There"

Break: 1:00 P.M. to 2:30 P.M.

The Afternoon Session: 2:30 P.M. to 6:00 P.M.
"A Taste of Honey" / "Do You Want to Know a Secret" /
"A Taste of Honey" [overdubs] /
"There's a Place" [overdubs] /
"I Saw Her Standing There" [overdubs] / "Misery"

Break: 6:00 P.M. to 7:30 P.M.

The Evening Session: 7:30 P.M. to 10:45 P.M.
"Hold Me Tight" / "Anna (Go to Him)" / "Boys" / "Chains" /
"Baby It's You" / "Twist and Shout"

A Real Find for Collectors
The "Please Please Me" single, edited by Vee Jay, has an interesting typo: on the label, Beatles was spelled Beattles, with two ts.

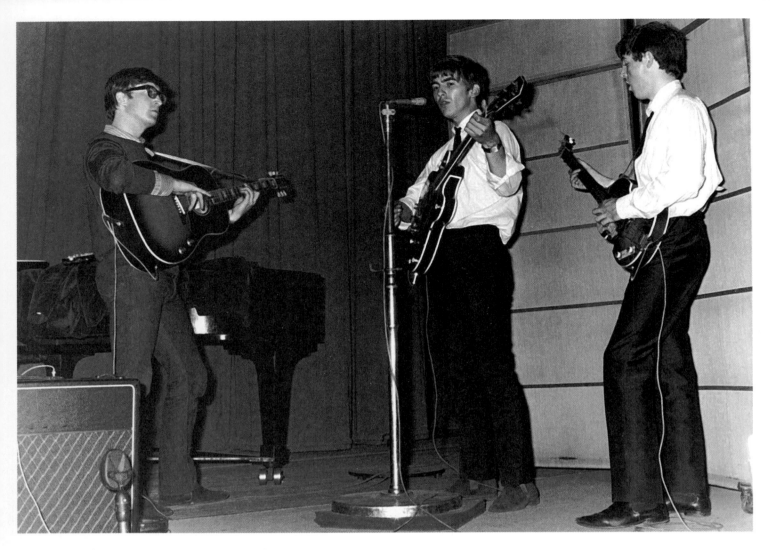

John, George, and Paul rehearsing in 1963.

The Instruments

John used a 1958 Rickenbacker 325 Capri, which remained one of his favorite guitars for the rest of his life. He bought this guitar for about £100 ($150 US) on a whim in Hamburg around the fall of 1960. In 1963, he had it repainted black: you can see it on the *Ed Sullivan Show*, as well as in the Hollywood Bowl concerts. He used it in the studio until 1965, and he used it during the recording sessions of his last solo album, *Double Fantasy* (this information was confirmed by producer Jack Douglas and Yoko Ono). Today it belongs to his second son, Sean.

Another guitar that John used as much as George was the Gibson J-160 E. It was an electric/acoustic guitar that each of them ordered in 1962 from Rushworth in Liverpool, and that they used to record every album from that point on. Ordered from

a catalogue, the guitars were shipped from the United States, but it is difficult to state that they arrived in time for the recording of "Love Me Do" on September 11.

Both George and Paul used the Vox AC-30 as an amplifier. In 1962, Brian Epstein had made a deal with Jennings Music Shop in London to purchase the same amplifiers as the Shadows. He had promised that his group, which he claimed would become bigger than Elvis, would never use another brand than Vox in concerts. Reg Clark, the manager of the store, believed him. Later on, he said of Brian, "He kept his word!"

Paul used a Hofner 500/1 bass, a violin bass that he bought in 1961, at Steinway's in Hamburg, for £30 ($45 US). The advantage for Paul, who was left-handed, was to have a symmetrical instrument

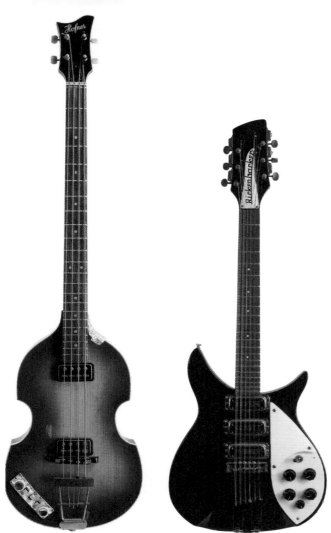

The Beatles' first guitars (from left): the Hofner 500/1 violin bass; the Rickenbacker 325 Capri, and the Gibson J-160 E.

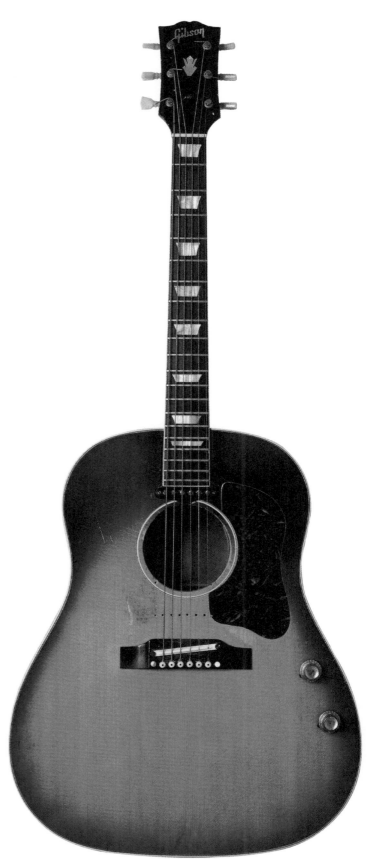

that would not look strange when held upside down. It seems that—there is controversy about this—he even ordered a tailor-made left-handed bass from Steinway. One thing is for sure: not being one of the richest men in Great Britain yet, he had to agree to buy it on credit in ten installments! His amplifier was a Leak TL 12 Plus, connected to the Tannoy Dual Concentric loudspeakers and cabinet. George used a Gretsch Duo Jet from 1957, a guitar he purchased in 1961 through an ad in the *Liverpool Echo* for the sum of £75 ($113 US). This guitar was soon replaced by a Gretsch Country Gentleman, which he used in Hamburg, at the Cavern Club, on tours in Europe and the United States (in 1964), and, from time to time, during the recordings. Ringo, finally, used Premier Mahogany Duroplastic drums that he bought in July 1962, just before joining the Beatles.

I Saw Her Standing There

McCartney-Lennon / 2:52

SONGWRITER
Paul

MUSICIANS
Paul: vocal, bass, hand claps
John: rhythm guitar, backing vocals, hand claps
George: lead guitar, hand claps
Ringo: drums, hand claps

RECORDED
Abbey Road: February 11, 1963 (Studio Two)

NUMBER OF TAKES: 12

MIXING
Abbey Road: February 25, 1963 (Studio One)

TECHNICAL TEAM
Producer: George Martin
Sound Engineer: Norman Smith
Assistant Engineers: Richard Langham, A. B. Lincoln

FOR BEATLES FANATICS

When the Vee Jay technicians received the master tape of *Please Please Me* to produce the American version of *Introducing the Beatles*, they thought Paul's countdown was an error that had gone unnoticed and tried hard to correct it, by more or less deleting it. Since they did not manage to correctly cut out the "4," they resigned themselves to leaving it in. So the song starts with "4!"

Genesis

The candor and expressive energy that exude from "I Saw Her Standing There" made it the right choice to start the album. Paul was entrusted with the honor of singing the very first song of the group for its very first record.

As with practically all the songs of that period, Paul composed it on his first guitar, a Zenith Model 17. It seems he got the inspiration for it when returning from a concert in Southport, one day in July 1962, as he was thinking about seventeen-year-old Iris Caldwell, his girlfriend at that time. Iris was the sister of Rory Storm, the leader of the rival yet friendly group, Rory Storm & the Hurricanes, which featured none other than Ringo Starr.

In 1988, Paul confided in Mark Lewisohn that he wrote the song with John in the living room at 20 Forthlin Road, in Liverpool, in September 1962, five months before it was recorded: "We sagged off school and wrote it on guitars and a little bit on the piano that I had there. I remember I had *Just seventeen never been a beauty queen*, John screamed with laughter, and said 'You're joking about that line, aren't you?' What? Must change that...We came up with: *You know what I mean*."[1] The song was finished that day. The bass line was inspired by "I'm Talking about You" by Chuck Berry (1961). Paul said, "I played exactly the same notes as he did and it fitted our number perfectly. Even now, when I tell people about it, I find few of them believe me. Therefore I maintain that a bass riff doesn't have to be original."[2] John claimed that Paul had done a good job in producing a piece that George Martin characterized as being "nutritious." He played this song with Elton John at Madison Square Garden in New York City on November 28, 1974, where he presented it to the public as a song written by a "old estranged fiancée of mine called Paul!"

Paul on bass and John on acoustic guitar, the "Dream Team" at work.

Production

"I Saw Her Standing There" was the second song to be recorded on Monday, February 11, 1963, after "There's a Place." "Seventeen," which was then its working title, required nine takes. Only the last take included the famous countdown, "1, 2, 3, 4!" called out by Paul. After the lunch break (to the surprise of the production team, the Beatles skipped the break to rehearse), Martin suggested adding hand claps to the first take, which was designated the best. The Beatles then added hand claps to take 1 (a process called overdub). After several attempts, they reached take 12. On February 25, Martin and his team proceeded to edit the song and picked up the countdown of the ninth take to paste it at the beginning of the twelfth take. After this, there was the mix, in the absence of the Beatles, who were on the road doing a concert in Leigh in Lancashire. Two versions—one mono and one stereo—were produced. In those days, the mix meant only putting the track of the playback at the level of the voices. Unlike current techniques, it was a rather simple and quick operation.

Technical Details

In 1963, recordings were only done on two-track BTR3 tape recorders called Twin Track: one track for playback and another for voice or solo instrument. It was the prehistoric times of multitrack recordings. The Beatles recorded on this type of machine from their first audition on June 6, 1962, up to the end of 1963, when EMI started using four-track tape recorders. The overdubs were fairly complicated to produce. Therefore, to record the hand claps of "I Saw Her Standing There," the technique consisted of injecting, through the mix console, the two tracks recorded that morning on the first Twin Track (take 9) into a second Twin Track, that recorded the hand claps in real time.

1. Lewisohn, *The Complete Beatles Recording Sessions*.
2. Barry Miles, *Paul McCartney: Many Years from Now* (London: Secker & Warburg, 1997).

Misery

McCartney-Lennon / 1:47

SONGWRITERS
John and Paul

MUSICIANS
John: vocals, guitar
Paul: backing vocals, bass
George: lead guitar
Ringo: drums
George Martin: piano

RECORDED
Abbey Road: February 11, 1963 (Studio Two) /
February 20, 1963 (Studio One)

NUMBER OF TAKES: 11

MIXING
Abbey Road: February 25, 1963 (Studio One)

TECHNICAL TEAM
Producer: George Martin
Sound Engineers: Norman Smith, Stuart Eltham
Assistant Engineers: Richard Langham, A. B.
Lincoln, Geoff Emerick

A Missed Opportunity≈
"I really hate myself… when I think I could have been the first artist to record a song of the Beatles, but I'm happy for good old Ken [Lynch] that he got the honor." Helen Shapiro, from her 1993 autobiography[1].

Genesis

On January 26, as they were giving a concert at King's Hall in Stroke-on-Trent, John and Paul found themselves backstage, where they wrote a song for Helen Shapiro, who was the star of the national tour in which they participated for the first time. Barely sixteen years old, she already had two number 1 hits on the charts in Great Britain ("You Don't Know" and "Walkin' Back to Happiness"). Therefore, having her perform this song would have been a coup for Lennon and McCartney. But Helen's manager, Norrie Paramor, declined the offer without even notifying the young singer. Why? Probably because the lyrics were too pessimistic, according to Paul. "Misery" was completed a few days later, at Forthlin Road. "It was kind of a John song more than a Paul song, but it was written together,"[2] John said in 1980. Finally, another singer from the tour, Kenny Lynch, ended up singing "Misery." He ended up making a rather saccharine version of it. It was the first remake of a Beatles song, although it was not a success.

Production

Toward the end of the afternoon, the Beatles tackled "Misery." George Harrison had problems playing the little guitar riff that accompanied the line *I'll remember all the little things we've done.* George Martin then decided to replace George with a piano solo, which he did on February 20. Martin had asked Norman Smith to record the song at twice the normal speed (30 ips [inches per second] rather than 15 ips) so that he could overdub his solo at the slower speed of 15 ips. The eleventh take was selected as the best. It was 6:00 P.M.

At this time, the Beatles were very much influenced by the pioneers of rock 'n' roll—Elvis Presley, Little Richard, Chuck Berry, and the like. And to sound

During the rehearsal for the TV show *Ready Steady Go,* on October 4, 1963, John danced with singer Helen Shapiro, who was originally supposed to sing the song "Misery."

like them, they altered the pronunciation of certain words to sound more American. For example, the sentence *Send her back to me* turned into *Shend her back to me.* On February 20, Martin returned to the studio by himself. He was assisted by Stuart Eltham and Geoff Emerick, who was then sixteen years old and became one of the main sound engineers of the group. Martin sat at the piano and recorded the riff to replace George. Five days later, "Misery" was mixed with the rest of the album.

Technical Details

When George Martin asked Norman Smith to record "Misery" at twice its speed, it was for a very specific reason: he wanted to play his piano part slower, at half speed. When the piano overdub was played at the normal (30 ips) speed, it had a crystal sound that resembled a tack piano or a harpsichord. Martin used this method many times, including the solo in "In My Life" in 1965. He added reverb while playing the piano part, which meant that, at normal speed, it acquired a distinctive sound.

1. Helen Shapiro, *Walking Back to Happiness* (New York: HarperCollins Publishers, 1993).
2. David Sheff, *The Playboy Interview with John Lennon & Yoko Ono: The Final Testament* (New York, Playboy Press, 1981) (September 1980 interview).

Anna (Go To Him)

Arthur Alexander / 2:54

MUSICIANS
John: vocal, acoustic guitar
Paul: backing vocals, bass
George: lead guitar, backing vocals
Ringo: drums

RECORDED
Abbey Road: February 11, 1963 (Studio Two)

NUMBER OF TAKES: 3

MIXING
Abbey Road: February 25, 1963 (Studio One)

TECHNICAL TEAM
Producer: George Martin
Sound Engineer: Norman Smith
Assistant Engineers: Richard Langham, A. B. Lincoln

FOR BEATLES FANATICS

Vee Jay Records, a black music label, was planning on producing "Anna (Go to Him)" as a single, on the flip side of "Ask Me Why." It seems then that the Beatles' performance was deemed likely to appeal to the black audience. Therefore, a very limited series of test records was pressed for disc jockeys. But ultimately the idea was dropped. Today, it is believed that there are only four copies left in the world. One of them was sold in July 2012 for $35,000. This was the highest bid for a single ever made by a Beatles collector.

1963

Genesis

"Anna (Go to Him)" was one of John's favorite songs. So he suggested doing a remake of it for their first album. The composer, Arthur Alexander, was an African-American singer and composer whose first success, in 1961, was "You Better Move On." In 1963, Arthur repeated this success with "Anna (Go to Him)." The original version, recorded in the great Fame Studios in Muscle Shoals (Alabama), was a bit faster-paced than the Beatles' version, and the orchestration, supported by violins, sounded like similar R&B records. But the adaptation of the Fab Four bests Alexander's version, thanks to John's voice, which is poignant and dynamic, and the background harmonies of Paul and George.

Production

After a break of only an hour and a half, during which it seems the Beatles kept improving their work, the entire team began the last session of the day. It was 7:30 P.M. and there remained six songs to record. After Paul's "Hold Me Tight," which was left off the album, they began the second remake of the day, "Anna (Go to Him)." Since the piece was part of the usual repertoire of the group, three takes were sufficient. John played his Gibson J-160 E and did the singing. It is noteworthy that the title of the song was "Anna (Go to Him)," whereas John, as well as Alexander, sang, "go with him." Totally performed live, the song did not require any editing. It was mixed along with the other songs on February 25.

Chains

Gerry Goffin–Carole King / 2:23

MUSICIANS
George: vocal, lead guitar
John: backing vocals, rhythm guitar, harmonica
Paul: backing vocals, bass
Ringo: drums

RECORDED
Abbey Road: February 11, 1963 (Studio Two)

NUMBER OF TAKES: 4

MIXING
Abbey Road: February 25, 1963 (Studio One)

TECHNICAL TEAM
Producer: George Martin
Sound Engineer: Norman Smith
Assistant Engineers: Richard Langham, A. B. Lincoln

FOR BEATLES FANATICS

Around 1:27 on this song, you can hear words that sound like "Is that enough?" or "Is that the rhythm?" The voice probably came from the control room, although it could have been John asking a question.

Gerry Goffin and Carole King.

Genesis

The Cookies were a black American female vocal trio formed in 1954 who, four years later, joined Ray Charles and became the Raelettes. Reestablished in 1961, the trio recorded "Chains" the following year, a composition by Gerry Goffin and Carole King, one of the famous songwriting duos that had offices in New York's Brill Building. "Chains" was a song that the Beatles had discovered less than three months before recording it. Performed by the Cookies in November 1962, it reached seventeenth on the American pop charts a month later. The enthusiasm it generated among British teenagers convinced the Beatles to include it on their album. Even though they gave the song an unbeatable dynamism and freshness, the real innovation came from the harmonica solo played by John in the intro. John used a chromatic harmonica in C.

Production

It was the second song performed by George on the album, after "Do You Want to Know a Secret," and it was the first song in which you could hear three-part harmony. It was not until "This Boy," in October 1963, that the Beatles would use three-part harmony again. Although four takes were recorded live during the evening session, George Martin kept the first one, ending the song with a fade-out. The song was mixed on October 25.

1963

Boys

Luther Dixon–Wes Farrell / 2:24

MUSICIANS
Ringo: vocal, drums
John: backing vocals, rhythm guitar, harmonica
Paul: backing vocals, bass
George: lead guitar, backing vocals

RECORDED
Abbey Road: February 11, 1963 (Studio Two)

NUMBER OF TAKES: 1

MIXING
Abbey Road: February 25, 1963 (Studio One)

TECHNICAL TEAM
Producer: George Martin
Sound Engineer: Norman Smith
Assistant Engineers: Richard Langham, A. B. Lincoln

FOR BEATLES FANATICS

Although Ringo had a reputation for being a human metronome, it was not exactly the case during the recording of "Boys." From the beginning (about 150 quarter-notes per minute) to the ending of the song (about 140), there is a rather significant difference in tempo.

Genesis

The Shirelles, a black American female vocal group formed in 1958, landed their first number 1 on the American charts on January 30, 1961. "Will You Love Me Tomorrow" was written by Gerry Goffin and Carole King, who also wrote "Chains." Side B, "Boys," was a song by Luther Dixon and Wes Farrell, both American author-composers, producers, and musicians who created hundreds of songs performed by Elvis Presley, the Jackson Five, David Cassidy, and others. "Boys" soon became one of the favorite songs of the Merseybeat groups. As soon as the Beatles included this piece in their repertoire, Pete Best sang it regularly in concerts. Ringo, who played it several times with Rory Storm & the Hurricanes, adopted it in turn, without the words (which would normally be sung by women) offending anyone. Paul recalled: "It was a Shirelles hit and they were girls singing it but we never thought we should call it 'Girls' just because Ringo was a boy."[1] "Boys" became Ringo's signature tune, and, without fail, it drove his fans wild whenever he sang it.

Production

The original version by the Shirelles was less fast-paced, with an accompaniment on piano and a sax chorus. The Beatles turned it into a highly dynamic song, with an excellent solo by George that was very much influenced by Chet Atkins, one of his heroes. John and Paul both supplied a tight rhythm section, while Ringo sang and played drums with expressive conviction. The *bop-shoo-wop* of the choruses contributed an indispensable kitsch touch to the whole number. You could feel the group working together, happy to feature Ringo, who in turn did not fail to shout out the solo of his guitar-playing colleague, *"All Right, George!"* "Boys" was the

1963

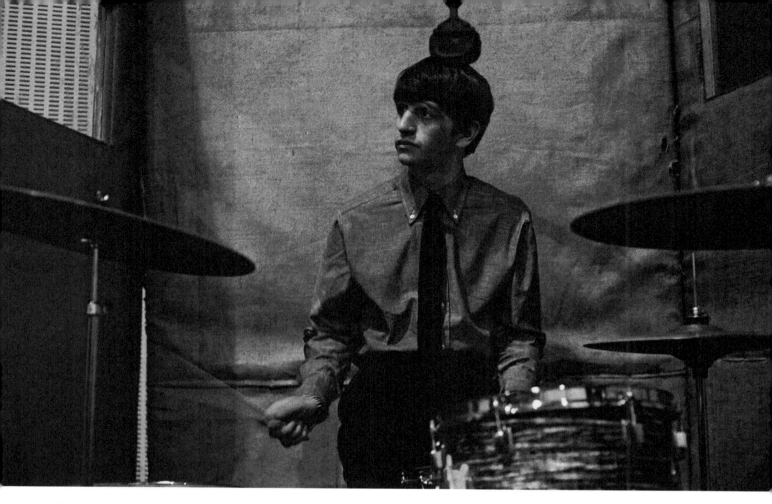

Ringo on drums in the Abbey Road Studios in 1963. There is an STC 4038 microphone above the drums.

third song to be recorded during the last session of the day. The first take was chosen as the best. The mix took place on February 25 and the piece ended with a fade-out. "Boys" was the very first song sung by Ringo on record.

Technical Details

Norman Smith tried to isolate Ringo's voice from the sound of his drums as much as possible. Since the drums and vocals were performed together, it was not possible to mix them separately. For the first and only time, he recorded both the drums and Ringo's vocals to track 2 after first establishing a balance between the two. Track 1 was used for the other instruments.

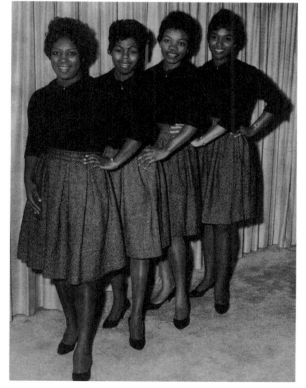

The Shirelles in 1963.

1. *The Beatles Anthology* (Paris: Le Seuil, 2000).

Ask Me Why

McCartney-Lennon / 2:24

SONGWRITER
John

MUSICIANS
John: vocal, rhythm guitar
Paul: backing vocals, bass
George: backing vocals, lead guitar
Ringo: drums

RECORDED
Abbey Road: June 6 (Studios Two or Three) / November 26, 1962 (Studio Two)

NUMBER OF TAKES: 6

MIXING
Abbey Road: November 30, 1962 (Studio Two)

TECHNICAL TEAM
Producer: George Martin
Sound Engineer: Norman Smith
Assistant Engineer: Chris Neal

RELEASED AS A SINGLE

"Please Please Me" / "Ask Me Why"
Great Britain: January 11, 1963 / No. 1 in January
United States: February 25, 1963 (through Vee Jay)

Genesis

"It was John's original idea and we both sat down and wrote it together, just did a job only. It was mostly John's,"[1] Paul admitted to Barry Miles. John, who deeply admired Smokey Robinson & the Miracles, was strongly inspired by the intro of "What's So Good about Goodbye," which came out in December 1961. Smokey remained a major influence on his first years of writing, during which the words were relegated to the background, and, according to John and Paul, the music took priority.

Production

"Ask Me Why" was one of the four songs recorded by the Beatles during the audition on June 6, 1962. Five months later, on Monday, November 26, they met to record their second single, "Please Please Me," which was their first real success. They needed a second song for side B. After a break, they worked on a piece they knew well and which they performed regularly for several months, "Ask Me Why." The recording went smoothly: only two takes were required. The musical quality of the song was not to be underestimated. The vocal harmonies were superb and the two guitars joined with finesse, John on his electroacoustic J-160 E Gibson and George on his Gretsch Duo Jet. The whole song had a slightly jazzy feel, which was unusual in their repertoire. The mix was carried out on November 30 without the participation of the Beatles, but in those days that was typical.

Technical Details

During the June 6 and November 26 recording sessions, "Please Please Me" and "Ask Me Why" were simultaneously recorded in mono and stereo by means of a system called Delta-Mono. This technique was soon dropped and replaced by solely mono recording with Twin Track tape recorders.

1. Miles, *Paul McCartney.*

Smokey Robinson & the Miracles onstage at the Fox Theater in Brooklyn in 1963.

Please Please Me

McCartney-Lennon / 2:00

SONGWRITER
John

MUSICIANS
John: vocal, rhythm guitar, harmonica
Paul: backing vocals, bass
George: backing vocals, lead guitar
Ringo: drums

RECORDED
Abbey Road: September 11 (Studio Two) / November 26, 1962 (Studio Two)

NUMBER OF TAKES: 18

MIXING
Abbey Road: November 30, 1962 (Studio Two) / February 25, 1963 (Studio One)

TECHNICAL TEAM
Producer: George Martin
Sound Engineer: Norman Smith
Assistant Engineers: unknown for the recording sessions on September 11, September 26, and November 30, 1962; for the February 25, 1963, recording session: A. B. Lincoln

RELEASED AS A SINGLE

"Please Please Me" / "Ask Me Why"
Great Britain: January 11, 1963 / No. 1 in January
United States: February 25, 1963 (through Vee Jay)

Genesis

In 1980, John assumed full responsibility for creating "Please Please Me." He was trying to write a song in the style of Roy Orbison's "Only the Lonely," which was number 1 on the charts in Great Britain in October 1960. The title "Please" of Bing Crosby's 1932 song, which his mother Julia used to sing him, was another source of inspiration. The sentence *Please lend your ears to my pleas* captured his attention: "I was always intrigued by the double use of the word of 'Please.' So it was a combination of Bing Crosby and Roy Orbison."[1]

John remembered writing "Please Please Me" in his room at Menlove Avenue, at his aunt Mimi's house in Liverpool. Another influence was the 1960 Everly Brothers tune, "Cathy's Clown," which was the origin of Paul's voice in the couplets, while John sang the melody. Paul claimed, "I did the trick of remaining on the top note while the melody cascaded down from it. A cadence."[2]

Production

The song that gave its name to the album was recorded a few months earlier, on Monday, November 26, 1962, for the second single. On Tuesday, September 11, the group was in the studio to rerecord "Love Me Do." Since two hours were sufficient to produce it, there remained one hour of studio time at their disposal. Ron Richards, who was managing the session during the temporary absence of George Martin, asked them if they had a new song to propose. According to Geoff Emerick, the four musicians immediately suggested "Please Please Me." George Martin listened to the song but found it rather monotonous. "It was like a Roy Orbison number, very slow, bluesy vocals. It was obvious to me that it badly needed pepping up."[3] He recommended then that they

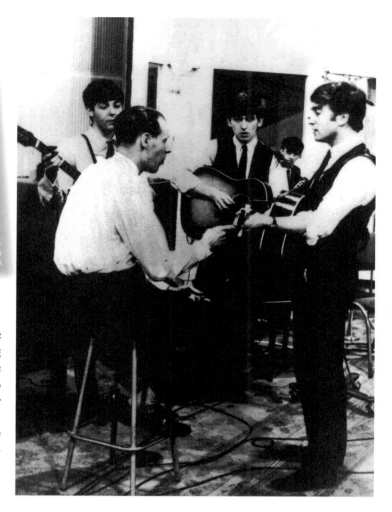

Paul, George, and John listen closely to the comments of George Martin in the Abbey Road Studios.

play it faster and harmonize John's voice with the choruses. Then he asked them to try it again during a further session. He admitted to Ron Richards: "We haven't quite got 'Please Please Me' right, but it's too good a song to just throw away. We'll leave it for another time.[4]

On Monday, November 26, the song was largely redone, and they rehearsed for an hour during the session before recording it. George Martin was impressed. At 7:00 p.m., they were ready. It took eighteen takes. John's harmonica was recorded by means of overdub. The final results thrilled Martin, "It went beautifully. The whole session was a joy. At the end of it, I pressed the intercom button in the control room and said, 'Gentlemen, you've just made your first number-one record.'"[5] John was also enthusiastic: "We changed the tempo a little, we altered the words slightly and we went over the idea of featuring the harmonica, just as we'd done on 'Love Me Do.' By the time the session came around we were so happy with the result, we couldn't get it recorded fast enough."[6]

On November 30, without the presence of the Beatles, Martin and Smith produced one mono and one stereo mix. "Please Please Me" / "Ask Me Why," their second single in Great Britain and their first in the United States, came out on January 11 and February 25, 1963, respectively. In the land of Her Majesty, it was number 2 in the *Record Retailer*, but number 1 on all other charts. After its British release, Dick James, their new publisher, moved heaven and earth to promote his new artists. On January 19, he landed their first significant television show, *Thank Your Lucky Stars*, which was very popular with British teenagers. They only performed one song—"Please Please Me": for most of the public, it was the revelation. Beatlemania was born.

Technical Details

On February 25, when George Martin joined Norman Smith to do the mix of the whole album, they produced a mono and a stereo version of each of the songs. However, for "Please Please Me," they only had one mono mix available, dated November 30. Since they could not find the original tapes, they had to create different takes on November 26. They chose the sixteenth, seventeenth, and eighteenth takes to complete the new stereo mix. The difference from the mono version was found at the end of the song, where John could be heard discreetly chortling at 1:33 on the first *Come on*, because of an error in the text committed in the preceding sentence.

1. Sheff, *The Playboy Interview with John Lennon & Yoko Ono.*
2. Miles, *Paul McCartney.*
3. Ibid.
4. Sheff, *The Playboy Interview with John Lennon & Yoko Ono.*
5. Miles, *Paul McCartney.*
6. *The Beatles Anthology* (Paris: Le Seuil, 2000).

The Beatles were the stars of the famous TV show *Thank Your Lucky Stars* in December 1963.

Love Me Do

McCartney-Lennon / 2:19

SONGWRITERS
John and Paul

MUSICIANS
Paul: vocal, bass, hand claps
John: backing vocals, harmonica, hand claps
George: rhythm guitar, hand claps
Ringo: drums (version 1), tambourine (version 2), hand claps
Andy White: drums (version 2)

RECORDED
Abbey Road: September 4–11, 1962 (Studio Two)

NUMBER OF TAKES: 18

MIXING
Abbey Road: September 11, 1962 (Studio Two) / February 25, 1963 (Studio One)

TECHNICAL TEAM
Producer: George Martin
Sound Engineer: Norman Smith
Assistant Engineers: unknown for the recording sessions on September 4 and 11, 1962
February 25, 1963: A. B. Lincoln

RELEASED AS A SINGLE

"Love Me Do" / "P.S. I Love You"
Great Britain: October 5, 1962 / No. 17 on December 27, 1962
United States: April 27, 1964 / No. 1 on May 30, 1964

Genesis

In a 1972 (*Hit Parader*) interview John said, "'Love Me Do,' one of the first ones we wrote, Paul started when he must have been about fifteen. It was the first one we dared do of our own." Oddly, John mostly credited Paul for writing the song, whereas the latter remembered a shared creation: "'Love Me Do' was completely cowritten. It might have been my original idea but some of them really were 50-50s, and I think that one was."[1] Pete Best related having heard it under the title "Love, Love Me Do" one April 1962 afternoon when they were rehearsing in their Hamburg apartment, during their third stay in Germany. They tried to make it sound like blues, but, as Paul admitted himself, "It sounded white, because we were young white musicians from Liverpool." "We did 'Love Me Do' and 'I Saw Her Standing There,' and got the basis of a partnership going. . . . The harmonica is a great hit. John was a good harmonica player."[2] Although George Martin did not like the words much, Paul claimed them as his creation.

Production

"Love Me Do" was one of the four songs recorded by the Beatles for the test on June 6, 1962. During the first session on September 4, Martin wanted to add some harmonica and asked: "Can anyone play harmonica? It would be rather nice. Couldn't think of some sort of bluesy thing, could you, John?"[4] John, who usually sang lead, could no longer do it while playing harmonica. Martin then asked Paul to replace him as the

1. Miles, *Paul McCartney.*
2. *The Beatles Anthology.*
3. Miles, *Paul McCartney.*
4. Geoff Emerick, *Here, There and Everywhere: My Life Recording the Music of the Beatles* (New York, Gotham Books, 2007).
5. Miles, *Paul McCartney.*

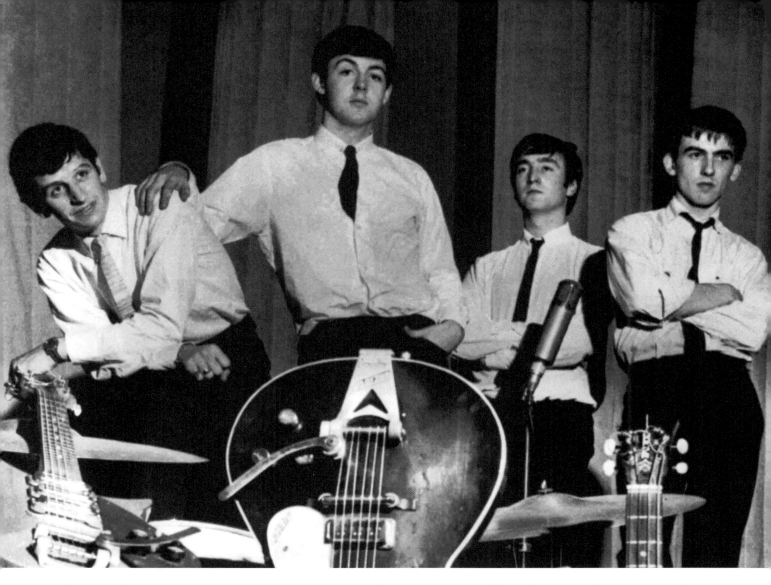

Ringo, Paul, John, and George posing in front of the camera during the recording of "Love Me Do," on September 4, 1962.

FOR BEATLES FANATICS

The copyrights of "P.S. I Love You," as for "Love Me Do," today belong to Paul through his publishing company, MPL Communications Ltd. Originally, Ardmore & Beechwood held the rights of the first single, "Love Me Do" / "P.S. I Love You." "Paul was able to get these rights back, years later, as part of a subsequent deal with EMI"[3] It is hard to believe that Paul is only the owner of two songs written with John out of the entire Beatles catalogue. As for John, he did not own any of them. The two songs have entered the public domain in Europe, thanks to a fifty-year limit on copyrights.

Brian Epstein, the owner of the largest record store in Liverpool, became the manager of the Beatles in December 1961.

Chromatic or Diatonic?

According to Pete Best, John probably stole his harmonica from a Dutch store while the Beatles were on their way to Hamburg for their first stay. He'd played harmonica since his childhood, but he had a bit of a complex about using a chromatic harmonica. Real blues players only played diatonic harmonicas. John recalled in 1974, "I remember Brian Jones asked me:

'Are you playing a harmonica or a harp on "Love Me Do"'? Because he knew I'd got this bottom note. I said, 'A harmonica with a button,' which wasn't really funky-blues enough; but you couldn't get 'Hey! Baby' licks on a blues harp and we were also doing 'Hey! Baby' by Bruce Channel."[9]

lead singer. "I didn't even know how to sing it."[5] Paul remembered in 1997. "I'd never done it before.... I can still hear the nervousness in my voice!"[6] As this version of "Love Me Do" was not satisfactory, the Beatles returned to the studio on September 11.

In this second version, which was kept for the record, Paul was on bass and lead vocal, and John was in charge of vocal harmonies and harmonica. It seems that he did not play guitar in this piece. Only George Harrison performed on his acoustic guitar, apparently the Gibson J-160 E. Finally, Andy White, a session drummer hired by Martin to make sure it was a hit, was on drums to replace poor Ringo, who was relegated to tambourine. He was the only musician who ever replaced one of the Beatles in the studio! The eighteenth take was deemed the best. The mono mix was carried out afterwards; then on February 25, 1963, a stereo mix was produced. It is funny that the first version of the single "Love Me Do" (with "P.S. I Love You" on side B) came out on October 5, 1962, based on the September 4 version (version 1), the one in which Ringo plays the drums. The error was quickly corrected and the album's version featured Andy White (version 2). To distinguish the versions, you have to listen for the tambourine! The version on September 4 did not have any. "Love Me Do" quickly rose to seventeenth place in the British charts.

The Legend

Legend has it that Brian Epstein, the owner of NEMS, the largest record store in Liverpool, bought 10,000 singles to make "Love Me Do" climb in the British ratings. But this story, which was never confirmed, was challenged by many people. In 1963, John exclaimed, "The best thing was it came into the chart in two days and everybody thought it was a fiddle, because our manager's stores sent in these returns and everybody down South thought, 'Ah-ha, he's buying them himself or he's just fiddling the charts.' But he wasn't."[7] In his 1964 autobiography, Epstein stated, "Possible though this would have been—had I the money, which I hadn't—I did no such thing. [The Beatles] progressed and succeeded on natural impetus, without benefit of stunt or back-door tricks."[8] "Love Me Do" ultimately did not go higher than seventeenth place in Great Britain. In the United States, Vee Jay Records released "Love Me Do" / "P.S. I Love You" on April 27, 1964. A month later, on May 30, the record was number 1 in the charts.

6. Ibid.
7. *The Beatles Anthology.*
8. Brian Epstein, *A Cellarfull of Noise* (London: Souvenir Press, 1964).
9. Translation by the author from *The Beatles Anthology* (San Francisco: Chronicle Books, 2000).

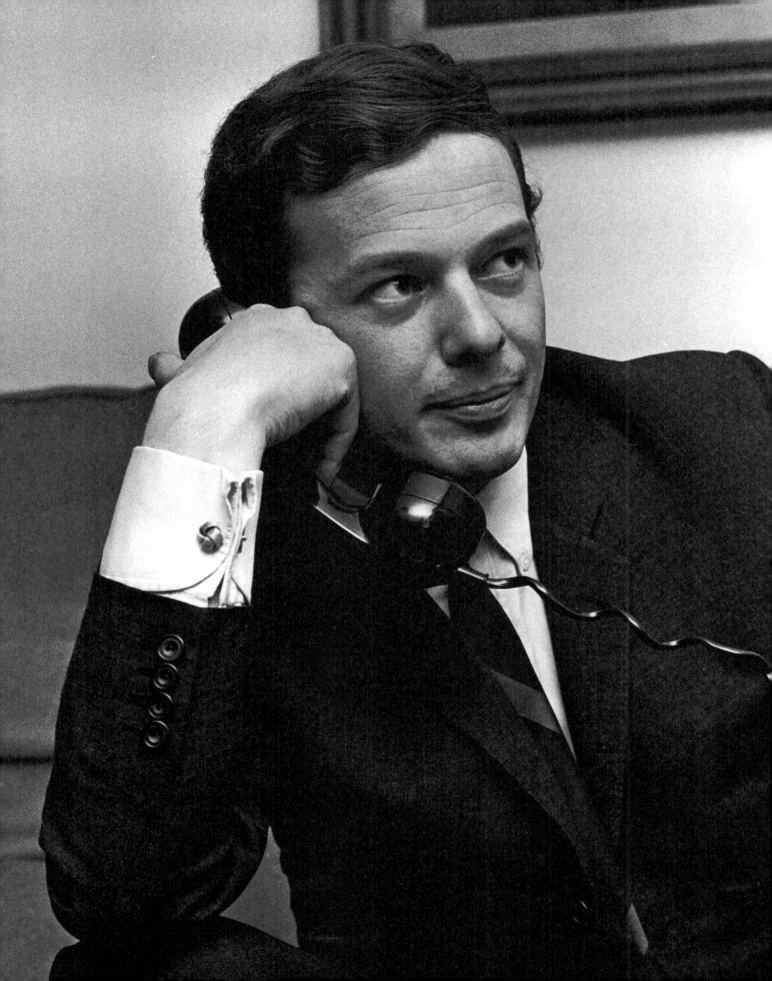

P.S. I Love You

McCartney-Lennon / 2:02

SONGWRITER
Paul

MUSICIANS
Paul: vocal, bass
John: backing vocals, rhythm guitar
George: backing vocals, rhythm guitar
Ringo: maracas
Andy White: bongos

RECORDED
Abbey Road: September 11, 1962 (Studio Two)

NUMBER OF TAKES: 10

MIXING
Abbey Road: September 11, 1962 (Studio Two) /
February 25, 1963 (Studio One)

TECHNICAL TEAM
Producer: George Martin
Sound Engineer: Norman Smith
Assistant Engineers: unknown for the recording sessions on September 11, 1962
February 25, 1963: A. B. Lincoln

Genesis

"It's just an idea for a song really, a theme song based on a letter . . . It was pretty much mine. I don't think John had much of a hand in it. . . . It's not based in reality, nor did I write it to my girlfriend [Dot Rhone] from Hamburg, which some people think."[1] These few words from Paul put an end to a persistent rumor that claimed that "P.S. I Love You" had been dedicated to his girlfriend from those days, Dorothy—"Dot"—Rhone. This song, which was written shortly before the June 6, 1962, audition, did not come from John. As he said to David Sheff in 1980: "That's Paul's song. He was trying to write a 'Soldier Boy' like the Shirelles. He wrote that in Germany or when we were going to and from Hamburg."[2]

Production

"P.S. I Love You," which was finally selected for side B of the first single, was recorded on September 11. After a few attempts, the decision was made to use bongos rather than drums, since they were better suited to the Latin flair of this piece. Andy White played the bongo part. Geoff Emerick remembered that Ringo was crashed out in a corner of the control room. Ron Richards, who was in charge of this session, suggested that he play the maracas. The recording went quickly. The tenth take was the best one. The Beatles immediately went to the control room and were thrilled while listening to the results. They even wanted to use it on side A. Ron Richards immediately dissuaded them from that: first, the piece was not powerful enough to be a side A; secondly, "P.S. I Love You" was also the title of a 1934 song, written by Gordon Jenkins and Johnny Mercer, that had been performed by many singers, including Frank Sinatra and Billie Holiday. The song was mixed in mono on that day and in stereo on February 25, 1963.

1. *Miles, Paul McCartney.*
2. Sheff, *The Playboy Interview with John Lennon & Yoko Ono.*

In 1963, the Beatles began appearing in live BBC shows. During the following two years, they played around five songs per program.

Baby It's You

Mack David–Barney Williams–Burt Bacharach / 2:35

MUSICIANS
John: vocal, guitar
Paul: backing vocals, bass
George: backing vocals, guitar
Ringo: drums
George Martin: celesta

RECORDED
Abbey Road: February 11, 1963 (Studio Two) / February 20, 1963 (Studio One)

NUMBER OF TAKES: 3

MIXING
Abbey Road: February 25, 1963 (Studio One)

TECHNICAL TEAM
Producer: George Martin
Sound Engineers: Norman Smith, Stuart Eltham
Assistant Engineers: Richard Langham, Geoff Emerick, A. B. Lincoln

Genesis

This was the second song by the Shirelles to appear on *Please Please Me*. Lennon, who was a real fan of that group, was primarily responsible for its inclusion. "Baby It's You" was originally called "I'll Cherish You." This song had been written by Burt Bacharach, one of the most talented American composers of American pop, who also wrote "I Say a Little Prayer," "Raindrops Keep Fallin' on My Head," and "I'll Never Fall in Love Again." The joint creation of the text was done by American Mack David—a famous lyricist who wrote over a thousand songs, including the adaptation of *La Vie en rose* by Édith Piaf—and Barney Williams (the pseudonym for Luther Dixon, the producer of the Shirelles), who was also the author of "Boys," which was picked up by the Beatles. The Shirelles single came out in 1961 and reached number 8 on the American charts on January 1, 1962.

Production

"Baby It's You," recorded on February 11 during the evening session, was the second-to-last song of the day.

Burt Bacharach, left, beside Hal David, the elder brother of Mack David. Both Hal and Mack David were lyricists.

1963

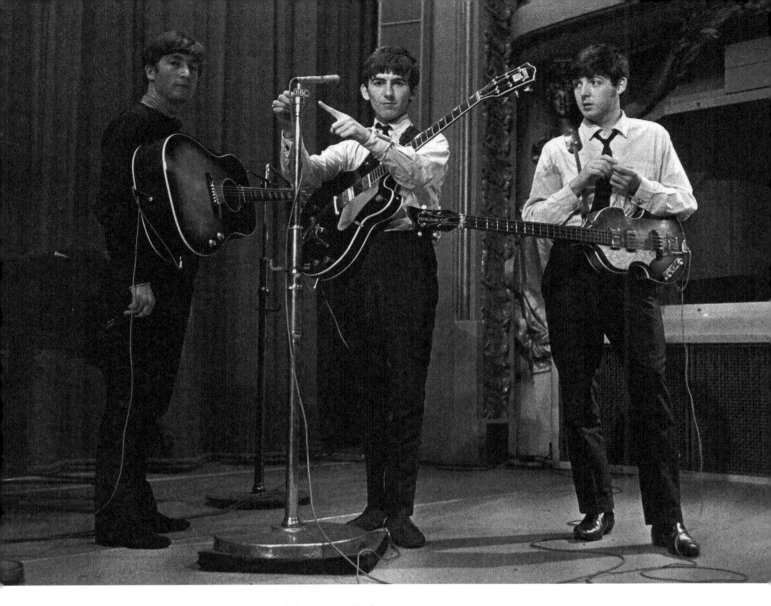

The musicians were starting to get tired. It was no doubt one of the rare covers by the Beatles that could hardly match the original version. Although John had a seasoned voice, loaded with emotion, the whole song was sung slightly out of breath. The intro's harmonies were not quite right, even though this lent a certain charm to the whole song. The Shirelles' performance remained better, with richer harmonies, and the arrangements of the Fab Four hardly matched those of Bacharach. Only three takes were enough to complete the piece around 10:00 P.M. On February 20, George Martin decided to dub in a part on celesta, as well as a part on piano (that would not be retained). The mono and stereo mixes were done on February 25. According to the session report,[1] the stereo mix was completed before the mono mix, which was not usual or even logical. Was this an error or a decision?

FOR BEATLES FANATICS

The celesta used by George Martin was most likely the Schiedmayer Celeste, which is still used at Abbey Road. It also appeared in 1968 in the song "Good Night" on the *White Album*.

1. Lewisohn, *The Complete Beatles Recording Sessions.*

Do You Want To Know A Secret

McCartney-Lennon / 1:56

SONGWRITER
John

MUSICIANS
George: vocal, lead guitar
John: backing vocals, rhythm guitar
Paul: backing vocals, bass
Ringo: drums

RECORDED
Abbey Road: February 11, 1963 (Studio Two)

NUMBER OF TAKES: 8

MIXING
Abbey Road: February 25, 1963 (Studio One)

TECHNICAL TEAM
Producer: George Martin
Sound Engineer: Norman Smith
Assistant Engineers: Richard Langham, A. B. Lincoln

Genesis

In 1980, Paul admitted that, right from the start, he and John shared the songwriting without seriously considering letting George or Ringo participate, "But since both of them had many fans, we wrote songs for them."[1] *Do You Want to Know a Secret*, written by Lennon and McCartney, was the first song that George sang, even though, originally, it was not written for him. John wrote it in the apartment lent to him by Brian Epstein, at 36 Faulkner Street in London, where he lived with his first wife, Cynthia. The concept came from a song called "I'm Wishing," taken from the Disney movie *Snow White and the Seven Dwarfs*, that his mother, Julia, used to sing to him when he was a little boy: "'*Want to know a secret? Promise not to tell? We are standing by a wishing well*.' I wrote it and just gave it to George to sing. I thought it would be a good vehicle for him because it only had three notes and he wasn't the best singer in the world. He has improved a lot since then, but in those days his singing ability was very poor."[2] George replied: "I didn't like my vocal on it. I didn't know how to sing; nobody told me how to."[3] To tell the truth, George did quite well for himself for a first time. Musically, "Do You Want to Know a Secret" was no doubt very much influenced by the 1961 tune of the American group, the Stereos, "I Really Love You." George paid hommage to them in 1982 on his album *Gone Troppo*.

1963

George and John rehearsing in their hotel room (1963).

1. Sheff, *The Playboy Interview with John Lennon & Yoko Ono.*
2. Ibid.
3. *The Beatles Anthology.*

Production

The second song to be recorded on Monday, February 11, during the afternoon session, "Do You Want to Know a Secret" required six takes. In fact, the best take was the sixth, since the seventh and eighth were overdub recordings to insert choruses, hand claps (in the seventh), and rim-shots (in the eighth). The mono and stereo mixes were done on February 25, with a fade-out at the end. Vee Jay released the single "Do You Want to Know a Secret" / "Thank You Girl" in the United States on March 23, 1964. It climbed to second place on the charts by April 11.

FOR BEATLES FANATICS

The lack of time spent on producing the song explains why some mistakes were not corrected. George sang in the bridge, *"I've known a secret for the week or two"* instead of "a week or two." As for Paul, he made a few rather unusual minor mistakes on bass around 1:10 and 1:50 in the coda.

A Taste Of Honey

Bobby Scott–Rick Marlow / 2:01

MUSICIANS
Paul: vocal, bass
John: backing vocals, guitar
George: backing vocals, guitar
Ringo: drums

RECORDED
Abbey Road: February 11, 1963 (Studio Two)

NUMBER OF TAKES: 7

MIXING
Abbey Road: February 25, 1963 (Studio One)

TECHNICAL TEAM
Producer: George Martin
Sound Engineer: Norman Smith
Assistant Engineers: Richard Langham, A. B. Lincoln

Genesis

Bobby Scott, an American musician, producer, and author-composer, created "A Taste of Honey." The song was originally an instrumental, composed in 1960 for the Broadway adaptation of the play by the same name by British playwright Shelagh Delaney. In 1962, American songwriter and actor Rick Marlow added lyrics to it and the American variety singer Lenny Welch produced the first sung version of the song. This was the version that caught McCartney's attention. Although John did not like it (he renamed it "A Waste of Money") they performed it onstage many times. Their version resembled the one released by Welch, which was perhaps even more jazzy. This is what John called "Paul's granny music" when he wanted to assert that the tastes of his colleague were sometimes old-fashioned ("Honey Pie," "Maxwell's Silver Hammer," etc.). Paul gladly admitted that "A Taste of Honey" belonged to "things which were slightly to the left and the right of rock 'n' rock."[1] Its presence on the album was no doubt also partly due to the insistence of George Martin and Brian Epstein, who hoped this song would make it possible to reach a more mature audience.

Production

The Beatles began their second recording session of the day around 2:30 P.M. with "A Taste of Honey." The fifth take was the best. John and George supplied guitar and choruses, Paul was on bass (in walking bass at the bridge) and Ringo was using brushes. However, Martin deemed it necessary to double Paul's voice at the bridge, in order to reinforce it. For the first time that day, he used the overdub technique (see "I Saw Her Standing There"). They kept the seventh take. It was the only time on the whole record that a voice was entirely doubled. On February 25, the mono and stereo mixes were done.

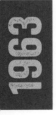

Technical Details

When Paul doubled his own voice at the bridge of "A Taste of Honey," he discovered a method that the Beatles would use over and over again throughout their career. The double-tracking technique consisted of re-creating on a second track the same vocal delivery (or instrumental delivery, such as a guitar solo) while trying to be as precise as possible in sticking to the first voice. This results in a stronger and warmer performance. Double-tracking was one of the Beatles' favorite effects, and they used it throughout their career.

1. *The Beatles Anthology.*

There's A Place

McCartney-Lennon / 1:49

SONGWRITERS
John and Paul

MUSICIANS
John: vocal, guitar, harmonica
Paul: backing vocals, vocal, bass
George: backing vocals, guitar
Ringo: drums

RECORDED
Abbey Road: February 11, 1963 (Studio Two)

NUMBER OF TAKES: 13

MIXING
Abbey Road: February 25, 1963 (Studio One)

TECHNICAL TEAM
Producer: George Martin
Sound Engineer: Norman Smith
Assistant Engineers: Richard Langham, A. B. Lincoln

Genesis

In Abbey Road, Studio Two, at 10:00 A.M., the Beatles recorded "There's a Place," the very first song they worked on that day. John claimed in 1980 that he was the author of it. "'There's a Place' was my attempt at a sort of Motown, black thing."[1] But Paul remembered that it was a collaboration. According to his version, it was written at his place at Forthlin Road. The concept occurred to him while listening to the original tape of the film *West Side Story*, written by Leonard Bernstein, in which the song "Somewhere" begins with the line: *There's a place for us*. But the song seemed to correspond to John's dream world: introspection, mental traveling, so many themes that begat masterpieces such as "Strawberry Fields Forever" and "I'm Only Sleeping." It is likely that the Beatles invested a lot of hope in this song to record it at the top of the list. It was written shortly before the recording session, and the Beatles thought that it was a hit. However, it was never included among the major works of the Fab Four, even though it had the unique charm of the "Beatles sound."

Production

"There's a Place" was recorded live, just like the rest of the album. The first take was rather surprising, because Paul played each of the eighth notes on bass, giving the whole song a rock 'n' roll flavor. John had not yet played his part on harmonica. George had trouble playing the different phrases on guitar. The group was not yet warmed up. Not until the tenth take did they reach the best version. During the second session in the afternoon John overdubbed his harmonica part (no doubt a chromatic in C). The thirteenth take was the final one. It was mixed on February 25, together with the other songs.

1. Sheff, *The Playboy Interview with John Lennon & Yoko Ono.*

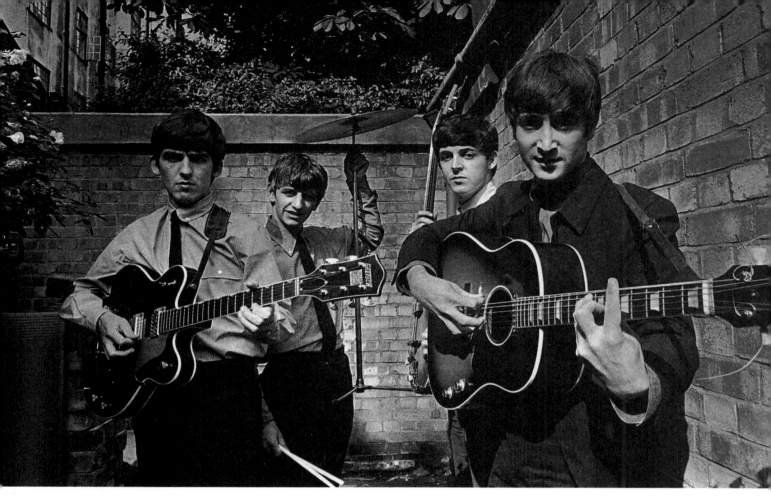

The Beatles posing for posterity at the back of Abbey Road Studios on July 1, 1963.

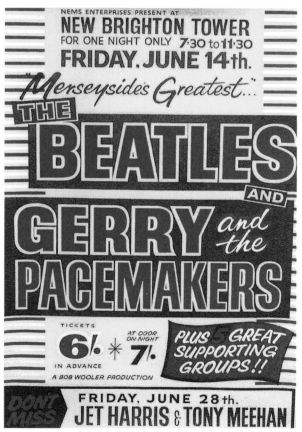

FOR BEATLES FANATICS

Around 1:41, you can hear Ringo clicking his sticks in his tom break.

On June 14, 1963, the Beatles were featured at the Tower Ballroom in New Brighton.

Twist And Shout

Phil Medley–Bert Russell / 2:33

MUSICIANS
John: vocal, guitar
Paul: backing vocals, bass
George: backing vocals, guitar
Ringo: drums

RECORDED
Abbey Road: February 11, 1963 (Studio Two)

NUMBER OF TAKES: 2

MIXING
Abbey Road: February 25, 1963 (Studio One)

TECHNICAL TEAM
Producer: George Martin
Sound Engineer: Norman Smith
Assistant Engineers: Richard Langham, A. B. Lincoln

A Masterpiece to Close the Session

Geoff Emerick remembered that Richard Langham, the session's assistant engineer, had told him John had sung "Twist and Shout" without his shirt on despite his cold, the cold temperature, and the humidity of the studio!

Genesis

"Twist and Shout" was a composition by Phil Medley and Bert Berns, alias Bert Russell, both American author-composers. Originally, the tune was called "Shake It Up Baby." In 1961, the Top Notes, a rhythm 'n' blues combo at Atlantic Records, had made a version that had little in common with the one by the Fab Four. Phil Spector, in charge of producing it, had, according to Bert Russell, only managed to destroy it. Russell then produced it the following year and offered it to the Isley Brothers, an African-American doo-wop group, who changed the title to "Twist and Shout." The song was a mediocre success, climbing to seventeenth place on the charts on June 30, 1962. This version was the one that inspired the Beatles. It should be noted that the performance of the Isley Brothers was highly explosive and wild, and worthy of the great standards of rock 'n' roll.

Production

The Beatles had just concluded "Baby It's You," it was late, and there was still one song left to record. There are two different explanations as to why "Twist and Shout" ended up being the last song of the day to be recorded. George Martin, knowing the song meant real torture for the vocal chords, decided to record it at the end of the day: "'We're not not going to record that until the very end of the day, because if we record it early on, you're not going to have any voice left.'"[1] According to Norman Smith, it was during a break that the team chose to end the session with this number. One thing was certain: John had hardly any voice left;

1. Martin and Hornsby, *All You Need Is Ears.*
2. Lewisohn, *The Complete Beatles Recording Sessions.*
3. *The Beatles Anthology.*
4. *The Beatles Anthology.*

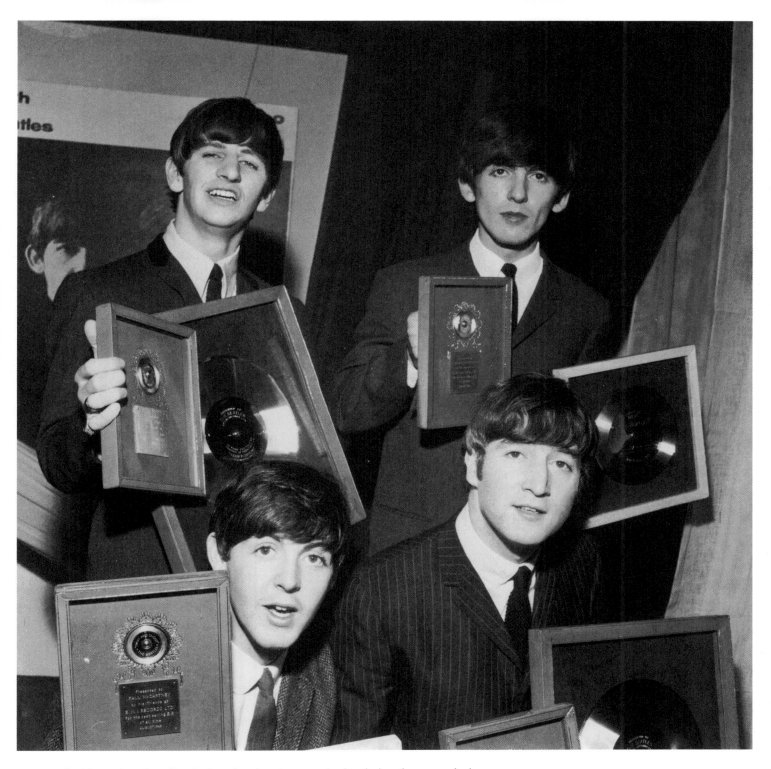

On November 18, 1963, the four Beatles photographed with the silver records they received from EMI for the record sales of "Please Please Me" and "Twist And Shout."

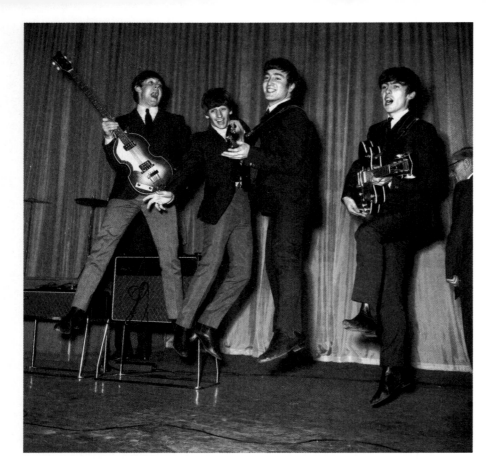

A spirited rehearsal just before the concert of the Royal Command Performance at the Prince of Wales Theatre on November 4, 1963.

FOR BEATLES FANATICS

During the November 4, 1963 Royal Command Performance, in the presence of the Queen Mother and Princess Margaret, John dared to utter his famous line, "For our last number I'd like to ask your help. The people in the cheaper seats clap their hands, and the rest of you if you'd just rattle your jewelry. We'd like to sing a song called 'Twist and Shout'"[4]

he was sick, his throat was burning, and he was burned out. Everyone was aware that it would be difficult to go beyond one take. "John sucked on a few Zubes cough drops, gargled with some milk, and launched into the recording," remembered Norman. At barely 2:30, John delivered an extraordinary performance, a real lesson in rock 'n' roll, supported brilliantly by his partners. What we hear now is exactly what John and his buddies sang and played in Studio Two of Abbey Road on that cold evening on February 11, 1963, around 10:00 P.M. There was absolutely no editing or overdub of any kind: everything was recorded and delivered as they experienced it together. At the end of the evening, someone apparently heard George Martin saying: "I don't know how they do it. We've been recording all day but the longer we go on the better they get"[2]

The Beatles had just finished their first album. Legend has it that there was only one take for this song; in fact, there was a second one, which was complete and with no false starts, but John had no more voice.

It is strange that John never really liked his vocal performance. In 1963, he felt he was a usurper, and in 1976, he admitted, "The last song nearly killed me. My voice wasn't the same for a long time after; every time I swallowed it was like sandpaper. I was always bitterly ashamed of it, because I could sing it better than that; but now it doesn't bother me. You can hear that I'm just a frantic guy doing his best."[3]

Technical Details
One of the characteristics of the "Beatles sound" between 1962 and 1964 was due to the EMI RS114 limiter. This in-house machine, with only six copies made in 1956 for all the EMI studios, was meant to limit the sound to keep it from saturating the sound signal during the production of volume that was too high. Norman Smith especially enjoyed it, which was not the case with all the in-house engineers. It proved very useful, especially on John's voice, which was at the peak of its power on "Twist and Shout."

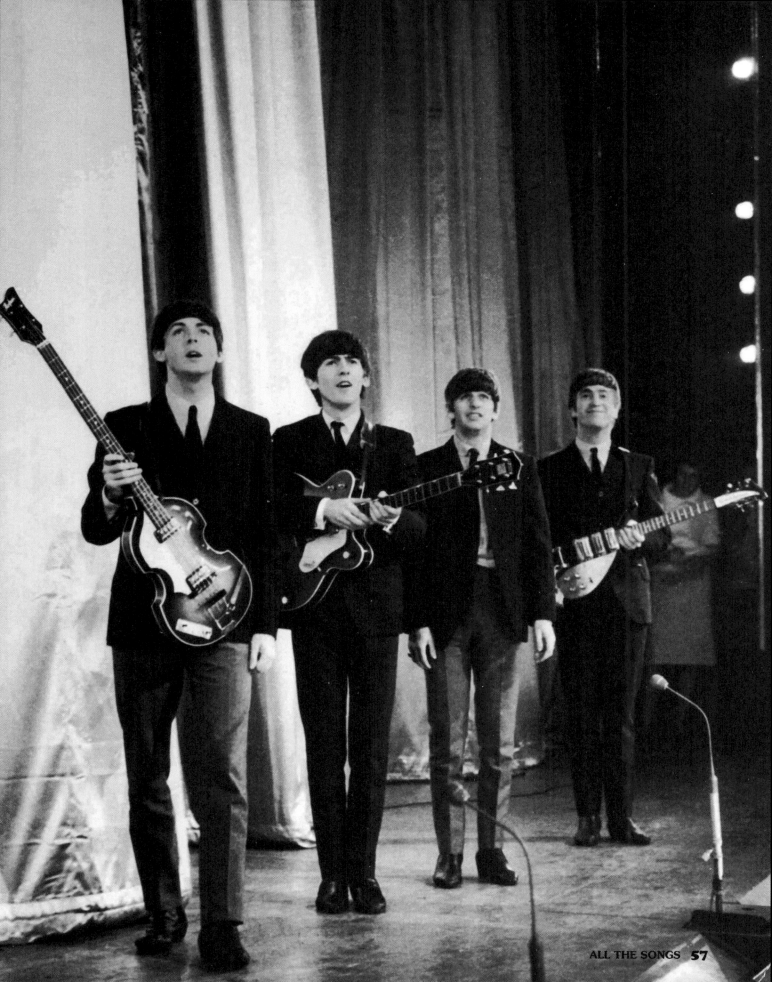

1963

From Me to You /
Thank You Girl

SINGLE
RELEASED AS A SINGLE

Great Britain: April 11, 1963 /
No. 1 for 7 weeks, beginning on May 2, 1963
United States: May 27, 1963; republished on January 30, 1964 /
No. 41 on March 7, 1964

From Me To You

McCartney-Lennon / 1:56

SONGWRITERS
John and Paul

MUSICIANS
John: vocal, rhythm guitar, harmonica
Paul: vocal, bass
George: lead guitar
Ringo: drums

RECORDED
Abbey Road: March 5, 1963 (Studio Two)

NUMBER OF TAKES: 13

MIXING
Abbey Road: March 14, 1963 (Studio Two)

TECHNICAL TEAM
Producer: George Martin
Sound Engineer: Norman Smith on session held March 5, 1963; unknown on session held March 14, 1963
Assistant Engineers: Richard Langham on session held March 5, 1963; unknown on session held March 14, 1963

Genesis

The song "From Me to You" was written on February 28, 1963, by John and Paul, who were on Helen Shapiro's tour, in the car between York and Shrewsbury. John said: "We weren't taking ourselves seriously—just fooling about on the guitar—when we began to get a good melody line, and we really started to work at it. Before that journey was over, we'd completed the lyric, everything. I think the first line was mine and we took it from there. . . ." Paul: "I remember being very pleased with the middle eight because there was a strange chord in it, and it went into a minor: 'I've got arms that long. . .' We thought that was a very big step."[1] John also remembered being intrigued by the title and the subject they had chosen for the song. While browsing through the *New Musical Express*, he realized that he was inspired unconsciously by the title of the column "From You to Us!" In her memoirs, Helen Shapiro related that John and Paul asked her to help them choose the song for their next single. They could not decide between "From Me to You" and "Thank You Girl." "We crowded around a piano and Paul played, while the two of them sang their latest composition, 'From Me to You,' which I liked best."[2]

Production

On March 5, 1963, the Beatles were once again at Abbey Road to record their third single. It was the first recording since the epic session of February 11. The session began with the recording of the rhythm section and the vocals live. The seventh take was considered the best one. Then John concentrated on a harmonica part that he recorded on the intro, the solo part, and the end of the song. Norman Smith was still using the same overdubbing technique as he had on the *Please Please Me* album. During the eighth take, John successfully

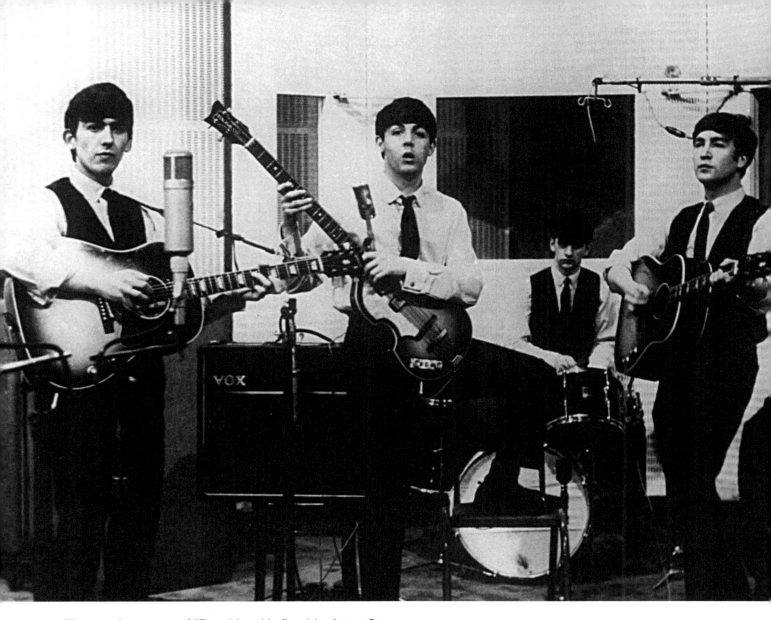

The recording session of "From Me to You" on March 5, 1963.

overdubbed the harmonica intro, but it took two more takes to complete the harmonica overdubs for the solo and ending. George Martin then decided to have John and Paul sing in the intro, thus doubling the harmonica part. In the first try, their mouths were closed as they were singing. The following try was the one used on the record, with their mouths open (*dada da dada dum dum da*). A final attempt with a falsetto part was not used. Nine days later, during the absence of the Beatles, who were giving a concert in Wolverhampton, George Martin edited four different takes together (takes 12, 8, 9, and 10) to produce the master. Finally, a mono and a stereo mix were completed.

1. *The Beatles Anthology*.
2. Shapiro, *Walking Back to Happiness*.

FOR BEATLES FANATICS

While returning from Teddington on April 14, 1963, after having recorded "From Me to You" for the *Thank Your Lucky Stars* show, the Beatles heard the Rolling Stones for the first time at the Crawdaddy Club in Richmond. Hired as the press attaché for Brian Epstein, Andrew Loog Oldham introduced the Beatles to this promising group, of which he later became the manager.

Thank You Girl

McCartney-Lennon / 2:02

SONGWRITERS
John and Paul

MUSICIANS
John: vocal, rhythm guitar, harmonica
Paul: vocal, bass
George: lead guitar
Ringo: drums

RECORDED
Abbey Road: March 5–13, 1963 (Studio Two)

NUMBER OF TAKES: 28

MIXING
Abbey Road: March 13, 1963 (Studio Two)

TECHNICAL TEAM
Producer: George Martin
Sound Engineer: Norman Smith
Assistant Engineers: Richard Langham, Geoff Emerick

Genesis

"We knew that if we wrote a song called 'Thank You Girl,' a lot of the girls who wrote us fan letters would take it as a genuine 'thank-you.' So a lot of our songs were directly addressed to the fans."[1] Before writing "From Me to You," John and Paul were convinced that this song, composed by four hands, would be side A of their new single. But despite their efforts, it turned out to be rather weak compared to "From Me to You" and ended up on side B of the record.

Production

"Thank You Little Girl," which was the working title of "Thank You Girl," was recorded on the same day as "From Me to You"—Tuesday, March 5. It took the Beatles six takes to record it. Then seven other attempts were necessary to redo the last part of the song (starting at 1:40), in order to let Ringo have the opportunity to insert his first real drumming fills. The thirteenth take was definitive. On March 13, John returned alone to Abbey Road to record a harmonica part (diatonic harmonica in G.) In his memoirs, Geoff Emerick, who was then assistant engineer, related that John, who was totally out of commission because of a bad cold, arrived at the studio without his harmonica. He borrowed one from Malcolm Davies, a technician in the etching department. At the end of the session, instead of thanking him, John reproached him for lending him a harmonica that "tasted like a sack of potatoes."[2] He recorded fourteen harmonica takes, because his cold frequently forced him to stop (on takes 14 to 28). Norman Smith then proceeded with the editing. The master resulted from the assembly of takes 6, 13, 17, 20, 21, and 23. A mono and a stereo mix were completed afterwards.

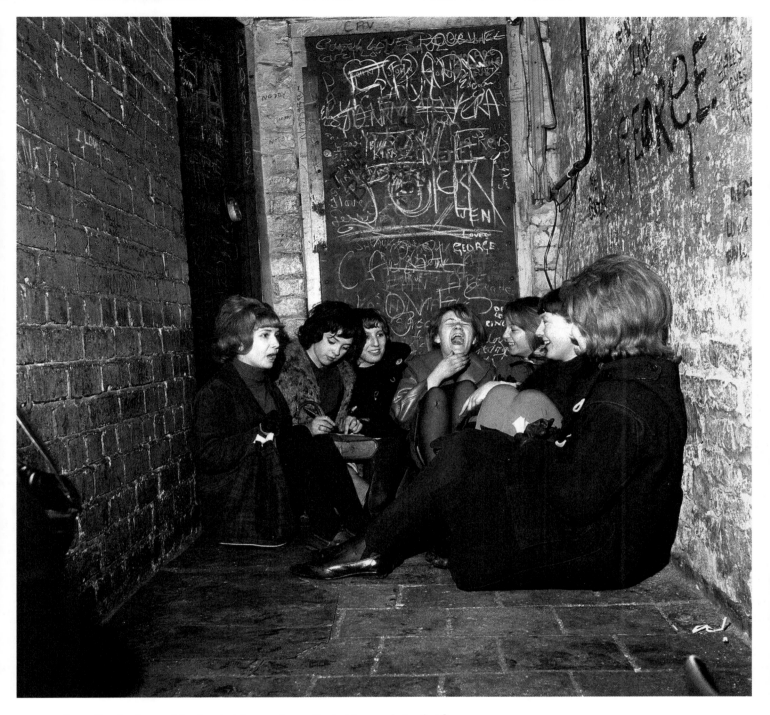

Some Beatles fans waiting for their heroes in an alley in Liverpool, April 1963.

Technical Details

During the session on March 5, Norman Smith drastically changed his recording method. From that point on, he wanted to avoid leakage of drums or guitar into the vocal microphones. He separated John and Paul from Ringo, making them sing before Neumann U 48 mics in a 'figure-eight' position. This way, the microphones only recorded the sound in front of and behind them, while rejecting whatever was on their sides. The sound of the group remained live, while being more precise. Another session, on March 11, was required to complete the recording of both songs.

1. Lewisohn, *The Complete Beatles Recording Sessions*.
2. Emerick, Here, *There and Everywhere*.

1963

She Loves You / I'll Get You

SINGLE
RELEASED AS A SINGLE

Great Britain: August 23, 1963 / No. 1 for 6 weeks,
beginning on September 12, 1963
United States: September 16, 1963 /
No. 1 for 2 weeks, beginning on March 21, 1964

She Loves You

Lennon-McCartney / 2:20

SONGWRITERS
John and Paul

MUSICIANS
John: vocal, rhythm guitar
Paul: vocal, bass
George: backing vocals, lead guitar
Ringo: drums

RECORDED
Abbey Road: July 1, 1963 (Studio Two)

NUMBER OF TAKES: UNKNOWN

MIXING
Abbey Road: July 4, 1963 (Studio Two) / November 8, 1966 (Stereo version, Room 53)

TECHNICAL TEAM
Producer: George Martin
Sound Engineer: Norman Smith
Assistant Engineer: Geoff Emerick

SIE LIEBT DICH (German version of "She Loves You")
Recorded: July 1, 1963 (Abbey Road, Studio Two) / January 29, 1964 (EMI Pathé Marconi Studios, Paris, France)
Number of Takes: 14
Mixed: March 10 and 12, 1964 (Abbey Road, Studio Three control room)
Producer: George Martin
Engineer: Norman Smith
Assistant Engineer: (July 1) Geoff Emerick, (Jan. 29) Jacques Esmenjaud
Released: March 5, 1964

Genesis

"She Loves You," produced to surf on the wave of success of "From Me to You," was the first Beatles single to sell a million copies. Inspired by the Bobby Rydell song, "Forget Him," Paul thought of writing a song in the third person. Sitting on facing twin beds, Paul and John composed "She Loves You" in a room of the Turk's Hotel in Newcastle-upon-Tyne, on June 26, after a concert at the Majestic Ballroom. Apparently, the next day, they completed it at Paul's place, once they were back in Liverpool. John said in 1963: "We'd written the song and we needed more, so we had *yeah, yeah, yeah,* and it caught on."[1] After the yeahs, there were the wooos. In 1980, he said "The 'woo woo' was taken from the Isley Brothers's 'Twist and Shout,' which we stuck into everything—'From Me to You,' 'She Loves You'—they had all that 'woo woo.' The 'yeah-yeah' I don't know."[2] According to Cynthia Lennon, John's first wife, the idea for the song went back to their first Christmas together. John had written her a love letter in which he said, *Our first Chrismas, I love you, yes, yes, yes.*[3]

The single came out in Great Britain on August 23, 1963, and right away it was very successful. In the United States, still faced with the persistent rejection of Capitol Records, Brian Epstein felt forced to negotiate a contract with Swan Records in place of Vee Jay. Unnoticed when it first came out, on September 16, the record took off after a second pressing, in mid-January 1964, and reached the top of the charts on March 21.

1. Sheff, *The Playboy Interview with John Lennon & Yoko Ono.*
2. Ibid.
3. Cynthia Lennon, *John* (New York: Three Rivers Press, 2006).

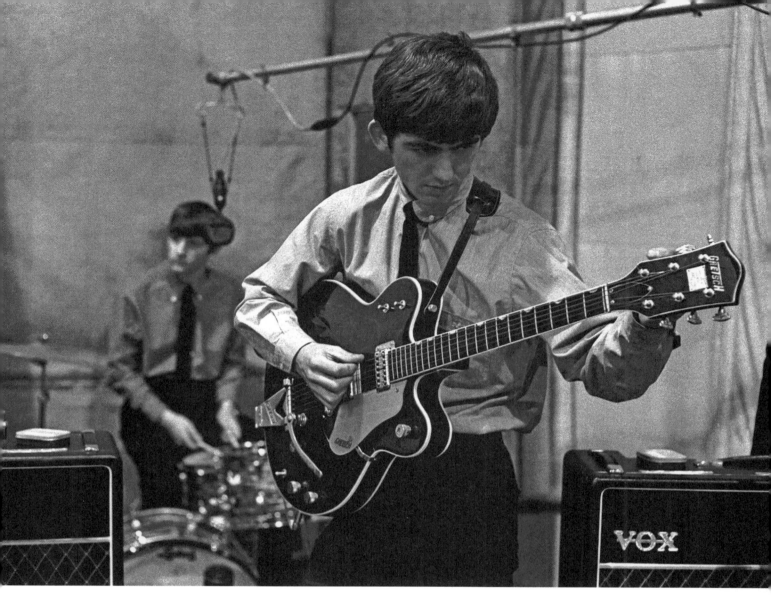

While recording "She Loves You," on July 1, 1963, for the first time, George used his new Gretsch Country Gentleman, which was connected to a Vox amplifier.

FOR BEATLES FANATICS

"She Loves You" was the first song to be credited to "Lennon-McCartney." The exception is the French 45 rpm record, which, despite indicating correct credits on the record itself, was still attributed to "McCartney-Lennon" on the back of the sleeve. Incidentally, a fragment of the song reappeared in 1967 in the recording of "All You Need Is Love," when John and Paul sang the line *She loves you yeah, yeah, yeah* at the end of the coda.

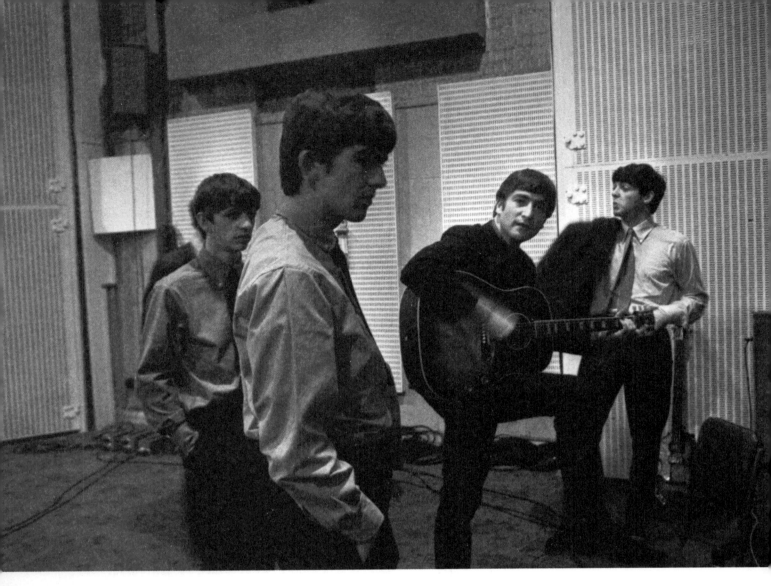

The recording session of "She Loves You" and "I'll Get You," on July 1, 1963.

Prisoners in the Studio

On the date the Beatles recorded "She Loves You," they began the day by posing for photos in the alleyway behind the studio. Geoff Emerick recalled that the size of the crowd who came to watch the Beatles was even larger than usual. By the time the Beatles began recording, the fans had overwhelmed the studio's minimal security. It was an unbelievable sight, straight out of the Keystone Kops: scores of hysterical, screaming girls racing down the corridors, being chased by a handful of out-of-breath, beleaguered London bobbies. In many ways, the "She Loves You" session was a turning point for the group, certainly in terms of their becoming virtual prisoners in the studio; it marked the loss of their freedom at the EMI facilities and the beginning of their incarceration.[5]

The Beatles in the studio with Dick James, left, their music publisher, and George Martin in the background.

Production

Norman Smith remembered: "I was setting up the microphone when I first saw the lyrics on the music stand, 'She loves you, yeah, yeah, yeah, She loves you, yeah, yeah, yeah, She loves you, yeah, yeah, yeah. Yeah.' I thought, Oh my God, what a lyric! This is going to be one that I *do not* like. But when they started to sing it—bang, wow, terrific, I was up at the mixer jogging around."[4] As for George Martin, he recalled that he did not like the major sixth chord that concluded the song, which was George Harrison's idea. He found it too jazzy, old-fashioned, in the style of Glenn Miller. But when the group insisted, he capitulated. The recording of "She Loves You" was a turning point in the Beatles' career and symbolized by itself the madness of growing Beatlemania. Hundreds of fans invaded the studios. High on the adrenaline, the four musicians delivered a rapid and overexcited performance of "She Loves You." Unfortunately, the archives of this recording were lost. But it is a known fact that the song underwent two mixes carried out at three years' interval: the first one, in mono, was done on July 4 by George Martin and his team without the presence of the Beatles; the second one, in stereo, was completed for the compilation, called *A Collection of Beatles Oldies*, on November 8, 1966, by Geoff Emerick.

Technical Details

As for guitar work, it was probably starting with this song that George began playing his new Gretsch Country Gentleman. And as for studio work, Norman Smith incessantly improved his recording method. He began using a compressor to limit significant divergences in level. He began placing a (STC-4038) microphone above Ringo's drums, which gave them a more precise sound and gave elbow room to the rhythm section. Finally, he moved the vocal microphones even farther from the drums. This was the configuration he used until he stopped working with the Beatles in 1965.

4. Lewisohn, *The Complete Beatles Recording Sessions.*
5. Emerick, *Here, There and Everywhere.*

I'll Get You

Lennon-McCartney / 2:04

SONGWRITERS
John and Paul

MUSICIANS
John: vocal, rhythm guitar, harmonica
Paul: vocal, bass
George: lead guitar
Ringo: drums

RECORDED
Abbey Road: July 1, 1963 (Studio Two)

NUMBER OF TAKES: UNKNOWN

MIXING
Abbey Road: July 4, 1963 (Studio Two)

TECHNICAL TEAM
Producer: George Martin
Sound Engineer: Norman Smith
Assistant Engineer: Geoff Emerick

Genesis

Initially called "Get You in the End," "I'll Get You" was one of the rare songs to be written at John's place, in the house of his Aunt Mimi on Menlove Avenue, in Liverpool. The inspiration for the refrain, *It's not like me to pretend*, comes from "All My Trials," a protest song by Joan Baez, from the early sixties, copied from a traditional chant from the Bahamas. Passing from the D major chord into A minor was an effect that John really liked. "I liked that slightly faggy way we sang 'Oh yeah, oh yeah,' which was very distinctive, very Beatles,"[1] he said. "I'll Get You," a song written just before "She Loves You," ended up as side B of their fourth single, whereas it was originally supposed to be on side A. Yet it remained one of Paul's favorites.

Production

Just as for "She Loves You," the studio sheets disappeared forever. There was no known stereo version. Along with "Love Me Do," "She Loves You," and "You Know My Name (Look Up the Number)," it was one of the four songs from the entire Beatles catalogue that was never mixed in stereo. ("She Loves You" received only a "mock stereo" mix.) Geoff Emerick noted that the session was relatively long, despite the apparent simplicity of the song. It can be imagined that John's harmonica (a diatonic in *sol*) was overdubbed, as Norman Smith had been doing since the beginnings of the group. The mono mix was completed at the same time as "She Loves You."

1963

1. Miles, *Paul McCartney.*

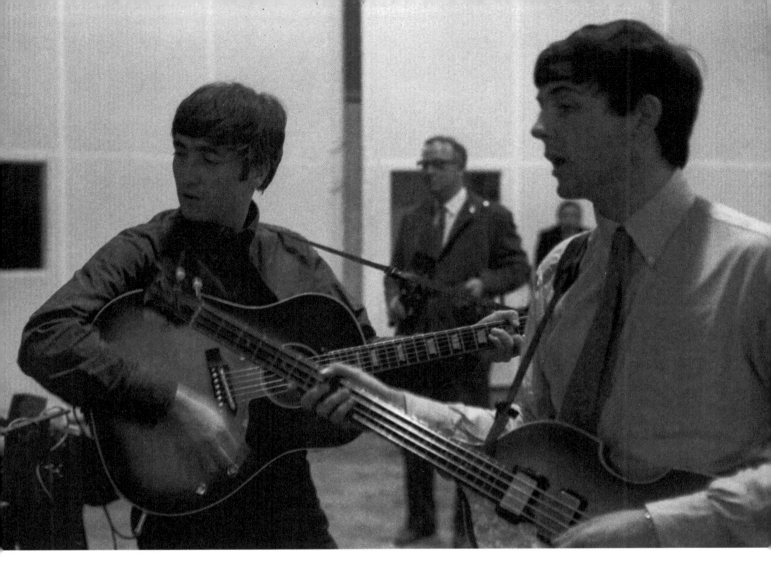

John on guitar and Paul on bass during the recording session on July 1, 1963.

FOR BEATLES FANATICS

In 1963, the Beatles were not famous enough to have studios available day and night. Being short of time, George Martin, who was in charge of the production budget, sometimes let certain errors slip through in recordings, hoping nobody would notice them. But with the precision of CDs, you can hear around 1:13 John singing *When I'm gonna make you mine*, whereas Paul was singing *When I'll make you change your mind!*

1963

I Want to Hold Your Hand/ This Boy

SINGLE
RELEASED AS A SINGLE

Great Britain: November 29, 1963 /
No. 1 on December 12, 1963
United States: December 26, 1963 /
No. 1 on February 1, 1964

I Want To Hold Your Hand

Lennon-McCartney / 2:25

SONGWRITERS
John and Paul

MUSICIANS
John: vocal, rhythm guitar, hand claps
Paul: vocal, bass, hand claps
George: lead guitar, hand claps
Ringo: drums, hand claps

RECORDED
Abbey Road: October 17, 1963 (Studio Two)

NUMBER OF TAKES: 17

MIXING
Abbey Road: October 21, 1963 (Studio One)

TECHNICAL TEAM
Producer: George Martin
Sound Engineer: Norman Smith
Assistant Engineer: Geoff Emerick

KOMM, GIB MIR DEINE HAND (German version of "I Want to Hold Your Hand")
Recorded: October 17, 1963 (Abbey Road, Studio Two) / January 29, 1964 (EMI Pathé Marconi Studios, Paris, France)
Number of Takes: 11
Mixed: March 10 and 12, 1964 (Abbey Road, Studio Three control room)
Producer: George Martin
Engineer: Norman Smith
Assistant Engineer: (Oct. 17) Geoff Emerick, (Jan. 29) Jacques Esmenjaud
Released: March 5, 1964

The Song That Gave Birth to Beatlemania

This vinyl record had a peculiar fate, since it helped launch Beatlemania in the United States. Right from the beginning, "I Want to Hold Your Hand" seemed destined for an exceptional future. In Great Britain, the reaction to this new single exceeded all expectations. When it came out, on Friday, November 29, 1963, prior sales had already reached a million copies. This had never been seen before! It surpassed "She Loves You" at the top of the charts as early as December 12. In the United States, despite the reluctance of Capitol Records, the American branch of EMI, it definitely knocked open the door of the New World and was heard on all American radio stations because of the Washington disc jockey Carroll James, who got a copy of the British single, at the insistent request of a female listener. After its first broadcast, the public's response was so enthusiastic that all radio stations followed suit.

Seeing this wave of success, Capitol Records finally realized the size of the phenomenon and decided to produce the single. They even moved up the date of its release from January 13, 1964, to December 26, 1963. By January 10, sales had already gone beyond a million copies! Every radio station played "I Want to Hold Your Hand" or "I Saw Her Standing There," which was on side B of the American single. During the night of January 16, 1964, George Martin, who was in Paris with the group at the Olympia, was awakened by a phone call. It was Brian Epstein: "George, I'm sorry to wake you up, but I just had to tell you the news. We're number one in America on next week's charts."[1] Brian Epstein organized their first American tour in February 1964. He landed an appearance on *The Ed Sullivan Show*, the most popular variety show on the west side of the Atlantic. Their TV performance on February 9

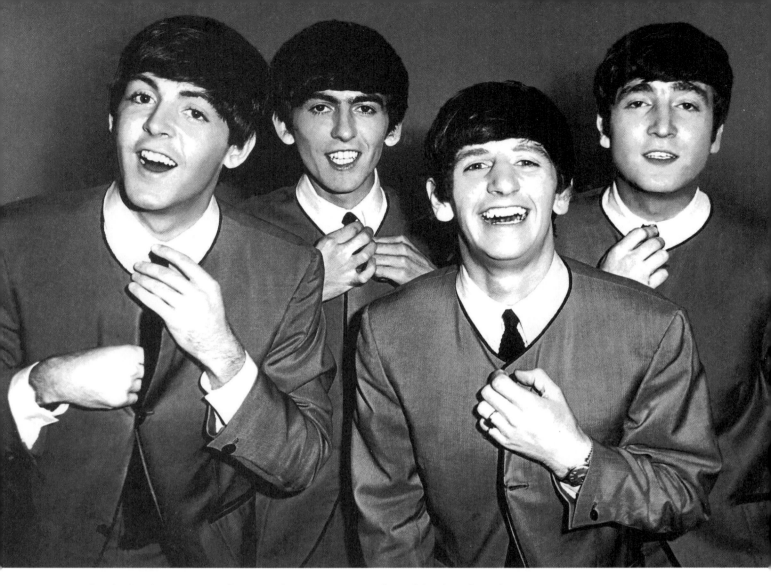

In 1963, the Beatles posing in a Cardin outfit without a collar. One of the shots from this photo session made it to the cover of the single "I Want to Hold Your Hand."

was watched by no less than 73 million spectators! It was estimated that in New York alone, nearly 10,000 copies of "I Want to Hold Your Hand" were sold every hour. By March, more than 3 million singles had been sold and later, the incredible number of 5 million copies was reached!

"It just seemed ridiculous—I mean, the idea of having a hit record over there. It was just something you could never do."[2] These few words summed up the feelings of John Lennon when contemplating the uncertainty of success in the United States. Nevertheless, it was the Beatles who made it possible for the British Invasion to infiltrate the impenetrable Yankee fortress. No other artist from the Old World had ever managed to keep a hit at the top of the U.S. charts. The Tornadoes had landed a minor hit in December 1962 with "Telstar." But the Beatles reigned for several years in a row.

An American Sound

Said Brian Epstein: "Moving around New York I found that there was without question an American 'sound' on disc, which appealed to the American public—a certain American feeling. This feeling, I was certain, existed in 'I Want to Hold Your Hand.'"[7]

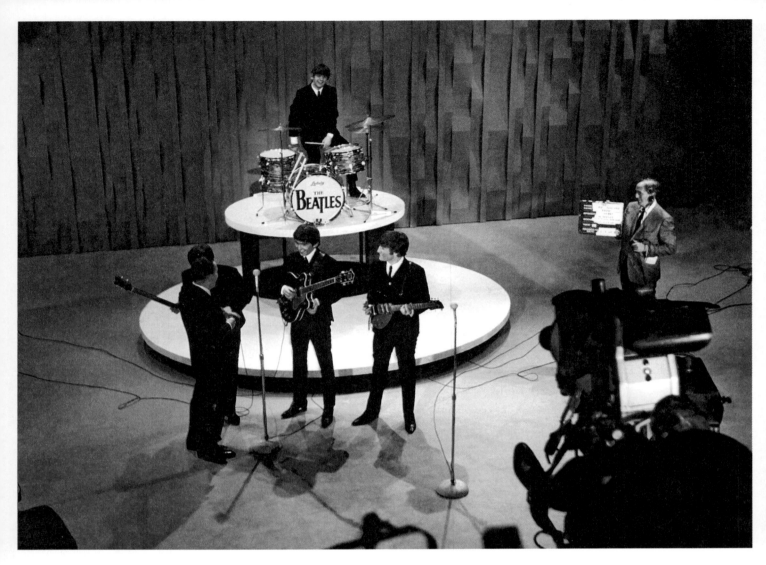

On February 9, 1964, the Beatles chat with Ed Sullivan before their first appearance on the famous American variety program.

Genesis

The song that propelled the Beatles to the top of the charts and sales worldwide was composed in one evening, the night before it was recorded. During the evening of October 16, John joined Paul in the little music room that the Asher family had made available for them, at 57 Wimpole Street, in London. John said in 1970: "I like 'I Want to Hold Your Hand.' It's a beautiful melody." Then he told *Playboy* in 1980: "I remember when we got the chord that made the song. We were in Jane Asher's house, downstairs in the cellar playing on the piano at the same time. And we had *Oh, you-u-u . . . got that something . . .* And Paul hits this chord and I turn to him and say, 'That's it!' I said, 'Do that again!' In those days we really used to absolutely write like that—both playing into each other's noses."[3] Paul confirmed this: "'Eyeball to eyeball' is a very good description of it. That's exactly how it was. 'I want to Hold Your Hand' was very cowritten."[4]

Production

Curiously, the production of "I Want to Hold Your Hand" was relatively simple compared to the impact that the song had on the group's career. According to Geoff Emerick, they had no doubt prepared it well beforehand. He did not know that the song had been written the night before. Needless to say, the Beatles, who had mastered their art, had become pros in the studio. It was their first song to be recorded on a four-track tape recorder. It took them seventeen takes to complete the song on that Thursday, October 17. After recording the rhythm on the first track, John and Paul concentrated on the vocals. Then George, under the admiring eye of the team, added his guitar work. Geoff Emerick claimed, "George Harrison really impressed us all that day, too. I felt that those little answering guitar licks he played in each verse provided the song's definitive hook."[5] Finally, gathered around the same mic, they closed the recording with hand claps, in a joyful

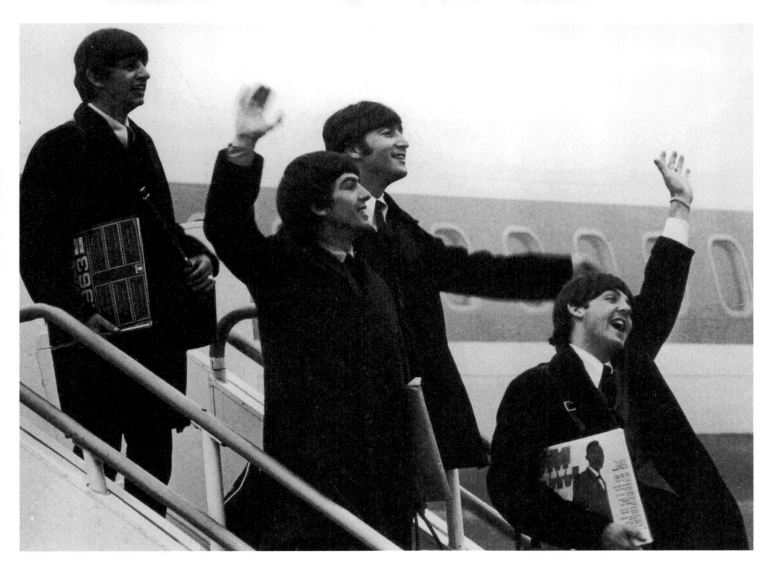

On February 22, 1964, the Fab Four received a triumphant greeting upon returning from their American tour.

atmosphere. In the control room, George Martin and Norman Smith "were thinking that 'I Want to Hold Your Hand' might be even bigger than 'She Loves You.'"[6] The mono and stereo mixes were done on October 21.

Technical Details

For the first time since their very first session on June 6, 1962, the Beatles crossed an important technological milestone: they could now record their songs on four-track tape recorders, on Telefunken T9u and M10. These tape recorders gave them a recording comfort that was until then unequaled. There were no more systematic overdubs, which forced George Martin and Norman Smith go to extremes to avoid degrading the sound. This new era led the Beatles to greater research and innovation in the studio. However, "I Want to Hold Your Hand" and "This Boy" would be the only songs recorded on four-track tape recorder in 1963.

FOR BEATLES FANATICS

When the Beatles performed "I Want to Hold Your Hand" during *The Ed Sullivan Show* on February 9, 1964, John's microphone was barely turned on, and only Paul's voice could be heard! In front of 73 million TV viewers!

1. Martin and Hornsby, *All You Need Is Ears.*
2. Julian Lennon, *Beatles Forever: La collection de Julian Lennon* (Paris, Hors Collection, 2010).
3. Sheff, *The Playboy Interview with John Lennon & Yoko Ono.*
4. Miles, *Paul McCartney.*
5. Emerick, *Here, There and Everywhere.*
6. Ibid.
7. Epstein, *A Cellarful of Noise.*

This Boy

Lennon-McCartney / 2:15

SONGWRITER
John and Paul

MUSICIANS
John: vocal, rhythm guitar
Paul: vocal, bass
George: vocal, lead guitar
Ringo: drums

RECORDED
Abbey Road: October 17, 1963 (Studio Two)

NUMBER OF TAKES: 17

MIXING
Abbey Road: October 21, 1963 (Studio One)

TECHNICAL TEAM
Producer: George Martin
Sound Engineer: Norman Smith
Assistant Engineer: Geoff Emerick

FOR BEATLES FANATICS

A Collection of Beatles Oldies was the first Beatles compilation. It came out on December 9, 1966 in the United Kingdom to appease fans during the lengthy delay between *Revolver* and *Sgt. Pepper's Lonely Hearts Club Band*. "Bad Boy," a song that had only been released in the United States on the June 1965 album, *Beatles VI*, was supposed to appear on *Collection* in stereo. However, during the establishment of the track listing, the staff of Abbey Road read "This Boy" instead of "Bad Boy." Being disciplined employees, they promptly pulled out the master tapes for "This Boy," dated from 1963. Luckily, the mistake was caught in time!

George, Paul, and John performing "This Boy," one of the group's rare songs to be written for three voices.

Genesis

"This Boy" was a superb song and one of only a few Beatles songs, including "Because" and "Yes It Is," that was written for a vocal trio. The most surprising thing was that the main writer of these three songs was John: "I think of some of my own songs—'In My Life'—'This Boy', I was writing melody with the best of them."[1] This is how he justified himself in 1980 to counter his image as a tough rocker. One of the influences on "This Boy" was probably the Smokey Robinson & the Miracles' song, "I've Been Good to You," which came out on December 14, 1961, on side B of "What's So Good about Goodbye." John said: "Just my attempt at writing one of those three-part harmony Smokey Robinson songs. Nothing in the lyrics; just a sound and harmony."[2]

Paul remembered collaborating on this song: "It was very cowritten. We wanted to do a close-harmony thing. We liked harmonies and we were quite good at them. We used to do a close-harmony version of the Teddy Bears' 'To Know Her Is to Love Her.'"[3] He specified that they worked on it in the same type of hotel as the one where they wrote "She Loves You," on twin beds, in a typically British olive green and orange room, "the colors of vomit!"

Production

Paul was saying: "'*Don't be nervous, John. Don't be nervous.*' And John said: '*I'm not!*'" This conversation, preceding the recording of the twelfth take, revealed the friendship and intimacy that united John and Paul.

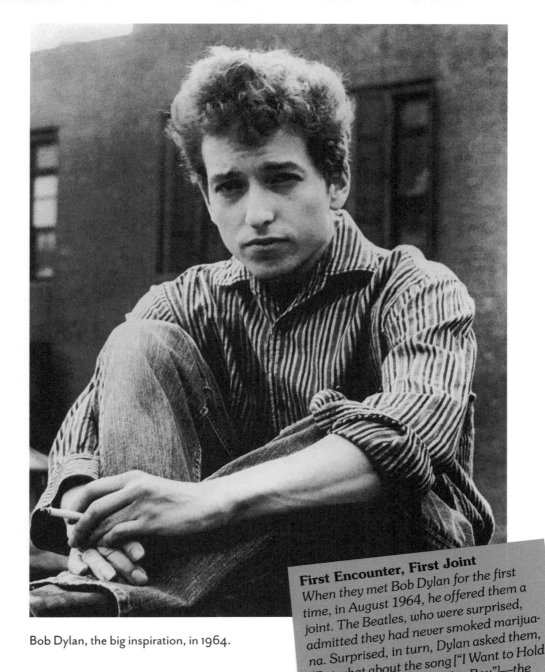

Bob Dylan, the big inspiration, in 1964.

On October 17, the Beatles worked on "This Boy" right after "I Want to Hold Your Hand." Written for side B of the single, this song emphasized their creative power. It took fifteen takes and two overdubs before they were satisfied. Geoff Emerick pointed out that "the most impressive thing about the recording of 'This Boy' was that the three Beatles sang it impeccably, in perfect three-part harmony, almost every time, from first take to last.[4] Unfortunately, George Martin felt that Harrison's guitar solo during the bridge was uninspired. So Martin decided to replace it with John's powerful vocal. Paul acknowledged: "Nice middle, John sang that great."[5] Despite uncertain editing at 1:28, the mono and stereo mixes were completed on October 21.

First Encounter, First Joint

When they met Bob Dylan for the first time, in August 1964, he offered them a joint. The Beatles, who were surprised, admitted they had never smoked marijuana. Surprised, in turn, Dylan asked them, "But what about the song ["I Want to Hold Your Hand," side A of "This Boy"]—the one about getting high?" "Which song?" John managed to ask. "You know... And when I touch you, I get high, I get high, I get high." Embarrassed, John answered him: "Those aren't the words. The words are, 'I can't hide, I can't hide, I can't hide...'"[6]

1. Sheff, *The Playboy Interview with John Lennon & Yoko Ono.*
2. Ibid.
3. Miles, *Paul McCartney.*
4. Emerick, *Here, There and Everywhere.*
5. Miles, *Paul McCartney.*
6. Peter Brown and Steve Gaines, *The Love You Make* (New York: McGraw-Hill Book Company, 1983).

It Won't Be Long
All I've Got to Do
All My Loving
Don't Bother Me
Little Child
Till There Was You
Please Mister Postman
Roll Over Beethoven
Hold Me Tight
You've Really Got a Hold On Me
I Wanna Be Your Man
Devil in Her Heart
Not a Second Time
Money (That's What I Want)

ALBUM
RELEASED

Great Britain: November 22, 1963 / No. 1 for 21 weeks
United States: January 20, 1964, released in the States under
the title *Meet the Beatles* / No. 1 for 11 weeks; April 10, 1964,
released under the title *The Beatles' Second Album*

With the Beatles:
The Confirmation

The number of songs and hits that the Beatles produced during 1963 is simply incredible: they recorded around thirty songs, including two albums and three singles that were number one "Please Please Me", "From Me to You," "She Loves You," and "I Want to Hold Your Hand"! This was done on a rush schedule, in a whirlwind of increasing madness that culminated in the beginning of 1964 with the conquest of America. Within one year, they sold nearly three million records. Hard to imagine, but Dick Rowe (from Decca) had rejected Brian Epstein the previous year, telling him that guitar groups had no future.

Just four months after the release of their first album, they returned to the studio to produce a second one. Although most of *Please Please Me* was created in one day, *With the Beatles* required around thirty hours spread over a period of three and a half months. During that period, they produced their fifth single, "I Want to Hold Your Hand," for which preorders reached a million copies.

During this period, the Beatles, were mostly on the road. They found time between concerts, often in hotel rooms, to write the material for *With the Beatles*. Out of fourteen songs, six were remakes. Strangely enough, there is only one Beatles classic on the album, "All My Loving." In 1963, 33 rpm records did not have any real homogeneity; they mainly consisted of a collection of songs. George Martin confirmed this: "We would record singles, and the ones that weren't issued as singles would be put onto an album, which is how the second album, *With the Beatles*, was put together. It was just a collection of their songs."[1] The influence of black American music, girl groups, and Smokey Robinson was predominant. John had a deep admiration for Smokey, which was felt in his own compositions ("All I've Got to Do"), as well as his remakes ("You Really Got

a Hold on Me"). Paul wrote the best piece on the album ("All My Loving") and expressed his taste for ballads ("Till There Was You"). George delivered his very first composition ("Don't Bother Me"), and Ringo let loose on "I Wanna Be Your Man."

It was George who probably expressed the most realistic appreciation of the record: "The second album was slightly better than the first, inasmuch as we spent more time on it, and there were more original songs."[2] Not more songs, George, there were just as many. Preorders exceeded 270,000 copies. It was the first album by a British group (or by any artist) to reach sales of a million copies.

John asked Robert Freeman, who moved in upstairs from him in London, to take the photo for the cover of *With the Beatles*. They had met during the group's first tour on the other side of the English Channel. A former Cambridge student, Freeman began his career as a photographer in the field of jazz. He produced the photos for five Beatles album covers from *With the Beatles* to *Rubber Soul*. Said George: "The cover for *With the Beatles* became one of the most copied designs of the decade. Robert Freeman took the cover picture. We showed him the pictures Astrid [Kirchherr] and Jurgen [Vollmer] had taken in Hamburg and said, 'Can't you do it like this?' We did the photo session in a room with a piece of black background."[3] The Beatles had to struggle long and hard to get the cover approved because EMI management found it gloomy, far from the smiling Beatles they expected. But the Beatles won their case, and this photo became one of the iconic images of the group.

1. *The Beatles Anthology.*
2. Ibid.
3. Ibid.
4. Ibid.

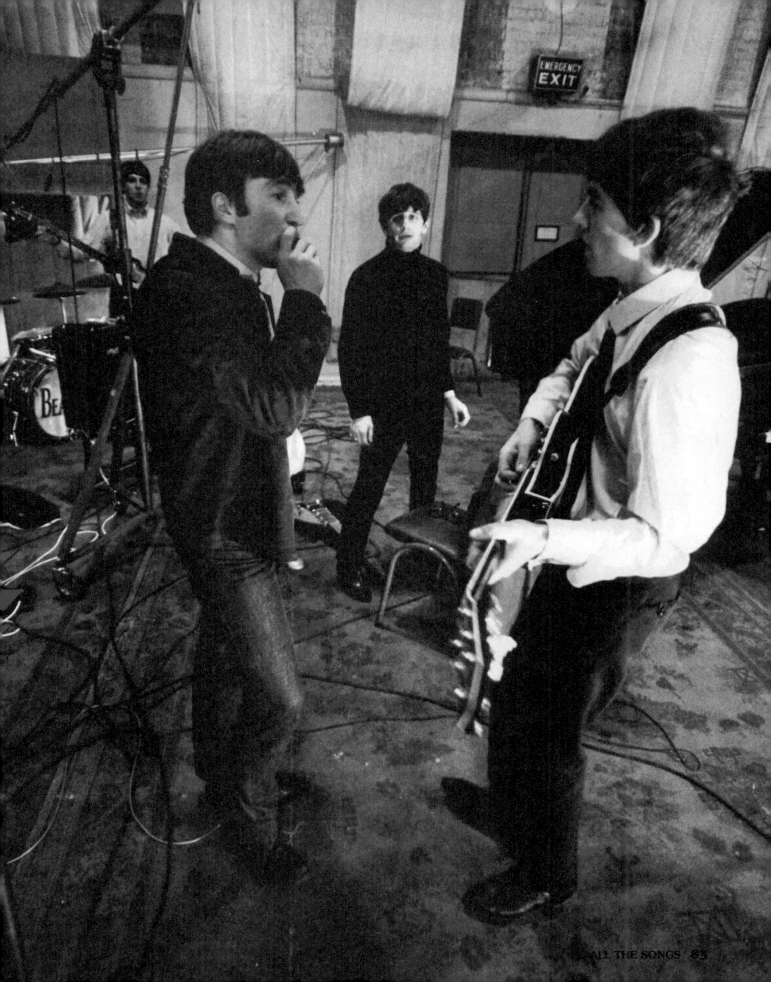

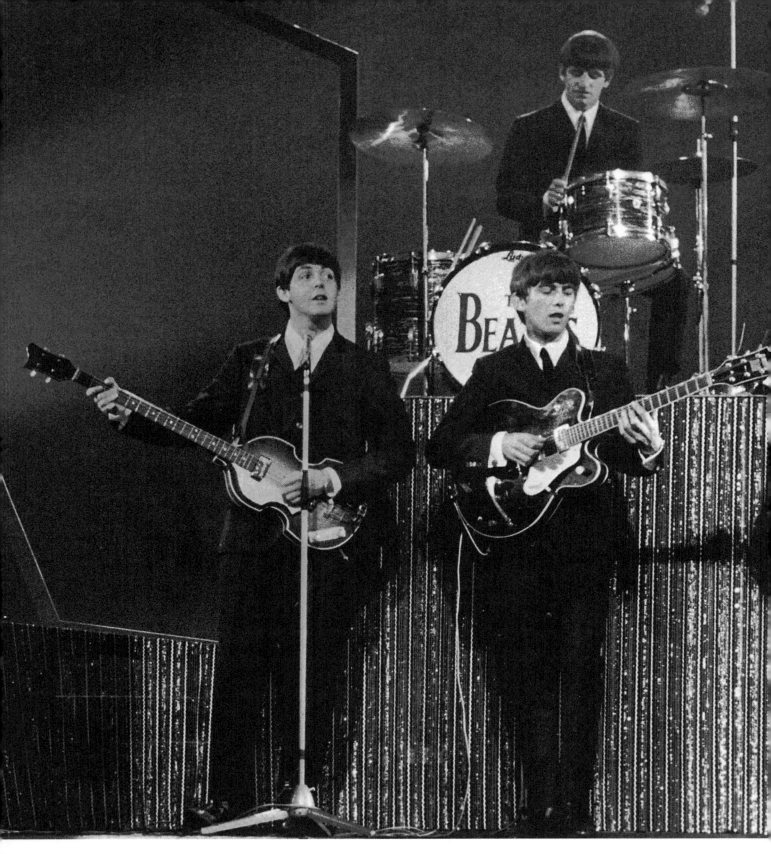

Ringo: "Going onstage at the Palladium was amazing." George: "To get on the Palladium and all those places, we wore the suits and we played their game. But a lot of the time we were thinking, 'Ha, we'll show these people.'"[4] Above, the Beatles onstage at the London Palladium, on October 13, 1963, and, at right, backstage.

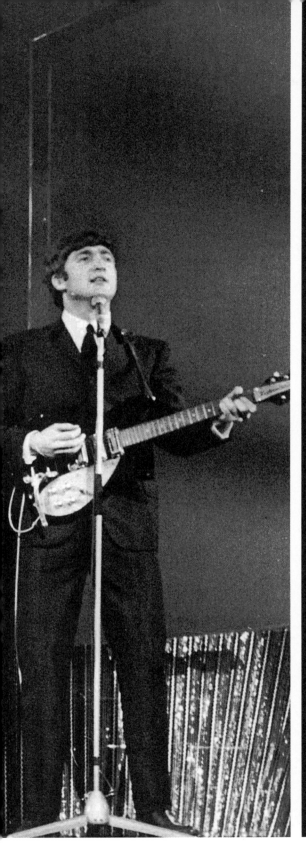

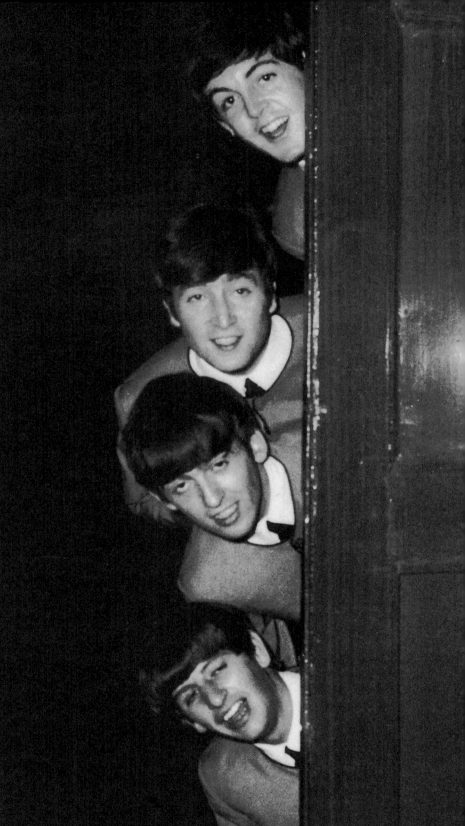

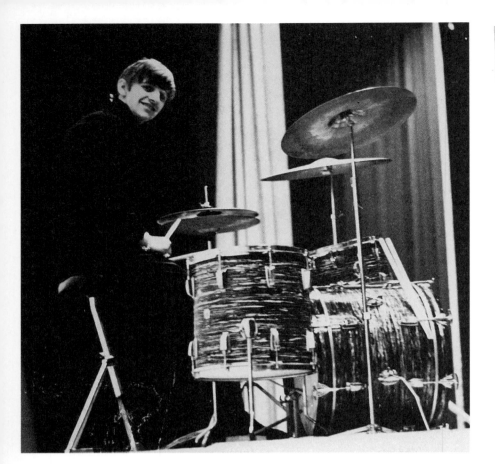

In April 1963, Ringo changed drums. He chose a Ludwig Oyster Black Pearl kit.

The Instruments

John kept the same equipment. Unfortunately, his Gibson J-160 E was stolen during "The Beatles' Christmas Show" on December 24, 1963, at the Astoria Cinema in London. Around October, Paul ordered a new left-handed Hofner 500/1 bass. It became his main instrument for years to come. He also changed amplifiers in March and, like John and George, chose a Vox amplifier, that is, a complete Vox T-60. Then in August, he opted for another amplifier head, a Vox AC-30 Super Twin, in order to have more power. Around March, George also acquired a superb Gretsch Chet Atkins Country Gentleman, which he used in the studio to record "She Loves You." He also played a classical guitar for "Till There Was You," probably a José Ramirez. Finally, Ringo changed drums toward April, when he chose the famous Ludwig Oyster Black Pearl. He used them during the sessions for *With the Beatles*.

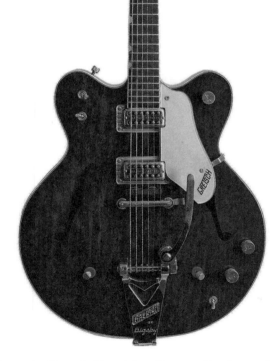

Above, the Gretsch Chet Atkins Country Gentleman that George acquired in March 1963. Opposite, George playing his famous Gretsch.

It Won't Be Long

Lennon-McCartney / 2:12

SONGWRITER
John

MUSICIANS
John: vocal, rhythm guitar
Paul: backing vocals, bass
George: backing vocals, lead guitar
Ringo: drums

RECORDED
Abbey Road: July 30, 1963 (Studio Two)

NUMBER OF TAKES: 23

MIXING
Abbey Road: August 21, 1963 (Studio Three) / October 29, 1963 (Studio Three)

TECHNICAL TEAM
Producer: George Martin
Sound Engineer: Norman Smith
Assistant Engineers: Richard Langham, Geoff Emerick, B. T. (full name unknown)

FOR BEATLES FANATICS

For his very first public appearance in 1964, at the Kelvin Cafeteria of a Winnipeg high school in Canada, Neil Young had the good taste to sing "Money" and "It Won't Be Long."

Genesis

In 1980, John recalled that "It Won't Be Long" had been designed to be their next single. But, as he admitted, "It never quite made it." It should be mentioned that, shortly afterwards, the Lennon-McCartney duo wrote "I Want to Hold Your Hand," which brought the United States to its knees. "It Won't Be Long" was inspired by John. "John mainly sang it, so I expect that it was his original idea but we both sat down and wrote it together,"[1] Paul confided to Barry Miles. "Like the double meaning. In *It won't be long till I belong to you* it was the same trip."[2] The lyrics revealed a more intimate side of John: hope following solitude. A typical love song or a reference to his difficult adolescence? One thing is for sure: after the *yeahs* of "She Loves You," the group followed up with another series of *yeahs*—no less than fifty-five in the whole song!

Production

This first song of the album was also the first original composition to be recorded on Tuesday, July 30. The session was broken down into two segments: in the morning, from 10:00 A.M. to 1:30 P.M., and in the evening, from 5:00 P.M. to 11:00 P.M. "It Won't Be Long," the second song of the day (after "Please Mister Postman"), required ten takes in the morning, and seven more at the end of the evening, plus six overdubs. The seventeenth and twenty-first takes were considered the best and were considered definitive. John, who did not like his voice, used the options of the Twin Track to double it. The vocal harmonies of this song were absolutely superb and proved that, in a very short time, the Beatles had matured to a surprising extent. This was obvious if you compared "It Won't Be Long" and "Love Me Do." The mono mix took place on August 21, and the stereo mix was done over two months later, on October 29.

1. *Miles, Paul McCartney.*
2. Ibid.

1963

All I've Got To Do

Lennon-McCartney / 2:02

SONGWRITER
John

MUSICIANS
John: vocal, rhythm guitar
Paul: backing vocals, bass
George: backing vocals, lead guitar
Ringo: drums

RECORDED
Abbey Road: September 11, 1963 (Studio Two)

NUMBER OF TAKES: 15

MIXING
Abbey Road: September 30, 1963 (Studio Two) / October 29, 1963 (Studio Three)

TECHNICAL TEAM
Producer: George Martin
Sound Engineer: Norman Smith
Assistant Engineer: Geoff Emerick

FOR BEATLES FANATICS

On the left in the stereo, it seems that dear old Ringo should have greased the pedal of his bass drum, because it squeaked throughout the song!

1963

Genesis

A song entirely composed by John—"That's me trying to do Smokey Robinson again,"[1] he said later—"All I've Got to Do" was only offered to Paul when he arrived at the studio, just before the recording. A lack of self-confidence? Possibly. John based the song on "You Can Depend on Me" by Smokey Robinson for the intro chord and the overall theme of the piece. It seemed that, as he was writing it, John had the American market in mind. The telephone, which is mentioned in the song, was more common at this time on the west side of the Atlantic than in Great Britain. "All I've Got to Do" was the only song among the Beatles catalog in which the ending is hummed.

Production

On September 11, 1963, one year to the day after they recorded their first single, the group once again went to the studio to record five new songs for their second album. The day was divided into two sessions, "All I've Got to Do" being recorded in the first session. The piece required fourteen takes—and a fifteenth one for an overdub. The mono mix was done on September 30 without the presence of the Beatles, who were then on vacation: John was in Paris; George was in New York and then in St. Louis; and Paul and Ringo were in Greece. The stereo mix took place on October 29.

1. Miles, *Paul McCartney.*

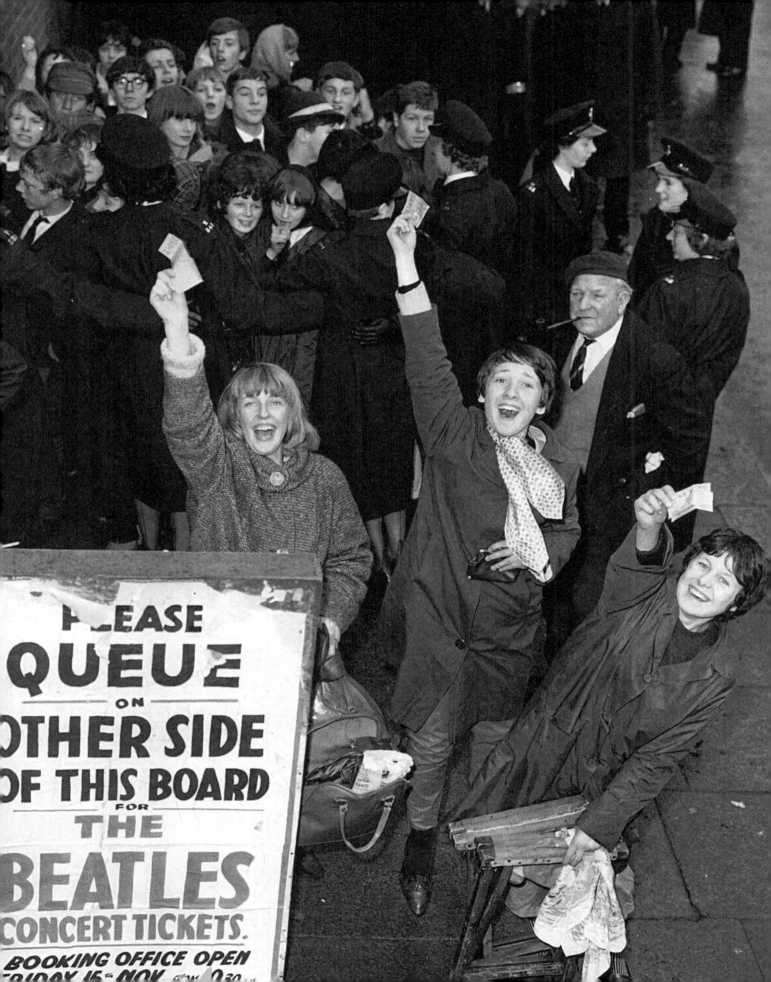

PLEASE QUEUE ON OTHER SIDE OF THIS BOARD FOR THE BEATLES CONCERT TICKETS. BOOKING OFFICE OPEN FRIDAY 15th NOV

All My Loving

Lennon-McCartney / 2:06

SONGWRITER
Paul

MUSICIANS
Paul: vocal, bass
John: backing vocals, rhythm guitar
George: backing vocals, lead guitar
Ringo: drums

RECORDED
Abbey Road: July 30, 1963 (Studio Two)

NUMBER OF TAKES: 14

MIXING
Abbey Road: August 21, 1963 (Studio Three) / October 29, 1963 (Studio Three)

TECHNICAL TEAM
Producer: George Martin
Sound Engineer: Norman Smith
Assistant Engineers: Richard Langham, Geoff Emerick, B. T. (full name unknown)

FOR BEATLES FANATICS

Although this song was exclusively written by Paul, Cynthia Lennon believed in 2005 that John had written it for her.

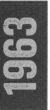

Genesis

Sometime between May 18 and June 9, 1963, Paul wrote the lyrics for "All My Loving," on the bus that drove the group through the country for its third national tour, with Roy Orbison. "All My Loving" was exclusively his work. "It was the first song where I wrote the words without the tune,"[1] he confided in 1988. John admitted that it was one of Paul's best songs. "'All My Loving' is Paul, I regret to say. Ha-ha-ha. Because it's a damn good piece of work. [Singing] 'All my loving . . .' But I play a pretty mean guitar in the back."[2]

Paul, who thought at first that "All My Loving" was only meant to be included on an album, realized its potential after it was broadcast on *Top of the Pops*, the famous BBC show hosted by the very popular disc jockey David Jacobs. "I think from that moment it did become a big favorite for people."[3] On February 9, 1964, the song was used to start the first appearance of the Beatles on *The Ed Sullivan Show* in front of 73 million American viewers! According to Paul, it was perfect for the stage and worked very well. This explained why it was often included in the Beatles' concert set lists and in Paul's concerts during his solo career.

The lyrics, written in the form of a poem, were probably inspired by actress Jane Asher, whom Paul met during a BBC concert on April 18, 1963. With this song, John also discovered the talents of a partner who risked giving him a run for his money when it came to writing future singles.

1. Lewisohn, *The Complete Beatles Recording Sessions.*
2. Sheff, *The Playboy Interview with John Lennon & Yoko Ono.*
3. Lewisohn, *The Complete Beatles Recording Sessions.*

The Beatles in their dressing room with Roy Orbison, right, and members of Gerry and the Pacemakers during one of their six UK Tours in May 1963.

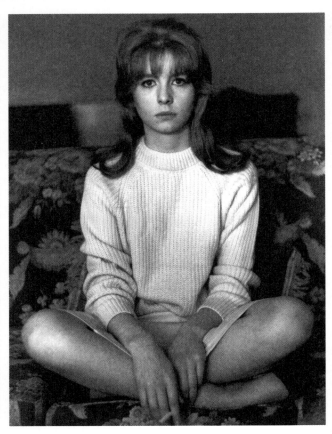

Jane Asher, who probably inspired Paul to write this song.

At right, John was always proud of his rhythm guitar part on "All My Loving."

Production

On July 30, the second session for the new Beatles album took place. "All My Loving" was the last song of the day to be recorded. Only fourteen takes were required to record it (actually, thirteen, since take 5 was noted by mistake). Takes 12 to 14 were overdubs. Paul doubled his own voice (as can be easily seen at 0:27 on the word *kissing* or again at 0:35 on *will come true*) and also sang the harmony on the third verse. He played a walking bass, as he did later for "Penny Lane" and "Lady Madonna" (at the bridge). With his new guitar, the great Gretsch Country Gentleman, George played one of his first fantastic solos in the style of Chet Atkins, while John, on his Rickenbacker 325, delivered on rhythm a "superb piece of guitar," as he said later himself. The rhythm was in triplets and reminiscent of the Crystals on "Da Doo Ron Ron."

The session ended at 11:00 P.M. In the control room of Studio Three, the mono mix was done on August 21. The stereo mix occurred on October 29. A live version was also recorded a year later on August 23, 1964, during the Beatles' concert at the Hollywood Bowl in Los Angeles.

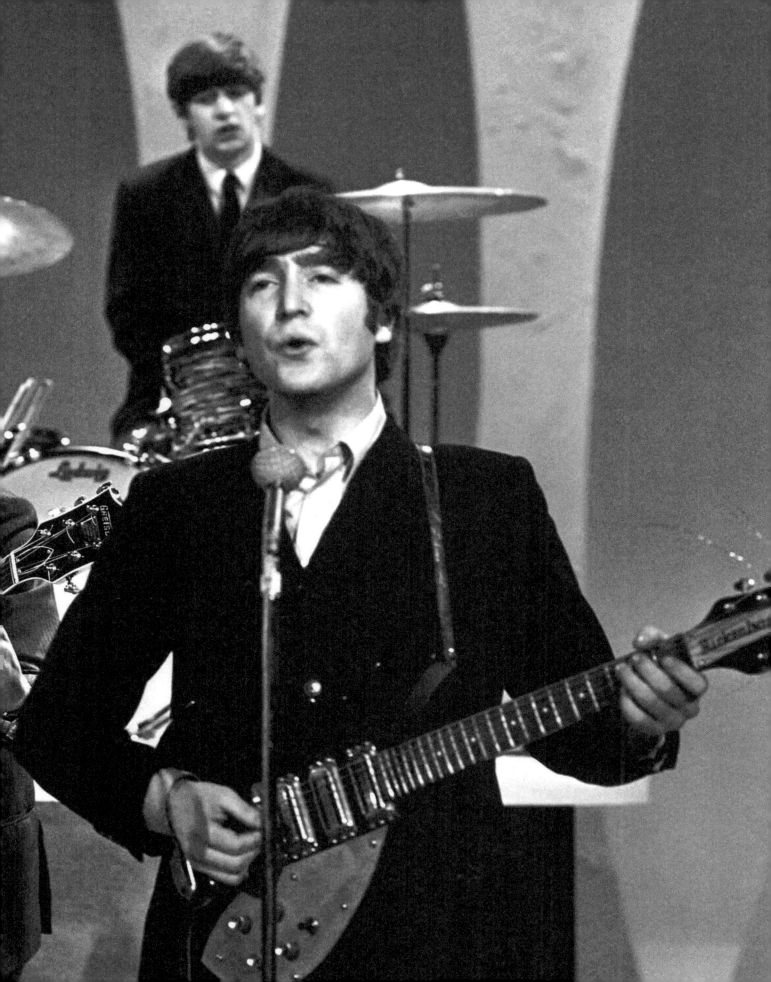

Don't Bother Me

George Harrison / 2:26

MUSICIANS
George: vocal, lead guitar and rhythm guitar
John: rhythm guitar, tambourine
Paul: bass, claves
Ringo: drums, bongos

RECORDED
Abbey Road: September 11–12, 1963 (Studio Two)

NUMBER OF TAKES: 19

MIXING
Abbey Road: September 30, 1963 (Studio Two) / October 29, 1963 (Studio Three)

TECHNICAL TEAM
Producer: George Martin
Sound Engineer: Norman Smith
Assistant Engineers: Richard Langham, Geoff Emerick

FOR BEATLES FANATICS

George was still sick and feverish when Robert Freeman took the photograph of the group that appeared on the cover of the *With the Beatles* album.

Genesis

On tour in Bournemouth from August 19 to 24, George, who had the flu, was bedridden in his hotel room. He used this time to write his very first song, "Don't Bother Me." His feverish condition was probably responsible for the theme of the song: "I wrote it as an exercise to see if I could write a song,"[1] he admitted in his autobiography. Watching his two colleagues write one song after another with so much ease led him to try songwriting. But poor George did not receive any encouragement from his bandmates during his entire career with the Beatles. It was only on their last album, *Abbey Road*, that they became aware of his value. George Martin admitted it: "I think the trouble with George was that he was never treated on the same level as having the same quality of songwriting, by anyone—by John, by Paul, or by me. . . . The other problem was that he didn't have a collaborator. . . . George was a loner and I'm afraid that was made the worse by the three of us. I'm sorry about that now."[2] Paul even revealed much later that they had made the decision with John to keep him away from songwriting right from the start. This did not prevent George from writing several songs that were included among the treasures of the Beatles ("While My Guitar Gently Weeps," "Something," and "Here Comes the Sun"). Although George did not find that "Don't Bother Me" worked very well, it at least gave him the opportunity to try his hand at writing.

Production

Recorded on Wednesday, September 11, during the evening session, "Don't Bother Me" took seven takes, including three overdubs. The results were not satisfactory. The group decided to postpone its production to

The Fab Four in the studio: George singing, Paul, John, and Ringo on percussion (rhythm sticks, bongos, and tambourine).

the next day. Returning to the studio, the Beatles began a session around 7:00 P.M. that started with "Don't Bother Me," with a reworked structure. The thirteenth take was considered satisfactory. The rhythmic basis worked well. John supplied excellent rhythm guitar, which had a powerful tremolo; Paul played bass very efficiently, and Ringo supported the whole group with a semi-Latin, semirock beat. Finally, a series of overdubs were done. George doubled his own voice, while John played tambourine, Paul played rhythm sticks, and Ringo played bongos. The fifteenth take became the master. The mono mix took place on September 30, and the stereo mix on October 29.

1. George Harrison, *I Me Mine* (New York, Simon & Schuster, 1980).
2. *The Beatles Anthology.*

A Credit Error
"Don't Bother Me" was heard in their first film, A Hard Day's Night, which came out on July 6, 1964. In the original version of the movie, the credits mistakenly claimed it was written by Lennon-McCartney!

Little Child

Lennon-McCartney / 1:45

SONGWRITERS
John and Paul

MUSICIANS
John: vocal, rhythm guitar, harmonica
Paul: bass, backing vocals, piano
George: lead guitar (?)
Ringo: drums

RECORDED
Abbey Road: September 11–12, 1963 (Studio Two) /
October 3, 1963 (Studio Two)

NUMBER OF TAKES: 21

MIXING
Abbey Road: September 30, 1963 (Studio Two) /
October 23, 1963 (Studio Two) / October 29, 1963
(Studio Three)

TECHNICAL TEAM
Producer: George Martin
Sound Engineer: Norman Smith
Assistant Engineers: Richard Langham, Geoff Emerick,
B. T. (full name unknown)

1963

Genesis

"Little Child" was not one of the group's masterpieces. Lennon and McCartney knew how to differentiate a hit song from a song that would be part of an album. Although they dedicated all their energy and their talent to their work when they were inspired, they had a bad habit of neglecting songs they wrote for others—even for Ringo or George. This was the case for "Little Child." John in 1980: "'Little Child was another effort by Paul and me to write a song for somebody. It was probably Ringo."[1] In 1997, Paul explained: "They [songs written for Ringo] had to be fairly simple. [Ringo] didn't have a large vocal range but he could handle things with good *con brio* and *spirito* if they were nice and simple. It had to be something he could get behind. If he couldn't picture it, you were in trouble."[2] In fact, John lent his voice to "Little Child," Ringo preferring to share his brilliant, spirited singing on another song of the album, "I Wanna Be Your Man." Even though the piece was rather basic rock, Paul acknowledged that part of the melody was somewhat influenced by the song "Whistle My Love," performed by Elton Hayes in a 1952 Disney production (*Robin Hood*), which was the opposite of rock music.

Production

The production of "Little Child" proved to be difficult. The afternoon session on September 11 began with "I Wanna Be Your Man" and "Little Child." Two unsatisfactory takes were completed. The group chose to postpone rerecording these songs until the next day. Therefore, on September 12, after having worked on George's "Don't Bother Me," they redid the song. The seventh take was used as the basis for the many overdubs that

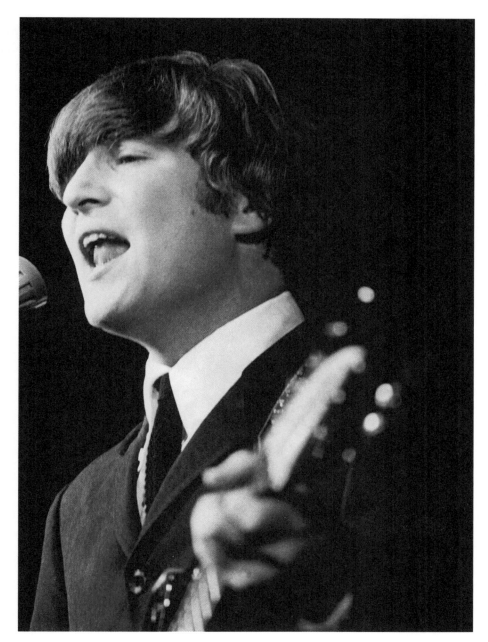

Paul (opposite, on piano) and John (above), producing the masterful alchemy of the sixties sound.

followed. John added some harmonica (diatonic in A) on the thirteenth take, Paul added some piano on the fifteenth, and John added another harmonica solo on the eighteenth take. On September 30, Martin and his team edited the thirteenth and fifteenth takes for a mono mix that was not kept. Then on October 3, other overdubs completed the piece, with John no doubt doubling his voice (takes 19 to 21). Finally, on October 23 the mono mix was completed. The stereo mix was done on October 29. Despite the numerous takes, the results were not there, and you could feel the group and Martin struggling to make it sound good. John did not really apply himself (for instance, in the doubling of his own voice at 0:35, he did not even repeat the right lyrics). The guitars were drowned out in the mix, and the stereo version had some very strange quirks (such as the return of the voices right after the harmonica solo). "Little Child" did not please everybody during the recording or the mix. Just an "album filler."

1. Sheff, *The Playboy Interview with John Lennon & Yoko Ono.*
2. Miles, *Paul McCartney.*

Till There Was You

Meredith Willson / 2:12

MUSICIANS
Paul: vocal, bass
John: rhythm guitar
George: guitar solo
Ringo: bongos

RECORDED
Abbey Road: July 18–30, 1963 (Studio Two)

NUMBER OF TAKES: 8

MIXING
Abbey Road: August 21, 1963 (Studio Three) / October 29, 1963 (Studio Three)

TECHNICAL TEAM
Producer: George Martin
Sound Engineer: Norman Smith
Assistant Engineers: Richard Langham, Geoff Emerick, B. T. (full name unknown)

FOR BEATLES FANATICS

When he was rehearsing "Till There Was You" with his Beatles colleagues, Paul did not suspect that, a few years later, the song's rights would belong to him through his publishing house MPL Communications Ltd., which acquired the musical rights for the comedy *The Music Man*.

Genesis

Meredith Willson, from Mason City, Iowa, studied music at the prestigious Julliard School in New York. Finding his first taste of success in Hollywood, as the composer of the score for Charlie Chaplin's *The Great Dictator* (1940) and William Wyler's *The Viper* (1941), Willson triumphed on Broadway years later with the musical comedy *The Music Man* (1957). Part of the score was the song "Till There Was You." This song was recorded for the first time by Sue Raney in November 1957. Then it was performed by Anita Bryant, Peggy Lee, and the Beatles.

Paul: "There were records other than rock 'n' roll that were important to me. And that would come out in the Beatles doing songs like 'Till There Was You.'[1] Indeed, Paul always flirted with the world of musical theater. By his own admission, he never differentiated between a beautiful melody and a cool rock 'n' roll song. His family had encouraged him to widen his musical taste. At the age of sixteen, he wrote "When I'm Sixty-Four" and, later, "Your Mother Should Know," "Honey Pie," and many others—"granny music," as John called it. "Till There Was You" was performed during the Royal Command Performance on November 4, 1963 and during the Beatles' first appearance on *The Ed Sullivan Show* on February 9, 1964.

Production

Three takes of "Till There Was You" were recorded during the very first session of July 18 that was dedicated to their second album. Considered unsatisfactory, the song was set aside until Tuesday, July 30. John was on rhythm on his Gibson J-160 E, George probably played on a José Ramírez classical guitar and produced

1963

Paul singing and playing bass on "Till There Was You."

an excellent solo, Ringo left the drums to play the bongos that were more appropriate for this piece, and Paul supplied the singing and the bass. The eighth take was the best one. The song was mixed in mono on August 21 and in stereo on October 29.

1. *The Beatles Anthology.*
2. Epstein, *A Cellarful of Noise.*

Please Mister Postman

Georgia Dobbins–William Garrett–Freddie Gorman–Brian Holland–Robert Bateman / 2:32

MUSICIANS
John: vocal, rhythm guitar, hand claps
Paul: backing vocals, bass, hand claps
George: lead guitar, backing vocals, hand claps
Ringo: drums, hand claps

RECORDED
Abbey Road: July 30, 1963 (Studio Two)

NUMBER OF TAKES: 9

MIXING
Abbey Road: August 21, 1963 (Studio Three) / October 29, 1963 (Studio Three)

TECHNICAL TEAM
Producer: George Martin
Sound Engineer: Norman Smith
Assistant Engineers: Richard Langham, Geoff Emerick, B. T. (full name unknown)

FOR BEATLES FANATICS

On the Marvelettes version, the exact title of the song was "Please Mr. Postman." The Beatles replaced the abbreviation *Mr.* with *Mister.*

Genesis

In April 1961, the vocal group known as the Marvels landed an audition with Tamla-Motown. In order to convince Berry Gordy to sign a contract as soon as possible, Georgia Dobbins, who was then a member of the group, "borrowed" a blues song from her friend William Garrett and reworked it in depth under the name "Please Mr. Postman." The audition proved decisive. Despite this, Dobbins quit the group, which Gordy renamed the Marvelettes, and brought to the studio. So, on October 16, 1961, the Marvelettes were the first girl group to give Gordy a number 1 hit. Regarding the long list of songwriters on the song's credits: Berry Gordy did find the song in its raw state, and it needed to be reworked. He then brought in the duo of Brian Holland and Robert Bateman (also known under the pen name of Brianbert). Holland in turn solicited the help of a friend to provide the finishing touches, Freddie Gorman, who was actually a mailman!

The Beatles' version was clearly more joyous than the original. The enthusiasm overflowed, John was at the peak of his form, the group sang in unison: the years of training had given them remarkable mastery and self-confidence. In 1984, Paul specified that the idea of remaking this song came from their fans, who, on the back of the letters of fan mail, added notes such as, "Postman, postman, hurry up and do like the Beatles, and go, man, go!"

Production

After the first session on July 18, which was spent recording four new covers ("You Really Got a Hold on Me," "Money," "Devil in Her Heart," and "Till There

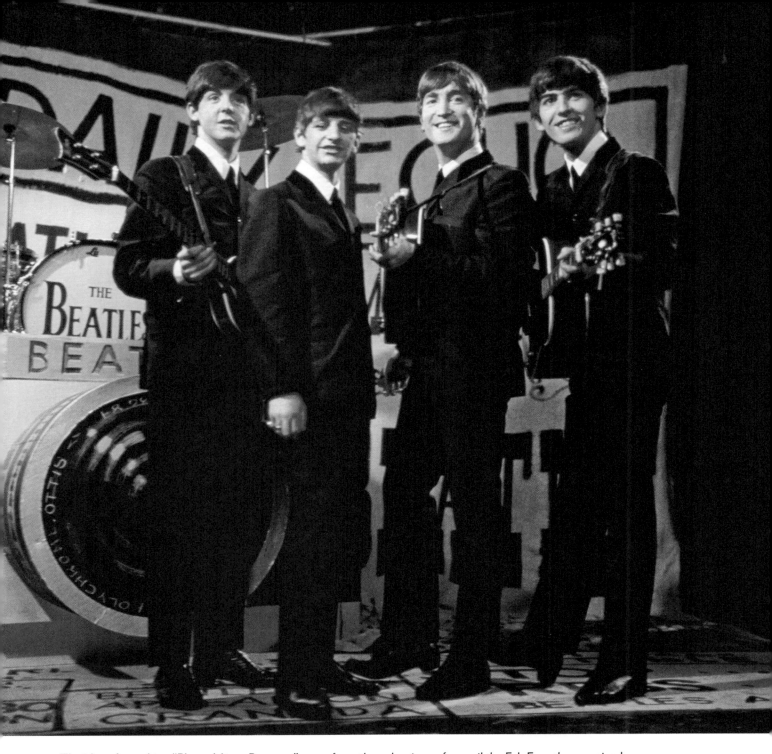

The idea of remaking "Please Mister Postman" came from the voluminous fan mail the Fab Four then received.

Was You"), the Beatles started with another remake, "Please Mister Postman," on the Tuesday morning, July 30. Why did they begin the sessions of the new album with five remakes? No doubt the Beatles needed to reassure themselves in the studio before taking on their own compositions. Their overbooked schedule did not make the job any easier. Seven takes were necessary to produce "Please Mister Postman." Two other overdubs completed the work with the doubling of John's voice and the addition of hand claps. The mix was done based on the ninth take, on August 21, for the mono version, and on October 29 for the stereo version.

Roll Over Beethoven

Chuck Berry / 2:44

MUSICIANS
George: vocal, lead guitar, hand claps
John: rhythm guitar, hand claps
Paul: bass, hand claps
Ringo: drums, hand claps

RECORDED
Abbey Road: July 30, 1963 (Studio Two)

NUMBER OF TAKES: 8

MIXING
Abbey Road: August 21, 1963 (Studio Three) / October 29, 1963 (Studio Three)

TECHNICAL TEAM
Producer: George Martin
Sound Engineer: Norman Smith
Assistant Engineers: Richard Langham, Geoff Emerick, B. T. (full name unknown)

FOR BEATLES FANATICS

In the score of the *Superman III* movie (1983), the Beatles' version of "Roll Over Beethoven" could be heard. One good reason for this was perhaps the fact that the director was none other than Richard Lester, who had directed the Fab Four in *A Hard Day's Night* and in *Help!*

Genesis

With his luminous intros and riffs carved in stone, Chuck Berry was certainly the pioneer of rock 'n' roll who most influenced young Brits in the sixties. Legend has it that the concept of this paean to youth came to him as a response to his sister, who was studying classical music on the family piano. One thing is certain: he recorded it on April 16, 1956, in the famous Chess studios in Chicago. The single came out the following month, with "Drifting Heart" on side B, and hit the American charts at the end of June. "Roll Over Beethoven" has been rated number 97 in the list of the 500 Greatest Songs of All Time, according to *Rolling Stone* magazine.

Like all apprentice musicians on this planet, the Beatles one day, together or separately, played some Chuck Berry. "Roll Over Beethoven" was no doubt one of the oldest songs they played on the stages of Hamburg or Liverpool. It was, therefore, logical to pay homage to it on their second album.

Production

George took the lead on "Roll Over Beethoven." The recording session took place on July 30 after they appeared on *Saturday Club*, a BBC show to which they had been invited. Five takes were recorded. George then doubled his own voice, played a rather convincing solo on his Gretsch Country Gentleman, and they all provided hand claps. Finally, George recorded separately the guitar chord that brought the piece to its conclusion. It was the eighth take. As early as August 21, Martin and his team proceeded to edit takes 7 and 8. The mono mix was carried out soon afterwards, and the stereo mix was done on October 29.

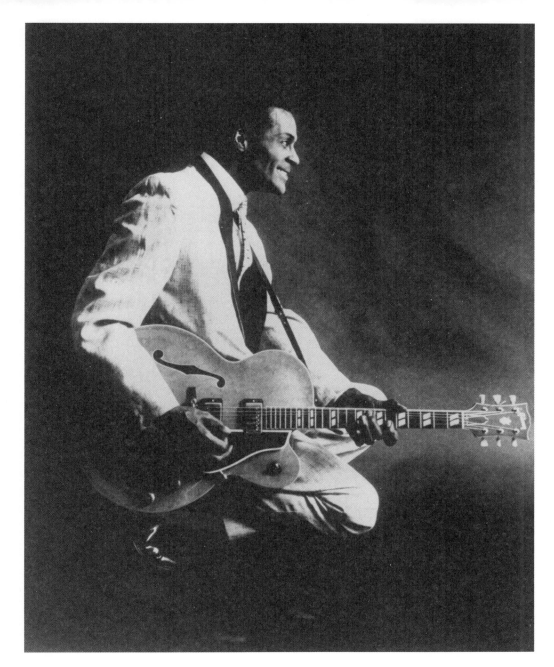

Chuck "Crazy Legs" Berry, the great composer of adolescent dreams

The Beatles seemed to lack conviction on "Roll Over Beethoven": George seemed ill at ease on his intro riff and Ringo did not really play with finesse. They could have harmonized it, as on the Hollywood Bowl version. The whole song sounded a bit too contrived. It must be remembered that the Beatles were first and foremost creators, and covers were mainly used (with a few exceptions) to fill albums. With their incessant tours in 1963, however, they did not have much time for original creation.

Technical Details

In 1963, headphones were not yet used in studios. To sing or play an overdub, a huge speaker broadcasted the playback in the studio to guide the singer or musician. The microphones inevitably picked up some of the original recording that then leaked into the overdubbed recording. One example can be heard in "Roll Over Beethoven" right after the drum break that introduced George's singing (0:17). In the stereo version, the sound became broader and widened considerably.

Hold Me Tight

Lennon-McCartney / 2:30

SONGWRITER
Paul

MUSICIANS
Paul: vocal, bass, hand claps
John: backing vocals, rhythm guitar, hand claps
George: backing vocals, lead guitar, hand claps
Ringo: drums, hand claps

RECORDED
Abbey Road: February 11, 1963 (Studio Two) /
September 12, 1963 (Studio Two)

NUMBER OF TAKES: 29

MIXING
Abbey Road: September 30, 1963 (Studio Two) /
October 23, 1963 (Studio Two) / October 29, 1963
(Studio Three)

TECHNICAL TEAM
Producer: George Martin
Sound Engineer: Norman Smith
Assistant Engineers: Richard Langham, Geoff Emerick,
B. T. (full name unknown)

FOR BEATLES FANATICS

On his 1973 solo album, *Red Rose Speedway*, Paul took only the title of this song for a totally different version that was included in the medley that closed the album.

1963

Genesis

Like all the songs they composed at that time, that ran around 2:30, "Hold Me Tight" was designed to be a hit. It was written at Forthlin Road. John and Paul based their inspiration on the joyful and sensual style of the African-American vocal groups whom they admired (they had already done a cover of "Boys" by the Shirelles on their first album, *Please Please Me*). But the magic was absent and the song, which was considered for a while as a potential single, ended up, according to Paul, simply as "acceptable album filler."[1] John was more categorical: "That was Paul's. Maybe I stuck some bits in there—I don't remember. It was a pretty poor song and I was never really interested in it either way."[2] Despite this unanimous rejection, they played it at the Cavern Club and even tried to record it for their first album.

Production

"Hold Me Tight" was among the songs selected for *Please Please Me* during the recording session on February 11. When the Beatles began the second session of this marathon day, there were still six songs left to record. "Hold Me Tight," the only original composition out of the six, was first in line. Out of thirteen takes, only two were satisfactory. But Martin finally decided not to use it. Reconsidered for their second album, a new attempt at the song began on September 12. The countdown of new takes began again at number 20. Takes 26 and 29 were edited together on September 30 and a first mix was done. The mono mix was finalized on October 23, and the stereo version was completed on October 29.

It seemed that "Hold Me Tight" just didn't motivate the group. It was one of the rare pieces produced

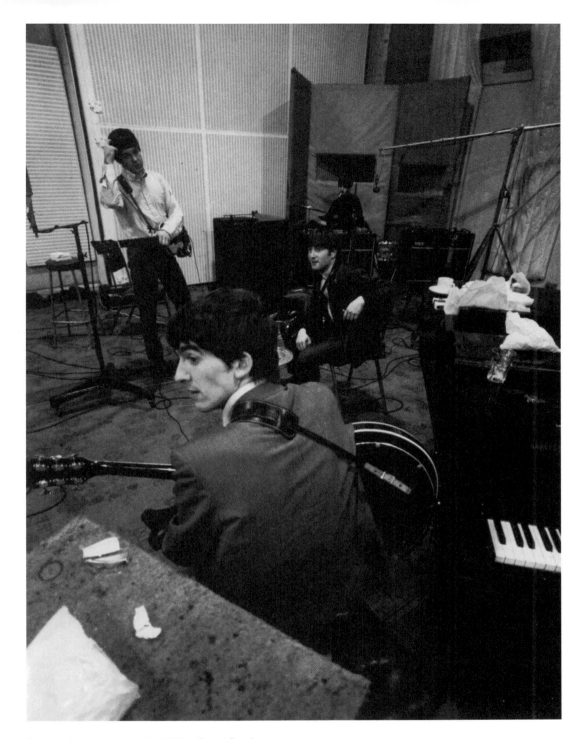

A recording session at the Abbey Road Studios.

with so little dedication: Paul was sometimes bordering on inappropriate; John invariably made mistakes on the sentence *It feels so right now*, which he rendered as *It feels so right so*; George ended up alone on the choruses at 1:27 (*Hold*); the bass did not exist; and the guitars were far from playing in perfect harmony. Probably because it was criticized so much, the piece ended up boring everyone, including George Martin. It was too bad, because if it had been produced properly it could

have had potential, as could be heard in the remake in the film *Across the Universe* (2007). It was the only song, along with "Wait" from Rubber Soul (which was initially recorded for *Help!*), to have been worked on and then relegated to the following album.

1. Miles, *Paul McCartney.*
2. Sheff, *The Playboy Interview with John Lennon & Yoko Ono.*

You've Really Got A Hold On Me

Smokey Robinson / 3:00

MUSICIANS
John: vocal, rhythm guitar
George: vocal, lead guitar
Paul: backing vocals, bass
Ringo: drums
George Martin: piano

RECORDED
Abbey Road: July 18, 1963 (Studio Two) / October 17, 1963 (Studio Two)

NUMBER OF TAKES: 12

MIXING
Abbey Road: August 21, 1963 (Studio Three) / October 29, 1963 (Studio Three)

TECHNICAL TEAM
Producer: George Martin
Sound Engineer: Norman Smith
Assistant Engineers: Richard Langham, Geoff Emerick, B. T. (full name unknown)

A Version They Never Used
The Beatles were not finished with this song: on January 26, 1969, they recorded it again in the Apple studios for the Get Back project during a medley. This version was mixed in stereo the very next day, but was never used!

Genesis

"You've Really Got a Hold on Me" was one of the most famous songs by the Miracles, with Smokey Robinson as a solo singer and Bobby Rogers as second tenor. The story line was about a man who refused to leave the woman he loved, despite the torture she put him through. The song, which was recorded in Motown's studio A on October 16, 1962, came out as side B of "Happy Landing," on November 9. "You've Really Got a Hold on Me" was immediately a favorite of disc jockeys, who made it possible for it to enter the *Billboard* ratings—and then reach first place on the rhythm & blues charts on January 12, 1963—the day after the Beatles' second single appeared in Great Britain.

Eighteen days after recording "She Loves You" / "I'll Get You," the Beatles returned to Abbey Road for their new album. Lennon, who was a fan of the leader of the Miracles, wanted to do a remake of "You've Really Got a Hold on Me." The Fab Four were all very receptive to Smokey's talent and their version, which is quite close to the original, nevertheless had a unique power that made it one of the group's best covers. Robinson always considered this remake as a great honor and credited the Beatles for recognizing the musical contributions of black American artists.

Production

The first song to open the sessions of their second album, "You Really Got a Hold on Me" was worked on by the Beatles as early as Thursday, July 18. Everyone liked the song, including George Martin, who accompanied them on piano. John delivered a superb vocal, supported by George Harrison, who harmonized his voice, and by Paul, who stepped

Paul McCartney and George Harrison in action. Both of them sang backing vocals on the version of "You've Really Got a Hold on Me" by Smokey Robinson.

in for the choruses. The whole song worked rather well and seven takes were required to land the basic track. Four overdubs were then recorded to perfect the performance of the word *Baby*, which ended the choruses, and fine-tune the riffs at the end of the piece. Editing of the seventh, tenth, and eleventh takes was done on August 21, followed the same day by a mono mix. But before going on to the stereo mix on October 29, the Beatles returned to the song on October 17, right after "I Want to Hold Your Hand." After first using a four-track tape recorder on that song, Lennon wanted to use it on "You've Really Got a Hold on Me." Geoff Emerick reported that John must have naively believed that going from a two-track to a four-track tape recorder could improve the song. They tried a final twelfth take. The edit of the different takes from August 21 became the final master.

I Wanna Be Your Man

Lennon-McCartney / 1:56

SONGWRITER
Paul

MUSICIANS
Ringo: vocal, drums, maracas, tambourine (?)
John: backing vocals, rhythm guitar
Paul: backing vocals, bass
George: lead guitar
George Martin: Hammond organ

RECORDED
Abbey Road: September 11–12 and 30, 1963 (Studio Two) / October 3 and 23, 1963 (Studio Two)

NUMBER OF TAKES: 16

MIXING
Abbey Road: October 23 and 29, 1963 (Studio Two)

TECHNICAL TEAM
Producer: George Martin
Sound Engineer: Norman Smith
Assistant Engineers: Richard Langham, Geoff Emerick, B. T. (full name unknown)

Genesis

Other than "Boys," Ringo did not have any new songs in his repertoire. Paul had in stock an unfinished song, called "I Wanna Be Your Man," that could suit Ringo and was vaguely inspired by "Fortune Teller" by Benny Spellman. But this piece had a peculiar fate. The night before its recording, which was scheduled for September 11, John and Paul met Andrew Loog Oldham, the manager of the Rolling Stones, at the door of the Savoy Hotel in London. He explained to them that his musicians were desperately searching for a new song to follow "Come On," their first single, which had been released on June 7, 1963. The two Beatles offered him "I Wanna Be Your Man," which they believed fit the style of the Stones. They immediately left to join the Stones, who were rehearsing at studio 51 and, under their bewildered eyes, completed the song in a corner of the room. Oldham remembered that the bridge was finished in the studio. "Right in front of their eyes we did it."[1] In his biography, which was published in 2010, Keith Richards related: "[John and Paul] played it through with us. Brian put on some nice slide guitar; we turned it into an unmistakably Stones rather than Beatles song. It was clear that we had a hit almost before they'd left the studio."[2]

According to John, it was at this moment that the author-composer duo of Mick and Keith was born. Seeing them return with their completed song, they apparently exclaimed: "Jesus, look at that. They just went in the corner and wrote it and came back!"[3]

Paul had a slightly different version of the story. According to him, as he was walking with John along Charing Cross Road after eating lunch at the Savoy Hotel, they noticed Mick and Keith in a taxi, accompanied them to their rehearsal, and that is when Mick supposedly asked them for a song for their next single.

Whichever is the case, the Stones released the single on November 1, and it debuted at twelfth place on the British charts.

Production

Offered the night before to the Rolling Stones, "I Wanna Be Your Man" was the first song to be recorded by the Beatles on September 11. The Beatles performed only one take on that day. The very next day, they returned to it, and six other takes were recorded. On September 30, George Martin, alone, added a Hammond organ part, while the Beatles were on vacation. There was a new session on October 3 with Ringo on maracas. Finally, on October 23, after one last take (number 16), the piece was mixed in mono on the very same day and then in stereo on October 29.

In order to give it a Bo Diddley flavor, John used very accentuated tremolo on his rhythm guitar. Ringo's maracas also helped. But the whole song remained rather banal and was not especially convincing. Ringo nevertheless played it for a long time onstage, including at the Hollywood Bowl and during the Beatles' last tour in 1966.

FOR BEATLES FANATICS

On the fifth and sixth lines (around 1:13 of the stereo version) hand claps can be heard in the distance on Ringo's track (the right channel). Was this track not edited properly or was it the enthusiasm of his colleagues who were supporting their drummer as he sang?

Technical Details

In order to avoid leakage from the other instruments during Ringo's vocal recording, Norman Smith used a different recording technique than he had used on "Boys." All the instruments were recorded on the first track of the Twin Track tape recorder, so he could leave the second track entirely free for Ringo's voice (which was doubled).

1. Andrew Loog Oldham, *Rolling Stoned* (Paris: Flammarion, 2006).
2. Keith Richards, *Life* (Paris: Robert Laffont, 2010).
3. *The Beatles Anthology*.

Devil In Her Heart

Richard Drapkin / 2:24

MUSICIANS
George: vocal, lead guitar
John: backing vocals, rhythm guitar
Paul: backing vocals, bass
Ringo: drums, maracas

RECORDED
Abbey Road: July 18, 1963 (Studio Two)

NUMBER OF TAKES: 6

MIXING
Abbey Road: August 21, 1963 (Studio Three) / October 29, 1963 (Studio Three)

TECHNICAL TEAM
Producer: George Martin
Sound Engineer: Norman Smith
Assistant Engineers: Richard Langham, Geoff Emerick, B. T. (full name unknown)

FOR BEATLES FANATICS

You can hear George's false start on guitar at 2:04 exactly!

Genesis

"Devil in His Heart" was a composition by Richard Drapkin, who recorded it under the name of Ricky Dee. The Donays, a rhythm & blues group from Detroit, recorded it in 1962 for Correctone Records. The New York label Brent bought the rights for it a few weeks later and released it again in August under the title "[There's a] Devil in Her Heart," on side B of "Bad Boy." The single was then marketed in Great Britain with Oriole, but did not make the charts. It was the only recording by the Donays. At NEMS, Brian Epstein's record store, the Beatles discovered this record, as well as many others. The store was full of American imports, which were often as obscure in their own country as in Great Britain. "That's where we found artists like Arthur Alexander and Ritchie Barrett. . . . 'Devil in Her Heart' and Barrett Strong's 'Money' were records that we'd picked up and played in the shop and thought were interesting."[1] As a result, the Beatles made Drapkin very happy, because his song would probably have never had such coverage and such success without them.

Production

Recorded on July 18 during the first session of the album, "Devil in Her Heart" was one of the three songs performed by George on this album. The Beatles carried out the recording of the basic track in barely three takes: it was faster than the original version and adapted to a female audience. Then three overdubs were done, to double George's voice and add maracas. The mono mix was completed on August 21, and the stereo on October 29.

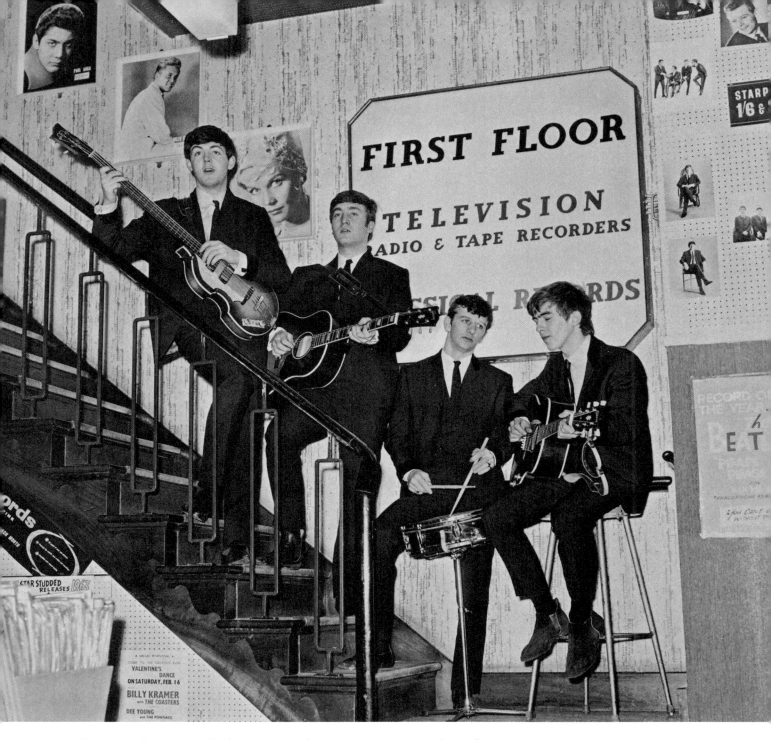

The Beatles on the stairs at NEMS, Brian Epstein's record store in Liverpool, in 1964. This was where they discovered American music and heard Richard Drapkin's "Devil in Her Heart" for the first time. They recorded it on July 18, 1963.

Technical Details

On one of the three overdubs, George Martin wanted George to redo the second sentence of the first couplet (*But her eyes they tantalize*). For this Martin asked him only to sing this sentence, while Norman Smith dubbed it into the song. On one of the two tracks of the Twin Track, he started recording at the point of entry of the sentence and stopped at the exit point. "This was a primitive version of 'punching in' to fix a small section of a recording."[2]

1. *The Beatles Anthology.*
2. Ryan and Kehew, *Recording the Beatles.*

Not A Second Time

Lennon-McCartney / 2:04

SONGWRITER
John

MUSICIANS
John: vocal, rhythm guitar
Paul: bass
George: rhythm guitar
Ringo: drums
George Martin: piano

RECORDED
Abbey Road: September 11, 1963 (Studio Two)

NUMBER OF TAKES: 9

MIXING
Abbey Road: September 30, 1963 (Studio Two) /
October 29, 1963 (Studio Three)

TECHNICAL TEAM
Producer: George Martin
Sound Engineer: Norman Smith
Assistant Engineers: Richard Langham, Geoff Emerick,
B. T. (full name unknown)

FOR BEATLES FANATICS

Times of London music critic William Mann, whom John called an imbecile in 1965, caused a scandal in musical circles by claiming that the Fab Four were the greatest composers since Schubert!

Genesis

A song totally written by John, "Not a Second Time" was one of the best songs on the album, although it was unfairly underestimated. Nevertheless, this song had caught the attention of those in artistic intellectual circles, thanks to an article by the celebrated *Times of London* critic, William Mann, who wrote in an article on December 23, 1963: "Harmonic interest is typical of their [the Beatles'] quicker songs, too, and one gets the impression that they think simultaneously of harmony and melody, so firmly are the major tonic sevenths and ninths built into their tunes, . . . so natural is the Aeolian cadence at the end of 'Not a Second Time' (the chord progression which ends Mahler's Song of the Earth)."[1] In 1965, John called him an imbecile but admitted that this article made it possible for them to reach a new audience. "It works and we were flattered. I wrote 'Not a Second Time' and, really, it was just chords like any other chords. To me, I was writing a Smokey Robinson–type tune or something at that time."[2] Indeed! The leader of Motown at that time was then one of his major influences. After "All I've Got to Do" and "You've Really Got a Hold on Me," it was the third song on the album that implicitly honored him. Enough to believe in Miracles . . .

Production

Recorded in nine takes, "Not a Second Time" began the second session of the day at 7:30 P.M. After a break, the Beatles worked on the song on Wednesday, September 11. This time, only John sings, while supplying the rhythm on his Gibson J-160 E. Contrary to what some people claim, George is very much present and provides the main guitar work. It is easy to check this

Paul, John, and George during a press conference at the Southend Odeon Cinema on December 9, 1963. "Not a Second Time," recorded three months earlier, made it possible for the Beatles to conquer the British intelligentsia.

in the stereo version: right from the intro, the sound of George's Gretsch is obvious as well as John's Gibson J-160E, which is audible in the background on the right (at 0:03). Paul is on bass (but not on vocal harmony) and Ringo is on drums. The fifth take was used as the basis for the different overdubs. Four other takes were required to complete the piece, with John doubling his own voice (going out of time in the coda after 1:58) and George Martin on piano, playing the solo. The ninth take was mixed in mono on September 30 and in stereo on October 29.

1. *The Beatles Anthology.*
2. Ibid.

Money (That's What I Want)

Berry Gordy–Janie Bradford / 2:49

MUSICIANS
John: vocal, rhythm guitar, hand claps
Paul: backing vocals, bass, hand claps
George: backing vocals, lead guitar, hand claps
Ringo: drums, hand claps
George Martin: piano

RECORDED
Abbey Road: July 18 and 30, 1963 (Studio Two) / September 30, 1963 (Studio Two)

NUMBER OF TAKES: 14

MIXING
Abbey Road: August 21, 1963 (Studio Three) / October 29–30, 1963 (Studio Three)

TECHNICAL TEAM
Producer: George Martin
Sound Engineer: Norman Smith
Assistant Engineers: Richard Langham, Geoff Emerick, A. B. Lincoln, B. T. (full name unknown)

FOR BEATLES FANATICS

Despite a strong piano performance by George Martin, he made several mistakes. Around 2:14 (stereo mix), he can be heard forgetting the chord changes.

Genesis

Singer Barrett Strong, a longtime friend of Berry Gordy (founder of Motown) and composer Janie Bradford, was an important contributor to the success of the Detroit record company in the first half of the sixties. Masterpieces, such as "I Heard It through the Grapevine," "War," and "Papa Was a Rolling Stone," all bore the trademark of his rich partnership with Norman Whitfield. What is not so well known, however, is that Motown owed him one of its very first hits. Coming out in 1959 with Anna Records, then with Tamla the following year, "Money" entered the rhythm & blues charts as early as March 1960. It turned out to be the last song performed by Strong.

Several people accused John of wanting "to be rich and famous"[1] because he decided to remake this song. But although John wanted recognition right from the start of his career, his position regarding money was never as categorical as that and it is more likely that his remake of "Money" was motivated by its considerable musical power rather than by its message. With this piece, John tried to repeat the success of "Twist and Shout." The delivery was wild—John's voice roared. "Money" was one of the group's best covers.

Production

"Money" was a song that the Beatles were familiar with; they had played it in Hamburg, and it was part of the fifteen songs in the Decca audition on January 1, 1962. When they undertook to record it on July 18, they did it live in seven takes, George Martin supplying the piano part. John, in top form, added some ad libbed vocals in the coda, stating, *I want to be free.* On July 30, George Martin recorded additional piano overdubs, which

Berry Gordy, founder of Detroit's Motown and composer of "Money (That's What I Want)," a song interpreted by the Beatles well before the recording of their second opus.

reinforced the song's riff. On August 21, after having edited takes 6 and 7, the song was mixed in mono. Strangely enough, Martin returned alone to his piano part on September 30. Three attempts were done by overdubbing on take 7. Then came October 29, the day scheduled for the stereo mix of the whole album, including "Money." Dissatisfied, Martin came back to it the very next day and produced the final stereo mix using two Twin Track tape recorders simultaneously, whose playback he recorded on a third machine in order to preserve the quality of the sound. The need for a real multitrack system was becoming critical.

1. *The Beatles Anthology.*

1964

A DAY IN

HARD 'S GHT

A Hard Day's Night
I Should Have Known Better
If I Fell
I'm Happy Just to Dance With You
And I Love Her
Tell Me Why
Can't Buy Me Love
Any Time at All
I'll Cry Instead
Things We Said Today
When I Get Home
You Can't Do That
I'll Be Back

ALBUM

RELEASED

Great Britain: July 10, 1964 / No. 1 for 21 weeks,
starting on July 25, 1964
United States: June 26, 1964 / No. 1 for 14 weeks,
starting July 20, 1964, under the title *Something New*

The First IOO Percent Lennon-McCartney Album

The José Ramirez classical guitar used by George during the recording of "A Hard Day's Night."

This third album by the group was the first to be entirely written by Lennon-McCartney. Although George had made an attempt at composition with "Don't Bother Me" on the preceding album, he did not write any songs for this album. Nor did Ringo have a chance to sing here, either. John and Paul ruled exclusively on this album. John was even dominant over his partner, because he wrote or cowrote ten of the thirteen songs. He admitted in a 1964 interview that writing the music for the movie with Paul was a pleasure, even though the deadlines were too tight: "We managed to finish two songs while we were in Paris, and three others in the United States under the sunshine at Miami Beach." Only the first seven songs were used in the film; the others were published on side 2 of the 33 rpm record. As for George Martin, he orchestrated instrumental adaptations of the songs.

John and Paul had made great strides in their writing. The harmonies became more complex ("If I Fell," "Things We Said Today"), the lyrics more personal and darker ("I'll Cry Instead," "I'll Be Back"). Paul confirmed his talent for writing melodies ("And I Love Her"), as did John ("If I Fell," "I'll Be Back"). Each of the two singles taken from the record exceeded a million sales ("A Hard Day's Night," "Can't Buy Me Love"). Recorded in Paris during the group's performance at the Olympia, "Can't Buy Me Love" solidified the popularity of the Beatles in the United States. They continued to break sales records. They received two Grammy Awards—for Performance by a Vocal Group and for Best New Artists for 1964. The album came out on July 10 in Great Britain. As early as July 25, it reached first place for twenty-one weeks on the other side of the English Channel and for fourteen weeks in the United States. The Beatles ruled the world and opened the door for the British Invasion.

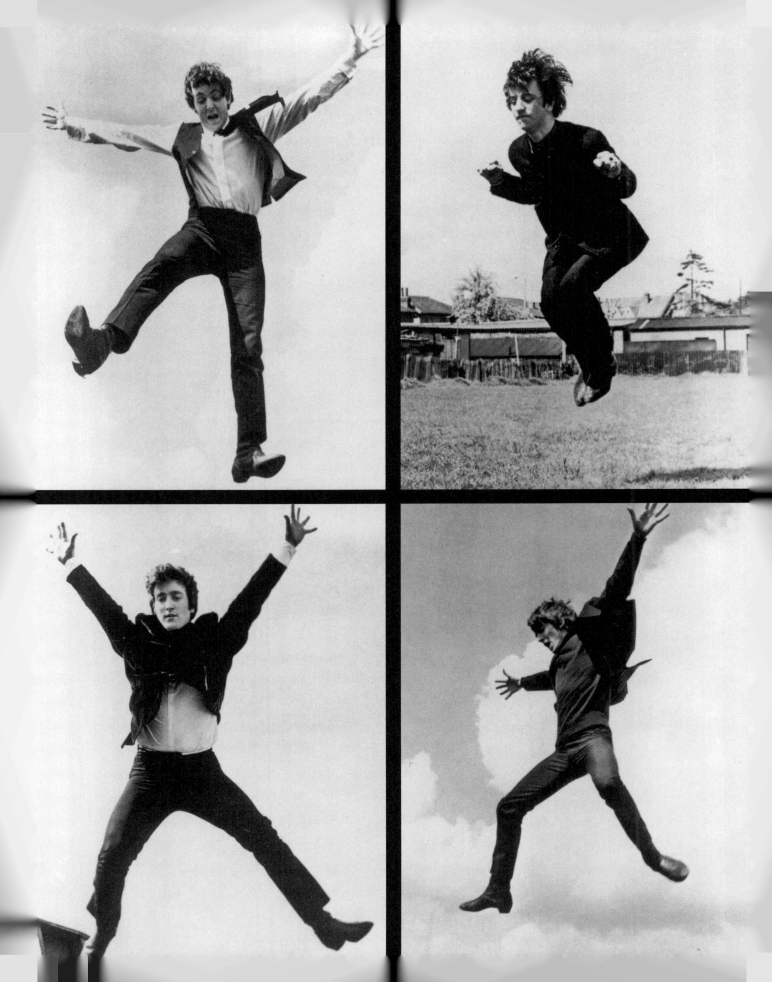

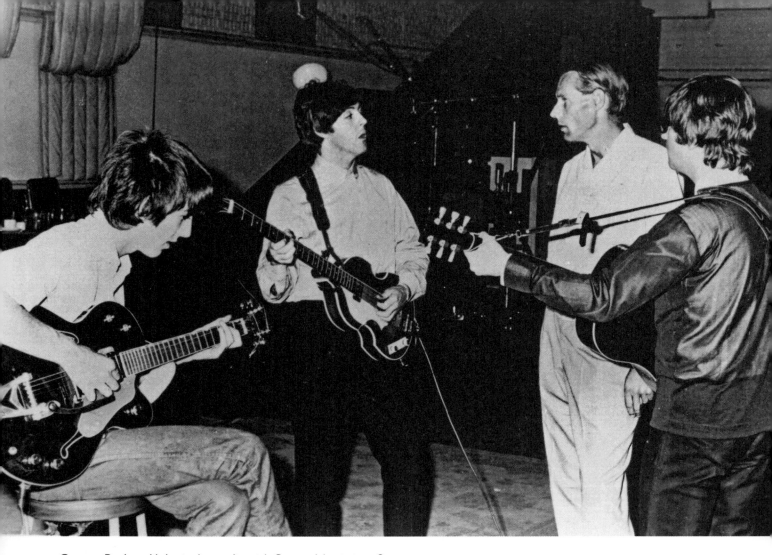

George, Paul, and John in the studio with George Martin in 1964.

The Movie

Brian Epstein wanted his musicians to perform in a movie. Richard Lester was selected as the director and Alun Owen as the scriptwriter. Filming began on Monday, March 2, and ended on Friday, April 24. During these eight weeks, the Beatles went through their initiation on camera. The theme was to follow the group in its everyday life. Scenes of Beatlemania, laid-back humor, freshness: the magic worked and the film was a success. United Artists, which produced it, made huge profits from it, especially since production costs were relatively low at that time (£200,000 [$303,000 U.S.]) The Beatles themselves only received a salary. The premiere took place on July 6 at the London Pavilion. The Academy Awards gave the movie two prizes: one to Alun Owen for Best Original Script and the second one to George Martin for Best Sound-track. The Beatles received nothing.

The Instruments

In 1964, it was the year for Rickenbackers. Although Paul kept his old 1963 Hofner, he was offered a Rickenbacker 4001 bass for the first time. For some unknown reason, he only started using it during the summer of 1965. George, bedridden in his hotel room with the flu the night before *The Ed Sullivan Show* on February 9, remembered seeing John walk in with a Rickenbacker 360/12, an extraordinary electric twelve-string guitar that he wanted George to try. It was love at first sight; he started using it right away. Better still, this guitar became the distinctive trademark of the group for the next two years. Described as the "Beatles' secret weapon," it influenced many American musicians, such as Roger McGuinn of the Byrds. A big fan of Andrés Segovia, George also wanted to play classical guitar, so he bought a José Ramirez model. As for John, he was not left out, since he traded in his Rickenbacker 325 of the early years for an identical model, dated 1964. Both of them kept their electric/acoustic guitars, Gibsons J-160 E. The amplifiers were Vox AC-50 and AC-100. Meanwhile, Ringo stayed loyal to his Ludwig Oyster Black Pearl drum kit.

The Beatles' secret weapon, the Rickenbacker 360/12.

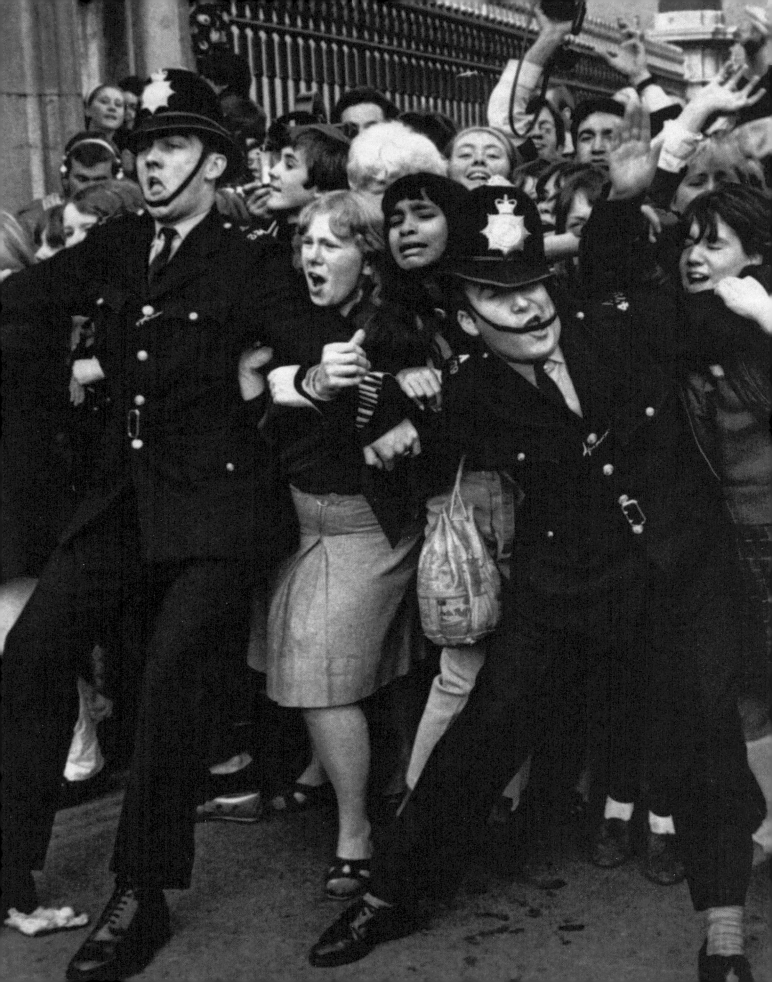

George: "That year, during the tours, it was demented. Not within the group. In the group, we were normal. But the rest of the people were crazy." Opposite, a regular scene of Beatlemania. Above, Paul reading a fan magazine about the Beatles.

A Hard Day's Night

Lennon-McCartney / 2:29

SONGWRITER
John

MUSICIANS
John: vocal, rhythm guitar
Paul: vocal, bass
George: lead guitar
Ringo: drums, cowbell, bongos (?)
George Martin: piano
Norman Smith: bongos (?)

RECORDED
Abbey Road: April 16, 1964 (Studio Two)

NUMBER OF TAKES: 9

MIXING
Abbey Road: April 20 and 23 (Studio Two) / June 9, 1964 (Studio Three) / June 22, 1964 (Studio One)

TECHNICAL TEAM
Producer: George Martin
Sound Engineer: Norman Smith
Assistant Engineers: Richard Langham, Geoff Emerick, A. B. Lincoln, David Lloyd, Ken Scott

RELEASED AS A SINGLE

"A Hard Day's Night" / "Things We Said Today"
Great Britain: July 10, 1964 / No. 1 on July 23, 1964
United States: July 13, 1964 / No. 1 on August 1, 1964

Genesis

Around March 19, Ringo stumbled onto the title of the movie and its theme song, "A Hard Day's Night." He said in an interview: "We'd worked all day and we happened to work all night. I came up still thinking, it was day, I suppose, and I said, 'It's been a hard day . . .' and I looked around and saw it was dark so I said, '. . . night!'" When Richard Lester heard this expression, he knew he had the title of his movie. On April 15 the filming was drawing to an end, but they still did not have a theme song. Lester asked the Beatles for one. Recalls John: "The next morning I brought in the song. 'Cause there was a little competition between Paul and me as to who got the A side, who got the hit singles."[1] It was recorded the next day, and on April 17 the announcement was released to the press: the movie would be called *A Hard Day's Night*.

Production

On April 16 the Beatles entered the studio to record this song, which, according to John, had been written the night before. On the first track, they concentrated on the rhythm section (acoustic and electric guitars, bass, and drums) and despite four false starts, only nine takes were required to finalize it. Ringo impressed Geoff Emerick with his power. John and Paul simultaneously recorded their vocals on the second track. John explained later, in 1980, that Paul was singing the high notes (*When I'm home, everything seems to be all right*), since John could not manage to do so. On the four initial takes of the piece, George used the echo of his twelve-string Rickenbacker for the first time, in order to reinforce the intensity of the intro chord, but

1. Sheff, *The Playboy Interview with John Lennon & Yoko Ono.*

1964

Hair grooming session for the Beatles during the filming. George's future wife, Pattie Boyd, can be seen right behind George.

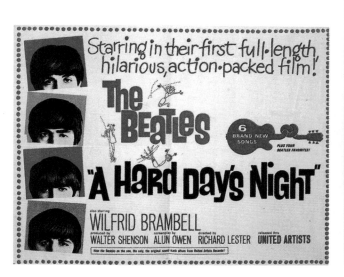

A poster for Richard Lester's feature film, which opened in Great Britain on July 6, 1964.

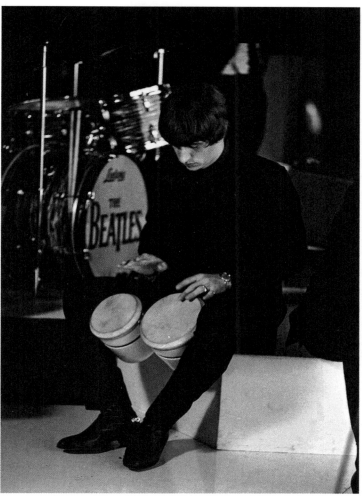

During the filming of *A Hard Day's Night*, Ringo plays the bongos, but it was Norman Smith who played them on the eponymous song.

this effect was not kept (it was not used until "Everybody's Trying to Be My Baby" on the following album). Lester strongly insisted that the intro of the piece be more "cinematic." Finally, this famous chord—a D major 7th sus 4—came from the mixture of John and George's guitars, Paul's bass, and George Martin's piano. In the guitar solo, George, who was not inspired or who was irritated by Lester's constant barging in, was struggling. Martin suggested that he come back to it later. The third track was then set aside for various overdubs: John doubled his Gibson J-160 E as well as the vocal parts he shared with Paul; a cowbell and bongos were added at the same time. With the first three tracks completed, George could now concentrate on his guitar work. Martin decided to do the same thing as he did on "Misery." He slowed down the tape recorder by

half to facilitate George's solo, which he doubled himself on piano, both of them playing together in unison and one octave lower. At the normal speed, both instruments sounded more clear, dynamic, and incisive. Lester wanted a dreamlike effect at the end of the song to connect with the first sequence of the film. George then picked up his twelve-string once again and on the slightly slower track, recorded a series of arpeggios that corresponded to the director's wishes. The song was finally completed; it was recorded in three hours! Afterwards, there were several mixes, some produced for the movie and others for the record. The final mono mix came from the session on April 23, and the stereo was made on June 22.

2. Ryan and Kehew, *Recording the Beatles*.

I Should Have Known Better

Lennon-McCartney / 2:41

SONGWRITER
John

MUSICIANS
John: vocal, rhythm guitar, harmonica
Paul: bass
George: lead guitar, rhythm guitar
Ringo: drums

RECORDED
Abbey Road: February 25–26, 1964 (Studio Two)

NUMBER OF TAKES: 22

MIXING
Abbey Road: March 3, 1964 (Studio One) / June 22, 1964 (Studio One)

TECHNICAL TEAM
Producer: George Martin
Sound Engineer: Norman Smith
Assistant Engineers: Richard Langham, Geoff Emerick, A. B. Lincoln

FOR BEATLES FANATICS

It was in the scene in the train car in *A Hard Day's Night,* and to the sound of "I Should Have Known Better," that Pattie Boyd, dressed like a high school girl, met George Harrison, her future husband.

Genesis

John admitted to David Sheff in 1980 that "I Should Have Known Better" was "just a song; it doesn't mean a damn thing."[1] In 1964 he counted it as one of his favorites in *A Hard Day's Night*: "There are four I really go for: 'Can't Buy Me Love,' 'If I Fell,' 'I Should Have Known Better,' . . . and 'Tell Me Why.'"[2] Even if the lyrics were not among his best, the melody was rather catchy. Besides, it was this piece that was at the beginning of the first sung scene in the movie. Like "Love Me Do," John was inspired by "Hey! Baby" by Bruce Channel. The harmonica intro and the beginning of the melody were relatively close.

Bruce Channel.

George Harrison and Pattie Boyd met during the filming of the Richard Lester movie.

Production

Recorded in three takes on February 25, during the first session set aside for the new album, "I Should Have Known Better" provoked the laughter of Paul, George, and Ringo because John was clowning around, according to Mark Lewisohn. Out of these three takes, a single one was complete. John supplied the singing, the rhythm guitar work, and the harmonica playing (diatonic in C). Paul was on bass, George on rhythm guitar and on electric (on his twelve-string Rickenbacker), and Ringo on drums. John was not satisfied with the results. Therefore, the group redid it the next day during a marathon session. Nineteen other takes were recorded, but very few of them went beyond the bridge. Finally, the ninth take was used as the basis for the various overdubs. John doubled his voice, without Paul's help, and supplied his harmonica part independent of the singing. On this song, John produced his last real riff on harmonica, the later harmonica playing being only accompaniments ("Rocky Raccoon," "All Together Now") or solos ("I'm a Loser"). The mono mix was carried out on March 3 and the stereo on June 22. In the latter (on the left channel), there was a mistake in the edit at exactly 2:15.

1. Sheff, *The Playboy Interview with John Lennon & Yoko Ono.*
2. *The Beatles Anthology.*

If I Fell

Lennon-McCartney / 2:18

SONGWRITER
John

MUSICIANS
John: vocal, rhythm guitar
Paul: vocal, bass
George: lead guitar
Ringo: drums

RECORDED
Abbey Road: February 27, 1964 (Studio Two)

NUMBER OF TAKES: 15

MIXING
Abbey Road: March 3, 1964 (Studio One) / June 22, 1964 (Studio One)

TECHNICAL TEAM
Producer: George Martin
Sound Engineer: Norman Smith
Assistant Engineers: Richard Langham, Geoff Emerick, A. B. Lincoln

1964

Contract Clauses
For A Hard Day's Night, a contract clause prevented the Beatles from courting women in order not to let down their female admirers. So to sing "If I Fell," John asked Ringo to do it, which caused much giggling on the film set!

Genesis

"If I Fell," which was mainly written by John, was a superb ballad that once again revealed his taste for melodies, and especially harmonies for several voices. This technique, which was hinted at in "This Boy," became apparent in the sublime "Because" in 1969. Paul realized that John was hiding beneath his acerbic and wincing mask a warm personality that he never wanted to reveal, lest he be rejected: "We wrote 'If I Fell' together but with the emphasis on John because he sang it. It was a nice harmony number."[1] As for John, he found in this song the seeds of "In My Life." "It has the same chord sequence as 'In My Life': D and B minor and E minor, those kinds of things. And it's semiautobiographical, but not consciously. It shows that I wrote sentimental love ballads, *silly love songs*."[2] Through semiautobiographical allusions, John implied his frequent tantrums and his unhappy marriage with Cynthia. In 1968, he admitted he had been too cowardly to leave her and live on his own.

Production

Recorded in fifteen takes on February 27, "If I Fell" developed as it was being recorded. Right from the third take, George Martin suggested they add some drums. At the eleventh take, John inserted his intro, accompanied by his Gibson J-160 E and George's Rickenbacker. The fifteenth take was the final one. What was significant in this song were the incredible vocal performances of John and Paul, especially since, at their request, they sang together on the same mike in order to preserve the unity of their voices. The results are really successful (on the stereo version, however, you can hear Paul's voice cracking at 1:45). The mono

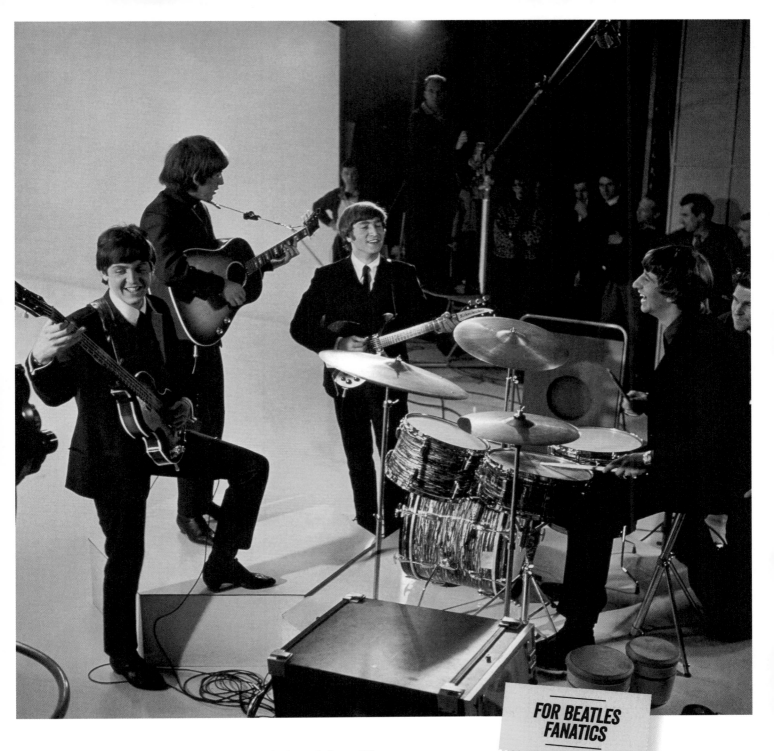

and stereo mixes followed on March 3 and June 22. Despite the difficulty of the vocals, the Beatles did not hesitate to play "If I Fell" in public, for example, at the Hollywood Bowl concerts in 1964 and 1965 (without, however, including it on the 1977 record).

FOR BEATLES FANATICS

Kurt Cobain of Nirvana loved this song and performed it in concert every time there was a technical problem.

1. Miles, *Paul McCartney.*
2. Sheff, *The Playboy Interview with John Lennon & Yoko Ono.*

I'm Happy Just To Dance With You

Lennon-McCartney / 1:55

SONGWRITER
John

MUSICIANS
George: vocal, rhythm guitar
John: backing vocals, rhythm guitar
Paul: backing vocals, bass
Ringo: drums, tom bass

RECORDED
Abbey Road: March 1, 1964 (Studio Two)

NUMBER OF TAKES: 4

MIXING
Abbey Road: March 3, 1964 (Studio One) / June 22, 1964 (Studio One)

TECHNICAL TEAM
Producer: George Martin
Sound Engineer: Norman Smith
Assistant Engineers: Richard Langham, Geoff Emerick, A. B. Lincoln

FOR BEATLES FANATICS

"I'm Happy Just to Dance with You" had the honor of being the first song recorded on a Sunday, which was a totally new practice at EMI in those days! It should be mentioned that the very next day, the Beatles were to begin filming the movie. Therefore, it was urgent!

Genesis

"We wrote 'I'm Happy Just to Dance with You' for George in the film. It was a bit of a formula song. . . . We wouldn't have actually wanted to sing it,"[1] Paul explained. John, who was nevertheless the author, also stated in 1980 that he could not have sung it. Neither he nor Paul were very concerned with the songs written for George, their own priorities being more egocentric. "George had his fans, so we would write a song for him. Nothing more, nothing less." "I'm Happy Just to Dance with You" was the last song that John and Paul wrote for him, because, starting in 1965, he wrote his own compositions.

Production

This song was worked on the day before the first day of filming of *A Hard Day's Night*. The Beatles concentrated on the rhythmic track of the song. Based on the staged performance in the movie, John played electric guitar on his Rickenbacker 325, while George played his Gibson J-160 E. Paul was on bass and Ringo on drums. Once the first two takes were recorded, George recorded his vocal, then doubled his voice, while John and Paul shared the vocal harmony. Finally, Ringo added a tom tom beat. The song was completed in only four takes. It was the only song on the record sung by George. Ringo had no vocals on the album. The mono mix was carried out on March 3, and the stereo mix on June 22.

1. Miles, *Paul McCartney.*

And I Love Her

Lennon-McCartney / 2:28

SONGWRITER
Paul

MUSICIANS
Paul: vocal, bass
John: rhythm guitar
George: classical guitar
Ringo: bongos, claves

RECORDED
Abbey Road: February 25–27, 1964 (Studio Two)

NUMBER OF TAKES: 21

MIXING
Abbey Road: March 3, 1964 (Studio One) / June 22, 1964 (Studio One)

TECHNICAL TEAM
Producer: George Martin
Sound Engineer: Norman Smith
Assistant Engineers: Richard Langham, Geoff Emerick, A. B. Lincoln

FOR BEATLES FANATICS

In the superb documentary filmed in 2011 by Martin Scorsese, *George Harrison: Living in the Material World,* Paul revealed that George was the author of the guitar riff on "And I Love Her."

Genesis

Written in the small music room of the Asher family at 57 Wimpole Street, in London, "And I Love Her" was Paul's first ballad, the first of a long series that made him one of the greatest melody composers of pop music. He admitted that he was surprised by the song and loved the chords and images it generated: "I like the imagery of the stars and the sky."[1] Despite his relationship with Jane Asher in those days, to whom he was engaged, he claimed in 1984, "It was a love song, really, written for no one in particular."[2] The title also played an important role: "The 'And' in the title was an important thing. 'And I Love Her,' it came right out of left field, you were right up to speed the minute you heard it."[3]

Dick James, their editor at the time, apparently remembered John and Paul asking for a break in the middle of the recording session in order to write a bridge in a corner of the studio. John claimed in 1972 that he had written the bridge of "And I Love Her," before recanting and being more subtle in 1980, when he claimed instead: "The middle eight, I helped with that."[4] Paul agreed: "The middle eight is mine. I would say that John probably helped with the middle eight, but he can't say 'It's mine.'"[5] From Smokey Robinson to Diana Krall, "And I Love Her" has been the subject of numerous covers throughout the world. Paul's favorite version was Esther Phillips's "And I Love Him."

Production

"And I Love Her" was recorded in two takes on February 25. Only the second one was complete. But the version was not satisfactory: the Beatles were searching for the right arrangement. The piece did not yet have the charm and lightness of the final version. George was on his twelve-string Rickenbacker, and Ringo supplied a regular rhythm on drums (See *Anthology 1*). The riff that was

Jane Asher may be the young actress who inspired Paul to write "And I Love Her."

so characteristic on guitar had not been found yet, and there was no bridge. The Beatles decided to return to it the next day. Sixteen other takes were then recorded. Ringo gave up his Ludwig to play claves and bongos. But the song still did not sound right. It appears that it was during this session that the bridge was added and George switched to his José Ramirez classical guitar. Paul said to Barry Miles, "George played really good guitar on it. It worked very well."[6] They reworked the song on February 27 and at the end of the twenty-first take, the group was finally satisfied. Interestingly, in the final version, the doubling of Paul's voice suddenly disappears between 1:08 and 1:17. Was this due to a failed "punch in" or an accidental deletion? The first mono mix took place on

March 3, for the record as well as for the movie. United Artists needed the completed songs for filming. The final mono and stereo mixes were completed on June 22.

Technical Details

Norman Smith captured the warmth of Paul's voice by means of the Neumann U 48 microphone, which he passed through the EMI RS114 limiter, one of his favorite effects.

1. Miles, *Paul McCartney.*
2. Ibid.
3. Ibid.
4. Sheff, *The Playboy Interview with John Lennon & Yoko Ono.*
5. Miles, *Paul McCartney.*
6. Ibid.

And the Beach Boys Tell the Story

"Tell Me Why" was one of the favorite songs of Brian Wilson, the brilliant composer from the Beach Boys, who did a remake of it on the Beach Boys' Party! album in 1965. It was probably its doo-wop aspect that attracted Brian.

Tell Me Why

Lennon-McCartney / 2:06

SONGWRITER
John

MUSICIANS
John: vocal, rhythm guitar
Paul: backing vocals, bass
George: backing vocals, lead guitar
Ringo: drums
George Martin: piano (?)

RECORDED
Abbey Road: February 27, 1964 (Studio Two)

NUMBER OF TAKES: 8

MIXING
Abbey Road: March 3, 1964 (Studio One) / June 22, 1964 (Studio One)

TECHNICAL TEAM
Producer: George Martin
Sound Engineer: Norman Smith
Assistant Engineers: Richard Langham, Geoff Emerick, A. B. Lincoln

1964

Genesis

In 1980, John admitted having written "Tell Me Why." "It was like a black New York girl-group song."[1] He was no doubt referring to the Shirelles, the Marvelettes, or the Donays, by whom the Beatles were greatly inspired. It was one of the seven songs kept for the *A Hard Day's Night* movie; John wrote it quickly: "They needed another upbeat song and I just knocked it off."[2] In 1964, he considered it one of his four favorite songs (see "I Should Have Known Better"). While the music and the tempo were joyful, the lyrics were definitely darker. Paul felt this song, like many others on the record, evoked in a roundabout way John's relationship problems at that time: "I think a lot of these [Lennon's] songs like 'Tell Me Why' may have been based on real experiences or affairs John was having, or arguments with Cynthia [Lennon's wife] or whatever, but it never occurred to us until later to put that slant on it all."[3]

Production

This song, which was recorded on February 27, after "And I Love Her" and before "If I Fell," did not involve any particular difficulty. The Beatles managed to complete it in barely eight takes, despite the rather complex vocal harmonies. John and George supplied an efficient rhythm section, Paul played a great part on walking bass, and Ringo beat the skins and the cymbals with energy. Only the doubling of John's voice left a bit to be desired, the launching of the choruses not being really in place. It also seems there was a piano in the mix, on the right of the stereo, although the session reports do not mention it. Was it George Martin or Paul? The mono mix of "Tell Me Why" was completed on March 3, and the stereo on June 22.

1. Sheff, *The Playboy Interview with John Lennon & Yoko Ono.*
2. Ibid
3. Miles, *Paul McCartney.*

Can't Buy Me Love

Lennon-McCartney / 2:12

SONGWRITER
Paul

MUSICIANS
Paul: vocal, bass
John: rhythm guitar
George: lead guitar
Ringo: drums

RECORDED
Studios EMI Pathé Marconi: January 29, 1964
Abbey Road: February 25, 1964 (Studio Two) / March 10, 1964 (Studio Two)

NUMBER OF TAKES: 4

MIXING
Abbey Road: February 26, 1964 (Studio Two) / March 10, 1964 (Studio Two)

TECHNICAL TEAM
Producer: George Martin
Sound Engineer: Norman Smith
Assistant Engineers: Jacques Esmenjaud (EMI Pathé Marconi), Richard Langham, Geoff Emerick

RELEASED AS A SINGLE

"Can't Buy Me Love" / "You Can't Do That"
Great Britain: March 20, 1964 / No. 1 on April 2, 1964
United States: March 16, 1964 / No. 1 on April 4, 1964

1. Miles, *Paul McCartney.*
2. Sheff, *The Playboy Interview with John Lennon & Yoko Ono.*
3. Ibid.
4. Ryan and Kehew, *Recording the Beatles.*
5. Martin and Hornsby, *All You Need Is Ears.*

Genesis

Between February 1 and December 31, 1964, the Beatles achieved the amazing feat of positioning six number 1 records on the *Billboard* Hot 100, including "Can't Buy Me Love," which culminated at the top of the charts for five weeks. This had never been done before! This song was composed and recorded in Paris. The Beatles were in the capital of France for nineteen shows at the Olympia. They were staying at the George V Hotel, near the Champs-Élysées, and at their request, a piano was installed in their room so they could work. Paul composed "Can't Buy Me Love" on this piano. "'Can't Buy Me Love' is my attempt to write in a bluesy mode. The idea behind it was that all these material possessions are all very well but they won't buy me what I really want."[1] John, who in 1972 attributed the song to "John and Paul, but principally Paul," acknowledged eight years later "that was entirely Paul's."[2] He added, "Maybe I had something to do with the chorus, but I don't know. I always considered it his song."[3]

Production

On Wednesday, January 29, 1964, for the first and only time during their career, the Beatles recorded in France, at the studios of EMI Pathé Marconi in Boulogne-Billancourt, at 62 rue de Sèvres. Norman Smith did not like this place, where "[There] was absolutely no atmosphere!"[4] Nevertheless, they managed to record the unforgettable German versions of two of their songs ("*Komm Gib Mir Deine Hand*"—"I Want to Hold Your Hand" and "*Sie Liebt Dich*"—"She Loves You") before tackling the latest composition by Paul, "Can't Buy Me Love." George Martin had a brilliant idea: "We need an intro, something that catches the ear immediately. So let's start with the chorus."[5] The Beatles followed his advice and only needed four takes to be satisfied. The

From January 16 to February 4, 1964, the Beatles appeared at the Olympia with French singer Sylvia Vartan, center, and American singer, guitarist, and actor Trini Lopez.

first two takes had a rhythm & blues feel: Paul was looking for a black intonation in his voice, while John and George answered him with very "girl group" choruses. The third take was close to the definitive version when the choruses were dropped. The fourth take was the best one. Paul then recorded his voice on a free track, while George performed a solo on his Gretsch Country Gentleman. On February 25, the Beatles returned to Abbey Road to finalize "Can't Buy Me Love." Meanwhile, the group left to conquer America: the Liverpool four were seen by 73 million television viewers and shook hands with Cassius Clay. Paul doubled his vocal and George rerecorded a new solo, this time on his new twelve-string Rickenbacker. But you could hear behind his solo traces of a previous take coming from a recording made in Paris! The very next day, Martin and Smith proceeded with the mono mix. On March 10, a first stereo mix was completed. But the definitive stereo mix came from the marathon day on June 22. "Can't Buy Me Love" became a colossal success. The single

appeared in the United States on March 16, four days before it came out in Great Britain. As soon as it did, it was immediately a golden record. In less than a week, Capitol sold over 2 million copies of it. On British soil, preorders went beyond a million singles. It was also the first song in the history of records to go directly from twenty-seventh to first place within a week. America went crazy. In the April 11, 1964 edition of *Billboard*, no less than fourteen Beatles songs were rated among the *Hot 100*. This record has never been broken.

(from left) John (on guitar), George, Brian Epstein, Ringo, and Paul in a room at the George V. It was in this Paris hotel that Paul wrote "Can't Buy Me Love."

Any Time At All

Lennon-McCartney / 2:10

SONGWRITER
John

MUSICIANS
John: vocal, rhythm guitar
Paul: bass, piano, backing vocals
George: lead guitar, classical rhythm guitar
Ringo: drums, cowbell

RECORDED
Abbey Road: June 2, 1964 (Studio Two)

NUMBER OF TAKES: 11

MIXING
Abbey Road: June 4, 1964 (Studio Two) / June 22, 1964 (Studio One)

TECHNICAL TEAM
Producer: George Martin
Sound Engineer: Norman Smith
Assistant Engineers: Ken Scott, Richard Langham, Geoff Emerick

FOR BEATLES FANATICS

If you listen carefully, you can make out an extra voice in the solo part at exactly 1:32. Another amusing detail is that John forgot to double his voice (or it got deleted) on the word Any at 1:59.

Genesis

It is extraordinary to realize that, despite a surrealistic year and schedule, John managed to write or cowrite ten songs out of thirteen on the album. "Any Time at All" may be underestimated, but it nevertheless had undeniable power and charm, with a remarkable vocal performance by its author. But John thought this song was only an attempt to compose something along the lines of "It Won't Be Long": "C to A minor, C to A minor—with me shouting,"[1] he said. He completed it shortly before the recording session.

Production

On Tuesday, June 2, the Beatles began the last recording day of *A Hard Day's Night*. The first song the group worked on was "Any Time at All." They recorded the basic track in seven takes, including John's voice. Everyone played their usual instruments, George adding a nylon string classical rhythm guitar and Ringo a cowbell (which was essentially buried in the mix). There was still a bridge missing in the song, so they decided to return to it later. After a break of an hour and a half, which they used to write the bridge, they redid the song after having recorded "When I Get Home." A rarity for the Beatles, the bridge was entirely instrumental: Paul performed it on piano, doubled by George's twelve-string Rickenbacker. Their unfailing efficiency and creativity were obvious here. The eleventh take was the best one. On June 3, there were some additional overdubs. Martin and his team completed two mono mixes, the first on June 4 and a second one, which became the final mix, on June 22, the same day as the stereo mix. The final chord, no doubt, came from the editing of a different take.

1. Sheff, *The Playboy Interview with John Lennon & Yoko Ono.*

I'll Cry Instead

Lennon-McCartney / 1:44

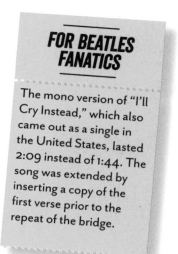

SONGWRITER
John

MUSICIANS
John: vocal, rhythm guitar
Paul: bass
George: lead guitar
Ringo: drums, tambourine

RECORDED
Abbey Road: June 1, 1964 (Studio Two)

NUMBER OF TAKES: 8

MIXING
Abbey Road: June 4, 1964 (Studio Two) / June 22, 1964 (Studio One)

TECHNICAL TEAM
Producer: George Martin
Sound Engineer: Norman Smith
Assistant Engineers: Ken Scott, Richard Langham, Geoff Emerick

Genesis

Paul believed that "I'll Cry Instead" was one of John's songs that consciously or not referred to his marital problems with Cynthia. On the other hand, John explained that this song, like "Tell Me Why" and "Any Time at All," reflected his frustration with success. Worshipped by millions of fans, John felt alone in his gilded cage. He thought his freedom and joie de vivre had vanished—the price of fame, so to speak. The dark lyrics were in contrast with this rather light imitation of country and western music. John was gradually leaving the world of teenage love affairs and plunging into a less serene realism. There was even some violence behind his words. "I'll Cry Instead" was initially planned for the scene in the movie where the Beatles were fooling around in a playground, but Richard Lester chose otherwise. In 1980, John said, "I wrote that for *A Hard Day's Night*, but Dick Lester didn't even want it. He resurrected 'Can't Buy Me Love' for that sequence instead."[1] It seemed apparent that John was hurt because of this. He admitted later that he especially liked the bridge of this song.

Production

Recorded on June 1, "I'll Cry Instead" was unusual in that it was recorded in two parts that were combined afterwards. The reason for this remains mysterious, especially since the song did not involve any special difficulty. Section A required six takes, and section B two takes. Everyone played their usual instruments: John doubled his voice and Ringo added a tambourine. The country flavor of the song was perfect for George's guitar: he delivered a very Chet Atkins type of accompaniment. The qualities of "I'll Cry Instead" meant it was remade several times, and sometimes better than

John and Cynthia Lennon. It seems that the couple's problems were the inspiration for several songs written by John at the time.

the Beatles' version (including by Joe Cocker, Billy Joel, Johnny Rivers, The Shooters). The mono mix was done on June 4, the stereo on June 22, and, just like the recording, they were done piecemeal, before being combined.

1. Sheff, *The Playboy Interview with John Lennon & Yoko Ono.*

In the Caribbean, Paul composed "Things We Said Today," a song about his relationship with Jane.

Things We Said Today

Lennon-McCartney / 2:35

SONGWRITER
Paul

MUSICIANS
Paul: vocal, bass, rhythm guitar (?)
John: rhythm guitar, piano
George: lead guitar, rhythm guitar (?)
Ringo: drums, tambourine

RECORDED
Abbey Road: June 2–3, 1964 (Studio Two)

NUMBER OF TAKES: 3

MIXING
Abbey Road: June 9, 1964 (Studio Three) / June 22, 1964 (Studio One)

TECHNICAL TEAM
Producer: George Martin
Sound Engineer: Norman Smith
Assistant Engineers: Ken Scott, Geoff Emerick

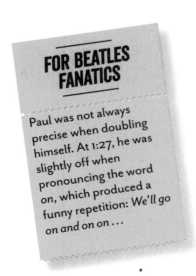

FOR BEATLES FANATICS

Paul was not always precise when doubling himself. At 1:27, he was slightly off when pronouncing the word on, which produced a funny repetition: *We'll go on and on on . . .*

Genesis

On May 2, a painting exhibition in Liverpool opened, dedicated to Stuart Sutcliffe, a musician-turned-artist many of the Beatles had originally played with. The Beatles, meanwhile, took off for some real holidays. John, Cynthia, George, and Pattie chose to go to Honolulu; Paul, Jane, Ringo, and Maureen preferred St. Thomas in the Virgin Islands. On the *Happy Days*, a yacht made available to them, Paul isolated himself in a cabin that smelled like oil and began to write "Things We Said Today." He ended the song on the deck, at the stern of the boat, far from the smell! His subject matter evoked in a very direct manner his relationship with actress Jane Asher. Because of their respective schedules, Paul and Jane began to drift apart. "The song projects itself into the future and then is nostalgic about the moment we're living in now, which is quite a good trick,"[1] Paul explained. Composing it on an acoustic guitar, Paul especially liked the chord changes of the piece. "It goes C, F, which is all normal, then the normal thing might be to go to F minor, but to go to the B flat was quite good. It was a sophisticated little tune."[2] John recognized this later on: "*Good song!*"[3] he said.

Production

Three takes were enough to record "Things We Said Today" on Tuesday, June 2. Paul was on bass, John on acoustic guitar, George on electric guitar, and Ringo on drums. The second take, which was considered satisfactory, was used as the basis for the overdubs: Paul doubled his voice, Ringo added tambourines, John was

1. Miles, *Paul McCartney.*
2. Ibid.
3. Sheff, *The Playboy Interview with John Lennon & Yoko Ono.*

on piano, and George (or Paul? John?) played a riff on acoustic guitar. The mono mix was carried out on June 9. But according to Mark Lewisohn, the decision was made to eliminate the piano. Since the instrument had been recorded by itself on one of the four tracks, this was not supposed to cause any problem. But the sound of piano had leaked into the other microphones. The stereo mix was done on June 22.

Technical Details

Norman Smith advised Ringo to put a tea towel over his snare drum to create a thicker and shorter snare sound. This practice was widely used throughout the Beatles' career.

When I Get Home

Lennon-McCartney / 2:15

SONGWRITER
John

MUSICIANS
John: vocal, rhythm guitar
Paul: backing vocals, bass
George: lead guitar, backing vocals
Ringo: drums

RECORDED
Abbey Road: June 2, 1964 (Studio Two)

NUMBER OF TAKES: 11

MIXING
Abbey Road: June 4, 1964 (Studio Two) / June 22, 1964 (Studio One)

TECHNICAL TEAM,
Producer: George Martin
Sound Engineer: Norman Smith
Assistant Engineers: Ken Scott, Geoff Emerick

1964

Genesis

"When I Get Home" is not among the Beatles' masterpieces. Written by John, probably to complete the album, it clearly lacked inspiration. Even though he tried to produce a Motown sound and was inspired by Wilson Pickett, the Stax recording artist, the results did not meet his expectations. The dynamics of this song are aggressive and the rhythm catchy, but you would want more magic. As for the lyrics, they certainly had something to do with his guilt towards Cynthia, from whom he was absent for long periods of time. As Paul suggested, "When I Get Home" was one of John's songs dealing with his relationship problems.

Production

This song was the last one to be recorded for *A Hard Day's Night* ("Any Time at All" being the very last song to be finalized). The Beatles, who had been in the studio on Tuesday, June 2 since 2:30 P.M., started working on "When I Get Home" at 7:00 P.M. Eleven takes were required for its production, which did not involve any major difficulty. Everyone played their usual instruments. Ringo was full of energy and played the cymbals wholeheartedly. John doubled his vocal and Paul, along with George, harmonized the choruses. On the other hand, Paul's voice definitely went off track on the *whoaaaa* at 0:36, and it could easily be heard in the stereo version on the right channel! The final mono and stereo mixes come from the session of June 22.

1. Sheff, *The Playboy Interview with John Lennon & Yoko Ono*

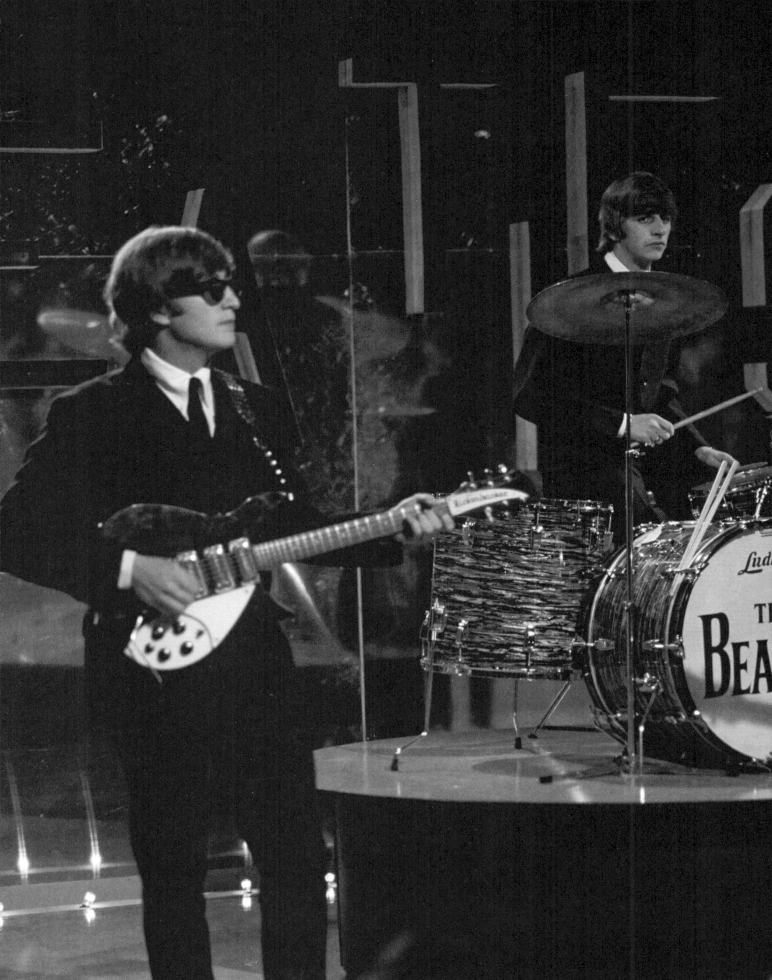

You Can't Do That

Lennon-McCartney / 2:33

SONGWRITER
John

MUSICIANS
John: vocal, lead guitar
Paul: backing vocals, bass, cowbell
George: rhythm guitar, backing vocals
Ringo: drums, bongos

RECORDED
Abbey Road: February 25, 1964 (Studio Two) / May 22, 1964 (Studio Two)

NUMBER OF TAKES: 9

MIXING
Abbey Road: February 26, 1964 (Studio Two) / March 10, 1964 (Studio Two) / June 22, 1964 (Studio One)

TECHNICAL TEAM
Producer: George Martin
Sound Engineer: Norman Smith
Assistant Engineers: Richard Langham, Geoff Emerick

RELEASED AS A SINGLE

"Can't Buy Me Love" / "You Can't Do That"
Great Britain: March 20, 1964 / No. 1 on April 2, 1964
United States: March 16, 1964 / No. 1 on April 4, 1964

Genesis

The first song recorded at Abbey Road for the Beatles' new album, "You Can't Do That" also provided John with the opportunity for his first guitar solo and George with the opportunity of using his brand new twelve-string Rickenbacker 360/12. According to George, John wrote the song in Miami Beach, during their first American tour. As for "You Can't Do That," John admitted being influenced by Wilson Pickett. "You know, a cowbell going four in the bar, and the chord going *cha-toong!*"[1] It seemed he was mistaken in mentioning Wilson Pickett, because in early 1964, Pickett had not yet recorded "In the Midnight Hour," even though it had a style corresponding to John's description. Did John wish to evoke the global influence of rhythm & blues, which was so important for the Beatles? Created for the movie, "You Can't Do That" was rejected by Richard Lester. Apparently, the director did not find the lyrics positive enough. It was true that John was assuming more and more distance from the canon of the pop songs of those days. In the song, he threatens to break up with his girlfriend if she keeps talking to someone else. Jealousy, threats, shame—John was not trying to be subtle. You could consider "You Can't Do That" a precursor to "Jealous Guy," which appeared on *Imagine* in 1971.

Production

Recorded in nine takes on February 25, the piece was not particularly difficult. The two guitars mixed together and supplied solid rhythm support worthy of the Stones. John said in a 1964 interview, "I'd find it a drag to play rhythm all the time, so I always work myself out something interesting to play. The best example I can think of is like I did on 'You Can't Do That.' There really isn't a lead guitarist and a rhythm guitarist on that, because I feel the rhythm guitarist

1. Sheff, *The Playboy Interview with John Lennon & Yoko Ono.*
2. Ray Coleman, *Lennon: The Definitive Biography* (New York: Macmillan, 1984).
3. Ibid.

John and Paul (in the background) during their 1964 stay in Paris.

role sounds too thin for records."[2] John played his very first solo, also with a brand-new Rickenbacker 325. "I never play anything as lead guitarist that George couldn't do better. But I like playing lead sometimes, so I do it,"[3] John admitted in 1964. His style resembled the one he used in "The End" on *Abbey Road*. Around 1:23, he could be heard switching the position of his mike, which he tipped toward the treble to start the solo. As for Paul, he produced an excellent bass sound that was unfortunately buried in the mix (you could also notice at 2:10 that there was a bad dropout on the bass). This was not the case for Ringo's

cymbals, which he kept beating throughout the piece. Too bad. But the whole song sounded good. You could feel the explosive energy of the group. The girl group–influenced choruses worked very well. Their joy was contagious. On the ninth take, the Beatles recorded different overdubs: John doubled himself, Paul was on the cowbell and Ringo was on bongos. Four mono mixes were done the next day: the second and third one were meant for the United States, and the fourth one for Europe. "You Can't Do That" was ready for side B of "Can't Buy Me Love." The definitive stereo mix was completed on June 22.

I'll Be Back

Lennon-McCartney / 2:20

SONGWRITER
John

MUSICIANS
John: vocal, rhythm guitar
Paul: backing vocals, bass
George: rhythm guitar, classical guitar
Ringo: drums

RECORDED
Abbey Road: June 1, 1964 (Studio Two)

NUMBER OF TAKES: 16

MIXING
Abbey Road: June 10, 1964 (Studio Two) / June 22, 1964 (Studio One)

TECHNICAL TEAM
Producer: George Martin
Sound Engineer: Norman Smith
Assistant Engineers: Ken Scott, Richard Langham, Geoff Emerick

Genesis

In 1980, John claimed he had written "I'll Be Back." Paul qualified this claim in *Many Years from Now*: "'I'll Be Back' was cowritten but it was largely John's idea."[1] No doubt, Paul helped him out, but the harmony and rather complex structure of the song were, in fact, more typical of John's style. The latter agreed he had done a "variation of the chords in a Del Shannon song," probably "Runaway," the 1961 hit. The chord sequence of the first part was similar to the one used in "I'll Be Back," although it was a "classical" harmonic descent used in hundreds of songs, for instance, in flamenco. For the first time, a Beatles song included two different bridges. Rather underestimated, "I'll Be Back" was a small jewel, similar to "Things We Said Today" by Paul, because of its atmosphere and acoustic arrangement. Once again, the lyrics were not full of serenity. John discussed a masochistic relationship (even though he feared his love would experience a nasty surprise upon his return and would make him suffer, he would come back). In a certain way, this song foreshadowed the ambivalent side of the duo, Paul with his optimism and John with his torment. "I'll Be Back" was a song that John always liked: he said in a 1972 interview, "A nice tune, though the middle is a bit tatty." Many artists recorded covers of it, for instance, Shawn Colvin, who produced an exceptional version of it in 2004.

Production

"I'll Be Back" was recorded in sixteen takes, on June 1, toward the end of the day. The first versions were written in 6/8 before being adapted to 4/4. The orchestration of the beginning was more electric; the mood was not yet acoustic. The Beatles then chose a more folklike

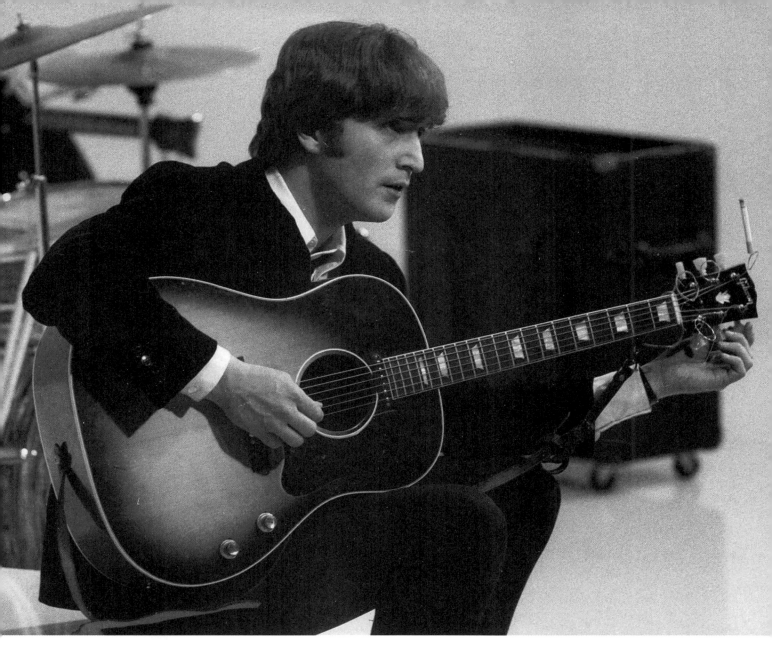

John tuning his Gibson J-160E during the filming of *A Hard Day's Night*. This acoustic guitar played a primary role in the sound of "I'll Be Back."

interpretation, leaving nice maneuvers for the Gibsons J-160S of John and George, Ringo and Paul playing with subtleness. The basic track used was the ninth take. Then there were a series of seven overdubs. The voices were added, John doubled himself, and George performed a nylon string classical guitar part as well as a very effective riff. The results were colored with nostalgia and finesse. The final mono and stereo mixes came from the session on June 22, 1964.

1. Miles, *Paul McCartney*.

BEA

1964

No Reply
I'm a Loser
Baby's in Black
Rock and Roll Music
I'll Follow the Sun
Mr. Moonlight
Kansas City / Hey Hey Hey Hey
Eight Days a Week
Words of Love
Honey Don't
Every Little Thing
I Don't Want to Spoil the Party
What You're Doing
Everybody's Trying to Be My Baby

ALBUM

RELEASED

Great Britain: December 4, 1964 / No. 1 for 11
weeks
United States: December 15, 1964,
under the title *Beatles 65* / No. 1 for 9 weeks;
June 14, 1965, under the title *Beatles VI* /
No. 1 for 6 weeks

Beatles for Sale: The Album in Black

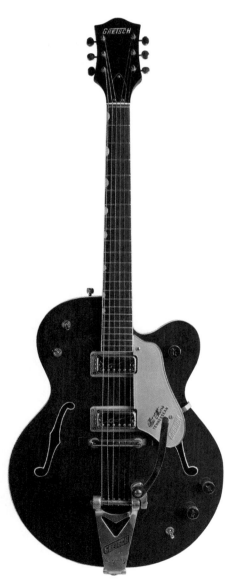

Above, Gretsch model Chet Atkins Tennessean that George acquired in 1963.

On August 11, 1964, just two months after the recording of their previous album, the Beatles went back into the studio to make *Beatles for Sale*. Brian Epstein wanted to release two albums a year. This new recording needed to be out for the holiday season. Even though John and Paul were productive, they lacked time to be creative. In six months, they had written thirteen songs, recorded six covers (including two in German), conquered America, and filmed their first movie. On June 4, they began their world tour: Denmark, the Netherlands, Hong Kong, Australia, New Zealand . . . When they were isolated in the Abbey Road Studios on August 11, they were war-weary, utterly exhausted, with their backs to the wall. In three months they recorded sixteen new songs, including ten originals and the new single "I Feel Fine," which immediately catapulted to the top of the charts on both sides of the Atlantic. So 1964 was a year of madness and folly.

The Beatles tapped into their Hamburg and Liverpool repertoires to complete *Beatles for Sale*. Out of fourteen tracks, six were covers. George still brought no songs to the table, although one of his titles, "You Know What to Do" (see *Anthology 1*), was considered for the album. John's writing was more and more autobiographical, dark, and cynical: "I'm a Loser," "No Reply"; Paul remained optimistic, "I'll Follow the Sun"; George covered his idol Carl Perkins's brilliant "Everybody's Trying to Be My Baby"; and Ringo took the microphone for Perkins's "Honey Don't." The second album was recorded entirely in four track. Little by little, the spirit in the sessions got higher. The Beatles worked on their songs in the studio, recording and polishing arrangements until everyone was satisfied. "For that album, we only rehearsed the new songs,"[1]

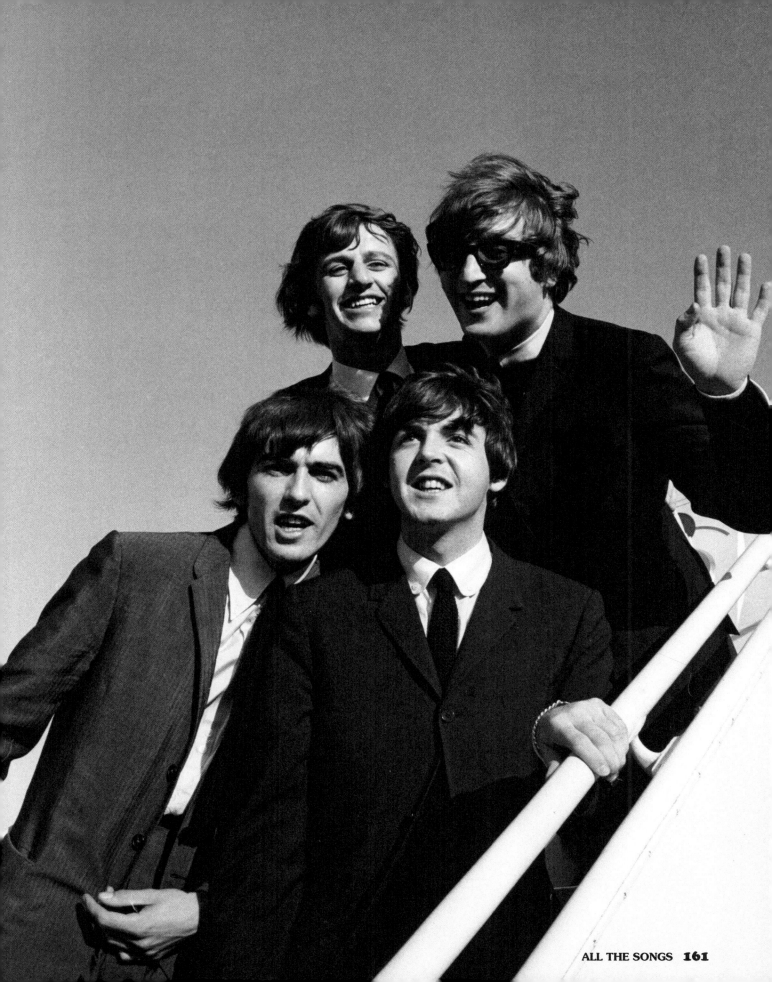

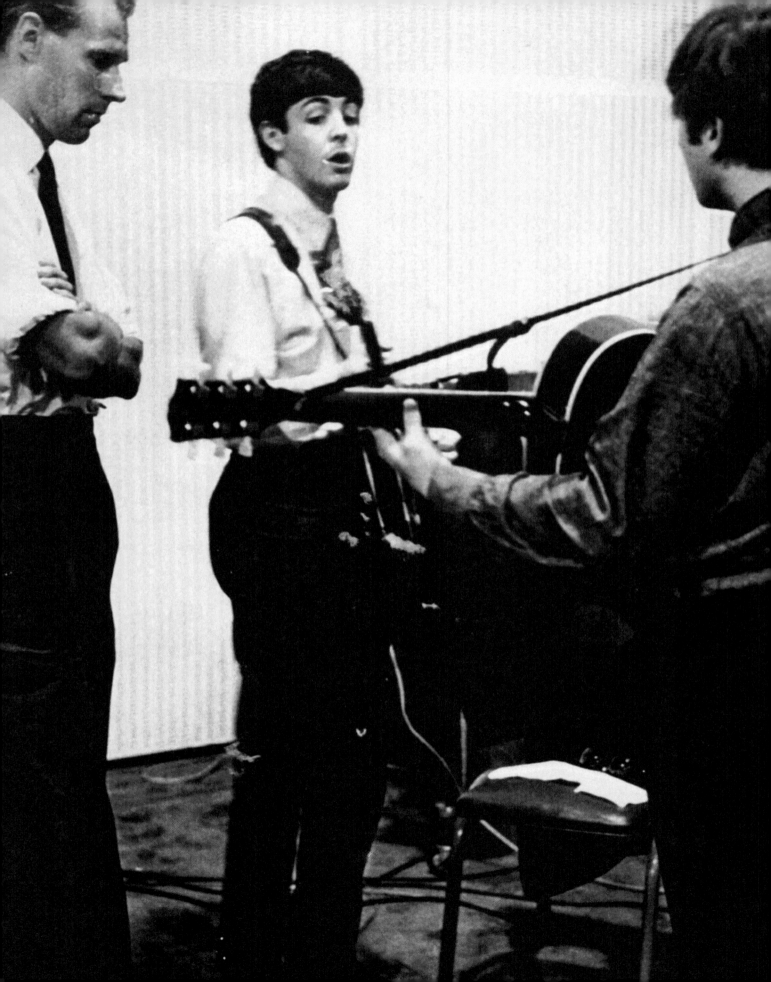

Left, Paul and John in rehearsal under the supervision of George Martin.
Above, George plays his Rickenbacker 360-12 backstage during the U.S. tour.

confirmed George. Indeed, the cover songs, their final homage to their early shows, were played live and often in one take. They demonstrated that they were excellent performers. John said in 1964: "We're really pleased with the record and with the new LP. There was a lousy period when we didn't seem to have any material for the LP and didn't have a single. Now that we're clear of things and they're due out, it's a bit of a relief."[2] In the United States, the album was split into two discs: *Beatles 65* and *Beatles VI*, each album being a mix of songs from *Beatles for Sale* and *Help!* as well as singles. Just as in England, these albums hit the top of the U.S. charts upon release. The Beatles are for sale? We're buying!

The cover of the album was photographed once again by Robert Freeman. The Beatles went to Hyde Park, near the Albert Memorial. Paul remembers: "It was easy. We did a session lasting a couple of hours and had a reasonable picture to use."[3] On Freeman's cover photograph, they look frazzled; you sense their exhaustion.

Beginning with this album, and especially during the recording session on October 26, the Beatles began attending mixing sessions. Until this time, the control room and the mixing were reserved for EMI members and staff, and the artists were excluded.

The Instruments

By the end of 1963, George acquired a new Gretsch, a Chet Atkins Tennessean model, which he played from 1964 to 1965 both in the studio and in concert on "Baby's in Black." In February John ordered a Rickenbacker 325 twelve-string that he briefly played in concert during the summer of 1964. The guitar was used in the studio, apparently on "Every Little Thing." The remaining instruments were the same ones used during the recording of *A Hard Day's Night*.

1. *The Beatles Anthology.*
2. Ibid.
3. Ibid.

On June 3, 1964, Paul, John, and George played with Jimmy Nicol, who replaced Ringo, who was sick. That same day the three Beatles recorded three songs at Abbey Road, including "No Reply."

On the next double-page spread: a common scene of the mass hysteria, known as Beatlemania, of the time.

No Reply

Lennon-McCartney / 2:15

SONGWRITER
John

MUSICIANS
John: vocals, rhythm guitar, hand claps
Paul: bass, vocal harmonies, hand claps
George: rhythm guitar, hand claps
Ringo: drums, hand claps
George Martin: piano

RECORDED
Abbey Road: September 30, 1964 (Studio Two)

NUMBER OF TAKES: 8

MIXING
Abbey Road: October 16, 1964 (Studio One) / November 4, 1964 (Studio Two)

TECHNICAL TEAM
Producer: George Martin
Sound Engineer: Norman Smith
Assistant Engineers: Ken Scott, A. B. Lincoln, Mike Stone

1964

FOR BEATLES FANATICS

When the Beatles recorded a demo of "No Reply" on June 3, neither Ringo Starr nor Jimmy Nicol, a session drummer who had filled in for Ringo during part of their 1964 tour, were present. However, there are drums in the title (see *Anthology 1*). Who is the drummer? Paul? Norman Smith? Or someone else?

Genesis

Hearing "No Reply," Dick James, the Beatles' music publisher, could not help but point out to John, "You're getting better now—that was a complete story." John commented in 1972, "Apparently, before that, he thought my songs wandered off." At age twenty-four, John definitely had abandoned writing for teenagers. He was married and the father of little Julian. His deeper sensibility gave him a glimpse of the cracks in the surrounding world. John could no longer write "I Want to Hold Your Hand." "No Reply" speaks of failures and ill-fated love. "It was my version of 'Silhouettes' [Rays, 1957]: I had that image of me walking down the street and seeing her silhouette in the window, even though she would not answer the phone."[1] Pure fiction, because during his teenage years the phone was rather rare in Britain! But John expresses once again a sense of latent deception (see "I'll Be Back" and "I'll Cry Instead").

Paul said, "We wrote 'No Reply' together, but based on a strong original idea of his."[2] In 1991 (1993 according to other sources), a demo of the song was found, corresponding to a recording dated June 3, 1964. On that day, the Beatles and Jimmy Nicol rehearsed at Abbey Road for a concert the next day in Denmark. Ringo, who was sick, was hospitalized in the morning. After the rehearsal, Nicol left the Beatles, who recorded three demos: George's never-released title "You Know What to Do," Paul's "It's for You" for Cilla Black, and, finally, "No Reply," which John intended for Tommy Quickly, a promising youngster in manager Epstein's stable of artists. Recorded, but never used, John finally decided to keep it for the Beatles.

1. *The Beatles Anthology.*
2. Miles, *Paul McCartney.*

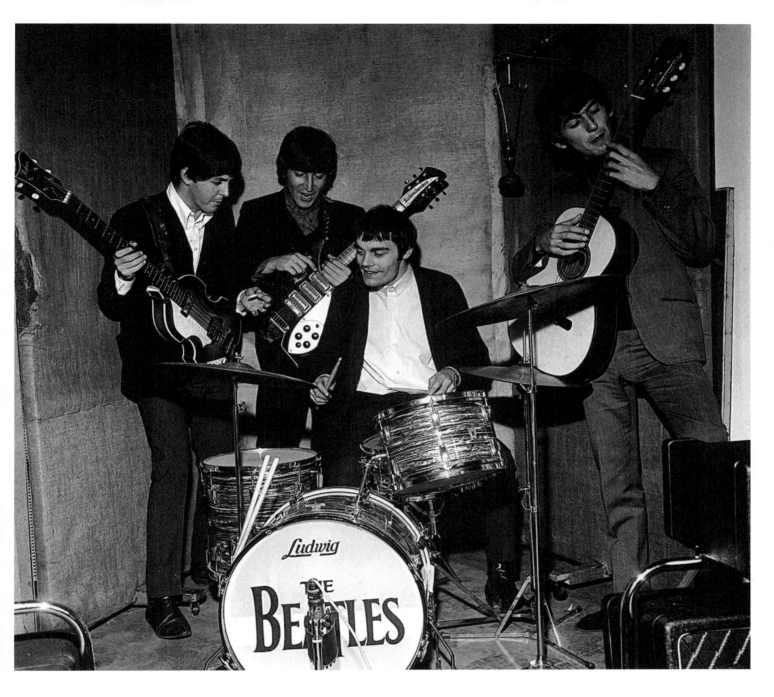

Production

On September 30, almost four months after the demo on June 3, the Beatles recorded "No Reply" in eight takes. After taping the rhythmic part, George Martin played a part at the piano while Ringo added cymbals and another bass drum (off the left channel in the stereo behind the chorus). Later John and Paul were gathered around a single microphone, a Neumann U 48 bidirectional; Paul was on the upper harmonies; and John, who has a tired voice, on the middle. On the last track, the piano and the vocals are doubled and hand claps are added. They tried to extend the song for more than a minute on the fifth take, before returning to the duration of the original version. The song had a Latin rock sound, due in part to John and George on the Gibson J-160E and Ringo's rimshot playing. "No Reply" was a success. The mono mix was made on October 16, and the stereo mix on November 4.

Technical Details

Norman Smith used a towel placed on Ringo's snare drum to dampen the sound.

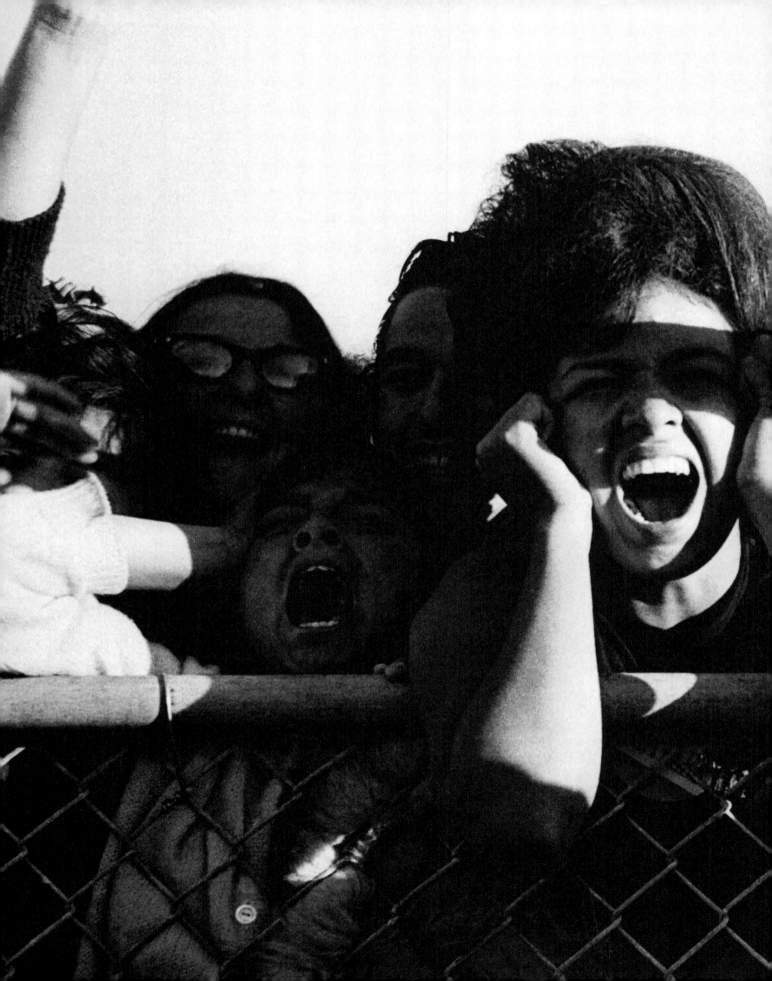

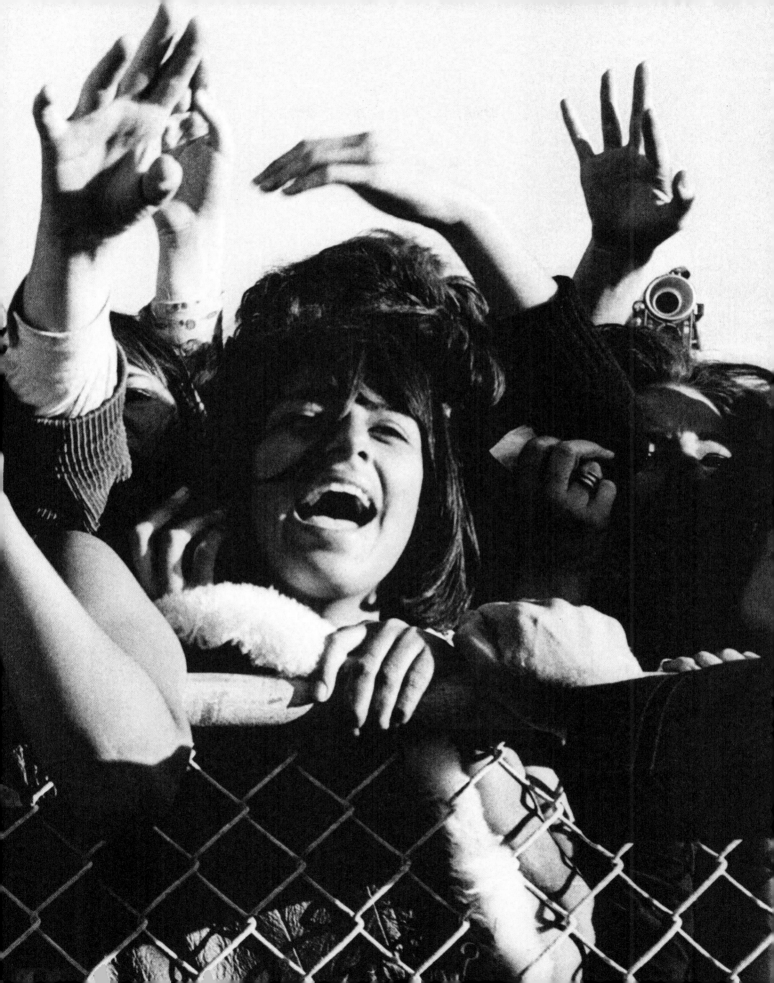

I'm A Loser

Lennon-McCartney / 2:29

SONGWRITER
John

MUSICIANS
John: vocals, rhythm guitar, harmonica
Paul: bass, vocal harmonies
George: lead guitar
Ringo: drums, tambourine

RECORDED
Abbey Road: August 14, 1964 (Studio Two)

NUMBER OF TAKES: 8

MIXING
Abbey Road: August 14, 1964 (Studio Two) / October 26, 1964 (Studio Two) / November 4, 1964 (Studio Two)

TECHNICAL TEAM
Producer: George Martin
Sound Engineer: Norman Smith
Assistant Engineers: Ron Pender, Tony Clark, Mike Stone

Genesis

Although Paul contributed to this song, John was the main composer. Strongly influenced by Dylan, the song surprised: How could John, at the height of his success and fortune, proclaim himself as a loser? He said later with a smile: "Part of me suspects I'm a loser and part of me thinks I'm God Almighty."[1] According to Paul, "I'm a Loser" and "Nowhere Man" were cries for help. John was uncomfortable with his success, as his song revealed: despite laughing and clowning around, it was not the "clown" he let appear. To hold himself together, he used alcohol and drugs. As for the influence of Dylan, he said in 1974: "I objected to the word *clown* because that was always artsy-fartsy. But as Dylan had used it, I thought it was all right."[2]

Production

On August 14, four days before they left for their first North American tour, "I'm a Loser" was recorded in eight takes. For the rhythm track, John was on the acoustic guitar, Paul on the bass (walking bass in the chorus), George played his Gretsch Tennessean, and Ringo his drums. On the next track, George recorded an excellent solo and Ringo added the tambourine over the chorus. Then came the vocals. Finally, on the last track, John doubled his vocal and played a truly inspired harmonica solo (diatonic harmonica in C). The song sounded good. Martin and his team immediately made an initial mono mix, but the final was recorded on October 26 and the stereo mix done on November 4.

1. Sheff, *The Playboy Interview with John Lennon & Yoko Ono.*
2. *The Beatles Anthology.*

1964

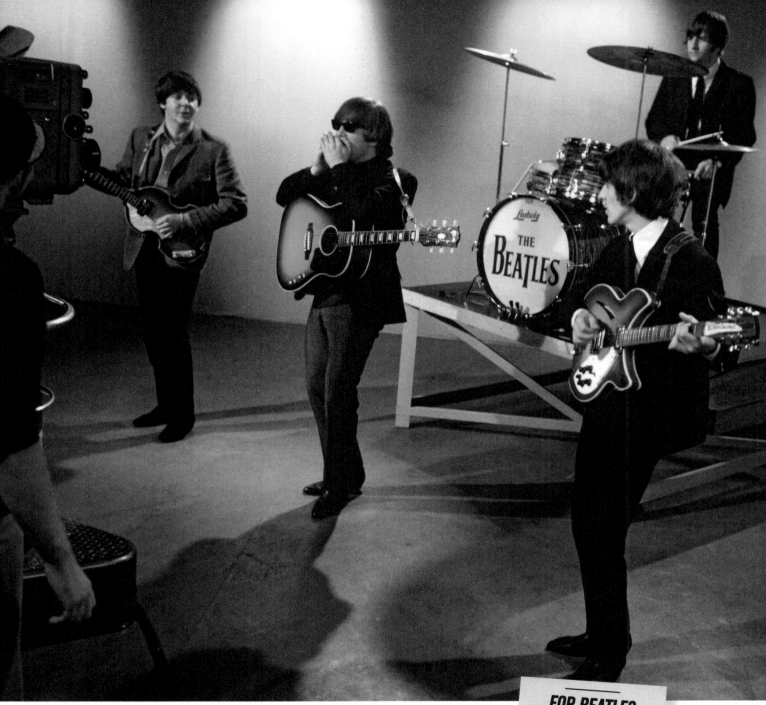

John playing acoustic guitar and solo harmonica on "I'm a Loser."

Technical Details

During the recording of *I'm not what I appear to be*, John invariably produced some plosives on the "p" in *appear*. George Martin, uncompromising when it came to that kind of error, consistently asked him to redo the line. He regretted not having done so more often, especially in their first period. But in the end, Martin always preferred the feeling to the perfect touch.

FOR BEATLES FANATICS

George played an excellent part on his Gretsch Tennessean. But, carried away by his enthusiasm, we can catch a short skid at 0:52, which was not corrected.

Baby's In Black

Lennon-McCartney / 2:04

SONGWRITERS
John and Paul

MUSICIANS
John: vocals, rhythm guitar
Paul: vocals, bass
George: lead guitar
Ringo: drums, tambourine

RECORDED
Abbey Road: August 11, 1964 (Studio Two)

NUMBER OF TAKES: 14

MIXING
Abbey Road: August 14, 1964 (Studio Two) / October 26, 1964 (Studio Two) / November 4, 1964 (Studio Two)

TECHNICAL TEAM
Producer: George Martin
Sound Engineers: Norman Smith, Hugh Davies
Assistant Engineers: Ron Pender, Tony Clark, Mike Stone

Genesis

"Baby's in Black" was the first song recorded for *Beatles for Sale*. Cowritten at Kenwood, the song revealed the determination of the duo to compose songs a little bit darker, more bluesy, "more grown-up, rather than just straight pop."[1] With this title, in which they adopted a waltz tempo, they also began taking liberties with their style. Paul admitted that they loved James Ray's song "If You Gotta Make a Fool of Somebody" (1961), "a cool three-four blues thing"[2] and the group had included in their live set list. If some people see the image of Astrid Kirchherr, the companion of the late Stuart Sutcliffe, in the woman in black, none of the Beatles has ever confirmed this rumor. It seems that they chose this topic to create a different atmosphere, with no reference to anyone in specific. "In addition, our favorite color was black,"[3] said Paul. "Baby's in Black" is a song they appreciated: it was often part of their set list, and they played this song until their last concert on August 29, 1966, in San Francisco.

The strength of "Baby's in Black" lies in a two-part vocal harmonization. When Dick James tried to make a transcription of the score, he asked who sang the main tune: John's lower or Paul's higher melody? "We did not know what to answer," said Paul—they were both the main melody. "We rather liked this one. There was a bit more cred about this one. It's got a good middle."[4]

Production

"With songs like 'Baby's in Black,' we had to learn and rehearse them,"[5] recalls George. The following Tuesday, August 11, was dedicated to this song. For the basic track, John played the Gibson J-160 E, Paul on

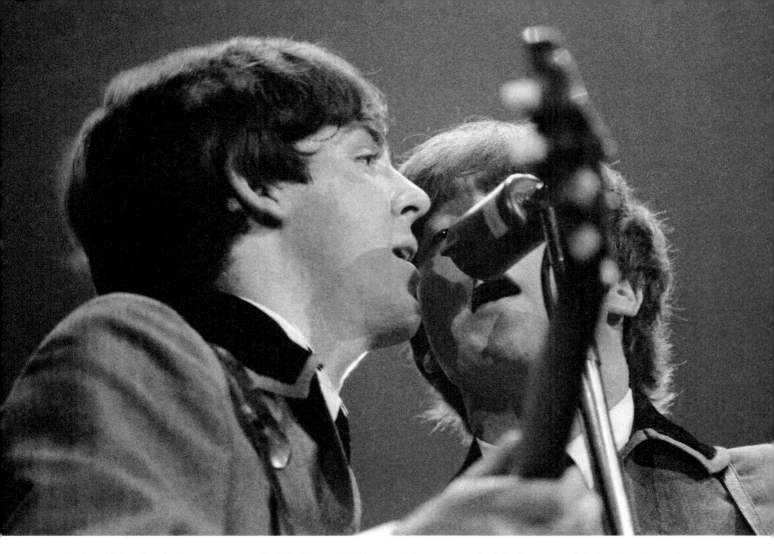

Paul and John sing during a concert at the Washington Coliseum, February 11, 1964. The harmony of their voices is a major asset of the Beatles sound, as confirmed by "Baby's in Black."

the bass, George the Gretsch Tennessean, and Ringo the drums. The Beatles at that time started doubling the instrumental parts; on the second track George doubled his guitar solo, for which he had some problems and requested multiple takes. Ringo, who accompanied him at the tambourine, was struggling to stay in tempo; he slowed down (1:30) before correcting his mistake (1:38). Moreover, at the time he entered (1:30), we noticed on the right channel of the stereo version a sudden strange sound increase, probably due to the playback of the previous take. John and Paul simultaneously sang through the same microphone as they had done for "If I Fell." They performed a sumptuous vocal part, particularly Paul's part on the bridge. Then they doubled the bridge vocals on the last track. "Baby's in Black" was recorded in fourteen takes. The final mix is dated October 26. The stereo version was done on November 4.

FOR BEATLES FANATICS

When the Beatles sang the James Ray hit, "If You Gotta Make a Fool of Somebody," onstage in Hamburg and Liverpool, George Harrison did not know that in 1987 he would record another song of Ray's, giving him his third and final number 1 hit in the United States as a solo artist (and the last number 1 of any of the solo Beatles): "Got My Mind Set on You."

1. *The Beatles Anthology.*
2. Ibid.
3. Ibid.
4. Miles, *Paul McCartney.*
5. *The Beatles Anthology.*

Rock And Roll Music

Chuck Berry / 2:30

MUSICIANS
John: vocals, rhythm guitar
Paul: bass (?), piano (?)
George: rhythm guitar (?), bass (?)
Ringo: drums
George Martin: piano (?)

RECORDED
Abbey Road: October 18, 1964 (Studio Two)

NUMBER OF TAKES: 1 OR 2

MIXING
Abbey Road: October 26, 1964 (Studio Two) / November 4, 1964 (Studio Two)

TECHNICAL TEAM
Producer: George Martin
Sound Engineer: Norman Smith
Assistant Engineers: Geoff Emerick, Tony Clark, Mike Stone

FOR BEATLES FANATICS

Note that the piano part disappears suddenly at 1:46 only to return a few seconds later (1:51). Error or intentional effect?

Genesis

Chuck Berry recorded "Rock and Roll Music" in Chicago at the Chess studios, either on May 6 or 21, 1957. This single was released in September; like most of Berry's songs, a few months later it hit the charts. Also, like most of his songs, "Rock and Roll Music" was covered by many rock bands, starting with the Beatles and the Beach Boys. After "Roll Over Beethoven" (see *With the Beatles*), it was the second tribute by the Beatles to the creator of the duckwalk. They knew the title perfectly, having performed it numerous times in Hamburg and Liverpool. When they entered the Abbey Road Studios on October 18, 1964 to record it, they did not know that this same day, Chuck Berry blew out thirty-eight birthday candles. What a birthday gift! This title, brought "back to life" on the occasion of this recording session, became part of their new set list: they played it until their last tour.

Production

A mystery about the creation of "Rock and Roll Music" remains: based on Derek Taylor's notes for the sleeve of the original LP in 1964, George Martin joins John and Paul on one piano. In his book, Mark Lewisohn[1] wrote that only George Martin was at the piano. Geoff Emerick, who was present at the recording session on October 18, 1964, provided another account: he recalled that Paul played while George Harrison covered on bass. Whom to believe? We can eliminate Taylor, since the studio reports indicated only one take. Three players on only one piano—that's a lot! Emerick also reported that John doubled his vocal, implying a second take. After listening carefully, we can state that his vocal was not doubled. And if George was on bass,

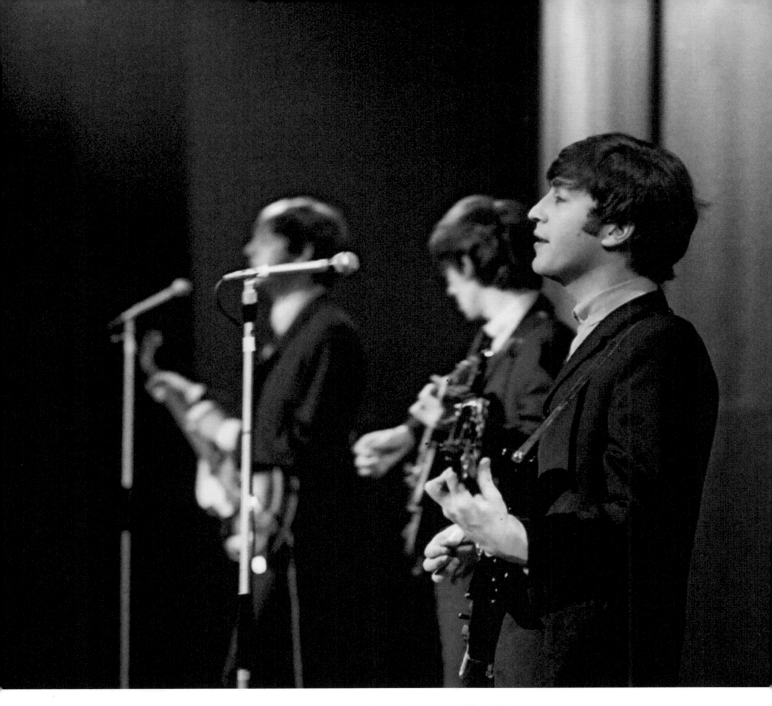

Above, John and George at the guitar, and Paul on bass, perform the music of Chuck Berry.

who then played the second guitar? Because it seems that there is another guitar, Lewisohn's version seems to be the most likely: all live with Martin at the piano. At his best, John delivered a superb vocal performance.

Technical Details
To reproduce the sound of his idols, John sings with a relatively short slapback echo, typical of the 1950s.

1. Lewisohn, *The Complete Beatles Recording Sessions.*

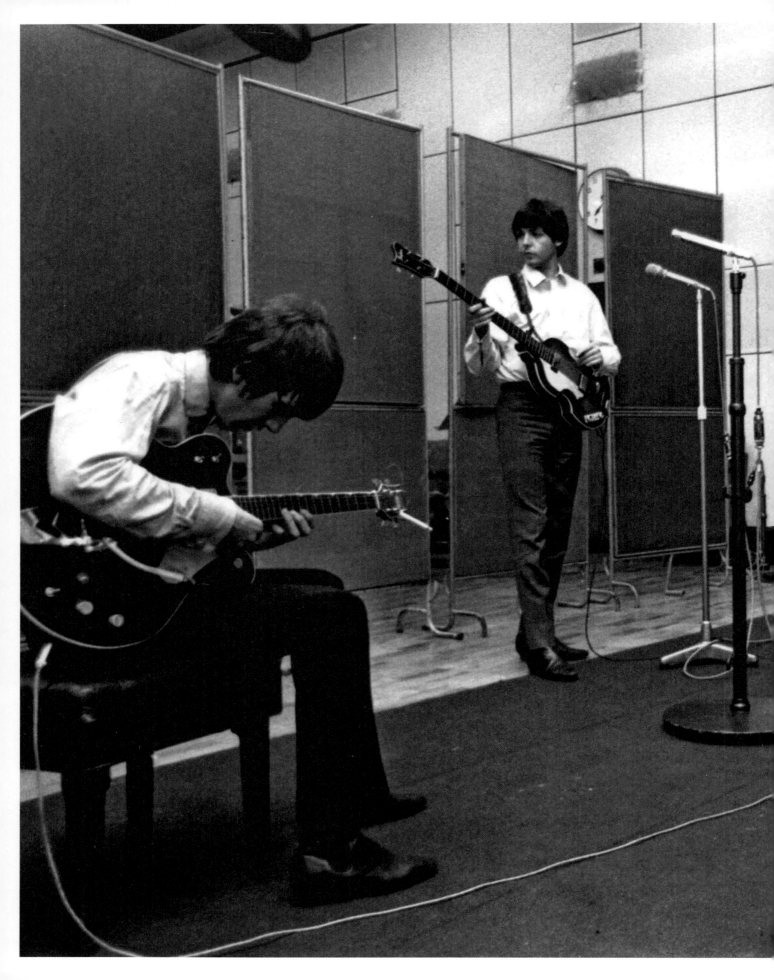

Recording session in
Studio Two.

I'll Follow The Sun

Lennon-McCartney / 1:47

SONGWRITER
Paul

MUSICIANS
Paul: vocals, acoustic guitar (?)
John: acoustic guitar (?), backing vocals
George: lead guitar
Ringo: percussion

RECORDED
Abbey Road: October 18, 1964 (Studio Two)

NUMBER OF TAKES: 8

MIXING
Abbey Road: October 21, 1964 (room 65) / November 4, 1964 (Studio Two)

TECHNICAL TEAM
Producer: George Martin
Sound Engineer: Norman Smith
Assistant Engineers: Geoff Emerick, Ron Pender, Mike Stone

1964

Genesis

"I'll Follow the Sun," described as a "very good song" by John, was also one of George Martin's favorites on *Beatles for Sale*. This song, written by Paul, has an undeniable charm. He remembers that he wrote the song in the front parlor in Forthlin Road after a bad flu at the age of sixteen. "There were certain songs I had from way back that I didn't really finish up . . . 'I'll Follow the Sun' was one of those."[1] But, at that time, the song was neither considered good enough nor adapted to their repertoire as rockers. Its inclusion in *Beatles for Sale* was a response to the urgent need for new songs. The optimism of the lyrics of this "inevitable Ballad of Paul" prompted John, speaking to David Sheff, to say, "This is something from Paul. Can't you tell? I mean *Tomorrow may rain so, I'll follow the sun.*"[2]

Production

There was a recording dating back to April–May 1960 on which the Quarrymen (John's first group) performs "I'll Follow the Sun." The song would have to wait four years before being immortalized by the Beatles on October 18, 1964. This new version was significantly different from the original, which was more skiffle in style. George Martin asked John to harmonize Paul's vocal on the bridges, whose lyrics had been rewritten for the occasion. Ringo sought an accompaniment on his drums, but Paul, wanting to evoke a less percussive atmosphere, and, above all, determined to innovate, suggested that Ringo just tap his knees with his hands. Geoff Emerick recalls, "Enthralled, I watched Norman carefully position a mike between Ringo's knees; then, back in the control room, he cranked up the EQ to add some extra depth to the sound."[3] The first track was reserved for acoustic guitars. It is difficult to say whether

Paul smokes, lost in thought (1964). According to John: "'I'll Follow the Sun' is his inevitable ballad."

John and/or Paul performed this role. A priori, there was only one guitar . . . nevertheless accompanied by Ringo's rhythm. George's rhythm guitar appeared on the second track, providing an excellent complement. Paul, accompanied by John on the bridges, recorded a beautiful vocal part on the third track. John, from the first take, performed an acoustic guitar solo. After George complained—"You know, I'd like to do the solo on this one. I am supposed to be the lead guitarist in this band, after all"[4]—John gave up. George performed the solo, but without inspiration and giving it a minimalist sound. Martin, somewhat annoyed by so many unsuccessful attempts, got impatient and refused to do another one: the solo left them all rather frustrated. The song was recorded in eight takes. The mono mix was done on October 21, the stereo on November 4.

Technical Details

Like those for "I Feel Fine" and "She's a Woman," the mono mix of "I'll Follow the Sun" on October 21 was not made in Studios Two or Three, but in Room 65, which was usually considered an "experimentation room."

1. Miles, *Paul McCartney.*
2. Sheff, *The Playboy Interview with John Lennon & Yoko Ono.*
3. Emerick, *Here, There and Everywhere.*
4. Ibid.

Mr. Moonlight

Roy Lee Johnson / 2:33 (mono version); 2:37 (stereo version)

MUSICIANS
John: vocals, rhythm guitar
Paul: bass, backing vocals, organ
George: lead guitar, percussion
Ringo: bongos

RECORDED
Abbey Road: August 14, 1964 (Studio Two) / October 18, 1964 (Studio Two)

NUMBER OF TAKES: 8

MIXING
Abbey Road: October 27, 1964 (Studio Two) / November 4, 1964 (Studio Two)

TECHNICAL TEAM
Producer: George Martin
Sound Engineer: Norman Smith
Assistant Engineers: Ron Pender, Geoff Emerick, Ken Scott, Mike Stone

Genesis

Georgia-born guitarist and singer Roy Lee Johnson was best known as the composer of "Mr. Moonlight" when, by the early 1960s, he began playing in Piano Red's band, better known under the name Dr. Feelgood & the Interns. The song is on the B side of the minor rhythm & blues single "Dr. Feelgood," released in the United States in 1962. If the song produced its effect in the barrelhouses of the Deep South, it also crossed the Atlantic and became a must-have for British beat and rhythm & blues groups. Thus, the Hollies recorded it for their first album at the end of 1963, a few months before the Beatles.

After "Please Mister Postman" and before "Mr. Mustard," they started working on the charming "Mr. Moonlight" on August 14, 1964. They were already playing it onstage in Hamburg. However, it is surprising that this title does not match the style of this album. Fortunately, John gave new life to the song with a superb vocal performance.

Production

The first cover for their fourth album, "Mr. Moonlight" was recorded in four takes on August 14. This version included a solo with a fast vibrato performed by George in a Hawaiian style. But the Beatles were not satisfied with it and decided to redo it. Only two months later they reworked it on October 18. After four new takes, the song was recorded with substantial changes. Although John loved George's frantic solo sound, Martin judged it decidedly too weird. Geoff Emerick says: "After some discussion, we decided to record a cheesy organ solo."[1] This solo, performed by Paul on a Hammond RT-3 connected to a PR-40 cabin, gave it the feel of lounge music.

John knew how to re-create "Mr. Moonlight," a composition of Roy Lee Johnson.

If we refer to the annotations made by Derek Taylor (reproduced in the booklet for the CD), Ringo is on the bongos and George played African percussions. In the end, the version was close to the original. Only John's sterling vocal redeemed the whole song. Done on October 27, the mono mix was from takes 4 and 8; the stereo mix was completed on November 4.

1. Emerick, *Here, There and Everywhere*.

Kansas City / Hey, Hey, Hey, Hey

Medley by Jerry Leiber–Mike Stoller and Richard W. Penniman / 2:36

MUSICIANS
Paul: vocals, bass guitar, hand claps
John: rhythm guitar, backing vocals, hand claps
George: rhythm guitar, backing vocals, hand claps
Ringo: drums, backing vocals, hand claps
George Martin: piano

RECORDED
Abbey Road: October 18, 1964 (Studio Two)

NUMBER OF TAKES: 2

MIXING
Abbey Road: October 26, 1964 (Studio Two)

TECHNICAL TEAM
Producer: George Martin
Sound Engineer: Norman Smith
Assistant Engineers: Geoff Emerick, Tony Clark

Genesis

The Beatles added this medley to their repertoire in Hamburg. The authors of the first song of the medley, Jerry Leiber and Mike Stoller, wrote an impressive number of rock 'n' roll and rhythm & blues hits in the 1950s. Elvis Presley owes them "Hound Dog" and "Jailhouse Rock"; the Coasters "Searchin'" and "Yakety Yak"; the Drifters "There Goes My Baby"; Ben E. King's, "Stand By Me." And to this list we must add "Kansas City," a song inspired by the musical universe of blues shouter Big Joe Turner, born in . . . Kansas City. This song was the first written by the duo to have been recorded by Little Willie Littlefield in 1952. However, Wilbert Harrison's version in 1959 placed the song at the top of the charts the same year. The second song is titled "Hey, Hey, Hey, Hey," a composition of Richard Penniman, aka Little Richard, which he had recorded on the B side of the single "Good Golly Miss Molly" in February 1958. Paul confessed to Geoff Emerick, during the recording session on October 18, that "Kansas City" was one of his favorite songs, just as Little Richard was one of his idols. Little Richard returned the compliment in 1963: "I've never heard that sound from English musicians before. Honestly, if I hadn't seen them with my own eyes I'd have thought they were a colored group from back home."

Production

Paul in 1988: "While I could get the vocal of 'Kansas City,' John encouraged me, saying, 'Come on! You can sing it better than that, man! Really hit it!'"[1] In the studio each supported the other. "Kansas City" is a complex piece; Paul recorded two final takes on October 18, but the first was the best. According to Lewisohn, the piece joined the list of the "one takes." Nevertheless,

Jerry Leiber and Mike Stoller (at the piano), the songwriters of "Kansas City," covered by the Beatles.

there were some overdubs, since we can hear some hand claps starting at 1:58. On the session worksheet, we noticed that track 4 had been reserved for piano and chorus. It is most likely that the piano (George Martin), chorus (with Ringo), and hand claps (all) were recorded later by overdubs. It is certain that the Beatles played it live, each on his usual instrument. It is a dazzling performance. Mono and stereo were completed on October 26.

FOR BEATLES FANATICS

One month before the recording of "Kansas City," on September 17, 1964, the Beatles performed this medley at the Municipal Stadium in . . . Kansas City! Is this where the idea to include this song on the album came from?

1. Lewisohn, *The Complete Beatles Recording Sessions.*

Eight Days A Week

Lennon-McCartney / 2:42

SONGWRITERS
John and Paul

MUSICIANS
John: vocals, rhythm guitar, hand claps
Paul: bass, backing vocals, hand claps
George: lead guitar, hand claps
Ringo: drums, hand claps, timpani (?)

RECORDED
Abbey Road: October 6 and 18, 1964 (Studio Two)

NUMBER OF TAKES: 15

MIXING
Abbey Road: October 12 and 27, 1964 (Studio Two)

TECHNICAL TEAM
Producer: George Martin
Sound Engineer: Norman Smith
Assistant Engineers: Ken Scott, Mike Stone, Geoff Emerick

FOR BEATLES FANATICS

Brian Wilson sang "Eight Days a Week" in concert at the Liverpool Philharmonic Hall in September 2009. Only problem, his voice was inaudible!

Genesis

A song written in Kenwood at John's house, "Eight Days a Week" is a joint creation, based on one of Paul's ideas. On the way to John's house, Paul asked his chauffeur: "How've you been?" "Oh, working hard," he said. "Working eight days a week!"[1] Paul rushed to John's house and said he had a brilliant idea for a new song: "Eight Days a Week"! And John continued, "*Oooh! . I need your love babe . . .*"[2] Paul: "And we wrote it. We were always quite fast to write. We would write on the spot. It would come very quickly."[3] John, on the other hand, is much less enthusiastic about the outcome: "We struggled to record it and struggled to make it into a song. It was his initial effort, but I think we both worked on it. I'm not sure. But it was lousy anyway."[4]

The song found its way to the charts, especially in the United States, where it reached number 1 for two weeks on March 13, 1965. Despite John's opinion, "Eight Days a Week" was well appreciated by the public.

Production

October 6 was the day dedicated to the recording session for "Eight Days a Week." For the first time, the Beatles were in the studio with an unfinished song. They experimented with different formulas to complete it. On the CD *Anthology 1*, we find different takes revealing the development of the song. Indeed, the intro and the end were truly problems. Ideas followed one after another: intro a cappella, with acoustic guitar . . . the Beatles hesitated. Ditto for the end. The body of the piece was well structured, even if the final chorus varied significantly from the initial takes. It was only at the end of the thirteenth take that they were satisfied

John and George tune their guitars in the studio. These are the same guitars used for "Eight Days a Week."

with the final rhythm track. However, the intro and the end were not yet set. After different overdubs of hand claps, guitars, and vocals, the title was put on hold. The recording notes to the CD booklet of the restructured version, released in 2009, mention a timpani. If there was a timpani, the instrument must be buried in the mix: we can hear Ringo's low tom-tom, but no timpani as in "Every Little Thing."

October 18, second session. This was a day of nine hours of recording, in the course of which the Beatles recorded five covers, three in only one take ("Kansas City" / "Hey, Hey, Hey, Hey," "Everybody's Trying to Be My Baby," and "Rock and Roll Music"); a new title as their next single ("I Feel Fine"); and an original piece to complete the album ("I'll Follow the Sun"). All this while strolling through entirely different styles. Geoff

Emerick, who first heard "Eight Days a Week" at the session, reacted by exclaiming, "This is a hit!" But, it still lacked the intro and end. John, Paul, and George gathered around the microphone and sang some vocals in unison. Considered ineffective, the test was aborted. The group worked on the ending with John and George on the guitar and Paul on bass. Then Norman Smith provided an introduction with a fade-in. The idea was quite innovative for the time and was immediately accepted: "Eight Days a Week" was complemented with takes 14 and 15. The final mono mix and stereo were from the session on October 27, with a mix of takes 13 and 15.

1. *The Beatles Anthology.*
2. Ibid.
3. Miles, *Paul McCartney.*
4. Sheff, *The Playboy Interview with John Lennon & Yoko Ono.*

Robert Whitaker's photo of
The Beatles during a tour in
Scotland in 1964.

Words Of Love

Buddy Holly / 2:12

MUSICIANS
John: vocals, rhythm guitar, hand claps
Paul: vocals, bass guitar, hand claps
George: vocals, lead guitar, hand claps
Ringo: drums, hand claps, percussion

RECORDED
Abbey Road: October 18, 1964 (Studio Two)

NUMBER OF TAKES: 3

MIXING
Abbey Road: October 26, 1964 (Studio Two) / November 4, 1964 (Studio Two)

TECHNICAL TEAM
Producer: George Martin
Sound Engineer: Norman Smith
Assistant Engineers: Geoff Emerick, A. B. Lincoln, Mike Stone

FOR BEATLES FANATICS

When Paul McCartney covered "Words of Love," by his idol Buddy Holly, he could not have imagined that a few years later it would be a part of his own catalogue. Today "Words of Love" belongs to Paul McCartney's publishing house, MPL Communications Ltd.

1964

Genesis

Buddy Holly is one of the rock and roll pioneers who had a significant influence on music of the sixties. On April 8, 1957, a few months after "That'll Be the Day," he recorded "Words of Love," a song he composed entirely on his own. Buddy Holly achieved a real feat by recording all the vocal parts himself, thanks to multitrack recording. But curiously it was the Diamonds' version of July 1957 that captured the attention of the general public. The Beatles, who interpreted "Words of Love" at the time of the Quarrymen and in Hamburg, had a long association with this song, due in large part to the admiration they had for Holly since their debut. In fact, Buddy Holly's backup band, the Crickets, were the inspiration for the Beatles' name. The Beatles sang Buddy Holly's songs until the end of their careers, including "Mailman Bring Me No More Blues," which originally appeared on the B side of Buddy Holly's "Words of Love," during the rehearsals for the *Get Back* project (see *Anthology 3*).

Production

"Words of Love" was the final song recorded on October 18. Only three takes were needed to finish it off. Geoff Emerick recalls that they were "worn out" when they started the song. Gathered around the same microphone, John, Paul, and George gave, according to the George, a superb vocal performance, full of sweetness and warmth. It is difficult to distinguish three different harmonies. It is more likely that George doubled John in unison to strengthen his vocal. Ringo, for his part, pushed the pedal of his drum to the floor so that we hear it squealing terribly throughout the piece

Buddy Holly had a significant influence on the Beatles and, in particular, on Paul McCartney.

(on the left channel in stereo). According to Derek Taylor's notes, Ringo used a cardboard box as well. In fact, Ringo had to exchange his snare drum for a cardboard box to obtain a less aggressive sound, more in character with the song. Some hand claps were added. George accompanied the piece with his Rickenbacker twelve-string, which he doubled, giving both a rich and tinny sound, similar to the "chorus" effect well-known to guitarists. The mono mix was done on October 26, the stereo on November 4.

Honey Don't

Carl Perkins / 2:55

MUSICIANS
Ringo: vocals, drums, tambourine
John: rhythm guitar
Paul: bass guitar
George: lead guitar

RECORDED
Abbey Road: October 26, 1964 (Studio Two)

NUMBER OF TAKES: 5

MIXING
Abbey Road: October 27, 1964 (Studio Two)

TECHNICAL TEAM
Producer: George Martin
Sound Engineer: Norman Smith
Assistant Engineers: A. B. Lincoln, Ken Scott

Genesis

Pioneer of rock 'n' roll and the true founder of rockabilly, Carl Perkins is the source of several hit songs during the 1950s. We can say that "Honey Don't" launched the trend, since this song was on the B side of Perkins's single "Blue Suede Shoes." That single was recorded at Sun Records in December 1955; then it catapulted to the second position on the *Billboard* charts on March 10, 1956. The four from Liverpool added this song to their repertoire as early as 1962, well before taping it. John sang the song before Ringo took ownership of it. In May 1964, Carl Perkins met the Beatles during their UK tour with Chuck Berry. Ringo took the opportunity to ask for permission to sing some of his titles. Perkins did not hesitate for a second. In an interview, he confessed to Gary James: "Sincerely, I knew they were talented boys. But I never thought that they would become so big. No one thought that four guys from Liverpool would become so huge!" As for the Beatles, they could have told him they wanted to re-create the distinctive sound of Sun Records.

FOR BEATLES FANATICS

You can hear Ringo making a vocal skid at 0:33, followed in the next second by Paul, who pulls too hard on his bass string, which is a bit out of tune. Ditto for the second chorus (between 1:00 and 1:04), an extremely rare error on his part (left channel in the stereo).

1964

For "Honey Don't," Ringo is on vocals and plays the drums.

Production

On October 26, the Fab Four were at the studio for their final recording session of *Beatles for Sale*. Ringo was happy: he was going to perform a new song, "Honey Don't." The song was recorded in five takes. Each of the Beatles played his usual instrument, with a tambourine added to support the rhythm. In the end, the piece was pretty close to the original, including George's solo, which was virtually identical to Carl Perkins's. Were they intimidated in the face of a master? If this was the case, it in no way compromised the cheerful and relaxed atmosphere of the interpretation. Ringo started the first George solo by saying "Ah, rock on George, one time for me!" and the second solo by a friendly "Ah, rock on George, for Ringo, one time!"

Every Little Thing

Lennon-McCartney / 2:01

SONGWRITER
Paul

MUSICIANS
John: vocals, rhythm guitar (?), guitar lead (?)
Paul: bass, backing vocals, piano
George: rhythm guitar (?), guitar lead (?)
Ringo: drums, timpani

RECORDED
Abbey Road: September 29–30, 1964 (Studio Two)

NUMBER OF TAKES: 4

MIXING
Abbey Road: October 27, 1964 (Studio Two)

TECHNICAL TEAM
Producer: George Martin
Sound Engineer: Norman Smith
Assistant Engineers: Ken Scott, Mike Stone

FOR BEATLES FANATICS

When the members of Yes recorded "Every Little Thing" in the spring of 1969, they obviously could not know that their future drummer, Alan White (he joined them in 1972), was on the verge of being hired by John Lennon to participate in the Toronto Rock and Roll Revival Festival on September 13. Similarly, they could not have imagined that White would participate in the recording of *All Things Must Pass* by George and *Imagine* by John.

Genesis

According to Barry Miles, Paul composed the song on guitar at the Ashers' house on Wimpole Street: " 'Every Little Thing,' like most of the stuff I did, was my attempt at the next single . . .,"[1] Paul said. Later, he submitted the song to Brian Epstein, who assembled a small committee to consider the new songs for the upcoming album. "I thought it was really catchy . . . it became an album filler rather than the great almighty single. It didn't have quite what was required,"[2] said Paul. However, Paul's recollection is disputed. Some sources, based on a 1964 interview, put its composition at around August 30, while the Beatles were in Atlantic City during their American tour.

This charming love song appears to have been inspired by Paul's fiancée, Jane Asher, although Paul did not confirm this. But he is certainly the primary author. John: " 'Every Little Thing' is his song. I might have thrown something in."[3] The fact remains that it is a beautiful title, clearly underestimated. Indeed, George and Paul cited the song during rehearsals for the project *Get Back* as one of their favorite pieces at the time.

Production

After twenty-five stops on their North American tour, including a memorable concert on August 23 at the Hollywood Bowl in Los Angeles, the Beatles returned to the studio on September 29. "Every Little Thing" was the first title they worked on that day. George was not at this first session. It took only four takes to tape it. After three, they nailed down the rhythmic part with John on acoustic guitar, Paul on bass, and Ringo on the drums. Although Paul is the author of the song, he only sang in unison and

Paul at the Hollywood Bowl concert, August 23, 1964. A month later, the Beatles recorded "Every Little Thing."

harmonized the choruses; John had the lead vocal. The next day, they resumed recording with George. According to Mark Lewisohn, the atmosphere was light and carefree. After five more takes, they added the intro using the Rickenbacker twelve-string, a low tone at the piano performed by Paul, and, for the first time, Ringo playing the timpani. In the intro, we can hear Paul, in the left channel of the stereo, hit a chord on his bass, which he "muffles" to guide the guitar overdub.

There are questions about the writing and recording of "Every Little Thing." John performed the guitar solo using his famous Rickenbacker 325/12. Paul reportedly confirmed in 1964 that John played an electric guitar riff while George played the acoustic guitar. It is possible, but George was absent during the first session (on September 29) when they recorded the basic track. So who played the acoustic guitar? It is a mystery. October 27 was dedicated to the mono and stereo mixes.

1. Miles, *Paul McCartney*.
2. Ibid.
3. Sheff, *The Playboy Interview with John Lennon & Yoko Ono*.

I Don't Want To Spoil The Party

Lennon-McCartney / 2:32

SONGWRITER
John

MUSICIANS
John: vocals, rhythm guitar
Paul: bass, backing vocal
George: guitar, lead, backing vocals (?)
Ringo: drums, tambourine

RECORDED
Abbey Road: September 29, 1964 (Studio Two)

NUMBER OF TAKES: 19

MIXING
Abbey Road: October 26, 1964 (Studio ?) / November 4, 1964 (Studio Two)

TECHNICAL TEAM
Producer: George Martin
Sound Engineer: Norman Smith
Assistant Engineers: Ken Scott, Mike Stone, Tony Clark

1964

Genesis

Probably dating from their U.S. tour and definitely in a country and western style, "I Don't Want to Spoil the Party" was originally written with Ringo in mind. According to John, it is a very personal song, reflecting either a love disappointment (with his wife?) or discomfort with success. The tone is like that of "I'm a Loser" or "No Reply"—nothing to smile about. Paul said he cowrote up to 20 percent of the song, pointing out: "Certain songs were inspirational, and certain songs were work—it didn't mean they were any less fun to write."[1] "I Don't Want to Spoil the Party" has known many covers, including by Rosanne Cash, who made a superb country version that went to number 1 on *Billboard*'s Hot Country Singles chart and on the Canadian *RPM* Country Tracks in June 1989.

Production

"I Don't Want to Spoil the Party" required nineteen takes before being taped on September 29. The session began with seven takes, and then, after a pause, continued with twelve others. Only five of them were complete, which suggests that the Beatles were struggling with it. George's guitar is no doubt part of the problem. His playing, always inspired by Chet Atkins, is not clear, while John and Paul's vocals were in perfect harmony and Ringo provided a metronomic rhythm supported by a tambourine on the bridges. The refrain, sung by John, Paul, and maybe George, emphasizes the end of the verses. The performance has a casual side, at variance with the lyrics. The mono mix was done on October 26, the stereo on November 4, the last session for *Beatles for Sale*.

1. Miles, *Paul McCartney*.

Technical Details

Norman Smith decided to change the microphone on Ringo's bass drum during two sessions on September 29–30. The 4033-A TCC was replaced by an AKG D20, which remained in use until the last album.

What You're Doing

Lennon-McCartney / 2:31

SONGWRITER
Paul

MUSICIANS
Paul: vocals, bass, piano (?)
John: rhythm guitar, backing vocals
George: lead guitar, backing vocals
Ringo: drums
George Martin: piano (?)

RECORDED
Abbey Road: September 29–30, 1964 (Studio Two) /
October 26, 1964 (Studio Two)

NUMBER OF TAKES: 19

MIXING
Abbey Road: October 27, 1964 (Studio Two)

TECHNICAL TEAM
Producer: George Martin
Sound Engineer: Norman Smith
Assistant Engineers: Ken Scott, Mike Stone, A. B. Lincoln

1964

Genesis

According to Paul, "What You're Doing," which he wrote together with John, dates from their summer U.S. tour: "I think it was a little more mine than John's—I don't have a very clear recollection, so to be on the safe side I'd put it as 50/50."[1] John was more firm: "His song; I might've done something."[2] Clearly, the song did not make much of an impression on either one of them. As Paul also noted, "You sometimes start a song and hope the best bit will arrive by the time you get to the chorus."[3] Even though it was an engaging song, "What You're Doing" struggled to take off. It was only "filler,"[4] says Paul.

Production

The production of "What You're Doing" had few problems. The first session was held on September 29, after the recording of "I Don't Want to Spoil the Party." The Beatles taped a basic track, with bass, drums, and guitars. After the seventh take, they decided to continue the next day. Ringo did not play during the introduction. John harmonized Paul's vocal throughout the verses; the piano solo embraced George's guitar riff, transposed by a semitone; and there was a brief piano/bass break before the coda. Dissatisfied, they decided to try again another and final time on October 26. That day, Paul guided Ringo in the intro on the drum, directly inspired by "Be My Baby" by the Ronettes. The snare drum was covered with cloth. John replaced

1. Miles, *Paul McCartney.*
2. Sheff, *The Playboy Interview with John Lennon & Yoko Ono.*
3. Miles, *Paul McCartney.*
4. Ibid.

"What You're Doing" is Paul's composition, and Ringo's drum at the beginning irresistibly recalls "Be My Baby" by the Ronettes.

the harmonization of Paul's vocal by the chorus that he shared with George, who gave a blistering guitar solo based on the piano part, which was quite inventive and probably played by George Martin. Some sources claimed that Paul was at the keyboard. This is difficult to confirm. The piece then took its final form, and take 19 was the best. "What You're Doing" was mixed the following day in mono and stereo versions.

This song marked one of the first examples of the research and experimentation that the Beatles undertook in the studio. They aimed at perfection. Paul acted more and more as the leader, not hesitating to show his colleagues how to play their own instrumental parts.

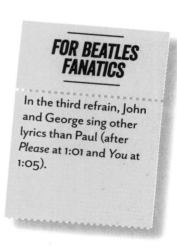

FOR BEATLES FANATICS

In the third refrain, John and George sing other lyrics than Paul (after *Please* at 1:01 and *You* at 1:05).

Everybody's Trying To Be My Baby

Carl Perkins / 2:23

MUSICIANS
George: VOCALS, LEAD GUITAR
JOHN: RHYTHM GUITAR
PAUL: BASS
RINGO: DRUMS, TAMBOURINE

RECORDED
Abbey Road: October 18, 1964 (Studio Two)

NUMBER OF TAKES: 1

MIXING
Abbey Road: October 21, 1964 (Room 65) / November 4, 1964 (Studio Two)

TECHNICAL TEAM
Producer: George Martin
Sound Engineer: Norman Smith
Assistant Engineers: Geoff Emerick, Ron Pender, Mike Stone

Genesis

To the success of "Honey Don't," we need to add "Everybody's Trying to Be My Baby," first recorded by Carl Perkins at the Memphis Sun Studios. This piece borrows its title and part of its lyrics from a hit by a country music singer of the 1930s, Rex Griffin, and was featured on the *Dance Album of Carl Perkins*, released in the United States in 1956. It's a blues-rock ballad in the style of the legendary "Blue Suede Shoes."

The Beatles had performed "Everybody's Trying to Be My Baby" since 1961. It is a title they played from Hamburg to Liverpool, and they played it up to the end. George admired Perkins, particularly his guitar playing. Perkins was also his main influence during the group's early years, as "Everybody's Trying to Be My Baby" shows. With no original compositions of his own since "Don't Bother Me" on *With the Beatles*, George delivered this performance on *Beatles for Sale*. Today, the original title is managed by MPL Communications Ltd., Paul McCartney's company.

Production

"Songs like 'Honey Don't' and 'Everybody's Trying to Be My Baby' we'd played live so often that we only had to get a sound on them and do them,"[1] said George. The recording date was set for October 18. "Everybody's Trying to Be My Baby" was played live, under the same conditions as the first album. George, full of confidence and inspired by Carl Perkins, played with brio and made the recording in a single take. Geoff Emerick recalls, "He not only sang it enthusiastically, but he played the guitar with confidence. Even his solo, played live, was perfect."[2] The other three Beatles provided the accompaniment, John on his Gibson J-160 E, Paul on his Hofner, and Ringo on his Ludwig. There were overdubs afterwards, although Lewisohn did not mention it, for we hear a tambourine,

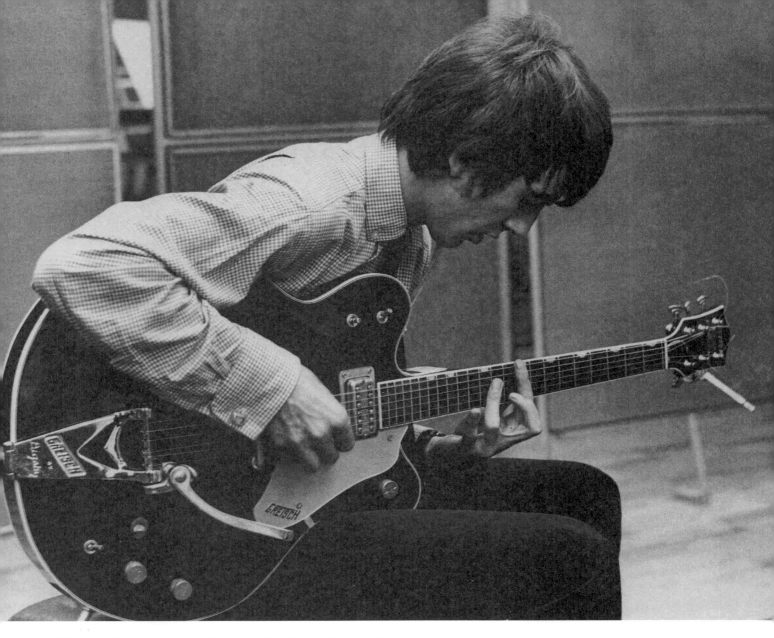

George polishes his guitar technique on his Gretsch Country Gentleman.

probably played by Ringo, and George's vocal, doubled on the choruses. The mono mix is from the October 21 session in Room 65, the so-called "experimental room," and the stereo mix from the November 4 session in the control room of Studio Two.

Technical Details

The slapback echo, created with the STEED (Single Tape Echo/Echo Delay), was added to George's vocals to create an effect characteristic of the pioneers of rock 'n' roll. The echo was recorded together with the vocals, so the guitars leaking into the vocal mike ended up getting the same treatment.

FOR BEATLES FANATICS

In 1985, George played "Everybody's Trying to Be My Baby" with Carl Perkins during a tribute titled Blue Suede Shoes: A Rockabilly Session. Among the guests: Ringo Starr, Eric Clapton, Dave Edmunds, and Rosanne Cash.

1. *The Beatles Anthology.*
2. Emerick, *Here, There and Everywhere.*

1964

I Feel Fine / She's a Woman

SINGLE
RELEASED AS A SINGLE

Great Britain: November 27, 1964 /
No. 1 on December 10, 1964
United States: November 23, 1964 /
No. 1 on December 26, 1964

I Feel Fine

Lennon-McCartney / 2:19

SONGWRITER
John

MUSICIANS
John: vocals, rhythm guitar
Paul: bass, backing vocals
George: lead guitar, backing vocals
Ringo: drums

RECORDED
Abbey Road: October 18, 1964 (Studio Two)

NUMBER OF TAKES: 9

MIXING
Abbey Road: October 21, 1964 (Room 65) / October 22, 1964 (Studio One) / November 4, 1964 (Studio Two)

TECHNICAL TEAM
Producer: George Martin
Sound Engineer: Norman Smith
Assistant Engineers: Geoff Emerick, Ron Pender, Mike Stone

1964

FOR BEATLES FANATICS

When we listen carefully, we can hear at the beginning, just before Ringo's entrance, his snare drum vibrate beneath the waves of the two guitars and the bass (from the left channel in stereo).

Genesis

Upon its release in November 1964, "I Feel Fine" breezed to the top of British and American charts. Before the end of the year, over a million singles had been sold. The Beatles then held a record: more than twenty songs on the *Billboard* charts—six of them number 1!

On October 6, while the Beatles were working on "Eight Days a Week," John tried a new guitar riff between takes. It became "I Feel Fine," a song "written during a recording session," strongly inspired by "Watch Your Step" by Bobby Parker, whose riff had captivated John. He took credit for "I Feel Fine": "That's me completely."[1] Paul is not quite of the same opinion: "We sat down and cowrote it with John's original idea." In any case, we owe the Larsen effect of the opening to John. Paul said that during the same session on October 6, "We were just about to walk away to listen to a take when John leaned his guitar against the amp. I can still see him doing it. He really should have turned the electric off. It was only on a tiny bit, and John just leaned it against the amp when it went, 'Nnnnnnwah-hhhh!' And we went, 'What's that? Voodoo!' 'No, it's feedback.' 'Wow, it's a great sound!' George Martin was there, so we said, 'Can we have that on the record?'"[2] Happy with the effect and his riff, he told his friends that he had used them to write a song. A few days later, he told Ringo when he arrived at the studio: "I wrote the song, but it's nothing."[3] "I Feel Fine" was to be their next number 1 single.

Production

"I Feel Fine" was recorded in nine takes, on October 18. From the first, the Larsen effect was present. It was

John is not the only one to recycle the riff of "Watch Your Step": just listen to the Rolling Stones ("19th Nervous Breakdown"), Led Zeppelin ("Moby Dick"), or Deep Purple ("Rat Bat Blue").

obtained with John's Gibson J-160 E vibrating up to the point of audio feedback with the support of a bass tone by Paul. Ringo delivered a superb drum part (based on both "Watch Your Step" by Bobby Parker and "What'd I Say" by Ray Charles), supported by Paul's huge bass, relentless and powerful. Neither of the first two takes included a solo. In the ninth take, which is the best rhythmic track, John provided an excellent vocal, accompanied by Paul and George in the harmonies and choruses. On the guitars, George played a solo that he doubled, and John backed the piece with rigor and precision on his Rickenbacker 325. On October 21, four mono mixes were made in Room 65, the third used for the British version, the fourth used for the American. The final stereo mix dates from November 4.

When Geoff Emerick heard the Larsen for the first time on October 18, he wondered if the noise was due to a disconnected cable or a faulty device. Norman Smith reassured him, saying this was a new sound that the Beatles had discovered during the previous working session. John took credit for his discovery: "I defy anybody to find a record—unless it's some old blues record in 1922—that uses feedback that way. I mean, everybody played with feedback onstage, and the Jimi Hendrix stuff was going on long before. In fact, the punk stuff now is only what people were doing in the clubs. So I claim it for the Beatles. Before Hendrix, before the Who, before anybody—the first feedback on any record."[4]

1. Sheff, *The Playboy Interview with John Lennon & Yoko Ono.*
2. Miles, *Paul McCartney.*
3. *The Beatles Anthology.*
4. Sheff, *The Playboy Interview with John Lennon & Yoko Ono.*

She's A Woman

Lennon-McCartney / 3:02

SONGWRITER
Paul

MUSICIANS
Paul: vocals, bass, piano
John: rhythm guitar
George: lead guitar
Ringo: drums, percussion

RECORDED
Abbey Road: October 8, 1964 (Studio Two)

NUMBER OF TAKES: 7

MIXING
Abbey Road: October 12, 1964 (Studio Two) / October 21, 1964 (Room 65)

TECHNICAL TEAM
Producer: George Martin
Sound Engineer: Norman Smith
Assistant Engineers: Ken Scott, Mike Stone, Ron Pender

FOR BEATLES FANATICS

In 1965, the famous Tex-Mex band, the Sir Douglas Quintet, had a hit with "She's About a Mover." Legend has it that their manager, Huey P. Meaux, was trying to discover the secret to the Beatles' success. So one night, while drinking, he found a similarity between the Beatles' music and Cajun music. He started a group featuring Doug Sahm and asked him to write a song on the model of "She's a Woman." And it worked!

Genesis

According to Paul, "She's a Woman" was written the same day it was recorded. He had a recollection of walking from St. John's Wood to Abbey Road with the song in his mind: "I might have written it at home and finished it up on the way to the studio, finally polished it in the studio, maybe just taken John aside for a second and checked with him, "What d'you think?" "Like it." "Good. Let's do it!"[1] Paul wanted to make a bluesy title in the vein of "Can't Buy Me Love," a rock song inspired by Little Richard, but with a raw sound. "Blues melodies are difficult to write, so I was quite happy to find this,"[2] he said. The piece sounds like blues rock with a touch of ska.

For the lyrics, "She's a Woman" has one of the Beatles' worst rhymes: *My love don't give me presents / I know that she's no peasant.* Fortunately, John introduced a phrase a little more hip, "We put in the words *turns me on*. We were so excited to say *turn me on*—you know, about marijuana and all that, using it as an expression."[3] Although John participated, "She's a Woman" was essentially Paul's work.

Production

October 8 was dedicated to "She's a Woman": the afternoon was reserved for the rhythmic track, the evening for overdubs. The song was not considered for an album, but destined for a single, which probably explained the time assigned. Yet, "I Feel Fine" by John was designated as the A side. It took seven takes to record the rhythmic track, which exceeded 6:00. The group went wild in a coda over 2:30 long. The sixth take served as the basis for the overdubs. Apparently, George did not participate in the session. Only John's

Sir Douglas Quintet, a Tex-Mex group formed at the urging of the manager Huey P. Meaux.

guitar was present. Paul: "John did a very good thing: instead of playing through it and putting like a water-color wash over it all with his guitar, he just stabbed on the off-beats. Ringo would play the snare and John did it with the guitar, which was good—it left a lot of space for the rest of the stuff."[4] Paul then added piano (at about 2:12 we can hear a small mistake) and provided an excellent lead vocal. John doubled his rhythm and Ringo added a shaker. George then added a superb guitar solo (doubled). Some said that it was Paul who did the interpretation, but the influence of Chet Atkins is

too obvious and corresponds perfectly to George's style of guitar playing. The mono and stereo mixes were done on October 12; another mono mix for the United States was done on October 21 in Room 65.

1. Miles, *Paul McCartney*.
2. Ibid.
3. Sheff, *The Playboy Interview with John Lennon & Yoko Ono*.
4. Miles, *Paul McCartney*.

1964

Long Tall Sally / I Call Your Name / Slow Down / Matchbox

EP

RELEASED

Great Britain: June 19, 1964 /
No. 1 at the *Record Retailer* on July 11, 1964

Long Tall Sally

Enotris Johnson–Robert Blackwell–Richard W. Penniman / 2:02

1964

MUSICIANS
Paul: vocals, bass
John: rhythm guitar and solo
George: rhythm guitar and solo
Ringo: drums
George Martin: piano

RECORDED
Abbey Road: March 1, 1964 (Studio Two)

NUMBER OF TAKES: 1

MIXING
Abbey Road: March 10, 1964 (Studio Two) / June 4 and 22, 1964 (Studio One)

TECHNICAL TEAM
Producer: George Martin
Sound Engineer: Norman Smith
Assistant Engineer: Richard Langham

FOR BEATLES FANATICS

When Little Richard played in Hamburg, none other than Billy Preston was at the keyboard. He had the honor of participating in two Beatles' albums. Preston was the only artist to be credited as part of the group: the 1969 single "Get Back" ("Don't Let Me Down" on the B side) was credited to "The Beatles with Billy Preston."

Genesis

"Long Tall Sally," originally released by Little Richard on February 10, 1956, is one of the most famous songs in rock 'n' roll. Little Richard and his mentor, Robert "Bumps" Blackwell, undertook the challenge of writing a song in a tempo so fast that Pat Boone—who had just released a version of Richard's "Tutti Frutti"—would not be able to handle it! It explained the song's colossal success, since the single reached number 1 on Billboard's Rhythm & Blues chart even before the song was covered by many other singers and groups. "We used to stand backstage at Hamburg's Star-Club and watch Little Richard play. . . . It was Brian Epstein who brought him . . . I still love him, he's one of the greatest,"[1] John confessed in 1973. "Long Tall Sally" is one of the oldest songs in the Beatles' repertoire. They played it from 1957 until their last concert in San Francisco's Candlestick Park on August 29, 1966, where it was also the last piece performed onstage! "Long Tall Sally" was also one of the titles that Paul allegedly played at the piano during his meeting with John on July 6, 1957, at the festival of Woolton Village. John was so fond of Little Richard's version that it featured prominently in his personal jukebox.

Production

On March 1, 1964, after having finished "I'm Happy Just to Dance with You" for the sound track of *A Hard Day's Night*, the group tackled "Long Tall Sally." They recorded it in one take, without overdubs, each playing his usual instrument, with George Martin at the piano. This dazzling recording certainly matches Little Richard's recording. Paul delivered an exceptional

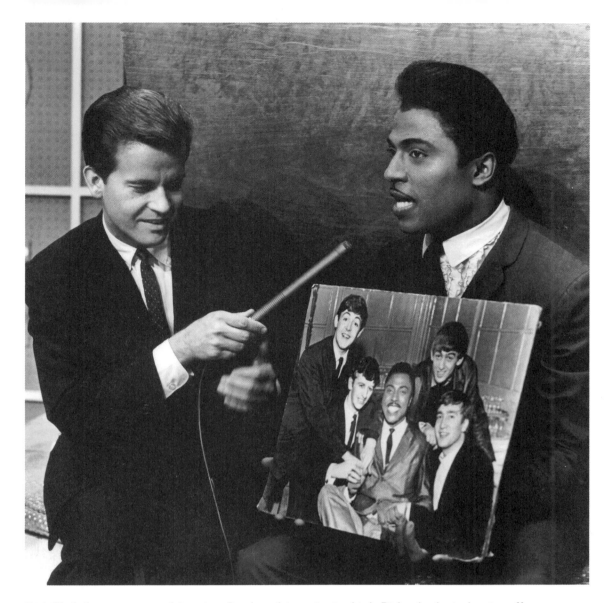

Dick Clark, famous emcee of *American Bandstand*, interviewing Little Richard, who is showing off a photograph where he is surrounded by all four Beatles.

vocal, equal to the one performed by the master—by the way, Little Richard said that he had revealed the secrets of how to sing it to Paul. The song featured two guitar solos. John played the first, and George the second. Ringo pushed forward on the drum, powerful and frantic, with some triplet breaks at the end of the song, which was technically quite difficult. Even George Martin provided a feverish part at the piano. The final mono mix is dated June 4. The stereo was made on June 22, three days after the release of the EP.

Two EPs with Unique Titles. . .
In the Beatles' career, only two extended plays (EPs) came out with new titles unavailable on other British albums: "Long Tall Sally" in 1964 and "Magical Mystery Tour" in December 1967. In this book, we consider only the U.K. singles. A notable exception is "Long Tall Sally," which was the fifth EP by the Beatles. It brought together four titles, not included on any other record, justifying our decision.

1. *The Beatles Anthology.*

I Call Your Name

Lennon-McCartney / 2:07

SONGWRITER
John

MUSICIANS
John: vocal, rhythm guitar
Paul: bass
George: lead guitar
Ringo: drums, cowbell

RECORDED
Abbey Road: March 1, 1964 (Studio Two)

NUMBER OF TAKES: 7

MIXING
Abbey Road: March 3, 1964 (Studio Two) / March 4, 1964
(Studio Three) / March 10, 1964 (Studio Two) / June 4, 1964
(Studio Two) / June 22, 1964 (Studio One)

TECHNICAL TEAM
Producer: George Martin
Sound Engineer: Norman Smith
Assistant Engineers: Richard Langham, A. B. Lincoln

FOR BEATLES FANATICS

Between 0:47 and 0:51 (on the right channel in stereo), George has a memory lapse and forgets his guitar part!

Genesis

"I Call Your Name" is one of John's first songs. "That was my song. When there was no Beatles and no group. I just had it around. . . . The first part had been written before Hamburg even."[1] John set out to compose a blues number: he added the bridge, probably in 1963. Paul remembered helping him and, years later, hearing these lyrics, he was surprised by the meaning of the words: "Wait a minute. What did he mean? 'I call your name but you're not there?' Is it his mother? His father?"[2] John often disguised his personal feelings in his songs, and it is only in hindsight that Paul grasped a hidden meaning in his partner's words.

In 1963, John gave the song "I Call Your Name" to another Brian Epstein–managed act, Billy J. Kramer & the Dakotas. The Dakotas had already covered "Do You Want to Know a Secret," backed by John's "Bad to Me," and that single had topped the UK charts on August 24 of the same year. While filming *A Hard Day's Night,* John thought again about this song and planned to include it in the film. Richard Lester preferred "A Hard Day's Night."

Production

The Beatles' version of "I Call Your Name" is far more compelling than Billy J. Kramer's. Recorded on March 1, just after "Long Tall Sally," the song was completed in seven takes. John was the only one singing. Paul and Ringo provided a solid rhythm section, including a shuffle rhythm in the bridge—according to John it was an attempt at a ska beat. George played his Rickenbacker 360/12 twelve-string for the first time. John later doubled his vocal line and Ringo added a cowbell. "I Call Your Name" was always intended for the *A Hard*

Billy J. Kramer & the Dakotas. John offered "I Call Your Name" to this Liverpool band in 1963.

Day's Night film sound track. A mono mix was made on March 3 for United Artists. The next day, George Martin attempted a first stereo mix, which was never used, and another on March 10. Meanwhile, John proposed the song "A Hard Day's Night," which took the place of "I Call Your Name." The song was eventually remixed as a single on June 4 using take 7, to which the better solo from take 5 was added. There were a total of four different mixes for the same song, each appearing on different records: two in the United States and two in Britain!

1. Sheff, *The Playboy Interview with John Lennon & Yoko Ono.*
2. Miles, *Paul McCartney.*

Slow Down

Larry Williams / 2:54

MUSICIANS
John: vocal, rhythm guitar
Paul: bass
George: lead guitar
Ringo: drums
George Martin: piano

RECORDED
Abbey Road: June 1, 1964 (Studio Two) / June 4, 1964 (Studio Two)

NUMBER OF TAKES: 6

MIXING
Abbey Road: June 4, 1964 (Studio Two) / June 22, 1964 (Studio One)

TECHNICAL TEAM
Producer: George Martin
Sound Engineer: Norman Smith
Assistant Engineers: Ken Scott, Richard Langham, Geoff Emerick

1964

Genesis

Singer, pianist, and songwriter Larry Williams contributed to the fame of Art Rupe's Specialty Records by offering him a selection of rock 'n' roll classics: "Dizzy Miss Lizzy," "Bad Boy," "She Said Yeah," and "Slow Down," a twenty-four-bar blues with a Deep South feeling, which he recorded in 1958. Like Carl Perkins, the Beatles adapted three of Williams's titles: "Dizzy Miss Lizzy," "Bad Boy," and "Slow Down."

"Slow Down," which the Beatles had sung since 1960, was a highlight of their repertoire. John and his bandmates played with a groove, infusing the song with energy and allowing it to soar. John's excellent interpretation revealed his admiration for Larry Williams. At a low point in his career, Williams sought to benefit from this publicity by trying to make a comeback with Johnny "Guitar" Watson. However, drugs and violence stalled any chance for success.

Production

"Slow Down" was recorded on June 1. The rhythm track took three takes, and three others were added for John's vocal, and probably also George's solo. The rhythm section is solid—Paul and Ringo provided the pulse to the piece, while John and George played their guitars and John performed a superb vocal. All together, the result was quite close to the original version. Unfortunately, the Beatles and George Martin gave little time to the production of this title, probably considering it unimportant. George's solo is somewhat embarrassing (his poor performance can be heard clearly between 2:14 and 2:17) as is the poor doubling of John's vocal (1:15, on the line *But now you got a boyfriend down the street*. Some words were replaced by others, such as changing *boyfriend* to *girlfriend*).

Larry Williams, composer of "Slow Down," a twenty-four-bar blues straight out of the Mississippi Delta.

On June 4, while the Beatles flew to Copenhagen without Ringo (he had been replaced by the session drummer Jimmy Nicol so that he could undergo a tonsillectomy), George Martin decided to add a piano part. Probably pressed for time, he gave a very pedestrian performance, lacking precision, as can be noted around 1:20 and 2:28. In addition, the piano momentarily is silent between 1:14 and 1:17 for no apparent reason, as if to hide a mistake. The mono mix was made during the same session, the stereo on June 22.

Matchbox

Carl Perkins / 1:57

MUSICIANS
Ringo: vocal, drums
John: lead guitar (?), rhythm guitar (?)
Paul: bass
George: lead guitar (?), rhythm guitar (?)
George Martin: piano

RECORDED
Abbey Road: June 1, 1964 (Studio Two)

NUMBER OF TAKES: 5

MIXING
Abbey Road: June 4, 1964 (Studio Two) / June 22, 1964 (Studio One)

TECHNICAL TEAM
Producer: George Martin
Sound Engineer: Norman Smith
Assistant Engineers: Ken Scott, Richard Langham, Geoff Emerick

FOR BEATLES FANATICS

During the first seconds of the song, we hear a quick sniff. Is Ringo trying to justify his impending tonsillectomy?

Genesis

The origins of "Matchbox" are lost in the history of the blues. As early as 1923, Ma Rainey evokes "Matchbox" in the recording of "Lost Wandering Blues," four years before Blind Lemon Jefferson recorded the first version, "Match Box Blues." In December 1956, Carl Perkins recorded "Matchbox" at Sun Records, accompanied by Jerry Lee Lewis at the piano. The release of his single in February 1957 influenced an impressive number of singers and musicians, notably the Beatles: the title became one of the first great rockabilly songs. Perkins maintained that he had never heard Jefferson's "Match Box Blues."

The song entered the Beatles' repertoire early on during the heyday of concerts in Hamburg and Liverpool. Pete Best was the first to sing the song between 1960 and 1962. After Best was kicked out of the group, John appropriated the vocal. When the Beatles decided to record "Matchbox," Ringo took over, all too happy to lead the song. On the day of recording, Carl Perkins, who was touring England with Chuck Berry, made a courtesy visit to the Abbey Road Studios at the request of the group. In an interview in 1964, Ringo confessed his discomfort at performing in front of the master: "Oh! Carl came to the session. I felt terribly embarrassed. I did it just two days before I went into the hospital for a tonsillectomy, so please forgive my throat!" With "Honey Don't" and "Everybody's Trying to Be My Baby," this was the third Perkins song covered by the Beatles—so much did they admire him! Their friendship endured long after the breakup of the group in 1970. Today, Paul administers the rights to these three titles through his company MPL Communications Ltd.

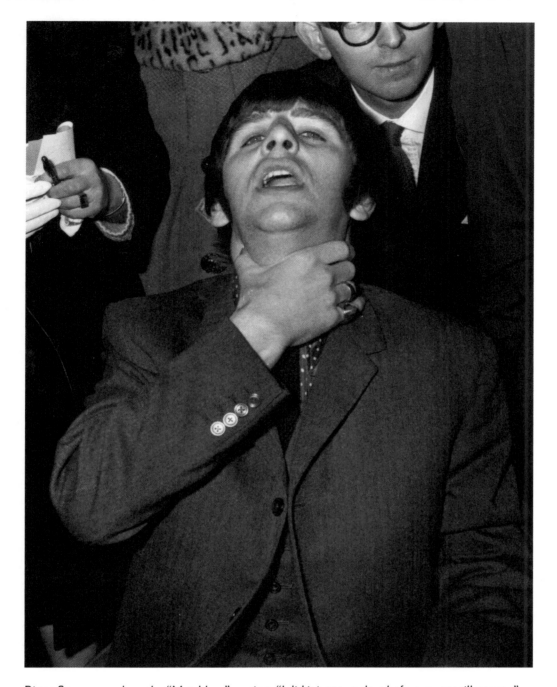

Ringo Starr remembers the "Matchbox" session: "I did it just two days before my tonsillectomy."

Production

On June 1, the Beatles decided to start the session with "Matchbox" under the watchful eye of Carl Perkins. After five takes, the song was recorded. Ringo simultaneously sang and played drums, despite his stage fright. His voice was not perfect, but he gave a good performance and kept the tempo firmly on track, backed by Paul on bass. The guitar solo was, in all likelihood, played by John and not by George—in fact, on the CD *Live at the BBC* we can hear Ringo start the solo with a friendly "All right John!" The solo was doubled, as was Ringo's vocal (which he struggled with). George Martin added piano. Beatles historians believe that Perkins and the Beatles played together before recording the song, but no official recordings confirm it. As with other titles on the EP, the mono mix was made on June 4 and the stereo came from the session on June 22.

H

1965

Help !
The Night Before
You've Got to Hide Your Love Away
I Need You
Another Girl
You're Going to Lose That Girl
Ticket to Ride
Act Naturally
It's Only Love
You Like Me Too Much
Tell Me What You See
I've Just Seen a Face
Yesterday
Dizzy Miss Lizzy

ALBUM
RELEASED

Great Britain: August 6, 1965 / No. 1 for 9 weeks
United States: June 14, 1965, *Beatles VI* / No. 1 for 6 weeks
June 20, 1966, *Yesterday and Today* / No. 1 for 5 weeks
August 13, 1965, *Help!* / No. 1 for 9 weeks
December 6, 1965, *Rubber Soul* / No. 1 for 6 weeks

Ringo, Paul, George, and
John on the snowy slopes of
Austria while filming *Help!*

Help!:
A Transitional Album

The Beatles ended the year 1964 with a new success ("I Feel Fine," number 1 on the charts on both sides of the Atlantic), and 1965 started under favorable auspices. On January 27, John, Paul, and Brian Epstein founded Maclen Music, a company created specifically to administer the group's rights in the United States. Recording sessions for the new album started on February 15 and on February 24 filming began for a new movie, *Help!* At the beginning of the year, the Beatles had a lot on their plate—seven new songs for the soundtrack of the feature film and seven others to complete the album.

On *Help!* the Beatles' songwriting and sound developed in remarkable ways. John, strongly influenced by Bob Dylan, wrote more edgy lyrics, realistic, dark, and cynical ("Help!," "You've Got to Hide Your Love Away"). Paul revealed many facets of his talent as a performer ("I've Just Seen a Face," "I'm Down") and wrote one of his more successful songs, "Yesterday." George finally asserted himself as a songwriter to be reckoned with: he completed two titles, one of them, "I Need You," was chosen for the soundtrack of the film. Ringo confirmed his love for country music with his cover of "Act Naturally." As for George Martin, he helped the Fab Four enhance their sound palette by suggesting the use of a string quartet on "Yesterday," for which Martin wrote the sublime arrangement. Now, the Beatles opened new musical horizons.

Upon the release of *Help!* on August 6 in the UK and on August 13 in the United States, the album reached the number 1 spot on the *Billboard* album charts. Across the Atlantic, to the dismay of the Beatles, Capitol Records distributed the songs of the album among four records: *Beatles VI*, *Yesterday and Today*, *Help!*, and *Rubber Soul*. The U.S. *Help!* album replaced the songs that did not appear in the film with instrumentals.

The Movie

The second Beatles movie, *Help!*, was used as a vehicle to spotlight Ringo's personality. The plot revolves around a magic ring that Ringo wears and a cult devoted to the goddess Kaili who wants to get the ring back at any price. Richard Lester returned as director for the film. Filming took place between February 24 and May 11 in the Bahamas and the Austrian Alps. As with *A Hard Day's Night* and later *Let It Be* (1969), additional filming took place in Twickenham Film Studios in London. Production of the film was completed on June 16.

Ringo had suggested *Eight Arms to Hold You* as the title for this new movie, but that was abandoned in favor of *Help!* We don't know who was responsible— Richard Lester or John? Unlike *A Hard Day's Night*, the Beatles did not invest much of themselves in the script, but the shooting allowed them to flee the pressure of the fans, to have fun, and to consume copious quantities of marijuana. The result is satisfying, nothing more.

Unlike *A Hard Day's Night*, Lester commissioned the film score not from George Martin, but from Ken Thorne. George Martin remembers: "Dick Lester and I didn't hit it off well on *A Hard Day's Night*, and the fact that I got an Academy Award nomination for musical direction probably didn't help either."[1] The premiere was at the London Pavilion on July 29. Despite relatively good reviews, the movie did not have the same success as the first Beatles movie.

For the *Help!* album, Robert Freeman was once again responsible for the design. The original idea was to feature the Beatles with their arms positioned to spell

1. *The Beatles Anthology.*

The Epiphone ES-230TD Casino, chosen by Paul McCartney for the recording sessions of the album *Help!*

Poster for the second film directed by Richard Lester with the Beatles.

out the word *Help* in semaphore. But the arrangement of the arms did not look good, so Freeman asked the Beatles to take other positions. The result was NUJV, which had no meaning! On the U.S. cover, slightly amended, we read NVUJ.

The Instruments

The Beatles' sound palette was enriched in 1965. At the beginning of that year, John and George bought two Fender Stratocaster Sonic Blue guitars. Although mainly used on *Rubber Soul*, they appeared on some tracks of the *Help!* album. For Christmas 1964, Paul bought two Epiphone guitars: an ES-230TD Casino, which he used for the first time to perform some solos ("Another Girl," "Ticket to Ride"), and a Texan acoustic flat top guitar, which he immortalized on "Yesterday." John's Framus Hootenanny twelve-string guitar made an appearance, too. Two new keyboards were also used: a Hohner Pianet electric piano and a Vox Continental portable organ.

Ringo, John, and Paul with director
Richard Lester.

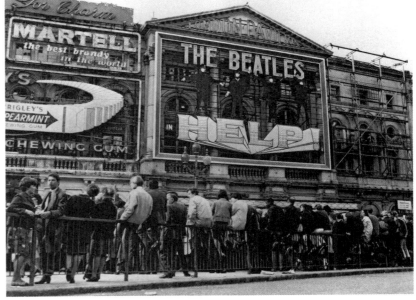

The premiere of *Help!* at the London Pavilion, Piccadilly Circus, July 29, 1965.

Help !

Lennon-McCartney / 2:18

SONGWRITER
John

MUSICIANS
John: vocal, rhythm guitar
Paul: bass, backing vocal
George: lead guitar, backing vocal
Ringo: drums, tambourine

RECORDED
Abbey Road: April 13, 1965 (Studio Two)

NUMBER OF TAKES: 12

MIXING
Abbey Road: April 18, 1965 (Room 65) / June 18, 1965 (Studio Two)

TECHNICAL TEAM
Producer: George Martin
Sound Engineer: Norman Smith
Assistant Engineers: Ken Scott, Phil McDonald

RELEASED AS A SINGLE

Help! / I'm Down
Great Britain: July 23, 1965 / No. 1 for 3 weeks from August 7, 1965
United States: July 19, 1965/ No. 1 for 3 weeks from September 4, 1965

Genesis

About 1973, John confessed to May Pang, his girlfriend at the time, that his favorite Beatles song was probably "Help!": "I'd like to redo 'Help!' someday. The way we did it, it never told all of the truth."[1] He would have preferred a more soulful, mellow version of the song, with a greater emotional impact. He didn't have the opportunity.

During a working session in April 1965, "Help!" was mentioned as the title of the second movie. John went home to compose the eponymous song. When Paul joined him, he already had the basis of the piano part. Paul says: "My main contribution is the counter-melody to John."[2] When the song was finished, John and Paul were satisfied and performed it for Cynthia and Maureen Cleave, the famous journalist from the *Evening Standard.* "Very nice," they said. "Like it."[3] "Most people think it's just a fast rock 'n' roll song. I didn't realize it at the time; I just wrote the song because I was commissioned to write it for the movie. But later, I knew I really was crying out for help,"[4] he said in 1980. At that time John was dissatisfied with himself—he felt ill at ease with success, honors, money, excess; he felt oppressed: "The whole Beatles thing was just beyond comprehension. I was eating and drinking like a pig and I was fat as a pig, dissatisfied with myself, and subconsciously I was crying out for help . . . So it was my fat Elvis period."[5] *Help!* became a kind of way out, and he poured all his dark and unhappy thoughts into his songs on the album. Dylan was right: *The times they are a-changin'.*

1. May Pang and Henry Edwards, *Loving John: The Untold Story* (London: Corgi Books, 1983).
2. Miles, *Paul McCartney.*
3. Ibid.
4. Sheff, *The Playboy Interview with John Lennon & Yoko Ono.*
5. Ibid.

FOR BEATLES FANATICS

When George recorded his descending arpeggio, there was only one free track (the fourth). But, listening to the record, it appears that the arpeggio has been doubled. Since no other track was available, John or Paul must have played it with him.

The scene in *Help!* where Ringo is threatened by a strange sect, that attempts to seize his ring by any means.

The Mystery of Mixes

A mystery surrounds the mixing sessions. The mono version (of the movie and the single mono LP) differs from the stereo version of June 18. The vocals are different, Ringo's tambourine has disappeared, and one word was replaced (And now this day / But now . . .). According to documents that recently surfaced, the Beatles went for unknown reasons to CTS London Studios, rather than Abbey Road Studios, to rerecord their vocals for the Help! film.

Production

On April 13, 1965, it took twelve takes and four hours for the Beatles to immortalize "Help!" John played his twelve-string Framus Hootenanny acoustic guitar, George his Gretsch Tennessean, Paul his Hohner, and Ringo his Ludwig kit. The first four takes were reserved for the basic rhythm. George executed little more than his descending arpeggio. At take 5, they decided to leave this section blank, John marked the tempo by strumming his strings. Take 9 was selected as the best take. John sang the lead vocal, backed by Paul and George. Then they doubled the vocals while Ringo added a tambourine. After freeing a track by a tape-to-tape reduction to a second tape recorder (see Technical Details), George was able to focus on his descending arpeggio. Take 12 was the final one. The mono mix for the movie soundtrack is dated April 18. Mono and stereo mixes for the album are dated June 18. An interesting detail: the doubling of John's vocal, judged bad in the first refrain, was eliminated.

Technical Details

"Help!" marked a significant technical change in the Beatles' recording process. With this song, George Martin and Norman Smith inaugurated a new recording method, also called a tape-to-tape "reduction." They transferred the first four tracks from the original tape recorder to a second four-track tape recorder, by remixing tracks 3 and 4 and then combining them into one track on a second tape. Thus, on the second recorder, tracks 1 and 2 were identical to the original, the third track was the premix of track 3 and 4 from the original tape, and track 4 became free. This process had to be used sparingly, since each reduction caused a loss of sound quality.

In 1965, the Beatles were still at the peak of their success.

The Night Before

Lennon-McCartney / 2:34

SONGWRITER
Paul

MUSICIANS
Paul: vocal, bass, lead guitar
John: Hohner Pianet piano, backing vocal
George: lead and rhythm guitar, backing vocal
Ringo: drums, maracas

RECORDED
Abbey Road: February 17, 1965 (Studio Two)

NUMBER OF TAKES: 2

MIXING
Abbey Road: February 18 and 23, 1965 (Studio Two)
/ April 18, 1965 (Room 65)

TECHNICAL TEAM
Producer: George Martin
Sound Engineer: Norman Smith
Assistant Engineers: Ken Scott, Malcolm Davies,
Phil McDonald

Genesis

"Do you feel that there's any change [from your last record]?" Paul answered this question at a press conference on August 29, 1965, in Los Angeles without hesitation: "We try to change every record. You know, we've tried to change from the first record we made."[1] Indeed, this was the case with "The Night Before." This song combined British rock and American rhythm & blues and carried germs of a future musical direction. It was the first time a Hohner Pianet electric piano appeared in a Beatles recording. The keyboard was used afterward by groups such as the Lovin' Spoonful and Roxy Music.

Paul remembered that he had composed the song alone at the apartment in Wimpole Street, owned by Jane Asher's parents. John did not dispute that: "That's Paul again. I'll just say it's Paul, meaning I don't remember anything about it except it was in the movie *Help!*"[2] Although it was well made, neither John nor Paul had strong memories about its creation. Chosen for the movie soundtrack, it was performed in an outdoor scene filmed on Salisbury Plain, where Stonehenge is located.

Production

On February 17, the third session devoted to the *Help!* soundtrack, "The Night Before" was taped and completed in only two takes. Paul was on vocal and bass, George on rhythm guitar, Ringo on drums, and John played a Hohner Pianet electric piano for the first time. Paul doubled his vocal, and Ringo added maracas. As for the guitar solo, it seems that Paul and George played in duo, doubling each other at the octave. However, George Martin mentions only George in *All You Need Is Ears*,"[3] while Barry Miles mentions Paul in

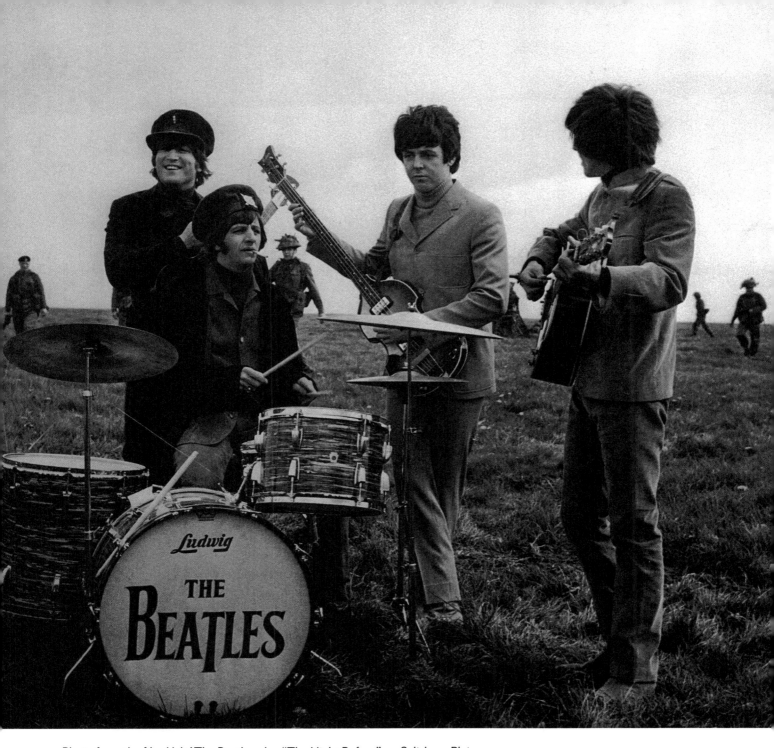

Photo from the film *Help!* The Beatles play "The Night Before" on Salisbury Plain.

Paul McCartney: Many Years from Now.[4] It is likely they played together; the four-track recording obliged them to save space. The song was mixed in mono on February 18, and stereo on February 23. Another stereo mix was made on April 18 in Room 65 for United Artists, but it was never used.

1. Larry Lange, *The Beatles Way: Fab Wisdom for Everyday Life* (New York: Atria Books, 2001).
2. Sheff, *The Playboy Interview with John Lennon & Yoko Ono.*
3. Martin and Hornsby, *All You Need Is Ears.*
4. Miles, *Paul McCartney.*

You've Got To Hide Your Love Away

Lennon-McCartney / 2:08

SONGWRITER
John

MUSICIANS
John: vocal, rhythm guitar
Paul: bass, maracas
George: rhythm guitar, classical guitar
Ringo: drums, tambourine
Johnnie Scott: tenor and alto flutes

RECORDED
Abbey Road: February 18, 1965 (Studio Two)

NUMBER OF TAKES: 9

MIXING
Abbey Road: February 20 and 23, 1965 (Studio Two)

TECHNICAL TEAM
Producer: George Martin
Sound Engineer: Norman Smith
Assistant Engineers: Ken Scott, Malcolm Davies

FOR BEATLES FANATICS

On February 18, while the Beatles were in the studio, their publishing company, Northern Songs Ltd., made its debut on the London Stock Exchange.

Genesis

John Lennon's childhood friend, Pete Shotton, had the honor of witnessing the creation of "You've Got to Hide Your Love Away." When John played his song for the first time for Paul, he mistakenly sang, *I can't go on feeling two-foot small* instead of . . . *two-foot tall*. "All those pseuds [pseudointellectuals] will really love it!," laughed Lennon, referring to the music critics Lennon felt misinterpreted his lyrics.[1] Pete claims he suggested the *Hey* at the beginning of the backing vocals.

Bob Dylan had a strong influence on the composition of this song. John discovered a realism and commitment in the poetry of the American singer's protest songs that brought a total rethinking to his approach to lyric writing and allowed him for the first time to express his true feelings: "Instead of projecting myself into a situation, I would try to express what I felt about myself, which I'd done in my books [*In His Own Write* and *A Spaniard in the Works*]. I think it was Dylan who helped me realize that—not by any discussion or anything, but by hearing his work."[2] Paul also recognized the significant influence of Bob on John at this time: "So Dylan's gobbledygook and his cluttered poetry was very appealing, it hit a chord in John. It was as if John felt, That should have been me."[3] Some saw in the lyrics to "You've Got to Hide Your Love Away" an allusion to Brian Epstein and his homosexuality; others to an adulterous adventure. What was certain was that John spoke of painful feelings and feeling different, alone against the world. After *Help!* John revealed the darkness of his soul, which, in spite of success, was in pain. He said in an interview with *Playboy:* "I am like a chameleon, influenced by whatever is going on. If Elvis can do it, I can do it. If the Everly Brothers can do it, me and Paul can. Same with Dylan."[4]

1965

An acoustic climate surrounded the recording of "You've Got to Hide Your Love Away." Above, John plays his Gibson.

Production

Thursday, February 18. For a fee of £6 [$9.00 U.S.] per session, flutist and musical arranger Johnnie Scott became a legend. Although he was not credited on the album, it was the first time the Beatles called an additional musician into a session, not including Andy White, who had replaced Ringo on September 11, 1962, to play drums for "Love Me Do" and "P.S. I Love You." Johnnie Scott created the solo by doubling an alto flute with a tenor flute.

The song was based around John's and George's acoustic guitars. Dylan had not only influenced the lyrics for the song, but also the atmosphere. "You've Got to Hide Your Love Away" was recorded in nine takes. The first track was reserved for the rhythm. John played his

twelve-string Framus Hootenanny; Paul was on bass; George probably used his José Ramirez classical guitar; and Ringo his brushes. John's vocal was recorded on the second track and, strangely, was not doubled. While on track 3, George also played his twelve-string guitar, Paul played maracas, and Ringo tambourine. Finally, on the last track, Johnnie Scott recorded his flute solo, imitating John's vocal on the second track. The mono mix was made on February 20, stereo on February 23.

1. Pete Shotton and Nicholas Schaffner, *John Lennon in My Life* (New York: Stein and Day, 1983).
2. *The Beatles Anthology.*
3. Miles, *Paul McCartney.*
4. Sheff, *The Playboy Interview with John Lennon & Yoko Ono.*

I Need You

George Harrison / 2:28

SONGWRITER
George

MUSICIANS
George: vocal, lead guitar
John: backing vocal, snare drum, rhythm guitar
Paul: bass, backing vocal
Ringo: drums, cowbell

RECORDED
Abbey Road: February 15–16, 1965 (Studio Two)

NUMBER OF TAKES: 5

MIXING
Abbey Road: February 18 and 23, 1965 (Studio Two)

TECHNICAL TEAM
Producer: George Martin
Sound Engineer: Norman Smith
Assistant Engineers: Ken Scott, Jerry Boys, Malcolm Davies

1965

Violoning

George used a volume foot pedal, allowing him to quickly increase or lower the sound level of the instrument according to the desired effect. This gives a characteristic effect called "violoning," not to be confused with the wah-wah pedal, immortalized by Jimi Hendrix, which in no way modulates the sound level of the instrument, but only varies its frequency.

Genesis

Curiously, George Harrison never commented on "I Need You," nor did he mention the title in his autobiography.[1] Yet, it was one of the first songs—after "Don't Bother Me" for *With the Beatles*—that George Harrison wrote for the group. In this love song, no doubt inspired by Pattie Boyd, George revealed his feelings: he needed her! Richard Lester thought this song was strong enough to be included among the seven songs chosen for the movie. The sequence, filmed at Salisbury Plain, features George singing with his friends in the middle of military tanks, obviously worried about the imminent arrival of the rain!

Production

Recorded on February 15, "I Need You" has a unique sound: George on vocal and lead guitar, Paul on bass, John on the snare drum (!), and Ringo contributing percussion by hitting the back of a Gibson Jumbo acoustic guitar! The Beatles were constantly searching for new sounds, and this surprising rhythm section is a good example. John simply marked the second and fourth beats of the measure while Ringo used the back of the guitar like a bongo. Take 5 was selected as the best. The next day, George performed the lead vocal, John and Paul contributed backing vocals, Ringo added a cowbell, and George, for the first time, played using a foot-controlled tone pedal that he plugged into his Rickenbacker twelve-string. In the movie, we see George playing on a Gibson Jumbo, John on the Rickenbacker 325, and Ringo on drums. In fact, they were only props—no one played these instruments on the recording. On February 18, the mono mix was made and on February 23, the stereo mix.

1. Harrison, *I Me Mine.*

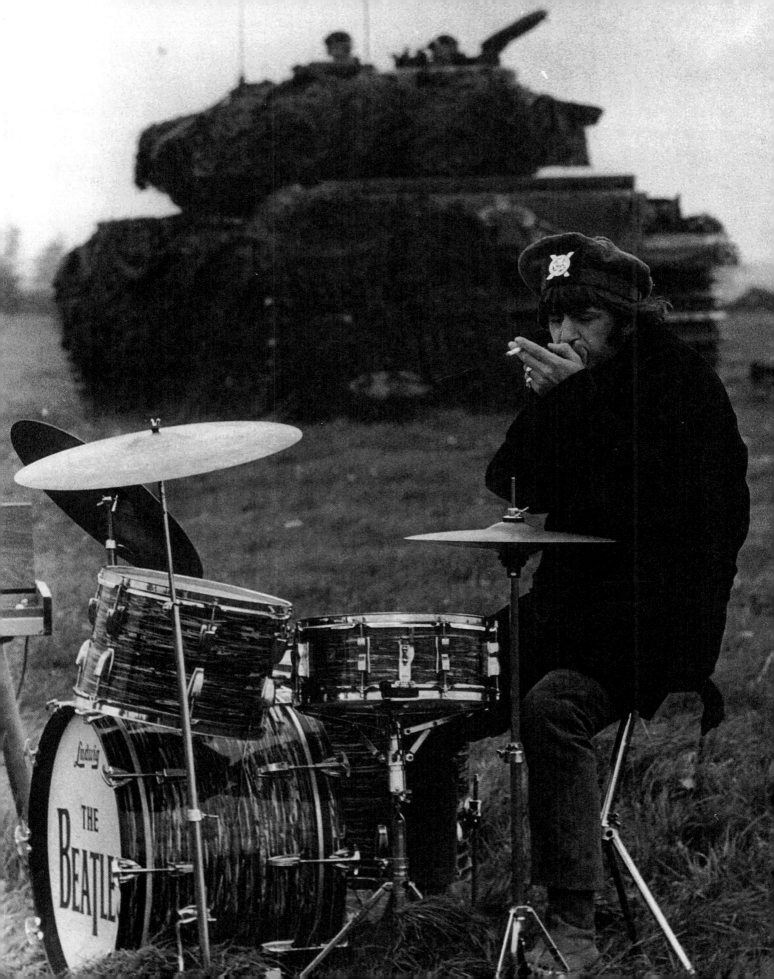

Another Girl

Lennon-McCartney / 2:04

SONGWRITER
Paul

MUSICIANS
Paul: vocal, bass, lead guitar
John: rhythm guitar, backing vocal
George: acoustic guitar, backing vocal
Ringo: drums

RECORDED
Abbey Road: February 15–16, 1965 (Studio Two)

NUMBER OF TAKES: 1

MIXING
Abbey Road: February 18 and 23, 1965 (Studio Two)

TECHNICAL TEAM
Producer: George Martin
Sound Engineer: Norman Smith
Assistant Engineers: Ken Scott, Jerry Boys, Malcolm Davies

1965

Genesis

Paul wrote "Another Girl" by himself after February 4 while on vacation in a villa in Hammamet, Tunisia, as a guest of the Tunisian Embassy. The words contain a double meaning, especially for his fiancée at the time, Jane Asher. Although the song is not one of Paul's strongest, it had passed the famous "Beatles test"—it took only one member of the group to dislike a song to veto it. According to Paul, "It's a bit much to call them fillers because I think they were a bit more than that. . . . We all had to like it. It could be vetoed by one person."[1] Richard Lester selected "Another Girl" as the second title for the *Help!* soundtrack.

Production

After Paul's return from Hammamet, he went to the studios on Monday, February 15. The Beatles adopted a new, more efficient approach to recording: they recorded a song by repeating it until they had a satisfactory rhythm track, which they would label TAKE 1. Therefore, "Another Girl" had more than a dozen attempts before selecting the first take. According to George Martin's notes, published in his book *Playback*,[2] George played on a Gibson Jumbo and John on the Fender Stratocaster Sonic Blue. Paul sang and played the bass, accompanied by John and George on backing vocal. Paul then doubled his voice, backed in some sections by John. George had some trouble with the guitar solo. The next day, Paul, unhappy with George's solo, replaced it with his own solo, played on his Epiphone Casino. This would not be the last time Paul provided a guitar solo for a Beatles song (see "Ticket to Ride"). The mono and stereo mixes were made on February 18 and 23.

1. Miles, *Paul McCartney.*
2. George Martin, *Playback: An Illustrated Memoir* (Guildford, Surrey, UK: Genesis Publications, 2002).

You're Going To Lose That Girl

Lennon-McCartney / 2:18

SONGWRITER
John

MUSICIANS
John: vocal, acoustic guitar
Paul: bass, backing vocal, piano
George: lead guitar, backing vocal
Ringo: drums, bongos

RECORDED
Abbey Road: February 19, 1965 (Studio Two) / March 30, 1965 (Studio Two)

NUMBER OF TAKES: 2

MIXING
Abbey Road: February 20–23, 1965 (Studio Two) / April 2, 1965 (Studio Two)

TECHNICAL TEAM
Producer: George Martin
Sound Engineer: Norman Smith
Assistant Engineers: Ken Scott, Malcolm Davies, Ron Pender, Vic Gann

Genesis

"You're Going to Lose That Girl" is one of the Beatles' most underrated songs (including by the Beatles themselves). Interviewed by David Sheff, John made no comment about it. Ditto for Paul, who only quantified John's contribution (60/40 in favor of John). In the movie, "You're Going to Lose That Girl" was the next to the last song that the Beatles filmed at Twickenham Film Studios for *Help!* The group lip-synched to their recording. It was also the last song they recorded for the soundtrack of the movie *Help!* before leaving England on February 22 for the Bahamas.

Production

On February 19, the group spent the afternoon on "You're Going to Lose That Girl," the only song recorded that day. Two takes were needed to record the rhythm track: John sang and accompanied himself on acoustic guitar, backed by superb vocals from Paul and George (both doubled). George played a priori on his Gretsch Country Gentleman, Paul was on bass and Ringo on drums. George performed an excellent guitar solo, accompanied by Paul's piano and Ringo's bongos. Other overdubs were recorded on March 30 but were not used. The mono mix was made on February 20. The stereo mix was more complicated: two mixes were attempted on both February 23 and April 2. The final mix was the second mix made on February 23.

The Beatles rehearsing before a recording session at Twickenham Film Studios (1965).

Ticket To Ride

Lennon-McCartney / 3:09

SONGWRITER
John

MUSICIANS
John: vocal, rhythm guitar
Paul: bass, backing vocal, lead guitar
George: guitar
Ringo: drums, tambourine

RECORDED
Abbey Road: February 15, 1965 (Studio Two)

NUMBER OF TAKES: 2

MIXING
Abbey Road: February 18 and 23, 1965 (Studio Two) /
March 15, 1965 (Studio Two)

TECHNICAL TEAM
Producer: George Martin
Sound Engineer: Norman Smith
Assistant Engineers: Ken Scott, Jerry Boys, Malcolm
Davies

Release as a Single

Ticket to Ride / Yes It Is
Great Britain: April 9, 1965 / No. 1 for 3 weeks
beginning on April 24, 1965
United States: April 19, 1965/ No. 1 for 1 week
beginning on May 22, 1965

Genesis

"Ticket to Ride" is a song that John liked and he described it as one of the earliest heavy metal records made. In 1970, he declared: "It's a heavy record and the drums are heavy, too. That's why I like it."[1] John considered the song as mainly his work and went on to say: "Paul's contribution was the way Ringo played the drums."[2] Paul's response: "John just didn't take the time to explain that we sat down together and worked on that song for a full three-hour songwriting session, and at the end of it all, we had all the words, we had the harmonies, and we had all the little bits."[3] Paul gave credit in favor of John at 60/40.

The origin of the title is unclear. Paul remembers the town Ryde being mentioned, but attributes the idea to John. Perhaps they remembered their visit to Bow Bars in the early 1960s, a pub run by Paul's cousin and her husband in the small town of Ryde. The double meaning between *Ryde* and *Ride* may have piqued their interest. According to another version, John explained that *ticket to ride* was a term used to describe the work permit issued to prostitutes by Hamburg's health services. One thing is certain: "Ticket to Ride" marked a turning point for the Beatles. The sound is different, more aggressive, away from pure rock 'n' roll, and the structure of the song itself is innovative for the time. Paul: "Instead of ending like the previous verse, we changed the tempo . . . We almost invented the idea of a new bit of a song on the fade-out with this song; . . . It was quite radical at the time."[4] Throughout the year 1965, music

1. Sheff, *The Playboy Interview with John Lennon & Yoko Ono.*
2. Ibid.
3. Miles, *Paul McCartney.*
4. Ibid.
5. Martin, *Playback.*

1965

Paul McCartney and John Lennon in costume for the shooting of a promotional video for "Ticket to Ride" in 1965.

became more electrified. The Rolling Stones released *(I Can't Get No) Satisfaction* on May 13. The Beatles had anticipated the change.

Production

The first song to be recorded for the album *Help!*, "Ticket to Ride" was immortalized on February 15 during a three-hour session. The Beatles continued

the practice of recording just the rhythm track on the multitrack tape. The first was a false start, but the second take was satisfactory. In his notes, George Martin[5] shows the breakdown of the tracks as follows: track 1: bass and drums / track 2: John on Fender and George on Rickenbacker twelve-string / track 3: John on vocal and Paul on some vocal parts / track 4: overdubs with John on vocal, Ringo on tambourine, George on

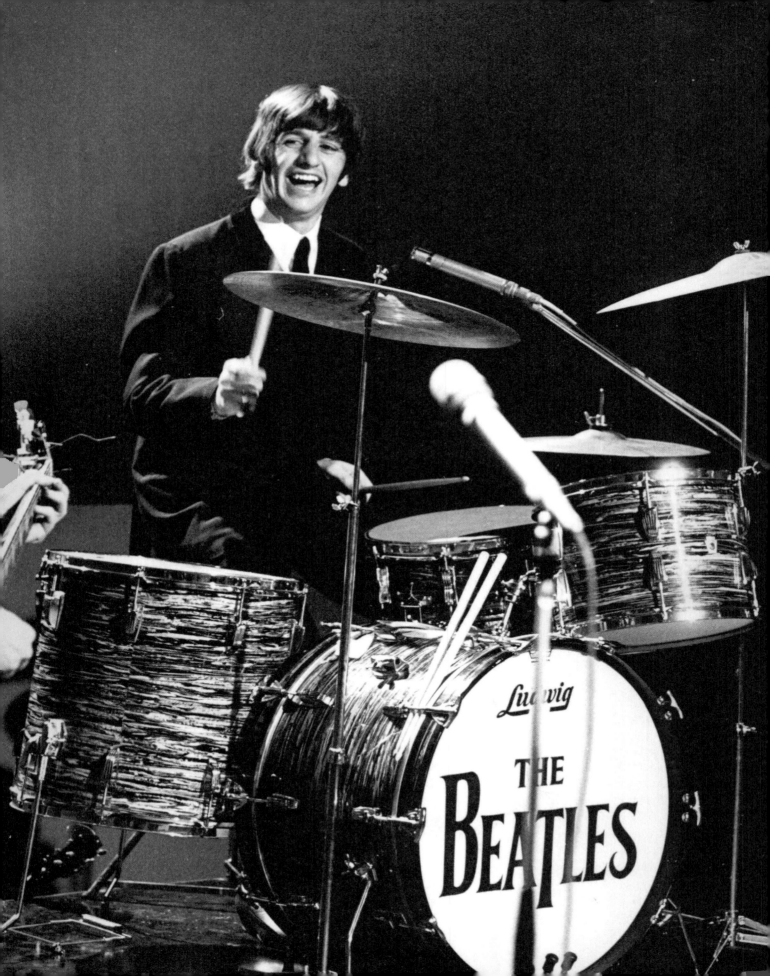

Left page, Ringo on his Ludwig kit.
Above, John and Paul skiing in Austria during the shooting of *Help!*

Fender, Paul on Epiphone. Note the new and predominant use of both Fender Stratocaster Sonic Blues. This song also marked Paul's first guitar solo in a Beatles recording. He played the lines at the end of the bridges and in the fade-out on his Epiphone Casino. George played the riff on his Rickenbacker and doubled it with his Fender. Paul arranged the bass, the backing vocals, the guitar solo, and even the drums, since he was the one who suggested what to play to Ringo. The mono mix was made on February 18. The stereo mix dates from February 23. On March 15, Norman Smith did a new mono mix for Capitol Records that was used for the American single and the movie.

FOR BEATLES FANATICS

The first versions of the U.S. single released on April 19 included the words "From the United Artists Release *Eight Arms to Hold You.*" Logical, because this was the first title of the movie before Richard Lester picked *Help!* The single from "Help!" was released three months later in the United States on July 19, 1965.

Act Naturally

Voni Morrison–Johnny Russell / 2:29

MUSICIANS
Ringo: vocal, drums, sticks
John: rhythm guitar (?)
Paul: bass, backing vocal
George: rhythm guitar (?), lead guitar

RECORDED
Abbey Road: June 17, 1965 (Studio Two)

NUMBER OF TAKES: 13

MIXING
Abbey Road: June 18, 1965 (Studio Two)

TECHNICAL TEAM
Producer: George Martin
Sound Engineer: Norman Smith
Assistant Engineer: Phil McDonald

1965

FOR BEATLES FANATICS

Buck Owens and Ringo teamed up for a new version of "Act Naturally" in 1989. The single peaked at number 27 on the U.S. *Billboard* Hot Country chart.

Genesis

"Act Naturally" is country and western singer Johnny Russell's most famous song. It was composed in 1961, on the evening before he left for a recording session in Los Angeles. *They are going to put me in the movies and make a big star out of me.* This line, sent to his girlfriend as a joke before leaving, became the first verse of his song. Two years later, "Act Naturally" had still not been recorded. In 1963, Voni Morrison, a composer who had worked with Russell for some time, suggested presenting the song to Buck Owens, a famous country music performer. Owens refused at first, and then, at the insistence of one of his musicians, eventually recorded the song on February 12, 1963. "Act Naturally" was released as a single the following March. It was Owens's first number 1 hit!

On June 17, 1965, the recording sessions of *Help!* came to an end and there was still no song for Ringo to sing. He was ultimately the one who provided the solution. "I sang 'Act Naturally' in *Help!* I found it on a Buck Owens record, and I said, 'This is the one I am going to be doing,' and they said 'OK.'"[1] Not only did Ringo perform the song on *Help!*, but the song was also released as the B-side of the American single, "Yesterday." The luckiest person of all was unquestionably Voni Morrison, who shares songwriting credits solely to comply with an agreement he made with Russell!

Production

"Act Naturally" was recorded on June 17, 1965, in thirteen takes at the last recording session devoted to *Help!* Ringo's vocal was recorded after performing the basic rhythm track for the song: himself on drums, George on guitar, and Paul on bass. A guitar solo, played by

George and doubled on his Gretsch Tennessean, was added, along with sticks by Ringo and a backing vocal by Paul. It appears that John did not participate in the recording. Mark Lewisohn[2] specifies in his notes that George also played an acoustic guitar. Mono and stereo mixes are made on June 18. "Act Naturally" was the last cover song recorded by the Beatles, except for a fragment of "Maggie Mae" on Let It Be.

1. The Beatles Anthology.
2. Lewisohn, The Complete Beatles Recording Sessions.

Discarded Song
On February 18, the Beatles met in the studio to record a composition written by John and Paul for Ringo: "If You've Got Trouble." But the song, considered too weak, was abandoned. The song reappeared in 1996 on Anthology 2.

It's Only Love

Lennon-McCartney / 1:55

SONGWRITER
John

MUSICIANS
John: vocal, acoustic rhythm guitar, electric guitar
Paul: bass
George: lead and rhythm guitars
Ringo: drums, tambourine

RECORDED
Abbey Road: June 15, 1965 (Studio Two)

NUMBER OF TAKES: 6

MIXING
Abbey Road: June 18, 1965 (Studio Two)

TECHNICAL TEAM
Producer: George Martin
Sound Engineer: Norman Smith
Assistant Engineer: Phil McDonald

FOR BEATLES FANATICS

On the stereo version, we can hear John in the right channel announcing the countdown preceding the vocals at 0:08: "one, two."

Genesis

In 1972 in an interview with *Hit Parader* magazine, John said about "It's Only Love": "That's the one song I really hate of mine. Terrible lyric." Later, with David Sheff, he added: "The lyrics were abysmal. I always hated that song."[1] It's certainly not as strong as "Yesterday" or "Strawberry Fields Forever," but the song has an undeniable charm, the "magic of the Beatles." Paul remembers helping John finish the song at John's home in Weybridge. Credit is assigned 60/40 in favor of John. "It's Only Love" is one of the last lyrics written by John out of necessity, with no real inspiration or personal reference.

Production

The Beatles recorded "It's Only Love" during an afternoon session on June 15 in only six takes. The rhythm track was provided by John on his Framus Hootenanny twelve-string, accompanied by George on his Gibson Jumbo, followed by Paul on bass and Ringo on drums. George then recorded a guitar part (probably on his Rickenbacker twelve-string) through a tremolo effect (possibly a Fender amp effect). Ringo added a tambourine, and John recorded an excellent lead vocal, rolling the *R* in *bright* for fun. Two other guitar parts enhance the piece: George played some phrases in the chorus, presumably with his Gretsch Tennessean, and John inserted a syncopated rhythm on his Rickenbacker 325 or his Stratocaster Sonic Blue. "It's Only Love" had no less than five different guitar parts and one bass. A lot of work for a song hated by the author! The mono and stereo mixes were made on June 18.

1. Sheff, *The Playboy Interview with John Lennon & Yoko Ono.*
2. *The Beatles Anthology.*

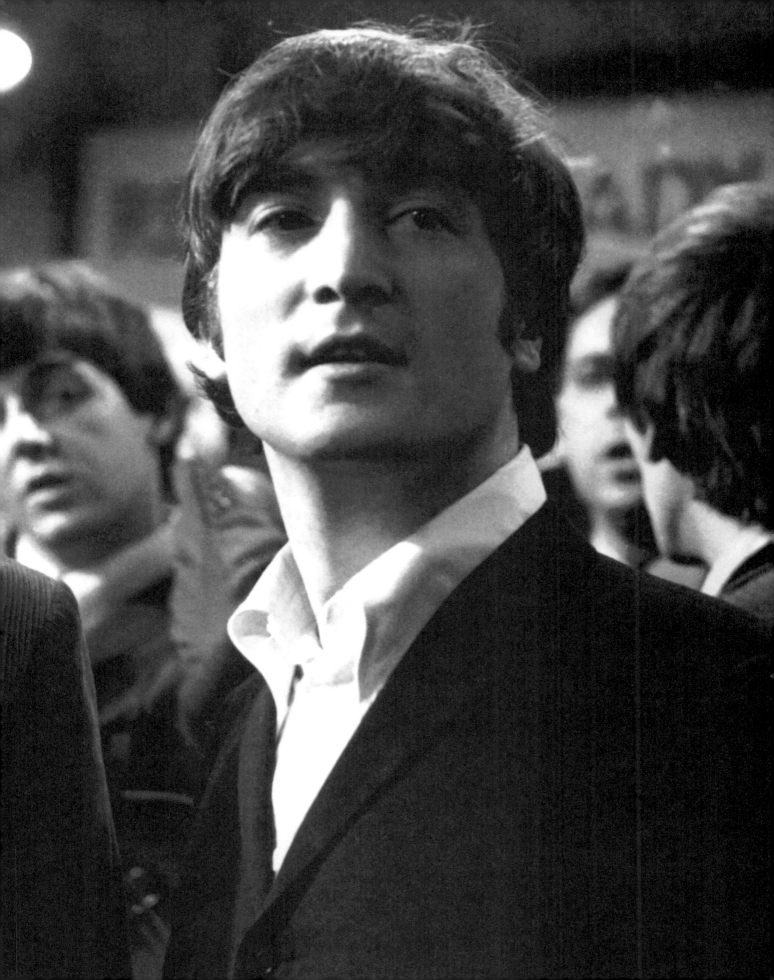

George Harrison and Pattie
Boyd, one of the most
glamorous couples of the
Swinging Sixties.

You Like Me Too Much

George Harrison / 2:35

MUSICIANS
George: vocal, lead guitar, rhythm guitar (?)
John: rhythm guitar (?), Hohner Pianet electric piano
Paul: bass, piano, backing vocal
Ringo: drums, tambourine
George Martin: piano

RECORDED
Abbey Road: February 17, 1965 (Studio Two)

NUMBER OF TAKES: 8

MIXING
Abbey Road: February 18–23, 1965 (Studio Two)

TECHNICAL TEAM
Producer: George Martin
Sound Engineer: Norman Smith
Assistant Engineers: Ken Scott, Malcolm Davies

1965

FOR BEATLES FANATICS

There is a "click" at
0:09, interrupting the
tremolo effect on the
Hohner Pianet.

Genesis
George did not say much more about "You Like Me Too Much" than he did about "I Need You." The song, obviously inspired by Pattie Boyd, revealed the commitment of the young man toward his beautiful fiancée, whom he married on January 21, 1966. This song was originally recorded for inclusion in the soundtrack of *Help!* before being abandoned by Richard Lester who preferred "I Need You." Starting with this album, George wrote one or more songs for each of the band's albums (including four on the *White Album*).

Production
February 17 was dedicated to "The Night Before" and "You Like Me Too Much." Four hours and eight takes were needed to finish this last title. To create the rhythm track, Ringo was on drums, Paul on bass, John on acoustic rhythm guitar, and George on lead guitar. George followed with a guitar solo with Ringo playing the tambourine. Then, as in "The Night Before," John played a part on a Hohner Pianet, which he executed perfectly. In the introduction, the Pianet was played through a tremolo effect. Then George performed the lead vocal, which he doubled, backed by Paul on backing vocal. Finally, to complete the song, George Martin and Paul played simultaneously on different ends of a Steinway piano, four hands playing the introduction and verses in response to George's guitar solo, all in a boogie-woogie style. The mono mix was made the next day and the stereo mix on February 23.

Tell Me What You See

Lennon-McCartney / 2:36

SONGWRITER
Paul

MUSICIANS
Paul: lead vocal, bass (?), Hohner Pianet electric piano, güiro
John: rhythm guitar, backing vocal
George: bass (?)
Ringo: drums, tambourine, claves
George Martin: piano

RECORDED
Abbey Road: February 18, 1965 (Studio Two)

NUMBER OF TAKES: 4

MIXING
Abbey Road: February 20–23, 1965 (Studio Two)

TECHNICAL TEAM
Producer: George Martin
Sound Engineer: Norman Smith
Assistant Engineers: Ken Scott, Malcolm Davies

FOR BEATLES FANATICS

Listening carefully during the introduction,
we can hear Paul repeating *If you let* twice
before starting his vocal. This appears to
be Paul warming up his vocal chords.

Genesis

"Tell Me What You See" is mainly Paul's composition. "I would claim it as a 60/40, but it might have been totally me."[2] John confirmed this without hesitation in an interview with David Sheff: "It's Paul's."[2] The song was offered to Richard Lester for the soundtrack of *Help!*, but was rejected, and "Tell Me What You See" was used for the second side of the album. Paul describes "Tell Me What You See" as an album filler: "Not one of the better songs but they did a job, they were very handy for albums or B-sides. You need those kind of sides."[3]

Production

"Tell Me What You See" was recorded in four takes at the end of the day on February 18. This time, Paul played the Pianet while John handled the rhythm on his Rickenbacker 325. George's role remains unclear. Perhaps he played on bass while Paul played the güiro, a Latin American percussion instrument. Ringo, in addition to his function as a drummer, played the claves as he had in "And I Love Her." He also played tambourine. In the end, Paul provided the lead vocal, backed by John, and then doubled the vocal.

The mono mix was made on February 20, and the stereo mix on February 23, one day after the Beatles flew to the Bahamas.

1. Miles, *Paul McCartney.*
2. Sheff, *The Playboy Interview with John Lennon & Yoko Ono.*
3. Miles, *Paul McCartney.*

Paul in a recording session at
Abbey Road Studios, an
everyday scene from the
extraordinary Fab Four's life.

I've Just Seen A Face

Lennon-McCartney / 2:03

SONGWRITER
Paul

MUSICIANS
Paul: vocal, acoustic lead guitar (?)
John: rhythm guitar
George: rhythm guitar, acoustic lead guitar (?)
Ringo: drums, maracas

RECORDED
Abbey Road: February 18, 1965 (Studio Two)

NUMBER OF TAKES: 4

MIXING
Abbey Road: February 20–23, 1965 (Studio Two)

TECHNICAL TEAM
Producer: George Martin
Sound Engineer: Norman Smith
Assistant Engineers: Ken Scott, Malcolm Davies

1965

FOR BEATLES FANATICS

Auntie Gin made another appearance in Paul's solo career with Wings. He references her in his 1976 hit "Let 'Em In" from *Wings at the Speed of Sound*.

Genesis

"I've Just Seen a Face," a superb acoustic country and western song, written at Jane Asher's parents' home, is one of Paul's favorites. According to some sources, it was an old instrumental tune that Paul played at the piano regularly, and his Aunt Gin expressed a liking for it. The working title was "Auntie Gin's Theme," and George Martin's orchestra recorded an instrumental version of it under this title in 1965. Paul was also quite pleased with the lyrics, probably inspired by his romance with the actress Jane Asher.

The artistic department at Capitol in the United States thought the song would resonate with the American public so they used it as the opening song on the U.S. version of *Rubber Soul*.

Production

"I've Just Seen a Face" was recorded on June 14—a memorable day dedicated to Paul's talent. On the program that day were "I've Just Seen a Face," "I'm Down," and "Yesterday"—three songs in three different styles. Ringo played the basic rhythm with brush sticks, George was probably on his Framus Hootenanny twelve-string, and John on his Gibson J-160 E. For the first time, a Beatles song lacked a bass guitar part; Paul contributed only vocals, which he harmonized and doubled. Ringo later added some maracas. Finally, Paul added an introduction and an acoustic solo on his Epiphone Texan. The song was completed in six takes. Mono and stereo mixes were made on June 18, 1965.

Yesterday

Lennon-McCartney / 2:04

SONGWRITER
Paul

MUSICIANS
Paul: vocal, acoustic guitar
Tony Gilbert: 1st violin
Sidney Sax: 2nd violin
Kenneth Essex: viola
Francisco Gabarro: cello

RECORDED
Abbey Road: June 14 and 17, 1965 (Studio Two)

NUMBER OF TAKES: 2

MIXING
Abbey Road: June 17–18, 1965 (Studio Two)

TECHNICAL TEAM
Producer: George Martin
Sound Engineer: Norman Smith
Assistant Engineer: Phil McDonald

FOR BEATLES FANATICS

By listening carefully to the left channel in stereo, we hear at 0:19 the creaking of a door, an instrument, or simply a sigh at the end of the word *believe*. It was probably the chair of one of the four string players.

Genesis

"I have had *so* much accolade for 'Yesterday.' That is Paul's song . . . and Paul's baby,"[1] declared John with humor when he mentioned the song inspired by Paul McCartney's dream. While staying at the Ashers' family home, 57 Wimpole Street, Paul woke up one morning in his small attic room at the top of the house: "I got out of bed, sat at the piano, found G, found F sharp minor 7th—and that leads you through then to B to E minor, and finally back to E. It all leads forward logically. I liked the melody a lot, but because I'd dreamed it I couldn't believe I'd written it."[2] Indeed, Paul was worried that he had plagiarized someone else's song. Suspicious, he played the melody to his close friends, who assured him that they had never heard this sublime melody before.

At this stage, the lyrics were not yet defined. The song's provisional title was "Scrambled Eggs" and the working opening verse was *Scrambled Eggs / Oh, my baby how I love your legs.*

During the shooting of *Help!*, Paul continued to work on the song. At one point, Richard Lester lost his temper and threatened to have Paul's piano removed! At the end of the shoot, the Beatles took a well-deserved vacation. Late in May, Paul and Jane flew to southern Portugal for a vacation in Albufeira, where they were invited to the home of Paul's friend, Bruce Welch, guitarist for the Shadows. On the way to

1. Sheff, *The Playboy Interview with John Lennon & Yoko Ono.*
2. Miles, *Paul McCartney.*
3. Ibid.
4. Sheff, *The Playboy Interview with John Lennon & Yoko Ono.*

YESTERDAY.

Yesterday, all my troubles seemed so far away,
now it looks as though they're here to stay,
oh I believe in yesterday.

Suddenly, I'm not half the man I used to be
There's a shadow hanging over me
Yesterday came suddenly.

middle.

Why she had to go, I don't know
she wouldn't say,
I said something wrong, now I long
for yesterday......

Yesterday, love was such an easy game to play
Now I need a place to hide away
oh I believe in yesterday.

The original text of "Yesterday," written in Paul's hand. It's in the British Library of St. Pancras in London.

his host's house, he came up with the song's title and the opening of the final verse. He borrowed a 1959 Martin acoustic guitar from Bruce Welch and polished the song. Two weeks later, the song was completed. "Generally, John and I would sit down and finish within three hours, but this was more organic,"[3] confessed Paul in an interview with Barry Miles. John declared to a *Playboy* reporter, "Although the lyrics don't resolve into any sense, they're *good* lines. They certainly work. You know what I mean? They're good—but if you read the whole song, it doesn't *say* anything; you don't know what happened. She left and he wishes it was yesterday—that much you get—but it doesn't really resolve. So, mine didn't used to resolve, either . . ." Before concluding: "Well done. Beautiful—and I never wished I'd written it."[4]

George Martin. He came up with the idea of having Paul's vocal and guitar accompanied by a string quartet—a brilliant and innovative idea.

Echoes of an Italian Song
In the 1960s–1970s, Lilli Greco, an Italian singer and producer, told anyone who would listen that "Yesterday" was extremely similar to an 1895 Neapolitan song, "Piccerè Che Vene A Dicere."

Contrary to its Neapolitan "relative," which no one had ever heard of, "Yesterday" is one of the most recorded songs in the history of popular music, and entered the Guinness Book of World Records with 3,000 cover versions!

Production

Listening to "Yesterday," John, George, and Ringo all had the same reaction: they did not know what to play and suggested that Paul sing it solo. George Martin had a totally surprising and innovative idea for the time. He suggested that Paul use a string quartet. "With 'Yesterday' we used orchestration for the first time; and from then on, we moved into whole new areas."[1] he recalled in 1979. Paul was initially reluctant, but Martin succeeded in persuading him and finally Paul agreed, under the condition that the musicians perform without vibrato.

On June 14, after the band had completed "I've Just Seen a Face" and "I'm Down," Paul was still fresh and energetic enough to end the recording session with "Yesterday." Alone, he recorded the song on his Epiphone Texan acoustic guitar in just two takes. The performance was remarkable. Paul tuned his instrument down a whole step for greater flexibility. Three days later on June 17, the string quartet was recorded. Satisfied by the musicians' excellent performance, George Martin asked Paul to perform an additional vocal, but it was judged inferior to the recording made on June 14, except for the line . . . *something wrong now I long for yesterday* (at 0:52). Norman Smith substituted the line in the mono mix made the same day. Paul had recorded the second vocal while listening to the original recording on the famous White Elephant speaker. Therefore, the original vocal track leaked from the studio speaker into the second recording, which gave the impression that Paul's vocal was doubled—but only for those seven words! The stereo mix was made the next day. Paul was delighted with the string quartet.

Before being recorded by Paul McCartney, "Yesterday," was rejected by two singers. Chris Farlowe thought the song was too soft and Billy J. Kramer did not think it fit into his repertoire. The Beatles feared that the song would affect their image as a rock 'n' roll band. "Yesterday" was never released as a single in Great Britain, despite the extraordinary reception to the song worldwide. In the United States, "Yesterday" breezed to the top of the charts on October 9 (John's birthday!), before being knocked down by "Get Off of My Cloud" by the Stones. "Yesterday" is the British song most played on American radio and television, with over 7 million performances.

1. Martin (George) & Hornsby (Jeremy), *All You Need Is Ears*, New York, St Martin's Press, 1979.

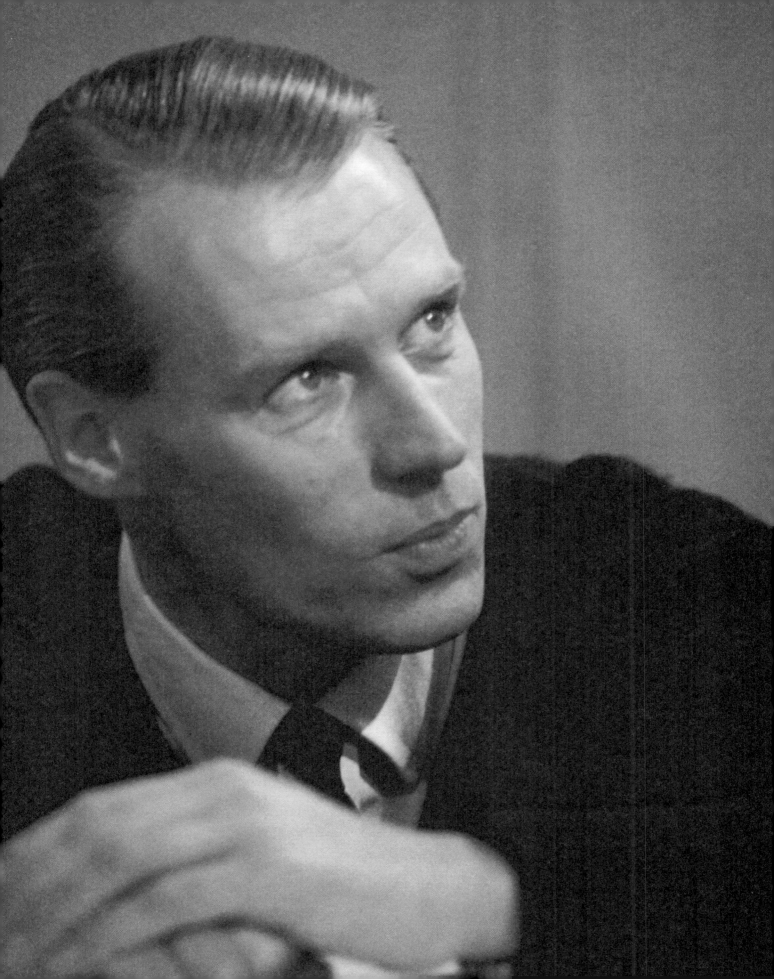

"Dizzy Miss Lizzy" was already
in the Beatles' live repertoire
in Hamburg. It was a favorite
in their live concerts.
Opposite, during a tour in the
United States in August 1964.

Next double-page spread: In
the Bahamas during the
filming of *Help!*

Dizzy Miss Lizzy

Larry Williams / 2:54

MUSICIANS
John: vocal, rhythm guitar
Paul: bass, Hohner Pianet electric piano
George: lead guitar
Ringo: drums, cowbell

RECORDED
Abbey Road: May 10, 1965 (Studio Two)

NUMBER OF TAKES: 7

MIXING
Abbey Road: May 10, 1965 (Studio Two)

TECHNICAL TEAM
Producer: George Martin
Sound Engineer: Norman Smith
Assistant Engineer: Ken Scott

1965

Genesis

Larry Williams is one of the most influential composers of rock 'n' roll and rhythm & blues. We only need to mention "Dizzy Miss Lizzy," originally released as a single on the B-side of "Slow Down" in March 1958. Since the end of the 1950s, this Southern anthem of rock 'n' roll has been covered by everyone from Ronnie Hawkins to the New York Dolls. However, the most famous version is the Beatles'.

They first performed this title with success during their formative years in Hamburg in 1960, and played it live frequently before recording it. "Dizzy Miss Lizzy" appeared on *Help!* after "Yesterday," as if the group wanted to remind the public that they had not forgotten their roots.

Production

The day after attending a Bob Dylan concert at the Royal Festival Hall in London on June 9, the Beatles recorded "Dizzy Miss Lizzy" and "Bad Boy." The group recorded two live takes of "Dizzy Miss Lizzy" before working on "Bad Boy." At George Martin's insistence, they recorded a further five takes and were finally satisfied with the seventh. Paul remembers, after recently listening to a recording session of "Dizzy Miss Lizzy," that at that time there were tensions between the Beatles and Martin. "After recording his vocal, John asked Martin, 'What's wrong with that?' and George Martin says, 'Erm . . . it wasn't exciting enough, John,' and John mumbles, 'Bloody hell'—that kind of thing was creeping in a bit—'It wasn't exciting enough, eh? Well, you come here and sing it, then!' "[1] Despite these inevitable confrontations, the Beatles recorded the rhythm track with their usual instruments, with George doubling and

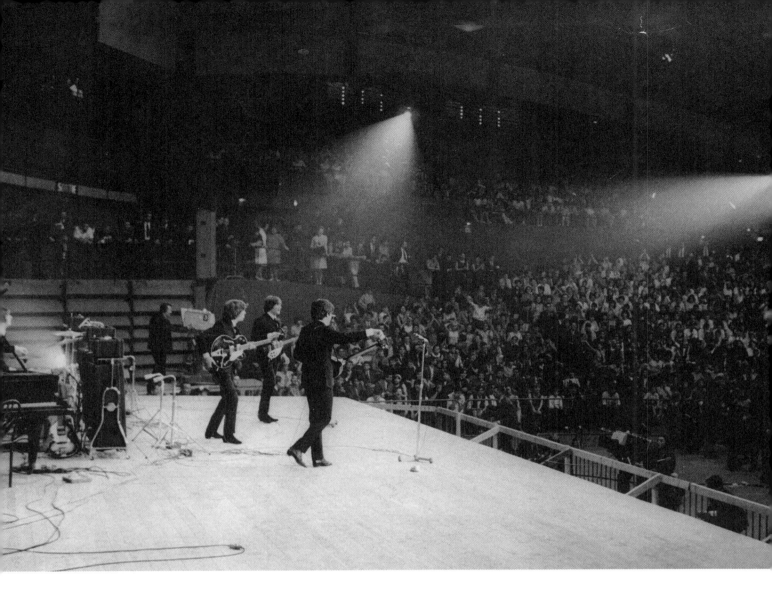

even tripling his guitar. Paul played the Hohner Pianet and Ringo added a cowbell while John sang the lead vocal. Mono and stereo mixes were made right away, and both copies of these two mixes were shipped to Capitol Records in Los Angeles the next day. Five weeks later, on June 14, 1965, *Beatles VI*, which featured the song, was available in American record bins.

Technical Details

In 1965, "Dizzy Miss Lizzy" was recorded with an echo effect, similar to the American 'slap-back' echo already used by the Beatles on "Everybody's Trying to Be My Baby."

FOR BEATLES FANATICS

We can hear George's guitar riff in different locations in the stereo version: alone in the middle of the range at 1:27, then doubled in the right channel at 1:30 and finally in the left channel at 1:33.

1. Miles, *Paul McCartney*.

Bad Boy

Larry Williams / 2:19

MUSICIANS
John: vocal, rhythm guitar, organ
Paul: bass, Hohner Pianet electric piano
George: lead guitar
Ringo: drums, tambourine

RECORDED
Abbey Road: May 10, 1965 (Studio Two)

NUMBER OF TAKES: 4

MIXING
Abbey Road: May 10, 1965 (Studio Two)

TECHNICAL TEAM
Producer: George Martin
Sound Engineer: Norman Smith
Assistant Engineer: Ken Scott

1965

Editor's Note:
"Bad Boy" was recorded for the American album Beatles VI, but in Europe it only appeared on the compilation, A Collection of Beatles Oldies, released in December 1966 for the European market.

Genesis

"Bad Boy" was the Beatles' third Larry Williams cover. Williams recorded "Bad Boy" in August 1958. Seven years later, the Beatles covered the song. Years before this recording, it was included in the Fab Four's live repertoire between 1960 and 1962. They had more or less abandoned it but, pressed for new material, they recorded it for the release of *Beatles VI* by Capitol Records on June 14, 1965. The European release had to wait for the appearance of the album *A Collection of Beatles Oldies* on December 9, 1966.

Production

"Bad Boy" was recorded in four takes on May 10 between two working sessions for "Dizzy Miss Lizzy." All the Beatles played their usual instruments. Paul added a Hohner Pianet part, John some organ (a Vox Continental), Ringo some tambourine, and George double-tracked his guitar solo. The song features John's blistering vocal delivery. Along with "Dizzy Miss Lizzy," "Bad Boy" was mixed right after the recording session to be shipped the next day to Capitol Records in Los Angeles.

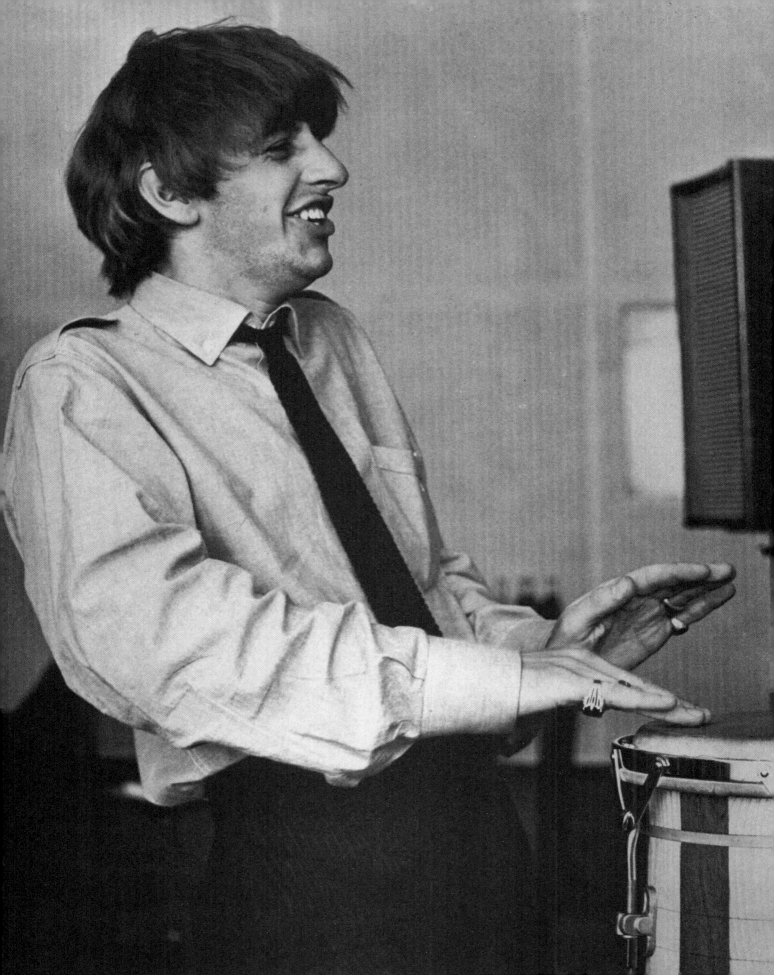

1965

Yes It Is

(B-side of "Ticket to Ride")

SINGLE
RELEASED

Ticket to Ride / Yes It Is
Great Britain: April 9, 1965 /
No. 1 for 3 weeks, starting on April 24, 1965
United States: April 19, 1965 /
No. 1 for 1 week, starting on May 22, 1965

Yes It Is

Lennon-McCartney / 2:41

SONGWRITER
John

MUSICIANS
John: vocal, rhythm guitar
Paul: bass, backing vocal
George: lead guitar, backing vocal
Ringo: drums

RECORDED
Abbey Road: February 16, 1965 (Studio Two)

NUMBER OF TAKES: 14

MIXING
Abbey Road: February 18 and 23, 1965 (Studio Two)

TECHNICAL TEAM
Producer: George Martin
Sound Engineer: Norman Smith
Assistant Engineers: Ken Scott, Jerry Boys, Malcolm Davies

FOR BEATLES FANATICS

When released in the United States, the single "Ticket to Ride" (A-side of "Yes It Is") included the note, "From the United Artists Release *Eight Arms to Hold You*, the first title for the movie *Help!*" This is true for "Ticket to Ride" (see the song), but not for "Yes It Is," which is not on the soundtrack for the movie!

Genesis

John: "That's me trying a rewrite of 'This Boy,' but it didn't work."[1] However, "Yes It Is" is a superb song filled with sweetness and nostalgia, showing the sensitivity of the Beatles. "Yes It Is" was written at Kenwood with Paul's assistance. Paul: ". . . I helped him finish off. "Yes It Is" is a very fine song of John's, a ballad, unusual for John. He wrote some beautiful ballads but I'm known generally as the balladeer."[2] George liked this song so much that he regretted that it was not chosen for the A-side of the single. What is strange is that "Yes It Is" was neither selected for the film soundtrack nor included on the *Help!* album. With respect to the group's work, it was John's songs that featured superb three-part backing vocal—"This Boy," "Yes It Is," and "Because."

Production

February 16 was the second day devoted to recording songs for the movie *Help!*, including "Yes It Is." At that time, the title was part of the movie soundtrack. The Beatles spent five hours in two recording sessions. During the first two-hour session, the group recorded the basic rhythm track in fourteen takes. John simultaneously played his Gibson J-160 E and sang. Paul was on bass, Ringo on drums, and George played his guitar with a volume pedal, as he did earlier in "I Need You." In the second session, John probably played the José Ramirez classical nylon-string guitar. At the end of this second take, a string of his J-160 E broke. John, Paul, and George recorded their three-part backing vocal on the best take, take 14. After several tries, the result was superb. George played a second guitar part using the volume pedal, and Ringo added cymbals. This second recording session took three hours. The mono mix was completed on February 18 and the stereo mix on February 23.

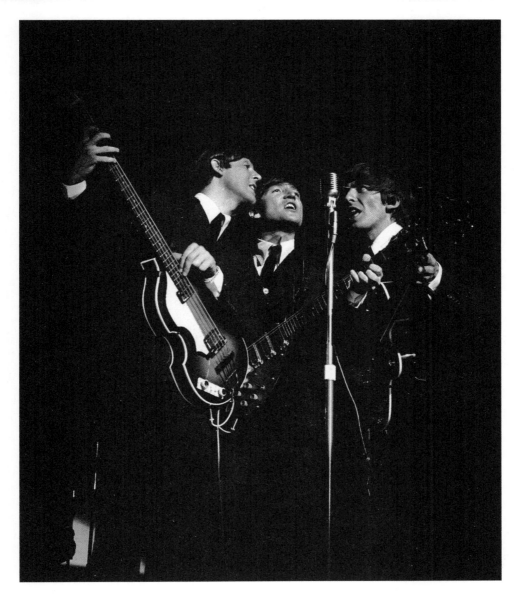

Paul, John, and George in concert. All three sang on the recording of "Yes It Is."

Technical Details

To record the three-part harmony and to limit track leak from the RLS10 White Elephant, Norman Smith positioned the singers as follows: John at the Neumann U48 microphone by himself and Paul facing George on another U48 in a figure-eight pattern (the microphone picks up the signal from its front and back while ignoring signals from the sides). The microphone was positioned perpendicular to the speakers to eliminate as much leakage as possible. Note that the Beatles did not begin using headphones until 1966.

1. Sheff, *The Playboy Interview with John Lennon & Yoko Ono.*
2. Miles, *Paul McCartney.*

1965

I'm Down

(B-side of "Help!")

SINGLE
RELEASED

Help! / I'm Down
Great Britain: July 23, 1965 /
No. 1 for 3 weeks, starting on August 7, 1965
United States: July 19, 1965 /
No. 1 for 1 week, starting on September 4, 1965

I'm Down

Lennon-McCartney / 2:30

SONGWRITER
Paul

MUSICIANS
Paul: bass, vocal
John: backing vocal, organ
George: lead backing vocal, rhythm guitar
Ringo: drums, bongos

RECORDED
Abbey Road: June 14, 1965 (Studio Two)

NUMBER OF TAKES: 7

MIXING
Abbey Road: June 18, 1965 (Studio Two)

TECHNICAL TEAM
Producer: George Martin
Sound Engineer: Norman Smith
Assistant Engineer: Phil McDonald

FOR BEATLES FANATICS

At the end of the first take (as heard on *Anthology 2*), we hear Paul say, "Plastic soul man, plastic soul." *Plastic soul* is an expression used by an old time blues singer to describe Mick Jagger's singing. Some time later the Beatles used it, with a slight modification, as the title of their sixth album, *Rubber Soul*.

Genesis

"I'm Down," written by Paul with, in all probability, John's help, is a tribute to Little Richard. Paul confided to Barry Miles, "I used to sing his stuff but there came a point when I wanted one of my own, so I wrote 'I'm Down.'"[1] He confessed, "And inasmuch as they are hard to write, I'm proud of it. These kind of songs with hardly any melody, rock 'n' roll songs, are much harder to write than ballads, because there's nothing to them."[2] Paul's voice is hoarse, as in "Long Tall Sally." The song is full of energy—one of the Beatles' most dynamic songs. They used "I'm Down" to conclude their American tour at Shea Stadium on August 15, 1965. That day, with an audience of 55,000 fans, Paul shouted out "I'm Down" next to John, unleashed at the keyboard, playing without restraint and accompanied by a wild laugh from George. John said later, "I was putting my foot on it and George couldn't play for laughing. . . . I was doing all Jerry Lee—I was jumping around and I only played about two bars of it."[3]

Production

Recorded on June 14, this qualifies as one of Paul's best performances. In a surprising demonstration of his musical versatility, he sang the beautiful vocal for "Yesterday" after bringing his voice to the breaking point on "I'm Down." Seven takes were needed to immortalize "I'm Down." The basic rhythm track included Ringo on drums, Paul on bass, George on rhythm guitar, and John playing for the first time on a Vox Continental portable organ. Paul sang, but was not double-tracked. Two distinctive choruses were added, and Ringo played the bongos in the coda. Finally, the two solos were recorded: George on his Gretsch Tennessean and John

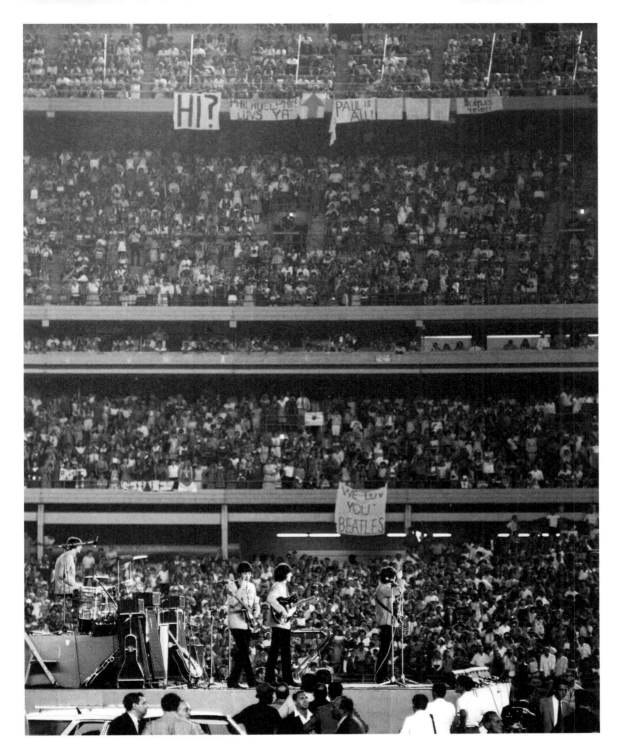

"I'm Down," recorded two months earlier, is immortalized on August 15, 1965, before a crowd of 55,000 at Shea Stadium in New York.

on a Vox Continental. George's solo is explosive, and in the background we hear a fragment of another solo from a previous take (from 0:47 to 0:58). "I'm Down" was mixed in mono and stereo on June 18. The result is electrifying—a true cure when you feel a bit down!

1. Miles, *Paul McCartney.*
2. Ibid.
3. *The Beatles Anthology.*

GRUB

GRUB

GRUB

GRUB

1965

BER
SOUL

Drive My Car
Norwegian Wood
You Won't See Me
Nowhere Man
Think for Yourself
The Word
Michelle
What Goes On
Girl
I'm Looking Through You
In My Life
Wait
If I Needed Someone
Run for Your Life

ALBUM
RELEASED

Great Britain: December 3, 1965 / No. 1 for 8 weeks
United States: December 6, 1965 / No. 1 for 6 weeks
June 20, 1966 (*Yesterday and Today*) / No. 1 for 5 weeks

Rubber Soul:
Setting a New Direction

On October 12, 1965, four months after the last recording session for *Help!*, the Beatles started the first session for *Rubber Soul*. Brian Epstein still wanted to produce two albums a year. The Christmas holidays were approaching. It was time to get back to work. According to both John and Paul, this time they were coming up short. Nevertheless, *Rubber Soul* consisted mostly of new songs. Even better, this new album was a major turning point in the Beatles' career in terms of musical composition and recording technique. Previously, the Beatles produced rough-cut diamonds. This time, however, their production exceeded all the usual standards of popular music and, right up until their separation, set a new path for the remainder of their career.

Rubber Soul is an album of change: new look, new sound, new instruments, new recording technique, new state of mind. *Help!* was a collection of pop songs. *Rubber Soul* brought a new way of thinking about music. Between these two albums, the Beatles were on a European tour, which began at the Palais des Sports (Sports Palace) in Paris. John had just published his second book, *A Spaniard in the Works*, and Ringo was about to become a father. Together they had concluded their second American tour with the largest concert ever at Shea Stadium in New York before an audience of 55,000 fans, and they had met their childhood idol, Elvis Presley. Thus, on October 12, when they walked into the studio, they must have been exhausted. Nevertheless, the album offers pure jewels. John demonstrates his talent as an innovator and songwriter creating some of his best songs, including "Girl," "Norwegian Wood," and "In My Life." Paul, the genial lyricist, created *Michelle*. George contributed two excellent songs,

George's Sitar
George, who considers *Rubber Soul the best Beatles album*, joined with Western youth in discovering Indian culture. On *Rubber Soul*, he introduces the sitar as a new instrument.

The harmonium is one of the unusual instruments on this album.

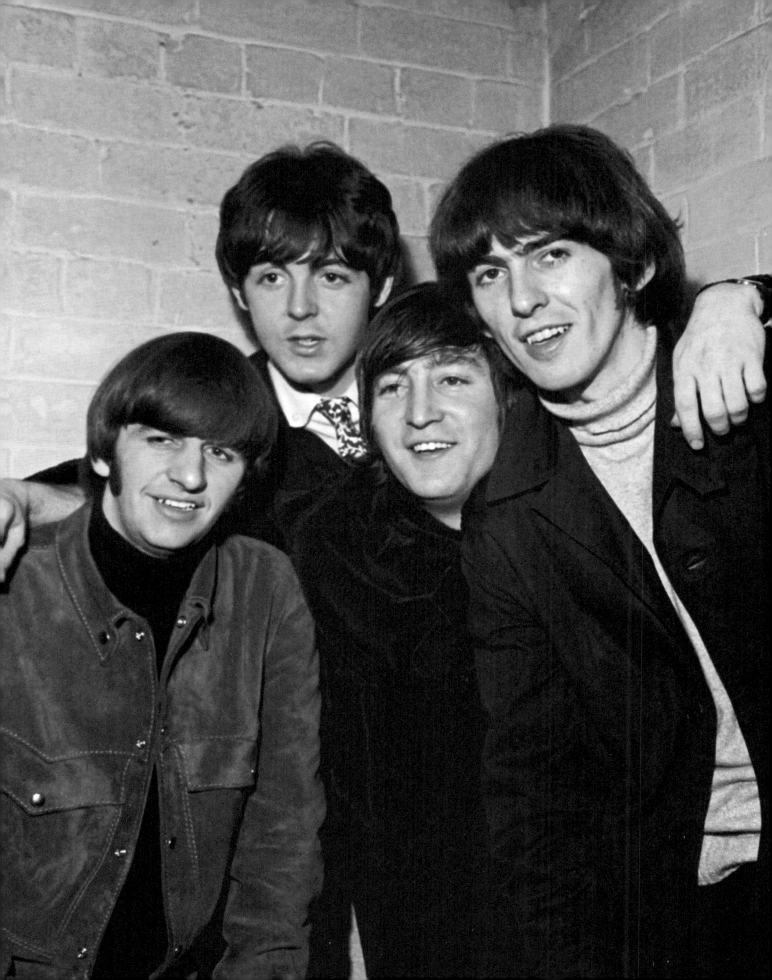

An Inspiring Album

Brian Wilson of the Beach Boys was very impressed by the quality of the songs on Rubber Soul, *and found in the album inspiration to compose what became one of the greatest rock albums of all time, the extraordinary* Pet Sounds.

A Small Group with a Strange Name

Norman Smith, the exceptional sound engineer who had recorded all the Beatles' music since their debut on June 6, 1962, left his position after recording Rubber Soul. *One of the main reasons was the atmosphere within the group. Paul acted more and more as the leader, and his colleagues—John in particular—followed him only with difficulty. Early in 1967, Smith began managing a small group with the odd name of Pink Floyd that he found promising. . .*

"Think for Yourself" and "If I Needed Someone," and Ringo co-composed his first title, "What Goes On."

On November 11, the final recordings were made. Within a month, the four from Liverpool had once more achieved their goal, but it was the last time they kept the pace of two albums a year. In the United States, songs from *Rubber Soul* appeared on the American *Rubber Soul* as well as *Yesterday and Today*.

As soon as it was released, *Rubber Soul* breezed to the top of the charts. The album received positive reviews and was often cited as one of the Beatles' greatest and one of the top albums of all time. The title *Rubber Soul* meant nothing by itself. It was just a pun on *rubber sole* and a reference to Mick Jagger in the slang of some bluesmen (see "I'm Down"): "It was just a pun on *sole à l'anglaise*—rubber sole. Nothing more," according to John Lennon. Paul McCartney said, "I think the title *Rubber Soul* came from a comment an old blues guy had said of Jagger. I've heard some out-takes of us doing 'I'm Down,' and at the front of it, I'm chatting on about Mick. I'm saying how I'd just read about an old bloke in the States who said, 'Mick Jagger, man. Well you know they're good—but it's plastic soul.' So 'plastic soul' was the germ of the *Rubber Soul* idea."[1]

The cover set the tone of the album: innovative and smoky. George commented, "I liked the way we got our faces to be longer on the album cover. We lost the 'little innocents' tag, the naiveté, and *Rubber Soul*

was the first one where we were full-fledged potheads."[2] Robert Freeman's superb photo was the result of pure chance. A photo shoot was organized at John's house in Weybridge, where each Beatle wore a turtleneck. Back in London, Freeman invited the Beatles over to show them the slides. He projected them onto a piece of cardboard to show what they would look like as an album cover. Suddenly, the cardboard fell backwards a little, elongating the picture. Paul, "[The picture] stretched and we went, 'That's it, Rubber So-o-oul, hey hey! Can you do it like that?' And he said, 'Well, yeah. I can print it that way.' And that was it."[3]

The Instruments

The sound of the Indian sitar was revolutionary on the album. George used this instrument in "Norwegian Wood." Paul took up his Rickenbacker 4001S bass, which he had used once in 1964. He used a new 50W Fender Bassman amplifier. George would later use this amplifier for his guitar. There is a harmonium part in "We Can Work It Out." John acquired a new Spanish classical guitar, probably a José Ramirez A1 Segovia. Finally, a distortion petal, a Tone Bender, was used on the bass in "Think for Yourself." Otherwise, the Beatles used the same instruments as on *Help!*

1. *The Beatles Anthology.*
2. Ibid.
3. Miles, *Paul McCartney.*
4. *The Beatles Anthology.*

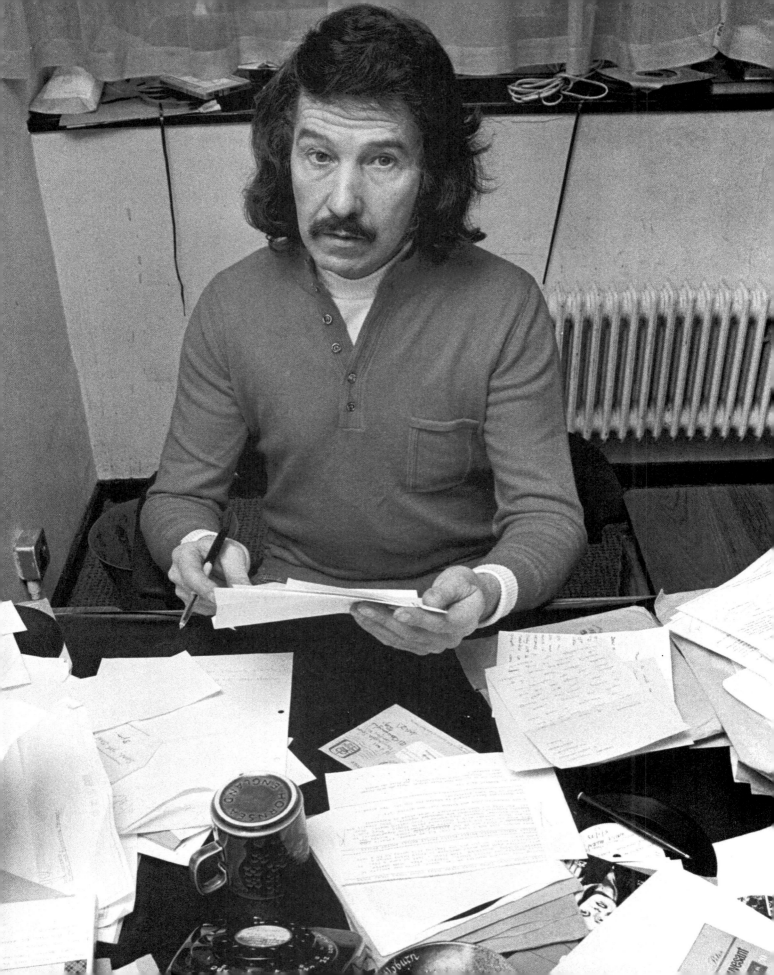

The year 1965 was marked by the scale and success of the North American tour, including the concert on August 15, 1965, in Shea Stadium in New York before over 55,000 fans. "This was the first time that a large stadium was used for a rock concert. Vox made special big 100-watt amplifiers for that tour. We went up from the 30-watt amp to the 100-watt amp and it obviously wasn't enough . . ." Ringo: "There were all those people and just a tiny PA system . . . I never felt people came to hear our show—I felt they came to see us. From the count-in on the first number, the volume of screams drowned everything else out."[4] The tour that confirmed their phenomenal success ended two weeks later in San Francisco.

Drive My Car

Lennon-McCartney / 2:27

SONGWRITER
Paul

MUSICIANS
Paul: vocal, bass, piano, lead guitar (?)
John: vocal, tambourine (?)
George: lead guitar, backing vocal
Ringo: drums, tambourine (?), cowbell

RECORDED
Abbey Road: October 13, 1965 (Studio Two)

NUMBER OF TAKES: 4

MIXING
Abbey Road: October 25–26, 1965 (Studio Two)

TECHNICAL TEAM
Producer: George Martin
Sound Engineer: Norman Smith
Assistant Engineers: Ken Scott, Ron Pender

FOR BEATLES FANATICS

In the background of the mix, between 1:42 and 1:52, we can hear some guitar phrases. Probably leakage from previous recordings.

Genesis

Paul was pleased with his tune, but not his lyrics. He hurried to John's house in Weybridge to rewrite the song. The basic idea was to work with a phrase about a ring, *You can buy me a golden ring.* Neither Paul nor John were inspired and they didn't get anywhere with this phrase, which Paul didn't like to begin with. After a cigarette break, Paul somehow came up with another phrase, and they settled on *drive my car* instead of *golden rings.* "To me it was LA chicks saying, 'You can be my chauffeur,' and it also meant 'You can be my lover.' *Drive my car* was an old blues euphemism for sex, so in the end all is revealed."[1] He added, "Once you've got the great idea, they do tend to write themselves."[3] Paul wrote the music and was coauthor of the lyrics with John. Paul credits the song in his favor, 70/30.

Production

The Beatles recorded "Drive My Car" on October 13. The session began at 7 P.M. and lasted past midnight—to 12:15 A.M., to be exact. It was the first time a recording session ended after midnight, a practice that quickly became a regular occurrence. The rhythm track was completed in only four takes. In 1977, George revealed that when Paul arrived at the studio to work on one of his titles, he usually imposed the musical arrangement he had envisioned on the others without asking them their opinion. However, this day, George reacted differently, "For 'Drive My Car' I simply played a guitar line that was, in fact, very close to 'Respect' by Otis Redding. I played this part, and Paul followed me on bass." Later, he was less clear: "I played the bass line on 'Drive My Car.' It was like the line from 'Respect' by

At the time of *Rubber Soul*, John and Paul wrote nonstop to the point that Paul later said that it almost became an obsession. They took a wicked pleasure in using expressions with a double meaning, such as *drive my car*.

Otis Redding."[3] However, it was more than likely that Paul was on bass.

One thing is certain, the effect is striking, giving the bass a totally new prominence. The rhythm track, supported by Ringo on drums and probably John, who did not play guitar, on tambourine (even though Mark Lewisohn mentions a rhythm guitar) is highly effective. The Beatles came close to the "soul" sound of their idols. George used his Fender Stratocaster Sonic Blue, Paul without a doubt his Rickenbacker 4001S. Ringo added a cowbell and Paul a piano part. The guitar solo is the subject of some debate. Presumably, George played the guitar solo, but some suggest it was Paul. The album notes do not cite him on guitar, but credit him with the piano. It is likely that they played the introduction together, George on his Strato and Paul

on his Epiphone Casino. Finally, the vocal parts were recorded. Paul and John sang in harmony and George came in with "beep beep." The mono mix was made on October 25 and the stereo mix on October 26, the same day that the Beatles collected their Medal of the British Empire (MBE) from the Queen.

Technical Details

There is a noticeable difference between the mono and stereo mixes of this song. The stereo mix enhances Ringo's cowbell and has more reverberation on the vocals.

1. Miles, *Paul McCartney.*
2. Ibid.
3. *The Beatles Anthology.*

Norwegian Wood (This Bird Has Flown)

Lennon-McCartney / 2:03

SONGWRITER
John

MUSICIANS
John: vocal, rhythm guitar
Paul: bass, piano, backing vocal
George: sitar, lead guitar
Ringo: drums, tambourine, finger cymbals

RECORDED
Abbey Road: October 12 and 21, 1965 (Studio Two)

NUMBER OF TAKES: 4

MIXING
Abbey Road: October 25–26, 1965 (Studio Two)

TECHNICAL TEAM
Producer: George Martin
Sound Engineer: Norman Smith
Assistant Engineers: Ken Scott, Ron Pender

Genesis

"Tears welled in Cynthia's eyes . . . 'There were an uncountable number,' John insisted, 'in hotel rooms throughout the bloody world! But I was afraid for you to find out. That's what "Norwegian Wood" was all about, the lyrics that nobody could understand. I wrote it about an affair and made it all gobbledygook so you wouldn't know.'"[1] This conversation between John and his wife was reported by Peter Brown, Brian Epstein's and the group's personal assistant. This charming song with an Irish flavor tells the story of an extramarital affair. John explained later to Peter Schiff, "I was trying to be sophisticated in writing about an affair. But in such a smokescreen way that you couldn't tell. But I can't remember any specific woman it had to do with."[2] His childhood friend, Pete Shotton, suggested that it was a female journalist. Speculation points to an affair with Maureen Cleave, a well-known journalist and the author of the famous *Evening Standard* article in which John made comments about Jesus Christ and Christianity that caused a scandal at the time (see *Revolver*). Was she the bird involved?

John took full credit for "Norwegian Wood" in 1980, but seems to have forgotten his partner. According to Paul, John had begun the song in January or February 1965 while on a skiing vacation in the Swiss Alps with his wife Cynthia and George Martin and his future wife. When Paul later joined him at Kenwood, his contribution was significant. It was Paul who came up with the idea of having the main actor set his mistress's apartment on fire as revenge when he wakes up and finds that she has left. According to Paul, credit is 60/40 in John's favor. John later told *Playboy* that he hadn't the faintest idea where the title came from. But Paul remembers that Peter Asher, Jane's brother,

1965

Ravi Shankar, the Indian sitar player, became a major influence on George, who was fascinated by Indian music.

had his room done in wood, which was fashionable at the time. *Norwegian wood* might have sounded more poetic.

Production

On October 12, the Beatles returned to the studio to begin the recording sessions for *Rubber Soul*. After "Run for Your Life," they started "Norwegian Wood" under the working title "This Bird Has Flown." The basic rhythm track was recorded, and John tried to find an arrangement expressing his intent. George had become familiar with Indian music during the filming of *Help!* and became fascinated with Ravi Shankar. He bought a sitar from a shop on Oxford Street called Indiancraft and played it for the first time in "Norwegian Wood." "We would usually start looking through the cupboard to see if we could come up with something, a

new sound, and I picked the sitar up—it was just lying around. I hadn't really figured out what to do with it. It was quite spontaneous. I found the notes that played the lick. It fitted and it worked."[3] This had enormous repercussions in the music world. From the Yardbirds to the Kinks and even the Stones, a multitude of artists and bands adopted this sound. John finally found the sound he was looking for.

On October 21, after trying different versions of the song, they arrived at the final arrangement with take 4. John was simultaneously on the vocal and played his Jumbo J-160 E, George was on his Framus Hootenanny twelve-string, and Paul was on bass and backing vocal. George later added his famous sitar, which, just like John's vocal, was not doubled. Ringo completed the piece with a bass drum, tambourine, and finger cymbals on the final guitar chord. On the tape

The Beatles with Maureen Cleave, a journalist at the *Evening Standard* with whom John may have had an affair.

we hear some hand claps, as if someone slapped his thigh (at about 0:44 and 1:34), but it is hard to figure out exactly what the sound is. Mono and stereo mixes were made on October 25 and 26.

Technical Details

Norman Smith had a hard time recording the sitar: "My meter would be going right over into the red, into distortion, without us getting [any] audible value for [the] money. I could have used a limiter, but that would have meant losing the sonorous quality."[4]

FOR BEATLES FANATICS

The first take of the song is in the key of D and dated October 12. The final version is in E.

1. Peter Brown and Steven Gaines, *The Love You Make: An Insider's Story of the Beatles* (New York: McGraw-Hill Book Company, 1983).
2. Sheff, *The Playboy Interview with John Lennon & Yoko Ono.*
3. *The Beatles Anthology.*
4. Lewisohn, *The Complete Beatles Recording Sessions.*

You Won't See Me

Lennon-McCartney / 3:19

SONGWRITER
Paul

MUSICIANS
Paul: vocal, bass, piano
John: backing vocal, tambourine (?)
George: rhythm guitar, backing vocal
Ringo: drums, tambourine (?)
Mal Evans: Hammond organ

RECORDED
Abbey Road: November 11, 1965 (Studio Two)

NUMBER OF TAKES: 2

MIXING
Abbey Road: November 15, 1965 (Studio One)

TECHNICAL TEAM
Producer: George Martin
Sound Engineer: Norman Smith
Assistant Engineers: Ken Scott, Richard Lush

FOR BEATLES FANATICS

There is a gradual slowing of tempo during the song. It starts at 119 bpm and ends at 113 bpm. Was Ringo getting tired?

Genesis

Typical of the songs Paul wrote at Wimpole Street, "You Won't See Me" is about his relationship with Jane Asher. A problem of communication and boredom, Paul made his little drama about a breakup that had not yet occurred. Without a doubt he mixed his own feelings into a purely fictional story. About the music, he wrote, ". . . this was written around two little notes, a very slim phrase, a two-note progression that I had very high on the first two strings of the guitar: the E and the B strings. I had it up on the high E position, and I just let the note on the B string descend a semitone at a time, and kept the top note the same, and against that I was playing a descending chromatic scale. Then I wrote the tune for 'You Won't See Me'."[1]

Production

On November 11, at 6 P.M., the Beatles returned to the studio to finish recording *Rubber Soul*. They left thirteen hours later at 7 in the morning. The first song they worked on was "You Won't See Me." They recorded two takes of the rhythm track, Paul at the piano, John on tambourine (a priori), George on rhythm guitar, and Ringo on drums. Paul later overdubbed his bass part—an unusual practice at the time. He sought the "Motown" flavor of his idol, the extraordinary bass player from Detroit, James Jamerson, a member of the well-known Motown house band, the Funk Brothers. Paul: "It was him, me, and Brian Wilson who were doing melodic bass lines at that time, all from completely different angles, LA, Detroit, and London, all picking up on what each other did."[1]

James Jamerson, the legendary Motown bass and one of the great influences on Paul.

Indeed, his bass line sounds remarkably like Jamerson. Ringo added a hi-hat part, and Mal Evans played the Hammond organ (probably an RT-3). His contribution consisted of an A note. Even though Mark Lewisohn couldn't hear, it is undoubtedly there, starting at 2:29 (in the left channel). Finally, the vocals were divided between Paul on double-track lead vocal and backing vocal, John and George on backing vocals. Because of the rush, mono and stereo mixes were both done on November 15 in Studio One. In spite of the hard tone of the text, "You Won't See Me" expresses optimism and freshness.

Technical Details

Norman Smith always recorded Ringo's drums using the Altec RS124 compressor. When Geoff Emerick took over on *Revolver*, he used another model, a Fairchild 660, which gave a more percussive sound. Curiously, in "You Won't See Me," Ringo's drums sound different from of the rest of the album, and it seems as if the Fairchild was used here, too. Was Norman Smith thinking of using the Fairchild in the future, as Geoff Emerick would soon do?

1. Miles, *Paul McCartney*.

Nowhere Man

Lennon-McCartney / 2:42

SONGWRITER
John

MUSICIANS
John: vocal, rhythm guitar, lead guitar
Paul: vocal, bass
George: lead guitar, backing vocal
Ringo: drums

RECORDED
Abbey Road: October 21–22, 1965 (Studio Two)

NUMBER OF TAKES: 5

MIXING
Abbey Road: October 25–26, 1965 (Studio One)

TECHNICAL TEAM
Producer: George Martin
Sound Engineer: Norman Smith
Assistant Engineers: Ken Scott, Ron Pender

FOR BEATLES FANATICS

"Nowhere Man" and "If I Needed Someone" were the only songs from *Rubber Soul* to be performed during the Beatles' last concert at San Francisco's Candlestick Park on August 29, 1966.

Genesis

Hiding out at home and totally uninspired, after five hours John was still struggling to write a new song for *Rubber Soul*. "I'd actually stopped trying to think of something. Nothing would come. I was cheesed off and went for a lie down, having given up. Then I thought of myself as Nowhere Man—*sitting in this Nowhere Land*. 'Nowhere Man' came, words and music, the whole damn thing. . . . So letting it go is what the whole game is."[1] In 1980, John explained to David Sheff that writing is ". . . like being possessed; like a *psychic* or a *medium*. The thing *has* to go down. It won't let you sleep, so you *have* to get up, *make* it into something, and then you're allowed to sleep."[2] Paul recognized that "Nowhere Man" was one of John's best songs, but in describing the song he also contradicted himself. In 1997, in *Paul McCartney: Many Years From Now*, he recalled, "John said he'd written it about himself, feeling like he wasn't going anywhere. I think actually it was about the state of his marriage with Cynthia."[3] Three years later, however, in *Anthology*, the same Paul declared that "Nowhere Man" "was about me" and not about John. The song was included in the animated film *Yellow Submarine*, which came out in 1968. Jeremy Hillary Boob, a strange gopher-like man from the Sea of Nothing is the "Nowhere man." Ringo takes pity on him and brings him into the Yellow Submarine. John's vocal was both intimate and universal. Who has not felt like this "Nowhere Man" at one time or another in life? John showed his true talent for bringing us into his vision of the world. Strawberry fields were not too far away.

John in the studio during a recording session for *Rubber Soul*. Double-page spread: John and Paul.

Production

On October 21, the Beatles made their first unsuccessful attempt to record the rhythm track. The next day, take 5 was acceptable. Ringo played drums, John his Jumbo J-160 E, and Paul the bass. George and John later used their Fender Stratocaster Sonic Blues. They probably played the melody and guitar solo together on a track reserved for them. George reported in a 1995 interview, "I played [the Sonic Blue Fender Stratocaster] a lot on that album, most noticeably the solo on 'Nowhere Man' which John and I both played in unison."[4] Paul told Mark Lewisohn that he wanted high-pitched guitars—as high as possible. The engineers were reluctant, but put three times the allowed value of treble in the song and obtained the desired effect: "They're among the most treble-y guitars I've ever heard on record,"[5] said Paul.

1. Hunter Davies, *The Beatles*, updated ed. (New York: W.W. Norton, 2010); Sheff, *The Playboy Interview with John Lennon & Yoko Ono*.
2. Sheff, *The Playboy Interview with John Lennon & Yoko Ono*.
3. *The Beatles Anthology*.
4. Babiuk, *Beatles Gear*.
5. Lewisohn, *The Complete Beatles Recording Sessions*.

Think For Yourself

George Harrison / 2:17

MUSICIANS
George: vocal, rhythm guitar
John: Hohner Pianet electric piano, backing vocal
Paul: bass, backing vocal
Ringo: drums, tambourine, maracas

RECORDED
Abbey Road: November 8, 1965 (Studio Two)

NUMBER OF TAKES: 1

MIXING
Abbey Road: November 9, 1965 (Room 65)

TECHNICAL TEAM
Producer: George Martin
Sound Engineer: Norman Smith
Assistant Engineers: Ken Scott, Jerry Boys

FOR BEATLES FANATICS

In 1969, Paul used the same fuzzbox on his bass for the recording of "Mean Mr. Mustard" on *Abbey Road*.

Genesis

"'Think for Yourself"' must be written about somebody from the sound of it—but all this time later I don't quite recall who inspired that tune. Probably the government."[1] George's words here do not help us understand the meaning of the song, the text of which could either refer to a romantic relationship or political criticism. George does not provide many clues. However, like his friends, he matured very quickly. He did not want to stick with the sentimental love songs that made the group's initial reputation. Their minds were open. A new social consciousness was born. When you are dealing with a friend of Bob Dylan, you have to pay attention to the words.

Production

This was George's second song for *Rubber Soul*. The Beatles worked on it on November 8 under the title "Won't Be There with You." The song shows musical development, employing a new sonority created by the use of a fuzz pedal on Paul's bass. After rehearsing the backing vocals of the song (including a short segment that found its way into the animated feature film *Yellow Submarine* in 1968), the Beatles recorded the bass track with George on rhythm guitar, Paul on bass, Ringo on drums, and John at the Hohner Pianet. Then Paul used his Rickenbacker 4001S connected to a fuzzbox to double his own bass part. George then added his lead vocal, accompanied by John and Paul in superb harmony. Ringo completed the song with tambourine and maracas. "Think for Yourself" was mixed in mono and stereo the following day.

1. Harrison, *I Me Mine*.
2. *The Beatles Anthology*.

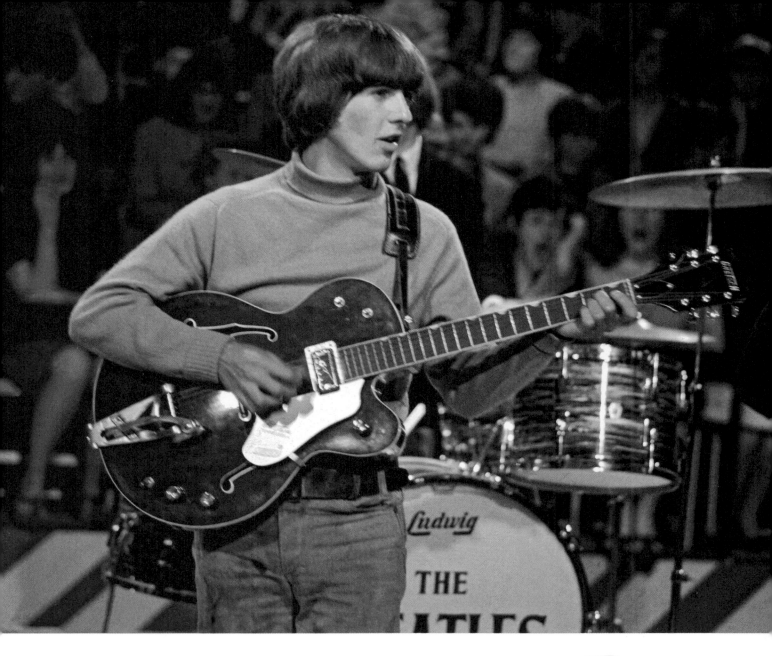

Did You Say Fuzzbox?

George later confirmed that Phil Spector, a famous producer during the 1960s and '70s who invented the recording technique known as Wall of Sound, was also the source of the idea of attaching a fuzzbox to Paul's bass. When Phil Spector recorded "Zip-a-Dee-Doo-Dah" by Bob B. Soxx & the Blue Jeans in 1963, the engineer who set up the track overloaded the microphone on the guitar and it became very distorted. Phil Spector said, 'Leave it like that. It's great.' Some years later everyone started to try to copy that sound, so they invented the fuzzbox. "We had one and tried the bass through it and it sounded really good,"[2] said George. For "Think for Yourself," the Beatles used the famous Tone Bender fuzzbox MK1.

The Word

Lennon-McCartney / 2:41

SONGWRITER
John

MUSICIANS
John: vocal, rhythm guitar
Paul: bass, piano, backing vocal
George: lead guitar, backing vocal
Ringo: drums, maracas
George Martin: harmonium

RECORDED
Abbey Road: November 10, 1965 (Studio Two)

NUMBER OF TAKES: 3

MIXING
Abbey Road: November 11, 1965 (Room 65) /
November 15, 1965 (Studio One)

TECHNICAL TEAM
Producer: George Martin
Sound Engineer: Norman Smith
Assistant Engineers: Ken Scott, Richard Lush

1965

Genesis

The song "The Word" was originally written around one note, like "Long Tall Sally." John and Paul cowrote the song, even if John later said in 1980, "'The Word was written together, but it's mainly mine. You read the words, it's all about gettin' smart. It's the marijuana period. It's love, it's the love-and-peace thing. The word is 'love,' right?"[1] During this *Rubber Soul* period, John understood the true meaning of love: "It seems like the underlying theme to the universe. Everything that was worthwhile got down to this love, love, love thing. And it is the struggle to love, be loved, and express that (just something about love) that's fantastic."[2] With "The Word," for the first time, the Beatles wrote about a universal topic. This message later culminated in "All You Need Is Love" in 1967. They were in tune with the times, and the hippie community quickly recognized them as soul mates. John: "Even though, I'm not always a loving person, I want to be that; I want to be as loving as possible."[3] Until his death, John lived in pursuit of this goal, despite his demons and weaknesses. After writing "The Word," John and Paul decided to relax a bit. They rolled a joint. Normally they did not smoke while working, but this time they illustrated their draft with multicolored psychedelic designs in watercolor (probably mostly Paul).

According to Barry Miles, at the end of 1965 Yoko Ono turned up at Paul's house asking for an original manuscript to give to John Cage for his fiftieth birthday. (Was this a pretext or a mistaken date? In 1965 Cage was fifty-three.) Cage collected musical scores from the twentieth century to compare the diversity of notation. Paul referred Yoko to John, who gave her the multicolored manuscript of "The Word."

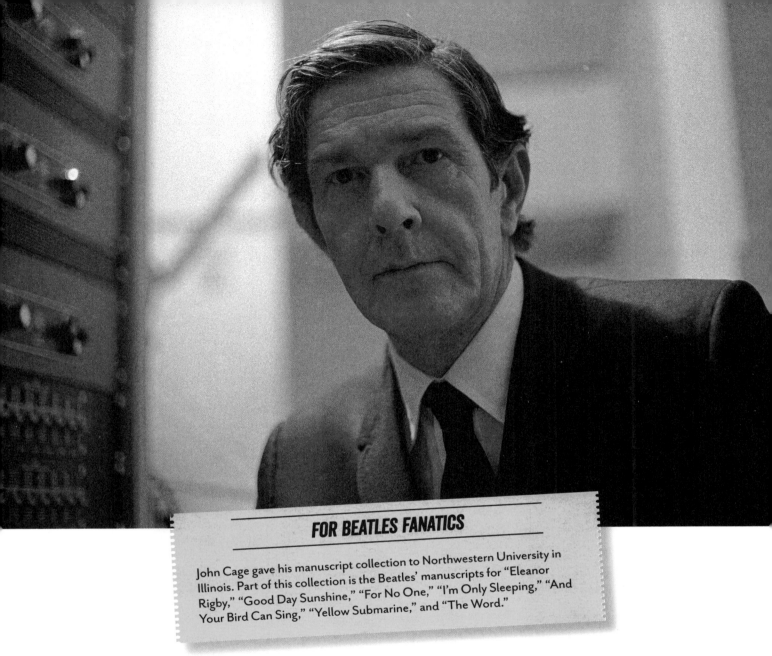

Curiously, it seems that John only met Yoko for the first time on November 9 at the Indica Gallery in almost one year later. Whatever the story, the manuscript of "The Word" is reproduced in John Cage's *Notations*, published in 1969.

Production

On November 10, John and his followers were in the studio to confirm that the "word" is "love." The rhythm track was recorded in three takes, John on rhythm guitar, George on lead guitar, Paul at the piano, and Ringo on drums. This was the second time after "Michelle" that Paul deliberately recorded his bass on a separate track. He was able to concentrate on his instrument, and he delivered a terrific part in a Motown bass style. George double-tracked his vocal on the bridges while George Martin played the harmonium solo and Ringo added maracas. John, Paul, and George sang the song in a superb three-part harmony (doubled). John double-tracked the middle eight vocal by himself. The final mono mix was made on November 11 and the stereo mix on November 15.

1. Sheff, *The Playboy Interview with John Lennon & Yoko Ono.*
2. *The Beatles Anthology.*
3. Ibid.

Michelle

Lennon-McCartney / 2:40

SONGWRITER
Paul

MUSICIANS
Paul: vocal, bass, rhythm guitar
John: backing vocal
George: rhythm guitar, lead backing vocal
Ringo: drums

RECORDED
Abbey Road: November 3, 1965 (Studio Two)

NUMBER OF TAKES: 1

MIXING
Abbey Road: November 9 and 15, 1965 (Studio Two)

TECHNICAL TEAM
Producer: George Martin
Sound Engineer: Norman Smith
Assistant Engineers: Ken Scott, Jerry Boys, Richard Lush

Genesis

"Michelle" was written when Paul was a student at the Liverpool Institute of Art (1953–1960). He wanted to write a tune in the style of Chet Atkins's "Trambone" style with a distinctive melody and a bass line. Although he did not master the finger-pickin' technique, he wrote an instrumental song, "Michelle," in a similar style. Years later, Austin Mitchell, who was one of John's teachers at art school, hosted a party during which Paul sang "Michelle," improvising French words in the style of Juliette Greco as a ploy to attract women. Both Paul and John admired Juliette Greco as the "muse" of the existential Saint German-des-Prés nights in the 1950s. In 1965, when they were looking for new titles for their album, John reminded Paul about the "French thing" that he used to do at Mitchell's parties. "Well, that's a good tune. You should do something with that."[1]

Paul took the melody and reworked the lyrics with Jan, a French teacher and the wife of his old friend Ivan Vaughan. He had this French style in mind and asked her for a word that rhymed with *Michelle*. "Ma belle," she replied. Then he asked, "What's French for *These are words that go together well?*"[2] "*Sont des mots qui vont très bien ensemble*,"[3] she said. John wrote the middle eight, inspired by Nina Simone's "I Put a Spell on You." "There was a line in it that went, *I love you, I love you, I love you*. That's what made me think of the middle eight."[4]

1. Miles, *Paul McCartney.*
2. Ibid.
3. Ibid.
4. Sheff, *The Playboy Interview with John Lennon & Yoko Ono.*
5. Lewisohn, *The Complete Beatles Recording Sessions.*
6. Miles, *Paul McCartney.*

Paul facing the famous Neumann mic. He recorded "Michelle" in the intimate Studio Two at Abbey Road in November 1965.

The title generated controversy. Who is Michelle? For some, it was Michelle Morgan; for others the sublime Michelle Phillips of the Mamas & the Papas, or the French singer Richard Anthony's first wife, who had charmed the Beatles. Whoever Michelle was, the song is one of the Beatles' most popular, along with "Yesterday." "Michelle" won the Grammy Award for song of the year in 1966 and in 1999 (BMI) listed "Michelle" as the forty-second most frequently performed song of the twentieth century.

Production

The recording of "Michelle" is also subject to speculation. The recording took place on November 3. That afternoon the band recorded the rhythm track. Paul was simultaneously on vocal and acoustic guitar, his Epiphone Texan. Ringo was on drums, and then Paul took his Rickenbacker 4001S, connected to an amplifier, a Fender Bassman, and, for the first time, recorded on a separate track. This quickly became the Beatles' usual practice in the studio, particularly with *Sgt. Pepper*.

Michelle Phillips, the lovely singer of the Mamas & the Papas, who perhaps inspired Paul to write one of his most beautiful melodies.

"I'll never forget putting the bass line in 'Michelle' because it was a kind of Bizet thing."[5] In fact, George added the guitar solo probably on his Stratocaster or his Tennessean. Precisely which is a subject of controversy. Some hear a bass. Others think that Paul is playing . . . In 1993, George Martin said on Swedish television, "The guitar solo in 'Michelle' is my composition. I actually wrote down the notes—'I'll play this. George, you can do these notes on the other guitar; we'll play in unison'—that kind of thing." Even though no keyboard is audible on the recording, it is possible that Martin guided George.

After a reduction onto a second tape recorder, the outstanding three-voice backing vocals were simultaneously added using George's Gibson J-120 E. He doubled Paul some of the time. The session ended at 11:30 P.M. after nine hours of work. The Beatles decided to redo the mono mix on November 15. Paul: "We would mix them, and it would take half an hour, maybe. Then it would go up on a shelf, in a quarter-inch tape box. And that was it."[6]

What Goes On

Lennon-McCartney-Starkey / 2:47

SONGWRITER
John

MUSICIANS
Ringo: vocal, drums
John: backing vocal, rhythm guitar
Paul: backing vocal, bass
George: lead guitar

RECORDED
Abbey Road: November 4, 1965 (Studio Two)

NUMBER OF TAKES: 1

MIXING
Abbey Road: November 9, 1965 (Room 65)

TECHNICAL TEAM
Producer: George Martin
Sound Engineer: Norman Smith
Assistant Engineers: Ken Scott, Graham Platt, Jerry Boys

FOR BEATLES FANATICS

Right at the end of the song, at about 2:36, Ringo can be heard in the right channel repeating *in your mind* twice.

Genesis

"What Goes On" is one of John's older songs. "That was an early Lennon, written before the Beatles when we were the Quarrymen or something like that,"[1] he confirmed. The Beatles wanted to record it on March 5, 1963, during the sessions for "From Me to You," but ran out of time. It turned up again for *Rubber Soul* in order to fill up the album. Originally sung by John, it was in the end performed by Ringo. John: "And resurrected with a middle eight thrown in, probably with Paul's help, to give Ringo a song."[2] Indeed! The Beatles had to keep Ringo's fans happy—particularly his American fans. It is one of the few Beatles songs where his name is associated with those of Lennon and McCartney. In a 1966 interview he explained that his contribution was limited to "about five words to 'What Goes On.' [Laughs] And I haven't done a thing since!"[3]

Production

The deadline had come to complete the new album. Paul recorded a homemade demo so that Ringo could learn the song faster. On November 4, the day of the recording, Ringo was ready. The rhythm track was recorded in one take. Ringo was on drums, Paul on bass, John on rhythm guitar and George performed a Chet Atkins–style solo on lead guitar. Then Ringo recorded his lead vocal and John and Paul overdubbed the harmony. "What Goes On" is not a masterpiece, but its country and western style is quite charming. It is nonetheless surprising that it was chosen to open the second side, unless perhaps this was done to please Ringo's fans. The mono and stereo mixes were made on November 9 in Room 65.

1. Sheff, *The Playboy Interview with John Lennon & Yoko Ono.*
2. Los Angeles press conference, August 24, 1966.
3. Miles, *Paul McCartney.*

Girl

Lennon-McCartney / 2:30

SONGWRITER
John

MUSICIANS
John: vocal, rhythm guitar
Paul: backing vocal, bass, acoustic guitar (?)
George: acoustic guitar (?), bouzoukis (?), backing vocal
Ringo: drums

RECORDED
Abbey Road: November 11, 1965 (Studio Two)

NUMBER OF TAKES: 2

MIXING
Abbey Road: November 15, 1965 (Studio One)

TECHNICAL TEAM
Producer: George Martin
Sound Engineer: Norman Smith
Assistant Engineers: Ken Scott, Richard Lush

FOR BEATLES FANATICS

John waited nearly fifteen years to write a sequel to "Girl." It was "Woman" from his last album, *Double Fantasy*, released in 1980.

Genesis

In an interview, John claimed, "I like this one. It was one of my best." "Girl" was undoubtedly his response to "Michelle." The instrumentation is similar, and the song offers the same intimate feelings. This magnificent ballad speaks of his dream girl, the one he was looking for. "It was Yoko,"[1] he said in 1980. However, the lyrics are ambiguous. The girl hurts, humiliates, and manipulates him—she is far from a dream girl. One sentence is surprising: *Was she told when she was young that pain would lead to pleasure?* Paul claimed to have written the line, but in 1970 John cited it as his and said it showed his opposition to Christianity. He said, "You have to be tortured to attain heaven." Written at Kenwood, the song was "based on John's idea" and finished with Paul's help. "Girl" was a great success, and deserved release as a single.

Production

The Beatles had to complete the album by November 11, 1965. They needed four more songs. During a thirteen-hour marathon session, starting at 6 P.M. and ending at 7 A.M. the next day, they recorded two new songs ("You Won't See Me" and "Girl") and completed two others. The rhythm track was done in two takes. John played acoustic guitar (using a capo), Paul bass, and Ringo drums and brushes. George's exact instrument is uncertain. It was probably a twelve-string guitar, but George Martin recalled that George Harrison was always looking for new sounds and played a bouzouki. "One day I was offered a bouzouki in Greece, and George tried it on this piece."[2] Paul later told Barry Miles, "We just did it on acoustic guitars instead of

Paul and John in rehearsal. Are they willing to sing their subversive onomatopoetic choruses under George Martin's nose?

bouzoukis."[3] Whom to believe? John recorded his vocal with emotion and an expressiveness unlike any he had used before. A high point was his intake of breath in the chorus. According to Paul, one of his best memories is seeing John take a deep breath and sing. "John wanted to hear the breathing, wanted it to be very intimate, so George Martin put a special compressor on the voice."[4] He is supported by George and Paul's superb backing vocals. All vocals were double-tracked, including the breathing. They found their inspiration for the bridge in one of the songs from the Beach Boys. Their first idea was to sing "dit dit dit dit," but they found "tit tit tit tit" more fun (*tit* meaning breast!). Paul: "George Martin might say: 'Was that "dit dit" or "tit tit" you were

singing?' 'Oh, "dit dit," George, but it does sound a bit like that, doesn't it?'"[5]

The "Zorba the Greek" theme at the end of the song was Paul's composition, inspired by his vacation in Greece with Jane, Ringo, and Maureen in September 1963. George played it on his bouzouki (or guitar), and Paul probably double-tracked it on acoustic guitar. The mono and stereo mixes were made on November 15, 1965.

1. Sheff, *The Playboy Interview with John Lennon & Yoko Ono.*
2. Ryan and Kehew, *Recording the Beatles.*
3. Miles, *Paul McCartney.*
4. Ibid.
5. Ibid.

I'm Looking Through You

Lennon-McCartney / 2:24

SONGWRITER
Paul

MUSICIANS
Paul: vocal, bass
John: backing vocal, rhythm guitar
George: lead guitar, tambourine (?)
Ringo: drums, percussion, Hammond organ

RECORDED
Abbey Road: October 24, 1965 (Studio Two) / November 6, 10, and 11, 1965 (Studio Two)

NUMBER OF TAKES: 4

MIXING
Abbey Road: November 15, 1965 (Studio Two)

TECHNICAL TEAM
Producer: George Martin
Sound Engineer: Norman Smith
Assistant Engineers: Ken Scott, Richard Lush

FOR BEATLES FANATICS

Several anomalies are noteworthy in this song. Among the most significant are slight audible feedback at 1:18 (after *above me*) and at about 1:53 we can hear wrong guitar notes, probably from an improperly erased previous solo (right channel on *did you go*). Finally, on the American stereo version of *Rubber Soul*, there are two guitar false entries. Fortunately, the errors are corrected on the UK version.

Genesis

Paul: "This one I remember particularly as me being disillusioned over her commitment."[1] Jane Asher, an actress at Bristol Old Vic, did not want to give up her career, as Paul so ardently wished. Paul suffered in this tumultuous relationship. During the recording sessions for *Rubber Soul*, three songs were written after an argument: "I'm Looking Through You," "You Won't See Me," and "We Can Work It Out" (released as a single). Paul confessed to Barry Miles that he knew that his fiancée did not correspond to the image he had of her and that he clearly saw through her. "Suffice it to say that this one was probably related to that romantic episode and I was seeing through her façade. And realizing that it wasn't quite all that it seemed. I would write it out in a song and then I've got rid of the emotion."[2] Putting his feelings into songs allowed him to release these tensions. Ironically, he wrote "I'm Looking Through You" in his room at the Ashers' house on Wimpole Street. The piece is highly acoustic, like many other titles on the *Rubber Soul* album.

Production

There were two versions of this song before it took its final form. The first dates from October 24, when, after nine hours in the studio, the Beatles first tried to make a master. This first version appears on *Anthology 2*, and uses hand clapping, classical guitar, a guitar solo, and bongos, all at a tempo noticeably slower than the final version. The first version lacked the middle eight of the final version and ended with a vocal improvisation. They were not happy with it and retaped it on November 6 but at a much too fast tempo (according to Mark Lewisohn). Finally on November 10, after the

Paul and Jane Asher in 1965. "I'm Looking Through You" highlights the couple's problematic relationship.

fourth try, they found the right tempo. Paul played bass, John acoustic guitar, and Ringo drums. George played the tambourine and the guitar solo, both added as overdubs. Ringo was particularly honored that day—in addition to the drums, he played a Hammond organ chord at the end of the verses and created a percussion sound using an unexpected instrument. In 1996, he revealed to Andy Babiuk "that he just tapped on a pack of matches with his finger!"[3] On November 11, they overdubbed the vocals. Paul double-tracked his bass lines, backed by John. It was 7 A.M. and the final session for *Rubber Soul* ended. On November 15, the last day to complete the album, mono and stereo mixes were made in a hurry to deliver the masters to the pressing plant. The album was released on December 3.

1. Miles, *Paul McCartney.*
2. Ibid.
3. Babiuk, *Beatles Gear.*

In My Life

Lennon-McCartney / 2:25

SONGWRITERS
John (?), Paul (?)

MUSICIANS
John: vocal, rhythm guitar
Paul: backing vocal, bass
George: lead guitar, backing vocal
Ringo: drums, tambourine
George Martin: piano

RECORDED
Abbey Road: October 18 and 22, 1965 (Studio Two)

NUMBER OF TAKES: 3

MIXING
Abbey Road: October 25–26, 1965 (Studio Two)

TECHNICAL TEAM
Producer: George Martin
Sound Engineer: Norman Smith
Assistant Engineers: Ken Scott, Mike Stone, Ron Pender

FOR BEATLES FANATICS

"In My Life" was performed at the funeral of Kurt Cobain, who idolized John Lennon.

Genesis

"In My Life" is one of those rare songs of uncertain paternity. John claimed that, other than the middle eight, he wrote the song. Paul claimed responsibility for the melody: "I arrived at John's house for a writing session and he had the very nice opening stanzas of the song. . . . But as I recall, he didn't have a tune to it, and my recollection, I think, is at variance with John's. I said, 'Well, you haven't got a tune, let me just go and work on it.' And I went down to the half-landing, where John had a Mellotron, and I sat there and put together a tune based in my mind on Smokey Robinson & the Miracles. Songs like 'You've Really Got a Hold on Me' and 'Tears of a Clown' had really been a big influence. . . . So it was John's original inspiration, I think my melody, I think my guitar riff [for the intro]."[1]

The song was inspired by a remark made by Kenneth Alsopf, a British journalist and writer, after the publication of John's book *In His Own Write*, asking why Lennon's songs weren't more serious. After thinking about it, John wrote "In My Life," his "first really big song," entirely on his own terms. His idea was to tell how key places in Liverpool had played a role in his life. "'In My Life' started out as a bus journey from my house on 250 Menlove Avenue to town, mentioning every place that I could remember. And it was ridiculous."[2] Then he recast his idea and came back to his early loves and friendships. John confessed to Pete Shotten that the phrase *Friends I still can recall, some are dead and some are living*, referred to Stuart Sutcliffe and Pete. So who's right—John or Paul? It doesn't matter. The only thing that counts is the results.

George Martin, a great and innovative producer, encouraged the Beatles to experiment. He also contributed to their experiments, as he brilliantly proved with "In My Life."

Production

On October 18, after several rehearsals of "In My Life," the group recorded the rhythm track of two guitars, a bass, and a drum in three takes. This track was used as the base for overdubs, adding another electric guitar and a tambourine. John recorded his vocal part, which was doubled and backed by Paul and George's backing vocals. The instrumental bridge was left aside. They thought about a guitar solo, but did not like it. The Beatles decided to take a break and come back later. George Martin resolved the middle eight on October 22: "John couldn't decide what to do in the middle and, while they were having their tea break, I put down a baroque piano solo, which John didn't hear until he came back."[3] Since the part was difficult and

Martin tried to reproduce a baroque-style harpsichord sound, he did it with a half-speed normal piano an octave lower (indeed, he first thought to play a Hammond organ solo). When the tape was played back at double speed, it sounded like a baroque harpsichord. The Beatles liked it. At the end of this solo (1:47), we can clearly hear (left channel) the last note of a previous guitar solo, probably something George Harrison wanted to try. The result is marvelous; a masterpiece in the Beatles' canon. The mono and stereo mixes were made on October 25 and 26, respectively.

1. Miles, *Paul McCartney.*
2. Sheff, *The Playboy Interview with John Lennon & Yoko Ono.*
3. *The Beatles Anthology.*

Wait

Lennon-McCartney / 2:13

SONGWRITER
Paul

MUSICIANS
John: vocal, rhythm guitar
Paul: vocal, bass
George: lead guitar
Ringo: drums, tambourine, maracas

RECORDED
Abbey Road: June 17, 1965 (Studio Two) / November 11, 1965 (Studio Two)

NUMBER OF TAKES: 4

MIXING
Abbey Road: June 18, 1965 (Studio One) / November 15, 1965 (Studio One)

TECHNICAL TEAM
Producer: George Martin
Sound Engineer: Norman Smith
Assistant Engineers: Phil McDonald, Ken Scott, Richard Lush

Genesis

This song was written while the Beatles were filming *Help!* in the Bahamas. "Wait" is entirely Paul's composition. The actor Brandon de Wilde was present while Paul worked on the song and was, so he said, interested in Paul's working method. "I seem to remember writing 'Wait' in front of him, and him being interested [in seeing] it being written."[1] The lyrics probably reflected his complex relationship with Jane Asher: *I am often away, but if you really love me, wait for me.* Not easy, life with the Beatles! "Wait" is more album filler than a masterpiece.

Production

The song was originally intended for the soundtrack of the movie *Help!* The Fab Four recorded "Wait" in four takes on June 17, 1965 (the same day as "Act Naturally"). It was resurrected on November 11 during the last recording session for *Rubber Soul.* They did not have enough time to write another song and thought "Wait" would complete the album. In the June 17 recording session, each of the Beatles played his usual instrument; the vocals were shared between John and Paul. A first mix was made on June 18. When they reworked the song on November 11, they added new instruments to the fourth take by overdubs. George played with a volume pedal on his guitar (see "Yes It Is" and "I Need You") and recorded two guitar parts. The group added maracas, tambourine, and other vocal parts. Although Paul wrote the song, John's voice dominated, except for the middle eight. The final mono and stereo mixes were made on November 15.

1. Miles, *Paul McCartney.*

Paul composed "Wait" in the Bahamas, during the filming of *Help!*

Technical Details

"Wait" is a classic example of a song with little reverb. The Beatles, in agreement with George Martin and Norman Smith, wanted a new esthetic—without a doubt under the strong influence of Bob Dylan—and decided to limit reverb as much as possible throughout the entire album.

FOR BEATLES FANATICS

George seems uncomfortable with the volume pedal on his guitar and lacks precision in the settings (left channel from 0:46 to 0:48). His guitar is cut out at 1:14 in the right channel.

If I Needed Someone

George Harrison / 2:20

MUSICIANS
George: vocal, lead guitar
John: backing vocal, rhythm guitar
Paul: backing vocal, bass
Ringo: drums, tambourine

RECORDED
Abbey Road: October 16 and 18, 1965 (Studio Two)

NUMBER OF TAKES: 1

MIXING
Abbey Road: October 25–26, 1965 (Studio Two)

TECHNICAL TEAM
Producer: George Martin
Sound Engineer: Norman Smith
Assistant Engineers: Ken Scott, Ron Pender

FOR BEATLES FANATICS

At 2:08, in the left channel, there is a noticeable drop-out where George's lead guitar disappears.

Genesis

In August 1965, the Beatles traveled to the United States for their concert tour. During this tour they met the Byrds and became acquainted with their music. The Byrds' single "Mr. Tambourine Man" was number 1 on the *Billboard* Hot 100 chart beginning on June 26. The California group used the same instruments as the Fab Four had since the release of *A Hard Day's Night* the year before. The twelve-string Rickenbacker became their trademark. George, appreciative of this tribute, approached them. On August 27, Paul and George visited them at the studio while the Byrds recorded "The Times They Are a-Changin'." The same evening, the Beatles met Elvis Presley at his house in Los Angeles.

Immersed in the California folk rock atmosphere, George wrote "If I Needed Someone" with the Byrds' music in mind. He acknowledged that "If I Needed Someone" was based on the guitar riff in the Byrds' "The Bells of Rhymney." However, the resemblance ends there, as George stated that the song "was like a million other songs written around the D chord." In 1980, he said, "If you move your fingers about, you get various little melodies. That guitar line, or variations on it, is found in many a song, and it amazes me that people still find new permutations of the same notes."[1] Beginning with his own music, in 1969 he wrote "Here Comes the Sun" using this technique. "If I Needed Someone" was the second title that George wrote for *Rubber Soul.*

1. Harrison, *I Me Mine.*

George Harrison took inspiration for his new song from the Rickenbacker folk rock sound of the Byrds.

Production

Late in the evening of October 16, after recording "Day Tripper," the Beatles rehearsed and polished "If I Needed Someone" and recorded the rhythm track. George played his Rickenbacker 320/12, John his Stratocaster Sonic Blue, Paul his 4001S, and Ringo his Ludwig drums, leaving overdubs for the next day. George recorded his vocals, and double-tracked them in the Beatles tradition, accompanied by John and Paul's backing vocals. He also played during the instrumental chorus, with Ringo adding tambourine. The mono mix was made on October 25, the stereo on October 26. It was the only piece George wrote that they sang onstage. It was part of the live set at their final concert in San Francisco's Candlestick Park on August 29, 1966.

Technical Details

This was most likely the first time George used his twelve-string Rickenbacker guitar with a capo placed at the seventh fret. He could play in D but the capo transposed it to A.

Run For Your Life

Lennon-McCartney / 2:19

SONGWRITER
John

MUSICIANS
John: vocal, rhythm guitar
Paul: backing vocal, bass
George: backing vocal, lead guitar
Ringo: drums, tambourine

RECORDED
Abbey Road: October 12, 1965 (Studio Two)

NUMBER OF TAKES: 5

MIXING
Abbey Road: November 9–10, 1965 (Room 65)

TECHNICAL TEAM
Producer: George Martin
Sound Engineer: Norman Smith
Assistant Engineers: Ken Scott, Jerry Boys

Genesis

John never liked "Run for Your Life" because it was "just a sort of throwaway song." He was inspired by Elvis Presley's 1955 song "Baby, Let's Play House," written by Arthur Gunter. He "borrowed" two lines from it: *I'd rather see you dead, little girl, than to be with another man.*[1] In 1970, he said: "I wrote it around that. I didn't think it was all that important, but it was always a favorite of George's."[2] Paul, however, thinks it was John who was running for his life. Barry Miles said in his book: "It was one of his confessional songs, transposed from first to the third person to veil the message."[3] John had a hard time living with Cynthia and hiding his affairs, unlike Paul who had a completely open relationship with Jane Asher. The lyrics may be interpreted through this prism, but their macho, threatening tone is still astonishing. John confessed in the lyrics, *I am a wicked guy . . . born with a jealous mind* and offered lines like *Baby, I'm determined and I'd rather see you dead.* What pushed John, the future advocate of peace, to write such verses? A mystery. These sentiments recur in songs such as "Getting Better" and "Jealous Guy," but these were written for other purposes.

Production

At Abbey Road Studios, on October 12, 1965, at 2:30 P.M., the Beatles began recording songs for their new album *Rubber Soul.* The first song taped for the album was "Run for Your Life." The rhythm track was recorded in five takes with each at his usual instrument: John on acoustic guitar and lead vocal, backed by Paul and George's backing vocals. All three of them double-tracked their vocals in the choruses. In the first take, John's voice was wrapped in a slap-back

Elvis Presley's shadow hovers above "Run for Your Life."

echo, which gives a rockabilly feel to the piece. Ringo played the omnipresent tambourine. George played at least three solo guitar passages: first for the distinctive riff (which he doubled) in the introduction, second for the solo, and, for the first time on a Beatles record, a doubled-tracked guitar on the main riff, plus a second guitar solo, and finally, chord "slides" accomplished by pulling the chord position on his left hand up to D major. The mono mix was made on November 9 and the stereo mix the next day. Despite John's cavalier dismissal of this song, "Run for Your Life" is an excellent tune.

Technical Details

With "Run for Your Life," we get a good idea of the problems that come from a lack of headphones. In the studio, John's singing was guided by the playback coming from the speaker (White Elephant). Thus, by listening to the right channel in the stereo mix, we hear the level of the playback increase up with John's voice.

1. Sheff, *The Playboy Interview with John Lennon & Yoko Ono.*
2. *The Beatles Anthology.*
3. Miles, *Paul McCartney.*

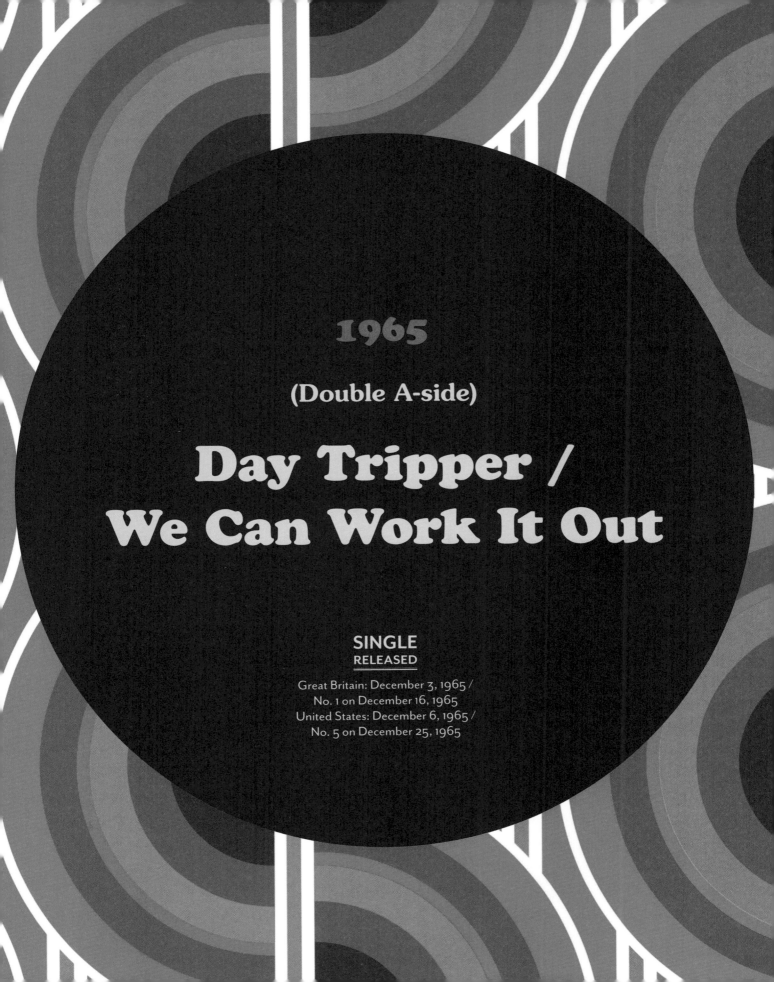

1965

(Double A-side)

Day Tripper / We Can Work It Out

SINGLE
RELEASED

Great Britain: December 3, 1965 /
No. 1 on December 16, 1965
United States: December 6, 1965 /
No. 5 on December 25, 1965

Day Tripper

Lennon-McCartney / 2:48

SONGWRITER
John

MUSICIANS
John: vocal, rhythm guitar
Paul: vocal, bass
George: lead guitar, backing vocal
Ringo: drums, tambourine

RECORDED
Abbey Road: October 16, 1965 (Studio Two)

NUMBER OF TAKES: 3

MIXING
Abbey Road: October 25–26 and 29, 1965 (Studio Two) /
November 10, 1966 (Room 65)

TECHNICAL TEAM
Producer: George Martin
Sound Engineers: Norman Smith, Pete Bown
Assistant Engineers: Ken Scott, Ron Pender, Graham Kirkby

1965

FOR BEATLES FANATICS

German radio was
reluctant to broadcast
Tripper because the word
is slang for "gonorrhea"
in the language of
Goethe.

Genesis

John wrote "Day Tripper" as a single. In 1969, he admits, "'Day Tripper' was [written] under complete pressure, based on an old folk song I wrote about a month previous. It was very hard going, that, and it sounds it."[1] The song, composed in 1965 right after their North American tour, is no less a hit for its guitar riff, which makes any self-respecting guitar player happy. John: "That's mine. Including the lick, the guitar break, and the whole bit. It's just a rock 'n' roll song."[2] The inspiration for the guitar riff might have come from Bobby Parker's "Watch Your Step," just as it did for "I Feel Fine." Paul recalls cowriting the song with John at John's house in Kenwood. The lyrics were an enigma for many fans at the time. First of all, what does *day tripper* mean? Literally, "people who go on a day trip." More than a day trip, however, the word refers to "trips" that provide artificial paradises—not a trip through the English countryside. In 1970, John said, "It wasn't a serious message song. It was a drug song."[3] But it wasn't only a drug song, because there are also sexual references, as Paul confessed to Barry Miles: "She's a big teaser, was 'she's a prick teaser.' The mums and dads didn't get it but the kids did."[4] The song is filled with hidden meanings . . .

Four days later, when Paul brought out "We Can Work It Out," it was preferred over "Day Tripper" for the A-side. John objected vociferously, and in an innovative and diplomatic compromise the Beatles' next single had a double A-side. Once again, the Beatles were ahead of their time.

1. *The Beatles Anthology.*
2. Sheff, *The Playboy Interview with John Lennon & Yoko Ono.*
3. *The Beatles Anthology.*
4. Miles, *Paul McCartney.*

Production

Most of October 16 was spent working on "Day Tripper." In an unusual move, Cynthia along with John's two half-sisters, Julia and Jacqui (born Dykins), were allowed to attend the recording session. After rehearsing, the Beatles finished the rhythm track in three takes with John on rhythm guitar, Paul on bass, George on lead guitar using his volume pedal in the middle eight, and Ringo on drums. After a break, John and Paul shared lead and backing vocals. The final overdub was complicated. John and Paul double-tracked their vocals and George provided a third harmonic line in the choruses of the instrumental bridge while double-tracking his lead guitar and also performing a guitar solo in the same bridge. Ringo played the tambourine. "Day Tripper" was completed, ready to climb to the top of the charts. The first mono mix was made on October 25 and then improved on October 29. The stereo mix was made on October 26. However, it was judged unacceptable, and Peter Bown redid it on November 10, 1966, adding more reverb to the vocals. The aim was to incorporate it into the first Beatles' compilation, *A Collection of Beatles Oldies*, released in Europe on December 9, 1966.

We Can Work It Out

Lennon-McCartney / 2:13

SONGWRITER
Paul

MUSICIANS
Paul: vocal, bass (?), acoustic guitar (?), harmonium (?)
John: backing vocal, acoustic guitar (?), harmonium, tambourine (?)
George: acoustic guitar (?), tambourine (?)
Ringo: drums

RECORDED
Abbey Road: October 20 and 29, 1965 (Studio Two)

NUMBER OF TAKES: 2

MIXING
Abbey Road: October 28–29, 1965 (Studio Two) / November 10, 1965 (Room 65) / November 10, 1966 (Room 65)

TECHNICAL TEAM
Producer: George Martin
Sound Engineers: Norman Smith, Pete Bown
Assistant Engineers: Ken Scott, Jerry Boys, Graham Kirkby

FOR BEATLES FANATICS

Paul bought Rembrandt, his father's house on Baskerville Road, Heswall, Liverpool, in 1964 for £8,750 [$13,000 U.S.]. The house still belongs to Paul, and since the death of his father in 1976, Paul stops by from time to time.

Genesis

Paul composed "We Can Work It Out" on his guitar at Rembrandt, the house he bought for his father in June 1964. The lyrics are very personal, probably a reference to his problematic relationship with his girlfriend, Jane Asher. As Paul explained to Barry Miles, "It is often a good way to talk to someone or to work your own thoughts out."[1] After writing the basic text of the song, he took it to John to finish it off. John said, "Paul wrote the first half, I did the middle eight," and he added that he could not restrain himself in the face of Paul's eternal optimism—*We can work it out—Life is very short and there's no time for fussing and fighting my friend.*[2] When Paul wrote the song, he was thinking of a title faster in tempo and more country and western in style. George contributed to the instrumental arrangements by suggesting a middle like a German waltz.

"We Can Work It Out" is a Beatles masterpiece. Innovation, intelligence, sophistication—all these ingredients came together to place the song in the forefront of everything they did at the time. John had to fight to prevent "Day Tripper" from ending up as the B-side of the single (see "Day Tripper"). As a result, both songs appeared as an A-side. Although "We Can Work It Out" was number 1 on the charts in the United States, "Day Tripper" peaked only in fifth place.

Production

On October 20, only four days after recording "Day Tripper," the Beatles were back at the studio to work on "We Can Work It Out." The rhythm track was recorded in two takes. The instrumental distribution is unclear, and there is no clear documentation for it. Nevertheless,

1965

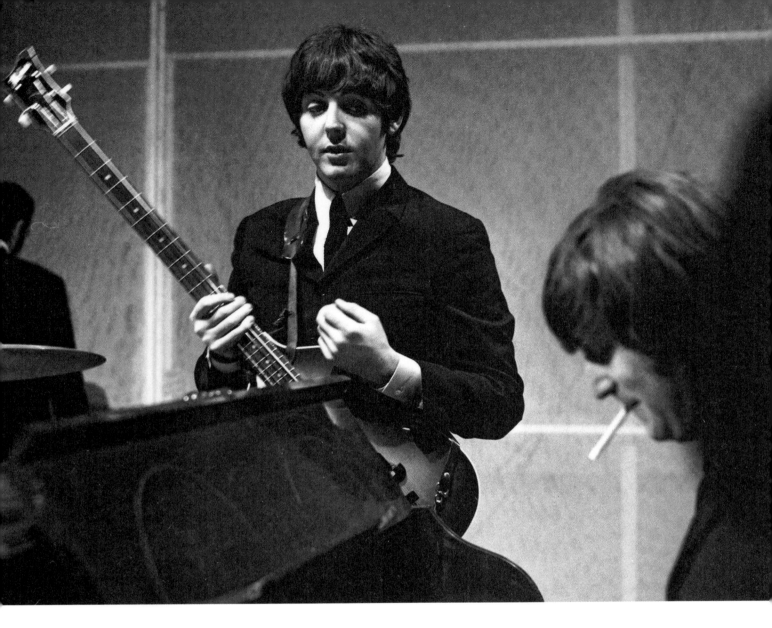

we can assume that Paul played his acoustic guitar while John and George were on bass and tambourine. The quality of the bass playing supports this hypothesis. Ringo played drums. During the session, the Beatles "found an old harmonium hidden away in the studio, and said, "Oh, this'd be a nice color on it."[3] Recorded on the second track, Paul, rather than John, probably played the harmonium. On the third track, Paul had the lead vocal, which was doubled-tracked, as was John's backing vocal in the middle eight. Finally, on the last track, we clearly hear John in a second harmonium part. The first mono mix was made on October 28 for a television show, *The Music of Lennon and McCartney*. However, when the Beatles heard the mix the next day, they decided to overdub more vocals by superposition. After two additional hours of recording vocals, the mono mix was finalized. As with "Day Tripper," Pete Bown redid the stereo mix on November 10, 1966, for the British compilation album, *A Collection of Beatles Oldies*.

Technical Details

It was the first time the Beatles used the harmonium. This instrument, found in a corner at Abbey Road, appears in various Beatles' songs, such as "Being for the Benefit of Mr. Kite." Today, this harmonium is in Paul's home studio.

1. Miles, *Paul McCartney*.
2. Ibid.
3. Ibid.

1966

REVO

Taxman
Eleanor Rigby
I'm Only Sleeping
Love You To
Here, There and Everywhere
Yellow Submarine
She Said She Said
Good Day Sunshine
And Your Bird Can Sing
For No One
Doctor Robert
I Want to Tell You
Got to Get You into My Life
Tomorrow Never Knows

ALBUM
RELEASED

Great Britain: August 5, 1966 / No. 1 for 7 weeks
United States: December 6, 1966 / No. 1 for 6 weeks;
June 20, 1966 (*Yesterday and Today*) / No. 1 for 5 weeks

Revolver:
The Metamorphosis

At the end of 1965, the Beatles wanted to undertake new projects: they planned on making a third movie, a new version of Richard Condon's *A Talent for Loving*. Their worldwide success was a fait accompli. All their records were at the top of the charts. On December 3, they started a final British tour. On January 21, George married Pattie Boyd; on March 4, John was interviewed by Maureen Cleave and got certain Catholic American circles angry; finally, on March 25, the four musicians posed as butchers for the famous cover of the American album *Butcher Cover*, a future collectors' item.

On April 6, 1966, the Beatles were back at Abbey Road. The first song they recorded was the extraordinary hit "Tomorrow Never Knows" by John. This song heralded the birth of a new era. It began what were called the Beatles' "studio years." With the help of Geoff Emerick, the sound engineer who at barely twenty years old had recently replaced Norman Smith, they invented unheard-of sound arrangements. Emerick was the witness, as were George Martin and the whole team, of the creation of a new musical language that was at once original, avant-garde, and popular. John went through an inner change and leapt into a dream world that was intimately connected with hallucinogens. He stated later, in 1972: "*Rubber Soul* was the pot album, and *Revolver* was the acid"[1] ("I'm Only Sleeping," "She Said She Said"); Paul displayed excellent skills at creating melodies ("Here, There and Everywhere"; "For No One"); George wrote three songs on the album, including "Love You To," that expressed his love for Indian culture; and finally, Ringo glorified the life of submarine sailors with "Yellow Submarine."

The Beatles were on a quest for new ideas and different sounds, to the point of seriously considering

1. *The Beatles Anthology.*

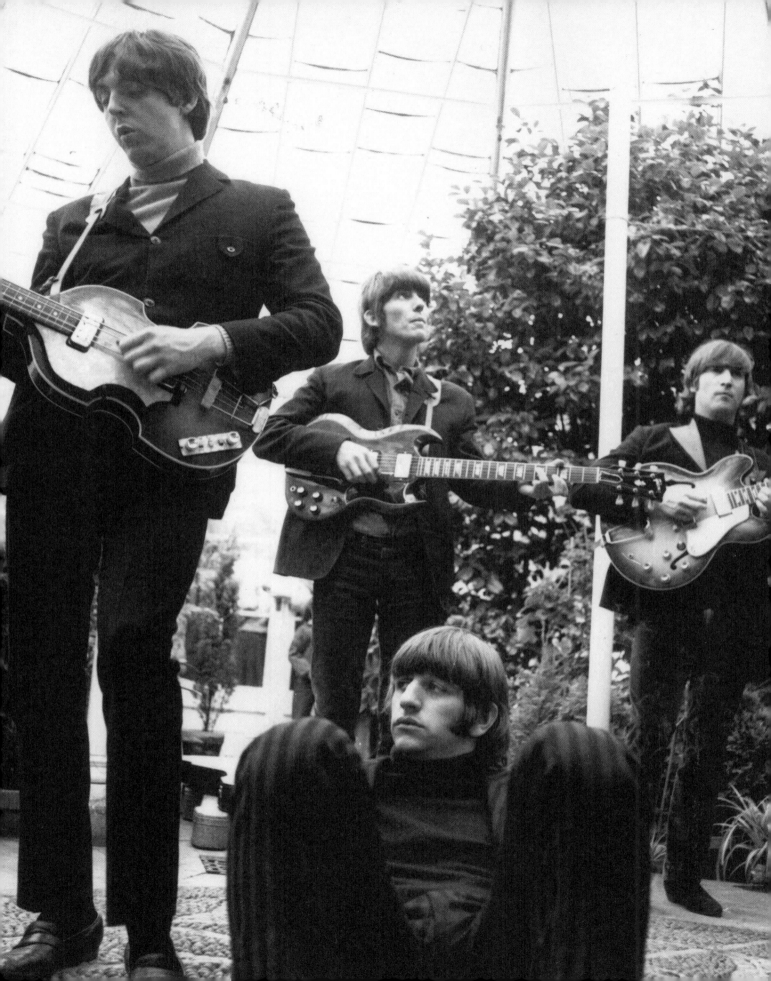

A faithful friend, Mal Evans, the jack-of-all-trades and mascot of the Beatles, unfortunately was shot to death in 1976.

"Revolving" the Vinyl

Abracadabra, Four Sides of the Eternal Triangle, and After Geography were a few of the titles suggested for their seventh album. But on June 24, in a Munich hotel room, they agreed on Revolver, a subtle reference to vinyl records revolving on record players.

recording in Memphis. But Abbey Road was where they produced *Revolver*, in a period of three hundred studio hours. Spending that amount of time on an album was unheard of at the time. When Revolver came out, its impact was tremendous, on the public and in artistic circles. The Beatles began to be taken seriously. From this point onwards, their music was no longer just pop songs.

In 1965, Klaus Voormann, a Hamburg graphics student who had befriended the Beatles a few years earlier, received a call from John: "How would you like to design the cover of our next album?" Surprised at first, he agreed and quickly found the main theme of the cover: for him, the Beatles' image was hair, lots of hair; and to stand out from the colorful fashion of those days, he chose black and white. The Beatles were pleased with Voormann's work. He was given a Grammy Award in 1967 for the best record cover for 1966. Although *Revolver* only paid him £50 [$75 U.S.] his name has remained forever in the hall of fame of Beatlemania. The Beatles solicited him nearly thirty years later for the cover of *The Beatles Anthology*.

Technical Details

Influenced by the sound of American records, the Beatles experimented in the studio: extreme equalizations (EQ), tapes played backwards, voices channeled through a Leslie cabinet, artificial double tracking (ADT), changes in tape speed, tape loops, etc.—the innovations were endless and went beyond established recording norms. One big change was that they could finally record with headphones!

The Instruments

In the spring of 1966, John and George each decided to do what Paul had done a year earlier, and purchased a Casino Epiphone. John was especially pleased with it, to the point that it remained his favorite guitar until the last Beatles record. George also acquired an SG Standard Gibson that he used until 1968. Finally, Fender Showman amplifiers appeared in the studio. As for the rest, the hardware remained identical to what they used in 1965.

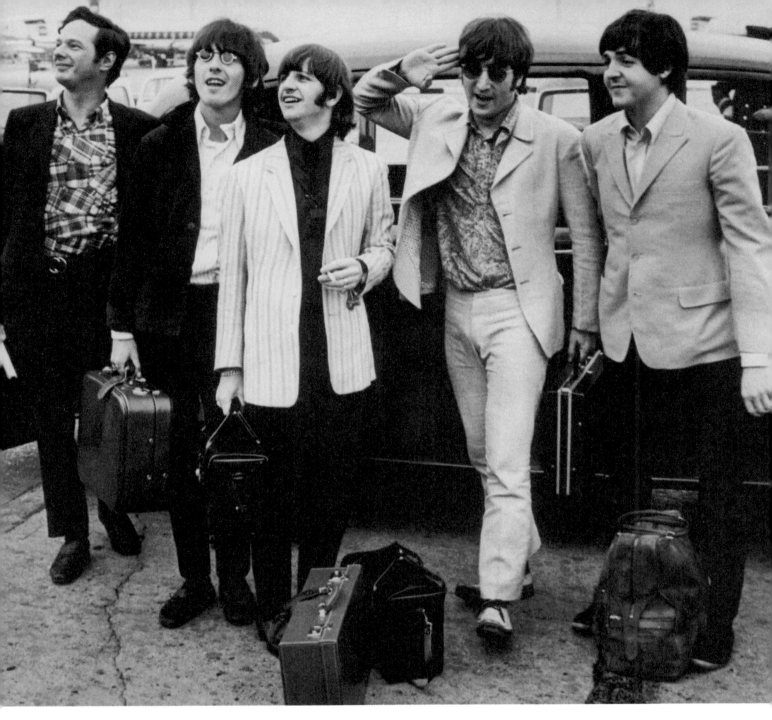

On July 8, 1966, the Beatles and Brian Epstein returned from their world tour through Europe and Asia. This was the last tour for the group, and it was immortalized by the lens of Robert Whitaker. Following double page: George, John, and Paul backstage during the June 26, 1966, concert at Ernst Merck Halle in Hamburg, the city where they began.

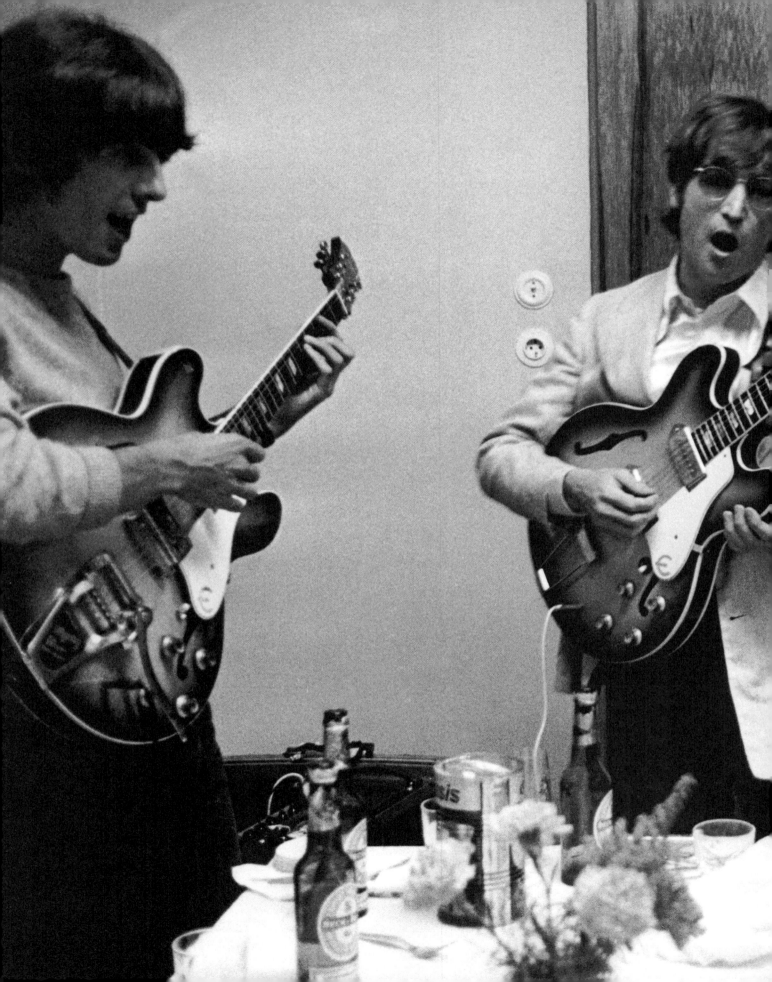

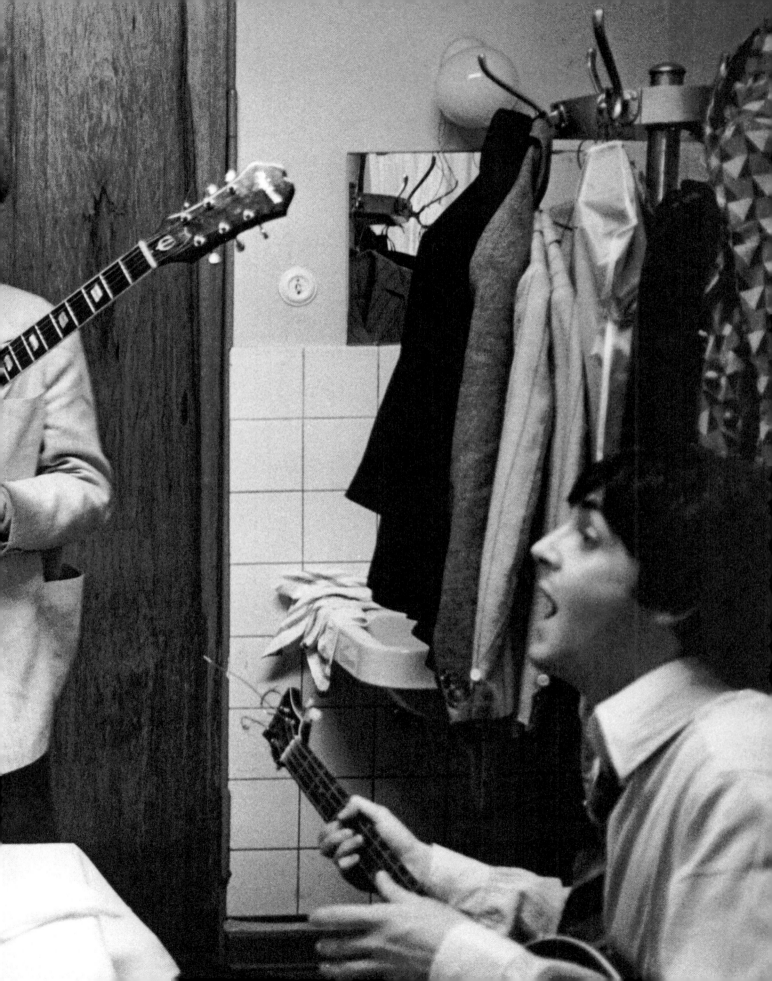

Taxman

George Harrison / 2:37

MUSICIANS
George: vocal, rhythm guitar
John: backing vocal
Paul: bass, lead guitar, backing vocal
Ringo: drums, tambourine, cowbell

RECORDED
Abbey Road: April 20–22, 1966 (Studio Two) / May 16, 1966 (Studio Two)

NUMBER OF TAKES: 12

MIXING
Abbey Road: April 27, 1966 (Studio Three) / May 16, 1966 (Studio Two) / June 21 (?), 1966 (Studio Three)

TECHNICAL TEAM
Producer: George Martin
Sound Engineer: Geoff Emerick
Assistant Engineer: Phil McDonald

Genesis

George, who from this point on made a lot of money, realized that taxes took a large portion of his income. At that time, income tax in Great Britain was exorbitant: over 90 percent. John also responded the same way in a 1969 interview: "'Taxman' was an anti-establishment tax song, where we said, 'If you walk the street, they'll tax your feet.'" George admitted that "Taxman" was no doubt the most autobiographical song of his Beatles period. John helped him write it. Said John: "He came to me because he couldn't go to Paul, because Paul wouldn't have helped him at that period. I didn't want to do it. I thought, Oh, no, don't tell me I have to work on George's stuff. It's enough doing my own and Paul's. But because I loved him and I didn't want to hurt him. [I] said OK."[1] In the choruses, George alluded to Mr. Wilson and Mr. Heath. These allusions referred to Harold Wilson, the Labor prime minister, and Edward Heath, the leader of the Conservative Party. They had the dubious honor of being the first public figures to be mentioned on a record by the Fab Four.

Production

On April 21, the Beatles who had dropped the first two takes of the night, redid everything all over again. The basic track was recorded with George on rhythm guitar, Paul on bass, and Ringo on drums. The bass/drums duet was especially well done, and the eleventh take was the best. George then doubled his vocal with the backing vocals of John and Paul, who repeated, *Anybody got a bit of money?* (also doubled). At the same time, Ringo added tambourines. George was now looking for a guitar solo. Geoff Emerick remembered waiting for it for many hours. Paul said later, "George let me try the solo, because I had an idea. . . .

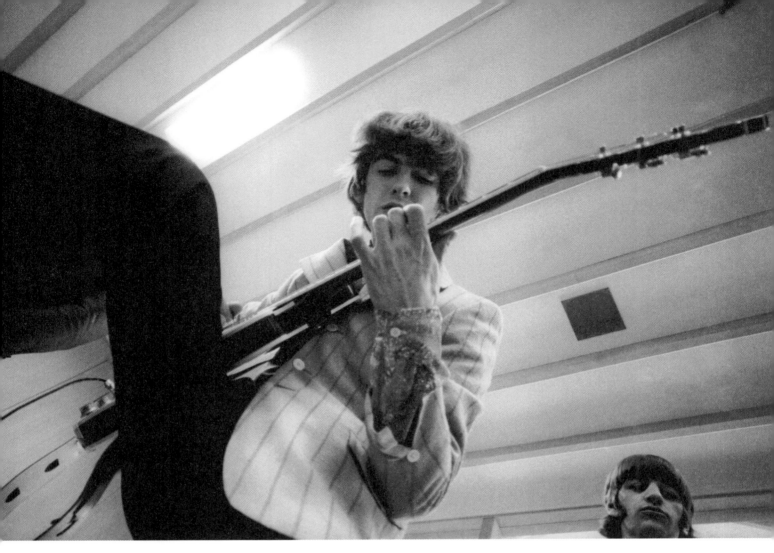

George rehearsing a few riffs before going onstage at the Nippon Budokan, in Tokyo, on July 2, 1966.

As I showed him what I wanted, he said to me, 'Well, all you have to do is play it.'"[2] In 1987, George admitted in an interview, "I was pleased to have Paul play that bit on 'Taxman.' If you notice, he did a little Indian bit on it for me." But Emerick claimed that George did not take well to Paul's intrusion and even left the room while they recorded the solo. One thing was for sure: Paul performed an absolutely brilliant solo on his Casino Epiphone. The next day, the Beatles replaced *Anybody got a bit of money?* with *Ah, ah! Mr. Wilson/Mr. Heath*. Finally, Ringo added a cowbell. The intro with the countdown was edited at the beginning of the tape on May 16. The definitive mono and stereo mixes go back to June 16. Emerick was in charge of duplicating Paul's solo and adding it to the end of the song. "Taxman" was a great song opening for *Revolver*.

FOR BEATLES FANATICS

Some people claim that the "Taxman" solo was the same one as in "Tomorrow Never Knows," but edited backwards. This is simply not true: if you listen to this solo in reverse you will see.

1. Sheff, *The Playboy Interview with John Lennon & Yoko Ono.*
2. Ryan and Kehew, *Recording the Beatles.*

Eleanor Rigby

Lennon-McCartney / 2:04

SONGWRITER
Paul

MUSICIANS
Paul: vocal
John: backing vocal
George: backing vocal
Tony Gilbert: 1st violin
Sidney Sax, John Sharpe, Jürgen Hess: 2nd violins
Stephen Shingles, John Underwood: violas
Derek Simpson, Norman Jones: cellos

RECORDED
Abbey Road: April 28, 1966 (Studio Two) / April 29, 1966 (Studio Three) / June 6, 1966 (Studio Three)

NUMBER OF TAKES: 15

MIXING
Abbey Road: April 29, 1966 (Studio Three) / June 22, 1966 (Studio Three)

TECHNICAL TEAM
Producer: George Martin
Sound Engineer: Geoff Emerick
Assistant Engineers: Phil McDonald, Jerry Boys

RELEASED AS A SINGLE

"Eleanor Rigby" / "Yellow Submarine"
Great Britain: August 5, 1966 / No. 1 on August 11, 1966
United States: August 8, 1966 / No. 11 on September 10, 1966

Genesis

"Eleanor Rigby," a song written by Paul on the Asher family piano, was built around a chord in E minor. The first lyrics occurred spontaneously to Paul: . . . *picks up the rice in a church where a wedding has been.* Although he had the main idea, he struggled to find a name that would sound real for the person in the song. He thought of Ola Na Tungee, of Daisy Hawkins, but finally used the first name of the actress Eleanor Bron, who played the role of the priestess in *Help!* and the name of a shop called Rigby & Evens Ltd. near the Bristol Theater, where his fiancée was in a show. This would be Eleanor Rigby! Once this problem was solved, he hurried to John's place to finish the song. John was with Mal Evans and Neil Aspinall when Paul burst in and exclaimed, "Hey, you guys, finish up the lyrics."[1] John mentioned this episode in 1980: "I was insulted and hurt that Paul had just thrown it out in the air. He actually meant he wanted me to do it, and of course there isn't a line of theirs in the song because I finally went off to a room with Paul and we finished the song. But that's how . . . That's the kind of insensitivity he would have, which upset me in later years."[2] John claimed to have practically written all the lyrics except for the first couplet. Paul disagreed. Pete Shotton,[3] a friend of John's, also challenged this version of the story in his book, which was published in 1983, and even claimed he was the source of the name of Father McKenzie as well as the final idea for the song. He also maintained that Ringo wrote the sentence: *Darning*

1. Sheff, *The Playboy Interview with John Lennon & Yoko Ono.*
2. Ibid.
3. Pete Shotton and Nicholas Schaffner, *John Lennon in My Life* (New York: Stein and Day, 1983).
4. Lewisohn, *The Complete Beatles Recording Sessions.*

The statue in effigy of Eleanor Rigby, in the Beatles District in Liverpool, was dedicated to all lonely people on the planet.

his socks in the night. As for George, he also said he helped compose the text. Fortunately, it was the only song, along with "In My Life," about which John and Paul contradicted each other. For those who love anecdotes, there are tombstones in the Woolton cemetery, in Liverpool, bearing the name of Eleanor Rigby, and with the name of McKenzie. A funny coincidence . . .

Production

Paul accompanied himself on guitar the first time he sang "Eleanor Rigby" to George Martin. According to Geoff Emerick, Martin immediately suggested they use a doubled string quartet. Paul agreed after first being reluctant, but insisted on the same conditions as for "Yesterday": no vibrato and he wanted chords with "bite." Martin based his arrangement on Bernard Herrmann's score for the movie *Psycho*. On April 28, the day of the recording, eight musicians were present, including Tony Gilbert and Sidney Sax who had already played on "Yesterday." It took them fourteen takes to record a version that was satisfactory, as John and Paul watched in the control room.

One of the musicians, Stephen Shingles, was rather bitter about the session: "I got about £5 [$7.50 U.S.]. . ., and it made billions of pounds."[4] The results were superb: George Martin had every reason to be satisfied. The next day, Paul recorded his lead vocal, with John and George on the backing vocals. The tape recorder was slowed down slightly, so that the song sounded higher in pitch at normal speed. Three mixes were carried out. But on June 6, Paul decided to sing his lead part over again and delete the percussion. Martin proposed a second vocal line for the last chorus: Paul loved it. "Eleanor Rigby" was mixed in mono and stereo on June 6, the anniversary of the Beatles' first audition in 1962.

Technical Details

Geoff Emerick innovated by placing his mics close to the instruments in order to achieve the bite that Paul wanted. But the musicians were furious, because for them such a close recording was an abomination. Between each take, they kept backing their chairs away from the microphones, which forced Emerick to move them closer!

I'm Only Sleeping

Lennon-McCartney / 2:58

SONGWRITER
John

MUSICIANS
John: vocal, acoustic guitar
Paul: bass, backing vocal
George: lead guitar, backing vocal
Ringo: drums

RECORDED
Abbey Road: April 27 and 29, 1966 (Studio Three) / May 5, 1966 (Studio Three) / May 6, 1966 (Studio Two)

NUMBER OF TAKES: 13

MIXING
Abbey Road: May 6, 1966 (Studio Two) / May 12, 1966 (Studio Three) / May 20, 1966 (Studio One) / June 6, 1966 (Studio Three)

TECHNICAL TEAM
Producer: George Martin
Sound Engineer: Geoff Emerick
Assistant Engineers: Phil McDonald, Jerry Boys

FOR BEATLES FANATICS

There were a few glitches here: at 0:39, Paul played off-key on bass; at 0:57, the beginning of the backing vocals seem to have been deleted; at 2:01 someone yawned (Paul?); with the rhythm track slowed down, the sound is deeper than in reality.

Genesis

"I'm Only Sleeping" was one of the first really experimental songs by John, with a dragging and lethargic voice, an intimate quality, a dreamy atmosphere, surrealistic-sounding words . . . The culmination of this style was the extraordinary "Strawberry Fields Forever." Sleep is a recurrent theme for him: he wrote "I'm So Tired" on the *White Album* and protested against war with Yoko by means of the bed-in in 1969. Paul came often to wake him in the early afternoon for a work session, which gave him the idea for the song: *That's me dreaming my life away*,[1] he said, and Paul found this sentence cute: *I'm not being lazy, I'm only sleeping, I'm yawning, I'm meditating, I'm having a lay-in.*[2] This superb song by John was written and arranged in one session with Paul's help. It is funny that the Kinks produced "Sunny Afternoon" on June 3 in Great Britain, with a relatively similar theme.

Production

The Beatles set up the ideal atmosphere to record "I'm Only Sleeping": they started recording at 11:30 P.M. on April 27. On the CD *Anthology 2* you could hear the group rehearsing the song with a rather unusual instrument, a vibraphone (which they decided not to use). After eleven takes, the rhythm track was recorded. John was on acoustic guitar, Paul was on bass, and Ringo on drums. On April 29, John recorded his voice by overdubbing it. The rhythm track was slowed down and the lead voice was sped up. The results were a deeper rhythm section and a higher vocal (each varying by two semitones). On May 5, George decided to add a guitar solo. While he was practicing, the tape was accidentally read backwards. Paul exclaimed, "My God, that is fantastic! Can we do that for real?"[3] George decided to

record a solo played specifically so that it would be read backwards. There are two ways of recording backwards instruments—one easy, one difficult. The Beatles chose the latter alternative. In fact, they made it doubly difficult: George wanted to record it in two guitar parts, one ordinary, one a fuzz guitar superimposed on top of one another.[4] After a long session lasting nearly six hours, they recorded the solo. The next day, John, Paul, and George added their splendid backing vocals. Two other overdubs meant the number of takes was up to thirteen.

A first mono mix was carried out on May 6 and another one on May 12 for *Yesterday and Today*. The final mono and stereo mixes were done on May 20 and June 6. One last detail: the final mix was also sped up; the Beatles loved *varispeed*, an effect created by changing the speed of the tape deck.

1. Sheff, *The Playboy Interview with John Lennon & Yoko Ono*.
2. Miles, *Paul McCartney*.
3. Ibid.
4. Lewisohn, *The Complete Beatles Recording Sessions*.

Love You To

George Harrison / 2:58

MUSICIANS
George: vocal, sitar, guitars
Paul: bass, backing vocal (?)
Ringo: tambourine
Anil Bhagwat: tabla
Other Indian musicians (uncredited): sitar, tambura

RECORDED
Abbey Road: April 11, 1966 (Studio Two) / April 13, 1966 (Studio Three)

NUMBER OF TAKES: 7

MIXING
Abbey Road: April 11, 1966 (Studio Two) / April 13, 1966 (Studio Three) / May 16, 1966 (Studio Two) / June 21, 1966 (Studio Three)

TECHNICAL TEAM
Producer: George Martin
Sound Engineer: Geoff Emerick
Assistant Engineers: Phil McDonald, Richard Lush

Genesis

Geoff Emerick first used the name of "Granny Smith" as the working title of "Love You To" as an allusion to his favorite apples. This was the first time the Beatles inserted an Indian-flavored composition on a record. After discovering Ravi Shankar, George was enchanted. Paul said in 1966, "He met Ravi [Shankar] and said, 'I was knocked out by him!'—Just as a person. He's an incredible fellow. He's one of the greatest."[1] After trying the sitar on "Norwegian Wood," George got immersed in Indian music. "I wrote 'Love You To' on the sitar, because the sitar sounded so nice, . . . and that was the first time we used a tabla player."[2] Then he recruited Indian musicians, including tabla player Anil Bhagwat.

George's lyrics were based on Buddhist teachings about the relationship of people to their surroundings. Quite aware that he had to live in the material world, he began a spiritual quest that lasted until his final days. George could be proud because "Taxman" opened the album *Revolver* and "Love You To" came in fourth place. This was a sign that John and Paul were starting to recognize his creativity. But it was not until the last album that he was considered an equal.

Production

On April 11, George recorded the basic track: he sang while accompanying himself on his Gibson J-160 E with Paul on backing vocal. A first sitar was added and then a fuzz guitar (probably the Tone Bender with the loud pedal), a bass, and, finally, a tabla played by Anil Bhagwat, the only identified Indian musician on the song and the first musician, along with Alan Civil (see "For No One"), to have his name mentioned on a Beatles album cover. The next day, after having performed a tape

George Harrison taking a sitar lesson. George played the instrument on "Love You To."

reduction to free up some tracks, George added another voice, Paul added harmony (which was not kept) and Ringo added tambourines. The mono mix was done on May 16 and the stereo on June 21.

Technical Details

In order to record the tabla, Emerick used a similar technique to what he did with drums and brass: he mic'd the instrument as close as possible and strongly compressed the signal. The result was a very dynamic sound. This was against the strict regulations of EMI.

FOR BEATLES FANATICS

Although John said in those days that he found Indian music fantastic, he didn't participate in "Love You To."

1. *The Beatles Anthology.*
2. Ibid.

Here, There And Everywhere

Lennon-McCartney / 2:23

SONGWRITER
Paul

MUSICIANS
Paul: vocal, bass, rhythm guitar (?), finger-snaps
John: backing vocal, finger-snaps
George: lead guitar, backing vocal, finger-snaps
Ringo: drums, finger-snaps

RECORDED
Abbey Road: June 14, 16, and 17, 1966 (Studio Two)

NUMBER OF TAKES: 14

MIXING
Abbey Road: June 17 and 21, 1966 (Studio Three)

TECHNICAL TEAM
Producer: George Martin
Sound Engineer: Geoff Emerick
Assistant Engineer: Phil McDonald

FOR BEATLES FANATICS

The finger-snapping sounded too fast, just like Paul's voice (starting at 1:56). Besides, there is one beat missing at 1:59.

Genesis

In the midst of this plethora of effects—of inverted tapes, sound effects, and processing of all kinds—there appeared this sublime song of Paul's, stripped of all artifice and delicately simple. "Here, There and Everywhere" was one of his most beautiful compositions and remained one of his favorites as well as one of John's. As he arrived at Kenwood, John's residence, on a nice June day for a session of work with John, the master of the house was still sleeping. Paul sat down by the pool with his guitar. "I started strumming in E, and soon had a few chords, and I think by the time he'd woken up, I had pretty much written the song."[1] Even though Paul talked about an 80/20 collaboration, John, full of admiration, stated in 1980 that the song was entirely written by Paul, before adding, "I think . . ." It was a very structured song, with each line beginning with one of the words of the title. The first line began with *Here*, the second one with *There*, and the last one with

At Kenwood, by the side of John's pool, Paul found the chords for "Here, There and Everywhere."

Paul was the composer of "Here, There and Everywhere."

Everywhere. Some people believed that they tried to reproduce the mood of the gentle songs that John's mother Julia used to listen to, such as "Wedding Bells (Are Breaking up that Old Gang of Mine)," popularized by Gene Vincent in 1956. If that is the case, "Here, There and Everywhere" works very well. But the song clearly owes its origins to the great album *Pet Sounds* by the Beach Boys, which had a major influence on Paul. During a visit in London in May 1966, Bruce Johnston, the bass player for this American group, met John and Paul through Keith Moon (from The Who), to whom he gave a copy of their album. Paul was stunned by the musical level he discovered, especially the beauty of the backing vocals.

Production

The Beatles spent a lot of time on Paul's new song: it was recorded over a period of three days—June 14, 16, and 17. On June 14, four takes were required to lay down the rhythm track. Paul was on rhythm guitar, George was on lead guitar, and Ringo on drums. Paul

recorded a first voice, and then was joined by the sumptuous vocal parts of John and George, the harmonies arranged with the help of George Martin. But the next day, during a nearly nine-hour session, they really built the song. After the thirteenth take, Paul, John, and George sang new backing vocals that were overdubbed, and Paul recorded his bass part on a track set aside for him. Cymbals, a second lead guitar and finger-snapping were then added. When Paul finally added his vocal, he was inspired by Marianne Faithfull for the interpretation, and tried to copy the singer's tone (in "As Tears Go By"). The tape recorder was therefore slowed down so that, at normal speed, it gained half a tone. On June 17, he doubled his vocal. On that day, George added guitar chords with his volume pedal at the end of the song. The final mono and stereo mixes were done on June 21.

1. Miles, *Paul McCartney*.

Yellow Submarine

Lennon-McCartney / 2:37

SONGWRITER
Paul

MUSICIANS
Ringo: vocal, drums
John: backing vocal, acoustic guitar
Paul: bass, backing vocal
George: backing vocal, tambourine
Brian Jones, Mick Jagger, Marianne Faithfull, Pattie Boyd, Mal Evans, Neil Aspinall, John Skinner, Terry Condon, Alf Bicknell: backing vocals and sound effects

RECORDED
Abbey Road: May 26, 1966 (Studio Three) / June 1, 1966 (Studio Two)

NUMBER OF TAKES: 5

MIXING
Abbey Road: June 2–3, 1966 (Studio Two) / June 22, 1966 (Studio Three)

TECHNICAL TEAM
Producer: George Martin
Sound Engineer: Geoff Emerick
Assistant Engineers: Phil McDonald, Jerry Boys

RELEASED AS A SINGLE

"Eleanor Rigby" / "Yellow Submarine"
Great Britain: August 5, 1966 / No. 1 on August 11, 1966
United States: August 8, 1966 / No. 11 on September 10, 1966

Genesis

One night, as he was falling asleep in his little room at the Ashers' house, Paul had an idea for a children's song. "The color yellow came to me, and a submarine came to me."[1] He thought it would perfectly suit Ringo and he composed a melody with a rather simple vocal range. Apart from John, their musician friend Donovan helped out with the lyrics: *Sky of blue, and sea of green / In our yellow submarine.* "It was nothing really, but he liked it and it stayed in."[2] Ringo also participated with a slip of the tongue! Instead of saying, *every one of us has all he needs*, he sang, *every one of us has all we need.* This error was immediately accepted!

Production

On May 26, George Martin was not available because he had food poisoning. Judy, his secretary and future wife, was in charge of representing him. After a long rehearsal, the recordings started: John was on acoustic guitar, Paul on bass, Ringo on drums, and George on tambourines. The fourth take of the rhythm track was good. The singing was then provided by Ringo, accompanied by his comrades' backing vocals (which were overdubbed). The tape recorder was slowed down to slightly raise the pitch to normal speed. John decided then to repeat the lyrics of the third couplet in order to make it more dynamic. A few days later, Phil McDonald accidentally deleted the two first sentences (around 1:44). Martin and Emerick had to be clever in order not to incur John's anger . . . After a reduction on a second machine, two new tracks were available.

On June 1, George Martin returned. This second session degenerated into chaos. In order to create a suitable atmosphere, the Beatles had invited a few

A friend of the Beatles, folk singer Donovan, had the privilege of joining in to help write a few Beatles songs, including "Yellow Submarine."

friends and members of the staff: Brian Jones, Mick Jagger, Marianne Faithfull, Pattie Boyd, Mal Evans, Neil Aspinall, John Skinner, Terry Condon, and Alf Bicknell . . . Very soon, joints were going around. Everyone searched in the studio's reserve, called the trap room, to find a weird instrument in order to create sound effects: glasses, whistles, bells, sirens, chains . . . John chose to blow bubbles with a straw in a bucket. As he got inspired, he then asked Geoff Emerick to record his voice underwater! A microphone covered with a condom was plunged into a milk bottle full of water: they could not get the desired effect, so the idea was dropped (Ken Townsend remembered a plastic box being used instead of a condom). It was party time! You could hear Pattie Boyd screaming on the second line around 0:56. John and Paul imitated various voices and Mal Evans was wandering around the studio carrying

a bass drum, followed by all the participants in the party! After everyone had added side effects and backing vocals, George Martin, no doubt inspired by Paul, decided to add the solo of a brass band. There are two stories about this solo: Martin was certain there was a brass band playing; on the other hand, Emerick claimed it was taken from a record, cut and edited randomly. The goal was to avoid paying musicians and royalties. In the introduction, an imaginative poem by John was read by Ringo with marching feet in the background (actually the sound of shoveling coal!). The idea was dropped during the mono mix of June 3, but you can hear it on the re-edit from the 1996 single "Real Love." The stereo mix was done on June 22.

1. Miles, *Paul McCartney.*
2. Ibid.

She Said She Said

Lennon-McCartney / 2:34

SONGWRITER
John

MUSICIANS
John: vocal, rhythm guitar, organ
Paul: bass (?)
George: lead guitar, backing vocal, bass (?)
Ringo: drums

RECORDED
Abbey Road: June 21, 1966 (Studio Two)

NUMBER OF TAKES: 4

MIXING
Abbey Road: June 21, 1966 (Studio Two) / June 22, 1966 (Studio Three)

TECHNICAL TEAM
Producer: George Martin
Sound Engineer: Geoff Emerick
Assistant Engineers: Phil McDonald, Jerry Boys

Genesis

"She Said She Said" was the last song recorded for *Revolver*. Written by John at the last minute, it had remarkable power and sound, and somehow represented the very essence of the album. Writer Ian MacDonald stated that the record was Paul's creation, but what would *Revolver* be without "Tomorrow Never Knows," "Doctor Robert," "I'm Only Sleeping," or "She Said She Said"? John Lennon gave the psychedelic and innovative tone to the whole album; he was the one who surprised listeners with his dreamy atmosphere, his intimate and provocative lyrics. This does not disparage McCartney's great talent in any way because his musical intelligence was exceptional. But to say that one of the two musicians dominated the other would be an oversimplification. This was not to forget George's essential contribution, because his Indian sounds and philosophy gave the album its definitive aura.

The song was created around a rather bizarre incident: while the Beatles were beginning their new American tour in August 1965, they rented a house in Benedict Canyon in North Hollywood. During a party with the Byrds and Peter Fonda, the future Wyatt from the film *Easy Rider*, John, George, and Ringo (without Paul, who preferred to abstain) decided that their second LSD trip would be voluntary (because the first time, they had been given the drug without their knowledge) . . . While they were all tripping, Peter came up to John and told him, "I know what it's like to be dead." John, flying high, did not want to hear about it and wanted to enjoy the sunshine, the pretty girls, and the party. Peter insisted, "I know what it's like to be dead." Annoyed, John fled from this ominous person, "Don't tell me about it! I don't want to know what it's like to be dead!"[1] This "conversation" triggered the song. George stated that he helped John

After a discussion with actor Peter Fonda (above in a scene from the cult film *Easy Rider*), during a drug party in North Hollywood, John got the idea for "She Said She Said."

gather a few scattered elements and structure them into a song. The first version was very acoustic and was called "He Said." Only in the studio, at the end of the session, did John come up with its final title.

Production

"She Said She Said," recorded on June 21, had a rather irregular rhythmic signature that was pretty typical of John. After rehearsing it for the better part of the session, the group needed three takes to lay down the rhythm track. Although this was not specified on the recording files, Paul did not think he played on it. "I think we'd had a barney [a fight] or something and I said, 'Oh, fuck you!' and they said, 'Well, we'll do it.' I think George played bass."[2]

Paul no doubt participated in the first takes before leaving the session. This was too bad, because Ringo performed superbly on drums, one of his best performances, along the lines of "Rain." Compression added extra power to his playing, which made it one of the major highlights of the piece. The sound of the guitars was another hallmark of "She Said She Said"—George's playing, saturated with Indian sounds, mixing perfectly with John's arpeggios. "The guitars are great on it,"[3] John said in 1980. After having recorded his vocal (which was doubled and slightly sped up), supported by George's backing vocal, John added a part on the Hammond organ, and George then doubled his guitar work. The mixes were done at the end of the session. The final version was produced the next day.

1. Sheff, *The Playboy Interview with John Lennon & Yoko Ono.*
2. Miles, *Paul McCartney.*
3. Sheff, *The Playboy Interview with John Lennon & Yoko Ono.*

Good Day Sunshine

Lennon-McCartney / 2:07

SONGWRITER
Paul

MUSICIANS
Paul: vocal, bass (?), piano, hand claps
John: rhythm guitar (?), backing vocal, hand claps
George: bass (?), backing vocal, hand claps
Ringo: drums
George Martin: piano

RECORDED
Abbey Road: June 8–9, 1966 (Studio Two)

NUMBER OF TAKES: 3

MIXING
Abbey Road: June 9, 1966 (Studio Two) / June 22, 1966 (Studio Three)

TECHNICAL TEAM
Producer: George Martin
Sound Engineer: Geoff Emerick
Assistant Engineers: Richard Lush, Phil McDonald, Jerry Boys

Genesis

George had launched side A with "Taxman," whereas Paul opened side B with "Good Day Sunshine." This superb song, which was one of the favorites of Leonard Bernstein, was inspired by "Daydream" by the Lovin' Spoonful, a song that did really well on the charts in the spring of 1966. "'Good Day Sunshine' was me trying to write something similar to 'Daydream.' John and I wrote it together at Kenwood, but it was basically mine, and he helped me with it."[1] Although the Beatles denied it, the lyrics were ambiguous: *I feel good in a special way* implies other pleasures apart from sunbathing, especially after they had written "Got to Get You into My Life," an ode to cannabis. "Good Day Sunshine" was certainly an expression of optimism and sunlight.

Production

On June 8, the Beatles rehearsed this song by Paul. Its working title was "A Good Day's Sunshine." After a rather long discussion, they settled down to produce the rhythm track. Paul was on piano (the Steinway B Grand Piano), Ringo on drums, and, no doubt, John was on rhythm guitar and George on bass. Although three takes were recorded, the first one was used for the overdub. In order to make the voices more dynamic, the sung parts were recorded with a slightly slowed-down tape recorder. Paul sang lead, and John and George the backing vocals. The very next day, Ringo added another bass drum, a snare drum, and cymbals. George Martin decided to record a piano solo for the song's middle eight and, as he did for the vocals, he slowed down the tape recorder: at normal speed it sounded honky tonk. Then there were hand claps and new backing vocals for the end of the song. As they did in "And I Love Her," the song was raised half a tone for this

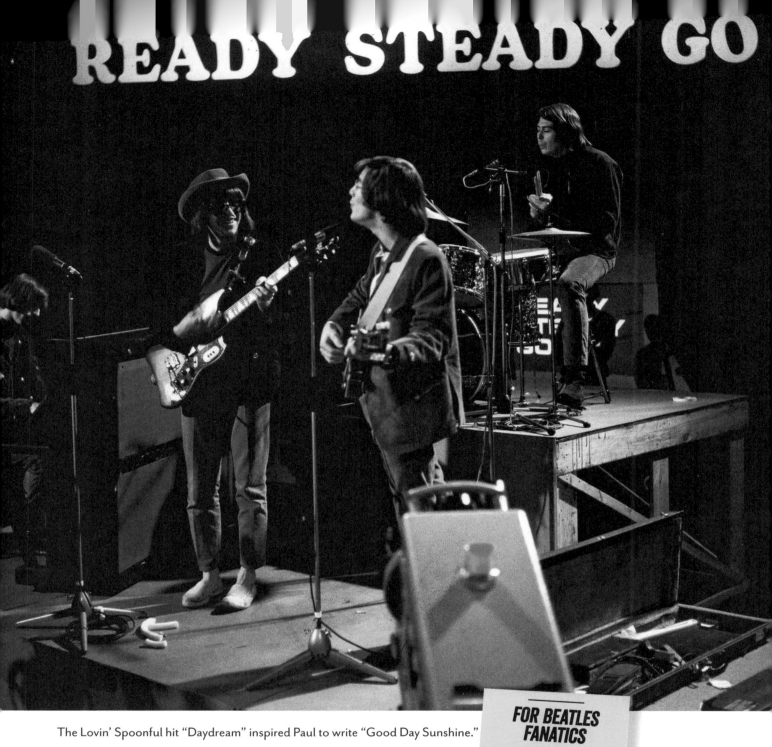

READY STEADY GO

The Lovin' Spoonful hit "Daydream" inspired Paul to write "Good Day Sunshine."

part. This gave the vocal a different dynamic, and they concluded the song in a remarkable way. The mono mix was carried out the same day and the stereo mix on June 22. The final title, "Good Day Sunshine," was then agreed on.

1. Miles, *Paul McCartney.*

And Your Bird Can Sing

Lennon-McCartney / 1:58

SONGWRITER
John

MUSICIANS
John: vocal, rhythm guitar, hand claps, tambourine (?)
Paul: bass, lead guitar, backing vocal, hand claps
George: lead guitar, backing vocal, hand claps
Ringo: drums, tambourine (?), hand claps

RECORDED
Abbey Road: April 20 and 26, 1966 (Studio Two)

NUMBER OF TAKES: 13

MIXING
Abbey Road: April 20, 1966 (Studio Two) / April 27, 1966 and May 12, 1966 (Studio Three) / May 20, 1966 (Studio One) / June 6, 1966 (Studio Three) / June 8, 1966 (Studio Two) [editing only]

TECHNICAL TEAM
Producer: George Martin
Sound Engineer: Geoff Emerick
Assistant Engineers: Phil McDonald, Jerry Boys

Genesis

"And Your Bird Can Sing" was a song by John with a rather mysterious title and lyrics: "Another of my throwaways,"[1] he said in 1972. There was much speculation about this *bird*—a bird in British slang can mean either a "whore" or a "girlfriend." The names of Mick Jagger and Marianne Faithfull were mentioned, as were those of Paul and Jane Asher. It was more likely that John was in the middle of a psychedelic delirium when he wrote it. Besides, on *Anthology 2*, you could hear him crack up laughing with Paul during the recording. Surely an effect of Mary Jane. In a 1995 interview, Paul stated about this episode, "One of my favorites on the *Anthology* is, 'And Your Bird Can Sing,' which is a nice song, . . . Sounds great just hearing us lose it on a take."[2]

Production

The rhythm track was recorded on April 20 after two takes. During this second take, John and Paul giggled uncontrollably. And John sang, while laughing, *When your bike is broken*, instead of *When your bird is broken*. Although five mixes were done by the end of this session, the song was entirely redone six days later. This was sad, because with a break toward the end and whistles on the coda, this first version would probably have been better than the one used on the record.

On April 26, thirteen takes were carried out, but the tenth one was kept for the overdubs. John was on rhythm guitar, George on lead, Paul on bass (giving an excellent performance), and Ringo on drums. Ringo added, apart from tambourines—(or was it John?), a drum part with cymbals at the bridges. John then recorded his voice, supported by Paul and George. But what distinguished this song was the guitar solo that was the envy of many novice guitar players. In fact, it

John practicing on harmonica, although he did not use it in any songs on *Revolver.*

was a guitar duo, played by George and Paul on their Casino Epiphones. In an interview with *Mojo* magazine in 2011, Paul confided in Michael Simmons, "George and I would work out a melody line, then I would work out the harmony to it. . . . That's me and George both playing electric guitars. It's just the two of us, live. It's a lot easier to do with two people, believe me."[3] The mono mix of May 12 for the American public for *Yesterday and Today* was in fact the edit of take 10 and of the end of take 6. The stereo mix was on May 20 and the mono for *Revolver* on June 6, with an edit of mixes 9 and 10 done on June 8. Despite the opinion of the composer, it was an excellent song that made the guitars sound great.

1. *The Beatles Anthology.*
2. Press kit, *The Beatles Anthology.*
3. Michael Simmons, "Macca on George," *Mojo* magazine (September 28, 2011).

For No One

Lennon-McCartney / 1:59

SONGWRITER
Paul

MUSICIANS
Paul: vocal, bass, piano, clavichord
Ringo: drums, tambourine, maracas
Alan Civil: French horn

RECORDED
Abbey Road: May 9 and 16, 1966 (Studio Two) /
May 19, 1966 (Studio Three)

NUMBER OF TAKES: 14

MIXING
Abbey Road: June 21, 1966 (Studio Three)

TECHNICAL TEAM
Producer: George Martin
Sound Engineer: Geoff Emerick
Assistant Engineer: Phil McDonald

Genesis

In March 1966, Paul went skiing with Jane in Klosters-Serneus, in Switzerland. In the cottage they rented, he isolated himself in the washroom—probably after a fight—to write a song about the end of a love affair: "Why Did It Die," the working title of "For No One." The lyrics, which were once again inspired by his difficult relationship with Jane, expressed his disillusionment. Later on, he said to Barry Miles, "I don't have an easy relationship with women, I never have. I talk too much truth."[2] A sad balance sheet of a failed affair, "For No One" was also one of his best songs. John also confirmed this. He said several times that "For No One" was one of his favorite songs, a "superb work."

Production

On May 9, ten takes were required to record the rhythm track. Paul was on piano and Ringo on drums. Paul then sat down at a clavichord, the ancestor of the piano (rented by George Martin through the AIR company): "It was a very strange instrument to record, and Paul played it."[3] Ringo added a drum part with a snare drum and maracas. Paul then recorded his voice, on May 16, on the tape recorder that had been slightly slowed down to gain over half a tone at normal speed. Martin and Emerick proceeded to reduce the whole song on another machine, while deleting the drums. Paul wanted the solo part to be played by a French horn, which was an instrument he had loved since childhood. Dennis Brain, a famous musician, was hired, but died in a car accident before the session. Alan Civil was then chosen to replace him. In the studio, Martin noted the solo that Paul was humming for him. He pointed out to him that one of the notes went beyond the register

In March 1966, Jane Asher going to Switzerland, where Paul wrote "For No One."

of the French horn. Paul insisted on trying it anyway. When Alan Civil examined the part, he noticed the same thing. "George, you've written a D."[4] George Martin and Paul did not comment, so Alan understood that they expected him to do something extraordinary. After many tries, he finally got the note out. Paul, who was not really paying attention to his performance, asked him to do another take. But when Alan got annoyed, Paul gave up. Along with Anil Bhagwat, he was the first freelance musician to be mentioned on a Beatles record cover. Paul and Ringo finished the session by recording a bass and a tambourine part, respectively. The final mono and stereo mixes were completed on June 21. Neither John nor George participated in the recording.

Technical Details
Contrary to Norman Smith, Geoff Emerick used very little reverb on *Revolver*. Certain songs benefited from this, for example "For No One."

1. Lewisohn, *The Complete Beatles Recording Sessions*.
2. Ibid.
3. *The Beatles Anthology*.
4. Miles, *Paul McCartney*.

Doctor Robert

Lennon-McCartney / 2:13

SONGWRITER
John

MUSICIANS
John: vocal, rhythm guitar, harmonium
Paul: bass, piano, backing vocal
George: lead guitar, backing vocal, maracas
Ringo: drums

RECORDED
Abbey Road: April 17 and 19, 1966 (Studio Two)

NUMBER OF TAKES: 7

MIXING
Abbey Road: April 19, 1966 (Studio Two) / May 12, 1966 (Studio Three) / May 20, 1966 (Studio One) / June 21, 1966 (Studio Three)

TECHNICAL TEAM
Producer: George Martin
Sound Engineer: Geoff Emerick
Assistant Engineers: Phil McDonald, Jerry Boys

Genesis

The identity of Dr. Robert was the subject of many hypotheses. Some thought it was Robert Fraser, who owned a gallery; others Dr. Charles Roberts, a doctor who treated Andy Warhol; still others Dr. John Riley, who had turned the Beatles on to LSD. It was more likely Dr. Robert Freeman, the owner of a New York clinic whose specialty was a cocktail of vitamin B12 with massive doses of amphetamines that he prescribed for celebrities in the Big Apple. In 1967 Paul said, "We'd hear people say, . . . this fellow who cured everyone of everything with all these pills . . . is like a joke. He just kept New York high. That's what 'Doctor Robert' is all about."[1] As for John, he confided that he wrote it about drugs and pills: "It was about myself: I was the one that carried all the pills on tour."[2] Pete Shotton remembers, "When John first played me the acetate of 'Dr. Robert,' he seemed beside himself with glee over the prospect of millions of record buyers innocently singing along."[3]

Production

On Sunday, April 17, the Beatles were in Studio Two at Abbey Road. They spent this day recording the rhythm track of "Doctor Robert." Everyone played his usual instrument. The sound overall sounded like rock, and slightly "garage band." The superb guitar parts by George and John were reminiscent of the Byrds or the Kinks. The seventh take was the best. George then added maracas and on the bridge (which contrasts

1. *The Beatles Anthology.*
2. Sheff, *The Playboy Interview with John Lennon & Yoko Ono.*
3. Shotton and Schaffner, *John Lennon in My Life.*

The Beatles loved mysteries. Who was the real *Doctor Robert* who put a twinkle in John's eye?

with the rest of the song), John was on harmonium and Paul on piano (but the latter is hardly audible in the mix). This type of rhythmic break was used once again in 1967 in "Your Mother Should Know." Two days later, they recorded the vocal parts. John sang lead, supported by the backing vocal of Paul, and then George, who joined them at the bridge. A first mono mix was carried out the very same day. On May 12, other mixes followed and the song was reduced from 2:56 to 2:13. The mix was meant for the American LP *Yesterday and Today.* On May 20, the stereo mixes were made for the American and British versions. It was noticeable that John's voice was highly processed: on the left, you could hear the ADT signal and on the right, his original voice. Finally, on June 21, the definitive mono mix was done.

FOR BEATLES ADDICTS

Whereas the Beatles described the uppers prescribed by the good "Doctor Robert," the Rolling Stones preferred barbiturates and in early July released "Mother's Little Helper."

I Want To Tell You

George Harrison / 2:26

MUSICIANS
George: vocal, lead guitar, hand claps
John: backing vocal, tambourine (?), hand claps
Paul: bass, piano, backing vocal, hand claps
Ringo: drums, maracas (?), hand claps

RECORDED
Abbey Road: June 2–3, 1966 (Studio Two)

NUMBER OF TAKES: 5

MIXING
Abbey Road: June 3, 1966 (Studio Two) / June 21, 1966 (Studio Three)

TECHNICAL TEAM
Producer: George Martin
Sound Engineer: Geoff Emerick
Assistant Engineer: Phil McDonald

Genesis
"I Want to Tell You" was George's third song on *Revolver*. It was the first and last time he placed so many songs on a single album (the *White Album* includes four, two per record). Even if John, Paul, or George Martin did not consider him as an equal, he gradually asserted himself. The influence of Indian philosophy and culture on him was becoming increasingly obvious. He wrote later in his autobiography, "'I Want to Tell You' is about the avalanche of thoughts that are so hard to write down and say or transmit."[1] It was also this difficulty that gave him the look of a "calm and relaxed Beatle." As usual, George struggled to find a title for his song. Geoff Emerick, who had already suggested "Granny Smith" as the title for "Love You To," jokingly proposed "Laxton's Superb" (another variety of apples). George used this title until the next day, when he renamed the song "I Don't Know," as a reply to Martin, who was asking him for the title. At the time of the mix, he finally chose the first line of the lyrics.

Production
On June 2, the Beatles recorded five takes of "I Want to Tell You." George was on lead guitar, Paul on piano, and Ringo on drums. It seems that John did not play guitar. George chose the third take as the basis for the overdubs. He overdubbed his lead vocal, accompanied by John and Paul's backing vocals. Paul incorporateed Indian intonations in the song's coda, no doubt to please his colleague. Then there were other overdubs: a (dissonant) piano, maracas, and tambourines. After

1. Harrison, *I Me Mine.*

George Harrison assumed more and more importance during the sessions of *Revolver*. Next double page: George and Paul offstage in the Nippon Budokan on June 30, 1965, before entering the stage for the first of their five concerts in this Olympic stadium.

a reduction, the Beatles added hand claps; the only thing missing was Paul's bass. It was recorded the very next day and the song was complete. This was a rather quick production at this stage of their career. "I Want to Tell You" was not George's best song, and definitely not as good as "Taxman." Nevertheless, it was well done. The mono mix was done on June 3 and the stereo on June 21.

FOR BEATLES FANATICS

In 1979, Ted Nugent did a superb remake of this song, which tends to show that with more arrangements and more work, George's song could have been much better.

Got To Get You Into My Life

Lennon-McCartney / 2:27

SONGWRITER
Paul

MUSICIANS
Paul: vocal, bass
John: lead guitar, organ
George: lead guitar, tambourine
Ringo: drums
Eddie Thornton, Ian Hamer, Les Condon: trumpet
Peter Coe, Alan Branscombe: tenor saxophone

RECORDED
Abbey Road: April 7, 1966 (Studio Three) / April 8 and 11, 1966 (Studio Two) / May 18, 1966 and June 17, 1966 (Studio Two)

NUMBER OF TAKES: 9

MIXING
Abbey Road: April 25, 1966 (Room 65) / May 18, 1966 and June 17, 1966 (Studio Two) / June 20, 1966 (Studio One) / June 22, 1966 (Studio Three)

TECHNICAL TEAM
Producer: George Martin
Sound Engineer: Geoff Emerick
Assistant Engineers: Phil McDonald, Jerry Boys

FOR BEATLES FANATICS

Even after they were replaced by the brass, the fuzz guitars could easily be heard in the left speaker of the stereo mix, each time the brass stepped in.

Genesis

As strange as this seems, "Got to Get You into My Life" was an ode to cannabis. Paul, who wrote the song, simply wanted to sing its praises, because he claimed it helped him withstand the stress of life without the disadvantages of alcohol. "In my mind, I've always likened it to the peace pipe of the Indians."[1] At first glance, the words sounded rather harmless, like the lyrics of any love song. However, sweet little Paul, who barely four years before was singing "Love Me Do," let go and delivered here a text with a hidden meaning. John especially liked it. ". . . the lyrics are good and I didn't write them. You see? When I say that he could write lyrics if he took the effort, here's an example."[2] A year later, Paul would deal with the same subject in "Fixing a Hole," on *Sgt. Pepper*.

Production

The Beatles went to the studio on April 7 to record "Got to Get You into My Life," the second song recorded for *Revolver*. Five takes were required to record the first version of the song. This version was radically different than the final one: an intro on organ, acoustic guitar, backing vocals, lyrics in different parts (*see Anthology 2*). They returned to it the next day and, on April 11, added fuzz guitars. On April 25, a rough mono remix was made for the purpose of cutting acetates for listening purposes.

The group tried the song again over a month later, on May 18. Paul decided to replace the fuzz guitars with brass. Two members of Georgie Fame & the Blue Flames were recruited (Eddie Thornton and Peter Coe), as well as three session jazz musicians (Ian Hamer, Les Condon, and Alan Branscombe). Paul was on piano and, at his request, George Martin explained

Paul McCartney during a press conference in the United States on August 25, 1966. "Got to Get You into My Life" is a song with a "Motown sound."

to the musicians what he expected from them. Geoff Emerick positioned the microphones inside the bells of the instruments. With a limiter up to the maximum, the sound was blaring but without distortion. The brass was recorded on two tracks, instead of the fuzz guitars and the voices. A new rhythm guitar was added. After a reduction, Paul sang lead once again (and doubled his voice) on track 3, while John played the organ on the coda and George played tambourine. Two mixes were carried out for listening purposes. Finally, on June 17, John and George recorded a guitar solo with strong vibrato. As the guitars were inserted on track 3, the

tambourine was suddenly cut off (at 1:44) and the doubling of Paul's voice disappeared (starting at 1:56). On June 20, Emerick reinforced the brass part by copying it (with a slight delay) by overdubbing, starting at remix 7, and the final mono mix was reached this way. The stereo was done on June 22. "Got to Get You into My Life" is a vibrant tribute to the "Tamla Motown" sound, specifically Stevie Wonder's "Uptight."

1. Miles, *Paul McCartney.*
2. Sheff, *The Playboy Interview with John Lennon & Yoko Ono.*

Tomorrow Never Knows

Lennon-McCartney / 2:57

SONGWRITER
John

MUSICIANS
John: vocal
Paul: bass, organ (?), piano, lead guitar (?)
George: lead guitar (?), tambura
Ringo: drums, tambourine

RECORDED
Abbey Road: April 6–7, 1966 (Studio Three) / April 22, 1966 (Studio Two)

NUMBER OF TAKES: 3

MIXING
Abbey Road: April 27, 1966 (Studio Three) / June 6 and 22, 1966 (Studio Three)

TECHNICAL TEAM
Producer: George Martin
Sound Engineer: Geoff Emerick
Assistant Engineers: Phil McDonald, Jerry Boys

Genesis

"[John] said, I wanted my voice to sound like the Dalai Lama chanting from a hilltop. Can you do something for me?" That was more or less the request that John addressed to George Martin. He had just written a new song, with a style inspired by Indian music, light-years away from "I Want to Hold Your Hand." He borrowed the theme from *The Psychedelic Experience*, a psychedelic adaptation of the *Tibetan Book of the Dead*, which had been written by the famous Dr. Timothy Leary: "Turn off your mind, relax, and float downstream." John said in 1972, "I did it just like he said in the book, and then I wrote 'Tomorrow Never Knows,' which was almost the first acid song."[1]

John presented his composition, built around a single chord in C, during a meeting at the London house of Brian Epstein. Paul found the concept brilliant, and George Martin, who was a bit surprised, found it very interesting. But when he heard Lennon in the studio, trying to sound like the Dalai Lama, Martin was dumbfounded. "It's a bit expensive going to Tibet. Can we make do with it here?"[2] The studio would have to be enough. This was a good thing, because afterwards, John realized he had in mind thousands of monks, chanting.

In order to lighten up the semi-philosophical, semi-esoteric lyrics, John chose for the title another malapropism by Ringo: "Tomorrow Never Knows." This was the title, representing the entire album, that they showed to Klaus Voormann, who was in charge of designing the record cover, to make him capture the essence of *Revolver*. "What was coming out of the loudspeakers into my ears, even in an incomplete state, was absolutely new . . . I perceived the beginning of a new musical era,"[3] he wrote in 2006. The Beatles brought

1. *The Beatles Anthology.*
2. Ibid.
3. Klaus Voormann, *Warum Spielst Du Imagine Nicht Auf Dem Weissen Klavier, John? (Why Don't You Play "Imagine" on the White Piano, John?: Memories of the Beatles and Many Other Friends)* (Munich: Wilhelm Heyne Verlag, 2006).
4. Lewisohn, *The Complete Beatles Recording Sessions.*
5. *The Beatles Anthology.*

John Lennon, photographed with his famous orange sunglasses. He was at the peak of his art when he composed "Tomorrow Never Knows."

For "Tomorrow Never Knows," John Lennon was inspired by *The Psychedelic Experience*, the book of LSD apostle Timothy Leary, which was adapted from the *Tibetan Book of the Dead*.

rock music to new heights: they prefigured their future masterpiece, *Sgt. Pepper*.

Production

Under the working title "Mark I," John brought his colleagues toward unheard-of musical horizons. The first session took place on April 6. "Tomorrow Never Knows" was the first song to be recorded since "Girl" on November 11, 1965. The first take consisted of Ringo's drums, Paul's bass, and John's vocal that was turned into a loop. Slowed down and drowned in the reverb, the effect was enticing. Meanwhile, George Martin was talking to Geoff Emerick (this was his very first recording session) about Lennon's "Dalai Lama" request. Emerick thought of passing John's vocal through a Leslie speaker, something that had never been done before. When the Beatles recorded this first take, their minds were totally blown away by the effect Emerick achieved. Emerick had just won them over. But the Beatles decided to do everything over again. The third take served as the basis for additional overdubs. Emerick then decided to break the rules of EMI and experiment with a new way to record the drums.

"I moved the bass drum microphone much closer to the drum than had been done before. There's an early picture of the Beatles wearing a woolen jumper with four necks. I stuffed that inside the drum to deaden the sound. Then we put the sound through Fairchild 660 valve limiters and compressors."[4] The results were magical: the sound was huge! Ringo was astonished and Emerick secured the job of Beatles' engineer.

At the end of the day, the rhythm track and John's vocal were recorded. Paul, who was a fan of contemporary music, solicited everyone to bring back loops. He worked on it all night and through to the next morning, bringing in a little plastic bag with about twenty tape loops. George and Ringo contributed to this as well. George said, "I don't recall what was on my loop; I think it was a grandfather clock."[5] Five loops were chosen, and five technicians were then assigned to various tape recorders throughout the entire Abbey Road complex to monitor the playback of the loops. The five loops went directly into the console of Studio Three. Martin, Emerick, Paul, and John manipulated the faders to create the ideal mix (that was recorded on track 2). Sounds of laughter, glasses, sitar, guitars, slowed down, sped up,

After listening to "Tomorrow Never Knows," Klaus Voormann designed the album cover of *Revolver*.

or passed through backwards created a surrealistic atmosphere.

During the third session, on April 22, John recorded his lead vocal again with the Leslie effect on the second part of the song; George simultaneously played a tamboura, which produced a hypnotic buzz. Then, on the last track, they added a second vocal by John, a tambourine, an organ, a piano part taken from the first take on April 6 and a guitar solo reproduced backwards and

played by Paul. Twelve mono mixes were carried out between April 27 and June 6, as well as six stereo mixes on June 22. The Beatles had just outdone themselves.

Technical Details

A loop was a piece of magnetic tape of variable length, on which a sound was recorded and which was taped together at each of its extremities. Played back on a tape recorder, the tape loop ran indefinitely.

On August 29, 1966, the Beatles performed a concert for 25,000 fans, who just went wild, at Candlestick Park in San Francisco, to culminate their world tour. This was the last concert they ever gave.

1966

Paperback Writer / Rain

SINGLE
RELEASED AS A SINGLE

Great Britain: June 10, 1966 / No. 1 on June 23, 1966
United States: May 30, 1966 / No. 1 on June 25, 1966

On June 16, 1966, the Beatles appeared for the only time live on the *Top of the Pops* show. They performed "Paperback Writer."

Paperback Writer

Lennon-McCartney / 2:17

SONGWRITER
Paul

MUSICIANS
Paul: vocal, bass, lead guitar
John: rhythm guitar, backing vocal
George: guitar, backing vocal, tambourine
Ringo: drums

RECORDED
Abbey Road: April 13–14, 1966 (Studio Three)

NUMBER OF TAKES: 2

MIXING
Abbey Road: April 14, 1966 (Studio Three) / October 31, 1966 (Studio One)

TECHNICAL TEAM
Producer: George Martin
Sound Engineer: Geoff Emerick
Assistant Engineers: Richard Lush, Phil McDonald

FOR BEATLES FANATICS

The Beatles filmed several promotional clips for the song. In the one for *The Ed Sullivan Show,* you could see Paul at 0:38 with a piece of tooth missing, the result of a moped accident on December 26, 1965!

Genesis

One day, Paul recalled an article he had read in the *Daily Mail* about the authors of paperback books and got the inspiration to write "Paperback Writer," a song in the form of a letter written by one of these authors to a publisher. "Penguin paperbacks was what I really thought of, the archetypal paperback,"[1] Paul said to Barry Miles. He had already attempted to write a song in the form of a letter with "P.S. I Love You," but this time, it was a real letter he wrote under the approving and amused look of John. On the original manuscript, you could read the signature, *Yours sincerely, Ian Iachimoe*; Ian Iachimoe being the phonetic rendition of Paul's name passed backwards on a tape, which his friends used to use to write him! In the song, he mentioned a novel inspired by someone called Lear. Some people think this is a reference to Edward Lear, a nineteenth-century writer and illustrator who wrote humorous and absurd poems and whose work Lennon loved. But Paul said in 1966, ". . . I can tell you our songs are nearly all imagination—90 percent imagination. I don't think Beethoven was in a really wicked mood all the time."[2] And he added later in an interview, "There's no story behind it and it wasn't inspired by real-life characters."[3] After having written the lyrics by himself, he worked with John on the music. "Then we went upstairs and put the melody to it. John and I sat down and finished it all up."[4] John stated in 1980, "'Paperback Writer' is the son of 'Day Tripper'"[5]

Production

The basic track of the song was recorded in barely two takes on April 13. Paul grouped his colleagues around the piano and played "Paperback Writer" for them. It was obvious that this would be their next single. For the first take, John was on rhythm guitar (with vibrato),

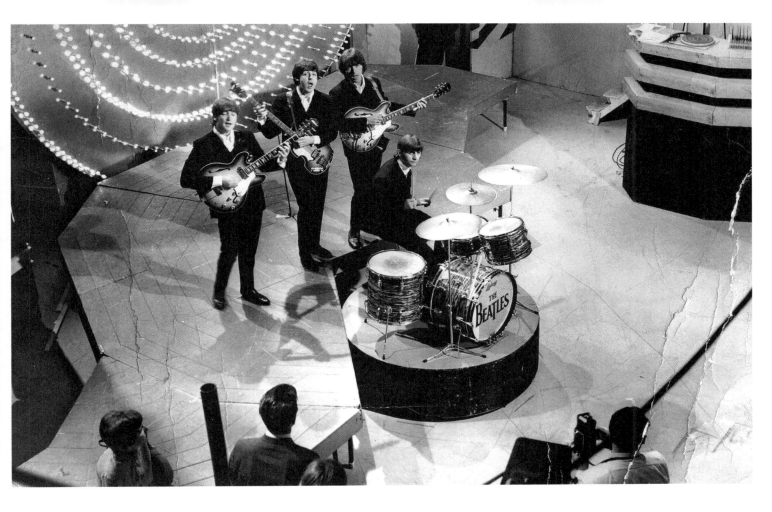

George on tambourines, Ringo on drums, and it was Paul and not George who played the superb intro riff on his Epiphone Casino (he confirmed this in 2005 to *Guitar Player* magazine).

The next day, the group redid the song. Paul recorded his bass, accompanied by George Martin on the "jangle box" piano, passed through a Leslie (the piano part was not kept). The Beatles always regretted having a more timid bass sound than American records. Paul asked Geoff Emerick to replicate the stronger bass sound that he heard on Motown recordings. With the help of Ken Townsend, Geoff Emerick decided to convert the famous White Elephant speaker to be used as a microphone. This created an enormous bass sound.

Paul, inspired by the Beach Boys' *Pet Sounds*, then searched for an idea for the backing vocal. According to the *Beatles Monthly*: ". . . he rushed to the piano and began playing 'Brother John.'" And you could actually hear the Beatles singing "Brother John" (in the vocals and with a British accent!), at 1:02 and at 1:20 (with a false start for one of the singers). After having tried and then rejected a Vox Continental organ part played by George Martin, the Beatles sang the lead vocal, as well as the backing vocals, which they doubled; George completed the song with guitar additions.

The mono mix followed the recording. Geoff Emerick added a fluttering echo at the end of each chorus by routing the vocals into a separate two-track machine and then connecting that machine's output to its input.[6] The stereo mix for the album *A Collection of Beatles Oldies* was only carried out after the single came out, on October 31. "Paperback Writer" was one of the heaviest songs by the Beatles: it influenced numerous musicians, including Humble Pie, which practically copied it in their song "Street Rats."

Technical Details

To help deal with the enormous sound of Paul's Rickenbacker 4001S in the recording, Tony Clark used a new machine, the ATOC (automatic transient overload control), which made it possible to have a greater tolerance for bass frequencies.

1. Miles, *Paul McCartney.*
2. *The Beatles Anthology.*
3. Alan Smith, *The Beatles Ultimate Experience* (June 16, 1966), http://www. beatlesinterviews.org/db1966.0616.beatles.html (accessed April 8, 2013).
4. *The Beatles Anthology.*
5. Sheff, *The Playboy Interview with John Lennon & Yoko Ono.*
6. Emerick, *Here, There and Everywhere.*

The Beatles in the gardens of
Chiswick House, on May 20,
1966, while they were filming
video promos for "Rain" and
"Paperback Writer."

Rain

Lennon-McCartney / 2:17

SONGWRITER
John

MUSICIANS
John: vocal, rhythm guitar
Paul: bass, rhythm guitar (?), backing vocal
George: rhythm guitar (?), backing vocal
Ringo: drums, tambourine

RECORDED
Abbey Road: April 14, 1966 (Studio Three) / April 16, 1966
(Studio Two)

NUMBER OF TAKES: 8

MIXING
Abbey Road: April 16, 1966 (Studio Two) / December 2,
1969 (Studio Two)

TECHNICAL TEAM
Producer: George Martin
Sound Engineer: Geoff Emerick
Assistant Engineers: Richard Lush, Phil McDonald

FOR BEATLES FANATICS

The promotional clips for "Rain" and "Paperback Writer" were filmed on May 19 in an Abbey Road studio. Paul still had a broken tooth . . .

Genesis

Although the concept had been mainly developed by John, Paul believed "Rain" was a joint creation. John said in 1969, "This was a song I wrote about people moaning about the weather all the time."[1] Half-mockingly, half-philosophically, he stated in the text, . . . *when it rains and shines, it's just a state of mind.* For the first time, he became aware of his influence and the import of his ideas, and he was going to use them to fight for peace and love, with lyrics such as *I can show you* and *Can you hear me?* A simple B-side, "Rain" nevertheless was one of the Beatles' first psychedelic songs. Its exceptional content and feel made it a must that prefigured *Revolver*. A revolution had begun . . .

Production

"Rain" was recorded on April 14, right after "Paperback Writer." Paul said, "On 'Rain,' I remember we couldn't get a backing track and we decided to play it fast and slow it down."[2] What came of it was a much heavier, thicker sound, with more depth. In a 1984 interview, Ringo stated, "My favorite piece of me is what I did on 'Rain.' I think I just played amazing. I was into the snare and hi-hat. I think it was the first time I used this trick of starting a break by hitting the hi-hat first instead of going directly to a drum off the hi-hat. . . I think it's the best out of all the records I've ever made. 'Rain' blows me away. It's out of left field. I know me and I know my playing, and then there's 'Rain.'"[3]

According to the studio records, John and Paul were on guitar. Leaving the studio in the wee hours of the morning, John went home fairly "stoned" (according to him), with a tape of the day's work. Dead tired, he decided to listen to the recording and accidentally threaded the tape backwards: he was stunned! On April

16, he returned to the studio exhilarated with his discovery. This blew everyone's mind! John asked Martin to insert his vocal backwards. "OK," said Martin, "we will do it at the end." Paul recorded an excellent part on bass, using the same process as in "Paperback Writer," and John then inserted his voice with the dragging and intimate tone that characterized his singing from then on. A reduction of all the tracks was carried out in order to gain space. Ringo added a tambourine part simultaneously with the backing vocals of the three other Beatles. Note that John sang the high notes. Martin finally inserted John's backwards vocal in the coda (2:35). Except for the loops on "Tomorrow Never Knows," it was the first recording to use backwards sounds. This was only the beginning . . . The mono mix was done soon afterwards using the process of artificial double tracking (ADT); curiously, the stereo mix was only finalized in 1969, on December 2, for its inclusion on the American compilation, *Hey Jude* (February 26, 1970).

1. *The Beatles Anthology.*
2. Ibid.
3. Max Weinberg, *The Big Beat* (Briarcliff, NY: Hudson Music, 1984).

1967

(Double A-Side)

Strawberry Fields Forever / Penny Lane

SINGLE
RELEASED

Great Britain: February 17, 1967 / No. 2
United States: February 13, 1967 /
No. 1 for 1 week on March 18, 1967
("Penny Lane")

Strawberry Fields Forever

Lennon-McCartney / 4:07

1967

SONGWRITER
John

MUSICIANS
John: vocal, rhythm guitar, Mellotron, percussion
Paul: bass, Mellotron, piano, lead guitar (?), percussion
George: swarmandal, maracas, percussion, lead guitar (?)
Ringo: drums, percussion
Mal Evans: tambourine
Neil Aspinall: percussion
Greg Bowen, Tony Fisher, Stanley Roderick, Derek Watkins: trumpets
John Hall, Norman Jones, Derek Simpson: cellos

RECORDED
Abbey Road : November 24 and 28–29, 1966 (Studio Two) / December 8–9, 15, and 21, 1966 (Studio Two)

NUMBER OF TAKES: 26

MIXING
Abbey Road: November 28–29, 1966 (Studio Two) / December 9, 15, and 22, 1966 (Studio Two) / December 29, 1966 (Studio Three)

TECHNICAL TEAM
Producers: George Martin, Dave Harries
Sound Engineers: Geoff Emerick, Dave Harries
Assistant Engineer: Phil McDonald

Genesis

"Strawberry Fields Forever," which summed up the essence of the Beatles' art in four minutes, is probably the key song in their entire repertoire. The creative power of the group was at its peak and its musical vision had reached an unrivaled strength. This song incarnated the spirit of the sixties and prefigured their masterpiece, *Sgt. Pepper's Lonely Hearts Club Band*.

After the concert in Candlestick Park in San Francisco, the last one they ever gave, the Beatles spread their wings toward other horizons. John left for Almería, in Spain, where he acted in Richard Lester's movie, *How I Won the War*. While he was there, he took advantage of the long waits between each set to write "Strawberry Fields Forever." Strawberry Field (singular) was the name of a Salvation Army center near his aunt Mimi's house in Liverpool, where he lived as a child. He said in 1980, "I don't know. But I just took the name—it had nothing to do with the Salvation Army. As an image—Strawberry Fields Forever."[1] The lyrics, rather obscure and surrealistic, expressed the feeling he always had that he was different, on which he reminisced in his 1980 *Playboy* interview, "Nobody seems to understand where I'm coming from. I seem to see things in a different way from most people."[2] John had perceived reality in a distorted way that isolated him from his surroundings ever since he was a child. This live-wire sensitivity made him suffer throughout his life, but was also the inspiration for masterpieces such as "Strawberry Fields Forever."

Production

"Strawberry Fields Forever" was one of the Beatles' most complicated and difficult recordings. It was recorded at the beginning of the sessions for the album that was to become *Sgt. Pepper*. The first time George Martin heard the song, John was singing with a soft and

1. Sheff, *The Playboy Interview with John Lennon & Yoko Ono*.
2. Ibid.
3. *The Beatles Anthology*.
4. Emerick, *Here, There and Everywhere*.
5. Martin and Hornsby, *All You Need Is Ears*.

moving voice while accompanying himself on guitar. George Martin: "When John sang 'Strawberry Fields' for the first time, just with an acoustic guitar accompaniment, it was magic. It was absolutely lovely."[3] Geoff Emerick confirmed, "just a great, great song, that was apparent from the first time John sang it for all of us."[4] The first session took place on November 24. John played a new musical instrument, a Mellotron. It was a revolutionary instrument, the precursor of our current samplers, that made it possible to reproduce various sounds, such as brass, strings, and woodwinds. Paul got hold of it and chose a flute sound. John was singing and playing rhythm guitar, George played maracas, while Ringo played the drums, with the skins covered with rags to muffle the sound. A slide guitar part was actually played (by George?) using a guitar setting on the Mellotron by using a pitch wheel that slowed the tape, thereby lowering its pitch. Although the results were endearing, they redid the song on November 28. During this session, Paul found the famous intro on the Mellotron. At the end of the fourth take, the song began to take shape. The next day, they took time to do overdubs on piano, bass, and vocals. John's vocal was treated with ADT. Despite a conclusive seventh take, John was not satisfied. At the end of the session, everyone went back home with an acetate to listen to. Before going on with the current version, John contacted Martin and told him he would like a "heavier" arrangement. Martin offered to write a score for trumpets and cellos. But before integrating these daring sound effects, the Beatles had to record a new rhythm track.

On December 8, George Martin and Geoff Emerick—who were invited to the premiere of the Cliff Richard film *Finders Keepers*—missed the beginning of the session. Dave Harries, the future collaborator with Martin at AIR Studios in London, replaced them until their return, around 11:00 P.M. The Beatles came up with a heavy and hypnotic rhythm track: backwards cymbals (made by playing a cymbal recording in reverse), kettledrums, bongos, tambourines, maracas. Everyone participated in the recording, including Mal Evans and Neil Aspinall. John, who usually ran out of patience, felt totally serene. The next day, after other reductions, Ringo added percussion and other drum parts, George added an Indian touch with a swarmandal, a small Indian harp, and Paul played lead guitar. John then sat down at the Mellotron to insert hypnotic flute sounds on the coda, and the pinched strings of a piano completed the arrangements (starting at 3:00). George Martin could finally write his score: four trumpets and three cellos were recorded on December 15. After another reduction mix, take 25 becoming take 26, John did a superb recording of his lead vocal and with his very peculiar sense of humor, slipped in at the end of the piece the famous *cranberry sauce*, two small words that at first seemed harmless but later launched the most fanciful rumors about the so-called death of Paul, some people hearing, *I buried Paul!*

Finally, on December 21, there was a new recording of John's vocal and Paul on piano. But John had a surprise for the whole team. He phoned George Martin and said, "I like the beginning of the first one, and I like the end of the second one. Why don't we just join them together?" Flabbergasted, Martin replied, "Well, there are only two things against it. One is that they're in different keys; the other is that they're in different tempos." "Yeah, but you can do something about it, I know.

John Lennon during the filming of Richard Lester's *How I Won the War*.

You can fix it, George."[5] Not wanting to let John down, Martin and Emerick decided to try something radical on December 22, after doing the mono mix for the song. The two versions were only a semitone different, and the tempos were fairly close. Speeding up the remix of the first version gradually (take 7) and slowing down the remix of the second (take 26) made the editing successful. The exact splicing point was at 0:59 at the beginning of the word *going*. John was finally satisfied with the results. For the mix, they used a fade-out/fade-in effect (around 3:00) that they used again on "Helter Skelter." The stereo mix was done on December 29. "Strawberry Fields Forever" was a masterpiece by the Beatles. Sure, it was John's song, but the results were due to the whole team's work.

Penny Lane

Lennon-McCartney / 2:57

SONGWRITER
Paul

MUSICIANS
Paul: vocal, bass, keyboards
John: rhythm guitar, backing vocal, harmonium (?), piano, hand claps, congas
George: backing vocal, percussion (?)
Ringo: drums, tambourine, tubular bell, percussion
George Martin: piano, hand claps
David Mason: piccolo trumpet
P. Goody, Ray Swinfield, Dennis Walton, Manny Winters: flutes, piccolos
Leon Calvert, Duncan Campbell, Freddy Clayton, Bert Courtley: trumpets, flugelhorns
Dick Morgan, Mike Winfield: oboes, English horns
Frank Clarke: double bass

RECORDED
Abbey Road: December 29–30, 1966 (Studio Two) / January 4–6 and 9, 1966 (Studio Two) / January 10 and 12, 1966 (Studio Three) / January 17, 1967 (Studio Two)

NUMBER OF TAKES: 9

MIXING
Abbey Road: December 29–30, 1966 (Studio Two) / January 9, 1966 (Studio Two) / January 12, 1967 (Studio Three) / January 17, 1967 (Studio Two) / January 25, 1967 (Studio One)

TECHNICAL TEAM
Producer: George Martin
Sound Engineer: Geoff Emerick
Assistant Engineer: Phil McDonald

Opposite and following page: a joint work session for Paul and George Martin on "Penny Lane," which evokes superbly the Liverpool of Paul's adolescence, for which Martin wrote the arrangements for brass, wind instruments, and cello.

Genesis

"Penny Lane" was Paul's reply to John's "Strawberry Fields Forever." These two songs, recalling childhood memories, constituted a form of perfection in the art of pop songs. Penny Lane is a Liverpool neighborhood, a street and a bus station through which Paul used to travel in order to get to John's house. "I lived in Penny Lane on a street called Newcastle Road. So I was the only Beatle that lived in Penny Lane,"[1] John explained in 1980. Later on, he left the neighborhood and moved to Woolton . . . Finally, it was Paul who dedicated a song to it. He had been thinking about the topic since 1965 and he used it when he was searching for ideas for the next album. He wrote it in his new Victorian residence on Cavendish Avenue, in a neighborhood called St. John's Wood.

As John had listed the places where he grew up in his original lyrics to "In My Life," Paul thought of the characters on Penny Lane, whether they were fictitious or real. For example, the barber Bioletti really existed, the fire station was nearby, there was a bank on the corner—even though the character of the banker was imaginary—and poppies were sold every year at the time of Remembrance Day (November 11). "Blue suburban skies . . .", Paul uses a poetic and fairly psychedelic vision to describe this neighborhood, which was basically quite ordinary.

John helped Paul write the third couplet. Both of them had fun slipping in dirty jokes: *four of fish and finger pie.* Paul explained it in 1967: "Most people wouldn't hear it, but 'finger pie' is just a nice little joke for the Liverpool lads who like a bit of smut."[2]

1. Sheff, *The Playboy Interview with John Lennon & Yoko Ono.*
2. *The Beatles Anthology.*
3. Martin and Hornsby, *All You Need Is Ears.*

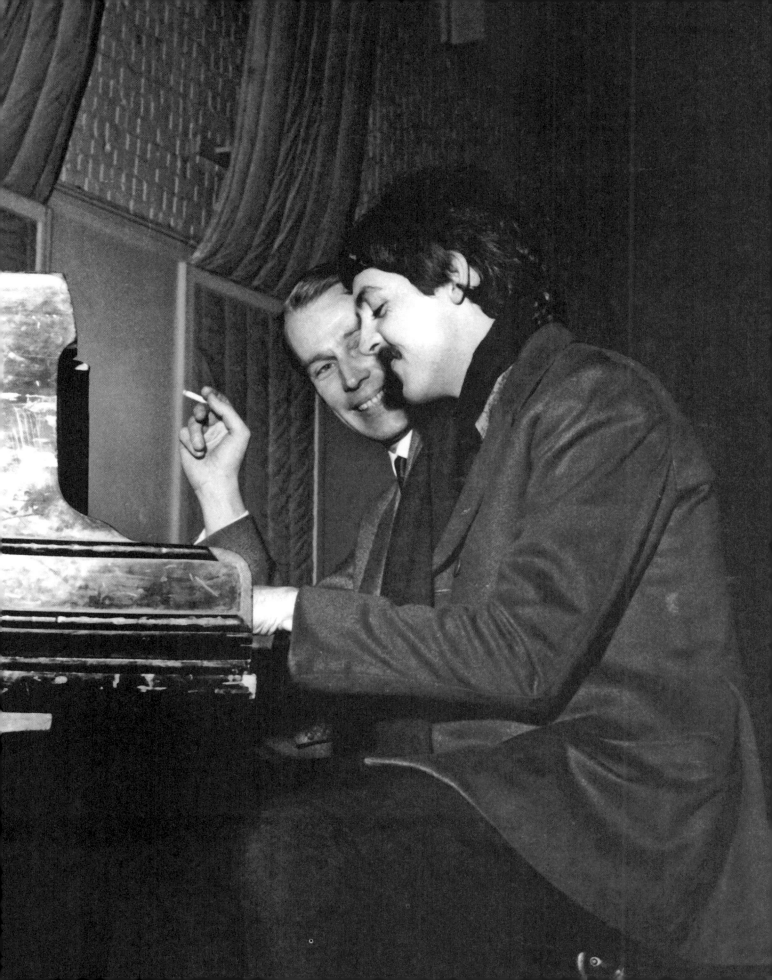

Production

The first session took place on December 29. Paul wanted a very clean sound, being influenced by American productions, such as *Pet Sounds* by the Beach Boys and, especially, "God Only Knows," a song he still considers one of the most beautiful ever written. Alone at the piano, it took him six takes to find the basic track, to which he then added a second piano, put through a Vox amplifier with vibrato and reverb, a honky tonk piano (the famous "Mrs. Mills" that was recorded at half-speed). Ringo played the tambourines. Finally, a harmonium, again fed through a Vox guitar amplifier, and percussion completed the sound. On the next day, Paul recorded his lead vocal, with John on harmony, and the tape recorder was slightly slowed down for recording, raising his pitch when played back at normal speed.

On January 4, 1967, after a failed attempt by George and John, on lead guitar and piano, respectively, Paul tried a new vocal that he replaced the very next day. On January 6, he recorded on his Rickenbacker 4001S a magnificent bass line, which was the backbone of the song. John accompanied him on rhythm guitar and congas. Ringo was on drums. The whole song was highly compressed by Geoff Emerick and recorded with a slower-than-normal tape speed. On the seventh take, John and George Martin were on piano and hand claps. Finally, George Harrison, John, and Paul provided backing vocals.

Paul then asked George Martin to help him write a score for brass and wind instruments. Martin's arrangement included four flutes, two trumpets, two piccolos, and a flugelhorn. These instruments were recorded on January 9 on track 2 of take 9. On the next day, Ringo overdubbed tubular bells. Then, on January 12, additional instruments were added, including two trumpets, two oboes, two English horns, and a double-bass.

Meanwhile, on January 11, during a rebroadcast on the BBC of Bach's *Brandenburg Concerto* no. 2, Paul discovered a trumpet player who impressed him. He spoke to Martin about him: "[I saw a guy] playing this fantastic high trumpet." "Yes, the piccolo trumpet, the Bach trumpet. Why?" "It's a great sound. Why can't we use it?" "Sure we can."[3] Dave Mason, a member of the prestigious New Philharmonia Orchestra of London, the trumpet player who so impressed Paul, was then recruited on January 17. Martin transcribed the solo that Paul sang for him. After three hours of waiting, Mason, who chose the piccolo in B flat among his nine trumpets, recorded a brilliant solo in only one take, despite the terrible instability of the instrument. Paul insisted on a second take. The trumpet player was dumbfounded and Martin flatly refused (he realized the feat that had just been accomplished), so Paul accepted this sole take. This did not prevent Mason from recording two other complementary parts, which come at the conclusion of the song. Out of all the mixes done during the different sessions, the eleventh mix was selected to be sent right away to Capitol, which was waiting to complete the group's next single. However, on January 25, the decision was made to delete the trumpet part that concluded the song. Three new mixes were redone and rushed to the United States. Despite their haste, promotional productions of the eleventh mix had already been made. Today these are real collectors' items! It took over three weeks to produce "Penny Lane." But what great results!

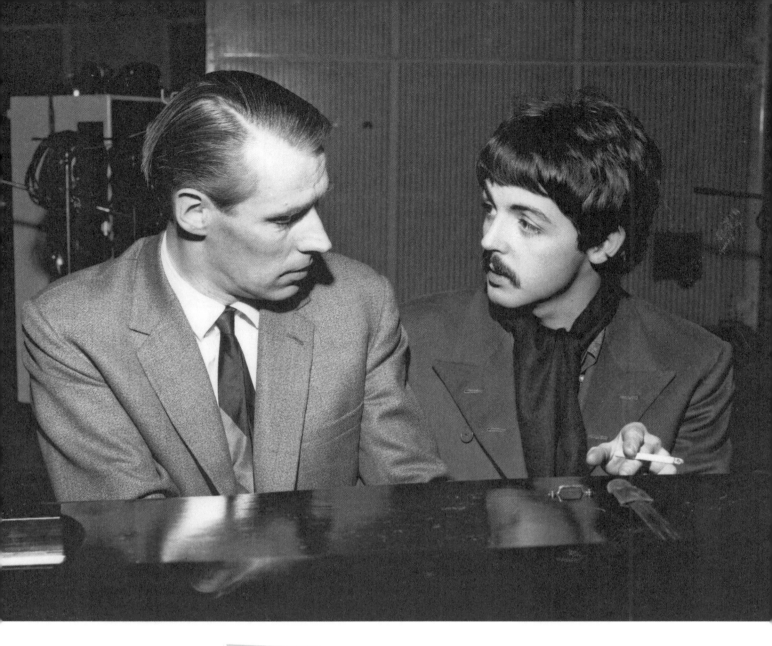

FOR BEATLES FANATICS

Surely, the Beatles were not aware of it, but Penny Lane was named after James Lane, a British eighteenth-century slave trader who was fiercely opposed to abolitionist legislation.

SGT. PE PE
LON
HEART'

1967

Sgt. Pepper's Lonely Hearts Club Band
With a Little Help from My Friends
Lucy in the Sky with Diamonds
Getting Better
Fixing a Hole
She's Leaving Home
Being for the Benefit of Mr. Kite !
Within You Without You
When I'm Sixty-Four
Lovely Rita
Good Morning Good Morning
Sgt. Pepper's Lonely Hearts Club Band (reprise)
A Day in the Life

ALBUM

RELEASED

Great Britain: June 1, 1967 / No. 1 for 27 weeks
United States: June 2, 1967 / No. 1 for 15 weeks

Sgt. Pepper's Lonely Hearts Club Band: A Genuine Masterpiece

As early as 1968, *Sgt. Pepper's Lonely Hearts Club Band* garnered a harvest of Grammy Awards: Best Album of 1967, Best Contemporary Album, Best Record Cover, and Best Non-Classical Recording. The *Sgt. Pepper* album, often referred to as the best album of all time, was the archetype of the rock 'n' roll record. It raised pop culture to a higher level. As soon as it came out, it created its own event: the concept, the lyrics, the music, the record cover, the printed lyrics, the length of recording (over five months)—everything was brand new! The Beatles themselves even changed their look: mustaches, multicolored uniforms, granny glasses for John. Even if this record was not an anthology of their best songs, as a whole it was exceptional. *Revolver* prefigured a change of direction, and *Sgt. Pepper* became their most exciting work yet. Unfortunately, this change also bore within itself the promise of the end of the group: Paul assumed ascendency over John, whose bossiness and work ethic irritated his colleagues. Nothing would ever be the same again. The brotherhood disintegrated. But before the final breakup of the group, they still recorded a few masterpieces, one of which is *Sgt. Pepper*.

The album was conceived in late 1966. After causing a scandal in fundamentalist circles in the southern United States by claiming they were more famous than Jesus Christ, and after almost getting lynched in Manila by refusing to attend a reception given by the Marcos family, the Beatles were on the verge of breaking up: freaking out about the madness they had been experiencing for three years, they decided that the August 29 concert in Candlestick Park in San Francisco would be the last concert of their career. A bit lost with this new freedom, every one of the Beatles escaped as he pleased: John acted in *How I Won the War* by Richard Lester, and was soon joined by Ringo in Spain; Paul wrote the music score for a movie called *The Family Way* before flying off to Kenya for a safari; and George left to study the sitar with Ravi Shankar in India. Returning to London, the four musicians came back to the studio to record "Strawberry Fields Forever," the first song of their next album. On November 24, 1966, the *Sgt. Pepper* sessions started. The tone had been set: watch out, this was going to be amazing!

The Concept of the Album

During his flight back from Nairobi to London, Paul thought of a new concept for the album: why not invent a fictitious band and pretend to play in its place—just so they would no longer be in the limelight and could leave their egos at the door? Along with Mal Evans, the Beatles' faithful road manager, Paul searched for a long name for the band—long band names were in fashion at the time. The salt and pepper shakers on his tray provided the solution: *Salt and Pepper . . . Sergeant Pepper!* But he needed the rest of the name. *Lonely Hearts Club* was a very popular name around dating agencies. Perfect! *Sgt. Pepper's Lonely Hearts Club Band* was born! Although right from the start it was a concept album, curiously, only the two first songs and the second to the last one, the so-called reprise, were designed in this light; the other songs were totally independent of the concept. In 1980, John confirmed that he was never concerned about this concept: "All

The photo session for the cover of the *Sgt. Pepper's Lonely Hearts Club Band* album, photographed by Michael Cooper.

my contributions to the album have absolutely nothing to do with this idea of Sgt. Pepper and his band; but it works 'cause we said it worked, and that's how the album appeared. But it was not as put together as it sounds, except for Sgt. Pepper introducing Billy Shears and the so-called reprise. Every other song could have been on any other album."[1]

The record cover was one of the most ambitious projects of its time. The overall cost, which was much higher than the standard, made a few people at EMI gnash their teeth. Robert Fraser introduced Paul to pop art artist Peter Blake, as well as photographer Michael Cooper, so that they would base the

cover on one of his drawings. The Beatles, Robert Fraser, and Peter Blake provided a host of personalities whose photo would appear in the background. Albert Einstein, Lewis Carroll, Aleister Crowley, Stuart Sutcliffe, and Karl Marx were all suggested. John wanted to be provocative by evoking Hitler and Jesus, but his idea was rejected. Eighty-five personalities and objects were selected. EMI was worried and asked Brian Epstein to obtain permission to reproduce each photograph. The photo session took place on March 30 and lasted roughly three hours—three hours that immortalized the peak of the greatest group in the history of rock.

The Instruments

The Beatles played the same instruments as on *Revolver*, using more keyboards, such as the Mellotron MKII and the Lowrey Heritage Deluxe organ. Paul still treated himself to a Fender Esquire, a new Selmer Thunderbird guitar amplifier, and, for his bass, a Vox 730 guitar amplifier. Various other instruments, types of percussion, and Indian instruments, such as the swarmandal, were used, not to mention a series of harmonicas.

1. Sheff, *The Playboy Interview with John Lennon & Yoko Ono.*

Paul's Rickenbacker 4001 S became the theme bass of the *Sgt. Pepper* recording sessions.

Sgt. Pepper's Lonely Hearts Club Band

Lennon-McCartney / 2:02

SONGWRITER
Paul

MUSICIANS
Paul: vocal, bass, guitars
John: backing vocal
George: guitar, backing vocal
Ringo: drums, backing vocal (?)
James W. Buck, John Burden, Tony Randall, Neil Sanders: French horns
Mal Evans, Neil Aspinall: backing vocals (?)

RECORDED
Abbey Road: February 1–2, 1967 (Studio Two) / March 3 and 6, 1967 (Studio Two)

NUMBER OF TAKES: 10

MIXING
Abbey Road: February 2, 1967 (Studio Two) / March 6, 1967 (Studio Two)

TECHNICAL TEAM
Producer: George Martin
Sound Engineer: Geoff Emerick
Assistant Engineer: Richard Lush

FOR BEATLES FANATICS

If you listen carefully, on the right side of the stereo version you can hear Paul (?) in the distance at exactly 0:09 calling, "Roll over boys!"

Genesis

Paul wrote the first line of the song: *It was twenty years ago today / Sgt. Pepper taught the band to play.* Here we have the image of a brass band. Paul goes on to develop the idea of Sergeant Pepper directing the members of an imaginary orchestra. This subterfuge was supposed to free the Beatles from the yoke of fame. They no longer had to "play" at being the Beatles, but could be satisfied with being the anonymous members of an anonymous band. It was a unifying theme that only extended to the first two songs of the album and the reprise of the title song: "Sgt. Pepper's Lonely Hearts Club Band," "With a Little Help from My Friends," and "Sgt. Pepper's Lonely Hearts Club Band" (reprise).

Production

On February 1, 1967, the Beatles recorded the rhythm track of "Sgt. Pepper" in nine takes. Ringo was on drums; Paul and George on electric guitar. According to Geoff Emerick, Paul received permission from John to play the rhythm guitar here. John played a bass that Paul would pick up once the rhythm track was recorded. The next day, with the accompaniment of John and George on backing vocals, Paul recorded a superb rock 'n' roll lead vocal, that was emphasized by a lot of reverb. According to Ryan and Kehew, the vocals in the choruses were then doubled by all four Beatles, joined by Mal Evans and Neil Aspinall.[1] And then there was a reduction of the first four tracks.

A month later, on March 3, the group redid the song. Four French horn players were recruited to liven up the concept of the brass band. As usual, George Martin noted down what Paul sang for him. George then added solo guitar. After numerous failed attempts, Paul grabbed the guitar with no consideration for poor

George and performed a superb solo (which was deleted too early at 1:54).

In order to re-create the atmosphere of a Sgt. Pepper concert, extracts of the orchestra tuning up, which had been recorded for "A Day in the Life," were added on March 6, as well as different noises of murmurs, laughter, and applause, drawn from one of George Martin's *Beyond the Fringe* live recordings. Finally, the yelling of the public, captured during a concert at the Hollywood Bowl, ensured the transition to "With a Little Help from My Friends." The final mixes were made the same day.

Technical Details

Using the direct box (DI box or Direct Injection box), an invention of Ken Townsend, Paul recorded his bass while connected directly to the console without going through an amplifier. This innovation was later used in studios worldwide.

The Hendrix Touch

On June 4, 1967, Brian Epstein introduced Jimi Hendrix at the Saville Theatre in London. Paul and George, who attended the concert, were startled by the unexpected cover that the American virtuoso did of "Sgt. Pepper's Lonely Hearts Club Band," since the album had only been released on June 1!

1. Ryan and Kehew, *Recording the Beatles*.

With A Little Help From My Friends

Lennon-McCartney / 2:43

SONGWRITERS
John and Paul

MUSICIANS
Ringo: vocal, drums, tambourine, timpani
John: rhythm guitar (?), backing vocal
Paul: bass, piano, backing vocal
George: lead guitar (?), organ (?), backing vocal
George Martin: organ (?)

RECORDED
Abbey Road: March 29–30, 1967 (Studio Two)

NUMBER OF TAKES: 11

MIXING
Abbey Road: March 31, 1967 (Studio Two) / April 7, 1967 (Studio Two)

TECHNICAL TEAM
Producer: George Martin
Sound Engineer: Geoff Emerick
Assistant Engineer: Richard Lush

FOR BEATLES FANATICS

Not only did Joe Cocker take this song to the top of the charts, but in February 2004, it was number 1 again in the U.K. as sung by Sam & Mark.

Genesis

"With a Little Help from My Friends" was the second and last song to fit into the concept of the album (except for the reprise at the end of the record). It follows "Sgt. Pepper's Lonely Hearts Club Band," which ends with the introduction of Billy Shears, alias Ringo. It was written at John's place in Weybridge, based on an original idea by Paul. Both of them knew Ringo needed a new title: his debonair attitude was the inspiration for the lyrics.

It was in fact a celebration of friendship, even if sentences like *I get high* had another meaning back then. Originally, the text began with *What would you do if I sang out of tune? Would you stand up and throw tomatoes at me?* Ringo objected, "There's not a chance in hell am I [sic] going to sing this line."[1] He was worried that during a tour, the fans might pick up on this suggestion! Rather daring allusions were also slipped into the text. Paul said. "I remember giggling with John as we wrote the lines: *What do you see when you turn out the light? I can't tell you but I know it's mine.*"[2] Juvenile humor . . . The song became enormously popular. Joe Cocker did a brilliant adaptation of it that shot to number 1 in Great Britain in 1968 and that he sang at Woodstock the following year.

Production

The recording session started on March 29. The working title was "Bad Finger Boogie" (which inspired the Iveys—the first group to record with Apple—who renamed themselves Badfinger). The Beatles, who had helped with preparations for the record's photo session on the same day, were in top shape. The rhythm track was recorded in ten takes. Ringo was on drums, George on guitar, Paul on the "Mrs. Mills" piano, and

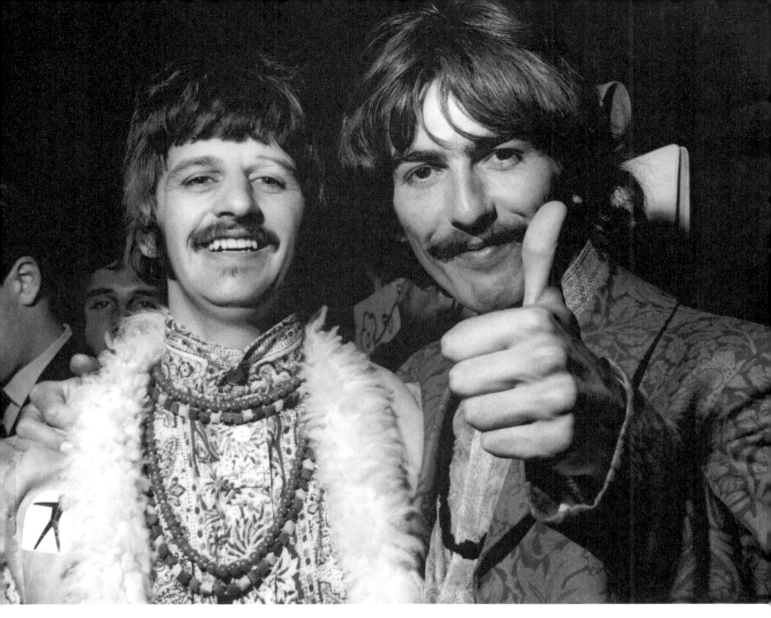

Ringo and George at the Abbey Road Studios on June 24, 1967. Ringo sang "With a Little Help from My Friends" with the support of his friends.

George Martin on the Hammond organ. According to Ryan and Kehew,[3] photos indicated that George Harrison was on organ while John was on guitar.

After the whole song was reduced, Ringo, who thought he could go home to bed, was invited by his colleagues to record his vocal. With their support, he did this with flying colors, although he was very nervous about hitting the song's last note, which was way outside his narrow vocal range. John, Paul, and George replied to Ringo's questions and answers in the lyrics. The Beatles also added the "Billy Shears" intro at the end of "Sgt. Pepper's Lonely Hearts Club Band," which segued right into "With a Little Help from My Friends." The next day, the Beatles were immortalized on the record cover. They went back to the studio for further

overdubs: kettledrum and snare drum for the intro, tambourine, guitar, and backup vocals. According to Emerick, Paul then recorded his superb bass line, set up alone in the control room with the engineers. The sound and melodic richness he drew from the instrument were reminiscent of Brian Wilson. He stated later on that it was one of the best bass lines of the album, along with that of "Lucy in the Sky with Diamonds." Mixed in mono on March 31, with the addition of ADT, flanging, and reverb on the vocal, it was mixed again for stereo on April 7.

1. *The Beatles Anthology.*
2. Miles, *Paul McCartney.*
3. Ryan and Kehew, *Recording the Beatles.*

Lucy In The Sky With Diamonds

Lennon-McCartney / 3:27

1967

SONGWRITER
John

MUSICIANS
John: vocal
Paul: bass, organ, backing vocal
George: guitars, tambura
Ringo: drums

RECORDED
Abbey Road: February 28, 1967 (Studio Two) / March 1–2, 1967 (Studio Two)

NUMBER OF TAKES: 8

MIXING
Abbey Road: March 2–3, 1967 (Studio Two) / April 7, 1967 (Studio Two)

TECHNICAL TEAM
Producer: George Martin
Sound Engineer: Geoff Emerick
Assistant Engineer: Richard Lush

FOR BEATLES FANATICS

The proud owner of the original drawing by Julian is none other than David Gilmour, the guitarist for Pink Floyd!

Genesis

There has been a lot of speculation about this song with the title whose initials form the acronym LSD. "It was purely unconscious . . . until somebody pointed it out, I never even thought of it,"[1] stated John. Even though the other Beatles confirmed this statement, as did George Martin, the legend goes on still. This misunderstanding meant the song was banned from the BBC airwaves when it came out.

The inspiration for Lucy was Lucy O'Donnell (who died in 2009), the best friend of John's son Julian, who was then three years old. And the background of the title could be explained by John's reaction to a drawing by Julian, who told him that he had depicted his friend Lucy in the sky with diamonds. John found the title brilliant and right away wrote a song, inspired by *Alice in Wonderland*. John said in 1980, "It was Alice in the boat. She is buying an egg and it turns into Humpty-Dumpty. The woman serving in the shop turns into a sheep and the next minute they are rowing in a rowing boat somewhere and I was visualizing that."[2] Paul remembered going to Kenwood and discovering Julian's drawing. He participated in writing the song and added the words *cellophane flowers* and *kaleidoscope eyes*, which produced *the girl with kaleidoscope eyes*. For John, this girl with kaleidoscope eyes was the unconscious image of the woman he was waiting for to save him. "It turned out to be Yoko, though I hadn't met Yoko yet,"[3] he said.

Production

The production of "Lucy in the Sky with Diamonds" began on February 28, 1967, with a long rehearsal. Only on March 1 did the group work on the rhythm track. For the first take, John recorded a scratch vocal, George an acoustic guitar (which was processed with

flanging), George Martin a piano part (which would be deleted), Ringo was on drums, and Paul added a part on the Lowrey Heritage DSO-1 organ, whose sound was similar to a harpsichord and gave the intro its peculiar sound. The seventh take was the best. George accompanied John's voice with a tambura. A tape reduction of the song was made the next day, with the playback occurring at a faster speed. Paul recorded his part on bass, which he considered one of the best of the album, while George played his Epiphone Casino, passed through a Leslie cabinet. George said, "In the middle eight of the song you can hear the guitar playing along with John's voice. I was trying to copy Indian classical music."[4] The rhythm track was slowed down by nearly one tone in order to record John's voice supported by Paul's harmony. The voices were then doubled. The recording was one of the fastest of the album. The final mono mix was carried out on March 3 with heavy reliance on ADT; the stereo mix was done on April 7. The psychedelic spirit of the lyrics was perfectly respected. It was a success.

On Earth as It Is in Heaven!

In 1974, when paleontologist Yves Coppens and his team in Ethiopia discovered the skeleton of a woman, who was at that time one of the oldest human beings ever found, they called her Lucy as a tribute to the Beatles song that they were listening to while marking the skeleton of the young Australopithecus.

1. Sheff, *The Playboy Interview with John Lennon & Yoko Ono.*
2. Ibid.
3. Ibid.
4. *The Beatles Anthology.*

Getting Better

Lennon-McCartney / 2:47

SONGWRITER
Paul

MUSICIANS
Paul: vocal, bass, lead guitar, piano (?), hand claps
John: rhythm guitar (?), backing vocal
George: rhythm guitar (?), tambura, backing vocal, hand claps
Ringo: drums, bongos, hand claps
George Martin: Hohmer Pianet electric piano

RECORDED
Abbey Road: March 9–10, 21, and 23, 1967 (Studio Two)

NUMBER OF TAKES: 15

MIXING
Abbey Road: March 23, 1967 (Studio Two) / April 17, 1967 (Studio Two)

TECHNICAL TEAM
Producers: George Martin, Peter Vince
Sound Engineers: Malcolm Addey, Ken Townsend, Geoff Emerick, Peter Vince
Assistant Engineers: Graham Kirkby, Richard Lush, Ken Scott

Genesis

Jimmy Nicol, who had replaced Ringo in June 1964, used to constantly repeat, "It's getting better." One day, Paul was walking around with Hunter Davies, the first official biographer of the group, and he remembered this expression and used it as the inspiration for his new song. He worked on it at Cavendish Avenue on his piano, which was painted by the psychedelic artists Binder, Edwards & Vaughan. When John came to help him write the lyrics, the music had already been composed. As Paul was singing, *It's getting better all the time*, John threw in bluntly, *It couldn't get no worse*. Always the same dialectic between their two personalities . . . Paul used this song to settle accounts with the teachers who taught him when he was young. John was more radical and confessed openly his violent nature: "I used to be cruel to my woman, and physically—any woman. I was a hitter. I couldn't express myself and I hit . . . ,"[1] and he admitted at the same time that "That is why I am always on about peace, you see. It is the most violent people who go for love and peace. . . .Everything's the opposite. . . . I am a violent man who has learned not to be violent and regrets his violence."[2]

Production

On March 9, a new team took over the recording, since Emerick and Lush were on vacation. After seven takes, the basic rhythm track was recorded with Paul on the Epiphone Casino, Ringo on drums, and George Martin on the Hohner Pianet. After a drumming overdub, reduction of the whole song was done. The next day, the usual engineers had returned; George overdubbed a droning tambura (with added flanging), an instrument that became important on the album; Ringo was on

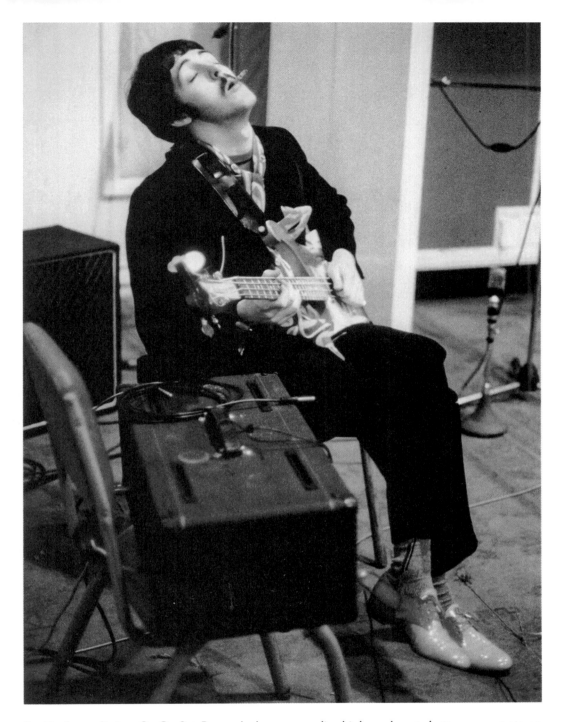

Paul in the studio in 1967. On *Sgt. Pepper,* he began recording his bass alone to better concentrate on the melodic lines.

drums, while Paul simultaneously recorded his bass. Emerick added to this a short reverb using the washroom as an echo chamber. Paul did not really appreciate this—but he agreed. On March 21, there was a new reduction. Paul delivered his lead vocal, accompanied by John and George on backing vocals, a process they doubled on another track. Finally, on March 23, with another production team, the Beatles concluded the

song with various overdubs of bongos played by Ringo, guitar (Paul, John, George?), piano (Paul?), and hand claps. The mono mix was done the same day and the stereo on April 17. This beautiful song, which seems simple, required difficult studio work.

1. Sheff, *The Playboy Interview with John Lennon & Yoko Ono.*
2. Ibid.

Fixing A Hole

Lennon-McCartney / 2:36

SONGWRITER
Paul

MUSICIANS
Paul: vocal, bass (?), harpsichord (?)
John: bass (?), backing vocal, maracas (?)
George: lead guitar, backing vocal
Ringo: drums
George Martin: harpsichord (?)

RECORDED
Regent Sound Studio: February 9, 1967 (Studio A)
Abbey Road: February 21, 1967 (Studio Two)

NUMBER OF TAKES: 3

MIXING
Abbey Road: February 21, 1967 (Studio Two) / April 7, 1967 (Studio Two)

TECHNICAL TEAM
Producer: George Martin
Sound Engineers: Adrian Ibbetson (Regent Sound Studio), Geoff Emerick
Assistant Engineer: Richard Lush

FOR BEATLES FANATICS

Glyn Johns, who participated in the "Get Back" project as a sound engineer, later became the manager of the Regent Sound Studio.

Genesis

Paul was the author of this great song, which John liked. The lyrics gave rise to numerous interpretations, such as references to shooting heroin, allusions to the pleasures of handicraft, and the like. In fact, Paul simply wanted to celebrate the joys of marijuana and, more generally, denounce all those who would not let him take drugs. Paul said to Barry Miles, "Fixing was the general idea. Wanting to be free enough to let my mind wander, let myself be artistic, let myself not sneer at avant-garde things."[1]

Paul wanted to run his own life and no longer be subject to external constraints. He was also troubled by the constant intrusiveness of Beatles fans. He mentioned an amusing anecdote along these lines. As he was getting ready to go record "Fixing a Hole," a stranger claiming he was Jesus showed up at his front door. Paul invited him in for tea and offered to let him attend the recording session if he kept quiet. Jesus kept his word and had the privilege of hearing the Beatles record in the studio. One more miracle . . .

Production

Accompanied by Jesus, Paul joined the group on February 9, not at Abbey Road, which was booked that evening, but at the Regent Sound Studio in downtown London, a small studio, although the Stones and the Kinks had already recorded there. George Martin who had become an independent producer, followed them there; but neither Geoff Emerick, nor Richard Lush, who were EMI employees, had permission to leave their jobs. Adrian Ibbetson, chief engineer at Regent Sound, was serving as the Beatles' sound engineer. The Beatles laid down three takes of the song, but the first two were both very good so onto the tape box was written *master* for take 1 and *final master* for take 2. Contrary

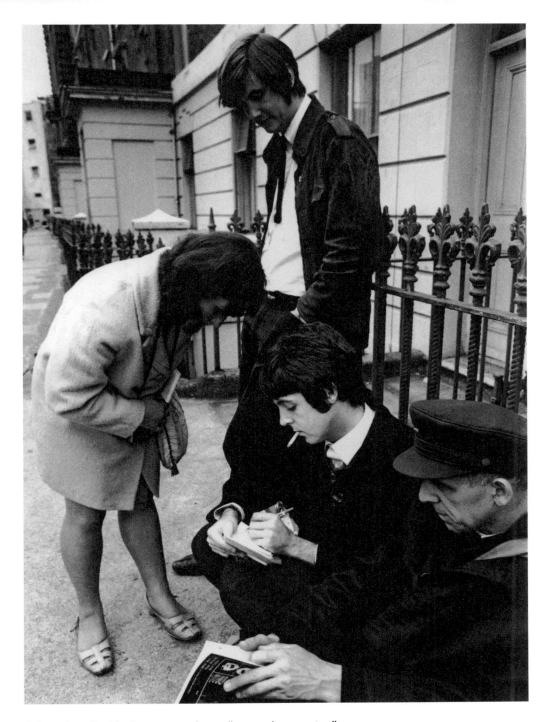

A fan asking Paul for his autograph—an "external constraint."

to their habit, the voices and instruments were recorded simultaneously. The normal recording procedure for the Beatles was to tape the rhythm track and overdub vocals later on. The distribution of roles between Paul, George Martin, and John is unclear. There was a harpsichord in the middle of the studio, rented for this session. It seemed as though it was Martin who played it. But Richard Lush and Neil Aspinall claimed it was Paul. If so, who was on bass, since the instruments were all played together? John? The playing and the sound of the bass are guesswork. Lush specified that John was playing a Fender. But nothing confirms this. Paul may have sung and played bass, with John on maracas and Martin on harpsichord. On the other hand, there was no doubt about George and Ringo: surely the former played a fantastic part on guitar with flanging, and Ringo a drum part that worked just as well. On February 21, they returned to Abbey Road for further overdubs, and probably some vocals. The mono mix was made the very same day, and the stereo on April 7.

1. Miles, *Paul McCartney.*

She's Leaving Home

Lennon-McCartney / 3:34

SONGWRITER
Paul

MUSICIANS
Paul: vocal
John: vocal
Erich Gruenberg, Derek Jacobs, Trevor Williams, José Luis Garcia: violins
John Underwood, Stephen Shingles: violas
Dennis Vigay, Alan Dalziel: cellos
Gordon Pearce: double bass
Sheila Bromberg: harp

RECORDED
Abbey Road: March 17 and 20, 1967 (Studio Two)

NUMBER OF TAKES: 9

MIXING
Abbey Road: March 20, 1967 (Studio Two) / April 17, 1967 (Studio Two)

TECHNICAL TEAM
Producer: George Martin
Sound Engineer: Geoff Emerick
Assistant Engineers: Richard Lush, Ken Scott

FOR BEATLES FANATICS

The mono version is slightly faster and higher by a semitone than the stereo version: during the stereo mix, the team forgot to "varispeed" the tape, as it did for the mono mix!

Genesis

In the *Daily Mail* of February 27, 1967, Paul found the inspiration for "She's Leaving Home." An article focused on a seventeen-year-old student, Melanie Coe, who had just run away from home, leaving behind her a mink coat, a diamond ring, and a car. "Her father was quoted as saying: 'I cannot imagine why she should run away, she has everything here.'" These were the days of hippie communes, squatters, and peace rallies. The slogan was *Peace and Love.* Paul found the topic compelling and, with John's help, he wrote this song. Paul said, "It was rather poignant. I like it as a song, and when I showed it to John, he added the Greek chorus, with long sustained notes."[1]

In the lyrics, there was also mention of a man from the automobile industry—*a man from the motor trade.* People thought this referred to Terry Doran, a friend of the Beatles and the future CEO of Apple Music: he had managed Brydor Cars, a luxury car dealer, for Brian Epstein. Paul denied this theory: "It was just fiction, like the sea captain in 'Yellow Submarine'; they weren't real people."[2]

"She's Leaving Home" was a superb song. Brian Wilson remembered that in April 1967, when he was working on "Vegetables" with the Beach Boys, Paul "sat down at the piano and played 'She's Leaving Home' for me and my wife. We both just cried, it was beautiful."[3]

Production

Once the song was completed, Paul asked George Martin to quickly write arrangements for him and come to his place the very next day for a work session. Martin could not do that because he was booked to record Cilla Black that day. "Come. You can come," insisted Paul. Martin would not give in. Paul hung up. The next day,

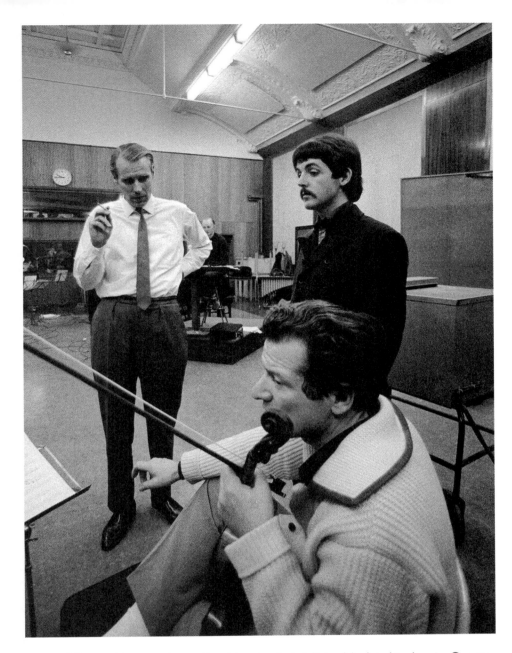

Paul and George Martin in the studio with a classical violinist. Much to his chagrin, George Martin did not orchestrate "She's Leaving Home."

Paul showed up at the studio with Mike Leander, whom he had hired in Martin's place to write the arrangements: "Here we are. I've got a score. We can record it now."[4] George Martin conducted the arrangement, but was deeply hurt. Paul appeared surprised by his reaction and responded by stating, "I was hurt that he didn't have time for me but he had time for Cilla."[5]

The recording on March 17 went smoothly. None of the Beatles played on the song. Only four violins, two violas, two cellos, a bass, and a harp were recorded. After a brief correction was made to the score (a short repetition of the cello that was deleted after each chorus), Martin directed the musicians with a master's

touch. Paul sang lead. Six takes were recorded. Ultimately, the first one was kept. On March 20, Paul doubled his voice and John provided the countermelody (which he doubled twice). The mono mix was done on the same day, and the stereo mix on April 17.

1. Miles, *Paul McCartney*.
2. Ibid.
3. Brian Wilson with Todd Gold, *Wouldn't It Be Nice: My Own Story* (New York: HarperCollins, 1991).
4. Martin and Hornsby, *All You Need Is Ears*.
5. Miles, *Paul McCartney*.

Being For The Benefit Of Mr. Kite !

Lennon-McCartney / 2:35

1967

SONGWRITER
John

MUSICIANS
John: vocal, organ, bass harmonica
Paul: bass, lead guitar, backing vocal, piano (?)
George: tambourine, backing vocal, bass harmonica
Ringo: drums
George Martin: harmonium, organ, Mellotron (?), glockenspiel (?)
Mal Evans: harmonica, organ
Neil Aspinall: bass harmonica

RECORDED
Abbey Road: February 17, 1967 (Studio Two) / February 20, 1967 (Studio Three) / March 28–29 and 31, 1967 (Studio Two)

NUMBER OF TAKES: 9

MIXING
Abbey Road: February 17, 1967 (Studio Two) / March 31, 1967 (Studio Two) / April 7, 1967 (Studio Two)

TECHNICAL TEAM
Producer: George Martin
Sound Engineer: Geoff Emerick
Assistant Engineer: Richard Lush

Genesis

On January 31, 1967, the Beatles were in Sevenoaks, Kent, filming a promotional video for "Strawberry Fields Forever." During the lunch break, John wandered into an antique shop and pulled out a framed Victorian circus poster from 1843, announcing Pablo Fanque's Circus Royal, coming to Town Meadows in Rochdale. He bought it. He hung the poster in his music room at his home in Weybridge and began to use it as the inspiration for a new song. All the main characters in the song are from that poster: Mr. Kite, the Hendersons, Pablo Fanque, Henry the Horse. Except the horse was not called Henry. Some might see an allusion to hard drugs, *horse* was another name for heroin. John explained, "I had never seen heroin in that period. No, it's all just from that poster."[1] With Paul's help, the song wrote itself very easily: "The song is pure, like a painting, a pure watercolor."[2] However, in 1967, he was not very proud of it when he declared, "There was no real work." Nevertheless, the poster gave him the inspiration for the *Sgt. Pepper* slogan, *A splendid time is guaranteed for all.*

Production

The production of this song was one of the most complicated in the history of the group. The rhythm track was recorded on February 17: John sang a scratch vocal, Paul played bass, George was on tambourine, Ringo on drums, and George Martin on harmonium. A first reduction was carried out and John recorded the definitive version of the vocal, which was slightly accelerated and doubled by means of ADT. On February 20, John announced to Martin that he wanted a sound atmosphere that smelled like the sawdust on a circus track. A bit confused, Martin tried in vain to rent a pipe

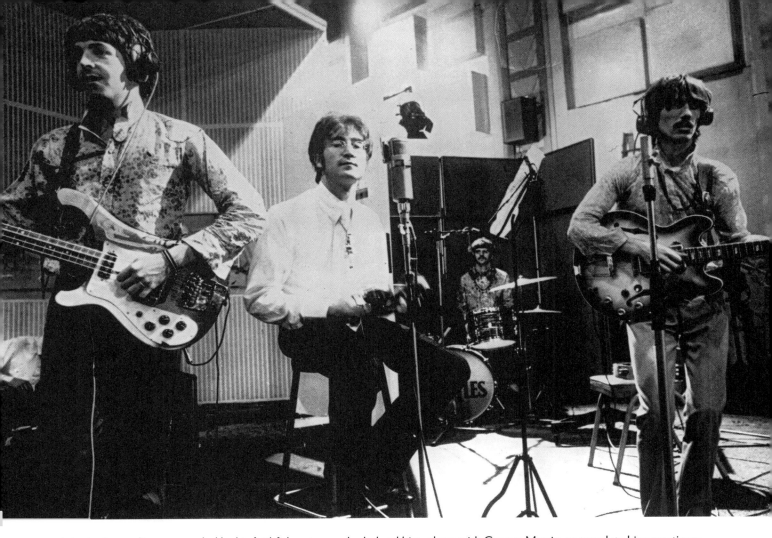

John in the studio, surrounded by his faithful partners who helped him, along with George Martin, to translate his sometimes disconcerting visions into music.

organ. He then decided to take extracts of pipe organ music in the sound library of Abbey Road, cut tapes of various lengths, throw them in the air, and assemble everything in the random order where they fell! Geoff Emerick claimed he had suggested this idea to Martin, reminding him they had already used this method for the brass band on "Yellow Submarine." Once the edit was carried out, the Beatles redid the song on March 28. While on the intro, Martin played a little melody (Mellotron?), while John and George added bass harmony. Then came the instrumental part (at 1:00). Facing the technical difficulty of his organ part, Martin preferred to record it at half-speed. John accompanied him on a second organ; George, Mal Evans, and Neil Aspinall each blew into a bass harmonica; Ringo beat a tambourine, and Paul played a part on lead guitar (at 1:16). The results of the whole recording at normal speed were mind-blowing! A brief part on piano concluded this instrumental section (at 1:26). On March 29, the editing of the so-called pipe organs from February

FOR BEATLES FANATICS

Because of an imprecise vocal overdub, the beginning of the fifth line of the third couplet (*having* at 1:43) was cut!

20 was added. Finally, on March 31, there was one last overdub of glockenspiel and organ before the mono mix was carried out on the same day. The stereo version was done on April 7.

1. Sheff, *The Playboy Interview with John Lennon & Yoko Ono.*
2. Ibid.

Within You Without You

George Harrison / 5:04

MUSICIANS
George: vocal, acoustic guitar, sitar, tambura
Neil Aspinall: tambura
Asian Music Circle Musicians: swarmandal, dilruba, tabla, tambura
Erich Gruenberg, Alan Loveday, Julien Gaillard, Paul Scherman, Ralph Elman, David Wolfsthal, Jack Rothstein, Jack Greene: violins
Reginald Kilbey, Allen Ford, Peter Beavan: cellos

RECORDED
Abbey Road: March 15 and 22, 1967 (Studio Two) / April 3, 1967 (Studio One)

NUMBER OF TAKES: 2

MIXING
Abbey Road: March 15 and 22, 1967 (Studio Two) / April 3–4, 1967 (Studio Two)

TECHNICAL TEAM
Producer: George Martin
Sound Engineer: Geoff Emerick
Assistant Engineer: Richard Lush

FOR BEATLES FANATICS

Patti Smith did a beautiful remake of this song in 2007 on her album *Twelve.*

Genesis

The production of *Sgt. Pepper* must not have been easy for George. Paul assumed more and more dominance over the group and he became more authoritarian. He took away many guitar solos from George, too often reducing his participation to shaking maracas. George Martin had rejected Harrison's first song for the album, "Only a Northern Song," which Martin considered too weak (it appeared on the master of *Yellow Submarine* in 1969). During an evening at his friend Klaus Voormann's place, George found the required inspiration for his next song. "At the time, we lived in Rainspark, and George often came over to visit. He was fascinated by my harmonium. While he played the keyboard, I was under him, working the pedals. This was how 'Within You Without You' was created," Voormann related in his memoirs.[1] George started with the ideas discussed during that evening to write the first lines—*We were talking*—and adapted a long piece by Ravi Shankar for the music: "I wrote a mini version of it, using sounds similar to those I'd discovered in his piece. I recorded in three segments and spliced them together later."[2] George got the approval of his colleagues. John even stated, "One of my favorites of his. . . . He's clear on that song. His mind and his music are clear. There is his innate talent; he brought that sound together."[3] Ringo loved it, too. As for Paul, he confided in Michael Simmons of *Mojo* magazine in 2011: "'Within You Without You' is . . . completely landmark, I would say, in Western recording."[4]

Production

The first recording session took place on March 15. Although the team was doubtful at first, they were

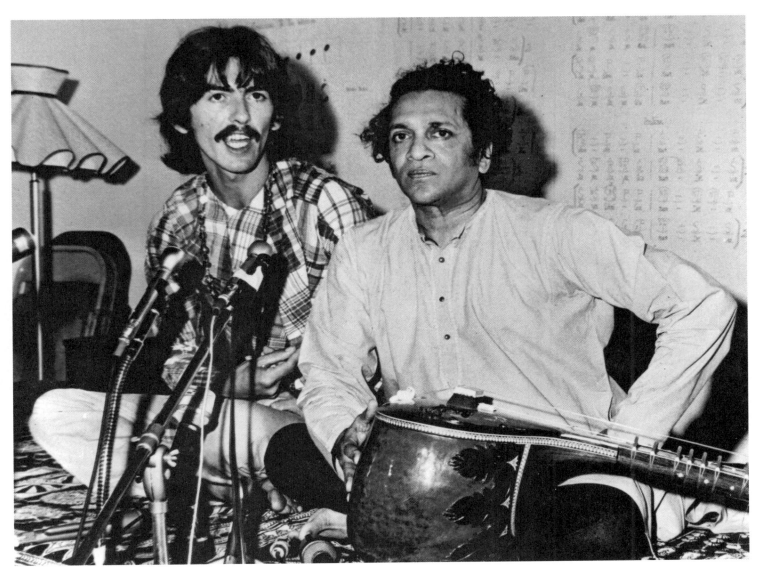

George, the disciple, and Ravi Shankar, the teacher. East and West do meet in the penetrating atmosphere of "Within You Without You."

rapidly seduced by the charm of George's song, which still did not have a title. For the first take, George and Neil Aspinall were on tambura, accompanied by musicians of the Asian Music Circle of London, who were playing various Indian instruments. On March 22, a dilruba was added on a tape recorder that was sped up in order to sound deeper at normal speed. Finally, on April 3, an eleven-hour session (!) began at 7:00 P.M. George Martin wrote a score for eight violins and three cellos. After much hard work, George then recorded his vocal. Dim lights, candles, and incense helped set the atmosphere. After guitar and sitar overdubs, George

had laughter added to the end of the song to lighten up the meaning of the lyrics. The mono and stereo mixes were completed on April 4. The whole team was enthusiastic. But none of the other Beatles attended the sessions. "Within You Without You" was the last song recorded for *Sgt. Pepper.*

1. Voormann, *Warum Spielst Du Imagine Nicht Auf Dem Weissen Klavier, John?*
2. *The Beatles Anthology.*
3. Sheff, *The Playboy Interview with John Lennon & Yoko Ono.*
4. Simmons, "Macca on George."

When I'm Sixty-Four

Lennon-McCartney / 2:37

SONGWRITER
Paul

MUSICIANS
Paul: vocal, bass, piano
John: lead guitar, backing vocal
George: backing vocal
Ringo: drums, chimes
Robert Burns, Henry MacKenzie, Frank Reidy: clarinets

RECORDED
Abbey Road: December 6, 1966 (Studio Two) / December 8, 1966 (Studio One) / December 20–21, 1966 (Studio Two)

NUMBER OF TAKES: 4

MIXING
Abbey Road: December 21, 1966 (Studio Two) / December 29, 1966 (Studio Three) / December 30, 1966 (Studio Two) / April 17, 1967 (Studio Two)

TECHNICAL TEAM
Producer: George Martin
Sound Engineer: Geoff Emerick
Assistant Engineers: Phil McDonald, Richard Lush

FOR BEATLES FANATICS

Since Paul's father celebrated turning sixty-four on July 7, 1966, it is possible that the Beatle resurrected the song for that event.

Genesis

Paul wrote "When I'm Sixty-Four" on his father's piano when he was sixteen. The musical atmosphere of his adolescence was rather eclectic and music halls were a deeply ingrained family tradition. It was not surprising that he always had a penchant for that style, which John called "granny music." Paul said, "I wrote that tune vaguely thinking it could come in handy in a musical comedy or something."[1] The song developed and John admitted in 1967 that they played it often at the Cavern Club: "We used to do them when the amps broke down, just sing it on the piano."[2] Paul added: "I thought it was a good little tune but it was too vaudevillian, so I had to get some cod lines to take the sting out of it, and put the tongue very firmly in cheek."[3] John, who was never stingy with compliments, admitted to David Sheff, "Paul's, completely. I would never even *dream* of writing a song like that. There's some things I never think about, and that's one of them."[4] Nevertheless, it had a charm and musical strength that made it indispensable for the album.

Production

After beginning the December 6 session by recording the Christmas messages for Radio London and Radio Caroline (the two major "pirate" radio stations operating off the coast of Britain that served as an alternative to the stricter BBC stations), the Beatles began working on the second piece of the album. Being familiar with its structure, they managed to record it in two takes, with Paul on piano and on bass, Ringo on drums and brushes, and John on guitar. On December 8, while his colleagues were absent, Paul recorded the lead vocal. Then, on December 20, he joined John and George to overdub the background vocals. As for Ringo, he

Paul beside his father and his brother Mike at the beginning of the 1960s. He composed the melody for "When I'm Sixty-Four" on the family piano.

added Premier Orchestral Chimes (tubular bells), that he also used for "Penny Lane." Paul wanted a more retro atmosphere and searched with George Martin for an adequate arrangement. They chose clarinets. On December 21, three clarinets, including a bass clarinet, played the score written by Martin. Finally, John added another vocal and Paul a piano part. The final mono mix was carried out on December 30. Because Paul was dissatisfied with the results, he asked Emerick to varispeed the tape in order to raise the whole song by as much as a semitone—a considerable difference. According to Emerick and Martin, Paul may have wanted his vocals to take on a more youthful air, as if he were, say, a sixteen-year-old.[5] But Paul related that what he wanted was a less pompous sound.[6] The stereo mix was done four months later, on April 17, 1967.

1. *The Beatles Anthology.*
2. Ibid.
3. Miles, *Paul McCartney.*
4. Sheff, *The Playboy Interview with John Lennon & Yoko Ono.*
5. Lewisohn, *The Complete Beatles Recording Sessions.*
6. Miles, *Paul McCartney.*

Lovely Rita

Lennon-McCartney / 2:42

SONGWRITER
Paul

MUSICIANS
John: rhythm guitar, backing vocal
Paul: vocal, bass, piano
George: rhythm guitar, backing vocal
Ringo: drums

RECORDED
Abbey Road: February 23–24, 1967 (Studio Two) / March 7 and 21, 1967 (Studio Two)

NUMBER OF TAKES: 11

MIXING
Abbey Road: March 21, 1967 (Studio Two) / April 17, 1967 (Studio Two)

TECHNICAL TEAM
Producer: George Martin
Sound Engineer: Geoff Emerick
Assistant Engineer: Richard Lush

Genesis

"Lovely Rita" is an example of the type of song that John despised. The context was fabricated, the character was fictitious, and there was no message. He thought these were boring stories about boring people: "I'm not interested in writing about people like that. I like to write about me, because I know me."[1] Paul, who wrote the song, talked about a "meter maid," in other words, a part-time worker. The sexual innuendo of the word *maid* amused him and was enough to stimulate his imagination. After the record came out, a lady called Meta Davies stated that she had given a ticket to Paul near St. John's Wood. Asking her what her first name was, Paul had told her he found it charming enough to write a song about her. Whether this was fact or fiction, "Lovely Rita" was definitely not the best lyric of the album.

Production

Paul wanted a sound like the Beach Boys for this song. On February 23, nine takes were required to record the rhythm track. John and George were on acoustic guitar, Paul on piano, and Ringo on drums. The intro of the piano was longer at this point than in the definitive version. After a first reduction, Paul recorded his bass. Geoff Emerick noted that this was a new habit: he began recording his bass alone, in order to concentrate on his instrument, which produced exceptional bass lines. On February 24, Paul recorded his vocal on a tape recorder that had been slowed down in order to gain almost a semitone at normal speed (just as they'd done for the rhythm track the night before). On March 7, there were a series of overdubs for the coda. All kinds of delirium, yells, amplified breathing, everything was drowned in a very pronounced echo: all four musicians

The four members of the original Pink Floyd band were Beatles fans. From left: Roger Waters, Nick Mason, Syd Barrett, and Rick Wright.

gathered around the same microphone, each one of them holding a comb wrapped in toilet paper (!) in front of their mouths to create unusual effects. On March 21, George struggled with the guitar solo. Emerick suggested replacing him with a piano solo. Much to his surprise, Paul asked Emerick to play the solo, but he was too embarrassed to do it. George Martin ended up playing the piano in a honky-tonk style. Recorded with the tape player running slow, it gained nearly three semitones at normal speed. Emerick also modified the sound by placing sticky editing tape on the guide rollers of the tape recorder, causing the tape to "wobble." The mono mix (also accelerated) was made on the same day, and the stereo was done on April 17.

1. Nick Mason, *Pink Floyd: L'histoire Selon Nick Mason* (Paris: Le Chêne, 2007); *Inside Out: A Personal History of Pink Floyd* (San Francisco: Chronicle Books, 2005).
2. Sheff, *The Playboy Interview with John Lennon & Yoko Ono*.

FOR BEATLES FANATICS

Norman Smith, the former sound engineer for the Beatles, now worked as the producer for Pink Floyd. On March 21, while Pink Floyd was recording its first record, *The Piper at the Gates of Dawn*, Smith brought the four members of the group to attend the mix of "Lovely Rita." Nick Mason said, "We sat down, humbly, at the back of the control room while they were working on the mix; then, after some time that we would have gladly extended, they asked us to leave. Every time the Beatles worked at Abbey Road, the atmosphere of the studios was transformed. You could feel their presence."[2]

Good Morning Good Morning

Lennon-McCartney / 2:41

1967

SONGWRITER
John

MUSICIANS
John: vocal
Paul: bass, lead guitar, backing vocal
George: rhythm guitar
Ringo: drums
Barry Cameron, David Glyde, Alan Holmes: saxophones
John Lee, unknown musician: trombones
Tom (unknown last name): French horn

RECORDED
Abbey Road: February 8, 1967 (Studio Two) / February 16, 1967 (Studio Three) / March 13, 28–29, 1967 (Studio Two)

NUMBER OF TAKES: 11

MIXING
Abbey Road: February 16 and 20, 1967 (Studio Three) / March 29, 1967 (Studio Two) / April 6 and 19, 1967 (Studio Two)

TECHNICAL TEAM
Producer: George Martin
Sound Engineer: Geoff Emerick
Assistant Engineer: Richard Lush

1. Sheff, *The Playboy Interview with John Lennon & Yoko Ono.*
2. Miles, *Paul McCartney.*
3. Sheff, *The Playboy Interview with John Lennon & Yoko Ono.*
4. Lewisohn, *The Complete Beatles Recording Sessions.*

Genesis

Absentmindedly watching television at home, John found the inspiration for this song. "The 'Good morning, good morning' was from a Kellogg's cereal commercial. I always had the TV on very low in the background when I was writing and it came over and then I wrote the song."[1] He found his middle-class lifestyle boring. He used to spend part of his spare time in his house in Weybridge watching the idiot box. His relationship with his wife was going downhill. Paul thought John felt trapped in a box living in suburbia: "I think he was also starting to get alarm bells."[2] The sentence *It's time for tea and Meet the Wife* alluded to the BBC sitcom *Meet the Wife* that John used to watch out of sheer boredom. John never liked this song; he called it "a piece of garbage."[3] It was amusing to notice that after "She Said She Said," he wrote "Good Morning Good Morning" and later "Cry Baby Cry" for the *White Album*. Were the double titles from force of habit of doubling himself in the studio? Was it an overdose of ADT?

Production

A demo of the song contains John singing while accompanying himself on his Mellotron with the sound of a string orchestra. The final version was drastically different. The details of the different takes are unclear. In the rhythm track recorded on February 8 (take 8), it seemed that John was singing, Paul was on bass, George was on rhythm guitar, and Ringo was on drums. A first reduction was done on February 16. Practically a month later, on March 13, a section of three saxophones was added, plus two trombones and a French horn. After spending a long time doing overdubs, John thought they sounded too clean. Geoff Emerick was then responsible for altering their sound with lots of compression, delay, equalization, flanging,

John Lennon's "Good Morning Good Morning" was inspired by a Kellogg's Cornflakes commercial.

and ADT. On March 28, there was a new vocal by John and a new reduction of the whole song. Once again, Paul assumed responsibility for the guitar solo that he played on his Fender Esquire. George must have felt increasingly useless. . . . Finally, John and Paul ended the song with backing vocals. John then had an amusing idea: he decided that he would like to end "Good Morning Good Morning" with a series of animal sound effects. Geoff Emerick recalled, "John said to me during one of the breaks that he wanted to have the sound of animals escaping and that each successive animal should be capable of frightening or devouring its predecessor!"⁴ Coincidentally, the connection between "Good Morning Good Morning" and "Sgt. Pepper's Lonely Hearts Club Band" (reprise) was the perfect blend of a hen clucking and the first note of

FOR BEATLES FANATICS

The saxophone players who recorded on March 13 were old friends of the Beatles: they were members of Sounds Incorporated, whom the Beatles had known at the Star Club in Hamburg. They had been under contract with Brian Epstein since 1963 and had opened for the Beatles at many of their concerts, including the concert at New York's Shea Stadium.

George's guitar solo. Emerick stated that this effect was deliberate, but Martin said later it was purely random. The final stereo mix was completed on April 6, and the mono on April 19.

Sgt. Pepper's Lonely Hearts Club Band (reprise)

Lennon-McCartney / 1:19

SONGWRITER
Paul

MUSICIANS
John: vocal, rhythm guitar, tambourine (?)
Paul: vocal, bass, organ
George: vocal, lead guitar, tambourine (?)
Ringo: vocal, drums, maracas

RECORDED
Abbey Road: April 1, 1967 (Studio One)

NUMBER OF TAKES: 9

MIXING
Abbey Road: April 1, 1967 (Studio One) / April 20, 1967 (Studio Three)

TECHNICAL TEAM
Producer: George Martin
Sound Engineer: Geoff Emerick
Assistant Engineer: Richard Lush

Genesis

It was Neil Aspinall who suggested the idea of a reprise, as Paul was completing the title song: "Why don't you have Sgt. Pepper as the master of ceremonies of the album? He comes on at the beginning of the show and introduces the band, and at the end he closes it."[1] Some time later, Lennon came up to him and told him, "Nobody likes a smart-arse, Neil."[2] which in Lennon language meant "good idea!" The reprise of "Sgt. Pepper" followed John's "Good Morning Good Morning," with its hen call connecting perfectly with the first note of George's guitar playing. And it introduced "A Day in the Life" for a grandiose finale.

Production

Saturday, April 1 was the day of the last recording session for the album. The Beatles, who realized that the end of these months and months of studio work was approaching, really felt on top of things. Paul was scheduled to leave two days later to join Jane Asher on the other side of the Atlantic. Because Studio Two was booked, only the huge Studio One was available. Geoff Emerick had to deal with reverb problems. He placed the group in a semicircle, so that each member could see the others, and placed large screens around them. They were once again going to play live. Right away you could feel the energy: Paul was on bass and singing lead, John and George both played guitar, and Ringo beat the drums as loudly as he could. The ninth take was best. The four Beatles then sang together and added maracas, tambourines, and an organ part played by Paul. The mono mix was carried out immediately with the addition of various sound effects, and the stereo mix, which was the very last mix of the album, was finalized on April 20. It was 6:00 A.M. It had taken them eleven hours to complete this last session.

1. The *Beatles Anthology*.
2. Miles, *Paul McCartney*.

Paul and John, wearing headphones, searching for the perfect sound.

A Day In The Life

Lennon-McCartney / 5:04

1967

SONGWRITER
John and Paul

MUSICIANS
John: vocal, rhythm guitar, piano
Paul: vocal, bass, piano
George: congas
Ringo: drums, maracas, piano
George Martin: piano, harmonium
Mal Evans: piano
Erich Gruenberg, Granville Jones, Bill Monro, Jürgen Hess, Hans Geiger, D. Bradley, Lionel Bentley, David McCallum, Donald Weekes, Henry Datyner, Sidney Sax, Ernest Scott: violins
John Underwood, Gwynne Edwards, Bernard Davis, John Meek: violas
Francisco Gabarro, Dennis Vigay, Alan Dalziel, Alex Nifosi: cellos
Cyril MacArther, Gordon Pearce: double bass
John Marson: harp
Roger Lord: oboe
Clifford Seville, David Sandeman: flutes
David Mason, Monty Montgomery, Harold Jackson: trumpets
Raymond Brown, Raymond Premru, T. Moore: trombones
Michael Barnes: tuba
Basil Tschaikov, Jack Brymer: clarinets
N. Fawcett, Alfred Waters: bassoons
Alan Civil, Neil Sanders: French horns
Tristan Fry: percussion

RECORDED
Abbey Road: January 19–20, 1967 (Studio Two) / February 3, 1967 (Studio Two) / February 10, 1967 (Studio One) / February 22, 1967 (Studio Two) / March 1, 1967 (Studio Two)

NUMBER OF TAKES: 7

MIXING
Abbey Road: January 30, 1967 (Studio Three) / February 13 and 22–23, 1967 (Studio Two)

TECHNICAL TEAM
Producer: George Martin
Sound Engineer: Geoff Emerick
Assistant Engineers: Phil McDonald, Richard Lush

Genesis

When the Beatles came to the studio to work on John's new song, it only had a provisional title: "In the Life of." And when John began singing it, along with his backup vocals, George Martin and Geoff Emerick were amazed: this was obviously a great song!

In order to write it, John had sat down in front of his piano with the *Daily Mail* of January 7 open before him and had built his text around two news items: the death of the Guinness heir, who had been killed in a car accident, and the repair of four thousand potholes in the streets of Blackburn, in Lancashire. When he went to Paul's house, the latter was impressed: "He was a bit shy about it," John said, "because I think he thought it was already a good song."[1] Paul suggested the fiery line *I'd love to turn you on*, a real provocation for the Establishment with its reference to drugs. John loved it! He also contributed the bridge, which created a wonderful transition between the orchestral part and the final verse. Paul said, "It was a little party piece of mine, although I didn't have any more written."[2] In 1980, John revealed that he was stuck on a word in the sentence, *Now they know how many holes it takes . . . the Albert Hall.* It was Terry Doran (the future CEO of Apple Ltd.) who proposed "*to fill.*" "A Day in the Life," which John called a "damn good piece," was one of the Beatles' most innovative songs. The BBC, who read into it allusions to illegal substances, banned it from the airwaves.

Production

The production of this song was epic. On the day of the first session, January 19, the song was not yet finished. The group recorded the rhythm track in a simple

John was inspired by the death of a Guinness heir to write "A Day in the Life."

manner (acoustic guitar, piano, bongos, and maracas). John's vocal, wrapped up in a heavy echo, was particularly moving. Instead of a traditional countdown, John called out "sugarplum fairy, sugarplum fairy." The whole team felt the emotion. Geoff Emerick remembered shivering as he heard this. The Beatles decided to leave twenty-four beats blank after the first and the second *I'd love to turn you on*, because they did not know at the time how to fill that space. It was Mal Evans who was in charge of counting the beats, and you can hear him as of 1:44 mixing up the numbers. Originally, his voice was supposed to disappear, but it was impossible to delete it—as well as the alarm clock ringing to indicate the end of the section! It was purely random that

the ringing perfectly coincided with Paul's bridge (*Woke up!*). John then recorded two different vocal takes and the very next day, a third one that made it possible to gather together the best parts of each one. After a first inconclusive attempt on January 20, Paul redid his voice and his bass playing on February 3, while Ringo redid his drumming. Initially reluctant to play too much, Ringo ultimately performed a remarkable part

1. *The Beatles Anthology.*
2. Ibid.
3. Martin and Hornsby, *All You Need Is Ears.*
4. Voormann, *Warum Spielst Du Imagine Nicht Auf Dem Weissen Klavier, John?*

On February 15, 1967, Paul directing the forty-musician symphonic orchestra playing during the sessions of "A Day in the Life."

on drums, one of his best ever. Geoff Emerick highlighted it by asking him to tune his toms very low and to remove the lower skins in order to slip in microphones, while everything was highly compressed.

On February 10, according to George Martin, John found a way to fill the twenty-four beats, "What I'd like to hear is a tremendous buildup, from nothing up to something absolutely like the end of the world,"[3] John said to George Martin by way of telling him to hire a symphonic orchestra. But Paul, according to Mark Lewisohn, claimed he was the one who came up with the idea. Being a lover of contemporary music, he may indeed have been the instigator. Whatever was the case, George Martin only reserved half a symphonic orchestra in order to save money, and on the day set

for recording, each of the forty musicians received a false nose, false breasts, gorilla hands, etc. What they did not know was that they were going to be asked to play randomly during twenty-four beats, starting from the lowest register of their instrument and then reaching gradually to the highest level. They were to do this without paying attention to the other musicians! Some friends were invited for the recording: among them were the Rolling Stones, Donovan, and Graham Nash. Klaus Voormann, who attended the session, related: "John arrived and announced, 'We are going to turn down the lights, and this way, no one will be able to tell if their neighbor is playing off key.' Bursts of laughter. The ice was broken. Sitting in the control room beside Ringo, we could hear George Martin call the first take:

"'A Day in the Life . . . take one' . . . As they started, we began getting goose bumps. As the crescendo progressed, the less they stayed put and encouraged by John and Paul, they were standing up one after another under the feverish direction of Martin. Everyone was staring at him, waiting for the signal for the end."

The orchestra was recorded several times on several tracks and this was then mixed down to one in order to boost the sound, an equivalent of 160 musicians. The results were amazing. All that was left was to figure out a conclusion at the climax of this. Paul tried to have everyone present hum one single note, but this did not work. The idea suddenly occurred to him—playing one single chord on several pianos at the same time! On February 22, John, Martin, Mal Evans, Paul, and Ringo together struck different keyboards and George Martin completed the effect with a harmonium. In order to prolong the sound as long as possible, Geoff Emerick gradually increased the recording level to the point where every bit of the sound was captured. The ninth attempt was the best. Duplicated three times, the effect was enormous. You can also hear Ringo's chair squeaking at 4:49! The mix required the synchronization of the orchestra's four-track tape recorders with the one of the Beatles' backing track. Ken Townsend found the technical solution and the final mono mix was done on the same day. The stereo version is dated February 23. After an attempt at a piano overdub, made on March 1 (which was not kept), "A Day in the Life," the major work of *Sgt. Pepper*, was finally complete.

1967

All You Need Is Love / Baby You're a Rich Man

SINGLE

RELEASED

Great Britain: July 7, 1967 /
No. 1 on July 19, 1967 for 3 weeks
United States: July 17, 1967 /
No. 1 on August 19, 1967 for 1 week

All You Need Is Love

Lennon-McCartney / 3:47

1967

SONGWRITER
John

MUSICIANS
John: vocal, harpsichord, banjo
Paul: bass, double bass, backing vocal
George: lead guitar, violin, backing vocals
Ringo: drums, percussion
George Martin: piano
Mike Vickers: conductor
Sidney Sax, Patrick Halling, Eric Bowie, John Ronayne: violins
Lionel Ross, Jack Holmes: cellos
Rex Morris, Don Honeywill: tenor saxophones
Evan Watkins, Harry Spain: trombones
Jack Emblow: accordion
Stanley Woods: trumpet, bugle
David Mason: piccolo trumpet

RECORDED
Olympic Sound Studios: June 14, 1967 (Studio One)
Abbey Road: June 19, 1967 (Studio Three) / June 23–25, 1967 (Studio One) / June 26, 1967 (Studio Two)

NUMBER OF TAKES: 58

MIXING
Abbey Road: June 21, 1967 (Room 53 + Studio Three) / June 26, 1967 (Studio Two) / November 1, 1967 (Room 53) / October 29, 1968 (Studio Three)

TECHNICAL TEAM
Producer: George Martin
Sound Engineers: Eddie Kramer (Olympic), Geoff Emerick, Malcolm Addey
Assistant Engineers: George Chkiantz (Olympic), Richard Lush, Phil McDonald, Martin Benge, Graham Kirkby

Genesis

The Beatles were chosen by the BBC to represent Great Britain in the first international satellite broadcast, which was scheduled for Sunday, June 25, 1967. The televised program, called *Our World*, was to connect five continents simultaneously and be watched by about 400 million viewers. John wrote a song for the event. He chose a very simple chorus, which everyone could understand, with a universal message—"All You Need Is Love." "I think if you get down to basics, whatever the problem is, it's usually to do with love. So I think 'All You Need Is Love' is a true statement," he said in 1971.[1] George was proud of this selection, "Everybody else was showing knitting in Canada, or Irish clog dances in Venezuela. We thought, 'Well, we'll sing "All You Need Is Love," because it's a subtle bit of PR for God.'"[2] The initial idea was to film the Beatles as they recorded. However, for technical reasons, they had to first produce a backing track for the broadcast (and it was also decided that the voices, the guitar solo, and the orchestra accompanying them would be live). George Martin asked them what arrangements they would like for the intro and the coda. "'Write absolutely anything you like, George,' they said. Put together any tunes you fancy, and just play it out like that."[3] Martin followed through and selected "La Marseillaise" (the French national anthem) for the introduction, a Bach invention, "Greensleeves," and a brief extract from "In the Mood" for the coda, because he was sure all these works were in the public domain. Unfortunately, the

1. http://www.beatlesinterviews.org/dba13tour.html.
2. *The Beatles Anthology.*
3. Martin and Hornsby, *All You Need Is Ears.*
4. *The Beatles Anthology.*
5. Ibid.

The Beatles celebrated the Summer of Love with "All You Need Is Love" and did not hesitate to state: "We are going to sing 'All You Need Is Love' because it is a subtle ad for God."[4]

arrangement of "In the Mood" was copyrighted and EMI had to come to an agreement with its copyright holder. Some guests came to the huge Studio One of Abbey Road on the day of the broadcast: Brian Jones, Mick Jagger, Keith Richards, Marianne Faithfull, Keith Moon, Eric Clapton, Graham Nash, and many others. All were dressed in colorful clothes. Although the program was broadcast in black and white, the show was a worldwide success. The single came out on July 7 and immediately shot up to the top of the charts: "All

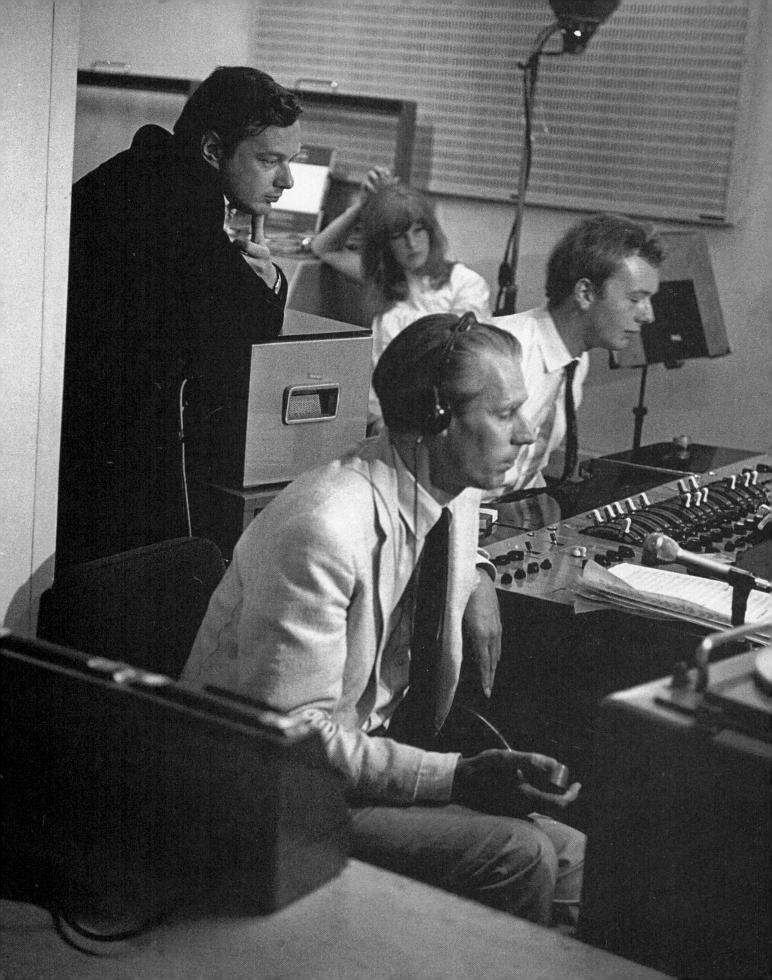

In the control room, George Martin (in the foreground), Brian Epstein (left), and Geoff Emerick getting ready to record the Beatles live for the program broadcast worldwide.

Following double-page spread: The Beatles rehearsing before the live recording of "All You Need Is Love."

The Beatles translated the title of their song into several languages for journalists who had come to immortalize the recording of their song of love.

You Need Is Love," emblematic of the Summer of Love, became the anthem of young people around the world, a hymn for peace and love.

Production

Since George Martin could not reserve Abbey Road on time, he ended up on June 14 with his group at Olympic Sound Studios for the second time. John said, "We just put a track down. Because I knew the chords I played it on whatever it was, harpsichord. George played a violin because we felt like doing it like that and Paul played a double bass. And they can't play them, so we got some nice little noises coming out."[5] Only Ringo played his usual instrument. After a reduction on tape, the Beatles finished the preliminary recording at Abbey Road on June 19: John sang lead, with Paul and George on backing vocals, George Martin on piano, and Ringo doing percussion. Then John added a part on banjo. According to Geoff Emerick, John announced foolheartedly that he would sing live. Meeting the challenge, Paul stated he would play his bass the same way. George, who was at first undecided about his guitar solo, ended up agreeing. Only Ringo would record on playback for technical reasons. On June 23 and 24, an orchestra of thirteen musicians rehearsed with the Beatles. The conductor of the orchestra was none other than Mike Vickers of Manfred Mann, in which Klaus Voormann played the bass and the flute. On June 25, there were a few final rehearsals before the live show. Everyone was nervous, especially John, who was worried about forgetting his words. According to Emerick, Harrison had a private conversation with the director of the show. Emerick thought he was suggesting that the camera not focus on him during his solo, because he was not very confident about his performance or he planned to replace it later. A camera was set up in the control room. But forty seconds before showtime, Martin received a call from the director who asked him to ensure contact with his cameraman, because the connection was disrupted! As soon as the live show began, the Beatles had no problem performing their sublime song. Up to the last note, it was an explosion of music, joy, and brotherhood: it was the hymn of a whole generation, the children of the sixties. It was also the success of a whole team, especially George Martin, who was going through a hard time, because his father had died two days before, his wife was pregnant, and they were moving into a new residence that very day! In order to thank him, his name was credited for the first time on a Beatles single!

Once the studio was empty, John redid two lines of the second couplet and Ringo replaced the snare drum roll that he had insisted on doing live. The mono mix was done the next day, but the stereo mix was not carried out until October 29, 1968. One last detail: it seems that it was John and not Paul who repeated *She loves you* on the coda.

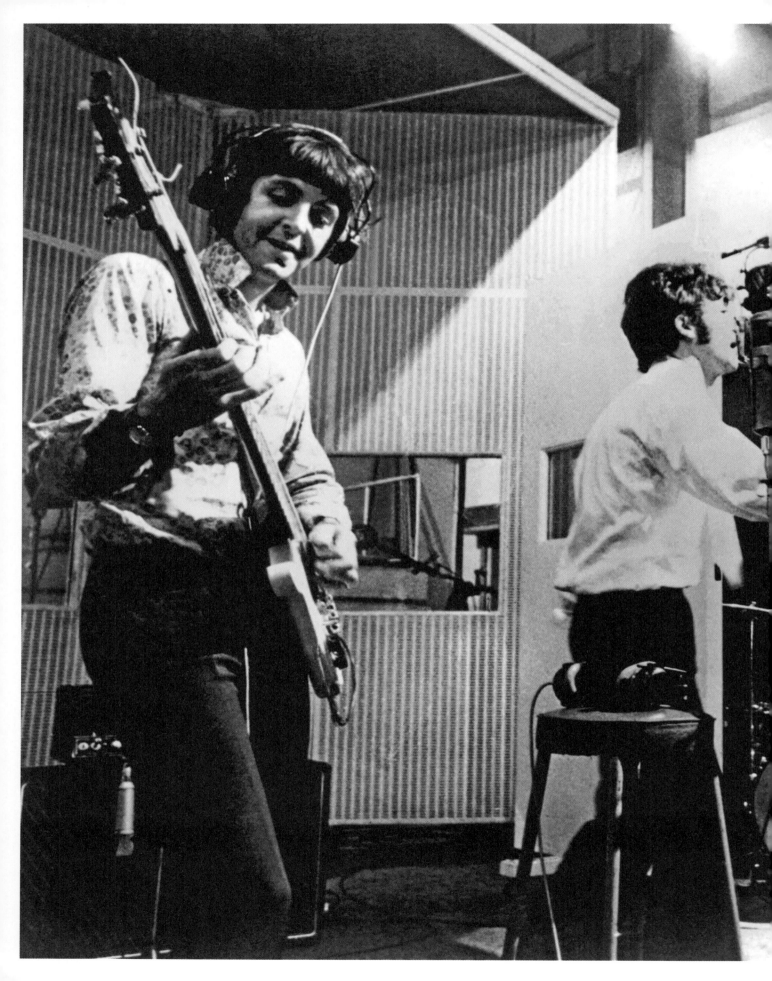

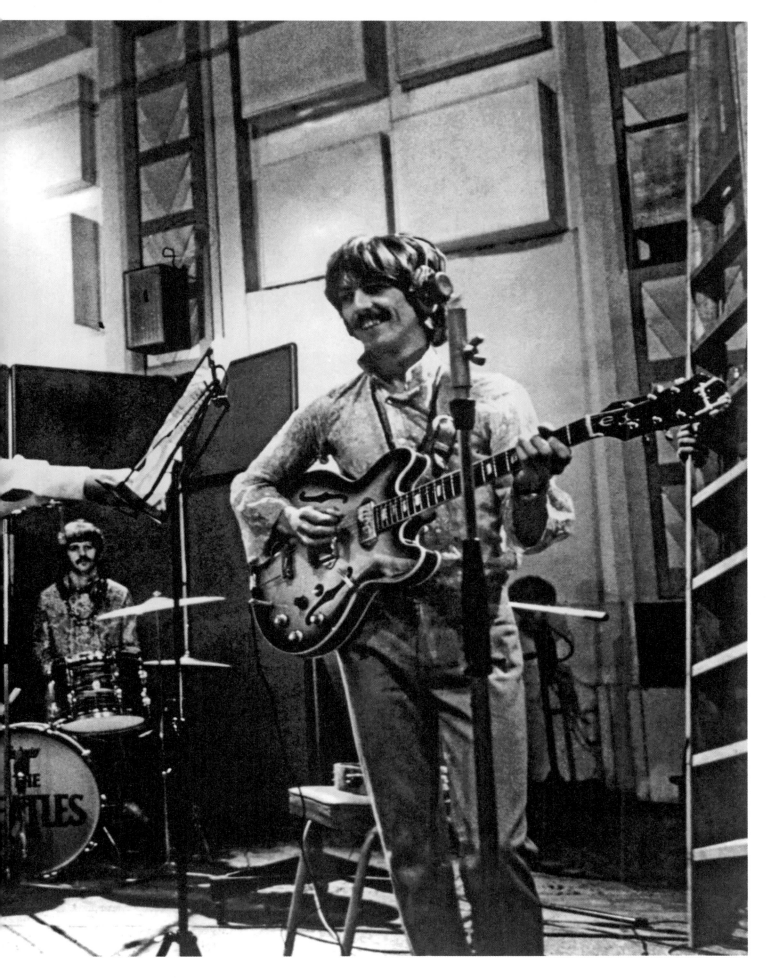

Baby You're A Rich Man

Lennon-McCartney / 2:59

1967

SONGWRITERS
John and Paul

MUSICIANS
John: vocal, piano, clavioline
Paul: bass, piano, backing vocal
George: lead guitar, backing vocal, hand claps
Ringo: drums, hand claps
Eddie Kramer: vibraphone (?)
Mick Jagger: backing vocal (?)

RECORDED
Olympic Sound Studios: May 11, 1967 (Studio One)

NUMBER OF TAKES: 12

MIXING
Olympic Sound Studios: May 11, 1967 (Studio One)

TECHNICAL TEAM
Producer: George Martin
Sound Engineer: Keith Grant
Assistant Engineers: Eddie Kramer

FOR BEATLES FANATICS

Eddie Kramer, who was then the assistant engineer at Olympic, soon became famous recording, among other rock icons, Jimi Hendrix, Led Zeppelin, the Rolling Stones, David Bowie, and Kiss.

Genesis

"Baby You're a Rich Man" was a combination of two unfinished songs: one by John for the verses (called "One of the Beautiful People") and another by Paul, for the choruses. During a work session on Cavendish Avenue, they worked on John's idea about the "Beautiful People," a name given to hippies. Paul said, "The question then was, how does it feel to be one of the beautiful people?"[1] Semi-ironic, semi-psychedelic, the message was, according to John, "Stop moaning. You're a rich man and we're all rich men, heh, heh, baby!"[2]

Originally, this song was supposed to be part of the soundtrack for the animated movie *Yellow Submarine*. It finally appeared on side B of the single "All You Need Is Love," but not on the album (although it was in the movie soundtrack).

Production

"Baby You're a Rich Man" was the first song to be entirely recorded outside Abbey Road. On May 11, the Beatles were together at the famous Olympic Sound Studios in London, where the Stones recorded in those days. The recording was done briskly by Keith Grant. John was on piano and on clavioline, a self-amplified electronic keyboard reproducing different sound effects. The sound used was close to that of a shenai, an Indian instrument that made the tune catchy (and made *Revolver* complete). Paul added a second piano and an excellent part on bass, partially muted. George was on lead guitar and Ringo on drums. Once the rhythm track was recorded, John sang and doubled his voice with Paul and George doing backing vocals. According to George Chkiantz, Keith Grant and Eddie Kramer marveled at John's voice. "They couldn't believe anyone could sing that well."[3] Maracas and tambourines

John Lennon on piano, one of the instruments he played in "Baby You're a Rich Man."

were then added, with, so it seems, Eddie Kramer on vibraphone. On one of the boxes containing the tapes, Mark Lewisohn noticed that Mick Jagger's name also appeared with a question mark. Since Jagger associated regularly with the Fab Four, it was quite possible that he sang backing vocals in the free-for-all choruses near the end of the song. The mix was done right afterwards and the Beatles took off with the master. Paul stated, "Keith Grant mixed it, instantly, right there. He stood up at the console as he mixed it."[4]

A French Invention

The clavioline that John used was a French invention created in Versailles in 1947 by Constant Martin and used in many songs, like "Runaway" (1961) by Del Shannon and "Telstar" (1962) by the Tornados.

1. Miles, *Paul McCartney*.
2. Jann Wenner, *Lennon Remembers: The Full Rolling Stone Interviews from 1970* (London and Brooklyn, NY: Verso Publishing, 2000), http://www.amazon.com/Lennon-Remembers-Rolling-Stone-Interviews/dp/1859846009/ ref=sr_1_1?ie=UTF8&qid=1366319599&sr=8-1& keywords = jann+wenner+lennon.
3. Lewisohn, *The Complete Beatles Recording Sessions*.
4. Miles, *Paul McCartney*.

Magical Mystery Tour
Your Mother Should Know
I Am the Walrus
The Fool on the Hill
Flying
Blue Jay Way

ALBUM

RELEASED

Great Britain: (EP) December 8, 1967 /
No. 1 on January 13, 1968 for 2 weeks
United States: (album) November 27, 1967 /
No. 1 on January 1, 1968 for 8 weeks

Magical Mystery Tour: Inspired Madness

The End of the Epstein Years

In late 1965, Brian Epstein had considered having his group perform in a feature film, called *A Talent for Loving*, that was based on the novel by Richard Condon for which Epstein had bought the copyright. The project fell through and it was not until April 1967 that the idea for a new film resurfaced. It came from Paul. On April 3, as soon as the recording of *Sgt. Pepper* was over, he went to join Jane Asher in the United States. When he arrived in Denver with his Super 8 camera, he remembered the bus trips he had taken during his childhood, when people took surprise trips, called "Mystery Tours." He thought of a television production in which a group of actors and friends would take off on a bus in search of adventure, filming what was going on from day to day. Upon his return to London, Paul discussed the project with Brian Epstein, who found it brilliant. The project was launched. On May 25, 1967, before starting to shoot, the Beatles founded their first company, Apple Music Ltd. That summer, they basked in the triumph of *Sgt. Pepper*, which appeared on June 1, and they agreed to represent Great Britain in the program *Our World* that would be broadcast before 400 million viewers on June 25. For this event, they performed the anthem of 1967, "All You Need Is Love," which immediately became number 1 worldwide.

In July, they left for Greece, where they planned on purchasing an island (a plan that fell through), signed a petition in *The Times* in favor of legalizing marijuana, then, after attending a conference on transcendental meditation delivered by someone called Maharishi Mahesh Yogi, they went to Wales, in order to take a course on meditation. Two days later, on August 27, 1967, Brian Epstein was found dead in his home, after swallowing a fatal cocktail—which was certainly accidental—of alcohol and sleeping pills. The Beatles were crushed. Their father figure and mentor was no longer there for them. On September 1, they gathered at Paul's place to decide what to do about their future. They agreed to carry on with the *Magical Mystery Tour* project and they went to the studio to finalize the songs. Among the six songs, John contributed the extraordinary song "I Am the Walrus" and Paul the irresistible "Fool on the Hill." George wrote a very well-done song called "Blue Jay Way." Finally, for the first time, an instrumental written by all four of them was recorded, called "Flying." The movie was a total failure and the Beatles were heavily criticized for it. On the other hand, the album was successful.

The Movie

The movie was completely improvised: no script, no logistics, no dialogue—everything was fun. Now that Brian Epstein was gone, the Beatles found out how difficult it was to organize a project of this magnitude. Right away, Paul became the director: he distributed the different scenes every day and picked the actors from *Spotlight* (a London actors' directory). The shoot began in London on September 11 and lasted two weeks. Thirty-three people took off on the bus with the team, which traveled at random through the British countryside. Nobody knew what would happen— and that was what excited the Beatles. Except for a few scenes that were rather fun (the clip of "I Am the Walrus" or the spaghetti scene), the results were mediocre. It took Paul eleven weeks to finalize the edit, instead of the two planned. The BBC bought the copyright for the ridiculous sum of £9,000 [$14,000 U.S.] and broadcast

The *Magical Mystery Tour* bus on a small bridge in the area of Dartmoor, in Devon. Opposite: While they were shooting the *Magical Mystery Tour*, the happy team posed before the camera on the steps of the Atlantic Hotel in Newquay, a seaside resort in Cornwall.

Magical Mystery Tour on December 26, in black and white, even though the special effects had specifically been designed for color. The very next day, the critics trashed the movie; it was the Beatles' first failure. Paul had to defend himself on *The David Frost Show*. Nevertheless, the movie raked in $2 million in the United States and the record brought in $8 million in the ten days that followed the beginning of sales on the other side of the Atlantic.

The Instruments

They used the same instruments as in *Sgt. Pepper*. The only difference was that they had their guitars painted in psychedelic colors; these were John's J-160 E and the Epiphone Casino, Paul's 4001S, and George's Fender Stratocaster, which he played on "All You Need Is Love."

RELEASED

EMI decided to edit the master collected on 2 extended plays (EPs), to which was added a booklet of 24 pages with photos, lyrics, and scripts adapted as a comic book.
Record 1—side 1: "Magical Mystery Tour" / "Your Mother Should Know"; side 2: "I Am the Walrus"
Record 2—side 1: "The Fool on the Hill" / "Flying"; side 2: "Blue Jay Way"

The American editors preferred to market a 33 rpm record with a different track order and grouped the following songs on side 2: "Hello, Goodbye" / "Strawberry Fields Forever" / "Penny Lane" / "Baby You're a Rich Man" / "All You Need Is Love."
Finally, EMI adopted the album configuration and abandoned the double EP format.

Magical Mystery Tour

Lennon-McCartney / 2:48

SONGWRITER
Paul

MUSICIANS
Paul: vocal, bass, piano, percussion
John: rhythm guitar, backing vocal, percussion
George: lead guitar, backing vocal, percussion
Ringo: drums, percussion
George Martin: celesta (?)
Mal Evans, Neil Aspinall: percussion
David Mason, Elgar Howarth, Roy Copestake, John Wilbraham: trumpets

RECORDED
Abbey Road: April 25–27, 1967 (Studio Three) / November 6, 1967 (Studio One)

NUMBER OF TAKES: 9

MIXING
Abbey Road: April 27, 1967 (Studio Three) / May 4, 1967 (Studio Three) / November 6, 1967 (Studio Three) / November 7, 1967 (Studio One)

TECHNICAL TEAM
Producer: George Martin
Sound Engineers: Geoff Emerick, Malcolm Addey
Assistant Engineers: Richard Lush, Ken Scott, Graham Kirkby

Genesis

After coming up with the idea for the movie, Paul wrote the theme song, although John said, "Paul's song. Maybe I did part of it, but it was his concept."[1] The song was based on memories of surprise trips that he and John had taken when they were children and evoked the carnival atmosphere, offering adventure and mystery. *Roll up! Roll up!* was an invitation to a trip that can be interpreted differently. Paul said, ". . . [it] was also a reference to rolling up a joint."[2] Obviously, in the days of psychedelics there were innuendos of all kinds. *It's dying to take you away* was an allusion, according to Paul, to the *Tibetan Book of the Dead*. It was a "Mystery Tour," but with hallucinogenic substances.

Production

Four days after the final touches to *Sgt. Pepper* and five weeks before the new record was marketed, the Beatles returned to the studio on April 25 to record "Magical Mystery Tour." The idea of adding trumpets was brought up right at the beginning of the session. For the time being, they built the rhythm track with Paul on piano, John and George on guitar, and Ringo on drums. The third track was satisfactory and reduced right away. While they were reducing, some flanging/chorus was applied to George's guitar and to the end on the piano. Someone proposed inserting the noise of a bus passing by. The coach sound effect from the Abbey Road sound effect collection was made into a tape loop, and would be added later to the song at the remix stage. The next day, Paul recorded his bass part. Then, with the help of Mal Evans and Neil Aspinall, the four musicians added a lot of percussion: maracas, cowbell, tambourines, snare drum, toms, etc. John, Paul, and George then tackled the backing vocals with

George, John, and Paul trying to play brass instruments while Brian Epstein looks on, amused.

the support of added echo and delay. There was a new reduction of the whole song. On April 27, Paul recorded his singing, backed up by John and George, while the tape recorder ran at a slower speed, raising the song's pitch when played at normal speed. There were four trumpets in the studio on May 3. Paul sang for George Martin what he wanted as an arrangement, but he was not satisfied with the results. Howarth, one of the trumpet players, tired of waiting, suggested the part to be played. The session ended with the addition of a celesta (?) at the end of the song. Six months later, on November 7, Paul redid other vocal parts and new sound effects were inserted. The final mono and stereo mixes were made the same day.

FOR BEATLES FANATICS

If you use a bit of imagination, you can hear the bus put the brakes on at 0:51 and crash at 0:53. Some people claimed, erroneously, that it was the accident in which Paul was killed.

1. Sheff, *The Playboy Interview with John Lennon & Yoko Ono.*
2. Miles, *Paul McCartney.*

Your Mother Should Know

Lennon-McCartney / 2:26

SONGWRITER
Paul

MUSICIANS
Paul: vocal, bass, piano
John: organ, backing vocal
George: tambura, backing vocal
Ringo: drums, tambourine

RECORDED
Chappel Recording Studios: August 22–23, 1967
Abbey Road: September 16, 1967 (Studio Three) /
September 29, 1967 (Studio Two)

NUMBER OF TAKES: 52

MIXING
Abbey Road: September 30, 1967 (Studio Three) / October
2, 1967 (Studio Three) / November 6, 1967 (Studio One)

TECHNICAL TEAM
Producer: George Martin
Sound Engineers: John Timperley (Chappell), Ken Scott,
Geoff Emerick
Assistant Engineers: John Iles (Chappell), Jeff Jarratt,
Graham Kirkby

FOR BEATLES FANATICS

The Chappell Recording Studios, used by artists such as Ella Fitzgerald, Cream, and the Who, attracted the finest internationally renowned musicians.

Genesis

"Your Mother Should Know" was another one of Paul's incursions into the world of music halls, in the same vein as "When I'm Sixty-Four," a song recorded nine months before for *Sgt. Pepper*. Composed originally for an important scene in *Magical Mystery Tour*, it was finally used in the sequence of the broad stairway (John almost missed a step at 0:15!). Paul wrote it on the harmonium on Cavendish Avenue in the presence of his aunt Jin and his uncle Harry, which perhaps accounted for the retro style of the song. "In 'Your Mother Should Know,' I was basically trying to say your mother might know more than you think she does. Give her credit."[1] It seemed that the song was a runner-up for the BBC program, *Our World*, but the song that was finally used was "All You Need Is Love."

Production

The Abbey Road Studios were not available, so the Beatles recorded on August 22 at the Chappell Recording Studios in London. Once again, they picked up the *Magical Mystery Tour* project that had been left on the back burner since May. There is a lack of information about the instruments played by each musician; nevertheless, for the rhythm track, we can assume Paul was on piano, John on organ, George on guitar and tambura (which was audible on the last notes), and Ringo on drums. The next day, they recorded the vocals, with Paul singing lead, and George and John contributing backing vocals. On September 16, they returned to Abbey Road to

More often than not, Paul played on the piano the melodies inspired by the music halls of his youth.

completely redo the song because Paul was dissatisfied with the work done at the Chappell Studios. In this new version, Ringo's snare drum, accompanied by a harmonium and a piano (see *Anthology 2*), was predominant. But on September 29, Paul was undecided and finally returned to the recording from Chappell Studios and, together with John, added bass and some organ. The mono mix was carried out on October 2 and the stereo on November 6.

1. Miles, *Paul McCartney*.

The Last Session

According to John Timperley, the sound engineer at Chappell Recording Studios, when Brian Epstein came to visit the Beatles on August 23, he looked rather gloomy and depressed. It was the very last session he attended. He was found dead in his bed on August 27, 1967.

I Am The Walrus

Lennon-McCartney / 4:33

SONGWRITER
John

MUSICIANS
John: vocal, Hohmer Pianet electric piano
Paul: bass, backing vocal, tambourine
George lead guitar, backing vocal
Ringo: drums
Sidney Sax, Jack Rothstein, Ralph Elman, Andrew McGee, Jack Greene, Louis Stevens, John Jezzard, Jack Richards: violins
Lionel Ross, Eldon Fox, Bram Martin, Terry Weil: cellos
Gordon Lewin: clarinet
Neil Sanders, Tony Tunstall, Morris Miller: horns
The Mike Sammes Singers: vocal effects

RECORDED
Abbey Road: September 5, 1967 (Studio One) / September 6, 1967 (Studio Two) / September 27, 1967 (Studios One and Two) / September 28, 1967 (Studio Two)

NUMBER OF TAKES: 17

MIXING
Abbey Road: September 5, 1967 (Studio One) / September 6 and 28–29, 1967 (Studio Two) / November 6, 1967 (Studio Three) / November 17, 1967 (Room 53)

TECHNICAL TEAM
Producer: George Martin
Sound Engineers: Ken Scott, Geoff Emerick
Assistant Engineers: Ken Scott, Richard Lush, Graham Kirkby

Released as a Single

"Hello, Goodbye" / "I Am the Walrus"
Great Britain: November 24, 1967 / No. 1 on December 6, 1967 for 7 weeks
United States: November 27, 1967 / No. 1 on December 30, 1967 for 3 weeks

Genesis

"I Am the Walrus" was among John's masterpieces. It was a song with multiple sources of inspiration, full of images from *Alice in Wonderland*, more specifically from the poem "The Walrus and the Carpenter." John revealed later that the beginning of the melody came to him when he heard the notes of a police car siren that was passing by while he was on the piano; "the first line was written on one acid trip one weekend, the second line on another acid trip the next weekend, and it was filled in after I met Yoko."[1] The lyrics were an anthology of surrealistic images, ideas, and allusions. This was a partly deliberate choice: John wanted to make fun of pseudointellectuals who interpreted his songs in a phony way. He asked his friend Pete Shotton for help and both searched their memories to compose this song. They recalled from their childhood the text of a song they used to sing: *Yellow matter custard, green slop pie / All mixed together with a dead dog's eye . . .*, then there was the memory of semolina, a sort of insipid pudding they ate as children, and pilchard, which was a sardine to feed cats. Shotton recalls seeing John writing feverishly: *Semolina pilchard climbing up the Eiffel Tower . . .* Then, turning to him with a smile, he quipped, "Let the fuckers work that one out, Pete!"[2] Some people read in the word *pilchard* a reference to the infamous Sergeant Pilcher, the terror of the rock circles of the sixties, who was known for sending the Stones to jail. John said, "In those days I was writing obscurely, à la Dylan, never saying what you mean but giving the *impression* of something, where more or less can be read into it."[3] Therefore, according to him, it was just "tongue in cheek . . . 'I am the eggman'? It could have been the pudding basin for all I care. It's not that serious."[4] The author Jeff Kent thought, on the

Throughout his career, John took pleasure in manipulating nonsense to confuse journalists and all the other commentators. "I Am the Walrus" was one of the best examples of this kind of obfuscation.

other hand, that John was alluding to his friend Eric Burdon who was nicknamed "Eggs," because of some of his favorite sexual practices. As for *Element'ry penguin*, he was targeting the Hare Krishna movement, and more specifically, Allen Ginsberg. John provoked the censors at the BBC, who did not appreciate the sentence *you let your knickers down*. The *walrus* would

The Evil Walrus
John would reveal later that he did not understand at the time he wrote this song that the walrus in Lewis Carroll's *Alice in Wonderland* was an evil character, symbolizing capitalism—one the author wanted to denounce!

1. Sheff, *The Playboy Interview with John Lennon & Yoko Ono*.
2. Shotton and Schaffner, *John Lennon in My Life*.
3. *The Beatles Anthology*.
4. Sheff, *The Playboy Interview with John Lennon & Yoko Ono*.
5. Miles, *Paul McCartney*.
6. *The Beatles Anthology*.

reappear in "Glass Onion" in 1968 and in "God," from John's first solo album, *Plastic Ono Band*.

Production

On September 5, the Beatles were now without a manager, and they found themselves in the studio for the first time since the funeral of Brian Epstein, on August 29. John's voice was full of emotion as he presented his song. He sang, *I'm crying*. George Martin felt lost. This tale of walruses and eggmen perplexed him. Despite it all, they recorded the rhythm track in sixteen takes: John was on the Hohner Pianet, Paul on tambourines, George on his Fender Stratocaster, and Ringo on drums. The next day, they reduced the whole song and added flanging/chorus on the Pianet. Then Paul recorded his bass and Ringo doubled his snare drum and bass drum. Finally, John delivered his superb vocal. According to Geoff Emerick, he had one requirement: he wanted it to sound as though it came from the moon. Emerick saturated the entrance of his preamplifier microphone and made John sing on a microphone of poor quality: the results were perfect. The following session was scheduled for September 27, giving George Martin the time to write an instrumental score meeting John's needs. On the day of the recording, the arrangements he made for eight violins, four cellos, a bass clarinet, and three French horns were extraordinary. To satisfy John, who also wanted a few bizarre sounds, he hired the Mike Sammes Singers, a vocal group of sixteen mixed choir singers. They sang different vocal effects that made the song unique: the *Ho-ho-ho, hee-hee-hee, ha-ha-ha; Oompah oompah, stick it up your jumper; Got one, got one, everybody's got one*; and other oddities! John

loved it and was splitting a gut laughing as he listened to them. "It was a fascinating session. That was John's baby, great one, a really good one,"[5] said Paul.

Several reductions and overdubs were done the next day. On September 29, there was an epic mixing session with Ringo tuning a radio and John inserting the random radio extracts! He stumbled upon a BBC program broadcasting *King Lear*. The voices in the coda are lines of William Shakespeare! The final mix resulted from the edit of mixes 10 (up to *Sitting in an English garden*) and 22 (for the ending). For the stereo mix, carried out on November 6, Geoff Emerick could not find the radio program chosen by Ringo (the radio and the four-track tape of the song had been injected live and simultaneously through the mix console to be recorded on the master tape) and decided to create an artificial stereo for the second part of the mono mix involved. The final stereo mix was done on November 17. John said in 1974, "'I Am the Walrus' is also one of my favorite tracks—because I did it, of course, but also because it's one of those that has enough little bitties going to keep you interested even a hundred years later."[6]

Technical Details

When George Martin recorded the string and wind instruments, he did it on a second tape recorder. Likewise for the choir. After mixing together all the tracks on one four-track tape recorder, Martin manually synchronized this tape with the four-track tape of the Beatles' performances on another tape recorder. This was why in some spots there was a gap between the orchestra and the rhythm track.

The Fool On The Hill

Lennon-McCartney / 2:57

1967

SONGWRITER
Paul

MUSICIANS
Paul: vocal, bass, piano, recorder
John: rhythm guitar, bass harmonica, maracas
George: acoustic guitar (?), bass harmonica
Ringo: drums, maracas, finger cymbals
Christopher and Richard Taylor, Jack Ellory: flutes

RECORDED
Abbey Road: September 6 and 25–26, 1967 (Studio Two) /
September 27, 1967 (Studios One and Two) / October 20,
1967 (Studio Three)

NUMBER OF TAKES: 6

MIXING
Abbey Road: September 25, 1967 (Studio Two) / September
27, 1967 (Studios One and Two) / October 25, 1967 (Studio
Two) / November 1, 1967 (Studio Three)

TECHNICAL TEAM
Producer: George Martin
Sound Engineers: Geoff Emerick, Ken Scott
Assistant Engineers: Ken Scott, Richard Lush, Phil
McDonald, Graham Kirkby

FOR BEATLES FANATICS

In the mid-sixties, the recorder went through a
surprising revival in rock music with songs such
as the Rolling Stones' "Ruby Tuesday." We
could also mention "I've Seen All Good
People" (1971) by Yes and "Stairway to
Heaven" (1971) by Led Zeppelin.

Genesis

"The Fool on the Hill" was one of Paul's most beauti-
ful ballads. Marijke Koger, a member of the group of
Dutch artist-designers called The Fool, regularly did his
tarot reading and he always pulled out the card of the
Fool, which symbolized innocence and childhood. This
inspired him and he wrote a song about someone like
the Maharishi. Paul explained, "His detractors called
him a fool. Because of his giggle he wasn't taken too
seriously. It was this idea of a fool on the hill, a guru in
a cave, I was attracted to."[1] Paul had played for John
a sketch of his song at the end of March, while they
were recording "With a Little Help from My Friends."
John liked it, noting, "Another good lyric. Shows he's
capable of writing complete songs."[2] It was probably
after attending the first conference of the Maharishi a
few months later, on August 24, that he could finish
writing the song.

Production

On September 6, Paul recorded a demo alone on the
piano. The lyrics were not definitive, but the charm and
the structure were already there: it was a great song.
On September 25 the real session began. The version
recorded after three takes and a reduction was fairly
distant from what was kept (see *Anthology 2*). The very
next day, the Beatles redid it almost entirely. A new
rhythm part was recorded with Paul on piano, George
(?) on acoustic guitar, Ringo on drums, and John (?) on
maracas. Then Paul added some "Mrs. Mills" piano,
some Schiedmayer celesta (as in "Baby It's You"), and a
recorder. Ringo was on finger cymbals. After a reduc-
tion, Paul sang and added another part with recorder.
John and George were each on their bass harmonica.
A loop, which was probably made with the sound of a

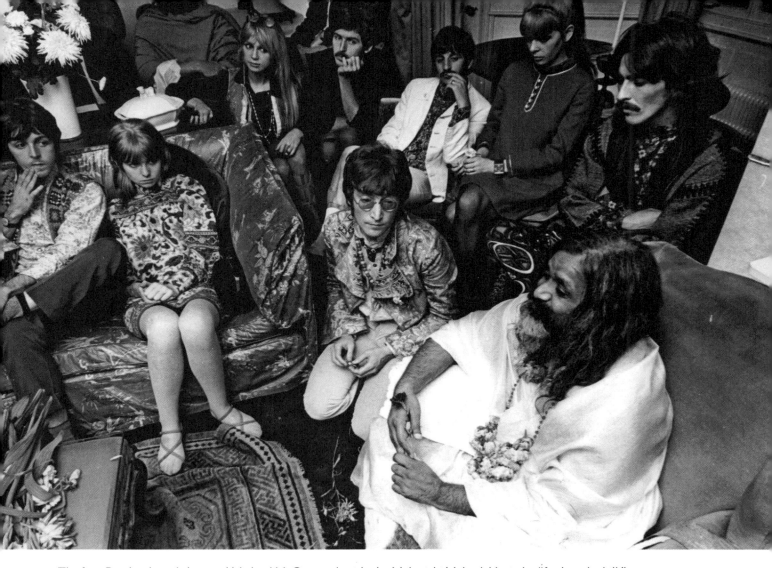

The four Beatles, Jane Asher, and Michael McCartney beside the Maharishi Mahesh Yogi, the "fool on the hill."

strongly varisped electric guitar was inserted at 2:40. On September 27, Paul provided another vocal. Then three flutists were hired for October 20. To record them, Ken Scott had to synchronize a second tape recorder while using the method Ken Townsend used for "A Day in the Life." The mono mix was done on October 25 and the stereo mix on November 1. "'The Fool on the Hill' was one of the movie's most complicated scenes for Paul to edit. The scene was filmed in the French back country near Nice. Paul danced on a hill while the song played on a cassette player. Unfortunately, Paul had not requested a clapboard, as is typically used in film when audio and video must be kept in sync. As a result, this created a nightmare during the editing process when Paul tried to line up the film with the song.

Recorder Lessons

Paul began composing music when he hit a D 6th chord on his father's piano in Liverpool.[3] And later, thanks to a few lessons from Jane Asher's mother, Margaret, he learned to play the recorder.

1. Miles, *Paul McCartney.*
2. Sheff, *The Playboy Interview with John Lennon & Yoko Ono.*
3. Miles, *Paul McCartney.*

Flying

Harrison-Lennon-McCartney-Starkey / 2:14

MUSICIANS
John: vocals, organ, Mellotron, sound effects
Paul: vocals, guitar, bass
George: vocals, guitar
Ringo: vocals, drums, maracas, sound effects

RECORDED
Abbey Road: September 8, 1967 (Studio Three) /
September 28, 1967 (Studio Two)

NUMBER OF TAKES: 8

MIXING
Abbey Road: September 8, 1967 (Studio Three) /
September 28, 1967 (Studio Two) / November 7, 1967
(Studios One and Two)

TECHNICAL TEAM
Producer: George Martin
Sound Engineers: Geoff Emerick, Ken Scott
Assistant Engineers: Richard Lush, Peter Mew, Graham
Kirkby

FOR BEATLES FANATICS

Chet Baker did an adaptation of "Flying" with saxophone and flute player Bud Shank.

Genesis

The Beatles wrote their first instrumental together under the title "Aerial Tour Instrumental." Of course, there had been "Cry for a Shadow" in 1961, but that song had been written by Harrison-Lennon and had been recorded under the name of the Beat Brothers. The group also played and composed other instrumentals ("Catswalk," "12-bar Original," etc.), but those either didn't come out as records or were adopted by other musicians.

In order to record "Flying," Paul suggested that everyone improvise in the studio, "We can keep it very very simple, we can make it a twelve-bar blues."[1] He brought the little melody that he performed on the Mellotron with a trombone sound. In the movie, "Flying" illustrated a dream sequence with views in the air. It was interesting that these views came from hours of rushes filmed over the Arctic during the final scene of Stanley Kubrick's *Doctor Strangelove* (1964), which Derek Taylor (Brian Epstein's former personal assistant) got hold of.

Production

On September 8, the Beatles needed six takes to record the rhythm track. Ringo was on drums, Paul on bass, John on the organ (?), and George played lead guitar. One saxophone part extracted from an unidentified jazz record was even added at the end of the piece! Geoff Emerick remembered plugging George's guitar into a DI box to pass the sound directly into the mixing console. This gave it a softer, more wooly sound. Besides, this was the most interesting instrumental part of the song. Three organ parts were then added and played backwards on a different track. After a reduction, Paul

The Fab Four aboard the "Magic Bus" that the Who would have loved.

recorded the melody on the Mellotron and all of them together sang the choruses. Ringo's voice was put forward in the mix to give the song a different color. The piece was over nine minutes long. On September 28, other overdubs were integrated: some Mellotron, guitar, maracas, and various percussion parts. John and Ringo then worked on sound effects, loops, and reversed sounds; namely, recorders played on the Mellotron for the coda. The mono and stereo mixes that trimmed the song to 2:14 were done on November 7.

1. Miles, *Paul McCartney.*

Blue Jay Way

George Harrison / 3:53

MUSICIANS
George: vocal, organ
John: organ (?), backing vocal
Paul: bass, backing vocal
Ringo: drums, tambourine
Unknown musician: cello

RECORDED
Abbey Road: September 6–7, 1967 (Studio Two) / October 6, 1967 (Studio Two)

NUMBER OF TAKES: 6

MIXING
Abbey Road: October 12, 1967 (Studio Three) / November 7, 1967 (Studios One and Two)

TECHNICAL TEAM
Producer: George Martin
Sound Engineers: Geoff Emerick, Peter Vince, Ken Scott
Assistant Engineers: Ken Scott, Richard Lush, Peter Mew, Graham Kirkby

Genesis

On August 1, 1967, George took off with Pattie for Los Angeles, where his friend Derek Taylor, Brian Epstein's former personal assistant, lived now. The couple rented a house on a street called Blue Jay Way. Derek was late in joining them, probably because he was delayed by the heavy fog that covered the city. Worn out by the trip and jet lag, George had fun playing a Hammond organ that he found in a corner of the house to fight against sleepiness, and he wrote this song while waiting for his friend. He said about his song, "The mood is also slightly Indian. Derek Taylor is slightly Welsh."[1] George does not recount whether the friend finally found the house in the fog.

In this sequence from *Magical Mystery Tour*, George was sitting on the ground in a suit playing on an organ drawn on the pavement. There were plenty of psychedelic effects: the atmosphere varied from amateurish to enlightened. Fortunately, there was the music.

Production

"Blue Jay Way" was the only Beatles song to use practically all the effects available at that time. The first recording session took place on September 6. The rhythm track was recorded in one take: bass, drums, and organ. George was on organ, but it was possible that John accompanied him. The next day there was a first reduction onto a second tape recorder. Accentuated flanging bringing the tape to its saturation point was added on both organs, especially at the end of the song. George then sang lead with his voice doubled simultaneously. On the choruses, the vocals were fed through a Leslie cabinet. George wanted to express the feeling of the fog that he was singing about. For the

Derek Taylor, a journalist at the *Liverpool Daily Post* and an art critic for several other publications, became the personal assistant of Brian Epstein in 1964.

next reduction, many of the instruments were enriched with phasing. Then George, John, and Paul recorded backing vocals through the Leslie cabinet once again. Finally, on October 6, a cello and a tambourine were added to complete the song. The first mix was stereo, and George decided to add intermittent backwards playback of the song through a Leslie cabinet. Since this operation was done live (like the radio on "I Am the Walrus"), it was impossible to reproduce exactly the same mix in mono. George Martin and Geoff Emerick decided to drop this effect for the mono mix. The final mixes are dated November 7.

1. Harrison, *I Me Mine.*

FOR BEATLES FANATICS

Most likely, the Small Faces song "Itchycoo Park," which came out in August 1967, influenced the massive use of flanging and phasing on "Blue Jay Way." "Itchycoo Park," which was recorded at the well-known Olympic Sound Studios, was one of the very first to use this type of effect.

1967

Hello, Goodbye

(A-side I Am the Walrus)

SINGLE
RELEASED

"Hello, Goodbye" / "I Am the Walrus"
Great Britain: November 24, 1967 /
No. 1 on December 6, 1967, for 7 weeks
United States: November 27, 1967 /
No. 1 on December 30, 1967, for 3 weeks

Hello, Goodbye

Lennon-McCartney / 3:27

SONGWRITER
Paul

MUSICIANS
Paul: vocal, bass, piano, percussion
John: lead guitar (?), organ, piano, percussion
George: lead guitar, tambourine, backing vocal
Ringo: drums, maracas, percussion
Leo Birnbaum, Ken Essex: violas

RECORDED
Abbey Road: October 2, 1967 (Studio Two) / October 19, 1967 (Studio One) / October 20, 1967 (Studio Three) / October 25, 1967 (Studio Two) / November 1, 1967 (Room 53) / November 2, 1967 (Studio Three)

NUMBER OF TAKES: 21

MIXING
Abbey Road: November 2 and 6, 1967 (Studio Three) / November 15, 1967 (Studio Two)

TECHNICAL TEAM
Producer: George Martin
Sound Engineers: Ken Scott, Geoff Emerick
Assistant Engineers: Graham Kirkby, Richard Lush, Phil McDonald, Jeff Jarratt, Ken Scott

FOR BEATLES FANATICS

At 1:15 and at 1:30 you can hear hand claps that seem accidental.

Genesis

As a Gemini, Paul chose duality as the theme of this song. "It's such a deep theme in the universe, duality—man woman, black white, ebony ivory, high low, right wrong, up down, hello goodbye—that it was a very easy song to write."[1] Being always positive, it was a chance for him to express it in a playful and simple way: "I was advocating the more positive side of the duality, and I still do to this day."[2] But John really did not like "Hello, Goodbye": "It wasn't a great piece; the best bit was the end, which we all ad-libbed in the studio, where I played the piano."[3] The bottom line was that John did not accept the fact that "Hello, Goodbye" was chosen as a new single instead of "I Am the Walrus," which he considered infinitely better. He was not wrong, but he confused commercial potential with works of art. Despite everything, without being a major opus, "Hello, Goodbye" remained an excellent song that stayed at the top of the charts for seven weeks in Great Britain, which surpassed the six-week record set by "She Loves You." As far as duality goes, Paul could have added: John and Paul . . .

Paul assumed responsibility for producing three little promotional movies. But he was soon out of his depth directing movies. He contented himself with setting up the group at the Saville Theatre in the West End, and filming them surrounded by Tahitian dancers for the coda. This was when they all appeared in *Sgt. Pepper* costumes (in the first clip) and John did a very good dance number!

Production

The Beatles worked on "Hello, Goodbye"—working title "Hello Hello"—on October 2. Seemingly simple, the production actually proved to be complex. The rhythm

John and Ringo at the Saville Theatre in London for the promotional movie for *Hello, Goodbye*.

track was recorded with Paul on piano, John on the organ, Ringo on drums, and George on tambourines. Congas, bongos, and maracas were added later and, after a reduction, the sixteenth take was selected. The coda, nicknamed "Maori Finale," was already part of the song from the first take. On October 19, two guitars were added and Paul recorded his vocal, double-tracked and with backing vocals by George and John, onto "Hello, Goodbye," still using the working title of "Hello Hello." After another reduction, two violas completed the song. George Martin, as usual, picked up what Paul dictated to him on piano. On October 25, there was a new reduction so that Paul could record his bass as an overdub. The fourth and last reduction was made on November 1. The process became critical because

such a large number of reductions could degrade the sound signal. Finally, the next day, Paul added a second bass line. The mono mix was done on the same day, and the stereo on November 7. Paul remembered that the "Maori" part did not sound good. So he asked Geoff Emerick to drown the toms in echo, ". . . it just came *alive*. We Phil Spector'd it!"[4] On November 15, another mono mix was carried out for the BBC without the violas, because the musicians union refused to allow prerecorded performances. Nevertheless, the clip could not air since the Beatles lip-synched their vocals!

1. Miles, *Paul McCartney*.
2. Ibid.
3. Sheff, *The Playboy Interview with John Lennon & Yoko Ono*.
4. Lewisohn, *The Complete Beatles Recording Sessions*.

1968

Lady Madonna /
The Inner Light

SINGLE
RELEASED

Great Britain: March 15, 1968 /
No. 1 on March 27, 1968, for 3 weeks
United States: March 18, 1968 /
No. 4 on March 23, 1968

Lady Madonna

Lennon-McCartney / 2:15

SONGWRITER
Paul

MUSICIANS
Paul: vocal, bass, piano, hand claps
John: lead guitar, backing vocal, hand claps
George: lead guitar, backing vocal, hand claps
Ringo: drums, tambourine
Ronnie Scott, Bill Povey: tenor saxophone
Harry Klein, Bill Jackman: baritone saxophone

RECORDED
Abbey Road: February 3, 1968 (Studio Three) / February 6, 1968 (Studio One)

NUMBER OF TAKES: 5

MIXING
Abbey Road: February 6, 1968 (Studio One) / February 15, 1968 (Studio Three) / December 2, 1969 (Studio Two)

TECHNICAL TEAM
Producer: George Martin
Sound Engineers: Ken Scott, Geoff Emerick, Phil McDonald
Assistant Engineers: Richard Lush, Jerry Boys, Martin Benge

FOR BEATLES FANATICS

From this point on, the Beatles released all subsequent singles on their own Apple record label.

Genesis

Paul's initial inspiration for "Lady Madonna" was the Virgin Mary, but then he quickly expanded it to include all women, especially mothers. Lady Madonna was a tribute to working-class women who courageously work and carry out their role as mothers. John was not impressed by the lyrics: "Good piano lick, but the song never really went anywhere. Maybe I helped him with some of the lyrics, but I'm not proud of them either way."[1] Years later, Paul realized that he mentioned every day of the week except Saturday. Lady Madonna likely went out this day. "So I figured it must have been a real night out."[2] The most distinctive feature of the song is the piano part based on a 1956 hit in England called "Bad Penny Blues" by trumpeter Humphrey Lyttleton, released on Parlophone. At the time, Martin was head of A&R for the label, but he did not work on the song. The piano and the lyrics were also a tribute to Fats Domino. Ringo recognized a different influence. In a 1968 interview he said, "It sounds like Elvis, doesn't it? No, it doesn't sound like Elvis . . . it is Elvis."

Production

The Beatles recorded "Lady Madonna" just before their trip to India, where they studied transcendental meditation under Maharishi Mahesh Yogi. They recorded three takes of the basic rhythm track on February 3. Paul probably recorded his superb piano part on the Steinway B grand piano, highly compressed by Ken Scott. Ringo, inspired by "Bad Penny Blues," played drums with brushes. The third take was the best. Ringo added another drum track, this time with drumsticks, also very compressed. Paul added a bass part; John

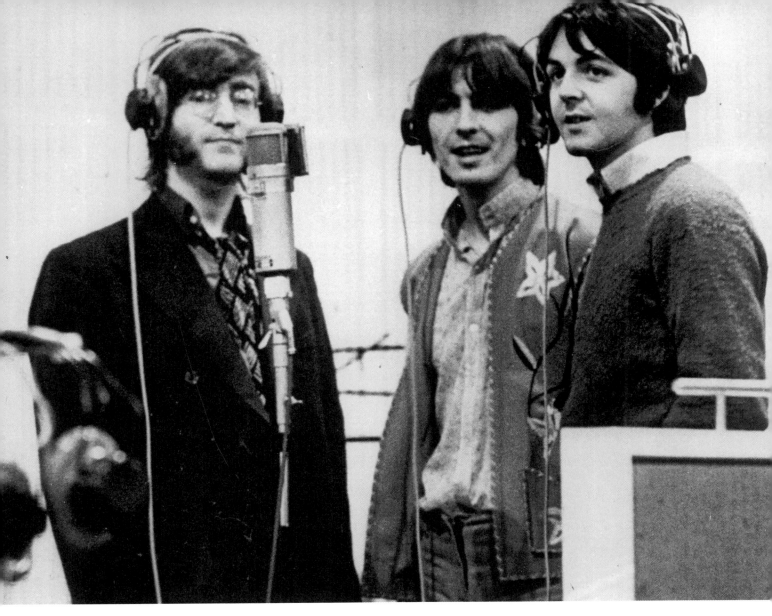

In 1968, John, George, and Paul recorded a song about working-class women, called "Lady Madonna."

and George both played fuzz-toned guitars through the same amplifier. Paul added his vocal, offering a Fats Domino impression. After a reduction on February 8, John, Paul, and George recorded a distinctive vocalized brass imitation, hand claps, and tambourine played by Ringo. They double-tracked their vocals right away. Paul then opted to include real brass. At the last minute, they called in two tenor saxophone players, including Ronnie Scott from the London Jazz Club and two baritone sax players. Paul did not have any arrangements written and the saxophonists largely improvised

their parts. After some rehearsals, the Beatles finally double-tracked guitar riffs and Ronnie Scott performed a wonderful tenor saxophone solo. Before ending the session, John, Paul, and George recorded *See how they run* vocals, and added final imitation brass vocals. The mono was mixed right away, and the stereo was made on December 2, 1969.

1. Sheff, *The Playboy Interview with John Lennon & Yoko Ono.*
2. Miles, *Paul McCartney.*

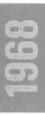
The Inner Light

George Harrison / 2:35

MUSICIANS
George: vocal
John: backing vocal
Paul: backing vocal
Ashish Khan: sarod
Mahapurush Misra: tabla, pakavaj
Sharad, Hanuman Jadev: shanhais
Shambu-Das, Indril Bhattacharya, Shankar Ghosh: sitars
Chandra Shakher: sur-bahar
Shiv Kumar Shermar: santoor
S. R. Kenkare, Hari Prasad Chaurasia: flutes
Vinaik Vora: thar-shanhai
Rij Ram Desad: dholak, harmonium, tabla-tarang
Note: Not all Indian musicians at the session recorded in Bombay participated in the recording. This is the complete list of musicians from the record sleeve.

RECORDED
EMI Recording Studio, Bombay (India): January 12, 1968
Abbey Road : February 6, 1968 (Studio One) / February 8, 1968 (Studio Two)

NUMBER OF TAKES: 6

MIXING
Abbey Road: February 6, 1968 (Studio One) / February 8, 1968 (Studio Two) / January 27, 1970 (Studio Two)

TECHNICAL TEAM
Producers: George Harrison (Bombay), George Martin
Sound Engineers: J. P. Sen and S. N. Gupta (Bombay), Geoff Emerick, Ken Scott, Peter Brown, Jeff Jarratt
Assistant Engineers: Jerry Boys, Richard Lush, John Barrett

Genesis

In 1968, Paul commented, "Forget the Indian music and listen to the melody. Don't you think it's a beautiful melody? It's really lovely." George's new song, with its exotic charm was subtle and spellbinding. The Beatles liked it so much that the song was chosen as the B-side of "Lady Madonna." It was the first George Harrison song to be featured on a Beatles single. The lyrics of "The Inner Light" were inspired by poem 48 of the *Tao Te Ching* by Lao Tzu, which Juan Mascaró, professor of Sanskrit at the University of Cambridge, had recommended to George. Mascaró had enjoyed "Within You Without You" on *Sgt. Pepper* and had suggested setting the poem to music. George set this Chinese text to Indian-sounding music. It was the last song that George wrote for the Beatles with an Asian inspiration. His "incursion" into Eastern music and philosophy had a considerable impact on Western youth at the time.

Production

In early January 1968, George went to India to record local musicians at the EMI studios in Mumbai for the sound track of *Wonderwall*, a film directed by Joe Massot. In 1967, Massot had asked George Harrison to write a score for his film. Harrison recorded the basic instrumental track of "The Inner Light" on January 12 during his stay in India. Upon his return to London, he went to Abbey Road on February 6 to record his vocal. Mal Evans helped create a soothing atmosphere with a lot of incense, candles, and dim lighting. But George was reluctant to perform. He did not feel confident that he could do the song justice. Jerry Boys, one of the assistant engineers, recalled, "I remember Paul saying, 'You must have a go, don't worry about it, it's *good*.'"[1]

Pattie Boyd and George Harrison wore Indian-style clothes during their stay in Bombay.

John and Paul were close by to encourage him, perched on high stools. Finally, he recorded a remarkable vocal and he was satisfied. On February 8, John and Paul overdubbed some background vocals at the very end of the song (2:18), before the final mono mix was completed. The stereo mix was done on January 27, 1970.

1. Lewisohn, *The Complete Beatles Recording Sessions*.

1968

BEAT

Back in the U.S.S.R

Dear Prudence

Glass Onion

Ob-La-Di, Ob-La-Da

Wild Honey Pie

The Continuing Story of Bungalow Bill

While My Guitar Gently Weeps

Happiness Is a Warm Gun

Martha My Dear

I'm So Tired

Blackbird

Piggies

Rocky Raccoon

Don't Pass Me By

Why Don't We Do It In The Road ?

I Will

Julia

Birthday

Yer Blues

Mother Nature's Son

Everybody's Got Something to Hide Except Me and My Monkey

Sexy Sadie

Helter Skelter

Long, Long, Long

Revolution 1

Honey Pie

Savoy Truffle

Cry Baby Cry

Revolution 9

Good Night

THE WHITE ALBUM

ALBUM
RELEASED

November 22, 1968 / No. 1 for 30 weeks

In 1968, Apple Corps, the Beatles' new company, was founded. It such as several divisions, such as the Apple Boutique, on Baker Street, which opened for business on December 7, 1967. The slogan, dreamed up by Paul, was *A beautiful place where the "beautiful people" can buy beautiful things.*

The Beatles:
The Album of Discord

Known as the *White Album* or the *Double Album*, this work by the Beatles was a radical return to a rock sound, a simplified approach to music that was very far from the complexity of *Sgt. Pepper* or *Magical Mystery Tour*. Paul said it plainly in November 1968: "We've tried to play more like a band this time—only using instruments when we had to—instead of just using them for the fun of it."[1] John shared this opinion in an interview with *Rolling Stone* magazine in 1970: "I don't care about the whole concept of *Pepper*, it might be better, but the music was better for me on the double album, because I'm being myself on it."[2] This new album was the beginning of the end of their psychedelic period. The days of "peace and love" were over.

In February 1968, the Beatles flew with their spouses and girlfriends, as well as male friends, for long weeks of transcendental meditation in Rishikesh, in India, under Maharishi Mahesh Yogi. In this studious atmosphere, they wrote most of the songs for the *White Album*. But in April, John wrongfully accused the Maharishi of trying to seduce actress Mia Farrow. John immediately went back to London. He interpreted this incident as treason on the part of the master, whom he suspected of being an imposter.

In May, the Beatles were busy: John and Paul officially announced the launch of Apple Corps, their new business venture; George was in Cannes to see the screening of *Wonderwall*, for which he composed the music; John presented Yoko Ono to the public for the first time, and on May 30, the recording sessions for the *White Album* began. On July 17, the animated movie *Yellow Submarine* premiered at the London Pavilion. In October, John and Yoko were arrested for possession of marijuana, and Paul invited American photographer Linda Eastman to live with him.

On November 8, the divorce between John and Cynthia was finalized and by November 22, the *White Album* had been completed. Seven days later, John and Yoko released the first of three experimental and controversial albums, *Two Virgins*, on the cover of which they both posed naked!

Having returned from Rishikesh with a large number of songs, the Beatles recorded their first double album. George Martin would have preferred to make it a single, but the Beatles had become more prolific: from now on, each of them wanted to express their talent equally. Although John and Paul continued to share most of the songwriting, George started to seriously compete with them by recording four songs, including the great "While My Guitar Gently Weeps." Even Ringo wrote his very first song, "Don't Pass Me By."

Paul still excelled at writing ballads ("Blackbird"), as well as rock ("Back in the U.S.S.R.") and even hard rock ("Helter Skelter"). As for John, he composed very tender songs ("Julia"), highly original tunes ("Happiness Is a Warm Gun"), and even avant-garde music ("Revolution 9").

The *White Album* was a collection of around thirty songs in very different musical genres, and it definitely signified the end of the brotherhood of the Beatles. Geoff Emerick, the faithful sound engineer, could not stand to see them tear each other apart and stopped working with them in mid-July. Ringo, fed up with the hateful atmosphere within the group, left them at the end of August. As for poor George Martin, who was no longer the captain of the ship, he got knocked around a lot by some of his protegées. From then on, it was every man for himself.

When the *White Album* appeared, it was a commercial hit. Although the starkness and eclectic

The Gibson J-200 acoustic guitar, which was omnipresent during the recording sessions for the *White Album*.

The Les Paul Standard Gibson guitar "Lucy," a dream guitar that Eric Clapton offered to his friend George Harrison.

character of the songs could be surprising at first, this album is considered one of the Beatles' best, despite the tension that pervaded the recording sessions.

Sober and Stark

Sobriety and *starkness* are the key words to describe this new work—perhaps as a reaction to the exuberance of *Sgt. Pepper*. This included the cover, which the group had Richard Hamilton produce, on the recommendation of Robert Fraser. The pop art artist suggested a sober cover, proposing an all-white cover and an extremely simple title, *The Beatles*. No more than that. Hamilton then got the idea of numbering each copy and engraving the embossed title, *The Beatles*. Convincing EMI was not easy, but they finally accepted the concept. Paul commented, "John got 0000001 because he shouted the loudest."[3] Hamilton designed the inside poster with Beatles photos and personal documents.

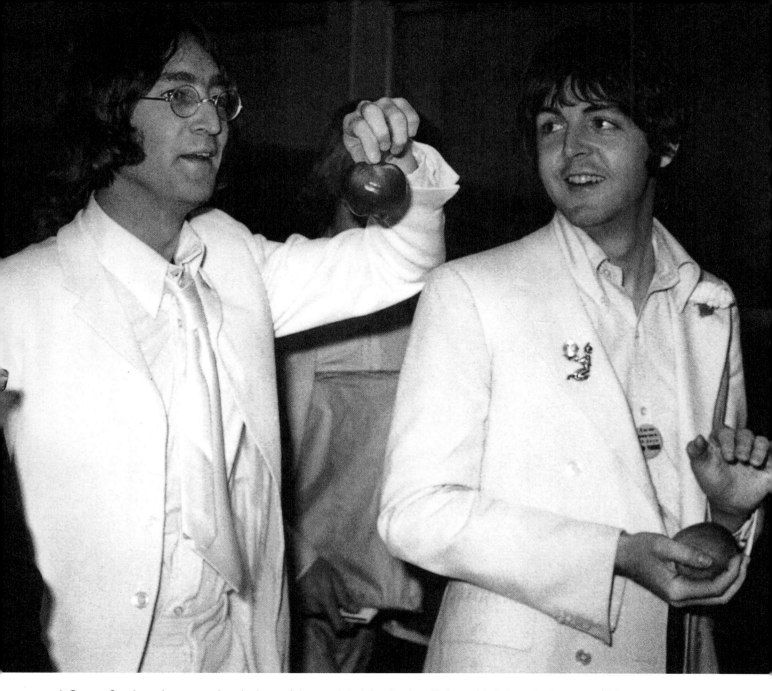

A Granny Smith apple was used as the logo of the new label that Paul and John publicly launched in May 1968. The concept was borrowed from a painting by René Magritte that Paul acquired. On the following double-page spread: the Beatles and their wives in the ashram of Maharishi Mahesh Yogi in Rishikesh, in India. Also present were Mia Farrow and her sister Prudence, road manager Mal Evans, and Mike Love of the Beach Boys.

Four portraits are also enclosed in the record. But there was no group photo.

The Instruments

Paul acquired an acoustic Martin D-28 guitar that was similar to the one John used in the film clip of *Hello, Goodbye* at the end of 1967. George purchased a Gibson J-200 acoustic guitar, and his friend Eric Clapton offered him a magnificent Les Paul Standard Gibson that he nicknamed "Lucy." John and George had the psychedelic paint job stripped off their guitars, and their Epiphone Casinos regained their natural clear wood look. Paul did the same in early 1969 with his Rickenbacker 4001S. The group also acquired a six-string Fender VI bass, a Fender Jazz Bass, Fender Deluxe amplifiers, and Vox wah-wah pedals.

1. Interview with Radio Luxembourg (November 20, 1968), http://www.beatlesinterviews.org/db1968.1120.beatles.html.
2. Wenner, *Lennon Remembers.*
3. Miles, *Paul McCartney.*

Back In The U.S.S.R.

Lennon-McCartney / 2:43

SONGWRITER
Paul

MUSICIANS
Paul: vocal, bass, piano, lead guitar, drums
John: bass, rhythm guitar, backing vocal, hand claps, snare drum
George: lead guitar, bass, backing vocal, hand claps

RECORDED
Abbey Road: August 22–23, 1968 (Studio Two)

NUMBER OF TAKES: 6

MIXING
Abbey Road: August 23, 1968 (Studio Two) / October 13, 1968 (Studio Two)

TECHNICAL TEAM
Producer: George Martin
Sound Engineer: Ken Scott
Assistant Engineer: John Smith

FOR BEATLES FANATICS

In 1988 Paul released an album of rock covers exclusively for the Soviet market, called **CHOBa B CCCP**, which was the Russian translation of *Back in the U.S.S.R.*

Genesis

"Back in the U.S.S.R." was a parody of Chuck Berry's "Back in the U.S.A." Paul pictured a Russian traveler coming home and joyfully finding his native land, the mountains of Georgia, and the charm of his country's women. Mike Love, the singer for the Beach Boys who stayed in Rishikesh with the Beatles, remembered, "I was sitting at the breakfast table and McCartney came down with his acoustic guitar and he was playing 'Back in the U.S.S.R.,' and I told him that what you ought to do is talk about the girls all around Russia, the Ukraine and Georgia."[1] Paul took this into account and finished writing the song upon returning from India. Ken Mansfield, the CEO of Apple in the United States, also claimed he made a few suggestions to Paul about this song.

In this song, which includes many inside jokes, the Beach Boys were honored: the Beatles imitated their irresistible harmonies in the bridge; likewise for Ray Charles whose 1960 hit "Georgia on My Mind" was referenced in the song.

Proposing a song in 1968 celebrating the joy of returning to the Soviet Union was pretty risky: this was during the Cold War and getting chummy with the U.S.S.R. was frowned upon. Some people called the Beatles anti-American, to which John replied with his usual irony: "That is very accurate, except we are not Americans . . ."

Production

When the Beatles met on August 22 to record "Back in the U.S.S.R.," they had already been working on the *White Album* in the studio for nearly three months. You could cut the tension in the air with a knife. Plus the omnipresence of Yoko added to everyone's discomfort. Geoff Emerick, who could no longer stand this

George, Mike Love, and John walking in the streets of Shankaracharyanagar in February 1968. Paul, not in this photo, wanted to offer a tribute to the Beach Boys with the backing vocals in "Back in the U.S.S.R."

atmosphere, left his job as a sound engineer in mid-July while George had gone to Greece to get some rest for a few days. When George returned, the atmosphere was extremely tense, at the expense of Ringo. Paul was constantly explaining to him how to do a fill on the toms. After many attempts and one last scolding, the drummer, who was fed up, left the group on August 22 and joined his friend Peter Sellers on his yacht in Sardinia. The three others were lost, but still carried on by redistributing the roles played by Ringo: Paul replaced Ringo on drums, John was on the Fender Bass VI, and George on his Les Paul Gibson. The rhythm track was recorded after five attempts. The next day there was an overdub session. It is hard to discern the exact distribution of the instruments. Paul probably added drumming

and a part with the Fender Jazz Bass that was doubled in some places by George on the six-string bass (that meant three basses in the same song!). John doubled the snare drum, and Paul was on piano and provided other guitar parts with John and George. Following a reduction, Paul recorded his voice while John and George supported his voice with Beach Boys–style harmonies and hand claps. Lastly, the final touch: the noise of an airplane taking off and landing, a British Viscount, was inserted during the mono mix that was carried out the same day. The stereo mix was done on October 13.

1. Miles, *Paul McCartney*.

Dear Prudence
Lennon-McCartney / 3:55

SONGWRITER
John

MUSICIANS
John: vocal, acoustic guitar
Paul: bass, piano, drums, bugle, backing vocal, hand claps, tambourine (?)
George: lead guitar, backing vocal, hand claps, tambourine (?)
Mal Evans, Jackie Lomax, John McCartney (Paul's cousin): hand claps and backing vocals

RECORDED
Trident Studios: August 28–30, 1968

NUMBER OF TAKES: 1

MIXING
Trident Studios: October 5, 1968
Abbey Road: October 13, 1968 (Studio Two)

TECHNICAL TEAM
Producer: George Martin
Sound Engineers: Barry Sheffield (Trident), Ken Scott
Assistant Engineer: John Smith

Genesis

When the Beatles arrived in Rishikesh to follow the transcendental meditation teachings of Maharishi Mahesh Yogi, Mia Farrow and her sister Prudence had already been there for a while. Recently divorced from Frank Sinatra, Mia inadvertently became the subject of a scandal that prompted John and George to leave India early and inspired the song "Sexy Sadie." But prior to this incident, Mia's sister Prudence was the center of attention of the entire ashram. She lived as a recluse in her little chalet, spending all her time meditating in solitude. "They selected me and George to try and bring her out because she would trust us,"[1] explained John. He wrote a song for her on this occasion, *Dear Prudence, won't you come out to play?* "We got her out of the house. She'd been locked in for three weeks and wouldn't come out, trying to reach God quicker than anybody else."[2] The Farrow sisters inspired two extraordinary John Lennon songs.

Production

Since Ringo had left the group on August 22, the three remaining Beatles met at Trident Studios in London on August 28 to use its eight-track technology. They were familiar with the studio because they had recorded "Hey Jude" there at the beginning of the month. In "Dear Prudence," John used a style of finger-picking that Donovan had taught him in Rishikesh. He composed many songs based on this technique, including "Julia." The rhythm track was recorded with John and George on guitar (finger-picking rhythm and lead, respectively) and Paul on drums. On August 29, John sang and double-tracked the lead vocal, Paul played bass and added backing vocals with George, along with hand claps and tambourines. Mal Evans, Jackie Lomax (an artist who was being

During his time in India, in the ashram of Maharishi Mahesh Yogi, John composed "Dear Prudence," which referred to Prudence Farrow.

recorded by George on the Beatles' Apple label), and a cousin of Paul's (John McCartney) joined them for hand claps and backing vocals. The master tape also indicated, according to Mark Lewisohn, that they were present at the end of the song to record applause, though this was mixed out of the finished master. The next day, the last day at Trident Studios, Paul overdubbed a piano part and, according to Lewisohn, added a short bugle passage, which is mostly inaudible (probably between 3:19 and 3:30). Although the song was recorded at Trident Studios, the final mixes were redone at Abbey Road on October 13. The vocals and hand claps were doubled by means of ADT.

FOR BEATLES FANATICS

Siouxsie and the Banshees performed an excellent version of this song, which rose to third place on the British charts in 1983.

1. Sheff, *The Playboy Interview with John Lennon & Yoko Ono.*
2. Ibid.

Glass Onion

Lennon-McCartney / 2:17

SONGWRITER
John

MUSICIANS
John: vocal, rhythm guitar
Paul: bass, piano, flute
George: lead guitar
Ringo: drums, tambourine
Henry Datymer, Eric Bowie, Norman Lederman, Ronald Thomas: violins
John Underwood, Keith Cummings: violas
Eldon Fox, Reginald Kilbey: cellos

RECORDED
Abbey Road: September 11–13, 16, and 26, 1968 / October 10, 1968 (Studio Two)

NUMBER OF TAKES: 34

MIXING
Abbey Road: September 26, 1968 (Studio Two) / October 10, 1968 (Studio Two)

TECHNICAL TEAM
Producers: Chris Thomas, George Martin
Sound Engineer: Ken Scott
Assistant Engineers: John Smith, Mike Sheady

Genesis

Glass Onion was the name that John planned to give to the Iveys, a group in the stable of Apple Records that gained some recognition in early 1970 and finally chose the name *Badfinger*. (The working title of "With a Little Help from My Friends" had been "Badfinger Boogie.") "Glass Onion" was a strange song that John wrote for the fans who found clues and double entendres in the Beatles' lyrics. The lyrics directly referenced the songs "Strawberry Fields Forever," "I Am the Walrus," "Lady Madonna," "The Fool on the Hill," and "Fixing a Hole." John took pleasure in sowing fanciful clues: "I threw in the line *The Walrus was Paul* just to confuse everybody a bit more. It could have been: *the fox terrier is Paul*."[1] He explained that "I [John] was feeling guilty because I was with Yoko and I was leaving Paul." He hoped this little allusion would make him happy, and show his thanks to Paul for maintaining the group's cohesiveness for such a long time. "It's a very perverse way of saying to Paul: 'Here have this crumb this illusion this stroke because I'm leaving.'"[2]

Not all the lyrics refer to the Beatles; for instance, the passage *the bent-backed tulips* alludes to the very exclusive London Parkes restaurant on Beauchamp Place that was run by Tom Benson, a friend of the group, and that was decorated with bent-backed tulips. As for *the Cast Iron shore*, that referred to the beach in Liverpool. What was most amusing was that out of all the songs quoted by John, two are his and three are Paul's. He must have felt really guilty . . .

Production

On September 11, six years to the day after the recording of "Love Me Do," the Beatles worked on the basic rhythm track of "Glass Onion." After thirty-four takes,

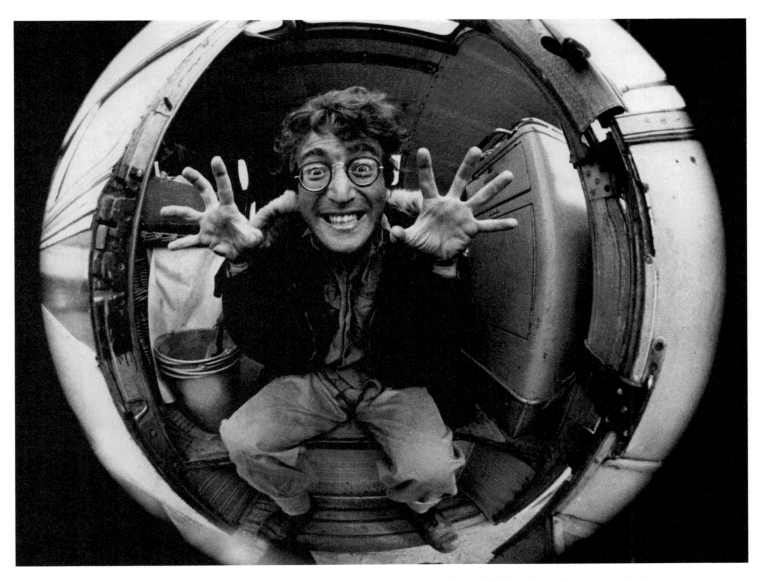

John Lennon, seen through a prism. The image was as strange as the atmosphere of "Glass Onion," a song in which John evoked other songs by the Beatles and expressed his gratitude to Paul.

they chose take 33. John was on acoustic guitar, Paul on bass, George on lead guitar, and Ringo, who finally rejoined the group on September 4, after his escapade in Sardinia, was on drums. The next day, John recorded his lead vocal, which was doubled in spots (it was reinforced by means of ADT during the mix), and Ringo supplied a part on tambourines. On September 13, Ringo added a snare drum and Paul added some piano. Three days later, someone suggested adding a few notes from a recorder to emphasize the allusion to the *fool on the hill*. It was probably played by Paul who doubled it (1:27). On September 26, John decided to insert sound effects: a telephone ringing, a note on

the organ, BBC soccer commentator Kenneth Wolstenholme, shouting "It's a goal!," and, finally, the sound of a window shattering (see *Anthology 3*). George Martin, who was back from vacation, suggested replacing these sound effects with strings. He wrote a score for four violins, two violas, and two cellos, and it was recorded as an overdub on October 10. The song was immediately mixed in mono and stereo. "Glass Onion" was one of George's favorite songs on the *White Album*.

1. The *Beatles Anthology*.
2. Ibid.

1968

Ob-La-Di, Ob-La-Da

Lennon-McCartney / 3:08

FOR BEATLES FANATICS

The group Marmalade did a version of "Ob-La-Di" in early 1969 that remained at the top of the British charts for three weeks.

SONGWRITER
Paul

MUSICIANS
Paul: vocal, bass, percussion, hand claps
John: piano, backing vocal, percussion, hand claps
George: acoustic guitar, backing vocal, percussion, hand claps
Ringo: drums, percussions, hand claps
Rex Morris (?), Ronnie Scott (?), and unknown musicians: saxophones

RECORDED
Abbey Road: July 3–5 and 8, 1968 (Studio Two) / July 9 and 11, 1968 (Studio Three) / July 15, 1968 (Studio Two)

NUMBER OF TAKES: 23

MIXING
Abbey Road: July 8, 1968 (Studio Two) / July 11, 1968 (Studio Three) / July 15, 1968 (Studio Two) / October 12, 1968 (Studio Two)

TECHNICAL TEAM
Producer: George Martin
Sound Engineers: Geoff Emerick, Ken Scott
Assistant Engineers: Richard Lush, Phil McDonald, John Smith

Genesis

In Rishikesh Paul wrote "Ob-La-Di, Ob-La-Da," a song that was extremely remote from the meditation environment and the teachings of Maharishi Mahesh. You can see it as the prototype of some of his post-Beatles songs, with words that have no real meaning but with infectious musical power, full of optimism and energy. The words were inspired by Jimmy Anonmuogharan Scott Emuakpor, a Nigerian musician, whom Paul knew from London clubs. He would often say, "Ob la di ob la da, life goes on, bra," an expression in Yoruba (one of the languages of Niger). Paul really loved this expression, and he let Jimmy Scott know he would surely use it in one of his future songs. Later on, Scott complained that he had not received a songwriting credit and Paul sent him a check to thank him. John grew to hate "Ob-La-Di, Ob-La-Da" and complained that the group spent more time on it than on any other piece on the album. You can see how the contrived lyrics could very well irritate him. Nevertheless, John contributed to this song by writing one or two of its lines. No matter what John thought, "Ob-La-Di, Ob-La-Da" was one of the most popular songs on the *White Album*.

Production

The Beatles spent a major part of the month of July producing the song. On July 3, they recorded the rhythm track with two acoustic guitars and drums. The next day, Paul recorded his lead vocal, accompanied by John and George on backing vocals. On July 5, three saxophone players and a percussionist stepped in. The percussionist was none other than conga player Jimmy Scott, from whom Paul "borrowed" the song's title. A piccolo was added and very soon was replaced by a bass line played by Paul on acoustic guitar, with

462 THE BEATLES

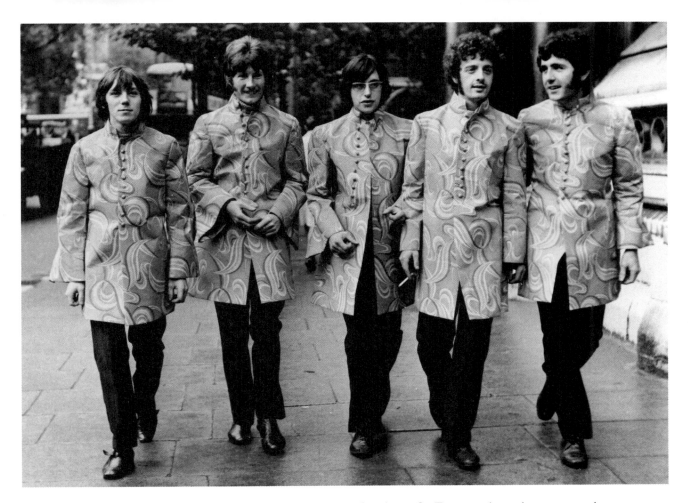

The members of Marmalade, photographed in a London street in October 1967. Two years later, they were number one on the British charts because of their spirited remake of "Ob-La-Di, Ob-La-Da."

the sound deliberately overloading the console. The results were rather good (see *Anthology 3*), but Paul decided to do everything over again on July 8, to the great chagrin of everyone, including the technical crew. Exasperated, John stormed out of the studio with Yoko, but returned a few hours later, completely stoned, and rushed—according to Geoff Emerick—to the piano, screaming, ". . . this is how the fucking song should go."[1] Lennon smashed the keys with all his might while playing the intro—which was the version used on the record—at a clearly faster tempo. Paul, at first surprised and furious, soon understood that he was adding the feel that the song had been lacking. In this deteriorating atmosphere, the new rhythm track was recorded, with Paul on fuzz bass, Ringo on drums, George on acoustic guitar, and John on piano. After various overdubs, with backing vocals and additional percussion, the session ended. The next day, Paul, an obsessed perfectionist, had the entire song redone a second time. The atmosphere got tenser. After two tries, he realized they would not do any better. The Beatles therefore returned to the version of July 8 and rerecorded the lead vocal,

the backing vocals (which were sped up), and added all sorts of little sentences, words, jokes, and screams, this time in a joking atmosphere. The session ended with the addition of vocal percussion and hand claps. On July 11, there was a new recording with the addition of three saxophones and a bass. The last session, on July 15, had negative consequences. Paul was dissatisfied with his own vocal and spent considerable time rerecording it. George Martin, who felt his role as producer slipping away, tactfully intervened to suggest to Paul a different phrasing. According to Emerick, Paul furiously yelled at him, "If you think you can do it better, why don't you fucking come down here and sing it yourself?"[2] Deeply hurt, Martin left the studio. After this incident, Geoff Emerick decided never again to record the Beatles. He could not stand to see the Beatles tear each other apart and left them the very next day. But he did join them again to record *Abbey Road*. The final mixes were carried out on October 12 with an addition of ADT on Paul's vocal.

1. Emerick, *Here, There and Everywhere.*
2. Ibid.

1968

Wild Honey Pie

Lennon-McCartney / 0:53

SONGWRITER
Paul

MUSICIAN
Paul: vocal, acoustic guitar, bass drum, percussions

RECORDED
Abbey Road: August 20, 1968 (Studio Two)

NUMBER OF TAKES: 1

MIXING
Abbey Road: August 20, 1968 / 13 October 1968 (Studio Two)

TECHNICAL TEAM
Producer: George Martin
Sound Engineer: Ken Scott
Assistant Engineer: John Smith

FOR BEATLES FANATICS

The Pixies' version of "Wild Honey Pie" needs to be listened to for its amazing energy.

Production

"Wild Honey Pie" was a short song written in India. The Beatles had just recorded John's song "Yer Blues," on August 20, in the storage area of the control room in Studio Two. They were in an experimental mood and Paul said, "Can I just make something up? I started off with the guitar and did a multitracking experiment in the control room or maybe in the little room next door."[1] Paul built it himself by superimposing harmonies over harmonies, guitars over guitars and sculpting it with a lot of vibrato on the strings, "pulling the strings madly."[2] They added bass drum, buried in reverb, and percussion, probably hitting the back of an acoustic guitar. The mono mix was done right away and the stereo mix on October 13.

"Wild Honey Pie" is a curious song, of a piece with John's sound experiments, such as "What's the New Mary Jane," recorded a few days before, but that song was not included on the *White Album*. Paul later said, "It was just a fragment of an instrumental which we were not sure about, but Patti Harrison liked it very much, so we decided to leave it on the album."[3] "Wild Honey Pie" was a reference to another one of Paul's songs, "Honey Pie," on which they worked in October.

1. Miles, *Paul McCartney.*
2. Ibid.
3. Geoffrey Giuliano and Denny Laine, *Blackbird: The Unauthorized Biography of Paul McCartney* (London: Smith Gryphon Limited, 1991).

The Continuing Story Of Bungalow Bill

Lennon-McCartney / 3:13

SONGWRITER
John

MUSICIANS
John: vocal, rhythm guitar
Paul: bass, backing vocal
George: rhythm guitar, backing vocal
Ringo: drums, tambourine, backing vocal
Chris Thomas: Mellotron, backing vocal
Yoko Ono: vocal, backing vocal
Maureen Starkey: backing vocal

RECORDED
Abbey Road: October 8, 1968 (Studio Two)

NUMBER OF TAKES: 3

MIXING
Abbey Road: October 9, 1968 (Studio Two)

TECHNICAL TEAM
Producer: George Martin
Sound Engineer: Ken Scott
Assistant Engineers: Mike Sheady, John Smith

FOR BEATLES FANATICS

On the left channel in stereo, you can hear someone in the distance go *oouuuhh!* at 0:30.

Genesis

Rishikesh made it possible for the Beatles to regroup and write a considerable number of songs. The healthy food and the peaceful atmosphere had rather beneficial effects on John. Even though the meditation affected his sleep (see "I'm So Tired"), he once again found his creative muse. He drew many of his ideas from his life at the ashram. And it was precisely the behavior of one of the devotees at the ashram that influenced "The Continuing Story of Bungalow Bill." "That was written about a guy in Maharishi's meditation camp who took a short break to go shoot a few poor tigers, and then came back to commune with God."[1] John did a caricature of him halfway between *Jungle Jim*—the American comic strip by Alex Raymond—and Buffalo Bill. As he said himself, it was a social criticism seen through the eyes of a teenager, as well as a farce. Paul found in his lyrics a hymn defending nature, "Funnily enough, John wasn't an overt animal activist, but I think by writing this song he showed that his sentiments were very much that way."[2] This is why it was one of Paul's favorite songs on the *White Album*.

When composing the music for the chorus, John was probably inspired by "Stay as Sweet as You Are," a song that Nat King Cole popularized in 1957. John's song was exuberant and the production, which was rushed, worked perfectly.

Production

Performed in barely three takes on October 8, "The Continuing Story of Bungalow Bill" was an opportunity for everyone in Studio Two to participate in a Beatles song by singing the chorus. The rhythm track was recorded with John and George on acoustic guitar, Paul on bass, and Ringo on drums. After John

John Lennon and Yoko Ono in December 1968. Yoko sang, *Not when he looked so fierce* in "The Continuing Story of Bungalow Bill."

double-tracked his lead vocal, the Beatles added percussion and tambourines. Then, Chris Thomas took over the Mellotron to play what he wanted. He chose an intro using a flamenco guitar loop from the Mellotron, then a mandolin sound for the verses, and a trombone part for the choruses. "You could do what you wanted," said Chris Thomas," until someone would tell you, 'I don't like it, don't do that.' You could improvise as you were playing. Nothing was forbidden, and that is what was brilliant!"[3] John wanted a live atmosphere, much in contrast to *Sgt. Pepper*. Yoko Ono sang one line solo at 1:47: *Not when he looked so fierce*, the first female lead vocal line on a Beatles recording. Everyone participated in the choruses, including Ringo's wife Maureen. At the very end of the piece, John, with his Liverpool accent, exclaims, *Ey, up!* (meaning "What's Up?" or "Look at that!"), which leads directly into George's "While My Guitar Gently Weeps." The mixes were done the very next day.

1. Sheff, *The Playboy Interview with John Lennon & Yoko Ono.*
2. Miles, *Paul McCartney.*
3. Ryan and Kehew, *Recording the Beatles.*

While My Guitar Gently Weeps

George Harrison / 4:43

MUSICIANS
George: vocal, acoustic guitar, organ
John: rhythm guitar, bass (?)
Paul: bass, piano, organ, backing vocal
Ringo: drums, tambourine
Eric Clapton: lead guitar

RECORDED
Abbey Road: July 25, 1968 (Studio Two) / August 16, 1968 (Studio Two) / September 3, 5–6, 1968 (Studio Two)

NUMBER OF TAKES: 25

MIXING
Abbey Road: October 7 and 14, 1968 (Studio Two)

TECHNICAL TEAM
Producer: George Martin
Sound Engineer: Ken Scott
Assistant Engineers: Richard Lush, Mike Sheady, John Smith

FOR BEATLES FANATICS

A few weeks after the end of the recording, George gave an acetate of the *White Album* to Eric Clapton. But when George heard that Clapton played the acetate for his friends, George was furious and called him to forbid him from playing the record for anybody else.

Genesis

"While My Guitar Gently Weeps" was one of George's greatest achievements. This magnificent song made it possible for George to establish his status as a writer on par with John and Paul.

The lyrics of the song were inspired by the *I Ching (Yi Jing)*, the Book of Changes. "I was thinking about the Chinese *I Ching*, the Book of Changes. In the West we think of coincidence as being something that just happens—it just happens that I am sitting here and the wind is blowing my hair, and so on. But the Eastern concept is that whatever happens is all meant to be, and that there's no such thing as coincidence—every little item that's going down has a purpose."[1] While visiting his parents in Warrington, he decided to open a book at random and use the first words he stumbled on as the basis of his lyrics. . . . He put the book down and wrote his song based on the two words he found: *gently* and *weeps*.

Production

"I always had to do about ten of Paul and John's songs before they'd give me the break,"[2] George complained in 1968. The sessions for "While My Guitar Gently Weeps" began on July 25, nearly two months after John's "Revolution 1." During the first day, the Beatles rehearsed several takes. George then recorded a solo vocal and a fantastic acoustic version, which was very simplified, playing his Gibson J-200 with the sole support of Paul on the organ (see *Anthology 3*). On August 16, he tried to involve his colleagues a bit more: they recorded some bass, some drums, some organ, and one guitar. The results of this session were transferred on September 3 to Abbey Road's brand-new 3M M23 eight-track. "While My Guitar Gently Weeps" was therefore the group's first song to benefit from this new tape recorder. Alone in

Eric Clapton (with George), nicknamed "God," performed the sublime guitar solo on "While My Guitar Gently Weeps," a song that boosted George's songwriting to the same level as Lennon-McCartney. They remained friends all their lives, as seen in this photo from 1985.

the studio, George attempted to record a backwards guitar solo in order to get the sound of a "weeping" guitar. Since this did not work, he dropped the idea. On September 5, Ringo, who had abandoned them in August, made his return. Some flowers were laid out all over his drums as a welcome! After completing the September 3 recordings, George heard a playback and decided to start everything all over again. This time by the end of the session, the rhythm track was right (take 25): George was on vocal and acoustic guitar, John on electric guitar, Ringo on drums, and Paul both on piano and organ. But George despaired of getting his colleagues interested: "They weren't taking it seriously and I don't think they were even all playing on it, and so I went home that night thinking, 'Well, that's a shame,' because I knew the song was pretty good."[3] The next day they added overdubs: George sang and doubled his voice, supported by Paul's backing vocal and high-pitched falsetto voices at the end of the song; Ringo added tambourines; and Paul, on the Fender Jazz Bass, recorded a powerful fuzz bass line, which he often played in power chords, and that was probably doubled by John on the six-string Fender bass guitar during the bridges.

But the most remarkable recording of that day was the guitar solo by Eric Clapton. George said: "The next day I was driving into London with Eric Clapton, and I said, 'What are you doing today? Why don't you come to the studio and play on this song for me?' He said, 'Oh, no—I can't do that. Nobody's ever played on a Beatles' record and the others wouldn't like it.' I said, 'Look, it's my song and I'd like you to play on it.'"[4] George brought him into the studio and lent him his own guitar (most likely Lucy, the Les Paul Gibson that Eric had given him as a present). From that moment on, all the Beatles concentrated and did their best. Eric said: "We did just one take, and I thought it sounded fantastic. John and Paul were fairly noncommittal, but I knew George was happy because he listened to it over and over in the control room."[5] George added one last part on organ and the session was finally complete. In the mix, a lot of flanging was added to Clapton's guitar playing at Clapton's request to make his guitar sound more like the Beatles.

Technical Details

The first eight-track tape recorder was built in 1954 and was invented by the great Les Paul. Other models appeared soon afterwards, and in 1968, many London studios had one—except for EMI. The 3M firm had indeed supplied them with two M23s around the end of 1967—one of the best eight-tracks on the market at that time—but the machine delivered on May 9 did not meet the technical requirements of Abbey Road. The Beatles impatiently pressured EMI for it to be operational as soon as possible. Only on September 3 did they finally record on an eight-track, after many other famous British groups had already recorded on eight-track!

1. *The Beatles Anthology.*
2. Lewisohn, *The Complete Beatles Recording Sessions.*
3. *The Beatles Anthology.*
4. Ibid.
5. Eric Clapton, *Clapton par Eric Clapton: autobiographie (Clapton: The Autobiography)* (Paris: Buchet-Chastel, 2007).

Happiness Is A Warm Gun

Lennon-McCartney / 2:42

SONGWRITER
John

MUSICIANS
John: vocal, lead guitar, piano (?), organ (?), tambourine (?)
Paul: bass, piano (?), organ (?), backing vocal
George: lead guitar, backing vocal
Ringo: drums
Unknown musician: tuba

RECORDED
Abbey Road: September 23–25, 1968 (Studio Two)

NUMBER OF TAKES: 70

MIXING
Abbey Road: September 25–26, 1968 (Studio Two) /
October 15, 1968 (Studio Two)

TECHNICAL TEAM
Producers: Chris Thomas, George Martin
Sound Engineer: Ken Scott
Assistant Engineers: Mike Sheady, John Smith

FOR BEATLES FANATICS

The structure of different parts of this song inspired the song "Paranoid Android" by Radiohead on their album *OK Computer*, which came out in 1997.

Genesis

One day, when George Martin handed John a gun magazine, he did not suspect that he had just given him a new idea for a song. The illustration on the cover was a smoking gun with the title, "Happiness Is a Warm Gun in Your Hand." John specified in 1971, "I thought it was a fantastic, insane thing to say. A warm gun means you've just shot something."[1] Around this idea, he developed a succession of sentences that piqued the curiosity of Beatles fans. Ken Mansfield, the American CEO of Apple Records, remembered asking him about the meaning of his sentence: *She's well acquainted with the touch of the velvet hand / Like a lizard on a window pane*" and getting the answer: "Nothing! I just made it up." But on that day, John revealed a secret to him: "We've learned over the years that if we wanted we could write anything that just felt good or sounded good, and it didn't necessarily have to have any particular meaning to us. As odd as it seemed to us, reviewers would take it upon themselves to interject their own meaning on our lyrics. So why strain me brain? Sometimes we sit and read other people's interpretations of our lyrics and think, 'Hey that's pretty good.'"[2]

Nevertheless, he was accused of alluding to heroin, which got the song banned from the BBC: "They all said it was about drugs but it was more about rock 'n' roll than drugs," he said to defend himself during an interview in 1972.[3] Yoko was also at the center of the song. Since their relationship had just begun, John admitted that when they were not in the studio, they were in bed. She was the *Mother Superior* of the lyrics, since John used to privately call her "Mother."

"Happiness Is a Warm Gun" resulted from the collation of three song fragments. It was among John's favorite songs: "I love it. I think it's a beautiful song. I like all the different things that are happening in it.[4]

John Lennon on August 24, 1968. Is "Happiness Is a Warm Gun" a song about heroin or about rock 'n' roll?

Paul and George agreed and found it one of the best songs of the *White Album*.

Production

On September 23, the Beatles undertook the complex production of "Happiness Is a Warm Gun in Your Hand," its working title. The structure of the song, with its contrasting time signatures, was difficult to establish. On the first day, they laid down no less than forty-five takes to produce the right rhythm track: John played his Epiphone Casino and provided a guide vocal, Paul was on bass, George on lead guitar, and Ringo on drums. But as early as the next day, twenty-five extra takes were required to find a satisfactory one, and this meant a total of seventy takes altogether—however, this was far from the two hundred takes of "Not Guilty" (see *Anthology 3*). On September 25, takes 53 and 65 were edited together to establish a basic master. Then began the overdubs: after doubling his guitar part, John added a superb lead vocal, harmonized at certain points by Paul. George then joined them for the irresistible *Bang bang shoot shoot* harmonies at the end, a successful comical allusion to the doo-wop groups of the fifties. An unknown musician then stepped in with a tuba (that could barely be heard), to double Paul's bass on the part that went, *I need a fix*. Finally, on the only remaining free track, they inserted, in turn, different instruments to complete the song: some organ in the intro, some fuzz guitar (from 0:44 to 0:58), some tambourines and hi-hat on the part of *Mother Superior*, and, at last, some piano for the finale. In the mix, the Beatles decided to mute John's voice in the first passage containing *I need a fix* and make that entirely instrumental (0:44). But the voice was reintroduced too soon, and you could still distinguish the word *down* just before the singing began again! (0:57). The mono mix was carried out on September 26, and the stereo on October 15. "Happiness Is a Warm Gun" was one of the group's best songs.

1. *The Beatles Anthology.*
2. Ken Mansfield, *The Beatles, The Bible, and Bodega Bay: My Long and Winding Road* (Nashville: Broadman & Holman Publishers, 2000).
3. "LENNON-MCCARTNEY Songalog: Who Wrote What," *Hit Parader* (February 1972).
4. Wenner, *Lennon Remembers.*

Martha My Dear

Lennon-McCartney / 2:28

SONGWRITER
Paul

MUSICIANS
Paul: vocal, bass, piano, guitar, drums, hand claps
Bernard Miller, Dennis McConnell, Lou Sofier, Les Maddox: violins
Leo Birnbaum, Henry Myerscough: violas
Reginald Kilbey, Frederick Alexander: cellos
Leon Calvert: trumpet, flugelhorn
Stanley Reynolds, Ronnie Hughes: trumpets
Tony Tunstall: French horn
Ted Barker: trombone
Alf Reece: tuba

RECORDED
Trident Studios: October 4–5, 1968 (Studio Two)

NUMBER OF TAKES: 1

MIXING
Trident Studios: October 5, 1968 (Studio Two)

TECHNICAL TEAM
Producer: George Martin
Sound Engineer: Barry Sheffield
Assistant Engineer: unknown

1. Miles, *Paul McCartney.*
2. Ibid.
3. Ibid.

Genesis

Paul revealed the identity of Martha, the heroine of his song, when he told Barry Miles[1] it was his own dog, a three-year-old Old English Sheepdog. The song was written in October 1968, no more than three days before going to the studio. When Paul composed the music, he tried to overcome his limitations on piano: "It's quite hard for me to play, it's a two-handed thing, like a little set piece."[2] And some lyrics popped into his mind, for no apparent reason, such as "Martha My Dear." The love story he made up had no real foundation: rather, it was a collection of images, a fantasy song. He was amused by the idea of getting his dog involved in it. "Martha My Dear" was a song with rather light lyrics, but with upbeat music. Neither John nor George—who would say to Paul disparagingly, "You used to make them up, they don't mean anything to you"[3]—appreciated this song. Some people claimed the lyrics were addressed to Jane Asher, but why would he call her Martha? In addition, at that time, Paul had already begun his relationship with Linda, and she moved in with him at the end of October.

Production

On October 4, the Beatles went to Trident Studios for the fourth time. Or, more precisely, Paul McCartney went there, since it seems his bandmates did not participate in the session. That day, seven musicians recorded the arrangement for "Honey Pie" and fourteen musicians the one for "Martha My Dear." For the latter, Paul provided the rhythm track by himself with some piano, drums, and vocals. The orchestra could then, under the direction of George Martin, interpret the great score no doubt written in a hurry (Paul obviously supplied him with a demo just before the session). Afterwards, Paul

There was no woman behind the name *Martha*, but, rather, a dog—Paul McCartney's Old English Sheepdog.

returned to overdub the lead vocal (applied with ADT) and hand claps. The next day, he added some bass and electric guitar. The results were remarkable. The song had soul and undeniable charm, and the McCartney/Martin collaboration worked marvelously. The mixes were done the same day at Trident.

Technical Details

Since Trident Studios used American machines based on the NAB (National Association of Broadcasters) standard, the EMI engineers had to convert the tapes that were mixed at Trident to the European format (Radiocommunication Sector).

I'm So Tired

Lennon-McCartney / 2:03

SONGWRITER
John

MUSICIANS
John: vocal, guitar, electric piano (?), organ (?)
Paul: bass, organ (?), backing vocals, electric piano (?)
George: lead guitar
Ringo: drums

RECORDED
Abbey Road: October 8, 1968 (Studio Two)

NUMBER OF TAKES: 14

MIXING
Abbey Road: October 15, 1968 (Studio Two)

TECHNICAL TEAM
Producer: George Martin
Sound Engineer: Ken Scott
Assistant Engineers: Mike Sheady, John Smith

FOR BEATLES FANATICS

At the end of the song, John whispered incomprehensible words (backwards and forwards). Mark Lewisohn heard: *"M'sieur, m'sieur, how about another one?"* Others heard: *"Paul is dead. Miss him, miss him."* But if you listen carefully, the phrase is completely incomprehensible. John no doubt added a tape loop on which he had recorded a sentence. The results had no meaning.

Genesis

"I'm So Tired" was another song written in Rishikesh. Sleep and dreams are recurrent themes in John's work (see "I'm Only Sleeping"). Pete Shotton pointed out that the only thing John hated more than going to bed at night was waking up the next morning.

John could not stand the long hours of daily meditation he practiced in India. He was depressed about his dead-end marriage with Cynthia, and Yoko, who incessantly reminded him of her by means of almost daily letters, made him confused. John was losing sleep over it. He confirmed this in 1980, "I couldn't sleep, I'm meditating all day and couldn't sleep at night. The story is that."[2] All his talent was required for him to transform banal insomnia into such an incisive text. Lack of sleep put his nerves on edge, and for that he blamed poor Walter Raleigh, a sixteenth-century British explorer and writer who introduced tobacco to England. John did not forgive Sir Walter for his own addiction to tobacco: *. . . and curse sir Walter Raleigh / He was such a stupid get.* Paul interpreted this song as ". . . very much John's comment to the world (!)"[1] and John found it was one of his best songs: "One of my favorite tracks. I just like the sound of it, and I sing it well."[3]

Production

The Beatles met on October 8 to record "I'm So Tired." John wanted a live atmosphere. Ultimately, there were rather few overdubs. The rhythm track was recorded in fourteen takes: John sang remarkably well while accompanying himself on rhythm guitar, with Paul on bass, George on lead guitar (with accents of Chuck Berry's "Memphis Tennessee" on the bridges), and Ringo on drums. Then there were the overdubs: John double-tracked his vocal in some spots, joined by Paul on

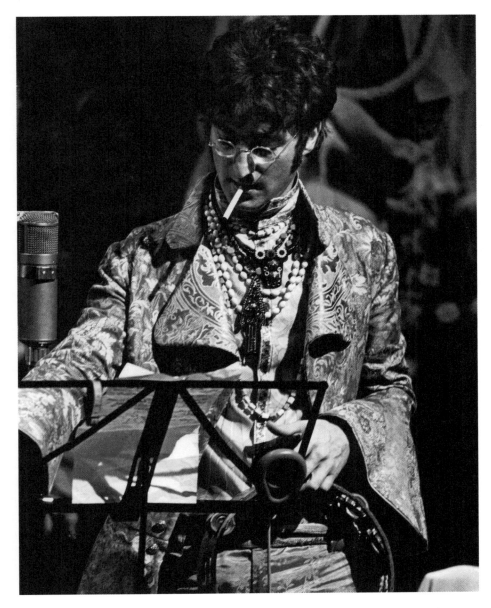

During his stay in India, John expressed all his artistic creativity, while he suffered from insomnia. "I'm So Tired" evokes this experience as well as his addiction to tobacco.

backing vocal. George added a second guitar, John (or Paul) did a part on electric piano that was barely audible, and Ringo doubled his snare drum, the bass drum, and the toms on the bridges. Finally, Paul (or John) completed the song with simultaneous organ behind a last guitar take. The mixes were done on October 15.

Technical Details
The recording of the rhythm track with the live voice caused "leakage" between the different microphones (that is, the sound from the instruments was picked up by multiple microphones). But during the mix, the Beatles used this flaw to deepen the sense of space between the instruments: in the stereo version, the drums were located on the left, John's vocal was in the center, and the guitars were on the right. With the leakage from each track, the results gave the impression of a widened sound image.

1. Lewisohn, *The Complete Beatles Recording Sessions.*
2. Sheff, *The Playboy Interview with John Lennon & Yoko Ono.*
3. Ibid.

Blackbird

Lennon-McCartney / 2:18

SONGWRITER
Paul

MUSICIANS
Paul: vocal, acoustic guitar, foot-tapping

RECORDED
Abbey Road: June 11, 1968 (Studio Two)

NUMBER OF TAKES: 32

MIXING
Abbey Road: June 11, 1968 (Studio Two) / October 13, 1968 (Studio Two)

TECHNICAL TEAM
Producer: George Martin
Sound Engineers: Geoff Emerick, Ken Scott
Assistant Engineers: Phil McDonald, John Smith

FOR BEATLES FANATICS

One of the most amazing remakes of "Blackbird" is no doubt the one by the great bass player Jaco Pastorius, who in 1981 recorded a version played on his fretless bass.

Genesis

"Blackbird" is certainly one of Paul's greatest successes. Paul wrote "Blackbird" at his farm in Scotland. The music was inspired by Johann Sebastian Bach's "Bourrée in E Minor," a piece that George and Paul had learned to play at an early age: "Part of its structure is a particular harmonic thing between the melody and the bass line which intrigued me."[1] Paul developed a guitar technique, all his own, that was different than the traditional finger-picking. Denny Laine, his future partner in Wings, has acknowledged "Blackbird" as one of Paul's greatest compositions: "It's such a simple melody to play. Every time I play it for people, they cannot believe something so simple to play could sound as good. But it's a fact. And that is one of the facets of Paul's incredible genius."[2]

This delicate melody underscored no less subtle lyrics. Paul confided in Barry Miles that he had in mind a black woman, rather than a bird. Feeling concerned about the issue of civil rights in the United States—especially since the assassination of Martin Luther King Jr. in April 1968, and more specifically by the struggle of black American women—Paul wanted to support them in their struggle against all the inequality they suffered, "Let me encourage you to keep trying, to keep your faith, there is hope."[3] It is possible that Angela Davis inspired him, but he mainly wanted to make "Blackbird" a symbol "so you could apply it to your particular problem."[4]

Production

Recorded in one single session on June 11, "Blackbird" required thirty-two takes to be completed. It is a solo performance, with Paul playing a Martin D-28 acoustic guitar as he was singing and keeping the beat with his

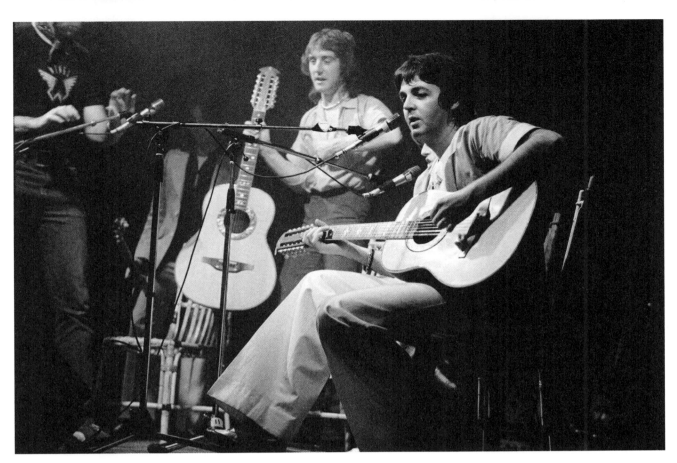

"Blackbird" was a superb acoustic song that Paul kept performing onstage after the breakup of the Beatles, specifically with Denny Laine (above) and Wings.

leather shoes. Only John was present at the beginning of the session, because George and Ringo had flown to California on June 7. John suggested brass arrangements for the end of the song. Paul agreed with the idea immediately, but only used it in "Mother Nature's Son." George Martin preferred a string quartet. Finally, Paul chose only his voice, which he double-tracked in spots, with his guitar and his foot-tapping. Geoff Emerick related that Paul wished to reproduce an outdoor atmosphere; he suggested to him to set him up on a stool, beside the echo chamber, where some fresh air was available. This was how this fantastic ballad was recorded on a soft evening in June. Finally, the sounds of a blackbird were supposed to complete the song. By mistake, John Smith, the assistant engineer, used the sound of a thrush from the sound effects library! Fortunately, Ken Scott caught the mistake in time and corrected Smith's error. The final mixes were dated October 13.

1. Miles, *Paul McCartney*.
2. Giuliano and Laine, *Blackbird*.
3. Miles, *Paul McCartney*.
4. Ibid.

Paul's Feet

It was long claimed that the percussion in "Blackbird" was the sound of a metronome, but indisputable factors prove that this is incorrect: the tempo fluctuated and varied between 89 and 94 bpm (which is impossible for a metronome). In fact, a film was made during the recording of "Blackbird" (see the documentary that accompanied the CD of the remastered album in 2009), in which one could clearly see Paul tapping his feet. Francie Schwartz, his erstwhile girlfriend, who was present during the recording, has confirmed this fact.

Piggies

George Harrison / 2:03

MUSICIANS
George: vocal, acoustic guitar
Paul: bass
Ringo: tambourine
Chris Thomas: harpsichord
John: tape loops
Henry Datyner, Eric Bowie, Norman Lederman, Ronald Thomas: violins
John Underwood, Keith Cummings: violas
Eldon Fox, Reginald Kilbey: cellos

RECORDED
Abbey Road: September 19–20, 1968 (Studio Two) / October 10, 1968 (Studio Two)

NUMBER OF TAKES: 12

MIXING
Abbey Road: October 11, 1968 (Studio Two)

TECHNICAL TEAM
Producers: Chris Thomas, George Martin
Sound Engineer: Ken Scott
Assistant Engineers: Mike Sheady, John Smith

Genesis

"Piggies" was an acidic social criticism in which George bashed the Establishment and the middle class. The rather simplistic message was not among the author's most meaningful ones. George, who usually flirted with Indian philosophy, let go and gave it all he had: *Everywhere there's lots of piggies / Living piggy lives / You can see them out for dinner / With their piggy wives.* As he had trouble with one line, his mother came to his rescue and suggested, *What they need is a damn good whacking.* "Lennon contributed the line "*clutching forks and knives to eat their bacon.*[1] Unfortunately, "Piggies" was one of the songs of the *White Album* fatally misinterpreted by Charles Manson and his "family" in 1969 (see "Helter Skelter"). After murdering the LaBianca couple using knives and forks on August 10, 1969, the "family" wrote *Death to pigs* on the wall of their residence in the victims' blood, as they did after the murder of Roman Polanski's wife Sharon Tate on the front door in Tate's blood.

Production

On September 19, the Beatles recorded "Piggies." Chris Thomas, who was standing in for George Martin as producer, suggested to George Harrison that they use a harpsichord that they had discovered in Studio One. Since it was reserved for a classical recording, the Beatles had to move their session into Studio One instead. Harrison suggested that Thomas, a former student of the Royal Academy of Music, play the keyboard. After eleven takes, they had the basic rhythm track: Chris Thomas was on harpsichord, George on acoustic guitar, Ringo on tambourines, and Paul on bass—this bass was certainly doubled (Fender Jazz Bass and the six-string Fender bass). The next day, they transferred

"Piggies" is a composition by George Harrison, in which he attacks the Establishment. It was a social critique light-years away from the Eastern philosophy of which he had become a fervent devotee.

the four-track recording to the eight-track recorder. George then recorded his lead vocal, with ADT later added to the phrases *play around in* and *damn good whacking*. Harrison wanted a nasal sound, as if he were pinching his nose while singing in the middle eight. Ken Townsend was in charge. He fed the microphone signal through an RS106 bandpass filter, creating the desired sound (0:48 to 1:03). John, who had remained uninvolved until then, concocted a loop of pig snorting and grunting, using a tape from the studios's sound effects collection. On October 10, George Martin, who had

returned from his vacation, wrote a score for George for four violins, two violas, and two cellos (performed by the same musicians he used on "Glass Onion"): he conducted the session. At the end of the recording, "Piggies" was completed. The mono and stereo mixes were done the next day.

1. Sheff, *The Playboy Interview with John Lennon & Yoko Ono*.

Rocky Raccoon

Lennon-McCartney / 3:33

SONGWRITER
Paul

MUSICIANS
Paul: vocal, bass (?), acoustic guitar
John: bass, harmonica, harmonium (?), backing vocal
George: backing vocal
Ringo: drums
George Martin: piano, harmonium (?)

RECORDED
Abbey Road: August 15, 1968 (Studio Two)

NUMBER OF TAKES: 10

MIXING
Abbey Road: August 15, 1968 (Studio Two) / October 10, 1968 (Studio Two)

TECHNICAL TEAM
Producer: George Martin
Sound Engineer: Ken Scott
Assistant Engineer: John Smith

Genesis

Sitting on the roof of the ashram in Rishikesh, while Paul was playing guitar, Paul, John, and Donovan tried to find lyrics for a melody. The three musicians developed the story around a cowboy called Rocky Sassoon, but Paul changed it to Rocky Raccoon. Paul reworked the song, but he was uncertain of the lyrics, changing verses as he went along until the recording session. This parody of a Western saloon, with cowboys, an alcoholic doctor, and the Gideon's Bible, had no other purpose than to be entertaining. Many artists have recorded cover versions of the song, even though John did not really like them, saying, "I saw Bob Hope doing it once on the telly years ago, I just thanked God, it wasn't one of mine."[1] This was the kind of song that stayed with you once you heard it.

Production

Rocky Raccoon was recorded on August 15 in one recording session. The basic rhythm track was completed after nine takes: Paul on vocals and on his Martin D-28 acoustic guitar, John on harmonica and on his Fender six-string bass guitar (with vibrato), and Ringo on drums. George was in the control room. Paul said, "It was a difficult song to record because it had to be all in one take, it would have been very hard to edit because of the quirkiness of the vocals, so I had to do a couple of takes until I got the right sort of feel. But it was fun to do."[2] John's bass and harmonica were deleted and replaced by a new overdubbed bass (Paul?). Ringo rerecorded his drums. This take was reduced in take ten. John played harmonica again in C and George Martin added a perfect honky-tonk piano solo by slowing down

Maharishi Mahesh Yogi with John, Paul, George, Mia Farrow, and Donovan, who contributed to the lyrics of "Rocky Raccoon."

the tape to half-speed as he had done for "In My Life." Later John or George Martin played harmonium, and finally, Paul, John, and George added backing vocals. The mono mix was done in the same session, and the stereo on October 10.

1. Giuliano and Laine, *Blackbird*.
2. Miles, *Paul McCartney*.

Don't Pass Me By

Richard Starkey / 3:50

MUSICIANS
Ringo: vocal, piano, drums, sleigh bells
Paul: bass, piano
Jack Fallon: violin

RECORDED
Abbey Road: June 5, 1968 (Studio Three) / June 6, 1968 (Studio Two) / July 12, 1968 (Studio Two) / July 22, 1968 (Studio One)

NUMBER OF TAKES: 7

MIXING
Abbey Road: June 6, 1968 (Studio Three) / July 12, 1968 (Studio Two) / October 11, 1968 (Studio Two)

TECHNICAL TEAM
Producer: George Martin
Sound Engineers: Geoff Emerick, Ken Scott
Assistant Engineers: Phil McDonald, Richard Lush, John Smith

FOR BEATLES FANATICS

At 1:48, we could hear an alarm clock and Ringo counting out eight beats before the break, which could be heard at 2:39.

Genesis

"Don't Pass Me By" was the first solo composition by Ringo. He wrote it when he was fiddling with the piano at home: "I wrote 'Don't Pass Me By' when I was sitting around at home. I only played three chords on the guitar and three on the piano. . . . It was great to get my first song down, one that I had written."[1] In fact, it had been several years since Ringo had tried to record it. He mentioned the song during an interview in 1964 with the BBC. It was likely that he finished "Don't Pass Me By" for the purposes of the *White Album*. Strangely enough, it was the second song recorded for the album after John's song "Revolution 1." Usually, the second song was one of Paul's. Geoff Emerick, in his book *Here, There and Everywhere*, said, "Ringo was getting a bit fed up, and they were trying to keep him happy." "Don't Pass Me By" has a country and western flavor and Ringo was happy with the song.

Production

Despite the reference to the song in the 1964 interview as "Don't Pass Me By," on June 5 the Beatles began recording it under the working title "Ringo's Tune (untitled)," and the following day as "This Is Some Friendly." The original title was restored on July 12. Only Ringo and Paul played; the two other Beatles were probably unmotivated. The basic track was recorded in three takes with Paul on piano and Ringo on drums. Another piano piece and sleigh bells were overdubbed on the third take. After two reduction mixes, Ringo overdubbed his lead vocal, which was recorded with a tape recorder running slowly, immediately erased, and replaced by a bass guitar (probably overdubbed) played by Paul. The following day, both of Paul's bass guitar tracks were erased and replaced by two lead vocals by Ringo. Paul later overdubbed his

Ringo Starr with Erich Segal, a novelist and scriptwriter, singing and playing piano on "Don't Pass Me By."

final bass part. On July 12, after more than a month of preparation, Ringo's song was completed. He was surprised when he saw Jack Fallon in the studio playing violin. Fallon was a former booking agent as well as a musician who had booked the Beatles during their first engagements in 1962 before the group signed with Parlophone. Ringo commented, "It was a very exciting time for me and everyone was really helpful, and recording that crazy violinist was a thrilling moment."[2] Paul added bass and Ringo added more piano. On July 22, Ringo recorded a piano introduction lasting forty-five seconds, which was edited down to eight seconds on October 11 during the mono and stereo mixes.

First Professional Engagement
Jack Fallon booked the Beatles on their first professional engagement under the direction of Brian Epstein on March 31, 1962, in Stroud, located near Gloucester in the South of England.

1. *The Beatles Anthology.*
2. Ibid.

Why Don't We Do It In The Road ?

Lennon-McCartney / 1:40

SONGWRITER
Paul

MUSICIANS
Paul: vocal, bass, piano, acoustic and lead guitar, hand claps
Ringo: drums, hand claps

RECORDED
Abbey Road: October 9, 1968 (Studio One) / October 10, 1968 (Studio Three)

NUMBER OF TAKES: 6

MIXING
Abbey Road: October 16–17, 1968 (Rooms 41 and 42, Studios One, Two, and Three)

TECHNICAL TEAM
Producer: none
Sound Engineer: Ken Townsend

Genesis

How do songs come to singers? Sometimes, the simplest way. One day Paul was meditating alone on the roof of the Maharishi's ashram in Rishikesh when he saw two monkeys copulating. Surprised by the rapidity and simplicity of this natural scenario, he realized that animals do not bother with formalities, as we humans do, and later he said, "'Why Don't We Do It In The Road?' was a primitive statement to do with sex or to do with freedom really."[1]

On October 9, 1968, the deadline to finalize the *White Album* was approaching, and the Beatles were under pressure. John and George were working on another song in a different studio while Paul and Ringo were free. Paul said, "It wasn't a deliberate thing. John and George were tied up finishing something and me and Ringo were free, just hanging around, so I said to Ringo, 'Let's go and do this'"[2] Paul took Ringo to an available studio to work on "Why Don't We Do It in the Road?" John was unhappy that Paul recorded the song without him and never forgave him for that. "Still, I can't speak for George, but I was always hurt when Paul would knock something off without involving us."[3] Paul in his defense argued that it was not deliberate, noting that John did the same thing with "Revolution 9." John loved this song, probably because it looked like his creation. "It was more an idea into John's style rather than one of my ideas," said Paul.

Production

Paul recorded the basic rhythm track on October 9, John's twenty-eighth birthday. Paul and Ringo were in Studio One, joined by Ken Townsend in the control room using a four-track tape recorder. John and George were using the eight-track recorder. Although

At Rishikesh, Paul wrote lyrics for several songs between transcendental meditation sessions, including "Why Don't We Do It in the Road?" This song was inspired by a scene of daily life.

Ringo was at his side, Paul recorded the rhythm track in five takes. He played acoustic guitar and simultaneously taped his lead vocal. As an introduction, he hit the back of his guitar. His initial idea was alternating between gentle and strident vocals with each verse, which can be heard on *Anthology 3*. Finally, on the fifth take, he decided to add a more strident vocal. At the end of the session, he overdubbed a piano part. The following day, Ringo added drums. Paul recorded his second lead vocal, bass, and hand claps with Ringo. After a reduction mix, he overdubbed a guitar part, probably using his Epiphone Casino. "Why Don't We Do It In The Road?" was finalized during the last mix sessions of the *White Album* on October 16 and 17.

1. Miles, *Paul McCartney*.
2. Davies, *The Beatles*.
3. Sheff, *The Playboy Interview with John Lennon & Yoko Ono*.

I Will

Lennon-McCartney / 1:45

SONGWRITER
Paul

MUSICIANS
Paul: vocal, acoustic guitar
John: percussion
Ringo: percussion

RECORDED
Abbey Road: September 16–17, 1968 (Studio Two)

NUMBER OF TAKES: 68

MIXING
Abbey Road: September 26, 1968 (Studio Two) / October 14, 1968 (Studio Two)

TECHNICAL TEAM
Producers: Chris Thomas, George Martin
Sound Engineer: Ken Scott
Assistant Engineers: Mike Sheady, John Smith

Genesis

Paul had "I Will" as a melody for years, but he did not have lyrics to go with it. At the release of the *White Album*, he said in an interview that during the Hamburg years the Beatles were not confined to rock 'n' roll. The audience often solicited rumbas or mambos, and they had to adapt to the audience, which explained the diversity of their live repertoire. Paul could easily alternate between hard rock such as "Helter Skelter" and gentle ballads such as "I Will." One evening in Rishikesh, Paul and Donovan were together after a day of meditation, and Paul played "I Will" for Donovan. They tried to write some words. Paul recalled, "We kicked around a few lyrics, something about the moon, but they weren't very satisfactory and I thought the melody was better than the words so I didn't use them. I kept searching for better words and I wrote my own set in the end; very simple words, straight love-song words really. I think they're quite effective. It's still one of my favorite melodies that I've written."[1]

Production

On September 16, the Beatles were all in the studio, except for George. The three of them recorded the basic rhythm track: Paul was on vocals and played his Martin D-28, Ringo played maracas and cymbals, and John was beating some metal with a piece of wood. Specific percussion instruments are difficult to make out, but probably there are woodbocks and bongos. It took sixty-seven takes to get the right rhythm track because Paul was uncertain about the final lyrics. The song was recorded with a number of ad-libs as the session progressed. During the session, he improvised a song called "Can You Take Me Back," an excerpt of which was placed after "Cry Baby Cry" on the final

Donovan, a Scottish folk singer who emerged from the British folk scene in the '60s with "Catch the Wind" and "Sunshine Superman," contributed to an early version of the lyrics of "I Will."

album, and an impromptu version of Cilla Black's 1968 hit single "Step Inside Love." Finally, take 65 was considered the best version and was transferred to the new eight-track tape recorder. The next day, "I Will" was complete with overdubs, all performed by Paul, with vocals, and with an amazing bass line, which he sang by imitating the sound of the bass (on the right channel in stereo). Finally, he added a second acoustic guitar. The mono mix was done on September 26, and the stereo on October 14.

1. Miles, *Paul McCartney*.

Julia

Lennon-McCartney / 2:53

SONGWRITER
John

MUSICIAN
John: vocal, acoustic guitar

RECORDED
Abbey Road: October 13, 1968 (Studio Two)

NUMBER OF TAKES: 3

MIXING
Abbey Road: October 13, 1968 (Studio Two)

TECHNICAL TEAM
Producer: George Martin
Sound Engineer: Ken Scott
Assistant Engineers: John Smith

The Thirty-Second Song

"Julia" was the thirty-second song and final song recorded for the Beatles' White Album. Two songs completed during the sessions were not included in the album, "Not Guilty" by George and "What's the New Mary Jane" by John.

Genesis

This beautiful ballad by John was written in India and was without a doubt a response to Paul's "Blackbird." John used a style of finger-picking that Donovan had taught him in Rishikesh, and composed "Julia" and "Dear Prudence" immediately afterwards. Julia was written for his mother, whose death, when he was a teenager, significantly affected him. In the 1980 interview, he said, "I lost her twice. When I was 5 and I moved to my auntie, and when she physically died" when I was seventeen. "She was killed by an off-duty cop who was drunk," Julia remained very present in his life as in his art, inspiring many songs: "Julia," "Mother," and "My Mummy's Dead" (the last two released on his first solo album *John Lennon / Plastic Ono Band*), and he named his first son, Julian, in memory of his mother Julia. John explained that "Julia" was also a tribute to Yoko, whose name in English means "Ocean child." "It was sort of a combination of Yoko and my mother blended into one."[1] With "Julia," John demonstrated that he knew how to navigate between gentle ballads and rock songs as well as Paul did.

Production

On Sunday, October 13, John was by himself in the studio to record "Julia," while Paul was observing and supporting him from the control room (see *Anthology 3*). In just three takes, the rhythm track was recorded. John had perfectly mastered the finger-picking technique and recorded a brilliant guitar part. He then recorded his soulful vocal twice, "the two vocal recordings allowing for an effective word overlap on the word *Julia* itself."[2] He also double-tracked an acoustic guitar part, and the

John Lennon in 1948 with his mother Julia who passed away when John was seventeen. The song "Julia" was a tribute to his mother as were "Mother" and "My Mummy's Dead."

song was immediately mixed for both mono and stereo. The song foreshadowed his remarkable solo album, released on December 11, 1970, after the dissolution of the group.

1. Sheff, *The Playboy Interview with John Lennon & Yoko Ono.*
2. Lewisohn, *The Complete Beatles Recording Sessions.*

Birthday

Lennon-McCartney / 2:42

SONGWRITERS
Paul and John

MUSICIANS
Paul: vocal, bass (?), piano, lead guitar (?)
John: vocal, lead guitar
George: lead guitar, bass (?), backing vocal, tambourine
Ringo: drums, hand claps
Mal Evans: hand claps
Pattie Boyd, Yoko Ono: backing vocal

RECORDED
Abbey Road: September 18, 1968 (Studio Two)

NUMBER OF TAKES: 22

MIXING
Abbey Road: September 18, 1968 (Studio Two) / October 14, 1968 (Studio Two)

TECHNICAL TEAM
Producers: Chris Thomas, George Martin
Sound Engineer: Ken Scott
Assistant Engineers: Mike Sheady, John Smith

FOR BEATLES FANATICS

When Paul sings *dance* at 2:08, we can hear the end of a previous take in the background. The result is *dance . . . aaannnce!*

Genesis

Chris Thomas, who replaced George Martin during his absence, mentioned to the Beatles that the film *The Girl Can't Help It*, whose cast features Little Richard, Gene Vincent, Eddie Cochran, Fats Domino, and others, was being shown for the first time on the BBC on September 18 at 9 P.M. The musicians had scheduled a recording session at 5 P.M. in order to watch the rock 'n' roll film at Paul's house on Cavendish Avenue close to Abbey Road.

On that day, Paul arrived earlier at the studio and played a piano riff. All together, they decided to write a song around that riff. They chose a twelve-bar blues pattern and built it sequence by sequence with no idea what the song was going to be. In 1968, Paul explained in an interview, "We just said, 'Okay. Twelve bars in A, and we'll change to D, and I'm gonna do a few beats in C.' And we really just did it like that . . . random thing." After watching the film at Paul's house, they returned to the studio and wrote some words to go with the music. "'Birthday' was just made up on the same evening." Paul said, "So that is 50-50 John and me. . . . I don't recall it being anybody's birthday in particular but it might have been, but the other reason for doing it is that, if you have a song that refers to Christmas or a birthday, it adds to the life of the song, if it's a good song, because people will pull it out on birthday shows, so I think there was a little bit of that at the back of our minds."[1] According to John, "'Birthday' was written in the studio. Just made up on the spot. I think Paul wanted to write a song like 'Happy Birthday Baby,' the old fifties hit. But it was sort of made up in the studio. It was a piece of garbage."[2]

The same day that the Beatles saw *The Girl Can't Help It*, produced by Frank Tashlin, a celebration of rock 'n' roll, John and Paul composed "Birthday."

Production

The Beatles were in the studio on September 18 at 5 o'clock. They recorded the rhythm track of "Birthday" in twenty takes on a four-track recorder. Although there is no record of the precise instrumental distribution, it is likely that Paul was on bass, John and George were on guitar, and Ringo was on drums. For a long time, it was suggested that George played bass; however, there is no tangible evidence of that. Back from their film break, they transferred their work to the new eight-track recorder. George added tambourine and wore a pair of gloves to protect against blisters! Ringo joined him and double-tracked his snare drum simultaneously. Paul and John recorded their lead vocals, predominantly Paul's—one of his finest vocal performances, backed by George

in certain passages—while Mal Evans and Ringo hand clapped. Vocals and hand claps were overdubbed and were highly treated with ADT during the mix. Finally, for the first time, Pattie Boyd and Yoko Ono contributed to the backing vocals, singing *Birthday!* with little high-pitched voices. Paul finished the recordings by adding a piano part with sound picked up by a Vox amp. According to Kevin Ryan and Brian Kehew,[3] Ken Scott turned the knob of midrange frequencies to simulate a wah-wah pedal, which was especially audible at the end of the piece. The mono mix was done the same day, and the stereo mix on October 14.

1. Miles, *Paul McCartney*.
2. Sheff, *The Playboy Interview with John Lennon & Yoko Ono*.
3. Ryan and Kehew, *Recording the Beatles*.

Dirty Mac, created for the Rolling Stones' TV special, consisted of John Lennon and Eric Clapton on lead guitar, Keith Richards on bass, and Mitch Mitchell on drums. A dream supergroup to perform "Yer Blues."

Yer Blues

Lennon-McCartney / 3:58

SONGWRITER
John

MUSICIANS
John: vocal, rhythm and lead guitar
Paul: bass, backing vocal
George: lead guitar
Ringo: drums

RECORDED
Abbey Road: August 13–14, 1968 (Studio Two) / August 20, 1968 (Studio Three)

NUMBER OF TAKES: 17

MIXING
Abbey Road: August 14, 1968 (Studio Two) / October 14, 1968 (Studio Two)

TECHNICAL TEAM
Producer: George Martin
Sound Engineer: Ken Scott
Assistant Engineer: John Smith

FOR BEATLES FANATICS

An excellent version of "Yer Blues" was recorded on September 11, 1968, by Dirty Mac, a one-time English super group formed for the Rolling Stones' TV special titled *The Rolling Stones Rock and Roll Circus*. The album for the event was released on CD and VHS in 1996; the DVD followed in 2004. John was on vocals and rhythm guitar, Eric Clapton on lead guitar, Keith Richards on bass, and Mitch Mitchell on drums.

Genesis

Following the teachings of Maharishi Mahesh Yogi was not an easy task for John. Weaned off drugs, troubled by Yoko who was regularly sending him secret letters, and exhausted by his meditation attempts, John was depressed. "'Yer Blues' was written in India, too. The same thing: up there trying to reach God and feeling suicidal."[1] Yet, he admitted it was a nice, secure scene. In fact, he could not explain his discomfort: "The funny thing about the [Maharishi's] camp was that although it was very beautiful and I was meditating about eight hours a day, I was writing the most miserable songs on earth. In 'Yer Blues,' when I wrote, *I'm so lonely I want to die*, I'm not kidding. That's how I felt."[2]

The song reflected his mood at the time: he felt down and even hated his rock 'n' roll music. He alluded to his insecurity with a reference to the enigmatic character Mr. Jones from Dylan's "Ballad of a Thin Man," extracted from one of his masterpieces, *Highway 61 Revisited* in 1965.

Production

On August 13, the Beatles, always on a quest for new sounds decided to record "Yer Blues," not in Studio Two but in the small room adjacent to the control room that was used to store tapes. Paul said, "It was quite a small room, about ten feet by four feet, a poky cupboard really that normally had tapes and microphones leads and jack plugs in it. And we said, 'Can we record in there?' And George Martin said, 'What, the whole band?' We said, 'Yes! Let's try it!"[3]

The four of them ended up in the small room with the amps turned toward the wall to avoid instruments and vocals spilling over into other tracks. John was standing in front of a microphone in the middle. "We liked being in close contact with each other, we felt it

added to the power of our music, and it did," said Paul. Ringo also remembered, "It was the four of us. That is what I'm saying: it was really because the four of us were in a box, a room about eight by eight, with no separation. It was this group that was *together*; it was like grunge rock of the Sixties—really, grunge blues."[4]

The rhythm track was completed after fourteen takes. John played his Epiphone Casino, George on his Les Paul "Lucy," Paul on his Fender Jazz Bass, and Ringo on his Ludwig. John and George each performed a solo. One can also hear previous solos starting at 2:54 in the background that spilled over into the first take. Satisfied, they still chose to replace the entire part after the solo with the sixth take. The edit occurred at 3:17 into the song and ran through to the fade-out. The edit was made directly on the master tape. The next day John recorded a new lead vocal backed by Paul,

and Ringo double-tracked his snare part and the break in the solo part. The mono mix was made the same day, and the stereo mix on August 20. "Yer Blues" was completed with Ringo recording a very short count-in for the introduction, a "two, three . . .," edited right away into mixes.

Technical Details
Ken Scott used an RCA 44-BX mic to record John's vocals, a microphone generally used for percussion.

1. Lewisohn, *The Complete Beatles Recording Sessions.*
2. *The Beatles Anthology.*
3. Miles, *Paul McCartney.*
4. *The Beatles Anthology.*

Mother Nature's Son

Lennon-McCartney / 2:47

SONGWRITER
Paul

MUSICIANS
Paul: vocal, acoustic guitar, bass drum, percussion
Unknown musicians: 2 trumpets, 2 trombones

RECORDED
Abbey Road: August 9 and 20, 1968 (Studio Two)

NUMBER OF TAKES: 26

MIXING
Abbey Road: August 20, 1968 (Studio Two) / October 12, 1968 (Studio Two)

TECHNICAL TEAM
Producer: George Martin
Sound Engineer: Ken Scott
Assistant Engineer: John Smith

Genesis

"Mother Nature's Son" was inspired by a lecture on nature by the Maharishi Mahesh Yogi in Rishikesh. Paul finished writing the song at his father's house in Liverpool. He was also influenced by Nat King Cole's 1948 recording of the song "Nature Boy,' which was a major hit.

John, who also attended the lecture, was inspired to write "I'm Just a Child of Nature." He released the song in 1971 with revised lyrics, under the title "Jealous Guy," for his second solo album *Imagine.* Paul cultivated a sincere love for nature. This was strengthened even more after he met Linda Eastman: "I'd always loved nature, and when Linda and I got together we discovered we had this deep love of nature in common."[1] The couple devoted their lives to the defense of the planet and Linda converted Paul to vegetarianism in 1975.

Production

On August 9, after recording take 102 (!) of George's song "Not Guilty," the Beatles left the studio, and Paul stayed behind to record "Mother Nature's Son." George's song "Not Guilty" was not included on the *White Album*, but a revised version was released on George Harrison's 1979 self-titled solo album. Paul recorded his vocals and acoustic guitar simultaneously, on the Martin D-28 acoustic guitar. Take 24 was the best.

On August 20, recording sessions resumed. Paul decided to follow John's advice given during the recording sessions of "Blackbird" and recorded overdubs of brass instruments. Two trumpet and two trombone players were in the studio to perform the delicate arrangement written by George Martin. After reduction, Paul, who played all the instruments, wanted an

Under the influence of Maharishi Mahesh Yogi, Paul composed "Mother Nature's Son." John (above) wrote "I'm Just a Child of Nature," which later turned into "Jealous Guy" for the 1971 *Imagine* album.

open effect on his bass drum to give a bongo sound on the third part of the song. According to Alan Brown, the technical engineer, Paul asked to be recorded in the corridor adjacent to Studio Two, where Ken Scott recalled there was a staircase. The bass drum was recorded with reverb, which is audible from 1:54. John Smith also remembered Paul listening to the playback in the control room, hitting a book he had brought (*The Song of Hiawatha* by Henry Wadsworth Longfellow), and he was satisfied with the sound effect. He asked Ken Scott to record it: the resulting percussion was Paul hitting his book! Finally, a second acoustic guitar was added at the end of the song. "Mother Nature's Son" was more of a solo work than a Beatles recording. Ken

Scott related an anecdote revealing the tension between them at that time: "Paul was downstairs going through the arrangement with George [Martin] and the brass players. Everything was great, everyone was in great spirits. It felt really good. Suddenly, half way through, John and Ringo walked in and you could cut the atmosphere with a knife. An instant change. It was like that for ten minutes and then as soon as they left it felt great again."[2] The final mixes were dated October 12.

1. Miles, *Paul McCartney.*
2. Lewisohn, *The Complete Beatles Recording Sessions.*

Everybody's Got Something To Hide Except Me And My Monkey

Lennon-McCartney / 2:24

SONGWRITER
John

MUSICIANS
John: vocal, rhythm guitar, hand claps
Paul: bass, fireman's bell, backing vocal, hand claps
George: lead guitar, backing vocal, hand claps
Ringo: drums, maracas, hand claps

RECORDED
Abbey Road: June 26–27, 1968 (Studio Two) / July 1 and 23, 1968 (Studio Two)

NUMBER OF TAKES: 12

MIXING
Abbey Road: July 23, 1968 (Studio Two) / October 12, 1968 (Studio Two)

TECHNICAL TEAM
Producer: George Martin
Sound Engineers: Geoff Emerick, Ken Scott
Assistant Engineers: Richard Lush, John Smith

FOR BEATLES FANATICS

Fats Domino released a cover of "Everybody's Got Something to Hide Except Me and My Monkey" in 1969. John liked it.

Genesis

"Everybody's Got Something to Hide Except Me and My Monkey" is the longest title in the Beatles' discography. John loved the sentence, which was about his relationship with his new girlfriend, Yoko Ono. The couple had to face the misunderstanding of their entourage and their fans' misunderstanding that quickly turned into hostility and even rejection. Yoko was subject to insults and threats. John said in 1980: "Everybody seemed to be paranoid except for us two, who were in the glow of love. . . . Everybody was sort of tense around us: You know, 'What is *she* doing here at the session? Why is she with him?' All this sort of madness is going on around us because we just happened to want to be together all the time."[1] For Paul, the song was a direct reference to John's heroin habit: a *monkey on your back* was a jazz-musician slang term for heroin addiction in the 1940s. It was a difficult period for John. Drugs, marriage breakdown, and tension within the group made him paranoid and aggressive. Pete Shotton remembered an episode when John thought he was the reincarnation of Jesus. Yoko was his savior, but not the savior of the group.

Production

On June 26, the Beatles rehearsed a new song by John that was to become "Everybody's Got Something to Hide Except Me and My Monkey." At this time, the Beatles recorded all their rehearsals and kept all the recordings in case they ended up with something they could use. The first day's recording session was a long rehearsal, and the following day they began the proper recording. The rhythm track was completed in eight takes with a tape recorder running slowly; John and George were on guitars with the volume turned up very

The relationship between John and Yoko created tension among the Beatles.

high. George played lead guitar magnificently, much more aggressively than his usual style. Ringo was on drums and Paul hit a huge fireman's bell with such vigor that Geoff Emerick did not assign a microphone to Paul because it was so loud. Paul had to take a break after each take because it was physically very difficult. The group seemed to have regained its vitality. The song lasted more than three minutes but was cut down to two minutes and twenty-nine seconds at normal speed. On July 1, John added a new lead vocal, and Paul recorded an excellent bass part that he double-tracked at the end beginning at 2:04. They reworked the song again on July 23. John recorded a new lead vocal, full of energy and enthusiasm, with Paul and George on backing vocals. They added hand claps to complete the recording. Final mixes were done on October 12. The Beatles spent a significant amount of time on this recording, but the results were well worth it.

1. Sheff, *The Playboy Interview with John Lennon & Yoko Ono.*

Sexy Sadie

Lennon-McCartney / 3:14

SONGWRITER
John

MUSICIANS
John: vocal, rhythm guitar, organ (?)
Paul: bass, piano, organ (?), backing vocal
George: lead guitar, backing vocal
Ringo: drums, tambourine

RECORDED
Abbey Road: July 19 and 24, 1968 (Studio Two) / August 13 and 21, 1968 (Studio Two)

NUMBER OF TAKES: 117

MIXING
Abbey Road: August 21, 1968 (Studio Two) / October 14, 1968 (Studio Two)

TECHNICAL TEAM
Producer: George Martin
Sound Engineer: Ken Scott
Assistant Engineers: Richard Lush, John Smith

Genesis

In April 1968, John and George were still in Rishikesh; Ringo and Paul were already back in London. The actress Mia Farrow, who studied the teachings of Maharishi Mahesh Yogi with them, said to John that the Maharishi had made a pass at her. Pattie Boyd, George's wife, mentioned in her memoirs[1] that Alexis Mardas—called "Magic Alex"—probably started the rumor to slander the Maharishi. Alex wanted to keep John away because he was afraid that his influence over the Beatles was about to be usurped by the Maharishi. After the Mia Farrow episode, Madras made another false accusation. For John, this incident was too much. He felt betrayed, and decided to leave Rishikesh right away with the whole group. The Maharishi, distraught about this total misunderstanding, asked John why they were leaving. John replied "If you're so cosmically conscious as you claim, then you should know why we're leaving."[2] This disappointment inspired John's song: "I wrote it when we had our bags packed and we were leaving. It was the last piece I wrote before I left India."[3] The song was originally called "Maharishi," but George persuaded John to change the title to "Sexy Sadie." John used the situation to express his feelings. Since the original words were a bit insulting, John changed the lyrics for the record. John left India with a bitter taste in his mouth. Pattie Boyd wondered if the rumor gave John a pretext to leave India and return to Yoko's side sooner.

Production

The first recording session began on July 19. The Beatles spent most of the day rehearsing, rather than recording a proper rhythm track. They recorded twenty-one takes with guitars, organ, and drums. Dissatisfied with the result, a remake was recorded on July 24. Even though take 47 was labeled the best, John was not

Maharishi Mahesh Yogi (left) with his student Mia Farrow (right), to whom the Maharishi might have made a pass. "Sexy Sadie" was inspired by this melodrama.

pleased by what he heard. On August 13, they began a third version. Curiously, this re-remake of "Sexy Sadie" began with a round number—take 100! This day, the rhythm track was considered the best, with John on rhythm guitar, George on lead guitar, Ringo on drums, and Paul at the piano on which there was a strong echo (at 1:18 we can hear it fluctuate erratically). John added a lead vocal. After a series of reduction mixes, the rhythm track was ready for overdubs to start on August 21 with a new vocal by John with Paul and George on backing vocals, Paul on bass, either John or Paul on organ, and Ringo on tambourine. Flanging was added to the chorus, which gave it some originality. The Beatles always searched for perfection, as evidenced once again with "Sexy Sadie." The mono mix was done at the end of the recording session, and the stereo mix on October 14. "Sexy Sadie" was a great Beatles masterpiece, probably underestimated, but strikingly original.

FOR BEATLES FANATICS

The opening lines were inspired by Smokey Robinson's song "I've Been Good to You" (1961), which begins, *Look what you've done / You made a fool out of someone.* John's opening lines were *Sexy Sadie, what have you done? / You made a fool of everyone.*

1. Pattie Boyd and Penny Junor, *Wonderful Tonight: George Harrison, Eric Clapton, and Me* (New York: Harmony Books [cloth]; Three Rivers Press [paper], 2007).
2. Miles, *Paul McCartney.*
3. Sheff, *The Playboy Interview with John Lennon & Yoko Ono.*

Helter Skelter

Lennon-McCartney / 4:29

SONGWRITER
Paul

MUSICIANS
Paul: vocal, bass, lead guitar, piano
John: bass, saxophone, backing vocal
George: lead guitar, backing vocal
Ringo: drums
Mal Evans: trumpet

RECORDED
Abbey Road: July 18, 1968 (Studio Two) / September 9–10, 1968 (Studio Three)

NUMBER OF TAKES: 21

MIXING
Abbey Road: September 17, 1968 (Studio Two) / October 9 and 12, 1968 (Studio Two)

TECHNICAL TEAM
Producers: George Martin, Chris Thomas
Sound Engineer: Ken Scott
Assistant Engineers: Richard Lush, John Smith, Mike Sheady

FOR BEATLES FANATICS

Just before Ringo started screaming, *I've got blisters on my fingers,* John could be heard in the distance asking, *How's that?* (4:24), to find out if his colleagues enjoyed his sax solo!

Genesis

Pete Townshend had been quoted in *Melody Maker* as describing the Who's new single "I Can See for Miles," as the loudest, rawest, dirtiest, and most uncompromising song they had ever done. Paul said, "Just that one little paragraph was enough to inspire me; to make me make a move. So I sat down and wrote 'Helter Skelter' to be the most raucous vocal, the loudest drums, et cetera et cetera."[1] He said in 1968, "I had this song called 'Helter Skelter,' which is just a ridiculous song. So we did it like that, 'cuz I like noise."[2] The results met his expectations, and "Helter Skelter" could be considered one of the very first hard rock songs in history. (When Paul actually heard the Who's single, he was disappointed to find out it was not as *dirty* as he expected!)

The lyrics did not have any real meaning, even if Paul told Barry Miles he wanted to symbolize the feeling of falling, "the fall of the Roman Empire" (*helter skelter* meaning a spiral slide). Unfortunately, these words were interpreted in a dramatic way by Charles Manson and his "family" in 1969, who read into them a call to murder.

Production

The first recording went back to July 18. It was different than the final version, as can be heard on *Anthology 3*: the tempo was much slower and, although the feeling was heavy, it was more blues-based. They recorded three takes, lasting 10:40, 12:35, and 27:11, respectively, the last was the longest recording in the group's career. They played live with two guitars, one bass, and drums. Almost two months went by before they redid "Helter Skelter" entirely on September 9. George Martin went on an unplanned vacation, leaving Chris Thomas in charge. When Thomas delivered the news that Martin was gone, Paul said, "Well if you wanna produce

Paul with Mal Evans, who played trumpet on "Helter Skelter," a "deluge of decibels" that the Manson family interpreted as a deadly message.

us you can produce us. If you don't, we might just tell you to fuck off."[3] After this friendly intro, Thomas used the eight-track 3M: it was the second song to be produced with this new equipment. Ringo was on drums, John played beautifully on the Fender six-string bass, with George and Paul on lead guitar. The best take was the twenty-first. With George Martin absent, the Beatles went wild. Brian Gibson, the technical engineer, remembered the session being out of control: "They were completely out of their heads that night."[4] The next day they began the overdubs: Paul recorded his extraordinary vocal performance, with John and George on backing vocals. More guitar parts were added by Paul and George, Ringo doubled his drumming with a snare drum boosted with echo, George performed a brief guitar solo, and John played saxophone, while Mal Evans played trumpet (both of which you can easily hear around 3:19). Finally, a dissonant piano and various mumblings completed the song. The atmosphere was as hot as it had been the night before. Chris Thomas remembered George running around the studio with an ashtray set on top of his head and flames coming out of it, while Paul recorded his raucous lead vocal. Ringo, who beat his drums like a real lumberjack for hours, was stressed out and screamed, as you could hear at the end of the piece (only in the stereo version), *I've got blisters on my fingers!* There was a difference between the mono and stereo mix (which, by the way, were very compressed): the mono mix, done on September 17, only lasted 3:36, but the stereo mix of October 12 fades back in after the fade-out, resulting in a time of 4:29.

The Four Horsemen of the Apocalypse

In August 1969, Charles Manson became infamous by leading the followers of his hippie community, the "family," to commit seven murders, including the killing of actress Sharon Tate, the wife of director Roman Polanski, who was eight months' pregnant. Manson, a fan of the Beatles, thought he deciphered messages in the White Album. He was convinced that "Helter Skelter" prophesied the rise of the black community in the near future and that other songs, like "Piggies" or "Revolution 9," concealed occult messages that he interpreted based on chapter 9 of the Book of Revelations. For him, the Beatles were none other than the Four Horsemen of the Apocalypse.

1. Miles, *Paul McCartney.*
2. Interview with Radio Luxembourg (November 20, 1968).
3. Lewisohn, *The Complete Beatles Recording Sessions.*
4. Ibid.

Long, Long, Long

George Harrison / 3:03

MUSICIANS
George: vocal, acoustic guitar
Paul: bass, organ, backing vocal
Ringo: drums
Chris Thomas: piano

RECORDED
Abbey Road: October 7–9, 1968 (Studio Two)

NUMBER OF TAKES: 67

MIXING
Abbey Road: October 10 and 12, 1968 (Studio Two)

TECHNICAL TEAM
Producer: George Martin
Sound Engineer: Ken Scott
Assistant Engineers: Mike Sheady, John Smith

Genesis

George's fourth song for the *White Album* was initially called "It's Been a Long Long Long Time." This beautiful ballad, full of tenderness and emotion, was inspired by George's growing religious faith. "The 'you' in 'Long Long Long' is God,"[1] he said. Simple words for a clear message: George moved stylistically from the music and lyrics of "Piggies" and "Savoy Truffle." Musically, the song "Sad-Eyed Lady of the Lowlands," by Bob Dylan, supplied him with a harmonic foundation that he adapted: "D to E minor, A and D, those three chords and the way they moved."[2]

Production

George's song, which was recorded on October 7, was only produced by three Beatles, while John was absent once again. Apart from "While My Guitar Gently Weeps," John did not participate in George's other songs, and only provided sound loops for "Piggies." The session nevertheless happened in a relaxed atmosphere, with incense sticks spread throughout the studio. George looked happy. For the rhythm track, which took sixty-seven takes, George was on acoustic guitar and vocal, Paul on organ, and Ringo on drums. "There's a sound near the end of the song [best heard on the right stereo channel] which is a bottle of Blue Nun wine rattling away on the top of a Leslie speaker cabinet," said Chris Thomas. "Paul hit a certain organ note and the bottle started vibrating. We thought it was so good that we set the mics up and did it again. The Beatles always took advantage of accidents."[3] Therefore, they inserted this at the very end of the song and, to reinforce the effect, Ringo added a snare drum roll, Paul added an organ chord, and George beat his guitar strings in an unexpected way. Ken Scott remembered,

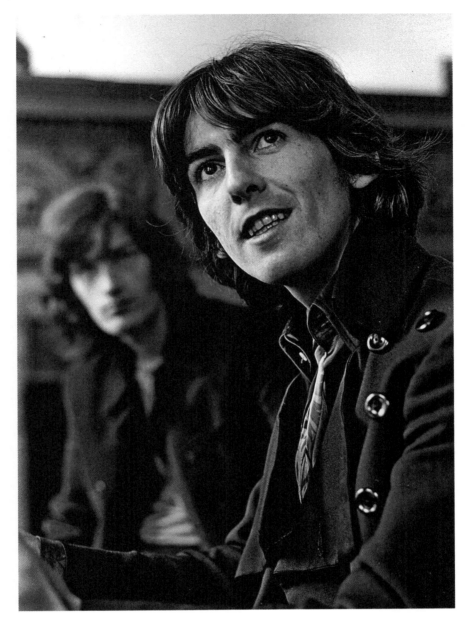

"Long, Long, Long" was George Harrison's fourth song for the *White Album*. It was a ballad that expressed his religious concerns.

"There is a particularly abrasive acoustic guitar sound underneath the sound of the bottle on the Leslie. That was George using the D19c [microphone] as a pick."[4] On October 8, George doubled his voice, added a second acoustic guitar, and Paul recorded his bass part. The next day, George and Paul asked Chris Thomas to record a piano part on the bridge, in the style of the Moody Blues. For four hours, they had him redo his part incessantly! He suspected they wanted to get revenge for the many times that he had interrupted them during recording. At the mix, reverb was added to the drums, echo was added to the vocals, and flanging/chorus was added to the organ. The stereo mix was carried out on October 10, and the mono on October 12.

Technical Details

"Long, Long, Long" was a song that benefited from the transition to digital. Originally, it was recorded on vinyl records in the last place of side A of the second record. In this location, there was a degradation of the sound signal and it lost a lot of its delicacy. The conversion to digital restored all its dynamism and fragility.

1. Harrison, *I Me Mine*.
2. Ibid.
3. Lewisohn, *The Complete Beatles Recording Sessions*.
4. Ryan and Kehew, *Recording the Beatles*.

Revolution 1

Lennon-McCartney / 4:14

SONGWRITER
John

MUSICIANS
John: vocal, acoustic and electric guitar
Paul: bass, piano, organ, backing vocal
George: acoustic and lead guitar, backing vocal
Ringo: drums, percussion
Freddy Clayton, Derek Watkins: trumpets
Don Long, Rex Morris, J. Power, Bill Povey: trombones

RECORDED
Abbey Road: May 30, 1968 (Studio Two) / May 31, 1968 (Studio Three) / June 4, 1968 (Studio Three) / June 21, 1968 (Studio Two)

NUMBER OF TAKES: 22

MIXING
Abbey Road: May 31, 1968 (Studio Three) / June 4, 1968 (Studio Three) / June 21 and 25, 1968 (Studio Two)

TECHNICAL TEAM
Producer: George Martin
Sound Engineers: Geoff Emerick, Pete Brown
Assistant Engineers: Phil McDonald, Richard Lush

1. Sheff, *The Playboy Interview with John Lennon & Yoko Ono.*
2. *The Beatles Anthology.*
3. Sheff, *The Playboy Interview with John Lennon & Yoko Ono.*
4. Ryan and Kehew, *Recording the Beatles.*

Genesis

It was the first and last time in the Beatles' career that one song had three different versions: "Revolution 1," "Revolution 9," and "Revolution." The first two appeared on the *White Album*, while the last one was the B side of the "Hey Jude" single. Originally, "Revolution 1" lasted 10:17, with the final six minutes being a totally delirious ad-lib and Yoko whispering, *you become naked*, with the addition of a number of sound effects. This coda formed the basis of "Revolution 9." It was the first intervention of an outside person into their closed circle. And Yoko Ono, John's new companion, added fuel to the fire by means of her omnipresence. "Revolution 1," the first song recorded for the *White Album*, gave John the opportunity to state the group's political positions about Vietnam, Mao, and Cuba. When he was alive, Brian Epstein had tried to temper John's moods, but John had wanted to express his views in his music. "But on one of the last tours, I said, 'I am going to answer about the war. We can't ignore it.'"[1] Strangely, his lyrics did not express a very clear commitment, but rather an ambiguous one. John understood and supported the revolution, but it had to be exempt from any outside influence and any violence. Being undecided about his position, he expressed it awkwardly: *Don't you know that you can count me out/in,* he sang. "There were two versions of that song, but the underground left only picked up on the one that said 'count me out.' The original version which ends up on the LP said 'count me in' too; I put in both because I was not sure. I didn't want to get killed."[2] As a result of this ambiguity, he was mocked by the leftists, who called him a "millionaire revolutionary." He was upset about this, so he got involved in politics more seriously at the beginning of his solo career, but this got him into heavy trouble with the Nixon administration.

"Revolution 1," a song denouncing the war in Vietnam and talking about Mao, was one of John's first political manifestos. In this photo, he was trying to find the right position to give a better vocal performance!

John wanted to release "Revolution 1" as the next Beatles single. But neither George nor Paul were very enthusiastic about that idea; they were certainly embarrassed by the lyrics. "George and Paul were resentful and said it wasn't fast enough."[3] John, who continued to push for the song's release agreed to record a second, faster version to satisfy his partners ("Revolution").

Production

On May 30, once again, one of John's songs launched the recording sessions for a new album. After eighteen takes, the rhythm track was recorded with piano, acoustic guitar, drums, and vocal. Lasting over 10:00, "Revolution" (the working title of "Revolution 1") had a long, chaotic ending, with a delirious coda in which John incessantly screamed *all right*. The atmosphere was electric. Something had changed. The next day, John recorded two separate vocals, hesitating on each take at the point of *count me out/in*, with Paul on bass. Paul and George also recorded backing vocals. John rerecorded his vocal on June 4. It was a day for experimentation. John chose a way of singing that had never been heard before. Brian Gibson, who was then the technical engineer, remembered it: "John decided he would feel more comfortable on the floor so I had to rig up a microphone which would be suspended on a boom above his mouth. It struck me as

somewhat odd, a little eccentric, but they were always looking for a different sound; something new."[4] (In certain photos, Yoko Ono could be seen lying by his side!) That very same day, Paul recorded some organ, Ringo recorded new drum parts and various percussion parts, while John played guitar that was saturated by means of a volume pedal. Other experiments that were not kept included Paul and George repeating incessantly, *Mama . . . Dada . . .* on the coda as well as loops of various effects that were close to chaos. On June 21, in the absence of Paul, who had left the night before for Los Angeles in order to announce to Capitol Records that from then on, their records were going to be labeled Apple, two trumpet players and four trombone players recorded arrangements to complete the song. Finally, George played a lead guitar part. During the mix of June 25, Geoff Emerick did a bad edit that added an extra beat. Although he wanted to correct his mistake, John told him he loved it like that (3:24). The mono and stereo mixes were done on June 25.

Technical Details

To record John as he lay on his back, Brian Gibson had to choose a lighter microphone than the Neumann U 47, lest it fall on him and injure him! He chose a Neumann KM 54 instead.

Honey Pie

Lennon-McCartney / 2:40

SONGWRITER
Paul

MUSICIANS
Paul: vocal, piano, lead guitar (?)
John: lead guitar
George: bass
Ringo: drums
Dennis Walton, Ronald Chamberlain, Jim Chester, Rex Morris, Harry Klein: saxophones
Raymond Newman, David Smith: clarinets

RECORDED
Abbey Road: October 1–2 and 4, 1968

NUMBER OF TAKES: 1

MIXING
Trident Studios: October 1 and 5, 1968

TECHNICAL TEAM
Producer: George Martin
Sound Engineer: Barry Sheffield
Assistant Engineer: unknown

FOR BEATLES FANATICS

An old guitar solo that was not deleted properly can be heard at 0:09.

Genesis

Paul was always a great fan of the vaudeville style. His attraction to music halls was already obvious in "Till There Was You" and "When I'm Sixty-Four." He confided in 1968, "I would quite like to have been a 1920s writer, because I like that thing, you know." It was not surprising that he used that style again on the exquisite "Honey Pie," which, according to him, is, "a nod to the vaudeville tradition that I was raised on."[1] Paul often claimed that John shared this taste for music halls. And John was particularly proud of his solo in "Honey Pie," but he constantly criticized Paul's songs afterwards. For "Honey Pie," he laughingly answered David Sheff, "I don't even want to think about that."[2]

However, the song is a success. The original demo for the song showed that even without an elaborate arrangement, it already was catchy. The studio production, with its imitation of 78 rpm records, gave it an irresistible flavor. As for the lyrics, which evoked a silver screen star, they only attempted to revive nostalgia for the 1920s. "So this is just me doing it, pretending I'm living in 1925," Paul said.[3]

Production

Having recorded "Hey Jude" and "Dear Prudence" at Trident Studios, the Beatles met for the third time at Trident to record "Honey Pie." On October 1, they worked on the rhythm track of "Honey Pie." Paul was on piano, John on lead guitar, George on bass, and Ringo on drums. Although only one take was mentioned, they rehearsed the song many times and, contrary to their usual habits, they systematically deleted the earlier recordings. In any case, during this first session, John performed one of his very best solos. George referred to it in an interview in 1987: "John played a brilliant solo on Honey Pie—sounded like Django Reinhardt or

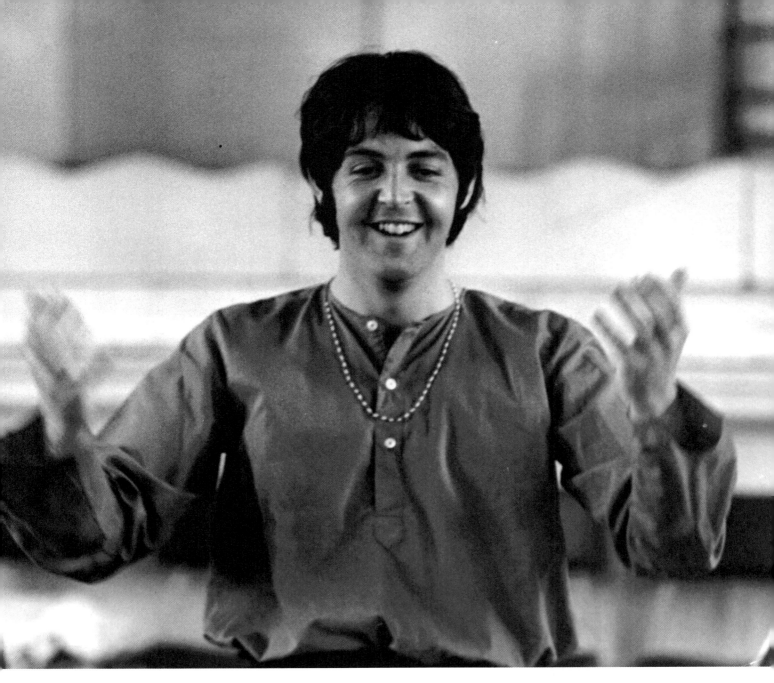

Paul, the author of "Honey Pie," expressed his attraction for vaudeville once again. John qualified this style as "granny music."

something. It was one of them where you just close your eyes and happen to hit all the right notes . . . sounded like a little jazz solo."[4]

Once the rhythm track was recorded, George Martin left again with a copy of the song to write arrangements for wind instruments. The next day, Paul recorded his lead vocal and added, according to Mark Lewisohn, a second lead guitar (but wasn't it more likely John?). On October 4, five saxophonists and two clarinet players were in the studio to interpret Martin's score (the same day, other arrangements were recorded for "Martha My Dear"). Paul then added a last touch by inserting the sentence, *Now she's hit the big time*, highly compressed and equalized against a background of old vinyl record crackling. The mono and stereo mixes were done at Trident on October 5.

1. Miles, *Paul McCartney*.
2. Sheff, *The Playboy Interview with John Lennon & Yoko Ono*.
3. Interview with Radio Luxembourg (November 20, 1968).

Savoy Truffle

George Harrison / 2:54

MUSICIANS
George: vocal, lead guitar
Paul: bass, backing vocal (?)
Ringo: drums, tambourine, bongos
Chris Thomas: organ (?), electric piano (?)
Art Ellefson, Danny Moss, Derek Collins, Harry Klein: tenor saxophones
Ronnie Ross, Bernard George: baritone saxophones

RECORDED
Trident Studios: October 3 and 5, 1968
Abbey Road: October 11 and 14, 1968 (Studio Two)

NUMBER OF TAKES: 1

MIXING
Abbey Road: October 14, 1968 (Studio Two)

TECHNICAL TEAM
Producer: George Martin
Sound Engineers: Barry Sheffield, Ken Scott
Assistant Engineer: John Smith

FOR BEATLES FANATICS

Some musical instruments were not mentioned in the recording sheets. Mark Lewisohn wrote them down, including an acoustic guitar that briefly appears at 0:36; a second backing vocal in the second and fourth couplets, most likely by Paul; and finally, an electric piano—probably a Hohner Pianet—was present right from the intro and returned at the end of the first couplet. Chris Thomas stated in interviews that he was the performer on piano, as well as on the organ.

Genesis

George always had two very highly evolved senses: friendship and humor. He proved it in "Savoy Truffle," a song written to make fun of his friend Eric Clapton's addiction to sweets. Eric could not resist a box of chocolates, which made him prey to cavities and painful dental treatments. George was inspired by this: "He was over at my house and I had a box of 'Good News' chocolates on the table and wrote the song from the names inside the lid."[1] Thus "creme tangerine," "montelimar," and "ginger sling"—all references in the song—have the sole purpose of gently mocking Clapton. And as George loved teasing his friends, he warned his friend in the song: *You'll have to have them all pulled out after the Savoy Truffle.* Derek Taylor helped him with the bridge. He came up with the line *You know that what you eat you are.* This famous quote from Brillat-Savarin, a celebrated French epicure from the end of the eighteenth century, became one of the favorite slogans of hippies who followed a macrobiotic diet. Finally, as John had done in "Glass Onion," George slipped in a little allusion to another song—Paul's "Ob-La-Di, Ob-Bla-Da."

Production

At Trident once again, George and his colleagues recorded this ode to chocolate on October 3. And this time, as well, only one take would be mentioned in the records, despite the many rehearsals. George was on lead guitar, Paul on bass, and Ringo remained faithful to his Ludwig drums (with a short delay added). John was not present on any of the recordings for "Savoy Truffle." On October 5, George overdubbed an ADT lead vocal. On October 11, two baritone and four tenor saxes recorded the arrangements, which had been

Eric Clapton, the guitar virtuoso lovingly ridiculed by George in "Savoy Truffle."

written by Chris Thomas. Ken Scott, who was proud of the quality of the recording, did a double take when George asked him to make the sound dirty by adding distortion to make the brass unrecognizable (although it was highly doubled by ADT). When the musicians came up to the control room to listen to a playback, George said to them, "Before you listen I've got to apologize for what I've done to your beautiful sound. Please forgive me—but it's the way I want it."[2] On October 14, George completed his song with a second guitar, and

Ringo on tambourines, bongos (which were inaudible), and organ. The mixes were done afterwards. George Martin, who controlled the mix, pointed out that the sound was very sharp. George answered, "Yeah, and I like it."[3] No comment.

1. Harrison, *I Me Mine.*
2. Lewisohn, *The Complete Beatles Recording Sessions.*
3. Ryan and Kehew, *Recording the Beatles.*

1968

Cry Baby Cry

Lennon-McCartney / 3:01

SONGWRITER
John

MUSICIANS
John: vocal, rhythm guitar, piano, organ (?), percussion
Paul: bass, organ (?), lead vocal, backing vocal
George: lead guitar, backing vocal
Ringo: drums, tambourine, percussion
George Martin: harmonium

RECORDED
Abbey Road: July 15–16 and 18, 1968 (Studio Two)

NUMBER OF TAKES: 12

MIXING
Trident Studios: October 15, 1968 (Studio Two)

TECHNICAL TEAM
Producer: George Martin
Sound Engineers: Geoff Emerick, Ken Scott
Assistant Engineers: Richard Lush, John Smith

Genesis

"Cry Baby Cry" was composed by John in India. This song with an *Alice in Wonderland* atmosphere was partly inspired by the traditional English nursery rhyme "Sing a Song of Sixpence" (*The queen was in the parlour / Eating bread and honey* in the nursery rhyme and *The queen was in the parlour / Playing piano for the children of the king* in John's lyrics). Among the characters of the song, there was some duchess of Kirkcaldy, whose name was perhaps chosen after the Scottish city of the same name where the Beatles had played on October 6, 1963, at the Carlton Theatre. Hunter Davies remembered that in 1968 John had revealed to him the origin of the title, "I think I got them from an advert—*Cry baby cry, make your mother buy.*[1] That was probable, since John liked to compose with the TV in the background (see "Good Morning Good Morning"). Curiously, his answer to David Sheff, who questioned him about the author of the song, was, "Not me, A piece of rubbish."[2] It was definitely a misunderstanding, a wrong transcription or a joke. Despite this rejection, "Cry Baby Cry" was an excellent song, stamped with typical Lennon poetry.

Production

On July 15, after ending "Ob-La-Di, Ob-La-Da" in a tense atmosphere, the Beatles rehearsed John's latest creation. Nothing is left of these takes. The next day, Geoff Emerick, although credited as one of the sound engineers, announced to the group that he was leaving. John tried to justify the tensions in the group by blaming the discomfort of the studio and the feeling they had of being in prison. But Geoff stuck to his decision and left them. Ken Scott was immediately asked to replace him. The recordings started once again, and the rhythm

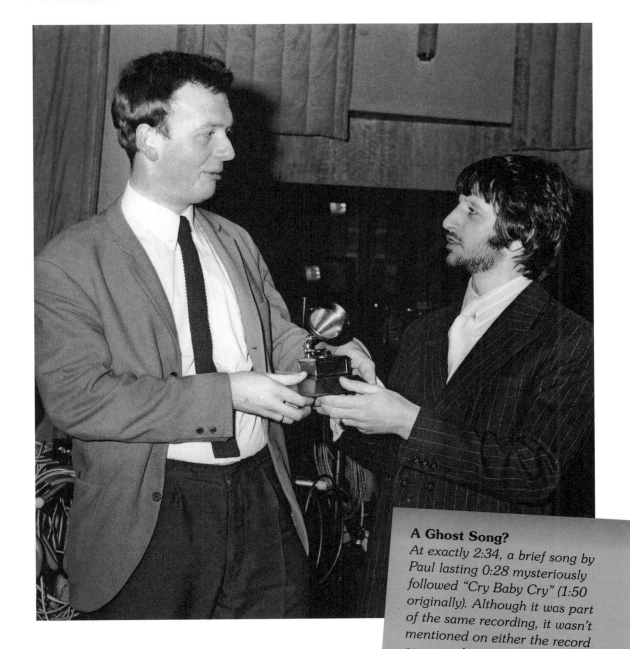

track was recorded in ten takes with vocals, acoustic guitar, bass drums, and an organ probably played by John or perhaps Paul. After a reduction, George Martin added a harmonium and John some piano. On July 18, there were other overdubs: a new vocal, backing vocals, some harmonium, tambourines, and sound effects (percussion, bird calls). "Cry Baby Cry" was transferred on September 17 to the new eight-track made available to the Beatles to allow for additional overdubs. But nothing else was added and the song was mixed on October 15. On this day, the acoustic guitar was treated with flanging right from the introduction.

1. Davies, *The Beatles.*
2. Sheff, *The Playboy Interview with John Lennon & Yoko Ono.*

Revolution 9

Lennon-McCartney / 8:21

SONGWRITER
John

MUSICIANS
Sound collage

RECORDED
Abbey Road: June 10, 1968 (Studio Three) / June 11, 1968 (Studio Two) / June 20, 1968 (Studios One, Two, and Three) / June 21, 1968 (Studio Two)

NUMBER OF TAKES: SOUND COLLAGE

MIXING
Abbey Road: June 21 and 25, 1968 (Studio Two) / August 20, 1968 (Studio Three) / August 26, 1968 (Studio Two)

TECHNICAL TEAM
Producer: George Martin
Sound Engineers: Geoff Emerick, Ken Scott
Assistant Engineers: Phil McDonald, Richard Lush, John Smith

FOR BEATLES FANATICS

"Revolution 9" was the last time that the Beatles recorded backwards instruments or vocals.

Genesis

"Revolution 9" was one of John's creations. As John admitted, the song was influenced heavily by Yoko Ono, who was an avant-garde artist. "Yoko was there for the whole thing and she made decisions about which loops to use. It was somewhat under her influence, I suppose."[1] George participated in it, but not Paul or Ringo. This sound collage, lasting 8:21, was not only the longest song the group ever recorded, but also the one that was the least typical, since it was an avant-garde collage leaning toward *musique concrète*. John created something unexpected for a Beatle. The events of 1968 prompted him to react to various protest movements. He was probably urged on by Yoko. "I thought I was painting in sound a picture of revolution—but I made a mistake. The mistake was that it was anti-revolution."[2] This quotation went back to 1970, when he was defending the Trotskyite and Marxist movements. It emphasized how much he fluctuated with every interview; his *count me out/ in* in "Revolution 1" indicated how uncertain he was about his commitments. Later, he denounced these radical movements. John was simply searching for authenticity.

Paul did not want "Revolution 9" on the *White Album*. He took it very badly, especially since he was very much involved in the avant-garde and had already created a similar sound edit in January 1967 for the *Carnival of Light* for the London Roundhouse Theatre. He had worked on it with the Beatles, but had never considered it a work that would fit on a Beatles album. John, who always had the last word, demanded that "Revolution 9" appear on the album. There was Beethoven's Ninth, there was John's Ninth . . .

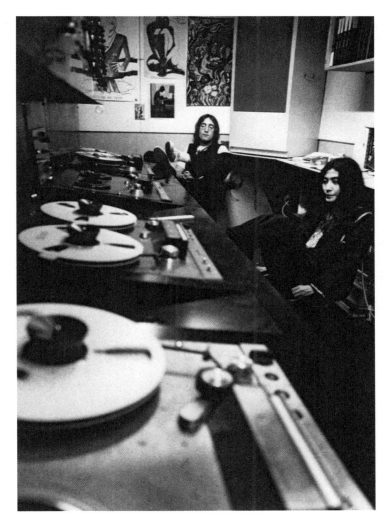

John and Yoko in the studio. An avant-garde joint effort resulted in "Revolution 9," a song on the cutting edge of *musique concrète.*

Production

The sound base of "Revolution 9" was built by combining a series of various tape loops on the chaotic coda of "Revolution 1." John explained to David Sheff in 1980, "It has the basic rhythm of the original Revolution [1] going on with some twenty loops we put on, things from the archives of EMI. We were cutting up classical music and making different-size loops, and then I got an engineer tape on which some test engineer was saying, 'number 9, number 9, number 9.' All those different bits of sound and noises are all compiled."[3] John therefore started by creating his numerous loops, on June 10 and 11. On June 20, he reserved three studios to mix them live: "There were about ten machines with people holding pencils on the loops—some only inches long and some a yard long."[4] This was exactly the same process used for "Tomorrow Never Knows," except this time John was assisted by Yoko during the mix. With

George, he recorded bits of text, including *Onion soup / The watusi / The twist / Take this brother, may it serve you well [John] / Who's to know? / Eldorado* [George]. And again Yoko: *If . . . you became naked.*

The list of sound effects was long, and every time you listen to the song it yields new surprises: a conversation between George Martin and Alistair Tailor in the intro, chorus, various orchestral passages, the atmosphere of a soccer game, a radio show, extracts from the orchestra part in "A Day in the Life," bass acoustic guitar, children screaming, inverted Mellotron, etc. On June 21, sound effects were added and the stereo mix was carried out. The mono mix was done on August 26.

1. Sheff, *The Playboy Interview with John Lennon & Yoko Ono.*
2. *The Beatles Anthology.*
3. Sheff, *The Playboy Interview with John Lennon & Yoko Ono.*
4. Ibid.

Good Night

Lennon-McCartney / 3:10

SONGWRITER
John

MUSICIANS
Ringo: vocal
George Martin: piano
The Mike Sammes Singers: backing vocals by 4 men and 4 women
Orchestra: 12 violins, 3 violas, 3 cellos, 1 harp, 3 flutes, clarinet, horn, vibraphone, double bass

RECORDED
Abbey Road: June 28, 1968 (Studio Two) / July 2, 1968 (Studio Two) / July 22, 1968 (Studio One)

NUMBER OF TAKES: 34

MIXING
Abbey Road: July 23, 1968 (Studio Two) / October 11, 1968 (Studio Two)

TECHNICAL TEAM
Producer: George Martin
Sound Engineers: Geoff Emerick, Pete Brown, Ken Scott
Assistant Engineers: Richard Lush, John Smith

FOR BEATLES FANATICS

The only time we can hear John singing "Good Night" a capella was on John and Yoko's *Wedding Album* on the song called "Amsterdam" (around 23:09).

Genesis

Vaguely inspired by Cole Porter's "True Love," the song "Good Night" was composed by John for his son Julian, who was then five years old. He let Ringo sing it. "Everybody thinks Paul wrote 'Good Night' for me to sing, but it was John who wrote it for me. He's got a lot of soul, John has."[1] It is surprising that the author of "Revolution" and "Everybody's Got Something to Hide Except Me and My Monkey" also composed this lullaby. According to Paul, John did not sing it himself because he did not want to tarnish his image: "I think John felt it might not be good for his image for him to sing it but it was fabulous to hear him do it, he sang it great. We heard him sing it in order to teach it to Ringo and he sang it very tenderly. John rarely showed his tender side, but my key memories of John are when he was tender, that's what has remained with me; those moments where he showed himself to be a very generous, loving person."[2]

When the *White Album* came out, Cynthia and John had just gotten divorced. She knew the song was on the album: "I had heard it when John had given it to Ringo to sing on the album and for a long time after our split I couldn't bring myself to listen to it or to play it to Julian. Eventually I did, though, telling him that his Dad had written the song for him, in the hope that it might provide him with some comfort."[3]

Production

On June 28, the recording sessions for "Good Night" began. After rehearsing, John and Ringo recorded the first takes without any other musicians: Ringo was singing and John was on guitar. At the beginning of each take, Ringo introduced the song with tender sentences for children. On July 2, he added a second vocal,

Ringo sang "Good Night," inspired by Cole Porter's 'True Love.'

supported by a backing vocal. At the end of the session, George Martin left with a copy of the tape in order to write an arrangement for orchestra. On July 22, the score was completed. The song was entirely redone. In the huge Studio One space, twenty-six musicians sat down to record. A celesta and a piano were made available for George Martin. Once the orchestra part was recorded, Ringo recorded his vocal, accompanied live by the Mike Sammes Singers, who once again joined the Beatles after their appearance on "I Am the Walrus." The slightly sad but warm intonation of Ringo's voice fit in perfectly. Listening to himself years later, he said, ". . . it's not bad at all, although I think I sound very nervous."[4] The final mixes were done on October 11.

1. *The Beatles Anthology.*
2. Miles, *Paul McCartney.*
3. Cynthia Lennon, *John.*
4. *The Beatles Anthology.*

1968

Hey Jude / Revolution

SINGLE
RELEASED

Great Britain: August 30, 1968 /
No. 1 on 11 September 1968 for 2 weeks
United States: August 26, 1968 /
No. 1 on September 28, 1968 for 9 weeks

Hey Jude

Lennon-McCartney / 7:09

MUSICIANS
Paul: vocal, bass, piano
John: acoustic guitar, backing vocal
George: electric guitar, backing vocal
Ringo: drums, tambourine, backing vocal
Orchestra: 10 violins, 3 violas, 3 cellos, 2 double basses, 2 flutes, 2 clarinets, 1 bass clarinet, 1 bassoon, 1 contrabassoon, 4 trumpets, 2 horns, 4 trombones, percussion

RECORDED
Abbey Road: July 29–30, 1968 (Studio Three)
Trident Studios: July 31, 1968 / August 1–2, 1968

NUMBER OF TAKES: 1

MIXING
Abbey Road: July 30, 1968 (Studio Two) / August 8, 1968 (Studio Two)
Trident Studios: August 2 and 6, 1968

TECHNICAL TEAM
Producer: George Martin
Sound Engineers: Ken Scott, Barry Sheffield (Trident)
Assistant Engineer: John Smith

Genesis

Paul drove out to visit Cynthia. "John and Cynthia were splitting up and I felt particularly sorry for Julian,"[1] he said. On his journey to Weybridge, he started singing, "*Hey Jules—don't make it bad*, take a sad song and make it better . . . It was optimistic, a hopeful message for Julian."[2] Cynthia recalled, "He [Paul] arrived one sunny afternoon, bearing a red rose, and said, 'I'm so sorry Cyn, I don't know what's come over him. This isn't right.' . . . He was the only member of the Beatles family who'd had the courage to defy John . . . In fact, musically and personally, the two were beginning to go in separate directions so perhaps Paul's visit to me was also a statement to John."[3] Many years later, Julian discovered that "Hey Jude" had been written for him, "He wrote this mythical song just because he was concerned for me, Mum, and our situation."[4]

Paul finished the song at Cavendish Avenue. He changed *Jules* to *Jude*, one of the characters in the movie *Oklahoma* (1955) called Jud Fry, played by Rod Steiger. When John heard the song, he thought the song was about him, "[With] the words 'go out and get her'—subconsciously he was saying, Go ahead, leave me. On a conscious level, he didn't want me to go ahead. The angel in him was saying, 'Bless you.' The devil in him didn't like it at all because he didn't want to lose his partner."[5] Paul wanted to change the line *The movement you need is on your shoulder* because he thought it was a bit crummy. John recommended keeping it. That's the best line in it! I know what it means, it's great."[6]

George Martin noted that "Hey Jude" lasted more than seven minutes. He told the Beatles that they could not make a single that long, because if they did, the song

might never be played on radio. John replied, "They will if it's us."[7] Paul also had doubts, especially because the Beatles had not decided which song would be the A-side: "Hey Jude" or "Revolution." Ken Mansfield, the director of Apple Records in the United States, offered to play both songs to the largest U.S. radio programmers. Unanimously, they all picked "Hey Jude."

"Hey Jude" was the first single released on the Beatles' Apple label, and the Beatles' most successful single. "Hey Jude" was the second best–selling record after "I Want to Hold Your Hand," with over 10 million records sold. John recognized "'Hey Jude' is one of [Paul's] masterpieces."[8]

Production

From the beginning, "Hey Jude" was not intended for the *White Album*, but was released as a single. The first recording session on July 29 was more like a rehearsal than an attempt at a good recording. Paul handled piano and vocals, George was on guitar, John on acoustic guitar (his Gibson J-160 E), and Ringo on drums. The long coda was already part of the song. It was apparently during this session that Paul and George had a disagreement over the song. George answered every line of the vocals with a guitar lick. Paul didn't like this, and

asked George to stop. Paul regretted it later, "He was pretty offended, and looking back, I think, Oh, shit of course you'd be offended. You're blowing the guy out."[9]

The following day, after the rehearsals and the first recording, the Beatles knew they were going to finish the song at Trident Studios, which had eight-track recording facilities. Abbey Road still used a four-track recorder until September 3. That day, a film crew was filming the recording session for the program *Music!*, which was produced by the National Music Council of Great Britain. The Beatles played the same instruments, but this time George did not play the guitar lick that echoed the vocals. On July 31, they rerecorded the whole song at Trident Studios. George joined them, but his contribution was very discreet. Paul played on a Bechstein piano, later used by Elton John, David Bowie, and Queen. During the recording of the rhythm track, Paul had not noticed that Ringo walked out to go to the bathroom, and it was just before his part that Paul realized that Ringo was not at his drums. Ringo quietly went to his drums and entered (at 0:50) flawlessly.

On August 1, Paul overdubbed a bass and a great lead vocal for the four-minute coda, "It wasn't intended to go on that long at the end but I was having such fun ad-libbing over the end when we put down the original track that I went on a long time."[10] John and George added beautiful backing vocals, and Ringo was on tambourine. Then thirty-six musicians performed George Martin's score, written the day before. Paul wanted to recreate the atmosphere of "A Day in the Life" and asked everyone to hand clap and sing *na na na na Hey Jude* at the end. Everyone agreed, except one musician who reportedly walked out, saying, "I'm not going to clap my hands and sing Paul McCartney's bloody song!"[11] The final mix was done on August 8 at Abbey Road.

1. *The Beatles Anthology.*
2. Ibid.
3. Cynthia Lennon, *John.*
4. Brian Southall and Julian Lennon, *Beatles Forever: la collection Julian Lennon* (Paris, Hors Collection, 2010).
5. Sheff, *The Playboy Interview with John Lennon & Yoko Ono.*
6. *The Beatles Anthology.*
7. Ibid.
8. Ibid.
9. Miles, *Paul McCartney.*
10. Ibid.
11. Martin and Hornsby, *All You Need Is Ears.*

Paul wrote "Hey Jude" thinking of Julian Lennon (above).
Following double-page spread: the recording session for "Hey Jude."

Technical Details

When Ken Scott listened to the tracks mixed at Trident Studios, he discovered that the recording quality was very poor with no treble. He was even more surprised because he had carefully listened to the tracks at Trident and had been impressed by their sound quality. As it turns out, there had been technical problems with Trident's equipment. George Martin asked Geoff Emerick for his help. After a lot of work, they succeeded in getting the mix to sound pretty good, and Martin left Ken Scott to finalize the mix.

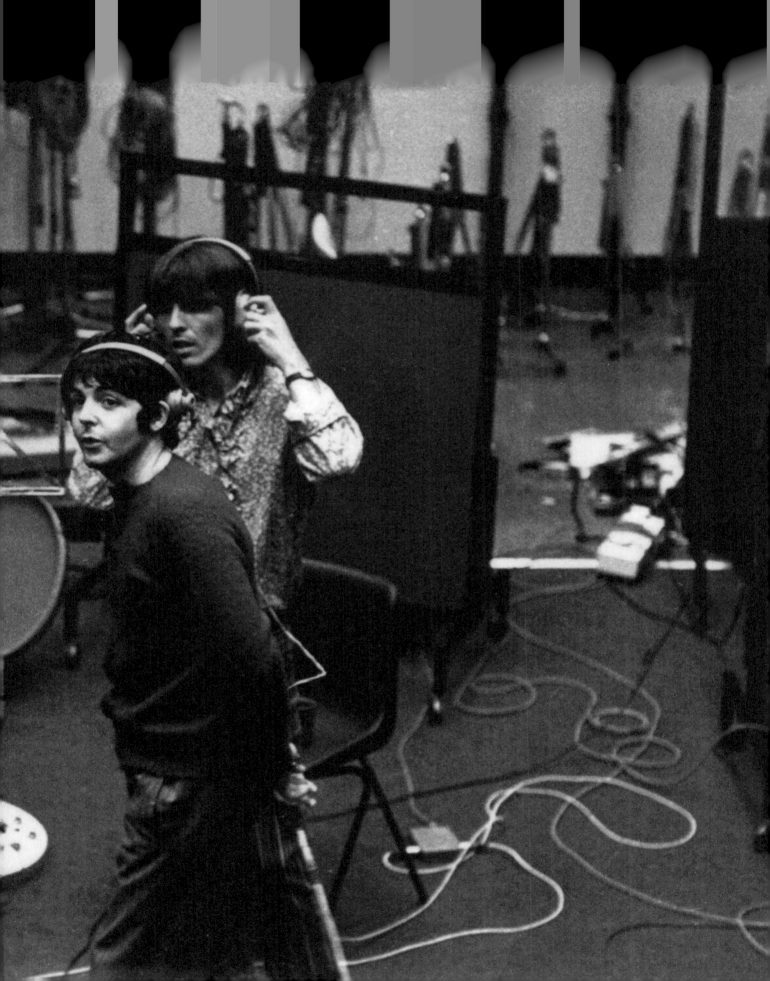

Revolution

Lennon-McCartney / 3:23

SONGWRITER
John

MUSICIANS
John: vocal, rhythm and lead guitar, hand claps
Paul: bass, hand claps
George: lead guitar, hand claps
Ringo: drums
Nicky Hopkins: electric piano

RECORDED
Abbey Road: July 9–11, 1968 (Studio Three) / July 12, 1968 (Studio Two)

NUMBER OF TAKES: 16

MIXING
Abbey Road: July 12 and 15, 1968 (Studio Two) / December 5, 1969 (Room 4)

TECHNICAL TEAM
Producer: George Martin
Sound Engineers: Geoff Emerick, Phil McDonald
Assistant Engineers: Richard Lush, Neil Richmond

FOR BEATLES FANATICS

To differentiate between the slow and up-tempo version of "Revolution," the Abbey Road staff called the slower song the "Glenn Miller" version. At the time of the recording, there was no number to differentiate between the versions.

Genesis

After three of the Beatles objected to "Revolution 1," considering the song too slow for the A-side of the single, John agreed to rerecord it in an up-tempo arrangement. This new version allowed him to decide between *count me in* and *count me out* (see "Revolution 1"). He chose *out*—"Count me out if it's for violence. Don't expect me on the barricades unless it's with flowers."[1] The release of "Revolution" provoked political reactions from the Left and Far Left. In the 1970s, John was close to Jerry Rubin and Abbie Hoffman before they became estranged. "As far as overthrowing something in the name of Marxism or Christianity, I want to know what you're going to do after you've knocked it all down,"[2] he said.

For John, "Revolution" was meant to be released as an A-side with a clear message. The other three Beatles saw in "Hey Jude" better potential for commercial success.

Production

On July 9, the Beatles rehearsed the new version of "Revolution." The following day, they began recording the rhythm track, with John and George on guitars, Paul on bass, and Ringo on drums. John wanted a really distorted sound. He asked Geoff Emerick to create the distinctive sound he was looking for. To do this, Geoff violated EMI's technical rules. He decided to put both guitars through the recording console, overloading the channel that was carrying John's guitar signal. The resulting sound pleased John. After ten takes, the Beatles had their rhythm track down. Ringo double-tracked his snare while his comrades added additional hand claps. After a first reduction, John recorded his

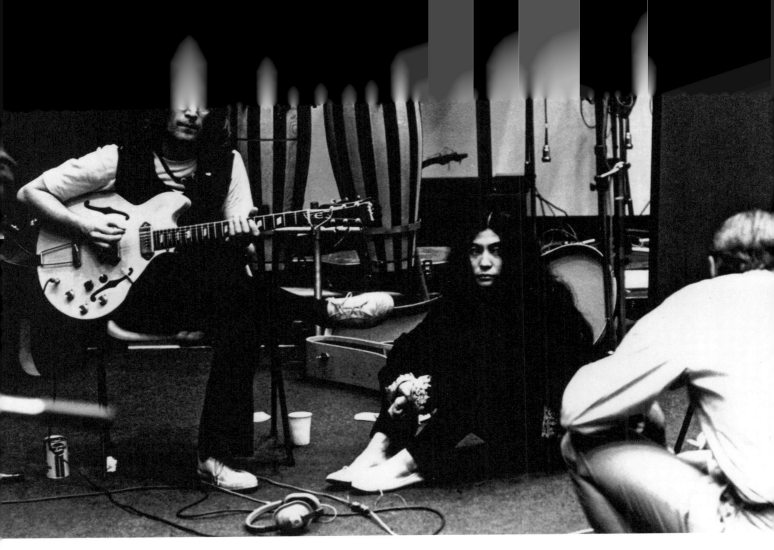

In July 1968, Yoko was always next to John during the recording sessions of a faster version of "Revolution" with Paul, George, and Ringo. This was the B-side of "Hey Jude."

vocal and right away he double-tracked it and gave the song a screaming introduction. The following day, Nicky Hopkins, who had made a name for himself by playing with other giants of rock 'n' roll, including the Rolling Stones, the Kinks, and the Who, added electric piano, backed on guitar by John. Finally, Paul recorded his bass. The mono mix of "Revolution" was made on July 15 and the stereo mix only on December 5, 1969.

Technical Details

For the first time, John, Paul, and George's guitars were put through the console directly via DI boxes and all three played in the control room, with Ringo on drums in the studio.

Paul Screaming

Filming for promotional videos of "Hey Jude" and "Revolution" took place on September 4 at Twickenham Film Studios, under the direction of Michael Lindsay-Hogg. We can see Paul screaming in the introduction, although he was miming to John's original recording.

1. Sheff, *The Playboy Interview with John Lennon & Yoko Ono.*
2. Ibid.

Side I
Yellow Submarine
Only a Northern Song
All Together Now
Hey Bulldog
It's All Too Much
All You Need Is Love /

Side 2
(Music by George Martin)
Pepperland
Sea of Time
Sea of Holes
Sea of Monsters
March of the Meanies
Pepperland Laid Waste
Yellow Submarine in Pepperland

ALBUM
RELEASED
Great Britain: January 17, 1969 / No. 3
United States: January 13, 1969 / No. 2

Yellow Submarine: The Animated Beatles

Yellow Submarine, the sound track of the film of the same name, did not appear until January 1969, six months after the film's premiere on July 17, 1968, at the London Pavilion. This delay was motivated by the fact that the *White Album* was still number 1 on the charts. The album is a collection of old and new songs, as well as instrumental music composed by George Martin. Fans were disappointed to find only four new songs, two by George ("Only a Northern Song" and "It's All Too Much") and two by Lennon-McCartney ("Hey Bulldog" and "All Together Now"). Only "Hey Bulldog" matches the quality of the album's previously recorded songs.

The idea for the project came from the cartoon series *The Beatles* produced by Al Brodax for ABC. These cartoons depicted caricatures of the Fab Four and were broadcast weekly from September 1965 to September 1969. The Beatles were never fans of the series, and they hated the voices of the actors. But with the success of the series, Brodax offered Brian Epstein a feature-length, animated film. Epstein, who still owed a Beatles film to United Artists, thought this would be the perfect means of honoring his commitment to United Artists. The group was not thrilled about participating in another motion picture, but a cartoon seemed like a lesser evil. The official announcement was made on June 7, 1967.

Epstein promised four original songs, but the Beatles felt that all the arrangements had been made without their being consulted. They delayed on delivering the songs and made no creative contribution to the film. They even joked: if a new song wasn't good enough for an album, use it in the film! John talked about the film with resentment even in 1980: "The *Yellow Submarine* people . . . were gross animals apart from the guy who drew the paintings for the movie. They lifted all the ideas for the movie out of our heads and didn't give us any credit."[1] In fact, the Beatles did not like the project because they feared that the movie would be too much like the TV series, with no real artistic content. Paul even wanted a style similar to that of Disney. However, when they saw the complete film for the first time, they were pleased with the quality of the script and drawings and regretted their lack of participation. The album received a positive reception, but not the success they usually had.

The Movie

In the paradise Pepperland, Sergeant Pepper's band is giving a concert when the evil Blue Meanies attack. The Blue Meanies want to eliminate all music, all happiness, and all love from the world. Young Fred, the leader of Pepper's band, has just enough time to escape aboard the Yellow Submarine to look for help in Liverpool. The four Beatles come to his rescue to deliver Pepperland from the horrible Blue Meanies. Guitars, music, flowers, and love will vanquish the monsters. *All you need is love*, sung by the Beatles! Upon its release, the film was a success, particularly in the United States. The animation conveys perfectly the psychedelic world of the Fab Four.

1. Sheff, *The Playboy Interview with John Lennon & Yoko Ono.*

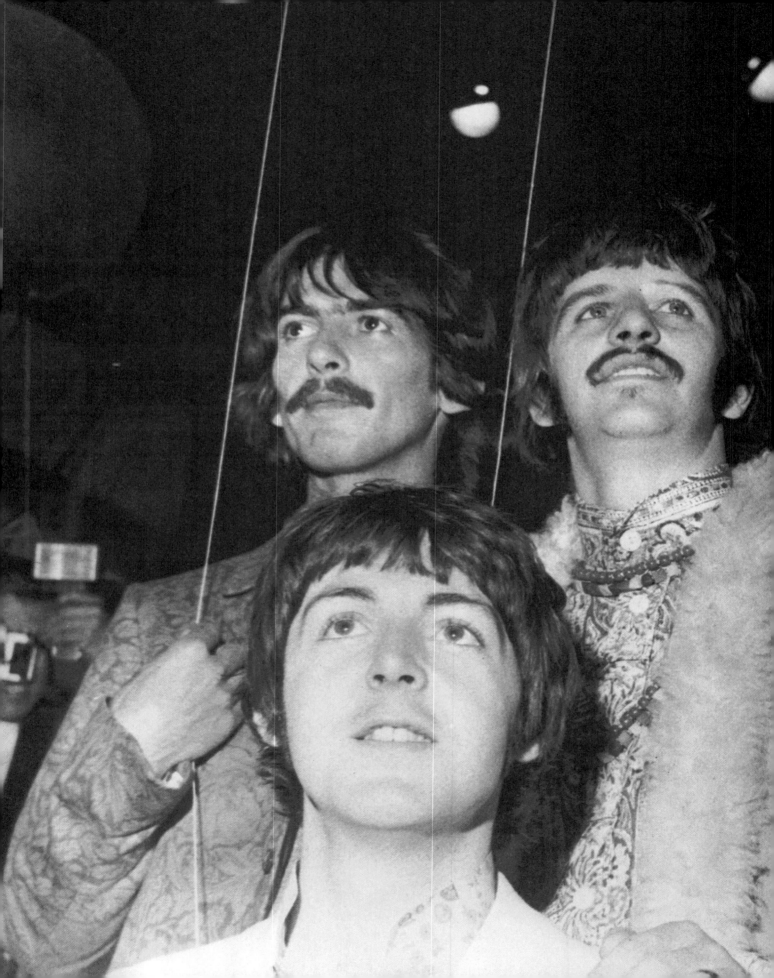

A NOTE TO READERS

For the title Yellow Submarine, *Lennon-McCartney / 2:37, see* Revolver.
For the title "All You Need Is Love," Lennon-McCartney / 3:47, see single: "All You Need Is Love" / "Baby You're a Rich Man."

Side 2 by George Martin

Side 2 of the LP features seven original instrumental pieces written and arranged by George Martin. They are of excellent quality. The music contributes substantially to the film and demonstrates Martin's talents as an orchestrator. But the music did not really belong on a Beatles record. The style is too far removed. So it is not discussed in this book.

On June 24, 1967, the Beatles gave a press conference to promote "All You Need Is Love." Two weeks earlier, on June 7, the project to create the movie *Yellow Submarine* was officially confirmed.

Only A Northern Song

George Harrison / 3:23

MUSICIANS
George: vocal, organ, sound effects
John: electric guitar (?) glockenspiel (?), piano, sound effects
Paul: bass, trumpet, sound effects
Ringo: drums

RECORDED
Abbey Road: February 13–14, 1967 (Studio Two) / April 20, 1967 (Studio Three)

NUMBER OF TAKES: 12

MIXING
Abbey Road: February 14, 1967 (Studio Two) / April 21, 1967 (Studio Two) / October 29, 1968 (Studio Three)

TECHNICAL TEAM
Producer: George Martin
Sound Engineer: Geoff Emerick
Assistant Engineers: Richard Lush, Graham Kirkby

Genesis

George originally wrote "Only a Northern Song" for *Sgt. Pepper*. Unfortunately, it was considered "too weak" for the album, so he had to write another song, "Within You Without You." "Only a Northern Song" is Asian in style and under the spell of India and its music. By writing "Only a Northern Song," George was also attacking the Beatles' music publishing company, Northern Songs Ltd., which had managed the Beatles' copyrights since February 22, 1963. At the company's creation in 1963, the stock was divided among Dick James, Charles Silver, Brian Epstein, John, and Paul. George and Ringo were left out and only on February 18, 1965, when the company went public, did they finally became a part of it, receiving just over 1 percent of the shares. In 1965, George signed a new three-year contract with Northern Songs. Over the years, he had been wronged, and he admitted in 1999, "I realized Dick James had conned me out of the copyrights for my own songs by offering to become my publisher. . . . But he never said, 'And incidentally, when you sign this document here, you're assigning me the ownership of the song.'" George wrote "Only a Northern Song" as a joke, denouncing the exploitation of which he considered himself a victim.

Production

On February 13, three days after recording the orchestra for "A Day in the Life," the Beatles started recording "Only a Northern Song" under the working title "Not Known." Although they made nine takes of the rhythm track, the best was the third. Ringo was on drums and Paul was on bass, connected to a DI box. Most likely, John played electric guitar while George played the

In "Only a Northern Song," George, above with Martin, denounced, with a bit of humor, the initial contract from Northern Songs Ltd., from which he was excluded.

organ. The following day George overdubbed two lead vocals. There were a total of twelve takes. On April 20, two months later, the Beatles reworked the piece after they had completed *Sgt. Pepper.* They discarded the vocals from February 14, and in their place added bass, trumpet, and glockenspiel. Paul: "I remember playing a silly trumpet. My dad used to play. I can't but I can mess around a lot—and that song gave me the perfect framework. It was very tongue in cheek."[1] After adding all these instruments, they used the new take and the eleventh take from February 14, and the two versions were mixed together in sync to produce the final mono version. The result is rather dissonant, but reflects George's dissatisfaction with Northern Songs

Ltd. The mono mix was made the following day and the stereo mix on October 29, 1968.

Technical Details

Because the engineers were unable to have both tape recorders begin the playback at exactly the same time, they had difficulty mixing the stereo version. Therefore, they created a fake stereo mix by artificially expanding the sound.

1. *The Beatles Anthology.*

All Together Now

Lennon-McCartney / 2:09

SONGWRITER
Paul

MUSICIANS
Paul: vocal, bass, acoustic guitar, percussion, hand claps
John: vocal, acoustic guitar, harmonica, percussion, hand claps
George: ukulele (?), backing vocal, percussion, hand claps
Ringo: drums, backing vocal, percussion, hand claps

RECORDED
Abbey Road: May 12, 1967 (Studio Two)

NUMBER OF TAKES: 9

MIXING
Abbey Road: May 12, 1967 (Studio Three) / May 15, 1967 (Studio ?) / October 29, 1968 (Studio Three)

TECHNICAL TEAM
Producer: none
Sound Engineer: Geoff Emerick
Assistant Engineers: Richard Lush, Graham Kirkby

FOR BEATLES FANATICS

Three days after the recording, Paul met Linda Eastman at Bag O'Nails, a trendy London club.

Genesis

"All Together Now" is a children's sing-along written in the music hall tradition and built around three chords. The lyrics, written mostly by Paul, correspond to the educational concepts usually taught in children's songs—alphabet, colors, numbers—except for the line *Can I take my friend to bed?*, which is subject to many interpretations . . . Paul took the title from the music hall call "All together now" with which the performers ask the audience to sing along. He explained, "I just took it and read another meaning into it, of we are all together now. So I used the dual meaning."[1] During the production, George Martin went on vacation, leaving the position of producer vacant. Geoff Emerick was in charge of the control room more or less officially and vividly recalls the atmosphere suddenly becoming more relaxed, just as it did when the Beatles recorded "Yellow Submarine" in Martin's absence. At that time John commented, "Well, now that the schoolmaster's out, we kids finally get a chance to play."[2] The result is certainly more relaxed. The song was featured on the soundtrack of the film *Yellow Submarine* at the end where the "live" Beatles appeared just before the credits. The song became a popular chant in football stadiums. In 1971 John said in an interview with Tariq Ali and Robin Blackburn: "I enjoyed it when football crowds in the early days would sing 'All together now.'"[3]

Production

The Beatles completed "All Together Now" in only one recording session on May 12. Even though the song's structure is simple, they added a number of overdubs. The Beatles invited friends in to sing the chorus and created a party atmosphere just as they had done for "Yellow Submarine." It took nine takes to get the rhythm

Paul, Ringo, and George with an image of John. "All Together Now" is an anthem to rally the audience.

track right: Paul was simultaneously on lead vocal and his Gibson J-160 E acoustic guitar. John sang the middle eight while accompanying himself on his Jumbo acoustic guitar. Ringo was on drums and George on the ukulele. Then they had a number of overdubs, including backing vocals, bass, finger cymbals, diatonic harmonica in G, percussion, klaxon, and hand claps. The Beatles and their friends had a bit of fun recording "All Together Now," which was much looser than the long

months of hard work on *Sgt. Pepper*. No reduction was necessary. The mono mix was made right away using ADT (automatic double-tracking) of the voices. The stereo mix was made on October 29, 1968.

1. Miles, *Paul McCartney*.
2. Emerick, *Here, There and Everywhere*.
3. Tariq Ali, *Street-Fighting Years: An Autobiography of the Sixties* (London and Brooklyn, NY: Verso, 2005), http://www.amazon.com/exec/obidos/ASIN/1844670295/counterpunchmaga.

Hey Bulldog

Lennon-McCartney / 3:09

SONGWRITER
John

MUSICIANS
John: vocal, piano
Paul: bass, backing vocal, tambourine
George: guitar
Ringo: drums

RECORDED
Abbey Road: February 11, 1968 (Studio Three)

NUMBER OF TAKES: 10

MIXING
Abbey Road: February 11, 1968 (Studio Three) / October 29, 1968 (Studio Three)

TECHNICAL TEAM
Producer: George Martin
Sound Engineer: Geoff Emerick
Assistant Engineers: Phil McDonald, Graham Kirkby

IMAGE MISTAKES
The video clip of "Lady Madonna" came from footage of the Beatles' recording "Hey Bulldog" and nobody noticed the discrepancy. Many years later, Neil Aspinall had the video recut to the song "Hey Bulldog." This video clip is the only one showing the Beatles recording something in Studio Three at Abbey Road.

Genesis

On February 11, the Beatles were being filmed in Studio Three for a promotional video for "Lady Madonna." Hunter Davies recounted how Paul tried working on an unfinished piece. John, who had written the main structure of a new song, proposed filming that instead of "Lady Madonna." According to Geoff Emerick, Paul was a bit annoyed, but John was like a steamroller that day and the decision stuck. The Beatles were in a good mood, creating a joyful atmosphere because they knew they would be heading to Maharishi Mahesh Yogi's ashram in India in a few days. The lyrics changed during the session. The original idea—*bullfrog*—was abandoned in favor of *bulldog* after Paul made a barking sound during the session that pleased John. The *sheepdog* in the song was the same breed as Paul's famous dog, Martha.

John's song was destined for the soundtrack of *Yellow Submarine*: "They wanted another song, so I knocked off 'Hey Bulldog.' It's a good sounding record that means nothing."[1] The recording was a success, taking even the Beatles themselves by surprise. Emerick remembered that John tried in vain to make the title the A-side of the single instead of "Lady Madonna." "Hey Bulldog" is probably one of the most underrated titles by the group.

Production

The Beatles recorded and mixed "Hey Bulldog" in less than ten hours on February 11. They made no intermediate reduction and were satisfied with the four basic rhythm tracks. A very determined John led his friends into a supercharged session. Ten takes were needed to complete the rhythm track. John was at the Steinway B piano used previously for "Lady Madonna," Paul played

"Hey Bulldog" is the best of the four original songs on *Yellow Submarine*.

tambourine, George was on his Gibson SG Standard, and Ringo was on drums. Paul recorded on the second track one of his most inventive and effective bass lines, using his Rickenbacker 4001S. Meanwhile, George double-tracked his riff while Ringo played drums with a strong reverb in the middle eight. Then John recorded his lead vocal on a third track, accompanied by Paul's backing vocals. At the coda, they performed all together a surrealistic passage consisting of barking, howling, and clowning. They were happy and inseparable friends for one of the last times—the following years would be less cheerful. On the last track, John double-tracked his vocal and George performed a sparkling solo, double-tracked as well. His amp was turned up very loud, with the encouragement of his friends. In the mix, the song is slightly sped up. The stereo mix was only made on October 29, 1968.

FOR BEATLES FANATICS

"Hey Bulldog" is the final recording session where only the four Beatles were together in the studio. Afterwards, Yoko became a permanent fixture in their private circle.

1. Sheff, *The Playboy Interview with John Lennon & Yoko Ono*.

It's All Too Much

George Harrison / 6:23

MUSICIANS
George: vocal, lead guitar, organ, hand claps, percussion
John: rhythm guitar, backing vocal, hand claps, percussion
Paul: bass, backing vocal, hand claps, percussion
Ringo: drums, hand claps, percussion
David Mason and 3 other unknown musicians: trumpets
Paul Harvey: bass clarinet

RECORDED
DeLane Lea Music Recording Studio: May 25 and 31, 1967 / June 2, 1967

NUMBER OF TAKES: 2

MIXING
DeLane Lea Music Recording Studio: October 12, 1967
Abbey Road: October 16–17, 1968 (Studio Two)

TECHNICAL TEAM
Producer: George Martin
Sound Engineers: Dave Siddle, Ken Scott
Assistant Engineers: Mike Weighell, Dave Harries

FOR BEATLES FANATICS

During the mixing of October 1968, sound engineers changed, for no apparent reason, the original take 2 to take 196.

Genesis

George wrote "It's All Too Much" to share his visions under the influence of LSD. Lyrics and music had little sense of direction. Said George, "I just wanted to write a rock 'n' roll song about the whole psychedelic thing of the time." Later, George reworked this song, to later affirm that only meditation, and not drugs, offered a real answer. "'It's All Too Much' was written in a childlike manner from realizations that appeared during and after some LSD experiences and which were later confirmed in meditation."[1]

The result is a bit chaotic: George seems to be seeking himself, but without any clear direction. In his text he alludes to the Merseys' 1966 hit single "Sorrow," *With your long blonde hair and your eyes of blue*, while also referring to his own wife. At the end of the coda, one of the trumpeters performs a short segment from Jeremiah Clarke's "Prince of Denmark March." The entire piece is dominated by an enormous saturated guitar sound, certainly influenced by the Beatles' idol, Jimi Hendrix.

Production

They began recording at De Lane Lea in London, which was used by Pink Floyd, Jimi Hendrix, Deep Purple, and Led Zeppelin. The rhythm track of the working title "Too Much" was completed on May 25 in four takes with George on Hammond organ, Paul on bass, Ringo on drums, and John probably at the guitar. On May 31, they returned to De Lane Lea Studios, adding a series of overdubs with George as lead vocal, John and Paul's backing vocals (which deviated a little in the coda with the chant *Too much* becoming *Tuba* then *Cuba*), hand claps, tambourine, cowbell,

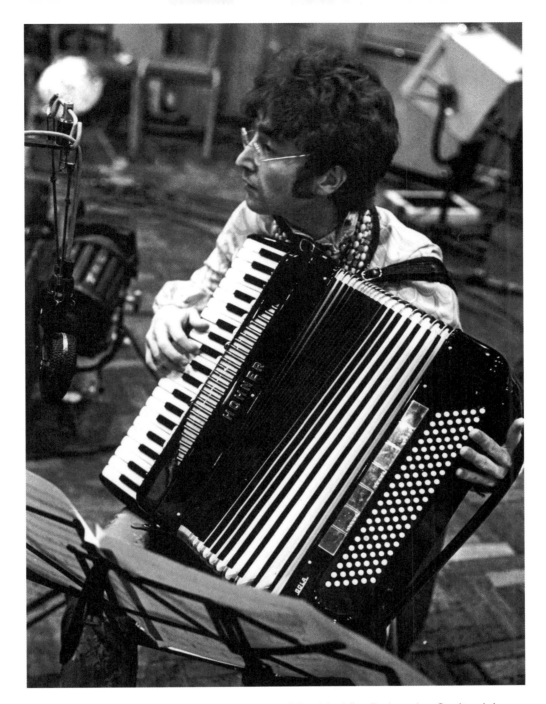

On the day set for mixing George Harrison's "It's All Too Much" at De Lane Lea Studios, John was in charge of the control room for the first time. He oversaw Shirley Evans's segment of *Magical Mystery Tour*, called "Shirley's Wild Accordion."

various percussion instruments, and certainly a lead guitar played by George, who added a lot of vibrato in the style of Hendrix. For the next session, on June 2, George Martin, back from vacation and resuming his function as producer, added four trumpets and a bass clarinet. David Mason, the trumpeter who performed on "Penny Lane" remembers that George did not really know what he wanted. Finally, several instruments, including a clarinet, colored the piece in the "Pepper" style. The final mixes were made over a year later at Abbey Road, on October 16–17, 1968, using ADT extensively on hand claps and vocals.

1. Harrison, *I Me Mine*.

1969

The Ballad of John and Yoko / Old Brown Shoe

SINGLE
RELEASED

Great Britain: May 30, 1969 /
No. 1 for 3 weeks beginning on June 11, 1969
United States: June 4, 1969 /
No. 8 on June 14, 1969

The Ballad Of John And Yoko

Lennon-McCartney / 2:58

SONGWRITER
John

MUSICIANS
John: vocal, guitar, percussion
Paul: drums, backing vocal, bass, piano, maracas

RECORDED
Abbey Road: April 14, 1969 (Studio Three)

NUMBER OF TAKES: 11

MIXING
Abbey Road: April 14, 1969 (Studio Three)

TECHNICAL TEAM
Producer: George Martin
Sound Engineer: Geoff Emerick
Assistant Engineer: John Kurlander

FOR BEATLES FANATICS

At 2:50, Peter Brown arrived at the studio and we can hear John welcoming him with "Hey! Peter!" Judge for yourself.

Caption top right: On March 24, 1969, John Lennon and Yoko Ono in front of the Pillars of Hercules with their certificate of marriage. It was John's second marriage and Yoko's third.

Genesis

In 1969, John called this song a "Johnny B. Paperback Writer." In 1980, he talked about the song as a journalistic chronicle, a folk song, "Well, *guess* who wrote that? I wrote that in Paris on our honeymoon. It's a piece of journalism. It's a folk song. That's why I called it 'The Ballad of . . .'" [1] It is about *events* surrounding John's marriage to Yoko. "We wanted to get married on a cross-channel ferry. That was the romantic part: when we went to Southampton and then we couldn't get on because she wasn't English and she couldn't get the day visa to go across."[2]

On March 16, four days after Paul and Linda's wedding, John and Yoko took off for Paris with the intention of getting married. However, after some complications, they were unable to. "They were in Paris and we were calling Peter Brown, and said, 'We want to get married. Where can we go?'"[3] Peter Brown, former right-hand man of Brian Epstein, manager of Apple Corp., and a close friend of the Lennon clan, found the solution to their problem by proposing that they get married in Gibraltar. On March 20, 1969, John married Yoko Ono in the British Consulate in Gibraltar. Peter Brown was one of the witnesses, and he was immortalized in the verse, *Peter Brown called to say, "You can make it okay. You can get married in Gibraltar, near Spain."*

The newlyweds stayed a little more than an hour in Gibraltar, just enough time for the ceremony, before returning to Paris, where, a few days later, they dined with Salvador Dalí. On March 25 they flew to Amsterdam, where they held a seven-day bed-in for peace at the Hilton Hotel, room 902. They returned to London on April 1.

As soon as the song was written, John brought it to Paul's house. Paul, discovering the lyrics and references to Christ, panicked. He said, "Jesus Christ, you're kidding, aren't you? Someone really is going to get upset about it,"[4] remembering the hostile reactions in the United States in 1966 to John's famous statement, "We're more popular than Jesus." John insisted. Despite his reservations, Paul helped John finish the final verse, and they went straight to Abbey Road to record it. Paul: "John was in an impatient mood so I was happy to help. It's quite a good song; it has always surprised me how with just the two of us on it, it ended up sounding like the Beatles."[5]

Production

John wanted the song out as soon as possible. The working title was "The Ballad of John and Yoko (They're Gonna Crucify Me)." At the beginning of April, Peter Brown told Geoff Emerick that John had composed a new song and asked Emerick to help John record the song. Without waiting for the other Beatles to return, Emerick reserved Studio Three on April 14 for the recording session of "The Ballad of John and Yoko." George and Ringo were away, George recording chants with Radha Krishna monks and Ringo filming a new Peter Sellers movie, *The Magic Christian*, directed by Joseph McGrath.

On December 15, 1969, John and Yoko's Plastic Ono Band took part in a benefit concert for the charity Unicef, at the Lyceum Ballroom in central London.

tensions and chaotic sessions of *Get Back*. They perfected a basic track in eleven takes with Paul on drums, as with "Back in the U.S.S.R." and "Dear Prudence," and John simultaneously on acoustic guitar and lead vocal. On the second track there is some German mixed with English. John explained to Mal Evans, "a string is kaput, damn!" Then, just before take 4, John says to the drumming Paul, "Go a bit faster, Ringo!" and Paul replies to the guitar-wielding John, "OK, George!"

Take 10 was the best basic track. John overdubbed two lead guitars and accented the beat by strumming his acoustic guitar. Paul provided bass, a piano part, backing vocals, and maracas, and John added percussion by playing on the back of his acoustic guitar. The recording session was completed in less than six hours. The song was mixed for stereo very quickly and, because of the new eight-track technology used during the recording, became the Beatles' first stereo single in Great Britain and consequently their first release not to be mixed in mono. George Martin confessed that he enjoyed working with John and Yoko. They were in their positive period. With this song, Martin said that John truly divorced himself from the Beatles; "It was a kind of thin end of the wedge, as far as they were concerned. John had already mentally left the group anyway, and I think that was just the beginning of it all."[8]

George said, "'The Ballad of John and Yoko' was none of my business. If it had been the "The Ballad of John and George and Yoko," then I would have been on it."[5] Similarly, Ringo was not offended to have been replaced by Paul, "We had no problems with that. There's good drums on 'The Ballad of John and Yoko.'"[6] In John's opinion, even though George and Ringo were absent, the record was still a Beatles record and not something separate: "It's the Beatles' next single, simple as that."[7]

The recording session took place in an atmosphere of camaraderie and good feeling between John and Paul, as in the good old days before the extreme

1. Sheff, *The Playboy Interview with John Lennon & Yoko Ono.*
2. *The Beatles Anthology.*
3. Ibid.
4. Lewisohn, *The Complete Beatles Recording Sessions.*
5. Miles, *Paul McCartney.*
6. Ibid.
7. "Beatles Music Straightforward on Next Album," *New Musical Express* (May 3, 1969).
8. *The Beatles Anthology.*

Old Brown Shoe

George Harrison / 3:16

MUSICIANS
George: vocal, electric guitar, Hammond organ, bass (?)
John: electric guitar, backing vocal, Hammond organ
Paul: bass (?), backing vocal, piano
Ringo: drums

RECORDED
Abbey Road: February 25, 1969 (Studio unknown) / April 16 and 18, 1969 (Studio Three)

NUMBER OF TAKES: 4

MIXING
Abbey Road: April 16 and 18, 1969 (Studio Three)

TECHNICAL TEAM
Producers: George Martin, Chris Thomas
Sound Engineers: Ken Scott, Phil McDonald, Jeff Jarratt
Assistant Engineers: Ken Scott, Richard Lush, John Kurlander

Genesis

In his book *I Me Mine*, published in 1980, George said that his inspiration for "Old Brown Shoe" came from a chord sequence on the piano, "which I don't really play, and then began writing ideas for the words from various opposites . . . Again, it's the duality of things—yes no, up down, left right, right wrong . . ."[1] George's song followed the model of McCartney's "Hello Goodbye." The title "Old Brown Shoe" does not have much to do with the lyrics, except that George found the allusion interesting.

Production

Between February 7 and 15, George was hospitalized for a problem with his wisdom teeth. Ten days later, February 25 to be exact, was his twenty-sixth birthday. To celebrate he went to the studio to record solo demos of three of his latest compositions—"Old Brown Shoe," "Something," and "All Things Must Pass." Each had a different fate. Assisted by Ken Scott in the control room, he recorded the basic rhythm track for each song—guitar and piano. Then he recorded the vocals. Those demos were sufficiently developed for the other Beatles to learn their parts later on. On April 16, more than a month and a half after George made these demos, the Beatles worked on "Old Brown Shoe." In two hours, a new demo was made, but it was immediately deleted and four new takes recorded. Each Beatle mastered his part perfectly. George was on lead vocal and had a shared guitar part with John, Paul was at the Challen "jangle box" (a kind of honky-tonk piano), and Ringo was on drums. The fourth take was the best. Paul added a bass line, doubled in certain parts by George's guitar, giving it a dynamic and powerful sound. Then came

A Challen "jangle box" piano, which gave "Old Brown Shoe" such a distinctive sound.

the backing vocals sung by Paul and John. George then retaped his lead vocal. This last take was recorded and the stereo and mono mixes made. However, two days later on April 18, George was apparently dissatisfied with the results, so Lennon's guitar part was deleted in favor of a Hammond organ part played by George as well as a guitar solo played through a Leslie speaker. George overdubbed his vocal. George delivered another one of his subtle and creative solos.

"Old Brown Shoe" was finally finished. The song was mixed in stereo following the recording session. There is some debate over whether Harrison played bass. According to the recording sheets and the sound of the bass, Paul may have doubled George's guitar. In an interview for *Creem* magazine published in December 1987, George affirmed that he played bass for the piece saying "that was me *going nuts*." He added: "I'm doing exactly what I do on the guitar."[2] If this is the case, he certainly played the six-string Fender bass.

Technical Detail

To obtain a distinctive sound and to give a natural echo to his voice, George turned toward one of the corners of Studio Three and sang into the wall.[3]

1. Harrison, *I Me Mine*.
2. J. Kordosh, "George Harrison: His Secret Beatle Past," *Creem* magazine (December 1987).
3. Lewisohn, *The Complete Beatles Recording Sessions*.

ABBEY
ROAD

Come Together
Something
Maxwell's Silver Hammer
Oh ! Darling
Octopus's Garden
I Want You (She's So Heavy)
Here Comes the Sun
Because
You Never Give Me Your Money
Sun King
Mean Mr. Mustard
Polythene Pam
She Came In Through the Bathroom Window
Golden Slumbers
Carry That Weight
The End
Her Majesty

ALBUM
RELEASED

Great Britain: September 26, 1969 / No. 1 on May 23, 1970, for 3 weeks
United States: October 1, 1969 / No. 1 for 11 weeks

Abbey Road:
A Leap into Eternity

Although *Let It Be* is the final original album released by the Beatles, *Abbey Road* is the final album they recorded. It was a triumph. Thanks to an expert advertising campaign by Allen Klein, the Beatles new manager, more than five million copies of *Abbey Road* were sold worldwide during the first year, nearly two million more than *Sgt. Pepper*. We can well understand why the managers at EMI decided to change the name of their studio to Abbey Road Studios! Since then the façade of the studio has been resurfaced innumerable times to erase the daily graffiti of fans from all over the world. The building, located at 3 Abbey Road in the heart of St. John's Wood, was registered as a historical monument on February 23, 2010.

The recording of *Get Back*, later known as *Let It Be*, started at the beginning of January 1969 and quickly turned into a nightmare. The bulk of the album was recorded at Twickenham Film Studios while the Beatles were being filmed for a planned documentary on the making of the album. George Martin's involvement is unclear. The documentation shows that Paul was in charge of most of the production. Tension, animosity, and fatigue led to a disaster. The results of the working session were unimpressive, despite the superb performance of the Beatles on the roof of Apple on January 30. The recording was set aside.

Paul was not deterred by failure. In early April, he re-motivated the team. George Martin wrote, "I was quite surprised when Paul rang me up and said, 'We're going to make another record—would you like to produce it?' My immediate answer was: 'Only if you let me produce it the way we used to.' He said, 'We will, we want to.'—'John included?'—'Yes, honestly.' So I said, 'Well, if you really want to, let's do it. Let's get together again.'"[1] Geoff Emerick, who had quit after the tense

and frustrating sessions for the *White Album*, agreed, at Paul's request, to be the sound engineer.

All knew, consciously or not, that the journey was at an end. All the Beatles were in top form for recording, composition, interpretation, instrumental parts, and backing vocals. Yet they rarely played together in the same studio. They avoided each other most of the time. John was even voluntarily absent for titles such as "Maxwell's Silver Hammer." The first week of the *Abbey Road* session, John could not attend the sessions in the studio because he had been in a car accident on July 1 in Scotland, along with Yoko and their respective children, Julian and Kyoko. He returned on July 9, but Yoko, more seriously injured and also pregnant, was ordered to stay in bed. John, wanting to keep an eye on her, had a bed delivered to the studio and suspended a microphone above it so that Yoko could comment on the recording sessions. The atmosphere became extremely tense. On the musical side, the Beatles delivered the best of their art, even if the old camaraderie and solidarity were gone. George Martin tried to lead them to a production in the style of *Sgt. Pepper*. He encouraged them to "think in symphonic terms." Paul thought this was a great idea, but John was a rock 'n' roller. As a result, side 1 leaned toward rock while side 2 was more symphonic. In 1970 John commented, "I liked the A side. I never liked that sort of pop opera on the other side. I think it's junk. It was just bits of song thrown together."[2]

John opened the album with a great rock song, "Come Together," and gave us one of the most beautiful melodies on the record with the sublime "Because."

1. *The Beatles Anthology.*
2. Wenner, *Lennon Remembers.*

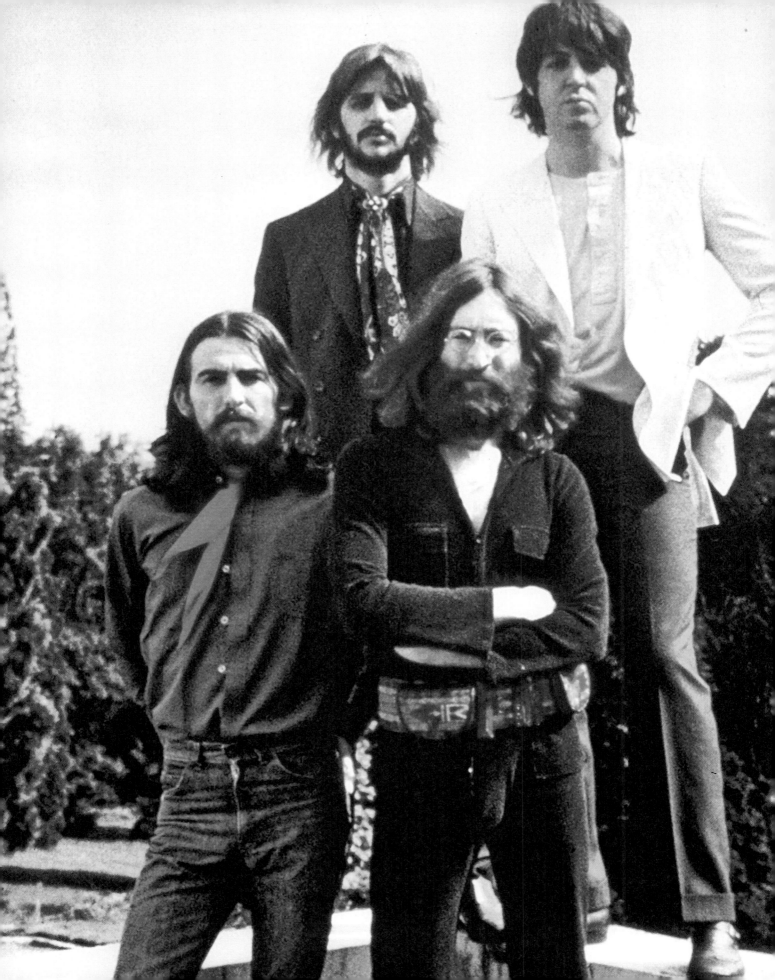

American Robert Moog posing in front of his creation. The Moog IIIP Synthesizer made a noticeable appearance during recording sessions for *Abbey Road*.

With "Here Comes the Sun" and "Something," George Harrison confirmed that he was the equal of Lennon-McCartney as a songwriter—both titles topped the charts and marked the first and last time one of his singles was featured on a Beatles A-side in the history of the group. For his part, Ringo brought his best song, "Octopus's Garden," and Paul concluded the record with a unique medley of his own compositions.

Even though some titles such as "Oh! Darling" were worked on in January 1969, the album was mostly recorded in July and August 1969. At its release, it quickly jumped to the top of the charts and became the Beatles' most successful album ever. Paul was continually harassed by enthusiastic fans. He preferred to escape from the sudden media pressure to his country house without telling anyone. This secret escape prompted the rumor of his death on October 12, 1969, and his replacement by a look-alike. Fans looked for clues everywhere, and the cover of the album provided a considerable number of them. The idea for the cover was born, according to some, in one of Ringo's jokes. Among the names suggested for the album was *Billy's Left Boot* and *Everest*, after the brand of cigarettes smoked by Geoff Emerick, and to go with a cover photo

in the foothills of Mount *Everest*. But, except for Paul, the idea appealed to no one, and Ringo joked, "Why don't we call it *Abbey Road*?" and "take the photo there." Other versions attribute the name and the idea to Paul. We do know that Paul gave the photographer, Iain MacMillan, a detailed cover sketch.

On August 8, at 11:30 A.M., McMillan had about ten minutes to take the picture from a stepladder while a police officer stopped traffic. The fifth picture was selected and features the four Beatles walking away from EMI studios. An omen? Ever since, this crosswalk has been a popular destination for Beatles fans from around the world. The crosswalk was registered as a historical landmark in 2010 because of its "cultural and historical value," but the famous crosswalk was actually moved a few yards away some thirty years later. Even today, the government can offer no reason for this relocation! The photo on the back of the album, taken by MacMillan just after the session with the group, shows the corner of Alexandra Road. When MacMillan took the picture, a girl in a blue dress ran in front of his camera. Although he thought the shot had been ruined, that was the one the Beatles selected! After *Abbey Road*, John and Paul did not play together again until

John, Ringo, Paul, and George waiting to be immortalized by photographer Ian MacMillan while walking away from the Abbey Road Studios on the famous crosswalk.

1974. Then, they met at the Record Plant Studios for an improvised recording session involving other celebrities, including Stevie Wonder and Harry Nilsson.

The Instruments

It is difficult to identify the instruments used in *Abbey Road* because few pictures were taken during recording sessions. Nevertheless, we can assume that they were nearly identical to those of the *White Album* or *Let It Be*, with the exception of the first synthesizer ever used by the Beatles, the Moog IIIP Synthesizer, and the Electric Solid-Body Baldwin harpsichord, the keyboard used in "Because."

FOR BEATLES FANATICS

The French version of *Abbey Road* has some funny misspellings. On the A-side: "Oh! Darling" is spelled "Oh Darlin" and "Octopus's Garden," normally credited to Richard Starkey, is credited to Ringo Starr. On the B-side: "She Came in Through the Bathroom Window" is listed as "She Came Through the Bathroom Window." And finally, "The End" became "Ending."

At their first seven-day bed-in for peace at the Hilton Hotel in Amsterdam, room 902, March 25–31, 1969, John and Yoko received journalists every day.

Come Together

Lennon-McCartney / 4:20

SONGWRITER
John

MUSICIANS
John: vocal, rhythm guitar, electric Fender Rhodes piano, backing vocal, hand claps, tambourine
Paul: bass
George: guitar
Ringo: drums, maracas

RECORDED
Abbey Road: July 21, 1969 (Studios Two and Three) / July 22 and 23, 1969 (Studio Three) / July 25, 1969 (Studio Two) / July 29–30,1969 (Studio Three)

NUMBER OF TAKES: 9

MIXING
Abbey Road: August 7, 1969 (Studio Two)

TECHNICAL TEAM
Producer: George Martin
Sound Engineers: Geoff Emerick, Phil McDonald
Assistant Engineer: John Kurlander

RELEASED AS A SINGLE

"Something" / "Come Together"
Great Britain: October 31, 1969 / No. 4
United States: October 6, 1969 / No. 1 for 1 week beginning on October 18, 1969

Genesis

The inspiration for this song was multifaceted and controversial: Timothy Leary on one side and Chuck Berry on the other. "Come Together" was conceived as a political rallying cry for Timothy Leary, the psychologist, writer, philosopher, and apostle of LSD. In 1969, the herald or messenger of the counterculture of the 1960s ran for governor of California against the Republican incumbent Ronald Reagan. His campaign slogan was *Come together, join the party*, with a double meaning for the word *party*: political "party" and "party" as a reference to the drug culture. On May 30, he visited John and Yoko in their Montreal bed-in, where he asked John to write a song for his political campaign. John, who admired Leary, agreed. However, despite numerous attempts, he was uninspired. He finally wrote a song with little connection to the original idea besides the title. Leary's campaign ended when the candidate was arrested for possession of marijuana at the same time as Lennon was writing the song. Leary's incarceration released John from any commitment, and he gave the song to the Beatles. He said he wrote most of the lyrics in the studio with the help of other group members, including George, who confirmed that he had suggested a few words—words he called "gibberish," totally removed from Leary's original message, but reflecting Lennon's taste for nonsense. Interestingly, the song has some similarity to "You Can't Catch Me," Chuck Berry's 1956 song. The two songs contain related lines. Berry wrote *Here come old flat top / He was movin' up with me*, while Lennon's lyrics included *Here come old flat top / He come groovin' up slowly*. After the release of the single, Morris Levy, the former owner of the New York club Birdland,

and publisher and copyright holder of "You Can't Catch Me," sued Lennon for copyright infringement. He contended that Lennon's song sounded similar to Berry's song and that similarities to the lyrics were obvious. They settled on October 12, 1973, with Lennon agreeing to record three songs from Levy's catalog for his next album *Rock 'n' Roll*. The completion of that album took longer than expected. John began work on the album, but the sessions dissolved into chaos. He was separated from Yoko, and from 1973 to 1975 he lived the legendary "lost weekend." Levy was impatient and eventually sold rehearsal tapes received from Lennon under the title *Roots* (released in early February 1975). Since this record is poor in quality and was not intended for release, only 1,270 copies were sold. Lennon sued Levy to stop him from selling *Roots*, and won.

A few years later, Leary reproached Lennon for "stealing the idea" and was formally challenged by John, saying that he owed Leary nothing. Despite all these difficulties, John confessed to David Sheff in 1980 that "Come Together" was one of his favorite songs: "It's funky, it's bluesy, and I'm singing it pretty well. I like the sound of the record. You can dance to it. I'd buy it!"[1]

Production

After his automobile accident, John returned to *Abbey Road* on July 9. Since "The Ballad of John and Yoko," he had not written anything new, but on July 21, he proposed "Come Together," which became one of his best songs. The first time John played it to Paul on his acoustic guitar, Paul immediately pointed out the obvious similarity to Chuck Berry's "You Can't Catch Me." He suggested modifying it as much as possible to give it a "swampy" sound and a slower tempo. The result

was the huge, deep bass riff and Ringo's superb drums, which transformed the character of the piece.

On the basic track, John recorded a guide vocal, hand claps in the intro, and tambourine; George, Paul, and Ringo played rhythm guitar, bass, and drums, respectively. The sound is awesome. George said in 1969, "['Come Together'] is one of the nicest things we've done musically. Ringo's drumming is great."[2] "Come Together" was recorded on a four-track tape recorder. Take 6, judged the best, was then transferred to eight-track.

July 21 also marked Geoff Emerick's return to Abbey Road as the first full-time, freelance sound engineer working for EMI. He had left during the recording sessions for the *White Album*, exasperated by the unpleasant atmosphere among the Beatles. Although things had gotten a little better, tensions were still high. The next day, John overdubbed his vocal with a short delay in the intro. At *shoot me* you can only hear *shoot*. The bass line falls where the *me* was. (These words took on a tragic prescience on December 8, 1980, when Mark David Chapman killed John Lennon with five bullets). According to Emerick, Paul then showed John an electric piano part. John liked it, but preferred to play it himself. Maracas and another rhythm guitar were added. When Paul suggested singing harmony with John, John replied, "Don't worry, I'll do the overdubs on this."[3] Paul said, "On 'Come Together' I would have liked to sing harmony with John and I think he would have liked me to but I was too embarrassed to ask him and I don't work to the best of my abilities in that situation."[4] John claimed that he did ask his three colleagues for arrangements. He realized that, with their experience, they knew what he wanted: "I think

Timothy Leary, master of psychedelic ceremonies, and his wife Rosemary, announcing his candidacy for governor of California in May 1969. He asked John to write his campaign song.

that's partly because we've played together a long time. So I said, 'Give me something funky.'"[5]

The sessions continued. Several guitar parts were recorded, including George's magnificent solo. Paul recorded a lot of heavy breathing at the end, which is partially buried and inaudible in the final stereo mix made on August 7.

FOR BEATLES FANATICS

Listen carefully at 2:30. Someone yells "Look out!" We assume it is John.

1. Sheff, *The Playboy Interview with John Lennon & Yoko Ono.*
2. "George Harrison on Abbey Road," *Rolling Stone* (October 18, 1969).
3. Emerick, *Here, There and Everywhere.*
4. Miles, *Paul McCartney.*
5. *The Beatles Anthology.*

Just before the beginning of their last album, John and Yoko held their second ten-day bed-in for peace at the Queen Elizabeth Hotel in Montreal, starting on June 1, 1969. "Give Peace a Chance" was the message of hope they sent to the world.

Something

George Harrison / 3:01

MUSICIANS
George: vocal, hand claps, guitar
Paul: bass, backing vocal, hand claps
John: rhythm guitar
Ringo: drums, hand claps
Billy Preston: piano, organ
Orchestra: 12 violins, 4 violas, 4 cellos, 1 double bass

RECORDED
Abbey Road: February 25, 1969 (Studio Three) / April 16, 1969 (Studio Three) / May 2, 1969 (Studio Three) / July 11, 1969 (Studio Two) / July 16, 1969 (Studio Three) / August 4, 1969 (Studio Two) / August 15, 1969 (Studios One and Two)
Olympic Sound Studios: May 5, 1969 (Studio One)

NUMBER OF TAKES: 39

MIXING
Abbey Road: February 25, 1969 (Studio Three) / July 11, 1969 (Studio Two) / August 19, 1969 (Studio Two)
Olympic Sound Studios: May 6, 1969 (Studio One)

TECHNICAL TEAM
Producers: George Martin, Chris Thomas, George Harrison
Sound Engineers: Ken Scott, Phil McDonald, Jeff Jarratt, Glyn Johns, Geoff Emerick
Assistant Engineers: Richard Lush, Nick Webb, Steve Vaughan, John Kurlander, Alan Parsons

RELEASED AS A SINGLE

"Something" / "Come Together"
Great Britain: October 31, 1969 / No. 4
United States: October 6, 1969 / No. 1 for 1 week beginning October 18, 1969

Genesis

George composed "Something" at the piano during the recording sessions for the *White Album* in 1968. He wrote it quickly in Studio One, the only one available since Paul was working in Studio Two. The song came to him so easily that he thought it was too obvious. To record the tune he did not think about the Beatles, but rather about Ray Charles, who later included the song on his 1971 album *Volcanic Action of My Soul*.

George did not really have any ideas for the lyrics, even if Pattie Boyd, his first wife, claimed in her autobiography that "Something" was written for her.[1] The first line came from "Something in the Way She Moves," the title of a song by James Taylor, who had just signed with Apple for his debut album released in 1968. Taylor's line stuck. Only the bridge required more work. In 1969, George told journalist David Wigg that John had given him some handy tips, "Once you start to write a song, try to finish it straight away while you're still in the same mood.' Sometimes you go back to it and you're in a whole different state of mind. So now, I do try to finish them straight away."[2]

On September 19, 1968, George worked on "Piggies." Between two takes, he played "Something" for Chris Thomas, who was standing in for George Martin that day. Thomas said, "That's great! Why don't we do that one instead?" George replied, "Do you like it, do you really think it's good?" When Thomas said Yes! George said, "Oh, maybe I'll give it to Jackie

1. Boyd and Junor, *Wonderful Tonight.*
2. David Wigg, *The Beatles Tapes from the David Wigg Interviews* (Polydor, 1976).
3. Lewisohn, *The Complete Beatles Recording Sessions.*
4. *The Beatles Anthology.*
5. Ibid.

Lomax then, he can do it as a single!"[3] "Something" was released on *Abbey Road* and as the A-side of the Beatles' next single. It was George's first A-side in the history of the group. "Something" is currently among the top twenty songs most performed in the world.

For John, "Something" is the best track on the album. George Martin was surprised that George was able to compose a piece of such quality—at the level of Lennon-McCartney's songwriting. It was with a sense of guilt that he regretted he had never treated George on the same level as his two pals, "'Something' is a wonderful song. But we didn't give him credit for it, and we never really thought, 'He's going to be a great songwriter.'"[4] Ringo concluded, "It is interesting that George was coming to the fore and we were just breaking up."[5]

Production

On February 25, 1969, his twenty-sixth birthday, George went alone to Abbey Road to record elaborate eight-track demos for three of his new compositions: "Old Brown Shoe," "All Things Must Pass," and "Something." "Old Brown Shoe" became the B-side of "The Ballad of John and Yoko." "All Things Must Pass" appeared on George's first solo triple album in 1970, while "Something" was the second most covered Beatles song after "Yesterday." George was solo on guitar, piano, and vocal with Ken Scott in the control room. He recorded the first version particularly softly. At this

point it was just a countermelody and lyrics, which eventually disappeared, to be replaced by the guitar solo from the final version. On April 16, the Beatles began to work together on the song, but it was only on May 2 that they recorded take 36 as the best basic track. George was on guitar through a Leslie speaker, Paul on bass, John on acoustic guitar, Billy Preston at the piano, and Ringo on drums. Take 36 lasted 7:48 and was characterized by a coda lasting more than four minutes, due entirely to John's long piano-led four-note instrumental fade-out. He later sped up the chord pattern to shorten the coda to 2:32 and used it as the basis for his song "Remember" (*John Lennon / Plastic Ono Band*, 1970).

Other sessions followed. On May 5, Paul rerecorded his bass part at the Olympic Sound Studios (with Glyn Johns at the console). The sound resulted from a new technique, increasingly used by sound engineers, consisting of combining the sound of the instrument plugged directly into the console with the sound coming back out of the amplifier. George, more self-assured, criticized Paul's bass line and asked him to simplify it. George later recorded a lead guitar part via a Leslie speaker.

On July 11, George attempted his first lead vocal with Preston at the organ. On July 16, he finally recorded his lead vocal. To help his concentration, the studio was given a cozy atmosphere with soft lighting and

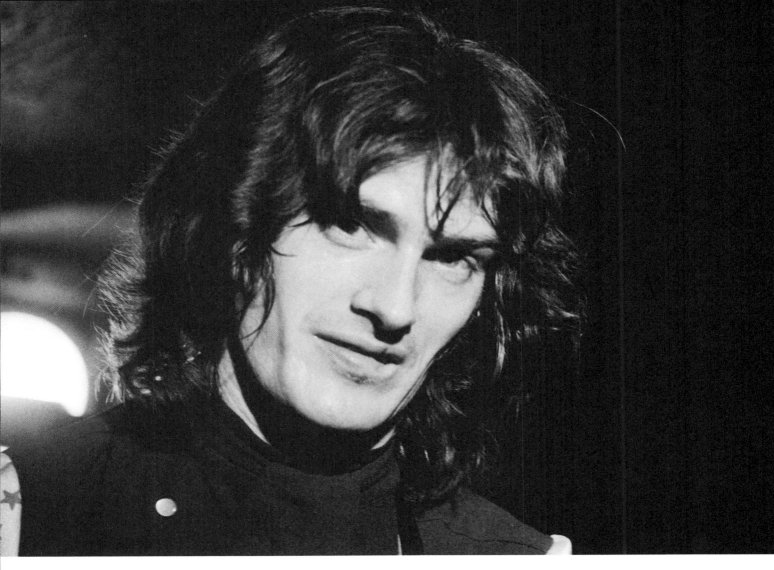

George thought of offering "Something" to Jackie Lomax (above) for whom he had already composed "Sour Milk Sea."

incense. Paul added backing vocals and, with George and Ringo, some hand clapping. On August 15, different orchestral tracks were recorded for "Golden Slumbers," "Carry That Weight," "The End," "Here Comes the Sun" and "Something." George Martin orchestrated the songs and conducted the orchestra in Studio One. There remained only one track to record the guitar and the orchestra. In Studio Two, connected by video, George had to perform along with the orchestra and, without hesitating, in one take, he delivered an inspired and dazzling solo. "Something" was finally completed. The stereo mix was made on August 19, and the long coda deleted.

FOR BEATLES FANATICS

Allen Klein insisted on releasing "Something" as a single to encourage George as a songwriter, but also to get a not inconsiderable sum of money.

For their last photo session, the Beatles posed among flowers. John stood behind, a symbolic position for someone who had moved away from the group to the point that he did not participate in the recording for "Maxwell's Silver Hammer."

Maxwell's Silver Hammer

Lennon-McCartney / 3:27

SONGWRITER
Paul

MUSICIANS
Paul: vocal, bass, piano, Moog IIIP synthesizer
George: guitar, backing vocal
Ringo: drums, backing vocal, anvil (?)
George Martin: organ
Mal Evans: anvil (?)

RECORDED
Abbey Road: July 9–11, 1969 (Studio Two) / August 6 and 25, 1969 (Studio Two)

NUMBER OF TAKES: 27

MIXING
Abbey Road: July 10, 1969 (Studio Two) / August 6, 12, and 14, 1969 (Studio Two)

TECHNICAL TEAM
Producer: George Martin
Sound Engineers: Phil McDonald, Tony Clark, Geoff Emerick
Assistant Engineers: John Kurlander, Alan Parsons

Genesis

Paul wrote "Maxwell's Silver Hammer" in 1968 during the recording sessions for the *White Album*. During the previous two years he had become interested in Alfred Jarry, author of *Ubu the King*, and his concept of pataphysics, philosophy of the absurd and surrealism. Paul, with amusement, referred to the concept, knowing that few people would understand: "I am the only person who ever put the name of pataphysics into the record charts, c'mon! It was great. I love those surreal little touches."[1] The theme of his song "Maxwell's Silver Hammer" was a way to deal with unexpected problems when everything goes well. It is a metaphor related to the plight of the Beatles. Why did he make the hammer silver? He said, "I don't know why it was silver, it just sounded better than Maxwell's hammer."[2]

Production

The Beatles rehearsed the song in January 1969 at Twickenham Film Studios as part of the *Get Back* sessions. On July 9, they started the recording session for "Maxwell's Silver Hammer," the same day that John returned to the studio after his car accident in Scotland. John did not like the song and dismissed it as "just more of Paul's granny music."[3] The basic rhythm track was completed after twenty-one takes, with Paul at the piano, George on bass, and Ringo on drums. On July 10, various overdubs to "Maxwell's Silver Hammer" were done—George on electric and acoustic guitar, Paul doubling his lead vocals, and George Martin at the Hammond organ. The session was highlighted by an unusual instrument. Paul asked Ringo to emphasize the "Bang! Bang!" in the choruses by hitting a blacksmith's anvil. Mal Evans rented it from a theatrical agency. According to Geoff Emerick, Mal Evans hit the anvil, as can be seen in the film *Let It Be*: "Ringo

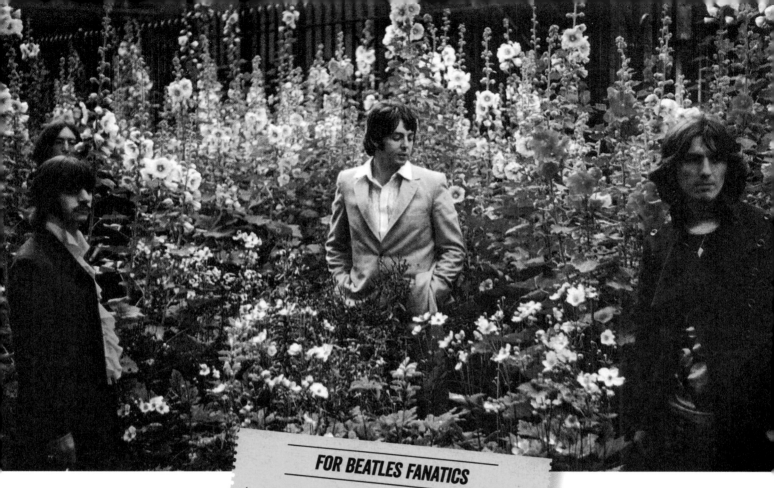

simply didn't have the strength to lift the hammer, so Mal ended up playing the part, but he didn't have a drummer's sense of timing, so it took a while to get a successful take."[4] After thirteen mixes were made, Paul was still dissatisfied. He nicely asked John to help with the backing vocals, but John refused, preferring to stay next to Yoko. Arms crossed, he sat in the back for a while before leaving for home. Tony Clark: "I got involved in the last three weeks of *Abbey Road*. They kept two studios running and I would be asked to sit in Studio Two or Three—usually Three—just to be there, at the Beatles' beck and call whenever someone wanted to come in and do an overdub. At this stage of the album I don't think I saw the four of them together."[5] John: "I believe he really ground George and Ringo into the ground recording it. We spent more money on that song than any of them on the whole album, I think."[6]

Paul wanted the bass on "Maxwell's Silver Hammer" "to sound like a tuba to make the recording sound old-fashioned."[7] He accomplished this by slurring the notes rather than articulating them. The following day, more guitar and vocal overdubs were added. On August 6, Paul recorded his Moog synthesizer part. This was the first Beatles song where this instrument was used.

Various mixes were made, first on August 14. On August 25, various sound effects were added but not used. The mix of August 14 became final.

1. Miles, *Paul McCartney*.
2. Ibid.
3. Emerick, *Here, There and Everywhere*.
4. Ibid.
5. Lewisohn, *The Complete Beatles Recording Sessions*.
6. *The Beatles Anthology*.
7. Emerick, *Here, There and Everywhere*.

Oh ! Darling

Lennon-McCartney / 3:27

SONGWRITER
Paul

MUSICIANS
Paul: vocal, piano (?),bass (?)
John: piano (?), bass (?), backing vocal
George: guitar, backing vocal
Ringo: drums
Billy Preston: electric piano

RECORDED
Abbey Road: January 27, 1969
Abbey Road: April 20, 1969 (Studio Three) / April 26, 1969
(Studio Two) / May 1, 1969 (Studio Three) / July 17–18 and
22–23, 1969 (Studio Three) / August 8, 1969 (Studio Three)
/ August 11, 1969 (Studio Two)

NUMBER OF TAKES: 26

MIXING
Abbey Road: April 20, 1969 (Studio Three) / May 1, 1969
(Studio Three) / August 12, 1969 (Studio Two)

TECHNICAL TEAM
Producers: George Martin, Chris Thomas
Sound Engineers: Glyn Johns, Jeff Jarratt, Phil McDonald,
Geoff Emerick, Tony Clark
Assistant Engineers: John Kurlander, Nick Webb, Alan
Parsons

FOR BEATLES FANATICS

Along with the other Beatles, John recorded
backing vocals on August 11. This was his last
recording session with the group. Afterwards,
he was only present in the studio for mixing, but
never to record.

Genesis

In a tribute to the 1950s, Paul wrote a great rock 'n' roll
ballad, demonstrating once again his immense talent as
a singer. "Oh! Darling (I'll Never Do You No Harm),"
as a working title, was already rehearsed and recorded
during a *Get Back* session on January 27, 1969, at the
Apple studio, under the shadow of the eccentric "Magic
Alex." At that time, "Oh! Darling" was recorded with
Paul on vocals and bass, George on guitar, John on
second vocal and second guitar, and Ringo on drums,
while Billy Preston played electric piano. Also during
this recording, John learned that the divorce between
Yoko and Anthony Cox, her second husband, had gone
through and was to be finalized on February 2, 1969.
He announced at the end of the song, as can be heard
on *Anthology 3*, "I just heard that Yoko's divorce has
just gone through. Free at last! I'm free. . . ." He showed
his joy by singing the song!

The Beatles did not return to Abbey Road Studios
until April 20 to record the song properly. Twenty-six
takes were needed. It has often been stated that Paul
was on bass and John at the piano. But after listening,
and especially by analyzing the sound of each instru-
ment, it seems to be the opposite. George without any
doubt was on rhythm guitar via a Leslie speaker and
Ringo on drums. They sought to create the feel of a live
recording. During this first session, Billy Preston played
the Hammond organ, replacing the electric piano, but
this was definitely erased on April 26.

Paul, who lived just a few blocks from Abbey Road,
regularly arrived one hour before the other Beatles to
rehearse, warm up, and record his voice. He kept rere-
cording the song, against the advice of George Martin,
who said the best version was already in hand. Paul:
"I came into the studios early every day for a week to

Paul's house a few blocks away from Abbey Road Studios. The location nearby allowed him to arrive early and warm up his voice.

I Can Do Better!

In 1980 John confessed to David Sheff for the Playboy interview, "'Oh! Darling' was a great one of Paul's that he didn't sing too well. I always thought that I could've done it better—it was more my style than his. He wrote it, so what the hell, he's going to sing it. If he'd had any sense, he should have let me sing it. [Laughing]¹

sing it by myself because at first my voice was too clear. I wanted it to sound as though I'd been performing it onstage all week."²

The interpretation was difficult. Paul sang the lead vocal with a head tone but failed to get the "scratchy" sound that he wanted. Alan Parsons, an assistant engineer, recalled, "Perhaps my main memory of the *Abbey Road* sessions is of Paul coming into Studio Three at two o'clock or 2:30 each afternoon, on his own, to do the vocal on 'Oh Darling.' . . . He'd come in, sing it and say 'No, that's not it, I'll try it tomorrow.' He only tried it once per day, I suppose he wanted to capture a certain rawness which could only be done once before the voice changed. I remember him saying 'Five years ago I could have done this in a flash,' referring, I suppose, to the days of 'Long Tall Sally' and 'Kansas City.'"³ John Kurlander also witnessed these overdubs: "I think Paul wanted this 'first thing in the morning' quality, or maybe it was 'last thing at night.' Whatever it was, he came in early each day, an hour before anybody else, to do this piece, always replacing the previous one until he got the one he liked."⁴ His final attempt was recorded on July 23. Paul had enough different takes to combine parts of each into a single good track.

August 8 was memorable: the Beatles were photographed crossing Abbey Road by Iain MacMillan. In the afternoon, Paul went alone into Studio Three to record a lead guitar solo and a tambourine part. These recordings were omitted from the final mix. Finally, during the recording session of August 11 backing vocals were overdubbed. The second vocal sung by John on January 27 disappeared in favor of backing vocals (see *Anthology 3*).

Paul's vocal performance, contrary to what John said later, was absolutely stunning. Ringo's drumming was sublime.

Technical Details

Paul, anxious to create a "live" atmosphere did not use a headset for singing in order to get feedback directly from the speakers, as the Beatles had done until 1966.

1. Sheff, *The Playboy Interview with John Lennon & Yoko Ono*.
2. *The Beatles Anthology*.
3. Lewisohn, *The Complete Beatles Recording Sessions*.
4. Ibid.

Octopus's Garden

Richard Starkey / 2:51

MUSICIANS
Ringo: vocal, drums
George: guitar solo, backing vocal
Paul: bass, piano, backing vocal
John: rhythm guitar

RECORDED
Abbey Road: April 26, 1969 (Studio Two) / April 29, 1969 (Studio Three) / July 17, 1969 (Studio Two) / July 18, 1969 (Studio Three)

NUMBER OF TAKES: 32

MIXING
Abbey Road: July 18, 1969 (Studio Two)

TECHNICAL TEAM
Producers: Chris Thomas, the Beatles, George Martin
Sound Engineers: Jeff Jarratt, Phil McDonald
Assistant Engineers: Richard Langham, Nick Webb, Alan Parsons

Genesis

On August 22, 1968, Ringo walked out of the sessions for the *White Album*. He could no longer bear the increasing tensions within the group or Paul's critical remarks, which made him doubt his abilities as a drummer. Disillusioned, bitter, and exhausted, he took his wife and children on vacation to Sardinia on a yacht lent to him by his friend, the actor Peter Sellers. A story from this vacation is the source of the name of the song. At lunch Ringo was served octopus instead of the fish and chips he expected. He asked the captain what this strange animal (which he had evidently never eaten) was. The captain told him about the habits of the octopus, his custom of accumulating objects and shellfish around his cave like a small garden. Ringo, amused, immediately wrote a song inspired by the story of the octopus's garden. It was his second composition after the *White Album*'s "Don't Pass Me By."

Upon his return from Sardinia, he offered the song to the group, but it was not used for the *White Album*. "Octopus's Garden" was first worked on in January 1969 during the *Get Back* sessions at Twickenham Film Studios. In the film *Let It Be*, we see George help Ringo write the bridge of the song at the piano, suggesting he start with a major chord instead of a minor, under the watchful eye of George Martin and John on drums!

In addition to being amusing, the lyrics implicitly evoked the band's difficulties at the time. Verses such as *We would be warm, below the storm* and *We would be so happy you and me / No one there to tell us what to do* may refer unconsciously to Ringo and George and the stress felt at the time just before the band broke up.

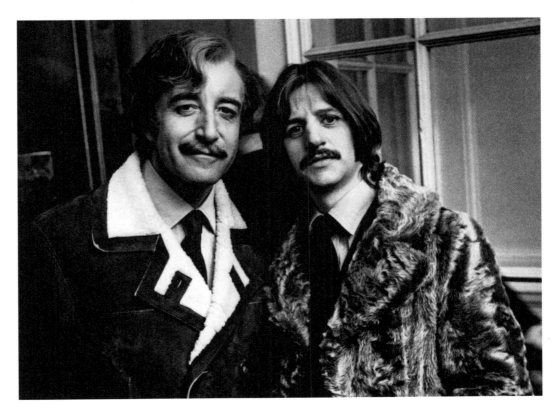

Ringo composed "Octopus's Garden" on his friend Peter Seller's yacht. (Above, Peter Sellers and Ringo in 1969.)

Production

Ringo, who did not have any lead vocals during the *Get Back* sessions, took the microphone for one of his own compositions, "Octopus's Garden." Geoff Emerick remembers both Paul and George as being in a good mood during the sessions while John was moping around, saying little and contributing next to nothing. More than usual, "They chipped in, putting as much effort into it as if it were one of their own songs."[1]

April 26 was the first day devoted to the song. They recorded no fewer than thirty-two takes. Paul was on bass, George on guitar solo—proving once again what a formidable guitarist he had become in the end—John on rhythm guitar and Ringo on drums and simultaneously lead vocal. On *Anthology 3*, we hear him ironically mocking himself after take 8: "Well, that was superb!" Paul added a piano part played on the slightly out of tune "Mrs. Mills" Steinway piano. Since the structure of the song was simple, the recording was relatively close to the final version at this stage. George Martin was not available. Curiously, the first day is credited to Chris Thomas and also to the Beatles as the producers. The role of each is unclear, especially because the Beatles were at this point able to produce themselves. On April 29, Ringo, dissatisfied, overdubbed his lead vocal again. The song was then put on the shelf until mid-July when it was revived on July 17 for more overdubs and mixing. Paul and George contributed backing vocals, singing in falsetto; Paul added piano notes, and George played guitar. Ringo blew bubbles into a glass of water, the same technique that had been used for the song "Yellow Submarine." "That was miced very closely to capture all the little bubbles and sounds,"[2] recalled Alan Brown, technical engineer on the session. Finally, the next day, Ringo recorded his final lead vocal and added tomtom beats before each chorus. The mix was made on July 18.

Technical Details

Ringo asked Geoff Emerick if he could make the vocals in the middle section sound as if they were being sung underwater. Emerick came up with a new effect: "After some experimentation I discovered that feeding the vocals into a compressor and triggering it from a pulsing tone (which I derived from George Harrison's Moog synthesizer) imparted a distinctive wobbly sound, almost like gargling."[3]

1. Emerick, *Here, There and Everywhere.*
2. Lewisohn, *The Complete Beatles Recording Sessions.*
3. Emerick, *Here, There and Everywhere.*

I Want You (She's So Heavy)

Lennon-McCartney / 7:44

SONGWRITER
John

MUSICIANS
John: vocal, rhythm guitar, lead guitar
Paul: bass, piano, backing vocal
George: rhythm guitar, lead guitar, backing vocal
Ringo: drums, congas
Billy Preston: Hammond organ RT-3

RECORDED
Apple Studios: January 29, 1969
Trident Studios: February 22, 1969
Abbey Road: April 18, 1969 (Studio Two) / April 20, 1969 (Studio Three) / August 8 and 11, 1969 (Studio Two) / August 20, 1969 (Studio Three)

NUMBER OF TAKES: 35

MIXING:
Trident Studios: February 23–24, 1969
Abbey Road: April 18, 1969 (Studio Two) / August 11, 1969 (Studio Two) / August 20, 1969 (Studio Three)

TECHNICAL TEAM
Producers: George Martin, Glyn Johns, Chris Thomas
Sound Engineers: Glyn Johns, Barry Sheffield (Trident), Jeff Jarratt, Geoff Emerick, Chris Thomas
Assistant Engineers: Alan Parsons, John Kurlander

Genesis

"'I Want You,' that's me about Yoko."[1] That's how John described the song during his last interview with David Sheff in 1980. As simple as that. There are only about a dozen words in the song, no more. This economy is what gives John's work its effectiveness and authenticity. He bared his soul, without compromise, as he always did.

John wrote the song about his passionate love for Yoko, his inspiration for both the lyrics and the music. "I Want You" was influenced by Mel Tormé's 1962 song "Comin' Home, Baby." John has structured it into two parts: singing and instrumental. The first part is based on a minor blues scale with the voice superimposed on a solo guitar. The second, completely independent from the verses, is based on a harmonic progression played in arpeggios by multitracked guitars for the song's coda. John increases the tension to express his obsession with Yoko.

Production

On January 29, the eve of their memorable concert on the Apple roof, the Beatles rehearsed "I Want You" ("She's So Heavy" was only added to the title on August 11). The first serious take was on February 22 at Trident Studios. The Apple studio was an acoustic disaster. "Magic Alex" had not quite worked the miracle that he had promised. The Beatles were forced to take some of the equipment installed at Apple back to Abbey Road and waited for Glyn Johns, chief sound engineer since the time of *Get Back*, and Billy Preston, both of whom

1. Sheff, *The Playboy Interview with John Lennon & Yoko Ono.*
2. Lewisohn, *The Complete Beatles Recording Sessions.*
3. Emerick, *Here, There and Everywhere.*
4. Ibid.
5. Ibid.

were in the United States at the time. In the meantime, on February 22 thirty-five takes were recorded at Trident. John provided a great vocal and shared the guitar part with George. Paul delivered an inspired bass part balanced between glissandos, bluesy riffs, and Latino flair. Billy Preston performed a flamboyant organ accompaniment while Ringo kept the rhythm with brio. Note that John performed the main guitar solo, but was not as good as George. The next day, John was not happy with any one take and insisted that three different takes be edited into one: take 9 for John's vocal at the beginning, take 20 for the middle eight, and take 32 for the rest. The total length of the resulting combination exceeds eight minutes. On February 24, a backup copy of the edited master was made. It was the end of the Trident recording.

Back at Abbey Road on April 18, John and George overdubbed a long series of guitar parts for the intro and the coda to the song. Jeff Jarratt recalled, "They wanted a *massive* sound, so they kept tracking and tracking, over and over."[2] The guitar arpeggios were played in unison. Both John and George had their guitars connected to a Fender Twin Reverb with the volume close to the maximum providing a massive sound. But the result of adding layers of guitars was that some of Billy Preston's Hammond organ parts were drowned out. After more reduction, on April 20 another Hammond organ was added (Paul?) with Ringo playing a set of conga drums.

On August 8 the sessions resumed. John added "white noise" from the Moog synthesizer. John was enamored of the "white noise," which was the scary and haunting synthetic sound used at the end of the song. Ringo added an additional snare drum part. Surprisingly, these final additions are not on the tape dated April 18, but on a recording dated February 22 at Trident Studios. Is this a labeling error? We do not know. On August 11, John, Paul, and George met in Studio Two, rerecorded the tremendous backing vocals, and sang *She's so heavy* onto the master of April 18. The choruses are impressive and the result striking. The song was completed, although John hesitated between the versions of April 18 and February 23. In both he had inserted *She's so Heavy*. Since the time of "Strawberry Fields Forever," John had acquired some production expertise. More than six months later on August 20, he made his final decision: he asked for a remix of both versions and then had the two edited together. The master is the Abbey Road version for the first 4:37 and then the original Trident tape for the rest of the song. The junction is at exactly 4:37, just after *She's so heavy*. John was becoming obsessed with the "white noise" and constantly implored Geoff Emerick to make it "Louder! louder!! . . . I want the track to build and build and build, . . . and then I want the white noise to completely take over and blot out the music together."[3] According to Emerick, Paul sat in a corner with his head down; he couldn't understand John's delirium. Emerick recalled, "I could see a dejected Paul, sitting slumped over, head down, staring at the floor. He didn't say a word, but his body language made it clear that he was very unhappy, not only with the song itself, but with the idea that the music . . . was being obliterated

John and Yoko during their first bed-in at the Hilton Hotel in Amsterdam. *Stay in bed, Grow your hair!* are some of the slogans written on the wall.

with noise."[4] Then, suddenly, twenty seconds before the track broke down, John said, "There! Cut the tape there." Surprised, Emerick "glanced over at George Martin who simply shrugged his shoulders" and executed the order. To everyone's surprise, the abrupt ending is incredibly effective, "a Lennon concept that really worked,"[5] Emerick said. It was certainly a very effective way to end the second side of the album. However, John wanted to reverse the two sides of the album, so that his song would end the *Abbey Road* album. "I Want You" is the last song on which the four Beatles were together inside the recording studio. After August 20, they never worked together again.

Technical Details

To strengthen the sound in the coda, the Moog synthesizer, snare drum, and guitars were treated with ADT, which gives the feeling of a "wall of sound." During the quiet moments, it is possible to hear quite clearly the various sounds created by the transfers to and from the tape recorders of the day. Recording on an eight-track tape recorder was very limited, and required reductions to save tracks for recording new sounds. This limited technology did not prevent the Beatles from recording most of their work, including *Sgt. Pepper's Lonely Hearts Club Band*, on a four-track tape recorder, even if they had to continuously synchronize the tape recorders.

George Harrison composed "Here Comes the Sun" in response to the difficulties facing the Beatles at the end of the 1960s. It was a lovely song with an incomparable melody.

Here Comes The Sun

George Harrison / 3:06

MUSICIANS
George: vocal, guitar, Moog synthesizer, harmonium, hand claps
Paul: bass, backing vocal, hand claps
Ringo: drums
Orchestra: 4 violas, 4 cellos, 1 double bass, 2 piccolos, 2 flutes, 2 alto flutes, 2 clarinets

RECORDED
Abbey Road: July 7–8, 1969 (Studio Two) / July 16, 1969 (Studio Three) / August 6, 1969 (Studio Three) / August 11, 1969 (Studio Two) / August 15, 1969 (Studios One and Two) / August 19, 1969 (Studio Two)

NUMBER OF TAKES: 15

MIXING:
Abbey Road: July 8, 1969 (Studio Two) / August 4, 1969 (Studio Two)

TECHNICAL TEAM
Producer: George Martin
Sound Engineers: Phil McDonald, Geoff Emerick
Assistant Engineers: Alan Parsons, John Kurlander

Genesis

The year 1969 was difficult for the Beatles. Legal and business disagreements, the breakdown of the *Get Back* project, and an omnipresent Yoko Ono were all serious threats to the overwhelmed, tired group. Each member was seeking more independence. George, in particular, was overwhelmed with accountants, attorneys, lawyers, bankers . . .

On a beautiful spring morning, George Harrison wrote "Here Comes the Sun" while visiting Eric Clapton at his house in Huntwood Edge, Surrey. "We were sitting at the top of a big field at the bottom of the garden. We had our guitars and we were just strumming away when he started singing 'de da de de, it's been a long cold lonely winter,' and bit by bit he fleshed it out, until it was time for lunch."[1]

In October 1969, George said to David Wigg, "The story behind that was, like Paul sung 'You Never Give Me Your Money.' I think, because whatever you're involved with rubs off and influences you. 'You Never Give Me Your Money' is, I think, during all these business things that we had to go through to sort out the past, so it came out in Paul's song. 'Here Comes the Sun' was the same period. We had meetings and meetings and with all this, you know, banks, bankers and lawyers and all sorts of things. And contracts and shares. And it was really awful, 'cuz it's not the sort of thing we enjoy. And one day I didn't come in to the office. I just sort of, it was like sagging off school. And I went to a friend's house in the country. And it was just sunny and it was all just the release of that tension that had been building up on me. And it was just a really nice sunny day. And I picked up the guitar, which was the first time I'd played the guitar for a couple of weeks because I'd been so busy. And the first thing that came out was that song. It just came. And I finished it later when I was on holiday in Sardinia."[2]

1. Clapton, *Clapton par Eric Clapton.*
2. Wigg, *The Beatles Tapes from the David Wigg Interviews.*
3. Voormann, *Warum Spielst Du Imagine Nicht Auf Dem Weissen Klavier, John?*

Journey into Space

American astronomer Carl Sagan developed the "Voyager Golden Record," which was included aboard both Voyager spacecraft in 1977. The record was a collection of sounds and images characterizing the diversity of life and culture on Earth and intended to be heard by extraterrestrial life or a future population finding the records. "Here Comes the Sun" was selected as part of that collection, but, unfortunately, EMI refused to release the copyright. Instead "Voyager Golden Record" spread the good vibes of rock 'n' roll with "Johnny B. Goode" by Chuck Berry.

He finished the song soon after June 1 while on vacation in Sardinia with Terry Doran, the press officer of the group, and his wife Pattie. Klaus Voormann joined them soon after. He recalled that one day at the pool he heard George repeat the same sentence several times, accompanied by his guitar, "'Here comes the sun, Here comes the sun.' I thought it sounded rather well."[3]

"Here Comes the Sun" was another of George's masterpieces. Both words and music are luminous, radiant. Like "Something," it proved that Harrison could write songs on the same level as John and Paul.

Production

July 7 was Ringo's twenty-ninth birthday and the first recording session for "Here Comes the Sun." John was still recovering from his car accident in Scotland. The three Beatles started recording the rhythm track—Paul on bass, Ringo on drums, and George on acoustic guitar and singing the guide vocal. The interpretation was dazzling. Ringo had no trouble mastering the unusual rhythm of the song, which switches between 11/8, 4/4, and 7/8 on the bridge. His ability to master any rhythm, often underestimated, allowed him to perform this task without difficulty. It was proof that he could keep to any tempo before there was an electronic metronome. Take 13 was the best basic track. George perfected his part on the Gibson J-200 for the last hour of the session. The following day he overdubbed his lead vocal, erasing his previous vocal, and overdubbing the superb backing vocals, Sun, Sun, Sun, that he shared and double-tracked with Paul. Paul also added the electric guitar parts, run through a Leslie speaker, while Ringo reinforced his snare. Take 13 was given a reduction using a second eight-track tape recorder. On track 16, George added the harmonium, hand claps that required a lot of practice to perfect, and overdubbed other backing vocals with Paul. On August 6 and 11, George added more guitar to the song. Then, on August 15, they had a nine-hour marathon session to record George Martin's orchestral arrangement. Surprisingly, even though the Beatles sold the most records in the history of rock, EMI still demanded rigorous adherence to the recording budget. Then, on the same day, George Martin recorded the orchestral parts of "Golden Slumbers," "Carry That Weight," "The End," "Something," and "Here Comes the Sun."

George's harmonium virtually disappeared in favor of strings. On August 19, he added a Moog synthesizer overdub onto take 15, his final touch to the song, in Room 43. The Moog masked the sound of woodwind and percussion instruments. The stereo mix, slightly varispeeded, was made the same day. The Gibson J-200 was reinforced with ADT, except in the introduction. Paul made a few sound loops especially for the song, but they were not selected for the final version.

John and Yoko at the piano. "Because" might have been inspired by a Beethoven sonata or it may just be a variation of "Stay in Bed," one of the songs on the *Wedding Album*, the couple's third solo album.

Because

Lennon-McCartney / 2:46

SONGWRITER
John

MUSICIANS
John: vocal, guitar
Paul: vocal, bass
George: vocal, Moog synthesizer
Ringo: guide rhythm
George Martin: harpsichord

RECORDED
Abbey Road: August 1 and 4, 1969 (Studio Two) / August 5, 1969 (Studios Two and Three, and Room 43)

NUMBER OF TAKES: 23

MIXING:
Abbey Road: August 12, 1969 (Studio Two)

TECHNICAL TEAM
Producer: George Martin
Sound Engineer: Geoff Emerick, Phil McDonald
Assistant Engineer: John Kurlander

Genesis

Yoko, who as a child was trained as a classical pianist, played Beethoven's "Moonlight Piano Sonata No. 14 in C sharp minor, Opus 27, No. 2" for John. John, lying on the couch listening, asked her to play the chords backwards. Later he said he was inspired by them to write "Because." Although it contains some similarities to Beethoven, even reversed, the relationship is not obvious. It seems instead that he combined the general feeling of the piece with memories of their recent visit to the Netherlands. Indeed, on the *Wedding Album*, the couple's solo album released on November 7, 1969, Yoko sang a song, apparently titled "Stay in Bed" with an arpeggio chord accompaniment performed by John that is very close to "Because." This recording is part of the experimental piece "Amsterdam" (at about 22:10), the second song on the record taped between March 25 and 31, 1969, during John and Yoko's bed-in in the presidential suite, room 902, at the Amsterdam Hilton Hotel. This hotel was immortalized in the song "The Ballad of John and Yoko": *drove from Paris to the Amsterdam Hilton . . ."*

According to Paul, Yoko had a strong influence on John's words: wind, sky, and earth are recurring themes in the work of the young woman. It was straight out of her book *Grapefruit* (1964). John, himself, found the words clear, speaking for themselves, "no bullshit, no imagery, no obscure references."[1] George thought "Because" was the best song on the record simply because he loved the three-part backing vocals. In October 1969, he said to David Wigg, "We've never done something like that for years, I think, since a B-side. [sings] *If you wear red tonight, and what I said tonight* [lyrics from 'Yes It Is' —ed.]. So I like that. I like lots of them. I like 'You Never Give Me Your Money'

1. Sheff, *The Playboy Interview with John Lennon & Yoko Ono.*
2. Wigg, *The Beatles Tapes from the David Wigg Interviews.*
3. Emerick, *Here, There and Everywhere.*
4. Ibid.

Opposite: John and Yoko at a press conference in Montreal on December 22, 1969. John is holding a "laughing bag" and Yoko a *War is Over* poster.
Above: Yoko, John, and John's son, Julian.

and 'Golden Slumbers' and things."[2] Paul also shared this opinion. He thought it one of the best songs on the *Abbey Road* album.

Production

On August 1, when George Martin listened to John's beautiful song "Because," he immediately saw that his experience would once again be useful, just as it had been in the past. Harmonizing vocal lines was still one of his great strengths. The first recording session consisted of John playing arpeggiated chords on his electric guitar and, as George Martin suggested, doubled-tracking the arpeggios on the Baldwin solid-body electric harpsichord recently acquired earlier that year by EMI (a kind of electric spinet harpsichord played by Martin himself). Ringo tapped out a steady tempo on a hi-hat cymbal for reference only. It was only for the musicians' headphones—it was not recorded on tape. George and Paul were in the control room. Paul was acting as producer; dissatisfied, he kept asking the three musicians to do take after take. Totally exhausted after twenty-three takes, the trio went to the control room to listen to the result. They soon found an excellent take (take 16) recorded an hour earlier. Geoff: "John didn't say anything, but he shot an embarrassed Paul

a dirty look."[3] Paul then recorded his bass, and Martin asked them, with the exception of Ringo, to rehearse the three-part backing vocal track that he had just written. Each diligently learned his part, then recorded the first take after three hours of intense work. On August 4, they decided to double and triple this first vocal track to enrich the backing vocals. John, Paul, and George recorded two additional takes of this magnificent three-part harmony. The lights were dimmed for atmosphere, the Beatles were sitting in a semicircle, and, despite their fatigue, no one gave up. It took more than five hours to record good takes. On August 5, George Harrison brought a final touch to the song in Room 43 by recording two synthesizer overdubs. The Moog synthesizer was a recent invention, and he was one of the first to use it in the UK. He bought the instrument on November 15, 1968, during his stay in California. He used it for *Electronic Sounds*, his CD released by Zapple, the experimental Apple label, on May 9. Emerick tried something new as well to keep the purity of the sound: "I had decided to use no signal processor whatsoever, no compressor or limiters."[4] Fully satisfied with the effect, he decided to mix the entire track without them on August 12. The final stereo mix was made the same date.

You Never Give Me Your Money

Lennon-McCartney / 4:03

SONGWRITER
Paul

MUSICIANS
Paul: piano, vocal, bass, chimes, guitar
John: guitar, backing vocal
George: guitar, bass, backing vocal
Ringo: drums, tambourine

RECORDED
Olympic Sound Studio: May 6, 1969 (Studio One)
Abbey Road: July 1 and 11, 1969 (Studio Two) / July 15, 1969 (Studio Three) / July 30, 1969 (Studios Two and Three) / July 31, 1969 (Studio Two) / August 5, 1969 (Studio Three)

NUMBER OF TAKES: 42

MIXING
Abbey Road: July 15, 1969 (Studio Three) / July 30, 1969 (Studios Two and Three) / August 13–14 and 21, 1969 (Studio Two)

TECHNICAL TEAM
Producer: George Martin
Sound Engineers: Glyn Johns, Phil McDonald, Geoff Emerick
Assistant Engineers: Steve Vaughan, Chris Blair, John Kurlander, Alan Parsons

Genesis

The opening of the famous Abbey Road medley, "You Never Give Me Your Money" resulted from a mix of five or six different song fragments. The idea was probably born at the time of the first recording session at Olympic Sound Studios in early May. George Martin suggested that Paul think "symphonically." This was an excellent idea, and immediately Paul and John started to put together pieces of unfinished songs. Paul said, "I think it was my idea to put all the spare bits together, but I'm a bit wary of claiming these things. I'm happy for it to be everyone's idea."[1] Ringo recalled that John and Paul recorded various pieces together as a medley: "A lot of work went into it, but they weren't writing together."[2] John said, "I've got stuff that I wrote around Sgt. Pepper . . . It was a good way of getting rid of bits of songs."[3]

Everything took shape under the leadership of Paul and George Martin, with George and Ringo helping with vocals and instrumental parts. John: "We've got twelve bars here—fill it in. And we'd fill it in on the spot."[4] However, Martin recalled that in the end John did not like the medley. He did not think it rocked enough. The medley was very difficult to record. Afterward, George said, "We did actually perform more like musicians again."[5]

"You Never Give Me Your Money," written in New York in October 1968, was about the Beatles' administrative and management difficulties, difficulties that were particularly hard on Paul. The phrase *But oh, that magic feeling, nowhere to go* referred to aimless walks he took with his wife Linda in the countryside near London. He admitted, "This was me lambasting Allen Klein's attitude to us: no money, just funny paper, all promises and it never works out."[6]

Allen Klein became the Beatles' manager in 1969. Paul McCartney refused to sign any contract with him.

Production

On May 6, 1969, the Beatles began work on "You Never Give Me Your Money" at Olympic Sound Studios in London, where they had recorded several times before. The basic rhythm track included Paul at the piano and guide vocal, John on distorted guitar, George on his Fender six-string bass and on a second guitar fed

Paul's Bells

Chimes used for Paul's bell sounds were previously used on "Penny Lane" for the sound of the fire truck. Today, these Premier Orchestral Chimes are in Paul's home recording studio.

1. *The Beatles Anthology.*
2. Ibid.
3. Ibid.
4. Ibid.
5. Ibid.
6. Miles, *Paul McCartney.*

The Beatles in a meeting at Apple. Opinions diverge...

The Influence of the Who

Paul recognized that the medley was influenced by Keith West's song "Excerpt from a Teenage Opera" (1967). But we can also assume that the Who's mini-opera, "A Quick One While He's Away" (on the Quick One album, 1966), and John's song "Happiness Is A Warm Gun" also played a significant role.

through a Leslie speaker, and Ringo on drums. After thirty-six takes, take 30 was judged the best. At this point, the song ended abruptly and the transition to "Sun King" was not clearly defined.

The Beatles resumed work on July 1, at Abbey Road. In fact, Paul was the only Beatle in the studio when he overdubbed a lead vocal. John was absent because of a car accident with his family in Scotland. This recording session marked the beginning of the sessions for the album. Ten days later, Paul added a bass line, then on July 15, all the Beatles got back together, and vocals, tambourine, and chimes were recorded. They tried backing vocals on the *out of college* section, but soon quit. For the session on July 30, the Beatles were in the control room to verify the sequence in "The Long One / Huge Melody," as the medley was called then. The songs all fit together perfectly, except for two small problems: Paul decided to eliminate "Her Majesty" permanently, and he was not happy with the transition from "You Never Give Me Your Money" to "Sun King," which was only a single long organ note at the time. The following day, other bass lines and honky-tonk piano were recorded for the *out of college* section (1:10 to 1:31). The piano part was played an octave lower on a Steinway B Grand Piano and recorded with the playback slowed down to half normal speed, which created the characteristic honky-tonk piano sound as heard in "Rocky Raccoon."

It is likely Paul played the piano track, not George Martin. Paul was confident enough and he played the piano in the introduction to the song.

On August 5, Paul found the solution for the transition between the two songs. As he had done for "Tomorrow Never Knows," "Paul took a plastic bag containing a dozen loose strands of mono tape into Abbey Road." The loops he chose sounded like "bells,

birds, bubbles and crickets chirping." These helped cre-
ate an effective transition, creating the atmosphere for
the Sun King's entrance.[6] On August 13, a number of
stereo mixes were made. The twenty-third mix was
selected. The following day, eleven attempts were made
to cross-fade "You Never Give Me Your Money" with
"Sun King" via Paul's tape loops. The cross-fading was
redone on August 21 to make the final.

FOR BEATLES FANATICS

Small funny detail: toward
3:50, the Beatles begin to
laugh.

The British blues band Fleetwood Mac, with John McVie, Danny Kirwan, Peter Green, Jeremy Spencer, and Mick Fleetwood. Their song "Albatross" influenced John's "Sun King" composition.

Sun King

Lennon-McCartney / 2:26

SONGWRITER
John

MUSICIANS
John: vocal, rhythm guitar
Paul: bass, piano, organ, backing vocal
George: guitar, backing vocal
Ringo: drums, maracas

RECORDED
Abbey Road: July 24–25, 1969 (Studio Two) / July 29, 1969 (Studio Three)

NUMBER OF TAKES: 35

MIXING
Abbey Road: July 30, 1969 (Studio Two) / August 14 and 21, 1969 (Studio Two)

TECHNICAL TEAM
Producer: George Martin
Sound Engineers: Geoff Emerick, Phil McDonald
Assistant Engineers: John Kurlander, Alan Parsons

FOR BEATLES FANATICS

George Harrison's Leslie cabinet model 147RV was a present from Eric Clapton.

Genesis

Although John Lennon most likely got the title "Sun King" from the British author Nancy Mitford's 1966 biography of Louis XIV, he alleged in 1971 that the song came to him in a dream. On the musical level, the major influence for the piece came from the guitar-based instrumental "Albatross," by Fleetwood Mac, released in January 1969. In 1987, George said, "At the time, 'Albatross' was out, with all the reverb on guitar. So we said, 'Let's be Fleetwood Mac doing 'Albatross,' just to get going.' It never really sounded like Fleetwood Mac . . . but [that] was the point of origin."[1] In 1969, John said, "When we came to sing it, to make them different we started joking, saying '*Cuando para mucho*' . . . Paul knew a few Spanish words from school, so we just strung any Spanish words that sounded vaguely like something. And of course we got '*chicka ferdi*'—that a Liverpool expression, it doesn't mean anything, just like 'ha ha ha.'"[2] He added, "We could have had 'paranoia,' but we forgot all about it. We used to call ourselves Los Para Noias."[3]

"Sun King" does not mean anything, with its strange lyrics in three languages! In 1980, in his interview with David Sheff, John said, "That's a piece of garbage I had around."[4]

Production

"Sun King," the working title of which was "Here Comes the Sun King" until July 29, took its final name that day to avoid confusion with George's "Here Comes the Sun." Two songs for the medley, "Sun King" and "Mean Mr. Mustard," were recorded in a single session on July 24. This was a challenge. The instrumental arrangement is identical—John on rhythm guitar and guide vocal, Paul on bass, George on a second guitar

fed through a Leslie speaker, and Ringo on drums. Both songs were John's compositions—provocative, surreal, and humorous. The following day was devoted to overdubs of vocals, piano, and organ. The atmosphere was friendly; John and Paul sang together. Geoff Emerick recalled, "They disappeared behind the screens at one point for a puff on a joint, just the two of them, and when they came out they had a fit of giggles as they sang the pseudo-Spanish gibberish at the end of 'Here Comes the Sun King'; in fact, they found it impossible to get through a take without dissolving into laughter."[5] On July 29, other vocals, organ, percussion, and piano were added. On the July 30, Paul was in the control room to listen to the sequence in the medley. Paul was not happy with the long organ note transition between "You Never Give Me Your Money" and "Sun King." It was only on August 5 that Paul found the solution, using tape loop sound effects to provide an atmospheric cross-fade link. On August 14, several remixes were made as well as a number of attempts to link "You Never Give Me Your Money" and "Sun King." The master was created on August 21.

Technical Details

George's guitar, fed through a Leslie speaker, is particularly obvious in the introduction of "Sun King." The spinning sound was used frequently in 1969. Geoff Emerick recalled that Ringo came up with the idea of "draping his tom-toms with heavy tea towels and playing them with timpani beaters in order to give John the 'jungle drum' sound he was after."[6]

1. Timothy White, *George Harrison: Reconsidered*, (Larchwood & Weir, 2013)
2. *The Beatles Anthology.*
3. Ibid.
4. Sheff, *The Playboy Interview with John Lennon & Yoko Ono.*
5. Emerick, *Here, There and Everywhere.*
6. Ibid.

Mean Mr. Mustard

Lennon-McCartney / 1:07

SONGWRITER
John

MUSICIANS
John: vocal, rhythm guitar, piano (?)
Paul: bass, organ (?), backing vocal
George: guitar, backing vocal
Ringo: drums, maracas

RECORDED
Abbey Road: July 24–25, 1969 (Studio Two) / July 29, 1969 (Studio Three)

NUMBER OF TAKES: 35

MIXING
Abbey Road: July 30, 1969 (Studio Two) / August 14 and 21, 1969 (Studio Two)

TECHNICAL TEAM
Producer: George Martin
Sound Engineers: Geoff Emerick, Phil McDonald
Assistant Engineers: John Kurlander, Alan Parsons

Genesis

It was spring 1968, and the Beatles were just back from Rishikesh. They met at George's home at Kinfauns to record demos of the songs intended for the *White Album.* Among these were "Mean Mr. Mustard" and "Polythene Pam." In 1980, John told a story to David Sheff: "I'd read somewhere in the newspaper about this mean guy who hid five-pound notes, not up his nose but somewhere else." He added, "No, it had nothing to do with cocaine,"[1] removing all doubt about his source of inspiration. Typical Lennon humor.

Mr. Mustard's sister was originally *his sister Shirley* (see *Anthology 3*), but John changed the name to *Pam* to create a connection with the next song, the famous and eccentric "Polythene Pam."

John described "Mean Mr. Mustard" "as a bit of crap that I wrote in India."[2] Paul judged it as "a nice fun song, typical of John." And he added, "I do not know what he was talking about." This comment proves that at the time the communication between them was not the best.

Production

"Mean Mr. Mustard" was taped right after "Sun King." The composition originally was over three minutes in length with a clear final chord. For the medley, John shortened the song to 1:10, keeping the same ending. On July 30, Paul did not like the transition between "Mean Mr. Mustard" and "Her Majesty." He asked John Kurlander to permanently eliminate "Her Majesty." Kurlander cut the track too short and deleted the last chord of "Mean Mr. Mustard." Although the transition to the next song, "Polythene Pam," was effective, the song nevertheless lacks the last chord. It can be heard in the

John found inspiration in Rishikesh for several of his songs, including "Mean Mr. Mustard," which was recorded over a year after he returned to the UK.

introduction of "Her Majesty," which was intended to follow "Mean Mr. Mustard."

Technical Details

John sang a lead vocal treated with ADT during mixing. Paul played a fuzz pedal on the bass, which produced a distorted and distinctive sound. As "Mean Mr. Mustard" and "Sun King" were recorded as one continuous piece, Paul probably switched on his Tone Bender fuzzbox. The identical volume pedal was used in "Think for Yourself" on the *Rubber Soul* album.

FOR BEATLES FANATICS

An amusing detail: Every time Paul's vocal enters, the sound of the tambourine disappears from the recording. Possibly his voice and the tambourine were kept on the same track to save space. Or the use of a compressor-limiter reduced the sound of the tambourine in favor of the vocal. As soon as the vocal disappears, the tambourine comes back.

1. Sheff, *The Playboy Interview with John Lennon & Yoko Ono.*
2. Ibid.

Polythene Pam

Lennon-McCartney / 1:13

SONGWRITER
John

MUSICIANS
John: vocal, guitar, piano (?)
Paul: bass, guitar, piano (?), backing vocal
George: lead guitar, backing vocal
Ringo: drums, percussion, tambourine

RECORDED
Abbey Road: July 25, 1969 (Studio Two) / July 28, 1969 (Studios Two and Three) / July 30, 1969 (Studio Two)

NUMBER OF TAKES: 40

MIXING
Abbey Road: July 30, 1969 (Studio Two) / August 14, 1969 (Studio Two)

TECHNICAL TEAM
Producer: George Martin
Sound Engineers: Geoff Emerick, Phil McDonald
Assistant Engineers: John Kurlander, Alan Parsons

1. Emerick, *Here, There and Everywhere.*
2. Sheff, *The Playboy Interview with John Lennon & Yoko Ono.*
3. Steve Turner, *A Hard Day's Write: The Stories Behind Every Beatles Song* (HarperCollins, 1994)
4. Miles, *Paul McCartney.*
5. Ibid.
6. Emerick, *Here, There and Everywhere.*
7. Ibid.
8. Ibid.

Genesis

The song referred to two encounters where polythene played an important role. The first was with a girl called Pat Hodgett, a diehard fan at the Cavern Club, who ate plastic and was nicknamed "Polythene Pat." The second encounter took place on August 8, 1963, when the Beatles played at the auditorium of Candie Gardens in Guernsey, the Channel Islands. But there are different versions of this story. According to John, the Beatles met the poet Royston Ellis (England's answer to Allen Ginsberg), in Liverpool in 1960 at a poetry reading at the university. At the time, he was working as a ferryboat engineer on the island for the summer. John claimed that Ellis proposed that John meet a girl dressed up in polyethylene. "He said, she dressed up in polythene, which she did. She didn't wear jack boots and kilts, I just sort of elaborated. Perverted sex in a polythene bag. Just looking for something to write about."[2]

Ellis, however, told Steve Turner in 1994, that he was with his girlfriend Stephanie and that they brought John to their apartment without any implied or perverse sex: "We'd read all these things about leather and we didn't have any leather but I had my oilskins and we had some polythene bags from somewhere. We all dressed up in them and wore them in bed. John stayed the night with us in the same bed. I don't think anything very exciting happened and we all wondered what the fun was in being 'kinky.'"[3] Paul's recollection accords with John's version. He remembered that "John went out to dinner with Royston and they ended up back at his apartment with a girl who dressed herself in polythene for John's amusement, so it was a kinky scene. She became Polythene Pam. She was a real

Royston Ellis, England's answer to Beat poet Allen Ginsberg, was a leading figure of the Beat Generation. Ellis might be the inspiration for "Polythene Pam."

character."[4] When John recorded the song he "used a thick Liverpool accent, because it was supposed to be about a mythical Liverpool scrubber dressed up in her jackboots and kilt."[5]

Production

Just as "Sun King" and "Mean Mr. Mustard" were recorded as one continuous piece, so were "Polythene Pam" and "She Came In Through the Bathroom Window." The first recording session was on July 25 and a total of thirty-nine takes were necessary. John provided rhythm guitar and guide vocal, Paul was on bass and provided another guide vocal, George was on guitar solo, and Ringo was on drums. John was very unhappy with Ringo's drumming. Geoff Emerick described "John commenting acidly at one point that it 'sounded like Dave Clark,'"[6] drummer of the group Dave Clark Five also known as The DC5. The DC5 was the second English pop rock group of the British Invasion and had knocked "I Want to Hold Your Hand" off the top of the UK singles charts in January 1964 with their single "Glad All Over." Annoyed by Ringo's inability to come up with a suitable part, he finally said, "Sod it, let's just put one down anyway."[7] Ringo, desperate, spent a good deal of time reworking

his part with Paul. He joined John when he finally felt ready. Exhausted, John lost his temper, "I'm not playing this bloody song again, Ring. If you want to redo the drums, go ahead and overdub them."[8]

With the help of Geoff Emerick, Ringo did just that. He recorded the new part using his previous drum track as a guide. On July 28, new guitar overdubs, percussion, and acoustic and electric pianos were added, as well as a new vocal. July 30 was devoted to overdubs of vocals, percussion, and guitars. Then after some finishing touches, they listened to the tape for the first time to check the transitions in the medley. Both songs passed the test. Finally, August 14 was the date of the final stereo mix: "Polythene Pam" and "She Came In Through the Bathroom Window" were completed and integrated into the medley.

Technical Details

Mark Lewisohn reported in *The Complete Beatles Recording Sessions* that John would have played a twelve-string acoustic guitar in the intro to "Polythene Pam." It is probably true, but it is difficult to distinguish among the series of overdubs of acoustic and electric guitars.

She Came In Through The Bathroom Window

Lennon-McCartney / 1:59

SONGWRITER
Paul

MUSICIANS
Paul: vocal, bass, guitar, piano (?)
John: guitar, backing vocal, piano (?)
George: lead guitar, backing vocal
Ringo: drums, percussion, tambourine

RECORDED
Apple Studio: January 22, 1969
Abbey Road: July 25, 1969 (Studio Two) / July 28, 1969
(Studios Two and Three) / July 30, 1969 (Studio Two)

NUMBER OF TAKES: 40

MIXING
Abbey Road: July 30, 1969 (Studio Two) / August 14, 1969
(Studio Two)

TECHNICAL TEAM
Producer: George Martin
Sound Engineers: Geoff Emerick, Phil McDonald, Glyn
Johns (Apple)
Assistant Engineers: John Kurlander, Alan Parsons

FOR BEATLES FANATICS

At 0:48 there is a "goof"
by an acoustic guitar—a
note that falls clearly
offbeat. Whose fault?

Genesis

"She Came In Through the Bathroom Window" was released as part of the medley, and is its only "classical" song, including an introduction, verses, and choruses. Paul's inspiration came on May 11, 1968, when he and John were in New York to officially launch Apple Corp. There are two stories about the source of the words. According to the first, the song was about the "Apple Scruffs," the Beatles' most extreme fans. Living near Abbey Road Studios, Paul was often their target. One of the fans, Diane Ashley, entered Paul's house, along with other girls, using a ladder in the garden to reach an open bathroom window. Margo Bird, a former "Apple Scruff" herself, confirmed this version. Margo had the honor of taking Martha, Paul's English Sheepdog, for a walk, before she was hired by the promotion department at Apple. Some items were stolen by Diane and her friends, including a photo to which Paul was particularly attached. Margo found it and returned it.

In a 2006 documentary, Mike Pinder, the former Moody Blues' keyboard player, offered another version. He told Paul that a groupie had entered the house of Ray Thomas, a vocalist and flutist with the Moody Blues, through an open bathroom window. When Paul heard about the incident, he began strumming on his guitar and improvising *She came in through the bathroom window*. Paul said that the end of the song, *And so I quit the police department*, came to him on October 31, 1968, in a taxi going to the airport in New York, when he saw the driver's medallion with his name, *Eugene Quits*, along with *New York Police Department*.[1] Paul had just spent two weeks with Linda and her daughter Heather in New York City.

In 1969 George said he thought it was a very good song with good lyrics, "but it's really hard to explain

Two "Apple Scruffs" looking into Paul's garden and hoping to see their idol. This kind of event might be the source of "She Came In Through the Bathroom Window."

what it's about," he added. John thought perhaps it was about Linda, whom Paul had just met, "Maybe she's the one that came in the window."[2]

Production

The Beatles first worked on this song, which originally had the title "Bathroom Window," in the chaotic Apple studios on January 22, 1969 with Billy Preston, who played electric piano. Although the song was recorded, the day was more like a rehearsal session. The version was slower than the one on *Abbey Road*. Moreover, at this stage, the song was not yet intended for the medley

because the idea of a medley only came up later in Paul's mind. On July 25 at Abbey Road Studios, the Beatles began working on Paul's composition, along with "Sun King," "Mean Mr. Mustard," and "Polythene Pam." George Martin was in charge of production.

1. Miles, *Paul McCartney.*
2. Sheff, *The Playboy Interview with John Lennon & Yoko Ono.*

Golden Slumbers

Lennon-McCartney / 1:32

SONGWRITER
Paul

MUSICIANS
Paul: vocal, piano, rhythm guitar, backing vocal, timpani (?)
George: bass, lead guitar, backing vocal
Ringo: drums, timpani (?), percussion, backing vocal
Orchestra: 12 violins, 4 violas, 4 cellos, 1 double bass, 4 French horns, 3 trumpets, 1 trombone, 1 bass trombone

RECORDED
Abbey Road: July 2–4, 1969 (Studio Two) / July 30, 1969 (Studio Three) / July 31, 1969 (Studio Two) / August 15, 1969 (Studios One and Two)

NUMBER OF TAKES: 17

MIXING
Abbey Road: July 3, 1969 (Studio Two) / July 30, 1969 (Studio Three) / August 18–19, 1969 (Studio Two)

TECHNICAL TEAM
Producer: George Martin
Sound Engineers: Phil McDonald, Geoff Emerick
Assistant Engineers: Chris Blair, John Kurlander, Alan Parsons

Genesis

Ruth McCartney, née Williams in 1960, is Paul's half-sister. Paul's father, Jim McCartney, adopted her after his marriage to Angela Williams on November 24, 1964. While Paul was at Rembrandt, his father's house in Liverpool, he found a very old lullaby from 1603 in Ruth's piano book. It was an extract from *The Pleasant Comedy of Pleasant Grissil*, adapted by Henry Chettle, William Haughton, and Thomas Dekker, the latter the author of the text. Seduced by the words, but unable to read the music, Paul moved to the piano and composed his own melody. He said to David Wigg, "I was just flicking through my sister Ruth's piano book, she was learning the piano and I came to Golden Slumbers, you know. So I just started . . . 'cuz I can't read music so I didn't know the tune, and I can't remember the old tune, you know. . . . So I started just playing *my* tune to it. And then I liked the words so I just kept that, you know."[1] Although he was inspired by Dekker's lullaby, Paul only kept four lines to which he made some changes: *Golden Slumbers kiss your eyes / Smiles awake you when you rise / Sleep, pretty wanton, do not cry / and I will sing a lullaby* (Dekker).

Production

"Golden Slumbers" was designed from the beginning to be connected to "Carry That Weight." Paul played both songs joined together during rehearsals for *Get Back*, even before thinking of the medley. It then became the third of his compositions to be recorded for the medley after "You Never Give Me Your Money" and "Her Majesty." At the first recording session on July 2, everyone wondered how John, still recovering from his car accident, would react to the medley. Although, according to Geoff Emerick, "there seemed to be an assumption that

Ruth McCartney in 1964 with her stepfather, Jim McCartney, and her mother, Angela Williams.

he would go along with it, and that this time around, in contrast to the White Album, he wouldn't be calling all the shots."[2] The Beatles, without John, recorded the basic rhythm track of "Golden Slumbers," the working title of "Golden Slumbers/Carry That Weight." Fifteen takes were recorded, Paul at the piano and guide vocal, George on his Fender bass six-string, and Ringo on drums. In the bonus *Anthology* DVD, George Martin pointed out to George Harrison that he probably played bass. Bass and piano were recorded together on the same track. Since Paul was at the piano, George was probably on bass. George Harrison did not remember, "OK? It might be me then, or John." But John was still recovering, so no doubt George played bass.

The following day, takes 13 and 15 were edited together. Overdubs were made on the edit take. Paul rerecorded two new vocals and added a rhythm guitar, and George played a guitar solo. Later on during the session, Paul, George, and Ringo were chanting in unison the chorus *carry that weight*. A reduction was made and new overdubs were recorded the following day. On July 30, Paul retaped another lead vocal, but the final is dated July 3. Paul said to Barry Miles, "I remember trying to get a very strong vocal on it, because it was such a gentle theme, so I worked on the strength of the vocal on it, and ended up quite pleased with it."[3] The session was also devoted to joining together all the songs for the medley. "Golden Slumbers/Carry That Weight"

passed the test. On August 4, Ringo overdubbed drums and timpani, along with Paul. We do not know exactly who played which part. On August 15, George Martin's orchestral arrangements were recorded. For economic reasons, all the Abbey Road orchestral overdubs were recorded the last day of the recording sessions in one go for "Golden Slumbers/Carry That Weight," "Something," "Here Comes the Sun," and "The End." On August 18, the final mix was made. The following day the transition to "The End" was made, finishing the album.

Technical Details

"Golden Slumbers" was one of the few songs on the *Abbey Road* album treated with ADT to enhance the orchestral sound recorded in mono on the eighth track. The orchestra is slightly off on one side of the stereo mix, while the ADT signal was installed on the opposite side.

1. Wigg, *The Beatles Tapes from the David Wigg Interviews.*
2. Emerick, *Here, There and Everywhere.*
3. Miles, *Paul McCartney.*

The four Beatles agreed to have their photo taken, but with the problems they were facing, none of them would smile.

Carry That Weight

Lennon-McCartney / 1:36

SONGWRITER
Paul

MUSICIANS
Paul: vocal, piano, rhythm guitar, backing vocals, timpani (?)
George: bass, lead guitar, backing vocal
Ringo: drums, percussion, backing vocal, timpani (?)
John: backing vocal
Orchestra: 12 violins, 4 violas, 4 cellos, 1 double bass, 4 French horns, 3 trumpets, 1 trombone, 1 bass trombone

RECORDED
Abbey Road: July 2–4, 1969 (Studio Two) / July 30, 1969 (Studio Three) / July 31, 1969 (Studio Two) / August 15, 1969 (Studios One and Two)

NUMBER OF TAKES: 17

MIXING
Abbey Road: July 3, 1969 (Studio Two) / July 30, 1969 (Studio Three) / August 18–19, 1969 (Studio Two)

TECHNICAL TEAM
Producer: George Martin
Sound Engineers: Phil McDonald, Geoff Emerick
Assistant Engineers: Chris Blair, John Kurlander, Alan Parsons

Genesis

"Carry That Weight" was another song about the financial difficulties the Beatles had at the time. Paul later said to Barry Miles, "I'm generally quite upbeat but at certain times things get to me so much that I just can't be upbeat any more and that was one of the times."[1] Drug problems, LSD, Klein, Apple—they all influenced "Carry That Weight." The atmosphere was tense. Friends, technicians, staff from Apple—all felt the tension. Paul: "It was heavy. 'Heavy' was a very operative word at that time. That's what 'Carry That Weight' was about. . . . In this heaviness there was no place to be. It was serious, paranoid heaviness and it was just very uncomfortable."[2] In 1980, in the interview with David Sheff, John merely commented, "I think he was under strain at that period."[3]

Production

"Carry That Weight" was a combination of three pieces: first, the chorus, *Boy, you're gonna carry that weight*, which is the only new McCartney composition; then a reprise of "You Never Give Me Your Money" (with new lyrics); and finally the ending repeats of the arpeggiated guitar motif derived from the *One two three . . . all good children go to heaven* section of "You Never Give Me Your Money." John contributed to the recording session on July 30 with some backing vocals.

Technical Details

Ringo added and overdubbed the snare hits and bass drum hits. This is particularly obvious in *Boy, you're gonna carry that weight*. The drum is on the left channel and overdubs are on the right channel. Furthermore, the Leslie speaker sound effect is very pronounced on George's guitar during the final arpeggio (after 1:27).

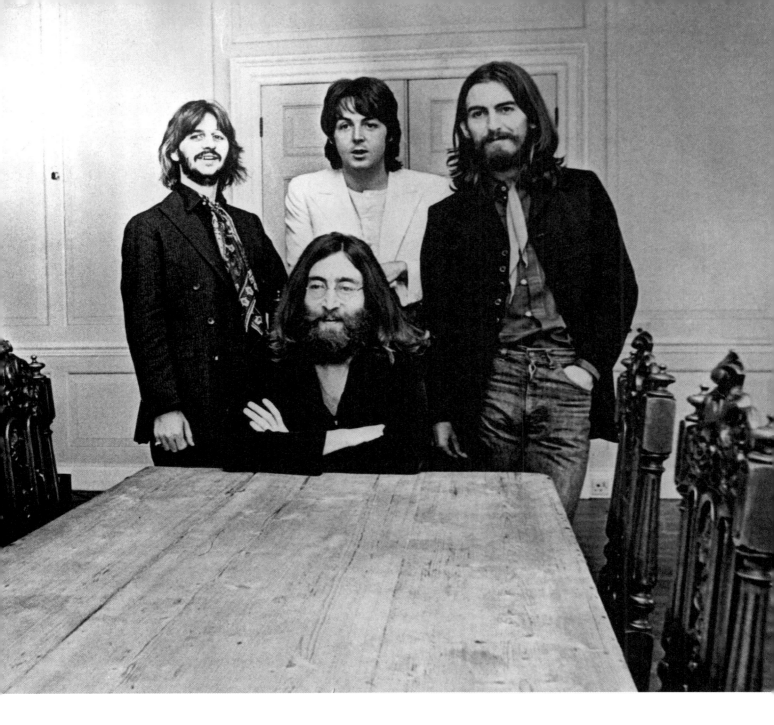

1. Miles, *Paul McCartney.*
2. Ibid.
3. Sheff, *The Playboy Interview with John Lennon & Yoko Ono.*

In "The End," destined to be the last song on *Abbey Road*, Ringo Starr played the only drum solo in his entire career.

The End

Lennon-McCartney / 2:19
(2:05 without the long pause preceding "Her Majesty")

SONGWRITER
Paul

MUSICIANS
Paul: vocal, bass, piano, guitar solo
John: backing vocal, guitar solo, rhythm guitar
George: backing vocal, guitar solo, rhythm guitar
Ringo: drums, percussion
Orchestra: 12 violins, 4 violas, 4 cellos, 1 double bass, 4 French horns, 3 trumpets, 1 trombone, 1 bass trombone

RECORDED
Abbey Road: July 23, 1969 (Studio Three) / August 5, 1969 (Studio Two) / August 7, 1969 (Studio Three) / August 8, 1969 (Studio Two) / August 15, 1969 (Studios One and Two) / August 18, 1969 (Studio Two)

NUMBER OF TAKES: 7

MIXING
Abbey Road: July 30, 1969 (Studio Two) / August 18–19 and 21, 1969 (Studio Two and Room 4)

TECHNICAL TEAM
Producer: George Martin
Sound Engineers: Geoff Emerick, Phil McDonald
Assistant Engineers: John Kurlander, Alan Parsons

FOR BEATLES FANATICS

Ringo's drum solo was inspired by the one Ron Bushy, drummer of the Iron Butterfly group, played on their great seventeen-minute hit, "In-A-Gadda-Da-Vida," released in June 1968.

Genesis

First titled "Ending," this song has a particular importance because it was the last complete song on *Abbey Road*. Did the Beatles already know during the summer of 1969 that their extraordinary adventure was coming to an end? This one song, by itself, embodies three important aspects of the band's career: first, it was the last track on their last album (excluding "Her Majesty," which was just an afterthought—see "Her Majesty"); it contains the only extended drum solo in Ringo's entire career; and, finally, it is the only time that Paul, George, and John together play a guitar solo. Ringo never wanted to play a drum solo, and to persuade him to do so was not an easy task. Paul recalled in an interview in 1988 that Ringo hated drum solos as much as the rest of the group: "When he joined the Beatles, we asked him, 'And what do you think of drum solos?' He replied, 'I hate them!' We shouted, 'Great! We love you!' So it was never done before the medley. I said, 'Uh, what do you think of a little solo?' He was upset and did not want to do it. But with a little persuasion and kindness he did." Ringo said, "Solos have never interested me. That drum solo is still the only one I've done. . . . I was opposed to it: 'I don't want to do no bloody solo!' George Martin convinced me. . . . Anyway, I did it, and it's out of the way."[1]

After this famous solo, Paul left quite a few measures to fill just as they had with the middle section of "A Day in the Life." After long discussions, George suggested a guitar solo. According to Geoff Emerick, John half-jokingly told him, "Yes, but this time you should let me play it."[2] Everyone laughed, including John. He did not drop the case, and said mischievously, "Why don't we *all* play the solo? We can take turns and trade licks."[3] Paul embraced the idea and immediately suggested that they

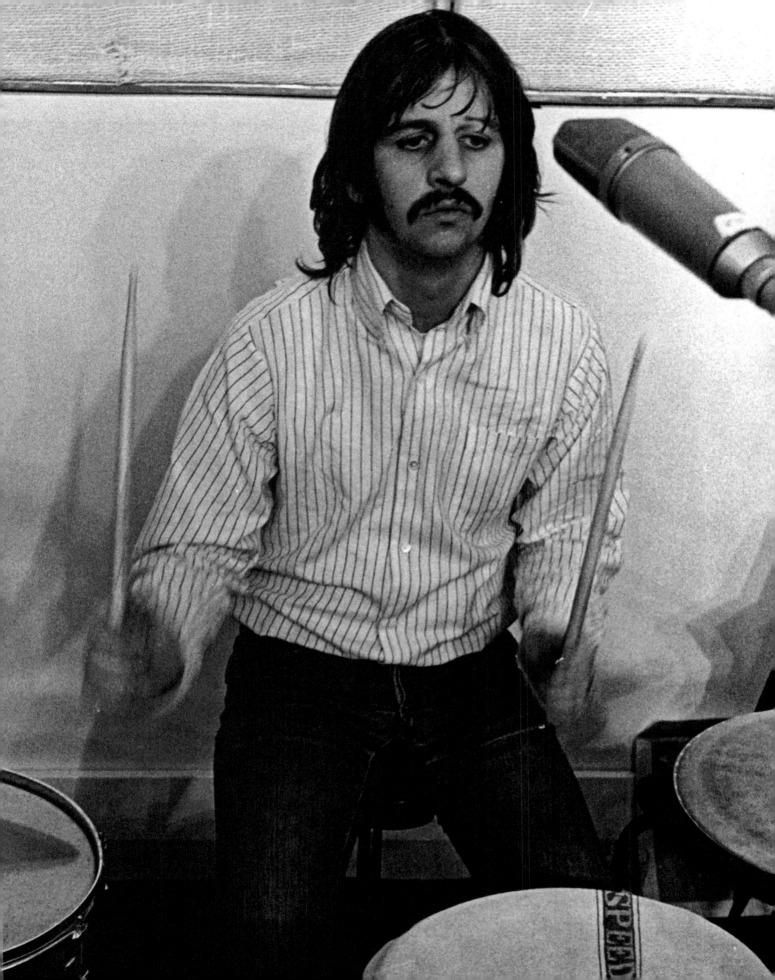

play the solos live. John loved the idea; George was initially reluctant before finally agreeing. Paul announced that he wanted to begin the solo, since it was his song. John, who did not want to be the last to decide, said he wanted to do the end because he had a great idea for it. George, as usual, got the middle spot by default. Yoko who was in the control room next to John while they were having this discussion, wanted to join John in the studio. He told her, "Wait here, luv; I won't be a minute." This unique three-part solo was a private affair, and she was denied access to the studio. It was decided that each, in the order agreed, would play a two-bar solo. First Paul, then George, and finally John. To the astonishment of all, they recorded it in a single take. Paul and John played on their Epiphone Casinos and George on his Gibson Les Paul "Lucy." Geoff Emerick was blown away by their performance and said: "For me, that session was undoubtedly the high point of the summer 1969, and listening to those guitar solos still never fails to bring a smile to my face."[4] About the lyrics, Paul explained: "I wanted it to end with a little meaningful couplet, so, I followed the Bard and wrote a couplet."[5] *And in the end / The love you take / Is equal to the love you make.* These inspired words were the last verses sung by the Beatles on the last song of their last album. Whether premonition or not, this song is called "The End." John willingly recognized the value of Paul's couplet, saying, "Very cosmic philosophical line," before adding, "Which again proves that if he wants to, he can think."[6]

Production

The production for "The End" was very difficult. After a period of rehearsal, the Beatles started recording the basic rhythm track on July 23 with John and George on guitar, Paul on bass, and Ringo on drums. Seven takes were necessary and for each one Ringo played a solo in a different style. The last attempt, take 7, was the best and 1:20 in length. Paul added piano and the group recorded the final part. After editing on the same day, the song was 2:05 in length. On July 30, they put all the songs together to mold the album medley. "The End" passed the test, even if the song was unfinished and required vocals. Paul double-tracked the song's first vocal, backed by John and George on backing vocals on August 5. On August 7, they overdubbed the choruses—the *love you*'s—over the instrumental part just after Ringo's drum solo. Apparently, some of these choruses were recorded at slow speed to acquire a higher pitch at normal speed. Then they recorded dual guitars. Originally, the long guitar solo started just after Ringo's solo. It was shortened for the final version to leave only the drum solo without any accompaniment. The following day, Paul added bass and Ringo added drums.

Ringo, Paul, John, and George on the steps of Abbey Road. The end was coming soon.

On August 15, George Martin conducted the orchestra in Studio One for his orchestral arrangements (see also "Golden Slumbers," "Carry That Weight," "Something," and "Here Comes the Sun").

On August 18, the session was devoted to stereo mixes, and Paul overdubbed a very brief piano track preceding his wonderfully philosophical line *And in the end / The love you take / Is equal to the love you make.* New mixes were done on August 19 and 21. However, Phil McDonald had to re-edit in Room 4 the orchestral part of the previous day because of some numbering confusions between orchestra and playback, including the final chord. The final mix was still not done. In the control room, they decided to extend the instrumental part immediately following Ringo's solo so that the whole piece would be lighter. To that effect, McDonald and Emerick remixed a number of bars without guitar chorus and inserted the result at the desired location. These lengthy instrumental and vocal parts increased the length form 2:05 to 2:41. Four days later, on August 25, the team re-edited the song and brought it back down again to 2:05. The song was then completed and inserted into the finished master.

Technical Details

"The End" is the only Beatles song where Ringo's drums were recorded in stereo. Even when Glyn Johns used two tracks on *Get Back*, one track was reserved for the bass drum and the second track for other elements. Geoff Emerick recorded "The End" using two stereo tracks only. Another technical detail about Ringo's drum sound, "just a personal thing of mine," as he himself said: "The drum sound on the record was the result of having new calf-heads. (And we know that Paul refused to use any animal products!) There's a lot of tom-tom work on that record. I got the new heads on the drum and I naturally used them a lot—they were so great. The magic of real records is that they *showed* tom-toms were so good."[7]

1. *The Beatles Anthology.*
2. Emerick, *Here, There and Everywhere.*
3. Ibid.
4. Emerick, *Here, There and Everywhere.*
5. Miles, *Paul McCartney.*
6. Sheff, *The Playboy Interview with John Lennon & Yoko Ono.*
7. *The Beatles Anthology.*

Her Majesty

Lennon-McCartney / 0:23

SONGWRITER
Paul

MUSICIAN
Paul: vocal, guitar

RECORDED
Abbey Road: July 2, 1969 (Studio Two)

NUMBER OF TAKES: 3

MIXING
Abbey Road: July 2 and 30, 1969 (Studio Two)

TECHNICAL TEAM
Producer: George Martin
Sound Engineer: Phil McDonald
Assistant Engineer: Chris Blair

FOR BEATLES FANATICS

On the original jacket of *Abbey Road*, "Her Majesty" was not mentioned to make the song a hidden bonus, although it is listed on the B-side label for the record. This was corrected, alas, on the CD version.

Genesis

The 0:23 "Her Majesty" has the dual distinction of being the shortest Beatles song and the dubious honor of being the last song on the last record, even though its placement was not intentional. In fact, the song was originally placed between "Mean Mr. Mustard" and "Polythene Pam." The sequence of songs was as follows: "You Never Give Me Your Money," "Sun King / Mean Mr. Mustard," "Her Majesty," "Polythene Pam / She Came In Through the Bathroom Window," "Golden Slumbers / Carry That Weight," and "The End." But on July 30, when the Beatles were together in the control room of Studio Two, to listen to how the songs fit together and detect any faults in the first version of "The Long One / Huge Melody" (the working title of the medley), Paul, on hearing "Her Majesty," asked John Kurlander, assistant engineer, to eliminate the song. He cut it awkwardly, one beat too early, on the last crashing note of "Mean Mr. Mustard." Kurlander tried to fix the mistake, when Paul stopped him: "Never mind, it's only a rough mix, it doesn't matter. 'What shall I do with it?' Throw it away."[1] But EMI had strict rules about never throwing anything away. After Paul left, Kurlander, following normal studio practice, picked it up off the floor, put about twenty seconds of red leader tape before it, and stuck it onto the end of the edit tape. Red leader tape was used to mark the end of a song. The following day, at the request of the group, his colleague Malcolm Davis made an acetate of the medley, but ignored the warning left by Kurlander on the box that "Her Majesty" was unwanted. Respecting the rule to never throw anything away, he included "Her Majesty" at the end after twenty seconds of silence. When Paul listened to the acetate, he liked hearing "Her Majesty" in its new

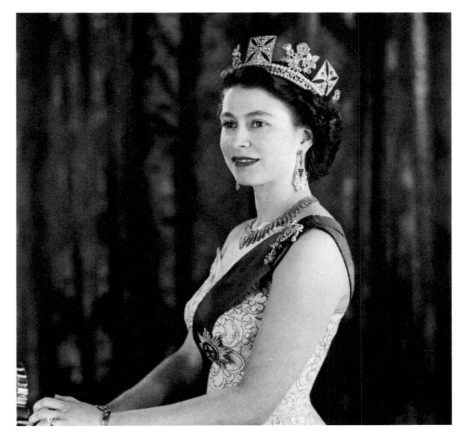

"Her Majesty" was Paul's tribute to Queen Elizabeth II.

position. It came as a nice surprise, and he decided to keep the song as a "hidden bonus" with the same twenty-second silence preceding it and the decaying chord with which it opens, which was actually the original final chord of "Mean Mr. Mustard." The long silence varies in length depending on the CD version.

Production

On July 2, Paul arrived first at the studio. He decided to record another of his short compositions before the arrival of George and Ringo. John was still recovering from his car accident. Paul said to David Wiggs in 1969, "I was in Scotland and I was just writing this little tune, you know. I can never tell, like, how tunes come out. I just wrote it as a joke, you know."[2] Paul wrote this little song in honor of Queen Elizabeth II, just before John returned his Medal of the British Empire (MBE) to the Queen in protest against the Vietnam War, the British involvement in Nigeria, and the fact that the Plastic Ono Band's first single, "Cold Turkey," did not climb in the charts (Lennon's idea of a joke!). Paul said, "It was quite funny because it's basically monarchist, with a mildly disrespectful tone, but it's very tongue in cheek. It's almost like a love song to the Queen."[3]

Just three takes, only two of which were complete, were necessary to record the song. The third, recorded live using just two eight-track tape recorders, was the best. The song had the shortest recording time of any Beatles song—another record. After hearing the song, Paul decided to keep it and "Her Majesty" joined the list of songs under consideration for the medley.

Technical Details

"Her Majesty" begins with the final chord of "Mean Mr. Mustard," but ends without a chord, just a note without resolution. As Geoff Emerick explained, it was Paul who made this decision, probably to balance the song: "Since 'Her Majesty' was starting with the last note of 'Mean Mr. Mustard,' she might as well not have a last note of her own."[4] More fun details: Both sides of the album end abruptly, "I Want You (She's So Heavy)" on side 1, "Her Majesty" on side 2. The last chord of "Her Majesty" is still at the beginning of "Polythene Pam," left from an early arrangement of the song, which originally followed "Her Majesty" in the "Huge Medley."

1. Lewisohn, *The Complete Beatles Recording Sessions*.
2. Wigg, *The Beatles Tapes from the David Wigg Interviews*.
3. Miles, *Paul McCartney*.
4. Emerick, *Here, There and Everywhere*.

1969

Don't Let Me Down

(Side B of "Get Back")

SINGLE
RELEASED

"Get Back" / "Don't Let Me Down"
Great Britain: April 11, 1969 /
No. 1 on April 23, 1969, for 6 weeks
United States: May 5, 1969 /
No. 1 on May 24, 1969, for 5 weeks

Don't Let Me Down

Lennon-McCartney / 3:33

SONGWRITER
John

MUSICIANS
John: vocal, rhythm guitar
Paul: bass, backing vocal
George: lead guitar
Ringo: drums
Billy Preston: electric piano

RECORDED
Abbey Road: January 22, 28, and 30, 1969

NUMBER OF TAKES: UNKNOWN

MIXING
Abbey Road: February 5, 1969 (Studio ?)
Olympic Sound Studios: March 4, 1969 / April 4 and 7, 1969

TECHNICAL TEAM
Producers: George Martin, Phil Spector
Sound Engineers: Glyn Johns, Jeff Jarratt
Assistant Engineer: Alan Parsons

Genesis

Early in 1969, John was going through a difficult period in his life. He clung to a double addiction—heroin and Yoko. His passion for his Japanese wife governed his daily routine and affected his relationships with others. Other members of the group communicated with a two-headed John, who referred to himself as "Johnandyoko." He answered David Sheff's question about "Don't Let Me Down" in 1980: "That's me, singing about Yoko."[1] John knew that he was committed to his relationship without compromise and that he was sacrificing the Beatles to it. Paul: "It was saying to Yoko, 'I am really letting my vulnerability be seen, so you must not let me down.' I think it was a genuine cry for help."[2] If "Don't Let Me Down" is beautiful proof of his love for Yoko, it was rather cruel to Cynthia, his former wife, because John said with Yoko he was in love for the first time. The song was originally intended for the *Get Back* project, before Phil Spector pulled it from the *Let It Be* album. It was released as the B-side of the single "Get Back." This great song deserved better.

Production

"Don't Let Me Down" was among the first songs recorded at the Apple Studio in Savile Row. The first day, January 22, was more like a rehearsal than a recording session. The Beatles tried to get comfortable in the new surroundings, and Billy Preston played keyboard with them for the first time. John exhorted Ringo "to give him a good crash on the cymbals to 'give me the courage to come screaming in.'"[3] The song was permanently recorded on January 28. John, on rhythm guitar, delivered a magnificent lead vocal. Paul was on bass and backing vocal, and George provided

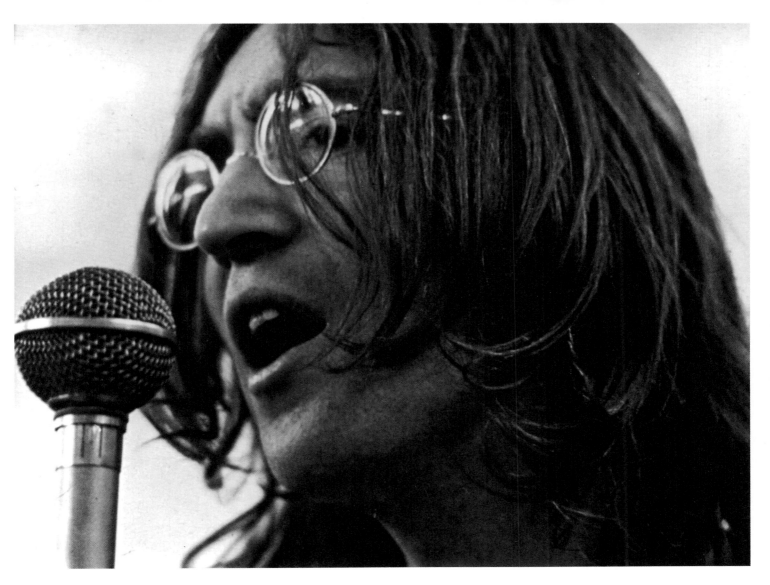

John Lennon singing "Don't Let Me Down," a superb tune, but dark, born of his dual dependency—on Yoko Ono and on heroin.

an excellent accompaniment to the lead guitar (with a strong vibrato). Ringo played drums, and Billy Preston accompanied the three Beatles remarkably. His electric piano playing gave the piece cohesion, and its "soul" flavor gave the song its special style. The song was not as simple as it might seem, and a cohesive ensemble was necessary to bring it to life. For weeks the Beatles had been in the studio without any enthusiasm, and suddenly they rediscovered their unity and their magic in this song. Stereo and mono mixes were made on April 7 at Olympic Sound Studios.

FOR BEATLES FANATICS

At 1:43, just after *It's a love that has no past*, John utters a few inaudible words. These are perhaps *Believe it, Good evening, It's an infinite*, or, most likely, *It's in E flat*. Except that the piece is in E major!

1. Sheff, *The Playboy Interview with John Lennon & Yoko Ono.*
2. Miles, *Paul McCartney.*
3. Lewisohn, *The Complete Beatles Recording Sessions.*

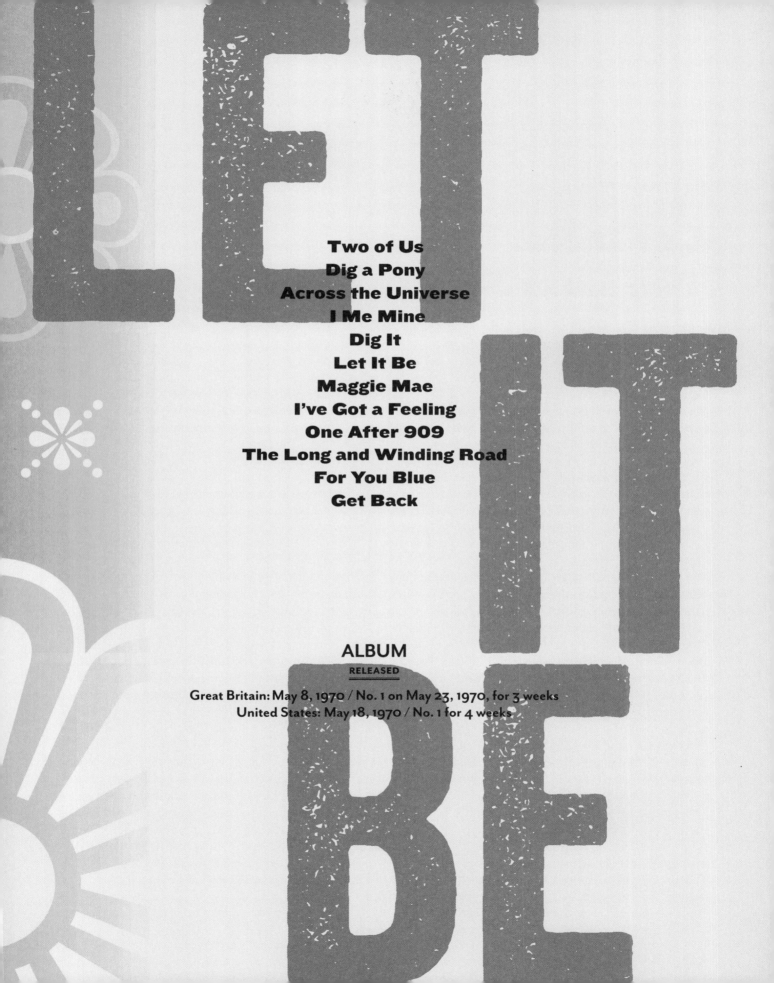

Two of Us
Dig a Pony
Across the Universe
I Me Mine
Dig It
Let It Be
Maggie Mae
I've Got a Feeling
One After 909
The Long and Winding Road
For You Blue
Get Back

ALBUM

RELEASED

Great Britain: May 8, 1970 / No. 1 on May 23, 1970, for 3 weeks
United States: May 18, 1970 / No. 1 for 4 weeks

Let It Be:
The Last Studio Album

After recording the *White Album*, the Beatles' cohesion was threatened. John was with Yoko, who was with John all the time, and John was addicted to heroin. George was involved in the production of other Apple artists, and Ringo was considering film projects. Paul, the driving force for unity, assumed the role of leader. He suggested that the Beatles go back out on the road. In Paul's view, touring was a way to bring the group together, as it had in the past. George and John vehemently opposed the idea. A compromise was reached: making a one-hour television show. They favored the Roundhouse Theatre in North London, and recruited director Michael Lindsay-Hogg, who then suggested an even more grandiose project: playing live in a Roman amphitheater in Tripoli! They eventually ended up at Twickenham Film Studios in Middlesex from January 2 to 17, 1969, where they had filmed *A Hard Day's Night* and *Help!*

The project, called *Get Back*, was well defined: they wanted to record a new album live in front of the cameras—no sound effects, no overdubs. In other words, an absolute return to basics. It was John's idea not to use any of the studio "tricks" they had used in the past. Glyn Johns was hired as a sound engineer. He had worked with celebrities like the Stones and other major groups, including the Who, the Kinks, and the Small Faces. On January 2, the camera crew filmed the Beatles rehearsing all day. John: "It was just a dreadful, dreadful feeling [in Twickenham Studio] and, being filmed all the time, I just wanted them to go away. We'd be there at eight in the morning and you couldn't make music at eight in the morning, or ten, or whenever it was, in a strange place with people filming you, and colored lights."[1] The atmosphere was tense and the Beatles were under tremendous pressure. A famous altercation between Paul and George took place while the cameras rolled. George became irritated after Paul suggested changes

to his guitar solo and walked out just as Ringo had done five months earlier during the recording sessions for the *White Album*. George returned on the insistence of his three bandmates, but George imposed conditions, including no more TV shows or concerts. They all agreed.

After two weeks of rehearsals at cold, drafty Twickenham, the Beatles decided to continue the project at Apple's headquarters, 3 Savile Row, in the heart of London's posh Mayfair district. Ringo said, "Twickenham just wasn't really conducive to any great atmosphere."[2] They were seeking a more comfortable and warmer place to work.

In July 1968, they asked their friend, Alexis Mardas, nicknamed "Magic Alex," to build them a studio in the basement of Apple. A mediocre inventor but a brilliant con artist, Alex told them he was going to build a revolutionary studio with a seventy-two-track facility instead of the eight-track tape recorder used at Abbey Road. "Magic Alex" won over the entire group, especially John. When they moved to Apple on January 20, they discovered that nothing was ready and Madras had been telling tales. Martin quickly ordered two mobile consoles and a 3M eight-track from EMI studios. Recording began on January 22. That same day, Harrison asked keyboard player Billy Preston to join the Beatles to help alleviate the tension in the group. They knew Preston from their early years in Hamburg when he had toured as part of Little Richard's band. With the addition of Preston, the Beatles began to perform like a cohesive band again. Finally on January 30, based on John's suggestion, according to Preston, they went to the rooftop of Apple's building in order to resolve the live concert idea and bring a conclusion to the film. The music from the rooftop created quite

1. *The Beatles Anthology.*
2. Ibid.

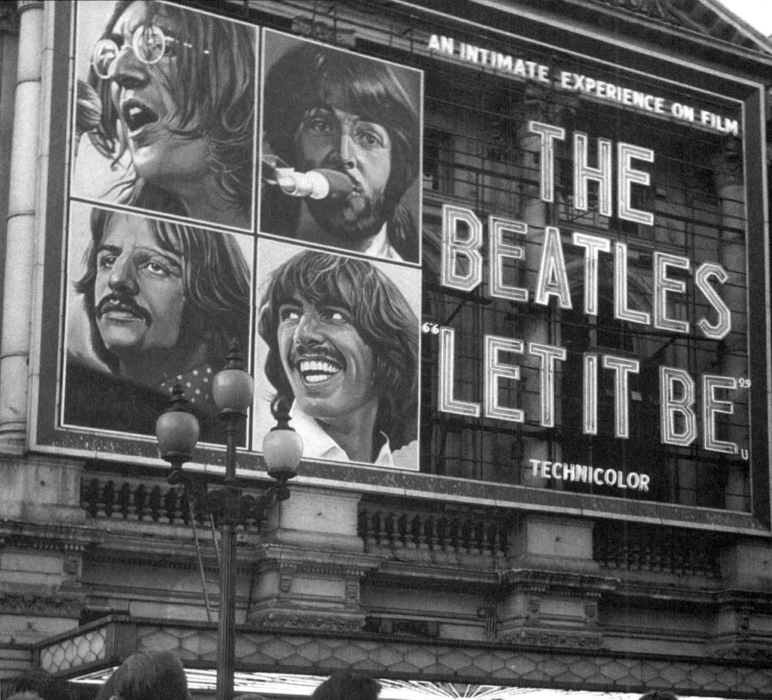

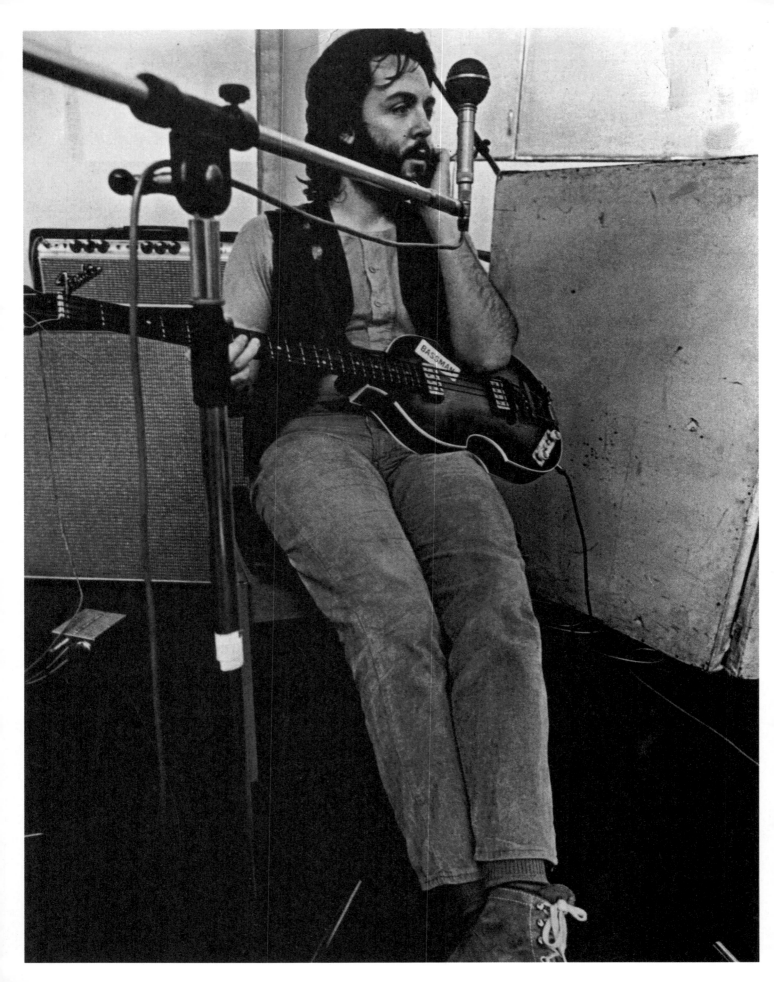

Opposite: Paul McCartney with his legendary Hofner.
Above: The Fender Rosewood Telecaster, used by George for the recording sessions of *Let It Be*.

WARNING

Recording session dates and the particular mixes for each song might not be accurate. Recording sheets from Apple are not as detailed as those at Abbey Road.

a stir in the offices and streets around the building. People gathered in the street, surprised to hear the music. By the time the police interrupted their performance, the Beatles had taped only five songs. It was the very last live concert of their career. Out of ninety hours of recording, including the rooftop performance, Glyn Johns selected several songs to create the *Get Back* album. It had a raw sound, with no studio trickery, corresponding to their initial vision. Paul liked it, but his bandmates didn't. The mixes remained shelved for several months until Allen Klein, the Beatles' new manager as of February 3, 1969, asked Phil Spector, architect of the Wall of Sound, to work on what would become *Let It Be*. In Paul's eyes, Specter committed a crime by adding over-the-top arrangements to songs like "Let It Be" and "The Long and Winding Road." Paul tried to oppose the release of the album,

renamed *Let It Be*, but in vain. On April 10, 1970, Paul McCartney publicly announced his departure from the group. This was the end of the Beatles.

In November 2003, a new version was released with the name *Let It Be . . . Naked*, closer to the original version without tricks, sound effects, or Specter's arrangements.

The Film

Let It Be showed the Beatles breaking up, disenchanted, their magic lost. Long camera sequences revealing these four musicians alternating between original songs, older songs, and covers, joking, chatting, arguing, and being annoyed are rather disappointing. Clearly, the Beatles were not at their best, shut up inside an icy Twickenham studio with the ever-present Yoko Ono. Fortunately, they recaptured some of their old magic with their extraordinary concert on the rooftop of the Apple building. *Let It Be* is still a valuable documentary, a moving film about the end of one of the most influential groups in the history of rock music.

The Instruments

In addition to the instruments used for previous albums, the Beatles used new instruments for *Let It Be*. George played an extraordinary Rosewood Telecaster prototype he had received from Fender. John used a "lap-steel" Hofner Hawaiian Standard to play slide guitar (on "For You Blue"); Paul played a Blüthner piano, and Ringo played on a Ludwig Hollywood maple-finish drum kit. A Fender Rhodes electric piano also appeared during the recording sessions.

Two Of Us

Lennon-McCartney / 3:34

SONGWRITER
Paul

MUSICIANS
Paul: vocal, acoustic guitar
John: vocal, acoustic guitar
George: lead guitar
Ringo: drums

RECORDED
Apple Studios: January 24–25 and 31, 1969

NUMBER OF TAKES: UNKNOWN

MIXING
Olympic Sound Studios: March 10, 1969
Abbey Road: April 25, 1969 (Room 4) / March 25, 1970 (Room 4)

TECHNICAL TEAM
Producers: George Martin, Phil Spector
Sound Engineers: Glyn Johns, Peter Bown
Assistant Engineers: Neil Richmond, Alan Parsons, Roger Ferris

Genesis

Paul wrote this gentle acoustic ballad, under the title "On Our Way Home," while he was with Linda Eastman. (In John's interview with David Sheff, John curiously said "Mine" about the authorship of "Two of Us.") As soon as she entered his life at the end of 1968, she pushed him to go on an adventure in the English countryside. They put Martha, Paul's Old English Sheepdog, in the back of their Aston Martin and drove off without looking at any signs, trying to get lost. Paul: "We'd just enjoy sitting out in nature. And this song was about that: doing nothing, trying to get lost. It's a favorite of mine because it reminds me of that period, getting together with Linda, and the wonderfully free attitude we were able to have."[1] Linda photographed Paul composing "Two of Us." "I had my guitar with me and I wrote it out on the road, and then maybe finished some of the verses at home later, but that picture is of my writing it."[2]

During a working session at Twickenham on January 10, 1969, George and Paul had an argument and George left the group. The altercation was recorded and filmed live by camera crews. Paul: "It's complicated now. We can get it simpler, and then complicate it where it needs complications." George: "It's not complicated." Paul: "This one is like, shall we play guitars through 'Hey Jude' . . . well, I don't think we should." George: "OK, well I don't mind. I'll play, you know, whatever you want me to play, or I won't play at all if you don't want me to play. Whatever it is that will please you, I'll do it."

Paul met Linda Eastman late in 1968. "Two of Us" was composed for her.

Production

In early performances of "Two of Us" the Beatles used electric guitars with a fast tempo. Unsatisfied with this style, they reworked the song on acoustic guitar. They developed the song at Twickenham, giving it a folk style on January 24 and 25 at the Apple studios, where they had just started working two days earlier. However, it was only on January 31, after the legendary concert on the rooftop, that the final version was recorded. Paul and John are both on their acoustic guitars and vocals just as the Everly Brothers had done. George played his rosewood Telecaster, while Ringo played bass drum. On March 25, 1970, Phil Spector made the final mix with some changes to the song. During the mixing session, Specter added an excerpt of film dialogue before the song.

FOR BEATLES FANATICS

When George walked out on January 10, 1969, he composed "Wah Wah" to clear his head. The song is included on his triple solo album *All Things Must Pass*, released in 1970.

1. Miles, *Paul McCartney.*
2. Ibid.

Dig A Pony

Lennon-McCartney / 3:53

SONGWRITER
John

MUSICIANS
John: vocal, rhythm guitar
Paul: bass, backing vocal
George: lead guitar
Ringo: drums
Billy Preston: electric piano

RECORDED
Apple Studios: January 22, 24, 28, and 30, 1969

NUMBER OF TAKES: UNKNOWN

MIXING
Apple Studios: February 5, 1969
Olympic Sound Studios: March 10, 1969
Abbey Road: March 23, 1970 (Room 4)

TECHNICAL TEAM
Producers: George Martin, Phil Spector
Sound Engineers: Glyn Johns, Peter Bown
Assistant Engineers: Neil Richmond, Alan Parsons, Roger Ferris

FOR BEATLES FANATICS

In the documentary *Imagine*, John discussed a slightly disturbed hippie who believed the lyrics to "Dig a Pony" and "Carry That Weight" (from *Abbey Road*) were addressed to him.

Genesis

"Dig a Pony" was one of John's last songs with nonsense lyrics, phrases strung together in what he referred to as a Bob Dylan style. In the film *Imagine*, he said, "I was just having fun with words. It was literally a nonsense song. You just take words and you stick them together, and you see if they have any meaning. Some of them do and some of them don't."

He took pieces of several songs to make one, and the lyrics were completed in the studio. The song was influenced by Ono and the chorus reflects his love to her: *All I want is you*. The chorus constituted the only meaningful part of the song. He inserted some references like *I pick a moondog*, referring to Johnny and the Moondogs, one of the early names for the Beatles. John had perfectly mastered the art of giving meaning to meaningless words. He teased the audience with an endless string of references. In 1980, John commented on his song as "another piece of garbage."[1]

Production

On January 22, the Beatles recorded for the first time in their new studio on Savile Row. They worked on several titles, including, "Dig a Pony," then under the working title "All I Want Is You." Two days later, several takes of *Get Back* were recorded. On January 28, they recorded additional takes and, during the lunch break, they discussed how to best play the song. It was not until January 30, during the famous concert on the rooftop, that they recorded the final version. After a false start, the performance of each of the Beatles was perfect, amazing because the song was difficult to play live. The Beatles enjoyed the technical challenge, and despite the freezing temperature, they succeeded admirably in recording it. The performance ended with John

John with his stripped-wood Epiphone Casino.

saying, "Thank you, brothers. . . Hands getting too cold to play the chords." Billy Preston was at the keyboard, John sang and simultaneously played rhythm guitar, Paul sang backing vocals and played bass, George was on lead guitar on his sublime Telecaster (he assumed a rock 'n' roll stance by kneeling at John's feet, laughing), and Ringo was on drums. At the beginning, we can hear Ringo shouting, "Hold it!" to stop his bandmates because he was still holding a cigarette. Based on the performance, it was clear that the Beatles enjoyed playing the song. Glyn Johns recorded the performance live from the studio in the basement of the building on the 3M eight-track machine. Phil Spector mixed the track on March 23 and deleted the phrase *All I want is you*, which was at the beginning and at the end of the song.

1. Sheff, *The Playboy Interview with John Lennon & Yoko Ono.*

Across The Universe

Lennon-McCartney / 3:45

SONGWRITER
John

MUSICIANS
John: vocal, guitar
Paul: bass, piano, backing vocal
George: tambura, sitar, maracas, backing vocal
Ringo: drums
Lizzie Bravo, Gayleen Pease: backing vocals
Orchestra: 18 violins, 4 violas, 4 cellos, 1 harp, 3 trumpets, 3 trombones, 2 acoustic guitars, 14 female vocalists

RECORDED
Abbey Road: February 4, 1968 (Studio Three), February 8, 1968 (Studio Two) / April 1, 1970 (Studios One and Three)

NUMBER OF TAKES: 9

MIXING
Abbey Road: February 8, 1968 (Studio Two) / October 2, 1969 (Room 4) / March 23, 1970 (Room 4) / April 2, 1970 (Room 4)
Olympic Sound Studios: January 5, 1970 (Studio One)

TECHNICAL TEAM
Producers: George Martin, Phil Spector
Sound Engineers: Martin Benge, Geoff Emerick, Ken Scott, Jeff Jarratt, Glyn Johns, Peter Bown
Assistant Engineers: Phil McDonald, Richard Lush, Alan Parsons, Roger Ferris

1. Barry Wigmore, "'Send my love to aliens,' says McCartney as Beatles tune is first to be beamed into space," *Mail Online* (February 6, 2008), http://www.dailymail.co.uk/news/article-511736/Send-love-aliens-says-Mc-Cartney-Beatles-tune-beamed-space.html.
2. Shotton and Schaffner, *John Lennon in My Life.*
3. Sheff, *The Playboy Interview with John Lennon & Yoko Ono.*
4. Lewisohn, *The Complete Beatles Recording Sessions.*
5. Emerick, *Here, There and Everywhere.*

Genesis

"Across the Universe" was not written in Rishikesh, as Barry Miles claimed in *Paul McCartney: Many Years From Now.* The first recording sessions for the song started on February 4, 1968, eleven days before John flew to Madras. The link to the chorus, *Jai guru deva om*, a Sanskrit phrase meaning "Victory to God Divine," is misleading. John was inspired by Maharishi Mahesh Yogi, whom he had discovered the previous year. Pete Shotton, John's close friend, commented that the song had "perhaps the most eloquent testament to John's feelings about [transcendental mediation]."[2] Paul confirmed that Lennon had borrowed the change-the-world theme from the Maharishi's philosophy.

The words come to John unexpectedly. He was lying in bed next to Cynthia, his first wife, and thinking about her reproach. "I was lying next to my first wife in bed, you know, and I was irritated. She must have been going on and on about something and she'd gone to sleep and I'd kept hearing these words over and over, flowing like an endless stream. I went downstairs and it turned into sort of a cosmic song rather than an irritated song; rather than a 'Why are you always mouthing off at me?' or whatever, right?" Fortunately, "The words stand, luckily, by themselves. They were purely inspirational and were given to me as *boom*! I don't own it, you know; it came through like that."[3] John regretted that the Beatles did not spend more time on the song. He even accused Paul of having more or less subconsciously sabotaged the song. He was disappointed with the recording sessions in February 1968 and gave the song to the World Wildlife Fund (WWF) of Great Britain for a charity drive on December 12, 1969. Later, in March 1970, Phil Spector revived "Across the Universe" and released it as part of the *Let It Be* album.

John and Yoko were never apart, even during the Beatles' recording sessions.

Production

When John recorded "Across the Universe" for the first time on February 4, 1968, he did not know "how to capture on tape the sounds he was hearing in his head."[4] The first take was the rhythm track, John on acoustic guitar, George on tambura, and Ringo on tom-toms, all three instruments fed through a revolving Leslie organ speaker and subjected to flanging. Then John recorded his lead vocal and added another guitar, and George created a splendid sitar intro, which Ken Scott enhanced by flanging. After a second vocal take, with the tape recorder running slightly slowly for faster playback, John and Paul suddenly came upon the idea of recording falsetto harmonies. However, finding vocalists on a Sunday without prior arrangements was not easy, even for the Beatles. Paul came up with a solution by simply stepping outside the studio to recruit two girls from among the fans who stood out front. The two lucky girls were Lizzie Bravo, a sixteen-year-old from Brazil, temporarily living in London, and Gayleen Pease, seventeen, a Londoner. After their performance, backwards bass and drum tracks were recorded and then erased, and various sound effects, including some humming, were added and similarly deleted. On

February 8, Geoff Emerick, absent during the previous session, found the performance superb: "He put so much feeling into the song, and his vocal was just incredible."[5] But John hesitated. He was still unsure what the song needed in the way of instruments. George Martin played an organ and John added a Mellotron piece, both were immediately erased and replaced by a tone wah-wah pedal guitar (John), piano (Paul), and maracas (George). John finally recorded several vocals, encouraged by his bandmates. In vain! Frustrated, he decided to shelve the song. Later, he offered the song to the comedian Spike Milligan for use on a charity album for the World Wildlife Fund, *No One's Gonna Change Our World*, compiled on October 3, 1969, by George Martin, who, at the last minute, added some bird sounds from Abbey Road's sound effects library at the beginning and end. The song was sped up slightly (see *Past Masters 2*). Two years later, on April 1, 1970, Phil Spector expanded the version of February 8, 1968, by adding an orchestra of strings, brass, and female vocalists. The speed of John's vocal was slowed by nearly a semitone, and the final mix was made on April 2. "Across the Universe" never did find its proper form. It remains one of the Beatles' few failures.

I Me Mine

George Harrison / 2:25

MUSICIANS
George: vocal, guitar
Paul: bass, acoustic guitar, organ, electric piano, backing vocal
Ringo: drums
Orchestra: 18 violins, 4 violas, 4 cellos, 1 harp, 3 trumpets, 3 trombones, 2 acoustic guitars

RECORDED
Abbey Road: January 3, 1970 (Studio Two) / April 1, 1970 (Studios One and Three)

NUMBER OF TAKES: 18

MIXING
Olympic Sound Studios: January 5, 1970 (Studio One)
Abbey Road: March 23, 1970 (Room 4) / April 1, 1970 (Studios One and Three) / April 2, 1970 (Room 4)

TECHNICAL TEAM
Producers: George Martin, Phil Spector
Sound Engineers: Phil McDonald, Glyn Johns, Peter Bown
Assistant Engineers: Richard Lush, Richard Langham, Roger Ferris

FOR BEATLES FANATICS

When Phil Spector decided to extend the song, he copied the part between 0:31 and the end of the song (January 3 version), and inserted it at 1:20.

Genesis

George composed "I Me Mine" in five minutes in January 1969. He played it for Ringo during the film *Let It Be*. Both John and Paul had little interest in the song. John, who did not participate, preferred to waltz with Yoko while his bandmates rehearsed. However, "I Me Mine" is a beautiful song, melodious and subtle. George was inspired once again by Indian teachings and denounces *everyone's* selfishness. He explained, "After having LSD, I looked around and everything I could see was relative to my ego, like 'that's my piece of paper' and 'that's my flannel' or 'give it to me' or 'I am.' It drove me crackers, I hated everything about my ego."[1] George was looking for truth, and asked himself, "Who am I? The truth within us has to be realized: when you realize that everything else that you see and do and touch and smell isn't real, then you may know what reality is and can answer 'who am I?'"[2]

Production

The short sequence of "I Me Mine" in the film *Let It Be* was not taped during the *Get Back* project in January 1969. Consequently, the Beatles needed to record the song. On January 3, 1970, Paul, Ringo, and George returned to the studio to work on the still unreleased *Get Back* album. John was vacationing in Denmark with Yoko, her ex-husband Anthony Cox, and their daughter Kyoko since December 29. George made fun of his absence just before launching into take 15: "You will all have read that Dave Dee is no longer with us. Micky and Tich and I would just like to carry on the good work that's always gone down in number two!"[3] (*Number two* refers to Studio Two at EMI.) (See *Anthology 3*.) "I Me Mine" was the last

George Harrison's song "I Me Mine" was recorded while John was vacationing in Denmark. Above: Phil Spector coproduced the song with George Martin. Here they both are in 1970, during the recording of George's triple album, *All Things Must Pass*.

new song the Beatles recorded. Take 16 was the best rhythm track: George was singing a guide vocal and playing acoustic guitar, Paul was on bass, connected directly to the console (via a DI box), and Ringo was on drums. Overdubs were recorded at the completion of the basic rhythm track, George played electric guitar, and Paul the Hammond organ. George recorded his lead vocal, which he double-tracked in the last verse, and all provided backing on the bridges. After additional instruments were added—electric piano and lead guitar—Paul and George each played acoustic guitar in unison. The song was supposed to be completed at this stage, which was 1:34, but Phil Spector

re-edited it on April 1. The final total time was 2:25. On this new master, he recorded strings and brass, arranged by Richard Hewson. Unlike the arrangement for "The Long and Winding Road," this arrangement is not so pompous and George did not complain. The following day, Spector made the stereo mix.

1. *The Beatles Anthology*.
2. Harrison, *I Me Mine*.
3. Lewisohn, *The Complete Beatles Recording Sessions*.

A group composition, "Dig It" referred to Dylan, B. B. King, and Matt Busby, manager of the Manchester United soccer club. John and George rehearsing.

Dig It

Harrison-Lennon-McCartney-Starkey / 0:50

SONGWRITER
John

MUSICIANS
John: vocal, bass
Paul: piano
George: lead guitar
Ringo: drums
Billy Preston: organ
George Martin: shaker

RECORDED
Abbey Road: January 24 and 26, 1969

NUMBER OF TAKES: UNKNOWN

MIXING
Olympic Sound Studios: March 4 and 13, 1969
Abbey Road: March 27, 1970 (Room 4)

TECHNICAL TEAM
Producers: George Martin, Phil Spector
Sound Engineers: Glyn Johns, Mike Sheady
Assistant Engineers: Neil Richmond, Roger Ferris

FOR BEATLES FANATICS

The improvisation from which this song originates began as a genuine cover of "Like a Rolling Stone" before changing into "Dig It." Spector might not have had much choice in extracting a short sequence for the song: the first six minutes of the track featured six-year-old Heather, Linda's daughter, on backing vocal!

Genesis

In the official Beatles' discography, "Dig It" was the second all-group composition coming after *Magical Mystery Tour*'s "Flying." John wrote and improvised "Dig It" during two studio jams. Based upon a sequence of I-IV-V chords, the jam was an excuse to free-associate a series of mostly nonsensical lyrics. All the Beatles contributed to the lyrics and the song was credited to all of them. After a reference to Dylan's "Like A Rolling Stone," all four threw in names: FBI, CIA, BBC, the bluesman B. B. King, actress Doris Day, and Matt Busby, manager of Manchester United, one of the best soccer clubs in the England.

Production

John led his bandmates through two recorded versions of his song "Dig It." The first version was recorded on January 24. It featured simple lyrics, *Can you dig it, yeah?* The arrangement was more bluesy, including a predominant slide guitar. The second version, recorded on January 26, was 12:25. A tiny 0:49 fragment of this take appeared on *Let It Be*. John played a Fender six-string bass and sang lead vocal. Paul was on piano, George on lead guitar, Ringo on drums, and Preston on organ, while George Martin furiously shook a shaker, as can be seen in the movie. Apparently, the atmosphere was happy and relaxed. Phil Spector mixed the piece on March 27, 1970. On the *Let It Be* album, the segment between 8:52 and 9:41 was used for the song. At the end, Spector inserted a funny comment, John sarcastically saying, *And now we'd like to do "Hark, the Angels Come."*

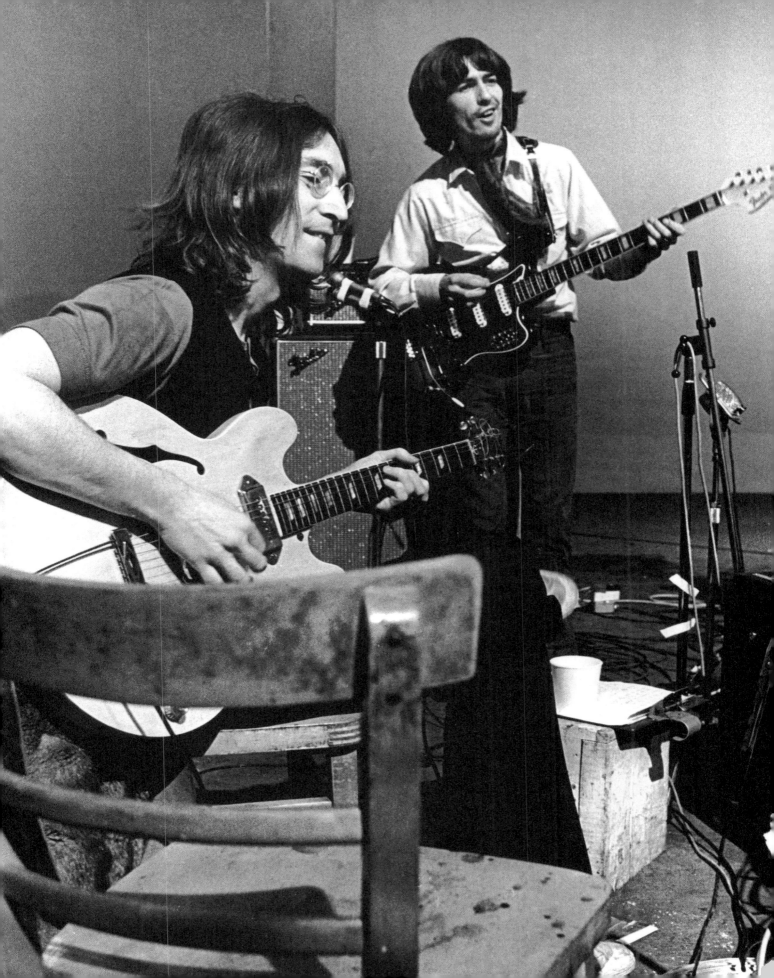

One of the most famous stills from the movie produced by Michael Lindsay-Hogg shows the Beatles and Yoko in the studio listening to "Let It Be."

FOR BEATLES FANATICS

At 2:58, Paul plays the wrong chord on the piano, but fixes it right away.

Let It Be

Lennon-McCartney / 4:02 (album version) / 3:49 (single version)

SONGWRITER
Paul

MUSICIANS
Paul: vocal, piano, bass, maracas
John: bass, backing vocal
George: lead guitar, backing vocal
Ringo: drums
Billy Preston: organ, electric piano
Linda McCartney, Mary Hopkin (?): backing vocal
Unknown musicians: 2 trumpets, 2 trombones, 1 tenor saxophone, cellos

RECORDED
Apple Studios: January 25–26 and 31, 1969
Abbey Road: April 30, 1969 (Studio Three) / January 4, 1970 (Room 4)

NUMBER OF TAKES: 30

MIXING
Olympic Sound Studios: March 4, 1969 / January 8, 1970
Abbey Road: January 4, 1970 (Studio Two) / March 26, 1970 (Room 4)

TECHNICAL TEAM
Producers: George Martin, Chris Thomas, Phil Spector
Sound Engineers: Glyn Johns, Jeff Jarratt, Phil McDonald, Peter Bown
Assistant Engineers: Alan Parsons, Neil Richmond, Nick Webb, Richard Langham, Roger Ferris

RELEASED AS A SINGLE

"Let It Be" / "You Know My Name (Look Up the Number)"
Great Britain: March 6, 1970 / No. 2 on March 14, 1970, for 9 weeks
United States: March 6, 1970 / No. 1 on April 11, 1970, for 2 weeks

Genesis

"Let It Be" is one of the best-known Beatles songs and one of the prettiest composed by Paul. As with "Yesterday," he was inspired by a dream. One night during this tense time in the Beatles' history, Paul dreamt of his mother Marie. She had died on October 31, 1956, from cancer. "It was so wonderful for me and she was very reassuring. In the dream she said, 'It'll be all right.' I'm not sure if she used the words 'Let it be' but that was the gist of her advice, it was, 'Don't worry too much, it will turn out okay.'"[1]

Despite his irrepressible optimism, Paul doubted his mother's assurances. Dissension and a troubled atmosphere reigned within the group; his relationship with John was beginning to crumble; Yoko was everywhere and there were problems with Apple. He felt he was losing control of the situation. He later summarized these feelings in the song "Carry That Weight" on *Abbey Road: Boy, you're gonna carry that weight / Carry that weight a long time.*

Even though it was not conceived as such, for many people "Let It Be" became a spiritual song. Its musical arrangement emphasizes the text: "Mother Mary makes it a quasi-religious thing, so you can take it that way. I don't mind. I'm quite happy if people want to use it to shore up their faith. I have no problem with that."[2]

John felt little affection for the song. In 1980, he said to David Sheff, "That's Paul. What can you say? Nothing to do with the Beatles. It could've been Wings. I don't know what he's thinking when he writes 'Let It

1. Miles, *Paul McCartney*.
2. Ibid.
3. Sheff, *The Playboy Interview with John Lennon & Yoko Ono*.
4. Lewisohn, *The Complete Beatles Recording Sessions*.
5. Ibid.

Ringo Starr played a superb drum part on "Let It Be."

Be.' I think it was inspired by 'Bridge Over Troubled Waters [sic].' That's my *feeling*, although I have nothing to go on. I know that he wanted to write a 'Bridge Over Troubled Waters' [sic]."[3] However, John was wrong because Simon & Garfunkel's hit was released at the beginning of 1970. Paul worked on his song during the recording sessions of the *White Album*. Chris Thomas recalled that at the time of the "Piggies" sessions on September 19, 1968, "There were a couple of other songs around at this time, Paul was running through 'Let It Be' between takes."[4]

We can also question John's intentions. During the album's mix he inserted at the beginning of the song, without asking Paul, his parody of *Hark the Angels Come* (see "Dig It") and linked it to *Maggie Mae*, a traditional Liverpool folk song about a prostitute who robbed a sailor.

Production

When the Beatles began the first recording sessions for "Let It Be" on January 25, they had already worked on the song at Twickenham. They began to work on the arrangement of the song. Paul was at the piano and lead vocal, John on six-string bass (sharing backing vocals with George on lead guitar), Ringo on drums, and Billy Preston on Hammond organ and electric piano. They decided to continue the following day. At a later session, on January 31, John asked Paul, "Are we supposed to giggle in the solo?" Paul replied, "Yeah."[5] On April 30, George added a new guitar solo overdubbed through a rotating Leslie speaker on take 27 (the number corresponds to the camera shot). The song was put aside for eight months, and they reworked it on January 4, 1970. Paul replaced John's bass line, since it lacked conviction, and George, Linda, and Paul

Paul provided magnificent vocal lines.

triple-tracked stunning backing vocals. Linda sang a high soprano part. It is possible that Apple recording artist Mary Hopkin also participated. George Martin scored the arrangement for two trumpets, two trombones, and tenor saxophone. After reduction, George added a new guitar solo with distortion (without Leslie), while Ringo added drums and Paul maracas. Cellos, scored again by George Martin, appear at the end of the song. Several members of the group worked together on the final take.

The single was available in stores on March 6, but the guitar solo was recorded on April 30, 1969. Phil Spector remixed "Let It Be" on March 26. He also added huge amounts of tape echo to Ringo's hi-hat in the second verse, extended the song by repeating part of the final chorus, and used the guitar solo of January 4. This was the "album" version.

True or False?
On the information sheet Echo Dernière n° 1 from February 26, 1970 and published by Pathé Marconi, it says that Paul wrote Let It Be for Aretha Franklin to record on her new album.

John and Paul during a recording session at the studio. Besides the Beatles, "Maggie Mae," a traditional Liverpool folk song, also inspired Rod Stewart in 1971.

Maggie Mae

Lennon-McCartney-Harrison-Starkey (arr.) / 0:39

TRADITIONAL FOLK SONG

MUSICIANS
John: vocal, acoustic guitar
Paul: vocal, acoustic guitar
George: lead guitar (?), bass (?)
Ringo: drums

RECORDED
Apple Studios: January 24, 1969

NUMBER OF TAKES: UNKNOWN

MIXING
Olympic Sound Studios: March 4 and 13, 1969
Abbey Road: March 26, 1970 (Room 4)

TECHNICAL TEAM
Producers: George Martin, Phil Spector
Sound Engineers: Glyn Johns, Peter Bown
Assistant Engineers: Neil Richmond, Roger Ferris

Genesis

"Maggie May" was a traditional Liverpool folk song and part of the repertoire of the Quarrymen. The song was originally written around 1757. For years, this story about a prostitute had been the unofficial anthem of the Fab Four's home. In 1964, "Maggie May" inspired Lionel Bart, writer and composer of British pop music and musicals, to adapt the song for a musical based on a libretto by Alun Owen. Alun Owen, a British screenwriter and actor, had coauthored the script for the 1964 Beatles classic film *A Hard Day's Night*. The Beatles had not recorded a cover song since 1965's "Act Naturally." "Maggie May," which they spelled "Maggie Mae," was the last cover of their career.

Production

The Beatles recorded the song on January 24 in tribute to their native city. John and Paul were on acoustic guitars, Ringo on drums, and George played on his Telecaster or his Fender six-string bass, as he did for "Two of Us." "Maggie Mae" was the second-shortest song released on an official Beatles album.

FOR BEATLES FANATICS

"Maggie May" was a big success for Rod Stewart in 1971 on his album *Every Picture Tells a Story*. Other than the title, the song had nothing in common with the traditional Liverpool folk song.

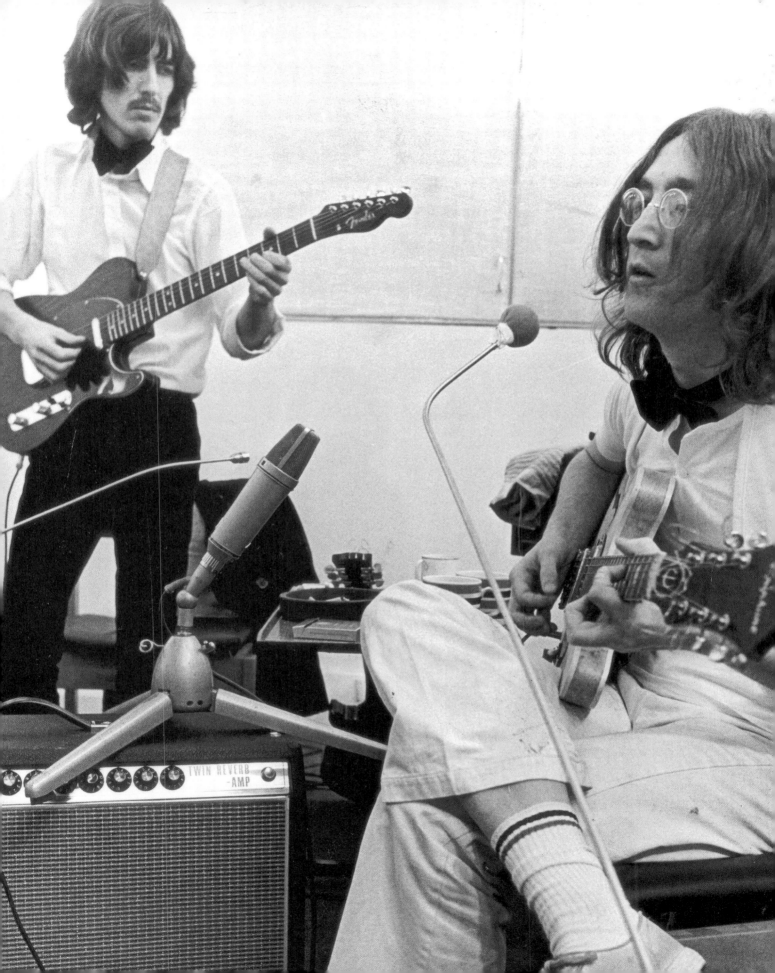

I've Got A Feeling

Lennon-McCartney / 3:35

SONGWRITERS
Paul and John

MUSICIANS
Paul: vocal, bass
John: vocal, rhythm guitar
George: lead guitar, backing vocal
Ringo: drums
Billy Preston: electric piano

RECORDED
Apple Studios: January 22, 24, 27–28, and 30, 1969

NUMBER OF TAKES: UNKNOWN

MIXING
Apple Studios: February 5, 1969
Olympic Sound Studios: March 4, 1969
Abbey Road: March 23, 1970 (Room 4)

TECHNICAL TEAM
Producers: George Martin, Phil Spector
Sound Engineers: Glyn Johns, Peter Bown
Assistant Engineers: Neil Richmond, Alan Parsons, Roger Ferris

Genesis

After "A Day in the Life," "I've Got a Feeling" was the last song John and Paul wrote together. They continued to help each other, but only to complete a phrase or an arrangement. The inspiration for this piece was Paul's. "I've Got a Feeling" was a love song written for Linda Eastman, whom he married on March 12, 1969. John went to Paul's house on Cavendish Avenue, bringing "Everybody Had a Hard Year," an unfinished song at the same tempo as "I've Got a Feeling." Indeed, the two matched perfectly and could be joined together. John also provided the beautiful arpeggio riff that introduces the song. John had just finished a difficult period: there had been dissension within the group, who had rejected Yoko; he had divorced Cynthia; he had been arrested for marijuana possession; Yoko had had a miscarriage . . . He sought to put all this into his lyrics. His pessimistic worldview, even when laced with humor, contrasted with Paul's optimism.

Production

On January 22, the Beatles started recording in their new studio at Apple's headquarters. "I've Got a Feeling" was one of the songs they recorded. On January 24, they recorded the song for release as part of the *Get Back* project. They continued recording three days later on January 27 and 28, during which time the song took on its final form. As with "Dig a Pony," it was the live performance on January 30 that appeared on the album. "I've Got a Feeling" was the third song performed that day on Apple's rooftop. The old live concert energy was back, even though they had stopped touring in August 1966 and had just been through two difficult weeks at Twickenham Film Studios. Paul

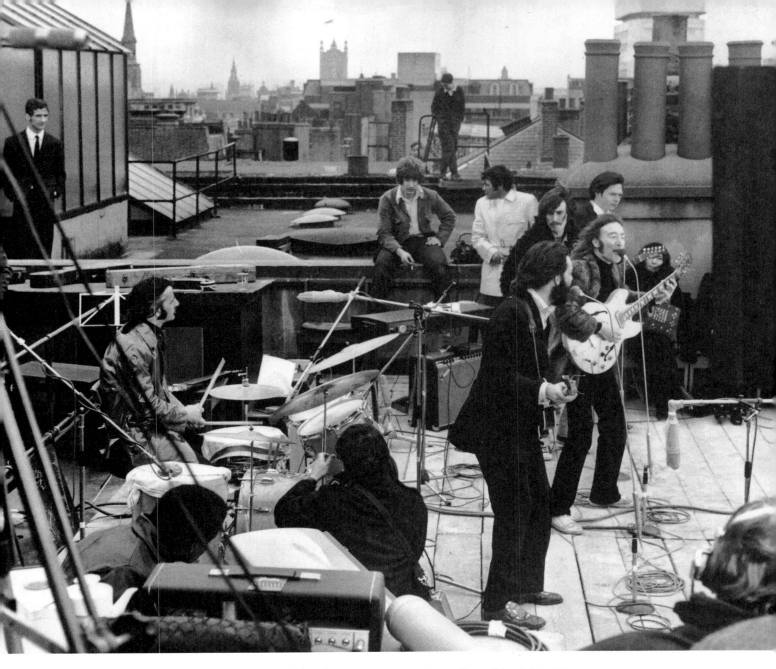

On January 30, 1969, the Beatles performed their last live concert on the rooftop of Apple's building—a unique moment in rock 'n' roll history. The scene was immortalized by Michael Lindsay-Hogg.

and John shared lead vocals, allowing Paul to give an exceptional vocal performance in a traditional rock 'n' roll style. In addition to bass and rhythm guitar, John played an arpeggio riff, the backbone of the song: George was on lead guitar and contributed briefly to the backing vocals. Ringo played his Ludwig, covering the snare and bass drums with towels to absorb hits. Finally, Billy Preston on electric piano brought a touch of soul to the piece. The final stereo mix was made on March 23, 1970.

FOR BEATLES FANATICS

John messed up his guitar riff at 2:41.

One After 909

Lennon-McCartney / 2:51

SONGWRITER
John

MUSICIANS
John: vocal, rhythm guitar
Paul: vocal, bass
George: lead guitar
Ringo: drums
Billy Preston: electric piano

RECORDED
Abbey Road: March 5, 1963 (Studio Two)
Apple Studios: January 28–30, 1969

NUMBER OF TAKES: 1

MIXING
Apple Studios: February 5, 1969
Abbey Road: March 23, 1970 (Room 4)

TECHNICAL TEAM
Producers: George Martin, Phil Spector
Sound Engineers: Norman Smith (1963), Glyn Johns, Peter Bown
Assistant Engineers: Richard Langham (1963), Alan Parsons, Roger Ferris

Genesis

The Beatles performed "One After 909" in 1960 in Liverpool and Hamburg. "That was something I wrote when I was about seventeen,"[1] said John. It was one of his first songs from the earliest days of his collaboration with Paul. Paul said, "It's not a great song but it's a great favorite of mine because it has great memories for me of John and I trying to write a bluesy freight-train song. There were a lot of those songs at the time like 'Midnight Special,' 'Freight Train,' 'Rock Island Line . . .'"[2] In the film *Let It Be*, Paul confessed that he hated the lyrics.

John also referred to the number nine: "It's just a number that follows me around."[3] He attached a lot of significance to it. In 1980, he commented: "I lived at 9 Newcastle Road. I was born on the ninth of October, the ninth [sic] month of the year."[4] Despite John's fascination with numerology, the girl in the song misses train 909 and takes the next one. What would Dr. Freud have thought?

Production

On March 5, 1963, after the recording of the Beatles' third single, "From Me to You" and the B-side "Thank You Girl," the remaining time was devoted to "One After 909," a new Beatles song. They recorded five takes, none of them satisfactory, and decided to set it aside. Six years later, in January 1969, they revived it. Paul said to Barry Miles, "It was a number we didn't used to do much but it was one that we always liked doing, and we rediscovered it."[5]

They reworked "One After 909" on January 28 and 29 without finalizing anything. At the concert on the rooftop of Apple's building, they brilliantly recorded the tune in one take. This was the fifth song in the set list. John sang and played his Epiphone Casino rhythm

John Lennon in Hamburg in 1961, around the time the Beatles played the original version of "One After 909."

guitar. Paul was on vocals and played bass on his Hofner 500/1. George played lead guitar on his Rosewood Telecaster, Ringo played his Ludwig drums, and Billy Preston played the electric piano. The group was full of energy and enjoyed giving a live performance. John concluded by performing a cappella an impromptu line from the Irish ballad "Danny Boy." Phil Spector mixed the song on March 23, 1970, without any additions. "One After 909" had been waiting exactly seven years and seventeen days before being completed.

FOR BEATLES FANATICS

The introduction on the guitar of the March 5, 1963, version is very similar to the one on "Thank You Girl," recorded just before (see *Anthology 1*).

1. Sheff, *The Playboy Interview with John Lennon & Yoko Ono.*
2. Miles, *Paul McCartney.*
3. Sheff, *The Playboy Interview with John Lennon & Yoko Ono.*
4. Ibid.
5. Miles, *Paul McCartney.*

John called in Phil Spector to complete the *Get Back* album and, in particular, "The Long and Winding Road."

The Long And Winding Road

Lennon-McCartney / 3:38

SONGWRITER
Paul

MUSICIANS
Paul: vocal, piano
John: bass
George: lead guitar
Ringo: drums
Billy Preston: electric piano, organ
Orchestra: 18 violins, 4 violas, 4 cellos, 1 harp, 3 trumpets, 3 trombones, 2 acoustic guitars, 14 female vocalists

RECORDED
Apple Studios: January 26 and 31, 1969
Abbey Road: April 1, 1970 (Studios One and Three)

NUMBER OF TAKES: 18

MIXING
Olympic Sound Studios: March 4, 1969
Abbey Road: March 26, 1970 (Room 4) / April 2, 1970 (Room 4)

TECHNICAL TEAM
Producer:s George Martin, Phil Spector
Sound Engineers: Glyn Johns, Peter Bown
Assistant Engineers: Neil Richmond, Alan Parsons, Roger Ferris, Richard Lush

RELEASED AS A SINGLE

"The Long and Winding Road" / "For You Blue"
United States: May 11, 1970 / No. 1 on June 13, 1970, for 2 weeks

Genesis

On September 19, 1968, during sessions for the *White Album*, Paul recorded demo versions of "Let It Be" and "The Long and Winding Road." The songs reflected the dissension and troubled atmosphere within the group. According to Paul, "I was a bit flipped out and tripped out at that time. It's a sad song because it's all about the unattainable; the door you never quite reach. This is the road that you never get to the end of."[1] Paul wrote the song with Ray Charles's voice in mind. "[Charles] would have probably had some bearing on the chord structure of ["The Long and Winding Road"], which is slightly jazzy."[2] Ray Charles later confessed that he had cried when he heard the song for the first time. He subsequently recorded his own version.

Unfortunately, the "long and winding road" lived up to its name, because it precipitated the end of the group. John called in Phil Spector, creator of the Wall of Sound, to finish the album in March 1970 and gave him the unfinished tapes from the *Get Back* project. In his remix, the original arrangements were accompanied by lavish orchestrations and other sound effects for several titles, including Paul's "Long and Winding Road."

Paul complained bitterly in mid-April in the columns of the *Evening Standard:* "The album was finished a year ago, but a few months ago American record producer Phil Spector was called in by Lennon to tidy up some of the tracks. But a few weeks ago, I was sent a re-mixed version of my song 'The Long and Winding Road,' with harps, horns, an orchestra

1. Miles, *Paul McCartney.*
2. Ibid.
3. Ibid.
4. Sheff, *The Playboy Interview with John Lennon & Yoko Ono.*
5. Lewisohn, *The Complete Beatles Recording Sessions.*

April Fool?
When Ringo recorded his drum part on April 1, 1970, he was the last Beatle to attend a recording session. The day marks the final recording ever made by a Fab Four member for one of the group's songs. Unfortunately, it was not an April Fool's Day joke.

and women's choir added. No one had asked me what I thought. I couldn't believe it. I would never have female voices on a Beatles record. The record came with a note from Allen Klein saying he thought the changes were necessary."[3] Despite Paul's protests, *Let It Be* was released with all the changes in Paul's compositions still in place. Paul then decided to leave the Beatles. In an interview released with Paul's first solo album, *McCartney*, Peter Brown asked if the duo Lennon-McCartney would continue to write more songs in the future. Paul unequivocally answered no. In 1980, John said, "Paul had a little spurt just before we split. I think the shock of Yoko Ono and what was happening gave him a creative spurt including 'Let It Be' and 'Long and Winding Road,' 'cause that was the last gasp from him."[4]

Production

On January 26, after a long series of rehearsals, the Beatles began recording "The Long and Winding Road" at Twickenham. Paul was on vocals and piano, John on his Fender six-string bass, George on guitar fed through a Leslie speaker, Ringo on drums, and Billy Preston on electric piano and organ. Recording resumed on January 31 with more takes. It was only fourteen months later that the song was completed with take 18. Phil Spector expanded the song with orchestra and female vocalists. The orchestra was scored and conducted by Richard Hewson, and the choral arrangements were completed by John Barham. Ringo added more drums. Brian Gibson, technical engineer, remembers, "He [Spector] wiped one of Paul's two vocal tracks in order to put the orchestra on."[5] The mix was made the next day.

The result was clearly not in the best taste. The female vocals and harp betrayed the musical aesthetics previously established by the group and George Martin. Spector tried to make the song into another Wall of Sound production. The song lacked the more subtle arrangements heard on other Beatles recordings. Additionally George's guitar and Preston's keyboard all but disappeared in the mix.

Technical Details

John was violently criticized for his bass performance. Ian McDonald even accused John of sabotage, noting many errors, wrong notes, bad guitar slides, etc. All this was exaggerated. John certainly committed some blunders, but he was not a bass player. The combination of a relatively rich harmony and a slow tempo made the bass accompaniment quite difficult to play. Even Paul, the perfectionist, chose to leave the bass part alone. Spector could have lowered the bass track in the mix—the Beatles were recording on an eight-track tape recorder at the time—to hide the errors instead of adding heavy orchestral parts.

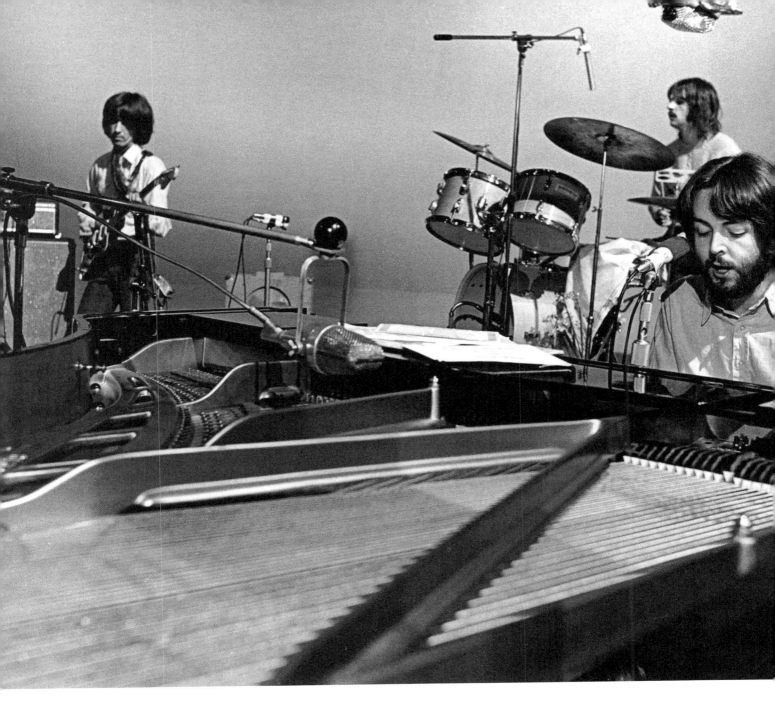

For You Blue

George Harrison / 2:30

MUSICIANS
George: vocal, acoustic guitar
John: lap steel guitar
Paul: piano, bass
Ringo: drums

RECORDED
Apple Studios: January 25, 1969
Olympic Sound Studios: January 8, 1970

NUMBER OF TAKES: 6

MIXING
Olympic Sound Studios: March 4, 1969 / January 8, 1970
Abbey Road: February 28, 1970 (Room 4) / March 25 and 30, 1970 (Room 4)

TECHNICAL TEAM
Producers: George Martin, Malcolm Davies, Phil Spector
Sound Engineers: Glyn Johns, Peter Bown, Mike Sheady, Eddie Klein
Assistant Engineers: Alan Parsons, Richard Langham, Roger Ferris

RELEASED AS A SINGLE

"The Long and Winding Road" / "For You Blue"
United States: May 11, 1970 / No. 1 on June 13, 1970 for 2 weeks

Genesis

In George's autobiography, *I, Me, Mine*, he said that "'For You Blue' is a simple twelve-bar song following all the normal twelve-bar principles except it's happy-go-lucky!"[1] George Harrison wrote this blues song for his wife Pattie. However, according to an interview in *Creem* magazine in 1987, the song did not make much of an impression on him. "I don't even remember that song. No, wait a minute—'For You Blue' was Paul, Paul was on that."[2]

Without being a major song, "For You Blue" was a playful piece, and the Beatles enjoyed playing it. During John's solo, George encouraged Lennon with a few allusions to Chuck Berry—saying "Go, Johnny, go!"—and to Elmore James, the Mississippi Blues guitarist, with the words *Elmore James got nothin' on this baby.* The song was the B-side of the U.S. single "The Long and Winding Road," released on May 11, 1970, and the eleventh track on the Beatles' final LP, *Let It Be*.

Production

The Fab Four recorded this song on January 25, 1969, under the title "George's Blues (Because You're Sweet and Lovely)." The sixth take of the rhythm track was final. George was on vocals and the Gibson J-200 acoustic guitar, Paul on acoustic piano, Ringo on drums, and John on a Hofner Hawaiian Standard lap-steel guitar. This is the only time John was recorded using this guitar. This guitar's shape allows the performer to play slide with the instrument on his knees to get a typical blues sound. This explains George's reference to Elmore James, although James played a normal guitar. Paul added more bass, barely audible in the

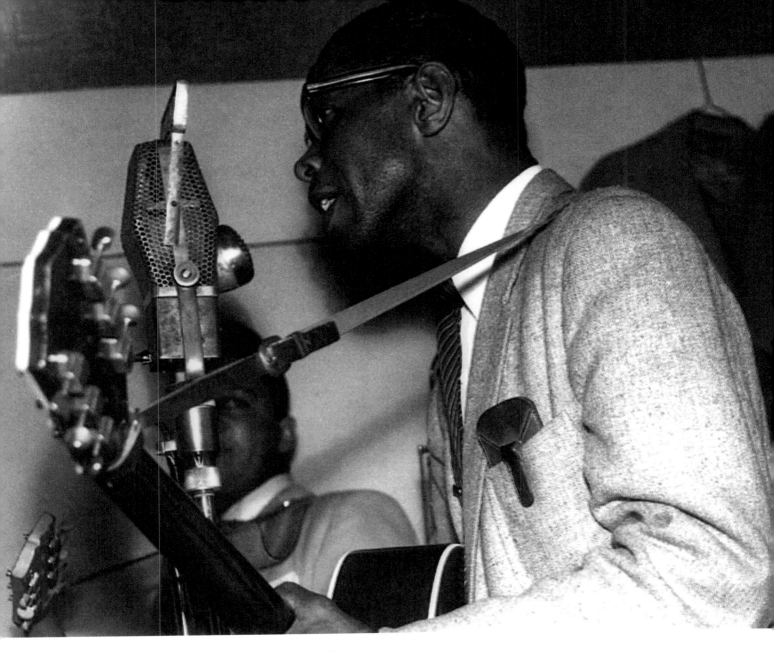

Elmore James, quoted in "For You Blue" by George Harrison.

mix, however. George confirmed in 1987 that Paul had played bass in this piece. George rerecorded his vocal on January 8, 1970. Phil Spector made the final mix on March 25, adding a slight delay to the vocal and the piano. On March 30, 1970, he added a curious introduction by John, extracted from the Twickenham film sessions: *Queen says no to pot-smoking FBI members.*

1. Harrison, *I Me Mine.*
2. Kordosh, "George Harrison: His Secret Beatle Past."

FOR BEATLES FANATICS

John played lap-steel guitar in the film *Let It Be.* Some thought he used a shotgun shell as a bottleneck, others a lighter. However, it was probably just the Hofner slide bottleneck sold with the guitar of the same name.

Billy Preston, an extraordinary keyboard player, made an immense contribution to "Get Back" and the *Let It Be* recording sessions.

Get Back

Lennon-McCartney / 3:10 (single version) / 3:07 (album version)

SONGWRITER
Paul

MUSICIANS
Paul: vocal, bass
John: lead guitar, backing vocal
George: rhythm guitar
Ringo: drums
Billy Preston: electric piano

RECORDED
Apple Studios: January 23, 27–28, and 30, 1969
Abbey Road: April 1, 1970 (Studios One and Three)

NUMBER OF TAKES: 10 (UNCERTAIN)

MIXING
Apple Studios: February 5, 1969
Olympic Sound Studios: March 4, 1969 / April 4 and 7, 1969
Abbey Road: March 26, 1969 (Studio unknown) / March 26, 1970 (Studio 4)

TECHNICAL TEAM
Producers: George Martin, Phil Spector
Sound Engineers: Glyn Johns, Jeff Jarratt, Peter Bown
Assistant Engineers: Alan Parsons, Jerry Boys, Roger Ferris

RELEASED AS A SINGLE

"Get Back" / "Don't Let Me Down"
Great Britain: April 11, 1969 / No. 1 on April 23, 1969, for 6 weeks
United States: May 5, 1969 / No. 1 on May 24, 1969, for 5 weeks

1. Miles, *Paul McCartney.*
2. Ibid.
3. Ibid.
4. Ibid.
5. Wenner, *Lennon Remembers.*

Genesis

Paul composed this song at Twickenham Studios. "Paul had a rough idea for the words and music and began jamming it out. John joined him and together they worked on some lyrics."[1] As with many of their titles, they took inspiration from newspaper stories. Great Britain was experiencing racial unrest at the time. The British Parliament tightened controls on immigration in 1968 in reaction to the waves of Kenyan immigrants. At the same time, many Pakistani immigrants were attacked by extreme right-wing groups. Paul and John did not hesitate to caricature immigration in their first drafts of the lyrics: *Don't dig no Pakistani taking all the people's jobs!*[2] They dropped the line early on, realizing that their antiracist message could be misconstrued. This did not, however, prevent accusations of racism from being leveled against them years later, when some journalists from the *Sun* rediscovered the first version and accused them of xenophobia. Paul: "If there was any group that was not racist, it was the Beatles."[3]

The Beatles did not want to be misrepresented, and the lyrics became lighter, with no real story, but rather a succession of images centering on the subject "Get back." The song featured fictional characters Loretta, who was actually a man, and Jo Jo, with whom many identified. Paul said, "Many people have since claimed to be the Jo Jo and they're not, let me put that straight! I had no particular person in mind, again it was a fictional character, half man, half woman, all very ambiguous."[4] Jo Jo Laine, wife of Dennis Laine, Paul's future partner in Wings, said she, a Beatles groupie at the time, influenced Paul. John loved this song, but he was convinced that Paul looked at Yoko while singing *Get back to where you once belonged.* No comment.

FOR BEATLES FANATICS

Paul's reference to Tucson in "Get Back" is perhaps a nod to his future wife, Linda Eastman, who had studied photography there. She was also cremated in Tucson in April 1998. Finally, Eric Clapton married Pattie Boyd, George Harrison's ex-wife, in Tucson.

During the rooftop concert on the Apple building on January 30, 1969, the Beatles gave a splendid performance, despite the cold, showing once again what good musicians they were.

Production

The first day devoted to "Get Back," January 23, also marked the debut of Alan Parsons as assistant engineer. He later engineered Pink Floyd's "Dark Side of the Moon" in 1973 and became founder of the Alan Parsons Project, which achieved international success in the 1970s. About ten takes were recorded. Besides words, the major difference between the version of the twenty-third and the final version was Ringo's drumming. On January 27, after many takes, they finally reached the final version. The following day the Beatles, still backed by the excellent Billy Preston on electric piano, found the song's groove and recorded the final version of "Get Back." Paul handled the vocals and played his 1963 Hofner bass, with John supporting on his Epiphone Casino, George on his rosewood Telecaster, and Ringo on his new Ludwig drums. John and Preston sang backing vocals wonderfully. John thanked Paul for having the kindness to

give him a solo. "Yes, I played the solo on ['Get Back']. When Paul was feeling kindly, he would give me a solo! Maybe if he was feeling guilty that he had most of the A-side or something, he would give me a solo. And I played the solo on that."[5]

On January 30, the day of the concert on the rooftop, "Get Back" was both the introduction and the conclusion to the forty-two-minute performance. But these versions were not included on the master. On the album, Phil Spector only kept from the rooftop performance Paul's acknowledgment of the fervent applause and cheering from Ringo's wife Maureen with "Thanks Mo!" and John's quote, "I'd like to say thank you on behalf of the group and ourselves, and I hope we've passed the audition." After many attempts, the final mix for the single version was made at the Olympic Sound Studios on April 7. Spector finalized the stereo mix (there was no mono) of the album version on March 26, 1970.

George Martin moved from producing the Beatles to working with the group America in the early 1970s. He produced seven of America's albums starting with *Holiday*. Above, the trio and George Martin in Hawaii in the 1970s.

The Misfortune of Some

The role of George Martin, sandwiched between Glyn Johns and the group, became very uncomfortable, even controversial at the time. The Beatles ignored him to the point that he is not credited on the single. Billy Preston, on the other hand, is the only artist credited on a single along with the Beatles. The Beatles with Billy Preston appears on the label.

1970

You Know My Name

(Side B of "Let It Be")

SINGLE
RELEASED

"Let It Be" / "You Know My Name
(Look Up the Number)"
Great Britain: March 6, 1970 /
No. 2 on March 14, 1970, for 9 weeks
United States: March 6, 1970 /
No. 1 on April 11, 1970, for 2 weeks

You Know My Name (Look Up The Number)

Lennon-McCartney / 4:19

SONGWRITER
John

MUSICIANS
John: vocal, guitar, harmonica, hand claps, other sound effects
Paul: vocal, bass, piano, vibraphone (?), hand claps, other sound effects
George: guitar, vibraphone (?), hand claps, other sound effects
Ringo: drums, bongos, hand claps, other sound effects
Brian Jones: alto saxophone
Mal Evans: other sound effects

RECORDED
Abbey Road: May 17, 1967 (Studio Two) / June 7–8, 1967 (Studio Two) / April 30, 1969 (Studio Three)

NUMBER OF TAKES: 30

MIXING
Abbey Road: June 7 and 9, 1967 (Studio Two) / April 30, 1969 (Studio Three) / November 26, 1969 (Studio Two)

TECHNICAL TEAM
Producers: George Martin, Geoff Emerick, Chris Thomas
Sound Engineers: Geoff Emerick, Jeff Jarratt
Assistant Engineers: Richard Lush, Nick Webb

FOR BEATLES FANATICS

"You Know My Name (Look Up the Number)" was initially destined for the soundtrack of *Yellow Submarine*, but was replaced by "It's All Too Much."

Genesis

John got the idea from a line on the cover of the 1967 London phone book that he found on Paul's piano: "You know the name, look up the number." The two worked together on the song, but left it unfinished for nearly two years. John: "That was a piece of unfinished music that I turned into a comedy record with Paul. I was waiting for him in his house, and I saw the phone book was on the piano with 'You know the name, look up the number.' That was like a logo, and I just changed it. It was going to be a Four Tops kind of song—the chord changes are like that—but it never developed and we made a joke of it."[1] Paul told Mark Lewisohn that it was probably one of his favorite songs. Paul, "It's so insane. All the memories . . . I mean, what would you do if a guy like John Lennon turned up at the studio and said, 'I've got a new song.' I said, 'What's the words?' and he replied, 'You know my name look up the number.' I asked, 'What's the rest of it?' 'No, no other words, those are the words. And I want to do it like a mantra!'"[2]

The Beatles worked on the song after *Sgt. Pepper* and finished it while working on *Abbey Road* in April 1969. It is in four different parts, constructed as a series of sketches. We hear Paul as a crooner, John chanting incomprehensible words, Mal Evans shaking a bag of gravel, and Brian Jones of the Rolling Stones playing an alto saxophone solo!

Because of dissension within the group in 1969, the song was set aside yet again until November 26. Then John decided to edit it with the intention of releasing it as a Plastic Ono Band single with "What's the New Mary Jane," a song rejected from the *White Album*, on the B-side. On November 28, 1969, Apple announced "You Know My Name (Look Up the Number)" as the next Plastic Ono Band single scheduled to be released on December 5. Apparently, John wanted

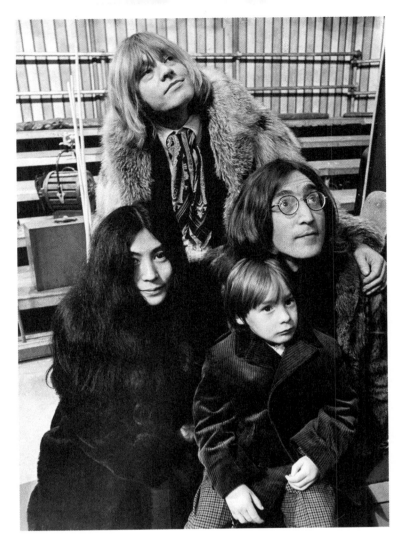

John, Yoko, and Julian, with Brian Jones, founder of the Rolling Stones. Jones played a short saxophone solo piece in "You Know My Name."

to shatter the Beatles' nice image. Finally, the project was abandoned for unknown reasons, and the song was released as the B-side of "Let It Be."

Production

On May 17, 1967 five days after finishing recording "All Together Now" for the *Yellow Submarine* soundtrack, the group began the first session for "You Know My Name." The tenth take was the best, with John and George on guitar, Paul on bass, Ringo on drums and bongos, and all four Beatles providing hand claps. The following session on June 7 was inconclusive, resulting only in a twenty-minute rhythm track marked *Instrumental—Unidentified*. The next day, the song took form with added piano, vibraphone, lead guitar, harmonica, bongos, and various other sound effects, including a whistle (birdsong). The highlight of the session was Brian Jones's performance on alto saxophone. Paul: "He arrived at Abbey Road in his big Afghan coat. . . . I thought it would be a fun idea to have him,

and I naturally thought he'd bring a guitar . . . but to our surprise he brought his saxophone. He opened up his sax case and started putting a reed in and warming up, playing a little bit. He was a really ropey sax player, so I thought, Ah-hah. We've got just the tune."[3] The first mixing and editing session took place on June 9. The duration of the song was 6:08 at this stage. John and Paul overdubbed their vocals on April 30, 1969, but neither Ringo nor George were present. The ever-faithful Mal Evans was charged with running a spade through a heap of gravel while John and Paul added vocal effects, strange noises, and hand claps. The song was mixed into a single mono version on the same day and was reduced to 4:19 on November 26.

1. Sheff, *The Playboy Interview with John Lennon & Yoko Ono.*
2. Miles, *Paul McCartney.*
3. Ibid.

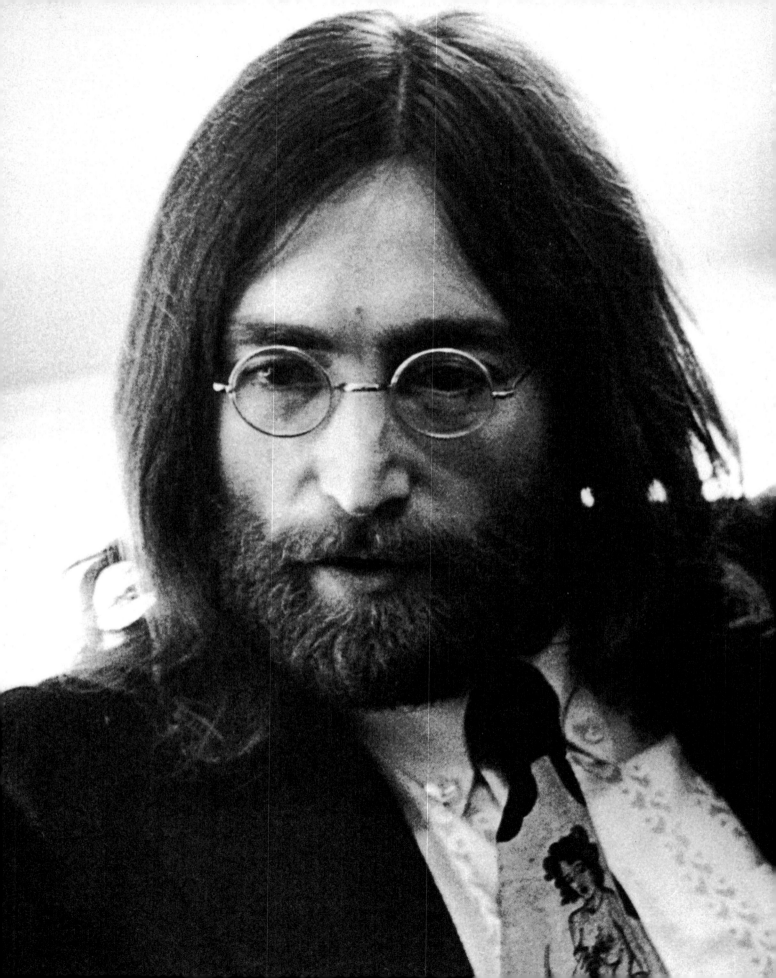

GLOSSARY

Acetate: similar to a vinyl record. Made from an aluminum disc coated with nitrocellulose, a single copy is made, which allows an artist to listen to his recorded work. Fragile, it could only be played a limited number of times.

Artificial double tracking (ADT): an electronic simulation system that doubles an artificial instrument or voice. This effect was designed by Ken Townsend, a member of the technical team at Abbey Road Studios.

Bottleneck: a piece of glass (or metal) that the guitar player places on his finger and slides on the strings in order to obtain a metallic sound. The name comes from the pioneers of the blues, who used a the neck of a bottle. Most often, the bottleneck is used in open tuning when the six strings of the instrument form a chord (G or D, for example).

Break: an instrumental interlude, which interrupts the development of a piece.

Bridge: a distinct musical passage between two parts of a song. A bridge usually connects the verse to the chorus.

Coda: an Italian term that refers to an added passage that concludes a song. Its length varies depending on the piece.

Compressor: an electronic circuit used to amplify the low sounds or, conversely, to reduce the volume of high sounds during a recording session.

Cover: a new performance or recording of a previously released song, often with a different arrangement from the original version.

Cowbell: a percussion instrument that we can hear both in popular music, rhythm & blues, classical music (Gustav Mahler, Richard Strauss) and avant-garde (Karlheinz Stockhausen, Olivier Messiaen). The Beatles used the sound of the cowbell on several of their songs, including "A Hard Day's Night," "Drive My Car," "I Need You," and "Everybody's Got Something to Hide Except Me and My Monkey."

Direct injection box (DI box): an electronic device, which lets the player connect an instrument directly to a mixing console without using an amplifier or a microphone.

Doubling: a second recording of the same vocal or instrument used to produce a "stronger" or "bigger" sound. The performer usually sings or plays while listening to his own prerecorded performance.

Dubbing, Postsynchronization: the addition of a vocal, sound effect, or instrumental recording added to an existing soundtrack. Adding a voiceover to a film is an example of dubbing.

Fade-in: the process of gradually increasing the sound (usually at the beginning of a song).

Fade-out: the process of gradually lowering the sound (usually at the end of a song).

Feedback: the return of an original sound to its source. This creates a loop. The level of feedback determines the level of noise. See Larsen.

Flanging: a sound effect produced by mixing two identical signals together, with one signal slightly delayed by a few milliseconds.

Fuzz: a distorted sound effect obtained by compressing the sound signal, in particular with a device called a distortion pedal (fuzzbox). The Beatles were the pioneers of the fuzzbox, along with the Rolling Stones ("[I Can't Get No] Satisfaction") and Jimi Hendrix ("Purple Haze"). Guitarists usually use this effect.

Gimmick: a musical phrase or sound effect designed to attract the attention of the listener. Musical gimmicks can be found in all types of music.

Groove: the "feel" of the rhythm or atmosphere of a song.

Honky-tonk: a style of music often found in the South that derives from the country and western music tradition. The music is based primarily on the piano, inspired by boogie-woogie and ragtime. Examples in popular music include the boogie-woogie pianist Meade Lux Lexis's recording of "Honky Tonk Train Blues" in 1927, Hank Williams's "Honky Tonk Blues," and, of course, the Rolling Stones' "Honky Tonk Woman."

Larsen: a physical phenomenon that occurs when the amplified output (speakers of an amplifier, for example) is too close to the audio input (such as the microphone of an electric guitar or a singer). A hissing or buzzing sound is produced. The effect was regularly used in the 1960s by rock guitarists. The best example is found in the guitar introduction of the song "I Feel Fine" by the Beatles, often cited as the first Larsen effect on record.

Lead: the term for the primary vocal or instrument in a song (lead vocal and lead guitar, for example).

Leslie speaker: a cabinet with a rotary speaker inside, typically associated with Hammond organs. The speed of spinning is adjusted to create the desired effect. The Beatles used the effect to enhance vocals and guitar sounds.

Middle eight: another name for the bridge. Even when a bridge was not

eight bars, the Beatles would often refer to it as the "middle eight."

Mute: a technique to turn off the sound on a channel strip. Alternatively, the term is used to mean deadening a string on a guitar.

Overdub: see Rerecording and Superimposition.

Pattern: a sequence that often repeats (it might be repeated indefinitely to create a "loop").

Peak: the maximum level reached by a sound or note, sometimes exceeding the level permitted by the mixer or other audio equipment.

Pedal: a small electronic device that lets the performer add an effect to the sound of an instrument. Musicians control the pedal with their foot. Several types of pedals were used by the Beatles, including volume pedals and fuzzboxes.

Playback: pressing "play" on a tape recorder so that the artist may hear a previous recording. A recording may be "played back" while the performer(s) overdub additional parts.

Power chord: a term typically used by guitarists, the "power chord" is a chord that consists of two notes, the root note and the fifth interval. It is highly effective in rock music, often accompanied by distortion.

Premix: an early mix of a song or a step in the recording process, which is created by mixing several tracks from a multitrack tape recorder to get a glimpse of the combined work. The "Premix" is also used in the process called "reduction" (see Reduction).

Reduction mix: a technique used with multitrack tape recorders. The technique

involves mixing together the tracks from one tape and recording them on fewer tracks of a second tape. The second tape can then be used to overdub additional parts.

Rerecording: a technique that allows one to record one or more tracks while simultaneously listening to previously recorded tracks.

Reverb: reverberation, or reverb, is created when a sound is produced in an enclosed space, creating echoes that decay over time. This effect can be recorded (for example, in an echo chamber) or simulated with studio effects.

Riff: abbreviation for rhythmic figure, is a short motif (or ostinato), a succession of notes or chords that appear repeatedly in a complete song. Some famous riffs are the guitar patterns in "Day Tripper" by the Beatles, "You Really Got Me" by the Kinks, and "(I Can't Get No) Satisfaction" by the Rolling Stones.

Rimshot: the sound produce by hitting the rim and the skin of the snare drum with drum sticks. This result is a sharp attack.

Roots: a musical term referring to the origins of popular music, from blues to Appalachian music.

Score: the written music for a musical song or arrangement.

Scratch vocal: a temporary vocal that is meant to be replaced by a final vocal.

Ska: a style of music that originated in Jamaica and is the precursor to reggae.

Skiffle: a musical style heavily influenced by blues and folk. In England, it had its heyday in the late

1950s with musicians such as Lonnie Donegan. The Quarrymen, the group formed by John Lennon, were initially a skiffle group.

Slap-back echo (echo or slapback): a short repeat or echo used by the pioneers of rock 'n' roll, such as Elvis Presley, Gene Vincent, and Buddy Holly. John Lennon used this audio effect on many records during his solo career.

STEED (single tape echo / echo delay): a form of echo unique to EMI Studios. It was created by sending a sound signal into the studio's echo chamber via the BTR2 tape recorder.

Superimposition: an EMI-specific term to describe a process by which new synchronized sounds are recorded alongside previous recordings. The more common term is "overdubbing." (See also Rerecording and Overdub.)

Track list: the list of songs on an album.

Varispeed: the process of changing the tape playback speed using an oscillator.

Violoning: an effect obtained by moving the potentiometers of a guitar or a volume pedal after a note or chord has been played. For example, a note may be played with the volume at zero, and a volume pedal is used to gradually increase the volume.

Walking bass: a style of bass accompaniment (or left hand at the piano) that consists of playing a new note on every beat of the music. This was a typical style of boogie-woogie pianists in the honky-tonks in the Deep South in the early years of the twentieth century.

INDEX OF ALBUMS AND SONGS

W

Y

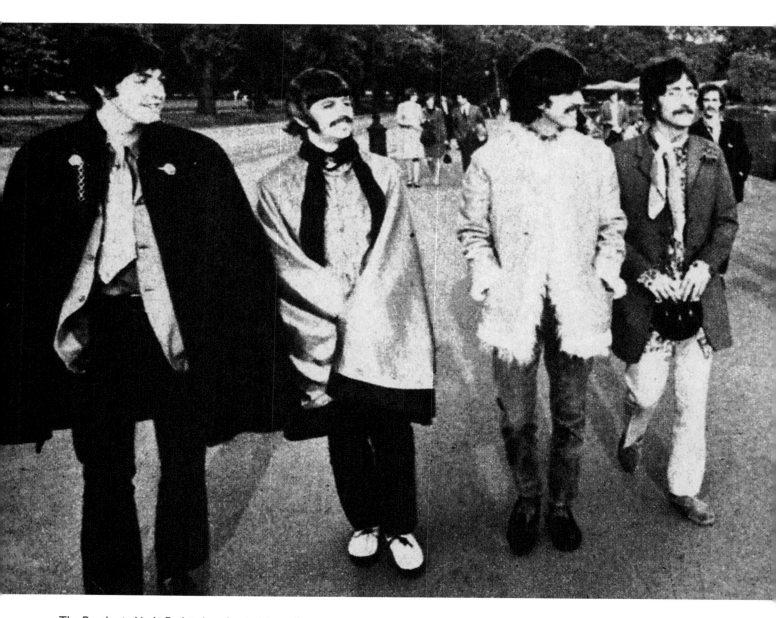

The Beatles in Hyde Park in London in May 1967

THE BEATLES LP RELEASE DATES

1. *Please Please Me* U.K. March 22, 1963
2. *With the Beatles* U.K. November 22, 1963
3. *Introducing The Beatles* U.S. January 10, 1964
4. *Meet The Beatles!* U.S. January 20, 1964
5. *The Beatles* Second Album U.S. April 10, 1964
6. *A Hard Day's Night* U.K. July 10, 1964/ U.S. June 26, 1964
7. *Something New* U.S. July 20, 1964
8. *The Beatles' Story* U.S. November 23, 1964
9. *Beatles for Sale* U.K. December 4, 1964
10. *Beatles '65* U.S. December 15, 1964
11. *The Early Beatle* U.S. March 22, 1965
12. *Beatles VI* U.S. June 14, 1965
13. *Help!* U.K. August 6, 1965/ U.S. August 13, 1965
14. *Rubber Soul* U.K. December 3, 1965/ U.S. December 6, 1965
15. *Yesterday... and Today* U.S. June 20, 1966
16. *Revolver* U.K August 5, 1966/ U.S. August 8, 1966
17. *A Collection of Beatles* Oldies U.K. December 9, 1966
18. *Sgt. Pepper's Lonely Hearts Club Band* U.K. June 1, 1967/ U.S. June 2, 1967
19. *Magical Mystery Tour* U.S. November 27, 1967/ U.K. November 19, 1976
20. *The Beatles* (The White Album) U.K. November 22, 1968/ U.S. November 25, 1968
21. *Yellow Submarine* U.K. January 17, 1969/ U.S. January 13, 1969
22. *Abbey Road* U.K. September 26, 1969/ U.S. October 1, 1969
23. Hey Jude U.S. February 26, 1970
24. Let It Be U.K. May 8, 1970/ U.S. May 18, 1970

THE BEATLES EP RELEASE DATES

1. *Twist and Shout* U.K. July 12, 1963
2. *The Beatles* U.S. March 23, 1964
3. *The Beatles' Hits* U.K. September 6, 1963
4. *The Beatles No. 1* U.K. November 1, 1963
5. *All My Loving* U.K February 7, 1964
6. *Four by The Beatles* U.S. May 11, 1964
7. *Long Tall Sally* June 19, 1964
8. *Extracts from the Film A Hard Day's Night* U.K. November 4, 1964
9. *Extracts from the Album A Hard Day's Night* U.K. November 6, 1964
10. *By the Beatles* U.S. February 1, 1965
11. *Beatles for Sale* U.K. April 6, 1965
12. *Beatles for Sale No. 2* U.K. June 4, 1965
13. *The Beatles' Million Sellers* U.K. December 6, 1965
14. *Yesterday* U.K. March 4, 1966
15. *Nowhere Man* U.K. July 8, 1966
16. *Magical Mystery Tour* U.K. December 8, 1967

THE BEATLES SINGLE RELEASE DATES

1. "My Bonnie / The Saints" U.K. January 5, 1962/ U.S. April 23, 1962
2. "Love Me Do / P.S. I Love You" U.K. October 5, 1962/ U.S. April 27, 1964
3. "Please Please Me / Ask Me Why" U.K. January 11, 1963/ U.S. February 25, 1963
4. "From Me to You / Thank You Girl" U.K. April 11, 1963/ U.S. May 27, 1963
5. "She Loves You / I'll Get You" U.K. August 23, 1963/ U.S. September 16, 1963
6. "I Want to Hold Your Hand / This Boy" U.K. November 29, 1963
7. "I Want to Hold Your Hand/ I Saw Her Standing There" U.S. December 26, 1963
8. "Please Please Me / From Me to You" U.S. January 3, 1964
9. "Twist and Shout / There's a Place" U.S. March 2, 1964
10. "Can't Buy Me Love / You Can't Do That" U.K. March 20, 1964/ U.S. March 16, 1964
11. "Do You Want to Know a Secret? / Thank You Girl" U.S. March 23, 1964
12. "Sie Liebt Dich / I'll Get You" U.S. May 21, 1964
13. "Sweet Georgia Brown / Take Out Some Insurance on Me Baby" U.S. June 1, 1964
14. "Ain't She Sweet / Nobody's Child" U.S. July 4, 1964
15. "A Hard Day's Night / Things We Said Today" U.K. J uly 10, 1964
16. "A Hard Day's Night / I Should Have Known Better" U.S. July 13, 1964
17. "I'll Cry Instead / I'm Happy Just to Dance With You" U.S. July 20, 1964
18. "And I Love Her / If I Fell" U.S. July 20, 1964
19. "Matchbox / Slow Down" U.S. August 24, 1964
20. "I Feel Fine / She's a Woman" U.K. November 27, 1964/ U.S. November 23, 1964
21. "Eight Days a Week / I Don't Want to Spoil the Party" U.S. February 15, 1965
22. "Ticket to Ride / Yes It Is" U.K. April 9, 1965/ U.S. April 19, 1965
23. "Help! / I'm Down" U.K. July 23, 1965/ U.S. July 19, 1965
24. "Yesterday / Act Naturally" U.S. September 13, 1965
25. "Day Tripper/ We Can Work It Out" U.K. December 3, 1965/ U.S. December 6, 1965
26. "Nowhere Man / What Goes On" U.S. February 21, 1966
27. "Paperback Writer / Rain" U.K. June 10, 1966/ U.S. May 30, 1966
28. "Yellow Submarine / Eleanor Rigby" U.K. August 5, 1966/ U.S. August 8, 1966
29. "Penny Lane/ Strawberry Fields Forever" U.K. February 17, 1967/ U.S. February 13, 1967
30. "All You Need Is Love / Baby You're a Rich Man" U.K. July 7, 1967/ U.S. July 17, 1967
31. "Hello Goodbye / I Am the Walrus" U.K. November 24, 1967/ U.S. November 27, 1967
32. "Lady Madonna / The Inner Light" U.K. March 15, 1968/ U.S. March 18, 1968
33. "Hey Jude / Revolution" U.K. August 30, 1968/ U.S August 26, 1968
34. "Get Back / Don't Let Me Down" U.K. April 11, 1969/ U.S. May 5, 1969
35. "The Ballad of John and Yoko / Old Brown Shoe" U.K. May 30, 1969/ U.S. June 4, 1969
36. "Come Together/ Something" U.K. October 31, 1969/ U.S. October 6, 1969
37. "Let It Be / You Know My Name" U.K. March 6, 1970/ U.S. March 11, 1970
38. "The Long and Winding Road / For You Blue" U.S. May 11, 1970

INDEX

Roderick, Stanley 366
Rogers, Bobby 108
Rolling Stones, The 28, 61, 201, 345, 406, 416, 525
Rolling Stones Rock and Roll Circus 492
Ronayne, John 410
Rory Storm & the Hurricanes 8, 12, 24, 32
Ross, Lionel 410, 428
Ross, Ronnie 508
Rothstein, Jack 394, 428
Rowe, Dick 37, 82
Roxy Music 226
Royston, Ellis 590, 591
"Ruby Tuesday" 432
"Runaway" 156, 417
Russell, Bert 54
Russell, Johnny 240
Rydell, Bobby 66

"Sad Eyed Lady of the Lowlands" 502
Sahm, Doug 202
Saints, the 10
Sandeman, David 404
Sanders, Neil 380, 404, 428
Saturday Club 104
Sax, Sidney 250, 326, 327, 404, 410, 428
Scherman, Paul 394
Scott, Ernest 404
Scott, Ken 128, 146, 148, 150, 152, 156, 164, 178, 182, 188, 190, 192, 194, 202, 210, 212, 220, 226, 228, 230, 232, 234, 236, 244, 246, 254, 258, 262, 276, 278, 282, 284, 288, 290, 292, 296, 298, 300, 302, 304, 306, 308, 312, 314, 386, 390, 424, 426, 428, 432, 433, 434, 436, 440, 444, 446, 456, 458, 460, 462, 464, 466, 468, 470, 474, 476, 477, 478, 480, 482, 484,

486, 488, 490, 491, 492, 493, 494, 495, 496, 498, 500, 502, 508, 509, 510, 511, 512, 514, 518, 521, 538, 546, 560, 562, 618
Scott, Ronnie 444, 445
Segovia, Andrés 125
Seville, Clifford 404
Shadows, the 10, 22
"Shake It Up Baby" 54
Shakher, Chandra 446
Shambu-Das 446
Shank, Bud 434
Shankar, Ravi 280, 330, 376, 394, 395
Shankar, Ghosh 446
Shannon, Del 156
Shapiro, Helen 26, 27, 60
Sharpe, John 326
Sheady, Mike 460, 466, 468, 470, 474, 478, 486, 490, 500, 502, 622, 638
Shea Stadium 266, 267, 270, 275
Sheff, David 44, 132, 176, 234, 242, 246, 278, 284, 396, 506, 510, 544, 556, 570, 588, 606, 614, 615, 624
Sheffield, Barry 458, 472, 506, 508, 518, 520, 570
Sheridan, Tony 8, 10, 11
Shermar, Shiv Kumar 446
"She's About a Mover" 202
Shingles Stephen 326, 327, 390
Shirelles, The 32
Shotton, Pete 228, 278, 302, 344, 428, 474, 496, 618
Siddle, Dave 538
Silhouettes 164
Silver, Charles 35, 532
Simpson, Derek 326, 366
Sinatra, Frank 8, 44, 458, 562
Siouxsie and the Banshees 459
Skinner, John 334, 335
Small Faces, The 610

Smith, David 506
Smith, John 456, 458, 460, 462, 464, 466, 468, 470, 474, 476, 477, 478, 480, 482, 484, 486, 488, 490, 492, 494, 495, 496, 498, 500, 502, 508, 510, 512, 514, 518
Smith, Norman 14, 18, 20, 24, 26, 27, 28, 30, 32, 33, 34, 36, 37, 40, 44, 46, 48, 50, 52, 54, 56, 60, 62, 63, 66, 69, 70, 74, 77, 78, 88, 90, 92, 96, 98, 100, 102, 104, 106, 108, 110, 111, 114, 115, 116, 118
Smokey Robinson & The Miracles 34, 35, 78, 302
Sofier, Lou 472
"Soldier Boy" 44
"Somewhere" 52
Spain, Harry 410
Spector, Phil 54, 289, 606, 610, 613, 614, 615, 616, 617, 618, 619, 620, 621, 622, 624, 627, 628, 630, 632, 633, 634, 636, 638, 640
Spellman, Benny 110
Spooky Tooth 431
"Stairway to Heaven" 432
Star Club 8, 401
"Stay as Sweet as You Are" 466
Stereos, The 48
Stewart, Rod 628
St John's Wood 14, 202, 550
Stoller, Mike 180, 181
Stone, Mike 164, 168, 170, 172, 176, 178, 182, 186, 190, 192, 194, 196, 200, 202, 302
"Street Rats" 361
Strong, Barret 114
Superman III 104
Sutcliffe, Stuart 8, 150, 170, 302, 378
Swan Records 66
Swinfield, Ray 370

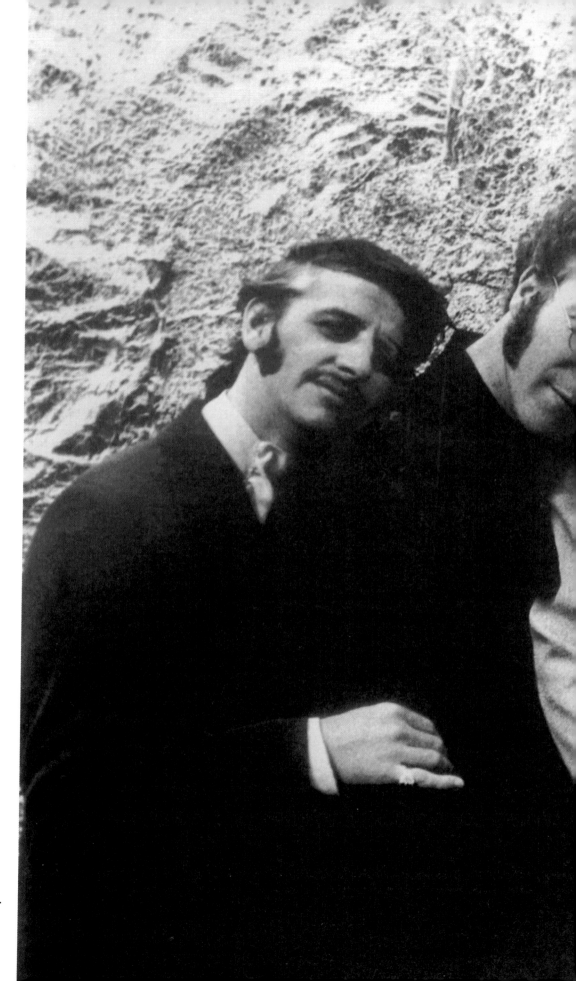

Portrait of the group in 1968.

PHOTOGRAPHY CREDITS

BIBLIOGRAPHY

Ali, Tariq. *Street-Fighting Years: An Autobiography of the Sixties.* London and Brooklyn, NY: Verso, 2005.

Babiuk, Andy. *Beatles Gear: All the Fab Four's Instruments from Stage to Studio.* London: Backbeat Books, 2001.

Boyd, Pattie, and Penny Junor. *Wonderful Tonight: George Harrison, Eric Clapton, and Me.* New York: Three Rivers Press, 2007.

Brown, Peter, and Steve Gaines. *The Love You Make.* New York: McGraw-Hill Book Company, 1983.

Clapton, Eric. *Clapton par Eric Clapton: autobiographie (Clapton: The Autobiography).* Paris: Buchet-Chastel, 2007.

Davies, Hunter. *The Beatles: The Illustrated and Updated Edition of the Bestselling Authorized Biography.* London: Cassell Illustrated, 2004.

Emerick, Geoff. *Here There and Everywhere: My Life Recording the Music of the Beatles.* New York: Gotham Books, 2007.

Epstein, Brian. *A Cellarfull of Noise.* London: Souvenir Press, 1964.

Giuliano, Geoffrey, and Denny Laine. *Blackbird: The Unauthorized Biography of Paul McCartney.* London: Smith Gryphon Limited, 1991.

Harrison, George. *I Me Mine.* New York: Simon & Schuster, 1980.

Lennon, Cynthia. *John.* New York: Three Rivers Press, 2005.

Lennon, Julian. *Beatles Forever: La collection de Julian Lennon.* Paris: Hors Collection, 2010.

Lewisohn, Mark. *The Complete Beatles Recording Sessions.* London: The Hamlyn Publishing Group/EMI, 1988.

Mansfield, Ken. *The Beatles, the Bible, and Bodega Bay: My Long and Winding Road.* Nashville: Broadman & Holman Publishers, 2000.

Martin, George. *Playback: An Illustrated Memoir.* Guildford (Surrey): Genesis Publications, 2002.

Martin, George, and Jeremy Hornsby. *All You Need Is Ears.* New York: St. Martin's Press, 1979.

Mason, Nick. *Inside Out: A Personal History of Pink Floyd.* San Francisco: Chronicle Books, 2005.

Miles, Barry. *Paul McCartney: Many Years from Now.* London: Secker & Warburg, 1997.

Oldham, Andrew Loog. *Rolling Stoned.* Paris: Flammarion (Pop Culture Collection), 2006.

Pang, May, and Henry Edwards. *Loving John: The Untold Story.* London: Corgi Books, 1983.

Richards, Keith. *Life.* New York: Little, Brown and Company, 2010.

Ryan, Kevin, and Brian Kehew. *Recording the Beatles.* Houston: Curvebender Publishing, 2006.

Shapiro, Helen. *Walking Back to Happiness.* New York: HarperCollins Publishers, 1993.

Sheff, David. *The Playboy Interview with John Lennon & Yoko Ono: The Final Testament.* New York: Playboy Press, 1981 (Interview, September 1980).

Shotton, Pete, and Nicholas Schaffner. *John Lennon in My Life.* New York: Stein and Day, 1983.

Southall, Brian, and Julian Lennon. *Beatles Forever: la collection Julian Lennon.* Paris: Hors Collection, 2010.

The Beatles Anthology. *Paris and San Francisco: Chronicle Books, 2000.*

Turner, Steve. *A Hard Day's Write: The Stories Behind Every Beatles Song.* New York: HarperCollins, 1994.

Voormann, Klaus. *Warum Spielst Du Imagine Nicht Auf Dem Weissen Klavier, John? (Why Don't You Play "Imagine" on the White Piano, John?: Memories of the Beatles and Many Other Friends).* Munich: Wilhelm Heyne Verlag, 2006.

Wenner, Jann. *Lennon Remembers: The Full Rolling Stone Interviews from 1970.* London and Brooklyn, NY: Verso Publishing, 2000.

White, Timothy. *George Harrison: Reconsidered.* Larchwood & Weir, 2013.

Wigg, David. *The Beatles Tapes from the David Wigg Interviews.* (Polydor, 1976).

Wilson, Brian. *Wouldn't It Be Nice: My Own Story.* New York: HarperCollins, 1991.

Copyright © 2013, Éditions du Chêne/EPA - Hachette Livre

Published by
Black Dog & Leventhal Publishers, Inc.
151 West 19th Street, New York, NY 10011

Distributed by
Workman Publishing Company
225 Varick Street, New York, NY 10014

Manufactured in China

ISBN:978-1-57912-952-1
h g f e d c b a
Library of Congress Cataloging-in-Publication data on file.